D0104948

Wisdom With
Understanding
is Better
Than Rubies

Lurine Karon Greenberg
Fine Arts Collection

THE
TREASURES
OF ANCIENT
GREECE

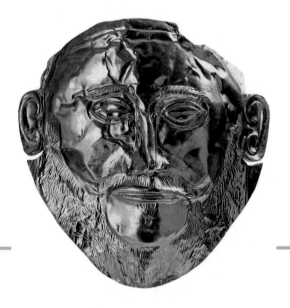

THE *RIZZOLI* ART GUIDES
NEW YORK

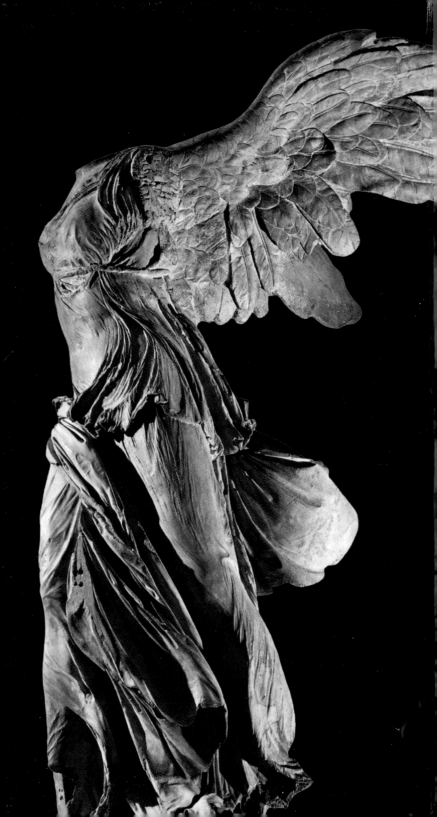

Contributors

TEXTS
Stefano Maggi
Cristina Troso

EDITORIAL PROJECT
Valeria Manferto De Fabianis
Laura Accomazzo
Enrico Lavagno

GRAPHIC DESIGNER
Patrizia Balocco Lovisetti
Paola Piacco

TRANSLATION
Timothy Stroud

ENGLISH VERSION REVISED BY
Rizzoli International Publications, New York

The initials at the end of each
text refer to its author.

First published in the United States of America in 2004 by
Rizzoli International Publications, Inc.
300 Park Avenue South, New York, NY 10010

© 2004 White Star S.r.l.
Via Candido Sassone 22/24, 13100 Vercelli, Italy

This edition published by arrangement with
White Star S.r.l., Vercelli, Italy

ISBN 0-8478-2615-5
Library of Congress Control Number: 2003116821

Printed in Italy by Grafiche Industriali, Foligno (PG)
Color separation by Fotomec, Turin, Italy.

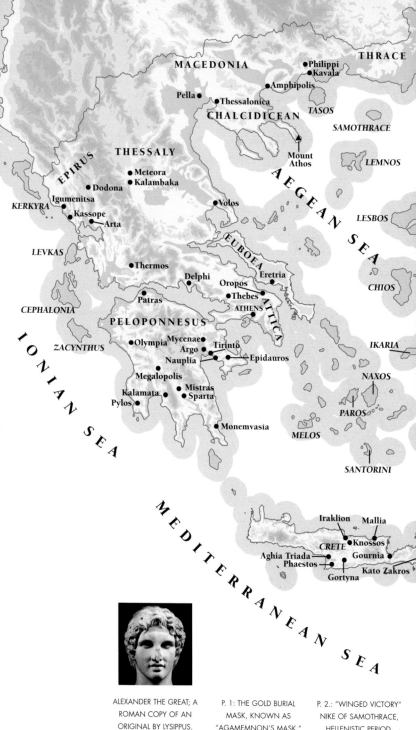

THRACE

MACEDONIA

Philippi
Kavala

Amphipolis

Pella

Thessalonica

TASOS

CHALCIDICEAN

SAMOTHRACE

Mount
Athos

THESSALY

Meteora
Kalambaka

LEMNOS

EPIRUS

Dodona

Igumenitsa

KERKYRA

Kassope

Arta

Volos

AEGEAN SEA

LESBOS

LEVKAS

EUBOEA

Thermos

Delphi

Oropos

Eretria

CHIOS

Patras

Thebes

ATTICA

ATHENS

CEPHALONIA

PELOPONNESUS

Olympia

Mycenae

Argo

Tirinto

IKARIA

ZACYNTHUS

Nauplia

Epidauros

IONIAN SEA

Megalopolis

NAXOS

Kalamata

Mistras

Sparta

Pylos

PAROS

Monemvasia

MELOS

SANTORINI

MEDITERRANEAN SEA

Iraklion

Mallia

Knossos

CRETE

Gournia

Aghia Triada

Phaestos

Gortyna

Kato Zakros

ALEXANDER THE GREAT; A
ROMAN COPY OF AN
ORIGINAL BY LYSIPPUS.

P. 1: THE GOLD BURIAL
MASK, KNOWN AS
"AGAMEMNON'S MASK,"
WAS FOUND BY
HEINRICH SCHLIEMANN
AT MYCENAE.

P. 2.: "WINGED VICTORY"
NIKE OF SAMOTHRACE,
HELLENISTIC PERIOD.

CONTENTS

SAMOS

PATMOS

COS

RHODES

C O N T E N T S

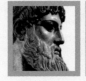

.............. NOTE TO THE READER

The country has been divided geographically into macro-regions: Athens, Attica, Peloponnesus, mainland Greece, and the islands. The last region is further divided into the Ionians, east Aegean, Dodecannesus, Cyclades and Crete, which are described on a north-south basis. Individual sites are described according to their position in each itinerary. Individual itineraries are indicated by a particular color.
The symbols refer to the type of site described:

 🏛 ancient site

 h byzantine site

 Ă fortress

Secondary localities and itineraries (which are not included in the section of sites described but cited in the introduction to each section) use the same symbols as the main localities and itineraries but are referred to by a neutral color.

INTRODUCTION

THE ANCIENT GREEKS AND US

For scholars of the ancient Mediterranean world, Greece, its history, art and traditions infused the cultural origins of the West: Greece is a therefore a fundamental starting point for understanding the modern world. But if we abandon that stance and ask what is the relationship between the ancient Greeks and ourselves, does the question have any sense? Has the distance between us and them grown insurmountable? Is the idea of a real and active relationship illusory? If we restrict ourselves purely to archaeology and art, we must recognize that today the "accessibility" of mass tourism to Greece's artistic heritage has caused a diminution in our ability to appreciate it. This is even more so if we lack information that would help us to understand it fully.

Thousands of historic objects and pieces have been removed from their original physical and spatial context, either taken to museums or the re-sited survivors of survived earthquakes, or other disasters. Or, when still in their original context (a statue on its base, with its epigraph and in its original location), they have lost their function. These sites have been conserved and organized as though they are museums; the result is that appreciation of the objects is based on visual contemplation – better if at a distance and in silence. When this is the case, the visitor's aesthetic experience and judgment is mixed in different proportions.

This contemporary situation has nothing to do with the way artificers expected that a certain building, statue, icon or vase would be perceived; in their day, all these entities were closely tied to their particular function. One can say this "museum" form of contemplation is the usual form of modern perception, one in which objects are detached from their context, even where that context still exists. Nonetheless, the archaeological sites of Greece are indisputably fascinating: tourists arrive in organized crowds, or small groups or even individually – in the cause "cultural tourism" or "experience trips." Take one example. In tourist-brochure cliché-speak, the Peloponnesus represents "simple, bucolic life, sun-soaked landscapes, tranquility, the green of nature and the red of the earth – and art, the art of the Classical and Byzantine periods, with a pinch of Venetian and dash of Turkish for piquancy." Unfortunately, all these wonderful characteristics are reduced to the commonplace and visitors' emotions are manipulated "industrially." Sadly, the tourist industry trivializes the values it pretends to laud, and those values end up by being destroyed. Clearly, a short visit to Greece cannot possibly provide an experience of the life, rituals, customs and period of a country so very different from the visitor's own. However, it is in part possible for visitors to familiarize themselves with the nature, art and history of this very varied country – the "microcosms" of the tourist guides: unspoilt Messenia, idyllic Arcadia, bare Laconia, sacred Elis, fertile Achaea, etc. Having some

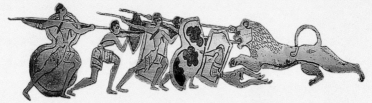

9: LION HUNT; GOLD AND SILVER DECORATION
ON A MYCENAEAN DAGGER.

sense of the historical dimension above all opens the way to an appreciation of the overall cultural value of the trip (and, more generally, of life). Thinking historically is the key to understanding the past and experiencing more fully the present and future. This conviction sets the "stratigraphic" approach that this guide takes in its visits to the Acropolis and Agora in Athens, the sanctuaries of Apollo at Delphi and Delos, the sanctuary of Zeus at Olympia, and Mistras and Meteora. Visitors to an archaeological site think they are seeing it in its original, earliest appearance: in fact, they are seeing a scene that never existed in the past as such. Monuments belonging to different epochs, separated perhaps by several centuries, today exist together in quite unreal ways. Of some buildings every trace has been lost, of others only the foundations remain; furthermore, rarely are we able to appreciate the original volumetric impact of a monumental site. How can we ensure that a visit to a famous or beautiful site is not reduced to a traipse between ruins "labeled" with their names and dates – but lacking all context? To understand a historic object's meaning requires that we considered it from a historical perspective. In other words, to try to understand it from its origins until its final phases. To be truly useful an archaeological guide must obeys this dictum: Illustrate what there is to see, but place it accurately in the widest

context of the history of the site. This guide therefore seeks to offer comprehensive, up-to-date pictures of sites, whether simple or complex, that reflect both ancient accounts of historical events and the material circumstances that excavation has since provided. This means that much more space is given to sites than to museum collections. It is clearly impossible to provide adequate information on the innumerable pieces displayed in museums; yet, without a full explanation, the significance of a piece is lost. The beauty and value of items exhibited in museums arouse admiration, but they are first and foremost historical documents. This fact may not be clearly apparent to visitors as the display of a particular piece in a museum takes it out of its historical context (even though while it may well safeguard its existence). To offer a full historical framework for the exhibits means providing the maximum amount of information, as only a professionally prepared museum catalogue can do. Increasingly, modern museums have organized themselves to meet this criterion; they offer long explanatory panels that present visitors with valid contextual knowledge. To provide a clearer understanding of the culture and art of ancient Greece, we have added a few brief paragraphs on themes and artists that we consider of particular importance and significance.

Cristina Troso, Stefano Maggi

GREEK ART

From the Neolithic age to the Bronze Age

The beginning of habitation on the Greek peninsula and in the Peloponnesus can be dated to the beginning of the 2nd millennium BC. Thessaly has yielded the most important signs of the Neolithic culture, in Sesklo and Dimini. In the former (4th millennium), distinguished by monochrome black or red pottery decorated with incised motifs, settlements were established gradually and rectangular stone houses replaced the original round huts. Sculpture appeared in the form of small clay idols. In the second phase (early 3rd millennium), the first forms of the *megaron* were introduced. Metalworking, brought in from the Orient during the middle of the 3rd millennium, also started to become widespread. Pottery evolved slowly during the Early Helladic III period (2600–2000 BC). Metal items were still rare (mainly spearheads and small daggers). The Cyclades produced a distinct type of art: marble idols whose geometric appearance contrasted with the naturalism of the idols from Sesklo and Dimini.

During the second half of this millennium (Ancient Minoan II, 2500–2200 BC), Crete evolved independently, in a very different way, typified by rich and dynamic inventiveness. It also experienced the extensive development seen in Egypt, Syria, and the great cities of Mesopotamia. Minoan art—named after Minos, the "first" king of Crete—flourished during a period (Ancient Minoan III and Middle Minoan I) marked by the beginning of urbanization (The Pre-Palatial period).

In its diversity of form and rich range of polychrome decorations, pottery reflected the profound trends of this fledgling art: imagination, creative freedom, and a taste for line and color (Kamares style).

During the Palatial period (Middle Minoan I–III and Late Minoan I), a unique civilization slowly developed on Crete, destined to leave a profound mark on the Greek mainland. Its most evident expression was initially tied to architecture, namely palaces and, on a smaller scale, large residences (and their painted decorations).

Despite important contacts with Egypt and the East, the palaces od Crete did not follow these traditions but took their design from the particular topographical conditions of the area. Great attention was paid to the terrain in order to fit the structure into the natural landscape. The palace was organized around a single court. As a result, the perimeter was not uniform, and the structure was not symmetrical. There were no internal access routes, which has led to this layout's later definition as "extravagant" and "anarchic"—the labyrinth can be considered its symbolic representation). It was a type of architecture that eschewed large interior areas, preferring limited but well-organized proportions that prized deep perspectives. It thus played on the effects of light and shadow by using numerous apertures (doors, windows) connecting the different areas. The palaces were decorated using rich and refined pictorial art. Frescoes—technically quite similar to those of the Italian Renaissance—were adapted in style and subject to the different areas in which they were used. Nature was a popular theme for these works: surreal landscapes

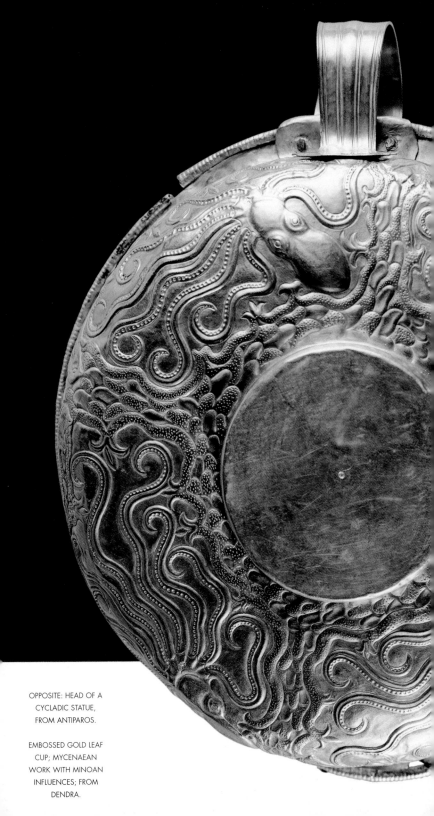

OPPOSITE: HEAD OF A
CYCLADIC STATUE,
FROM ANTIPAROS.

EMBOSSED GOLD LEAF
CUP; MYCENAEAN
WORK WITH MINOAN
INFLUENCES; FROM
DENDRA.

populated with real animals created fantasias evoking a plentiful, happy countryside. The figures were depicted in flat colors, without using any relief. Minoan sculpture expressed graphic values but without any true research into volume. These objects were generally small. The art of relief was particularly successful. The same taste for design and polychromy expressed by the frescoes can also be noted in Minoan pottery, with a marked preference for stylized plants. Thus, at the beginning of the 2nd millennium, the Greeks arrived in an area marked by what, essentially, was still a Neolithic way of life, although it was open to outside (specifically Oriental) influence.

Toward the late 17th and early 16th centuries (at the end of the Middle Helladic III), the Helladic culture began to feel the influence of Cretan art, through the Cyclades.

The Minoan experience—with contributions from Syria, Phoenicia, Anatolia and Egypt—formed the basis for Mycenaean art. Initially, Argolis and the region of Corinth played a fundamental role in defining the new civilization. Well-organized towns were established, with necropolises that flaunted significant wealth and artistic culture. The towns were distinguished by a palace connected to dignitaries' houses and was enclosed by a sturdy fortified wall (starting in about 1450 BC). The palace corresponds to a unitary, hierarchic architectural concept that was centered on a predominant unit, the *megaron*. More flexible and centrifugal in layout, it differed notably from the Minoan type.

Chamber tombs appeared in the late 16th century BC and during the 15th century BC. The late 14th BC century marked the beginning of the more monumental form of Mycenaean funerary architecture: the *tholos* (round) tomb.

Order, discipline, and rationality are the most evident signs of the Mycenaean temperament, just as schematization and the simplification of form marked Mycenaean aesthetics. Great painting developed significantly, as in Crete, whose tradition it effectively continued. Pottery was inspired by Minoan concepts, particularly with regard to naturalistic motifs. However, they were arranged in more precise and disciplined patterns, and they gradually became more rigid and more geometrized.

THE BIRTH OF GREEK ART

With respect to the great artistic cultures that preceded it (Mesopotamian, Assyrian, Egyptian), Greek art indubitably came across as something "new." However, a complex rapport links it to the art that arose in Crete during the Bronze Age and spread to the continent (and elsewhere) during the Mycenaean period. The transition from this artistic culture to the more strictly Greek one, through the Sub-Mycenaean and Proto-Geometric phases, is effectively a critical point in the history of our civilization. The phenomenon must be studied in its multiple aspects that, in addition to art, involve ethnogenesis, migratory movement, language, religion, and more. The crisis of the Mycenaean world triggered an enormous decline, with a sharp drop in the cultural tone of the Aegean area (end of the 2nd millennium BC).

OPPOSITE: OFFERINGS
TO A GODDESS,
FRESCO IN KNOSSOS.

RIGHT: DETAIL

Proto-Geometric pottery marked the period of recovery. The forms of the vases, reduced to about a dozen—compared to over sixty during the Minoan-Mycenaean period—rose to seventeen (though borrowing the ones from the late Mycenaean phase), however, they rapidly became independent also with regard to decoration. In this field, there was a decline in the geometric design of naturalistic forms (the conceptualization of a natural form in an abstract symbol), and there rapidly arose the desire to return to a sense of organic unity and uniformity. Vase decoration was coordinated in precise syntactical patterns that matched the structure of the vase, and it tended to cover the entire surface with a precious, gleaming "shell." A large quantity of pottery in Attica, and particularly in Athens, was made on a potter's wheel and was distinguished by a type of "paint" that, when fired, turned brown or glossy black. In the Proto-Geometric phase (10th century BC), the city was the only Mycenaean stronghold that was not destroyed by the Dorians, and its very continuity thus makes it a marvelous observatory for understanding the transitional phases from one culture to another. Athens proved to have an enormous capacity for spreading its decorative wealth: its products were traded throughout the Aegean and were also imitated locally.

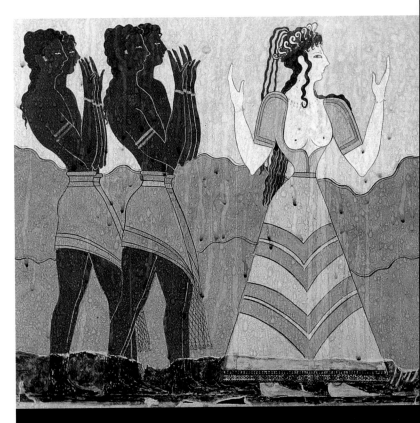

THE GEOMETRIC AGE (900-700 BC)

The structure of the vases became more complex, harmonious, and slender. Amphoras and craters reached monumental proportions and were also used as funerary markers. A more mature decorative sense gradually broke away from the severe chromatic unity of the black "paint", with the inclusion of an increasing number of ornamental bands (inspired by fabrics). Of these, the meander or Greek key motif came to be typical. Figured images (man, horse, deer, bird) were introduced to decoration and, toward the mid-8th century, elaborate scenes began to appear. The masterpiece of this era, the amphora by the Dipylon Master, shows the deceased laid out on his funeral bed, surrounded by mourners (This vase is now at the National Archaeological Museum in Athens). Processions of chariots and men on horseback, duels, and naval scenes (including shipwrecks) were also common subjects.

The portrayal of mythology (Helen and Paris, the Labors of Heracles, Ilioupersis) can undoubtedly be placed in the Late Geometric (760-700 BC): human figures became more corporeal, with limbs that were better articulated and the head depicted in detail. Animal figures were also less schematic. This "escape" from geometrizing abstraction ultimately relaxed stylistic cohesion, almost as if there were a feeling of intolerance toward strict Geometric laws, with a need for renewal and a new means of expression and narration.

As Athens grew, Corinth also developed gradually into a trade center. Its pottery gained a reputation for technical refinement and formal elegance in the vast trade network that stretched across the Mediterranean, as relations with the East intensified during the last decades of the 8th century. The Phoenicians played an important role in this. Oriental iconographies (animal figures, monsters, floral decorations) flourished in the first half of the 7th century BC, and they were ideal for the decorative apparatuses of Corinthian vases, which were generally small. A more narrative style would appear toward the middle of the century, the period in which masterpieces like the famous Chigi *olpe* (vases) were created. Miniaturist elegance, dynamism, and lively narration were combined with superb use of color (sources cite Corinth and nearby Sicyon as the cradles of the most ancient pictorial art). Several small-scale models—most of which were made of clay—found in sanctuaries (e.g., the Heraion of Perachora, the Heraion of Argos) give us a glimpse of what the sacred architecture of the era must have been like. As yet, there was no monumental statuary, and votive or funerary figurines portrayed human and animal figures, above all the horse, with increasingly lively forms.

ORIENTALIZATION (7TH CENTURY BC)

The "Orientalizing" style spread throughout the Greek world, although in a highly varied fashion as it was influenced by different Eastern areas (the Assyrian, Iranian, Urartian, Hittite, Lydian, Phoenician, Egyptian, etc.). In Attica, for example, the Geometric style showed stout resistance, but when the transition finally occurred, this new art burst onto the scene with impetuous and dramatic narrative force. The structure of the *polis* also changed during the 7th century. A new social class of traders and merchants acquired power, and city life became more cosmopolitan. Sanctuaries mushroomed along the great trade routes, as did the offerings that were made inside these shrines.

It is virtually impossible to divide this cultural age into rigidly defined periods.

Athens, faithful to its artistic ideals, continued to produce marvelous vases decorated with increasingly monumental and organic figures, with complex creative developments. A number of innovative figures appeared on the scene (e.g., the Checkerboard Painter, the Analatos Painter, the Polyphemus Painter). These artists modified technique through the more extensive use of outlining to contrast the bare areas of the ground, and they also introduced incising to make the details inside the "painted" parts dark. Other colors also began to be used (in particular white and purple). New figural and ornamental motifs, of Eastern origin appeared. The use of mythology became more widespread, it was characterized by a narrative language expressing the figures in physical and monumental forms. By the end of the 7th century, this art would triumph over Corinthian art, which had dominated the market in the second half of the century with pottery that was less refined from a decorative standpoint, as well as being more "ostentatious" and commonplace.

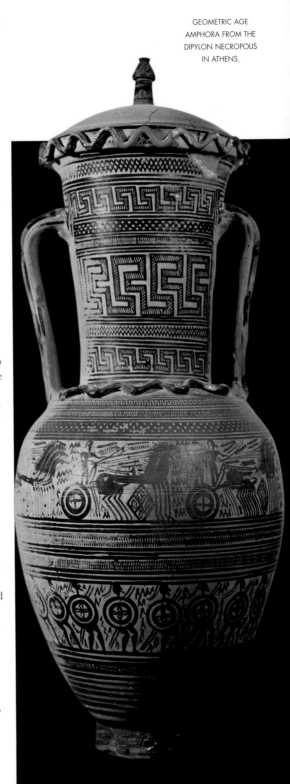

GEOMETRIC AGE AMPHORA FROM THE DIPYLON NECROPOLIS IN ATHENS.

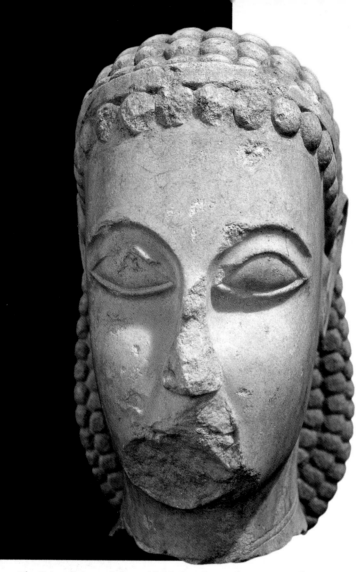

The Orientalizing period also marked the beginning of monumental statuary, referred to as "Daedalean." According to tradition, the legendary Daedalus was the inventor of the first "living" images of humans (well-positioned in space and without their primitive stiffness). It is significant that the Daedalean legend links this figure to the Minoan-Mycenaean world, in the myth of the labyrinths, whereas the art of *daidállein*—"to work artistically," "to adorn" (hence the name of the demiurge)—indicates that he was fully involved in the Orientalizing trend. Daedalean sculpture supplanted the miniaturist Minoan-Mycenaean and Geometric form. It was characterized by an increasingly articulated structure of the body, triangular faces, prominent eyes, large ears, and hair falling in large ringlets, similar to the Egyptian style (*klaft*). This version still reflects a somewhat abstract style, with the architectural arrangement of the structural parts in a majestic pattern (this also applied to small-scale sculpture, which was nevertheless influenced by a monumental vision). The Archaic sculptor showed little interest in

physiognomy, seeking ideal beauty and rationally constructing it in space. Human or divine, the male figure (the *kouros*) was nude. Thus, there was a search not only for the "typical" figure representing humanity, but also for principles of form that could be applied to the anthropomorphized divine image.

On the other hand, the female figures (*korai*) were clothed, but they too were undifferentiated, with the exception of inscriptions or attributes to qualify the deities with respect to the donors.

Sculpture broke away from static, rigid poses during the 6th century. Different stylistic views developed in Doric and Ionic sculpture. In the Doric style, the figure was created by decomposing the planes of the main views (front, the two profiles, the back), which came together in an angular shape that gave the statue a block-like appearance. In the latter, the four basic planes were recomposed to eliminate all angles, softening the intersecting points and thus achieving a rounded, cylindrical volume. When sculptors attempted to create depth for important details such as the eyes and mouth, their solution, applied to the rigid frontal plane, was to raise the corners of both facial features. The result was the characteristic appearance that is referred to as the "Archaic smile." Nonetheless, it is not an expression of serene benevolence or magical inner vitality. More simply (and realistically), it characterizes the method of constructing an image on parallel planes, without truly conquering the concept of three-dimensionality. Here again, although the Cretan and insular schools marked the birth of Archaic statuary to some extent, it was Athens that became preeminent in this field toward the beginning of the 6th century, with highly effective and monumental creations (for example, the famous Sounion *kouros* at the National Archaeological Museum). These works reflect the period's most controlled formulation of the nude male figure.

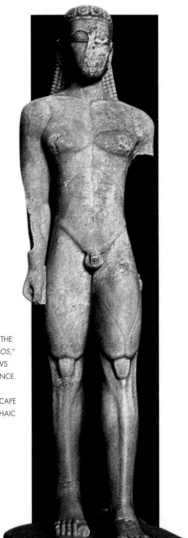

OPPOSITE: FRAGMENT OF THE "DIPYLON *KOUROS*," WHICH SHOWS EASTERN INFLUENCE.

KOUROS FROM CAPE SOUNION; ARCHAIC PERIOD.

The 7th and 6th centuries BC saw the slow but sure development of the temple structure. One of the fundamental creations of the Greek spirit, it was essentially the "house" for the anthropomorphized god. Following extensive technical and structural experimentation, canonical forms were finally established during the 6th century. The early technique involving a stone plinth and a raised platform made of coarse bricks developed so that the entire structure was made of stone. Likewise, the simple room evolved to include the *naos* (cellar) preceded by the *pronaos*, and the entire complex was later surrounded by a *peristasis*. Wooden supports were replaced by stone ones and, finally, by columns, and the flat roof gave way to

the double-sloped roof. Subsequently, this layout developed from one with the middle row of supports to the naos without a colonnade or with columns set close to the side walls, to permit the most favorable presentation of the deity's cult statue. The plans, which were initially quite elongated, became more proportional.

The creation of the column led to a definition of the architectural orders that would become the foundation of modern European architecture.

In the Doric order the temple is presented as a closed structure freely positioned in space. Initially it was given a very long plan but this tended to shorten and widen until, in the 6th century BC, and especially in the 5th, it

achieved a balanced rectangular form in the proportion 4:9. Doric temples were often given a ratio of *n* columns on the front and rear ends with *2n+1* on the long sides. The number of columns on the long side defines whether the temple is tetrastyle (4), hexastyle (6), or octastyle (8). The arrangement of the columns indicates whether the temple is peripteral (with a single line of columns on all four sides), prostyle (with columns only on the front), or amphiprostyle (with columns only on the two short sides). These definitions are also valid for all the other orders.

In plan, the temple has a peristasis, ambulacrum, and the closed body of the

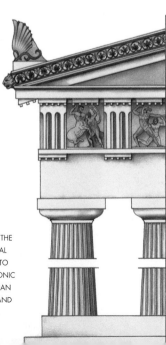 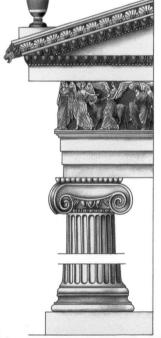

DRAWINGS OF THE ARCHITECTURAL ORDERS. LEFT TO RIGHT: DORIC, IONIC AND CORINTHIAN TRABEATIONS AND COLUMNS.

building. The latter comprises the pronaos (vestibule at the front of the temple), the naos (the cella that contained the simulacrum of the god and which was therefore the abode of that particular god), and possibly an adyton (part of the back of the naos, sometimes separate from the inside of the naos, that was reserved for particular ceremonies). With regard to the plan of the Ionic temple, right from the start emphasis was placed on the main side, which was determined by the backward position of the naos and the depth of the pronaos. The dipteral arrangement (with two lines of columns on all sides) gave the building monumentality. The definition of the orders imposed precise decorative requirements on the sculptures of the metopes in the Doric order, the figured frieze in the Ionic, and the pediments in both cases (as well as the acroters and 'minor' decorations). This strict concentration of research revolving around well-defined compositional problems (and a narrow range of subjects) fostered logical and structured elaboration, which gradually led to universally applied solutions.

The most demanding problem indubitably involved decorating the triangular field of the pediment. From the early use of painted clay (followed by low relief in stone, to high relief, and later, full relief in the second half of the 6th century) these works reflect the pursuit and gradual accomplishment of figured narration (pertaining to the specific cult deity). The narration was based on a composition that was as structured as possible despite the highly particular spatial limitations. Following initial attempts with apotropaic animals and monsters whose bodies were ideal for filling the sloping corners, there was a move toward mythological scenes, with a more unified and faster narrative pace. Consequently, at first the figures were gradually reduced in size. Later, however, lack of proportion was avoided through careful study of the layout,

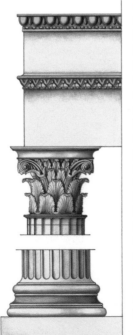

so that figures of the dead, reclining "spectators," or personifications were used to fill the narrow corner spaces. The outcome marvelously combined thematic and syntactical unity.

The organization of the Doric frieze was much simpler: in the transition from terracotta to stone and marble, the problem involved composing a figured motif that would fill a quadrangular field— which was thus "easier," albeit quite large—in a harmonious and condensed manner. The most prevalent groups were paired figures, as they lent themselves to a number of models that were not merely paratactic and could easily be coordinated in the sequence of one side of the temple.

Later, figured decoration was systematically introduced in the Ionic frieze, applied to a Panhellenic sanctuary like the one at Delphi in the second half of the 6th century, and it was also used for the Cnidian and Siphnian Treasuries (*thesauros*). The syntactical problem here differed with respect to the Doric frieze, as it required a unitary figured composition that had to be developed lengthwise. Its extraordinary organic development is evident at the Acropolis in Athens, and not only on buildings of the Ionic order (e.g., the Parthenon).

THE ARCHAIC AGE
(600-480 BC)

This period was characterized by immense, social transformations. In particular, there was an increase in the numbers of craftsmen, leading to greater productivity that, in turn, went hand in hand with vaster distribution of wealth and greater well-being. The political orders of the cities also changed: tyrannies were established. Both art and culture spread quite uniformly, backed by high-quality craftsmanship (obviously with differences linked to the different local situations). Techniques were perfected by exploiting the materials that each city could obtain. Thus, the local schools and shops specialized in different techniques (bronze, marble and terracotta sculptures, etc.). Artists also began to sign their names to their works. A more strictly artisan concept was abandoned. Particularly in the field of sculpture, conditions allowed artists to become more mobile, and this led to an intense exchange of experiences.

One of the leading figures in Athens was Endoios—the pupil of Daedalus, according to ancient sources—and he probably played a significant role in spreading the Ionic vision in Attica. In any event, toward the middle of the 6th century BC, true masterpieces appeared in the city. These included the *Moschophoros* or Calf-Bearer, the so-called *Marseilles Aphrodite*, the *Rampin Horseman,* and the celebrated *Kore in Dorian Peplos* (see the National Archaeological Museum of Athens), as well as the impressive series of *korai* from the second half of the century, clearly showing the Ionic influence. This influence imparted grace (*charis in Greek*)—to the solid Attic structure, with a new sense of monumentality. All this was fully expressed by Antenor, who sculpted the pediments of the Temple of Apollo at Delphi and the first group of *Tyrannicides*, stolen by Xerxes and redone by Critius (Kritios) and Nesiotes.

Toward the middle of the 6th century, as Corinthian pottery rapidly declined, Attic pottery instead rose to the highest technical and stylistic levels, spreading throughout the Mediterranean area. Vase forms as well as the black-slip and incision techniques had been perfected by this time, and a clear and controlled narrative language had developed (also imitating and reinterpreting Corinthian motifs and types). As a result, the Attic workshops conquered the international market. In this field as well, it became customary for artists (potters and vase painters alike) to sign their works.

Consequently, we are familiar with the names of great masters, such as Kleitias, who made the lovely François crater in about 570 BC, Sophilos, Nearchos, Lydos, and the Amasis Painter, one of the most prolific figures during the rule of Peisistratus. Alongside the heroic repertory, he also portrayed serene realism in both domestic and Dionysian scenes. The greatest was probably Exekias, active between 550 and 530 BC, who loved monumental figures full of dignity and pathos, concentrated in actions marked by great dramatic intensity: the confident, plastic line in his works is sustained by the elaborate interplay of incision used for the smaller detailing. Toward 530 BC, at the shop of vase painter Andokides, the technique of decorating vases was completely overturned. He left the figures on the reddish background of the clay and created the internal details using thin lines, more fluid brushstrokes, and even touches of white, purple, and green, then painting the rest of the field black. This method thus went beyond the sketched effect of black silhouettes with incised detailing to move toward decidedly more pictorial effects suggesting plasticity.

In addition to large vases, the *kylix* (plate) also developed notably. Toward

the end of the century, Oltos and Epiktetos became famous for their decorative work on plates, and their figurative experimentation was responsible for taking the discovery of foreshortening from great painting and bringing it to pottery (of which, obviously, nothing remains). Euphronios and Euthymides painted large vases, giving their figures this same new spatiality on a monumental scale.

Two exceptional artists appeared in about 500 BC: the Kleophrades Painter and the Berlin Painter. These figures, alongside the sculptors of the era, introduced a new stylistic vision known as the Severe Style, which moved beyond Archaic conventions.

During the first half of the 5th century, great painting discovered the humanization and dramatization of myth with Polygnotus (and his colleague Micon), and pottery allows us to discover the paths followed by the great masters. Vase painters like the Niobid Painter, who had mastered the art of foreshortening, demonstrated more complex schemata and a richer sense of depth, exemplifying what— centuries later—Pausanias (in his *Description of Greece*) described at Delphi (the Lesche of the Cnidians) and Athens (Stoa Poecile).

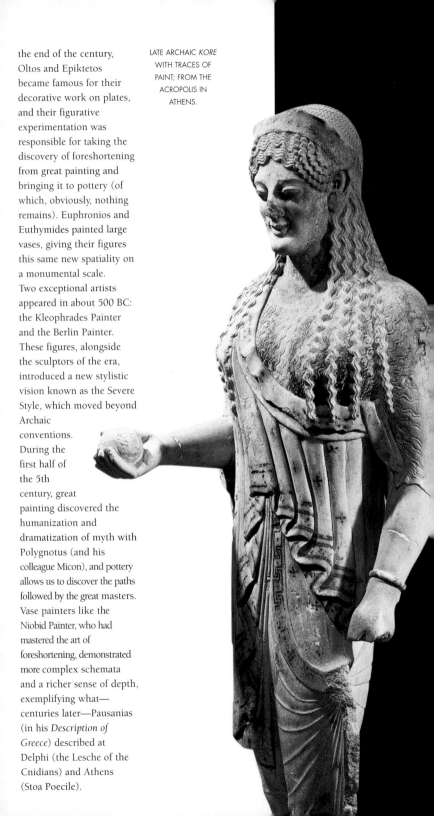

LATE ARCHAIC *KORE* WITH TRACES OF PAINT; FROM THE ACROPOLIS IN ATHENS.

THE SEVERE STYLE (480–450 BC)

The years of the Persian Wars marked the transition to the period in which the Archaic vision of the human figure in art was superseded by the introduction of greater naturalism in anatomic representation. This led to the decline of the "Archaic smile" (hence the invention of the entirely modern term "Severe Style").

As in painting, the interest in anatomy in sculpture stimulated the observation and representation of the body, with nudes that were clearly measured with vigorous, simple volumes articulated organically. Drapery tended to be freer and fitted more closely to the structure of the body and its movements, creating an increasingly naturalistic effect.

The severe athletic ideal of the Attic master is clearly expressed in the Critius *Ephebus*, made in about 480 BC (Acropolis Museum), whereas the ideal of the female form can be seen in the *Aphrodite Sosandra* of Kalamis (there is a lovely copy in Naples, at Baiae), dated approximately 465 BC.

With Myron, the problem of athletic representation acquired movement, and sculptural rhythm became more complex. The famous *Discus Thrower*, known through the numerous Roman copies that were made, shows the athlete as he is about the hurl the discus, and thus in a taut darting pose, crouching and daringly compressed between two parallel planes. There is no doubt that the most significant creations in the statuary art of the period are the pediments of the temple of Zeus at Olympia. Here, the vigorous, organic nudes and the dense, full-bodied drapery sketch out bold syntactical arrangements, with violent foreshortening that animates the fighting (on the west side) yet also the isolating language of expectation (on the east side).

THE CLASSICAL AGE (450–320 BC)

During the 150 years between the victories over the Persians and the reign of Alexander the Great, developments – also in art Greece, and in particular Athens, lay the foundations for Western culture and civilization.

The area of city planning tested the concept of the "regular" city laid out along lines set at right angles, with the calculated distribution and rational connection of public areas, with utilities, and residential areas. Aristotle explicitly attributed the invention of the "divided city" to Hippodamus of Miletus.

In sculpture, two sublime masters embody the concept of Classical art: Phidias and Polyclitus. The former refined his severe training by renewing traditional motifs and myths in his vivid sense of the flesh and in his fluid, impressionistic portrayal of hair, and he invented a model of fine, sheer, rippling fabric.

After the *Athena Promachos* on the Acropolis, Phidias cast the bronze figures for the gift of Marathon at Delphi and the *Athena* for the colonies on Lemnos (figs. 11-12). After his work on the Parthenon, he produced the colossal statue of *Zeus* for Olympia. He took part in the competition at Ephesus for the figures of Amazons for the local sanctuary of Artemis.

The *Anadoumenos* reveals the distinct influence of Polyclitus in the composition. Polyclitus rationally studied the problem of proportions for the human body, formulating his organic, vigorous canon – in a treatise (which has been lost) and a statue (the *Doryphoros*) – distinguished by a rhythm that finally shunned all traces of rigidity. The Canon (norms) dictated that the nude was

OPPOSITE BOTTOM: DETAIL OF PRAXITELES' HERMES FROM OLYMPIA.

RIGHT: ROMAN COPY OF POLYCLITUS' DORYPHORUS.

fully naturalistic and vigorous, with a rhythm created by the alternation of tense and relaxed limbs (referred to as "chiastic" from the letter χ in the Greek alphabet); to this was added a detailed study of the proportions.

Thus, starting with late Hellenism, Phidias' art would be praised for his sublime and venerable greatness linked with the highest form of beauty, above all in the sculptor's representation of the gods. Instead, Polyclitus would be celebrated for his rendering of the human figure, according to the precepts of classical *kalokagathia*. Phidias' circle included figures who rose to excellent artistic levels, such as Agorakritos and Alkamenes. Although they followed the master's teachings, they demonstrated personality and originality, the former by giving more fullness to the structure and modeling of his works (the *Nemesis* at Rhamnous, *Zeus-Hades*), whereas the latter took up individual Phidian motifs with a great sense of measure, balancing them in a truly Classicist manner. His works include an *Aphrodite*, *Hermes propylaios*, and the statue of Ares for the temple at the Agora in Athens.

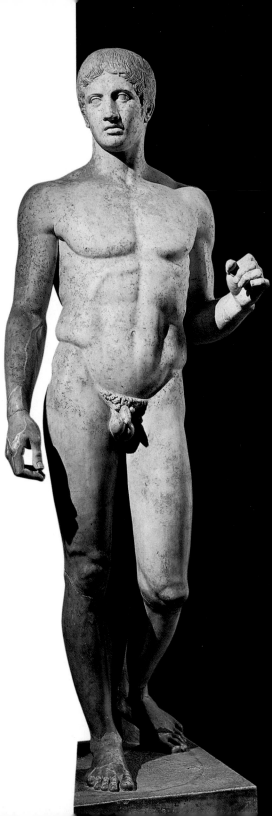

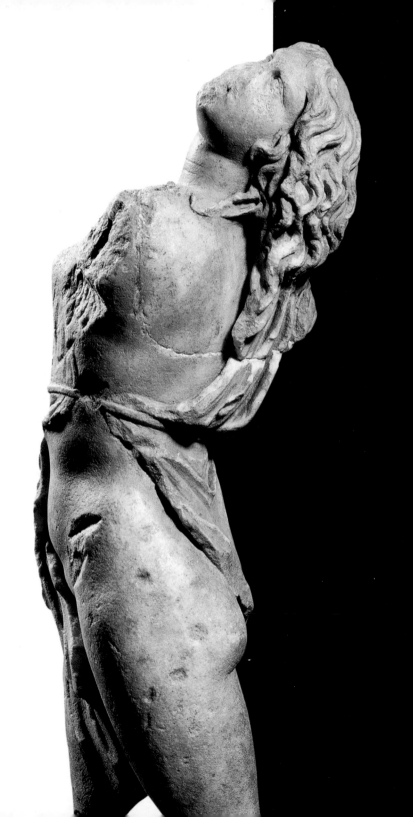

The imitation and interpretation of Phidias' formal language spawned a mannerist trend. Callimachus, for example, took the expressive potential offered by the new "wet" drapery to extremes in works such as the *Fréjus Aphrodite* (*Aphrodite Genetrix*), the *Nikai* of the balustrade of the *pyrgos* in the temple of Athena Nike, and the *Spartan dancers*. Paionios went even further in his famous *Nike* of Olympia, practically ignoring the limitations of the medium and turning his drapery into a virtuoso example, modeling this work with tender yet vibrant effects. This tradition of post-Phidian drapery discovered new effects that are vividly contrasted in the subtle transparency and dazzling tangle of folds—by this time without any organic relationship whatsoever to the body under them—in the works of Timotheus, including the acroters of the temple of Asclepius in Epidaurus as well as *Leda with the swan*. The Mannerist evolution of the Classical style can also be noted in the pottery of the late 5th century, with the Meidias Painter and the Eretria Painter. Naturally, this pottery reflects the great painting we know only from the sources: the study of perspective by Agatharcus of Samos, the

study of chiaroscuro by Apollodorus and Zeuxis, and Parrhasius' use of the "functional" line (giving bodies a three-dimensional sense).

In the 4th century BC, the renewal of the Classical conception arose above all in the quest for a more "human" appearance and more accentuated naturalism in figures, regardless of whether they were sculpted, painted, or drawn. Despite its political decline, once again Athens was the most active art center in the Greek area. The Attic spirit developed its qualities of *charis*—soft naturalism, chiaroscuro, relaxed rhythm—and it finally achieved the humanization of the classical ideal with the art of Praxiteles.

The Praxitelean figure united the new rhythm— off-center, gravitationally unbalanced and thus sinuously leaning against a lateral support—with an equally innovative way of handling surfaces. Nudes become soft and fleshy, and the muted surface changes created delicate shading, offset by rich chiaroscuro drapery or the rough texture of a trunk.

The work that is probably his masterpiece, the *Cnidian Aphrodite*, was produced in approximately 340 BC. *Hermes with the Infant Dionysus*, from

Olympia, seems to exhaust the master's canons: the effect of the figure's hair is so vivid that it approaches a Mannerist style. Several critics have attributed this work to another artist by the same name, from the 2nd century BC.

In painting, Apelles embodied the same ideal. Despite the decline and disappearance of painted pottery, we can still get an idea of the splendid development of great painting, not only through the sources but also from the copies made by the Italic populations and the Romans during the Late Republic.

Philoxenos, Aristeides, and Nikomachos expressed the same sensitivity toward the problems of color and the effects of light, spatial illusionism, and the psychological interpretation of the figures. Sopas was just the opposite in temperament. Born in Paros, he absorbed Classical concepts in Athens and learned Polyclitean rhythms and layouts in the Peloponnesus. Nevertheless, he created something new, removed from both traditions, in his exaggerated use of color, tension, and pathos that animated creations such as the pediment sculptures of the temple of Athena Alea at Tegea or his famous *Maenad*.

OPPOSITE: DANCING MAENAD;
ROMAN COPY OF THE LATE
CLASSICAL SCULPTURE BY SKOPAS.

There also were many other notable sculptors: Bryaxis, who carved colossal statues of the gods (Serapides); Leochares, whose name is linked above all to the Mausoleum of Halicarnassus and, later, to the Macedonian environment, with particular reference to the ivory portraits from a tomb at Vergina (Aegae). Silanion was also a leading 4th-century portraitist who sculpted the bust of Plato, which is known through its numerous copies, as well as the famous head of Satyros the Boxer. Euphranor is known instead for his study of proportion, introducing leaner limbs and slender height that, with Lysippus, were fully expressed as a new canon that adhered to "optical" principles. Euphranor was also a painter and treatise writer. A native of Sicyon, Lysippus enjoyed the culmination of his career in the years 328–325 BC, the years of Alexander the Great. In the *Apoxyomenos* (the athlete who cleans himself with a strigil, on opposite page), his artistic vision is apparent: the complexity of the pose, with one leg flexed, the sinuosity of the torso, the right arm held forward as though to conquer space, the raised head and the rising rhythm in which the legs are lengthened, the torso shortened, and the head small with thick, wavy locks of hair together create a new canon that transforms the mathematical and rational model used by Polyclitus. The new vision is "optical." illusionistic, and highly expressive. Lysippus produced many representations of the young Macedonian ruler: sources record one of Alexander with a spear, of which several smaller versions were made. The Macedonian "phenomenon," noted and studied in its historical aspects, has now also been grasped fully on the level of art history as a decisive moment in the evolution of 4th-century art and, above all, perhaps also in its proliferation.

Palatial architecture was revived in Macedonia. The new type, exported to the Greek world, is characterized by its spatial organization into a well-defined and closed square, a central space surrounded by porticos with the rooms arranged behind them. This was the principle of the Hellenistic house, well known at Olynthus and then Delos, and subsequently brought to the West, where it merged with the Italic traditions. This was also the principle used for the great civic constructions, such as gymnasia, palaestrae (open-air sports arenas), agoras (markets), and sanctuaries. Their originality lay in the adaptation of this plan to a large-scale building, associating rooms for both private and public use, all of which were given a new sense of monumentality. The originality of the Macedonian builders also emerges in their funerary architecture. A room with a vestibule, covered with an earthen tumulus, was finished with a façade distinguished by applied orders, decorated with stucco and rich polychrome frescoes. The integration of painting and stucco work with architecture is rooted in the extraordinary and rapid development of pictorial art at the Macedonian court. Zeuxis was already in the service of King Archelaos at the beginning of the 4th century BC, and Philip II then brought him to his capital city Pella. The recent discoveries at Vergina, together with those at Leucadia and Demetrias, provide works that are indubitably close to those of the great painters, as we have learned from the sources. The concept of the individual and lifelike portrait—as seen in the five little ivory heads discovered in a tomb at Vergina—was in full force by the era of Philip II, and thus before Alexander brought Lysippus to his own court.

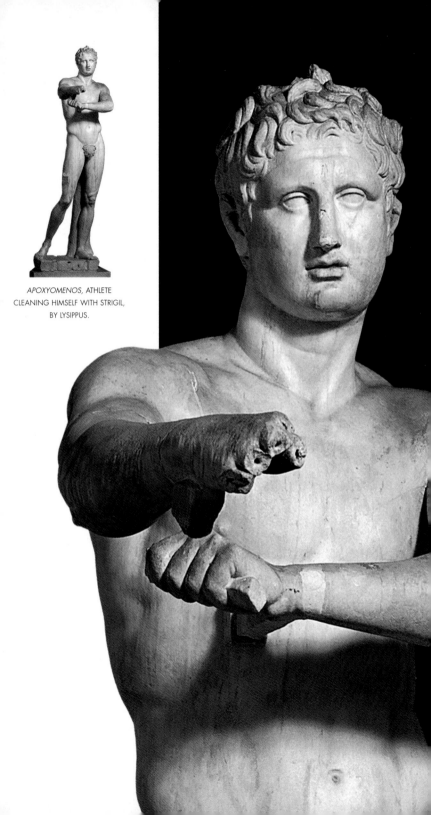

APOXYOMENOS, ATHLETE
CLEANING HIMSELF WITH STRIGIL,
BY LYSIPPUS.

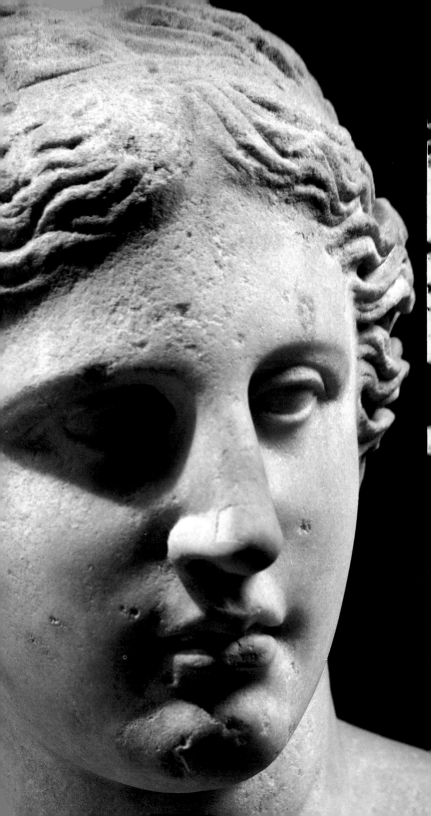

HELLENISM (320–30 BC)

Two problems that have always complicated research into the sculpture of the Hellenistic period can be defined as: (a) the drawing up of a chronological classification for the almost 300 years of production, and (b) the clear identification of the entity and quality of the works produced by the most renowned political and cultural centers.

A further problem is represented by the lack of information provided by ancient historiographers summarized by the famous passage in Pliny's *Natural History* (XXXIV, 52) on the death of art between 296 and 156 BC. Fortunately, new discoveries and revisions of existing knowledge have led to an improvement in our understanding of a traditional historical framework.

The principal aspects of the period are represented by a broad series of innovative processes that affected the choice of themes and the variety of stylistic vocabulary employed. The most significant thematic innovations were: the development of the treatment of facial features; the creation of complex sculptural groups; closer attention paid to reality (even of the crudest

OPPOSITE: APHRODITE OF MILO, DETAIL (VENUS DE MILO); HELLENISTIC SCULPTURE.

29: FEMALE FIGURE; RELIEF ON A HELLENISTIC FUNERARY STELE.

sort) and, in reaction, to the escape represented by the bucolic idyll.

The variety and autonomy of the local styles are perhaps the greatest hurdle to the creation of a general chronological classification. With Hellenism, Greek architecture produced buildings for man and his city: the house of a god no longer represented the greatness and the power of the *polis*; the image of a city was provided by its buildings, whether public or private, and by the functionality of the city. Thus, the private house became an object of interest and study, and hypostyle rooms (the roof supported by columns), *ekklesiasteria,* and *bouleuteria* became more widespread, and theaters, porticoes, and stoas became fundamental to Hellenistic architecture. In addition to a more structured integration of buildings into the city fabric, a more dialectical

relationship between the built-up environment and the natural landscape was investigated.

Creative skills in the choice of dimensional relationships, modular solutions, inventive ground plans, and the structuring of facilities developed. The multiplicity of centers where new artistic vocabularies were developed also became a fundamental characteristic of the architectural field. In the lands in the Orient that were subject to Hellenistic rulers, the characteristics of Greek artisan production and its figurative world changed completely, losing even its traditional iconography and vocabulary. For the first time glass, gilded glass, and faïence were used substantially in handcrafts. More easily available supplies of metals and precious stones resulted in an increase in jewelry, and painted pottery disappeared almost completely, to be replaced by ceramics decorated with reliefs inspired by metal models. Small bronzes and terracotta items were used for household furnishings.

THE ROMAN AGE

Athens' epochal loss of freedom in 146 BC, the damage caused by Sulla's sack in 86 BC, and the torments of the late republic did not impede the city from playing an important cultural role at the international level during the 1st century BC. It was in Athens, the most "historic" of ancient cities, that the gilded youth of the Roman ruling classes studied. Octavian, the future emperor Augustus, was among these students. During the Augustan period monumental building in Athens became indicative of the influence that central government in Rome had on the province of Achaia, even though its capital was not Athens but Corinth. Construction of the new agora (or "Roman agora") led to an archaeological "re-exhumation," i.e., the reproduction of the style that the Romans considered "characterized" the city. The term "mimetic insertion" has been used. Even the Ionic monopteral temple (i.e., with naos surrounded by columns) dedicated to Rome and Augustus on the Acropolis had a traditional character, though it was also in some way "mimetica."

In recompense, the building carried out in the ancient agora, which had in the meantime become a cultural center and taken on the character of an official area, altered the ways in which the city's collective life was expressed (a collective life that does not exist in Greek cities today).

In the field of sculpture, the Roman province of Achaia in general and Athens in particular played

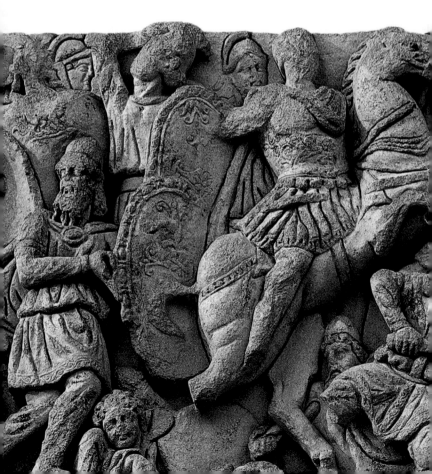

the primary cultural and formal roles during Augustus' reign, when Rome chose Classicism as the means to express its own ideals.

It should be stated straightaway that, after the crisis resulting from Sulla's sack, Athens and its region experienced a period of economic stagnation that led artists to work for the export market and even to emigrate. The result was the emergence of the "economic" side of artistic production, the emphasis on an "intensive" production, and the consequent but inevitable slide toward arts and crafts (though also of very high quality). Craftsmen set up workshops specializing in copies and that produced decorative objects like tables, candelabras, garden vases, and supports of various types. The products were academic and tended to hide the vacuum of ideas resulting from the new historical developments and the loss of liberty.

However, Classicism played a fundamental role: that of synthesizing the past, of merging Peloponnesian art with that of the Attic school, and creating a global, though eclectic, vision of Greek art. It was a "cultivated" art, something that characterized the whole of the Roman period, unlike what was happening in Italy and the West, or even in some regions of the Orient, such as Egypt, where a "popular" or "common" level of art flourished—in short, "uncultivated." This evident difference in the level of artistic production was purely qualitative and not caused by a difference in cultural background. During the mid-imperial period, the Attic workshops left academic Classicism behind, thanks to the influences of the Orient and Rome.

One of the most artistic productions was of sarcophagi. The Attic standard tended to emphasize the construction and architectural aspects, while the figures on the reliefs in many cases went so far as to annul academism with the use of dynamic, vibrant and uninhibited scenes. Whereas other centers in Greece felt the influence of Athens, Macedonia—which was a separate Roman province all to itself—produced an artistic vocabulary that was more open, more "Western," particularly internally.

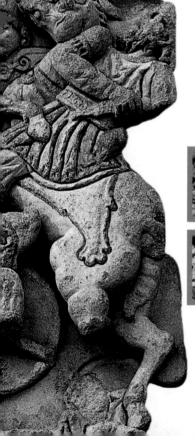

DETAILS FROM
THE ARCH OF GALERIUS,
THESSALONICA; LATE IMPERIAL AGE.

BYZANTINE ART

Artistically, the Byzantine period cannot be defined chronologically with precision. Constantinople developed its own artistic identity toward the end of the 4th century AD and Byzantine traditions continued until after 1453, the year when the Turks conquered the city. However, within that period it is not simple to define phases. In the Greek Orient, a basic conservatism emerged as a result of complex factors. One important factor was the awareness of the Byzantines

early Byzantine phase that culminated under Justinian (mid-6th century); a middle Byzantine age, split into two phases:, the Macedonian (826–1028) and the Comnenian (1081–1185); and a late Byzantine era known as the Paleologian period. The Iconoclastic crisis occurred during the first and second periods; and the Fourth Crusade and Latin conquest of Constantinople in 1204 happened in the middle and late periods.

Although the emperors and the elite in the capital were the major patrons of art,

Byzantine art was its involvement with religious thought and practice. Unquestionably the most important figurative medium was the mosaic. Even in the early Byzantine period, the portrayal of dematerialized figures on a gold background was the antithesis of the Classical statues and reliefs associated with pagan idolatry. Yet painting, whether on walls or icons, was the technique that was most widely employed. Christianity had existed in Greece since the time of St. Paul, yet resistance to the new

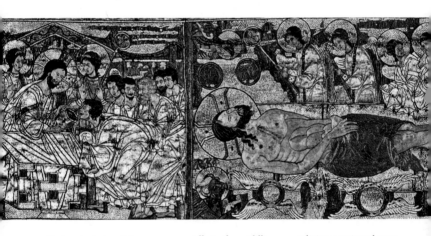

of being the heirs of the order of the Roman empire, and having the duty to safeguard ancient culture and civilization in a very changed world. Another was the control held by the political and religious authorities (do not forget the theocratic source of Byzantine power) of artistic activities, above all after the victory over the iconoclastic heresy (726–843). Nonetheless, three major periods can be identified: an

especially in the middle period or "golden age," the contribution of bishops and the provincial aristocracy was substantial, and the demand by the middle and lower classes for personal and domestic ornaments was also decisive. Architecture and the figurative arts were largely and deliberately used to display prestige, opulence, and power to the world at large; however, the most important factor in

religion continued even after the rule of Constantine, both in the countryside and the cities. No church seems to have been built in Athens before the middle of the 5th century, but the Christian communities were growing and large churches were soon constructed on the sites of ancient pagan sanctuaries. The plans of these churches were unusual, though influenced by Constantinople, Egypt,

and northern Italy. The most common were those in the form of a basilica (generally with a nave and 2 aisles, sometimes 4, but rarely with none) and *martyria*, i.e., places where martyrs and saints were worshiped among the tombs outside the city walls. These were usually cross-shaped, with a central square and a round or octagonal nucleus generally crowned by a dome.

The basilica "type" has an atrium, a narthex (vestibule preceding the nave), a nave flanked by two small aisles in which the columns were

Constantinople, basilicas with a gallery were seen and the plan with a cross-shaped transept became frequent. Atriums, narthexes, and annexes became increasingly complex. The precarious situation of the empire from the 7th to 9th centuries was reflected in religious architecture: new churches were humbler and relatively small in size, though their decorative programs were extremely rich and filled every corner of these reduced spaces. The 9th century saw the popularization of the "Greek cross" plan with an

particularly regarding construction techniques and decorations: *cloisonné* (enamel work) was widely used so that the strong contrasts of shifting light and shade were replaced by the use of color.

The decline of Byzantine independence began at the end of the 11th century, but it was not marked by a sudden disappearance of its art. Churches continued to offer repetitions and simplifications of the same schema up until the 15th century, while the ornamental design grew more complex in a "baroquizing" tendency until structural elements, overwhelmed and transformed by their decoration, lost their original significance and were merged into compositions of pure fantasy. The Seljuk Turks were masters in the use of tiles in ornamental bands, recesses, and pilasters and influenced the final era of Byzantine architecture, at first with an enrichment of profiles and surfaces, later with the use of polychrome. The increase in the amount of polychrome decoration employed on the exteriors of churches also led to beautiful mosaics and frescoes inside. The Byzantine aesthetic ideals in religious buildings during the middle period achieved their full realization in a

linked by low parapets, a short presbytery, and a *synthronon* (seating for the clergy) in the hemicycle of the apse. The use of a dome in the architecture of the *martyria* led to its employment in basilica structures and a progressive move away from traditional models. In place of the traditional wooden trussed covering over the nave and aisles, barrel vaults became more frequent. Following the example of

octagon at the center, and: the cross in a square or "quincunx" plan. This latter design was the most diffused during the Middle Byzantine.

During the 10th century, the influence of Islam was felt ever more keenly, especially in architectural decoration. In the regions of mainland Greece (with the exception of Salonica, called "little Byzantium"), religious architecture of this period was something apart,

DEPOSITION OF CHRIST; GOLD ARRAS ON SILK FROM THE EPITAPH IN THESSALONICA.

perfectly coherent series of painted and mosaic interiors. The large churches of the 11th century, like Hosios Lukas or Daphni, represented the "figure" of the Christian universe in which the divinity—incarnated in the figure of Christ—appears at the top of the central cupola and dominates the entire space. Under the Pantokrator lies his "court" of angels, prophets, apostles, martyrs, and saints in well-defined hierarchies that represent the preordained salvation offered by the Lord. Thus, the figure of Mary appears in the apse above the altar where the mystery of the Incarnation of the Eucharist occurs. The most important episodes in the life of Jesus—which constitute the "cycle of feasts" in the liturgical calendar—appear beneath the Savior. The building therefore represents the "earthly heaven" where the divinity resides and the figurative programs render this meaning explicit.

At the basis of this conception of architecture and its decoration lies the Neo-Platonic doctrine in which the perceptible world reflects the intelligible world, and form perceived through the senses can lead man to the supernatural sphere of God.

The artistic style that became codified in this period complied with the function of the image: the images are cleanly defined by outlines and created using a linear approach in which the color effects (a legacy from antiquity) confer solidity and organic unity on the figures. These, in turn, are rendered in a balance of naturalism and geometric stylization. As an integral part of the wall, they too are part of the "earthly heaven" but, at the same time, are detached from it by their very power and share the space with the worshiper and observer. Painting is the artistic expression in which it is easiest to understand the stylistic developments in Byzantine art. The key element is the persistent vitality of concepts and techniques inherited from Classical antiquity, of which first and foremost is the Hellenistic idea of the organic representation of the human figure. However, this interest in the representation of naturalistic and organic forms is constantly contrasted by an aspect of Roman art: a tendency to represent power or authority in terms of abstraction, geometrical interpretation, or dematerialization. This was seen at least until the 11th century when the two opposing forces began to achieve a certain balance. In the 12th century, new tendencies started to appear, like the "dramatic" effects of the so-called "dynamic" style in the late Comnenian period, or, a century later, the evolution of the two-dimensional vision toward a "volumetric" style. Later, in the Paleologian period, the emphasis was on a return to the naturalism derived from the Hellenistic age.

Byzantine art, indissolubly linked to the court, was essentially programmatic, an art that intended to instruct and teach. This was the starting point for the limits placed on its themes, carefully governed down to the tiniest details. Painting, in particular, was didactic, with the aim of displaying the facts of Christianity in a manner that was accessible to one and all.

Pagan idolatry raised terror in Christians (the Byzantine caution toward sculpture grew out of their fear of being "contaminated" by idolatry). An initial iconoclastic tendency increased until it led, in the first half of the 8th century, to a period in which representation of the human figure was rejected for 100 years. That exerted a profound influence on the next epoch and contributed to the development of the "spiritual" nature and "abstract" vocabulary that are typical of mature Byzantine art. Once the cult of images was re-established, a widespread distribution of icons occurred. Icons helped Christians in separating themselves from earthly reality with the result that the transcendent nature of anthropomorphic images was accentuated. On one hand, the stratum of popular art (re)emerges, nourished by the vitality of

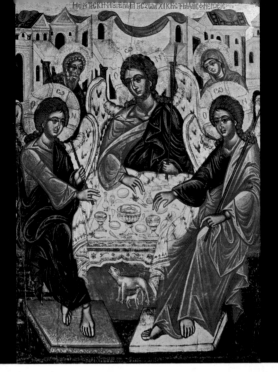

local traditions: for example, coarse expressionist realism, large heads, thick-set bodies, clumsy vehement movements, and a lengthy, ingenuous narration. On the other, a reaction set in that induced a return to Hellenistic, almost Neo-Classical, tradition which risked undermining the originality of Byzantine art. With the advent of the Macedonian dynasty (867–1056), the court rigorously exercised control in a sort of artistic monopoly that imposed linearity and calm, balanced compositions. Progressively greater moral commitment was required from painting; the abstract style was formed, intense with spirituality, that was to become the classic expression of religiousness. The principal means of artistic expression in the abstract style was the use of subtle and stylized linearity. Under the influence of court life, compositions became symmetrical and figures depicted frontally; everything was wrapped in an aura of solemnity. In the 13th century, the abstract tendency began to be replaced by that of optical unity. In this style, representation was given a spatial harmony, the use of different planes was introduced, greater volume given to elements in the landscape (especially buildings), and human figures were placed more freely in space, partly as a result of clothing rendered more volumetrically. During the period of what is termed the Paleologian renaissance (14th and 15th centuries), a unitary style became diffuse. Its initial phase centered on a pictorial approach and its second phase on a graphical stance that tended toward academism; both, however, shunned monumentality. The decoration in churches lost its rigorous unity and images were treated almost as icons—detached and isolated. Icon painting was of major significance in this period: Salonica stood out for its emphasis on realism, Mistras for being a hotbed of Hellenism. In the field of architecture, concepts existed that were common to all, but regional, if not provincial, schools began to determine their own way forward. External influences were also strong. (S.M.)

...

ABRAHAM AND THE THREE
ANGELS; LATE BYZANTINE PERIOD.

CHRONOLOGY

CRETE AND MYCENAE (3500–c. 1100 BC)

■ 3500–c. 1100 BC: Minoan culture. This is conventionally divided into the periods Ancient or Pre-Palatial Minoan I and II (3500–c. 2100), Middle Minoan I-III (2100–c. 1700) and Mycenaean (1600–1150).

■ c.2100: construction of the first palaces. Archaeological evidence suggests that political life and economy revolved around the palaces.

■ c.1700: destruction of the "first palaces," perhaps due to natural causes; construction of the "second palaces." The new buildings were larger and more refined, particularly at Knossos and Phaestous; there was probably a blooming of cultural life; "Linear A" script was invented.

■ 1600–1150: Mycenaean period.

■ c.1600: Achaeans arrive in mainland Greece. They were the first Hellenic race to settle in the peninsula.

■ 1450: Achaean conquest of Crete and settlement of the Mycenaeans in Knossos. The new arrivals impose their military and political supremacy but are influenced culturally by the Cretan civilization. They adapt the local script to their language, thereby creating "Linear B": this is the first form of Greek writing.

■ 1184: end of the Trojan War (traditional date). This episode marked the start of the decline of the Mycenaean civilization, which suffered as a result of internal struggles, raids by pirates (the "Sea People"), natural disasters, etc. The palaces were destroyed, probably by fire.

■ 1104: arrival of the Dorians in the Peloponnesus (traditional date). Passage from the Bronze Age to the Iron Age.

THE "HELLENIC DARK AGES" (1050–750)

■ 1050–750: the Hellenic Dark Ages or Middle Ages. This period marked the break-up of the old structures but also the creation of new political and residential forms that created the conditions for later developments. Ionians, Aeolians, and Dorians spread across mainland Greece, Asia Minor, and the islands.

■ c.800: writing began to spread. The alphabet used, with all its variants, was a development of the Phoenician script.

■ 776: the first Olympic Games were held. Sometimes the Greeks calculated the years and dates of events from this date.

THE ARCHAIC AGE (750–499)

■ 750–550: widespread colonization. Prompted by overpopulation, the flight of defeated

political factions, and the search for new commercial outlets, the Greeks journeyed to the western i Greci raggiungono il Mediterraneo Occidentale, gli Stretti e il Mar Nero Mediterranean, the Straits, and the Black Sea, where they founded coastal cities such as Syracuse, Catania, Crotone, Naples, and Marseilles. The new *poleis* were mostly independent of the mother country.

■ 624–620: legislation by Draco (traditional date). The administration of justice mostly passed from the *ghéne* (important families) to the State: penal law came into being.

■ 594–593: Solon's reforms. This great politician and poet laid down a timocratic system, i.e. based on wealth.

■ c.564-527: tyranny of Peisistratus in Athens. The college of the archons and Dionysian festivals were instituted; during the latter, theatrical performances were put on to pay homage to the great tragic and comic writers. The text of the Homeric poems that have survived to our day were written and defined. In the seventh and sixth centuries, the system of tyranny spread elsewhere. The term—which did not have the negative sense it has today—meant that power was held by a single citizen, usually of aristocratic origin, who reached the apex of the State without dynastic legitimation. Supported by a relatively broad social base, tyrants aided in freeing up situations of deadlock or excessive conflict between the various factions of society and often stimulated modernization.

■ 508: Cleisthenes' democratic reforms. New institutions like the *boulè* (council, with functions of government) and the *ekklesia* (assembly, to which all citizens belonged which had several responsibilities, including electing the magistrates) limited the power of the Areopagus (College of Elders).

THE IONIAN REVOLT AND THE PERSIAN WARS (499–479)

■ 499-494: the Persians put down the revolt of the Ionian cities. Once these cities had declined, the cultural center of the Greek world moved from the islands and Asia Minor—where epic poetry, lyric poetry, and philosophy had originated—to mainland Greece.

■ 480: the Second Persian War. The self-sacrifice of Leonidas at Thermopylae; the Athenian fleet defeat the Persians at Salamis.

■ **479**: the Greeks won two more battles, one on land at Plataea and a sea victory at Cape Micale,and proclaimed victory over the Persians. The threat of Persian invasion was permanently repelled.

THE CLASSICAL AGE AND THE PELOPONNESIAN WAR (479–404)

■ **478–477**: foundation of the Delian-Attic League. This assembled Athens' allies and countered the Peloponnesian League organized by Sparta. With the common enemy (the Persians) defeated, the two largest *poleis* contested supremacy over the Greeks and their relations worsened.

■ **461–430**: age of Pericles in Athens. Certain unsuccessful military initiatives were followed by a period of stability that marked the apogee of democracy and the power of Athens. The construction of the Parthenon represented an extraordinary cultural and monumental policy.

■ **431–404**: the Peloponnesian War. After a ten-year "study" phase and the ephemeral Peace of Nicias (421), the party led by Alcibiades prevailed in Athens and continued the war. One of its initiatives was the expedition to Sicily (415–413), which had clear expansionist aims, but it ended in disaster. The crushing peace terms offered by Sparta following its decisive victory at Aegospotamos (405) marked the end of Athenian power.

■ **430**: the plague in Athens. The plague claimed a high number of victims, one of whom was Pericles.

FROM SPARTAN SUPREMACY TO ALEXANDER THE GREAT (404–323)

■ **399**: Socrates condemned to death. Socrates was sentenced by the democrats, who had returned to power in 403 after ousting the oligarchy put in place by Sparta. The members of the oligarchy are ingloriously remembered in history as the "Thirty Tyrants."

■ **371–362**: Theban hegemony. This lasted a very short while between the battles of Leuctra and Mantinea. The two Theban generals, Pelopidas and Epaminondas, were its leading figures.

■ **359**: coronation of Philip II. Under Philip, Macedonia became an increasingly important factor and threat in the world of Greek politics, while at the same time its educated classes became rapidly Hellenized. Up till this time, we know very little of the Macedonians. They were probably descended from a line similar to the Dorians, but they were very coarse and backward. The Greeks were divided between supporters of an anti-Persian alliance with Macedonia and those who wished to defend Hellenic freedom at any cost against Philip. The two positions were represented and defended respectively by Isocrates and Demosthenes, the two greatest orators of the age.

■ **338**: battle of Cheronea. Philip II annihilated the coalition of the *poleis*, which lost their independence definitively. Two years later Philip was assassinated.

■ **336–323**: reign of Alexander the Great. Having taken his father's crown, the young ruler put down the last ambitions for independence of the *poleis* and united them—except for Sparta—in a. He occupied Syria and Egypt and conquered the Persians, inheriting the Persian Empire (330). He then continued as far as India where his series of conquests was halted only by a mutiny among his troops. He died at the age of thirty-three in Babylon (323).The empire he had created rapidly disintegrated, but the kingdoms created under his lieutenants (the Diadochs, literally "successors") were Hellenistic. The Greek language and culture spread beyond the borders of the motherland to achieve a cultural supremacy, which was destined to last for centuries, passed into history under the term Hellenism.

The *polis*, in the sense of a political organization, and mainland Greece began to decline, demographically and economically. Its marginalization in international commerce, the fall in the population, and the rise in banditry brought about a collapse in the quality of life.

THE HELLENISTIC AGE (323–31 BC)

■ **196**: Titus Quinctius Flamininus proclaimed the freedom of Greece. The Roman protectorate of the Hellenic peninsula began.

■ **168**: first defeat of the Macedonians at Pydna. Their king, Perseus, was taken to Rome in chains and, with him, his immense library; Macedonia was divided into four vassal statelets. There was a strong Hellenization of life, cultural and otherwise, in the *Urbe*.

■ **146**: final defeat of the Macedonians at Pydna. The Roman provinces of Macedonia and Achaea were created. That same year, Corinth was occupied and destroyed.

■ **86**: sack of Athens by Sulla. The internal struggles in Rome heavily involved the Hellenic peninsula, which was the theater for

bloody battles, sacking, and reprisals against the cities allied with the losers. Sanctuaries where large treasures had been deposited suffered particularly heavily.

■ **31 BC:** Octavian's victory at Actium and the end of the Roman civil wars. Reconstruction of Corinth and reorganization of the urban landscape in general. Mainland Greece remained at the edge of political life but experienced a period of stability and relative well-being for more than two centuries. In the second century AD, with the advent of the Second Sophism cultural movement, Greek language and culture also conquered the educated classes in the western part of the Roman empire. Under strongly philo-Hellenes like Hadrian and Marcus Aurelius, Greek antiquities, especially those in Athens, became objects of great interest.

THE IMPERIAL AGE (31 BC–395 AD)

■ **67 AD:** Nero proclaimed the liberty of Greece. But the declaration, which was in fact limited to fiscal exemption, was revoked after Nero's death.

■ **267:** the first barbarian invasions reach Greek territory.

■ **284:** ascent of Diocletian to the imperial throne. His reforms divided the immense and by then ungovernable empire into four prefectures (the so-called Tetrarchy) and transferred the imperial residence to Nicomedia (today Izmit, close to Istanbul). The eastern half acquired increasing importance and centrality compared to the western half, which suffered ruinous collapse as a result of military anarchy, a lack of stable rule, the deterioration of the social and administrative organizations, and the continual invasions of the barbarians.

■ **313:** Edict of Milan issued by Constantine granted freedom of worship to Christians.

■ **324–337:** reign of Constantine as sole emperor of Eastern and Western empires.

■ **330:** transfer of the imperial capital to Byzantium, which was renamed Constantinople.

■ **379–395:** reign of Theodosius I.

■ **c.393:** the 286th and last Olympic Games were held; the Games were then suppressed.

■ **380:** with the Edict of Thessalonica, Christianity became the state religion. Fanaticism, intolerance, and violence against paganism took root, and many buildings and masterpieces were destroyed.

■ **395:** on the death of Theodosius I, the empire was divided between his two sons:

Arcadius took power in the eastern provinces, and Honorius in the western provinces. The separation was consolidated over the centuries until it became definitive.

THE BYZANTINE AGE (395–1453)

■ **426:** the ruins of Olympia were razed to the ground on the orders of Theodosius II.

■ **450:** transfer of the Illyric prefecture to Thessalonica (today Salonika). The city became the main center in the Hellenic peninsula.

■ **451:** Council of Chalcedon. The Monophysite heresy was defeated but spread into Syria and Egypt, which were already on bad terms with Constantinople for economic and fiscal reasons. The unity of the Byzantine empire began to crack.

■ **476:** the Western Empire fell with the deposition of Romulus Augustulus.

■ **527–565:** reign of Justinian. Far-reaching reorganization of Roman law: compilation of *The Digest*, *The Institutions,* and the first and second *Codex Justinianus* into what is referred to as the *Corpus Iuris Civilis*; this was backed up by the creation of the current legislation, known collectively as the *Novellae.* The period was characterized by the exaltation of religiousness and the dream of reuniting the Empire under a single crown. Justinian's military campaigns in the West brought short-lived conquests and caused unsustainable expenses that led to the neglect of the southeastern borders. The Christian Church and monastic institutions increased their power and wealth; construction of the church of Hagia Sofia.

■ **529:** Justinian ordered the closure of the philosophy schools in Athens.

■ **641:** death of Heraclius. In previous years the Arabs had conquered Syria, Palestine, and Egypt; in those to come, they extended their dominion across all of North Africa. Latin was restricted to bureaucratic use; Byzantium lost its imperial dimension and was transformed into a Greek-speaking medieval kingdom.

■ **c. 730–843:** Iconoclastic period. The supporters of the Iconoclastic movement (literally "break the images"), which prohibited representation of any form of divinity, opposed the followers of the worship of holy icons and the extreme power of religious institutions. They were defeated, but the fallout of the episode led to a strong subordination of the ecclesiastical hierarchies to the State. Worsening of relations with the Church of Rome.

■ **867–1028**: period of the kingdom of the Macedonian dynasty. In its initial phase the Byzantine Renaissance occurred. Rediscovery of secular literature, in particular ancient literature; the patriarch Photius collected more than 300 works in his library. Important progress in the economic field, military recovery against the Arabs, and Christianization of the Slavs.

■ **1054**: schism between Rome and Byzantium following the bull that excommunicated the Patriarch Michael Cerularius.

■ **1071**: battle of Mantzikert (today Malazgirt). The Seljuk Turks succeeded in penetrating the territory of the Byzantine Empire. During this year, the fall of Bari to the Normans signified the loss of the last Byzantine holding in the Italic peninsula. Decline set in on all fronts; in economic difficulty, the Empire was forced to give trading favors to western merchants.

■ **1204**: sack of Constantinople during the Fourth Crusade. The Latin Empire was established on Byzantine territory. The burning of the libraries destroyed the last surviving copies of masterpieces from antiquity.

■ **1261**: the Latin Empire fell definitively with the reconquest of Constantinople.

■ **1274**: during the Council of Lyons, Emperor Michael VIII formally subjected himself to the Papacy. Despite this and other attempts, relations between the two Churches did not improve, which left Byzantium undefended against the advance of the Ottoman Turks. Serious internal disagreements and an economic crisis did the rest.

■ **1373**: Emperor John VI Cantacuzene was constrained to formally acknowledge the suzerainty of Sultan Murad I.

■ **1438–39**: during the Councils of Ferrara and Florence, the union of the two Churches was sanctioned, but Emperor John VIII did not dare to proclaim it officially.

■ **1453**: the Ottoman army stormed Constantinople (May 29) . The Byzantine Empire ceased to exist.

THE OTTOMAN AGE (1453–1833)

■ **1461**: the Ottomans conquered and subjected the Trebizond Empire, the last independent Byzantine territory. They later annexed the islands, including Cyprus (1571) and Crete (1669). Fragmentation of communities and difficult living conditions blocked every reaction by the Greeks.

■ **1571**: battle of Lepanto.

■ **1645–1669**: wars between Venice and the Ottomans. Crete passed to the Turks.

■ **1684–1715**: Venice occupied the Peloponnesus. Deterioration of the Empire's infrastructures and the growing strength of the Greeks in trade reopened the question of independence.

■ **1821**: insurrection in the Peloponnesus while the Ottomans fought Ali Pasha.

■ **1827**: at Navarin (today Pylos) the allied English, French, and Russian fleets destroyed the Ottoman navy. The brutal, centuries-old Ottoman domination was over.

■ **1830**: the protecting powers established the borders and constitutional form (monarchy) of the Greek state. The new kingdom covered only the territories south of Athens, excluding Thessaly and the Hellenic communities in Asia Minor. Otto of Bavaria was invited to take the throne.

■ **1833**: Otto of Bavaria lands in Greece.

FROM INDEPENDENCE TO THE MODERN ERA

■ **1834**: the capital was transferred from Nauplia to Athens.

■ **1864**: the Ionian islands passed to Greece.

■ **1881**: Thessaly and part of Epirus passed to Greece.

■ **1912–13**: two wars in the Balkans, Greece annexed Crete and part of Macedonia but not northern Epirus, which was included as part of the newly created Albania.

■ **1919**: after victory in World War I, Greece's requests for territories in Asia Minor clashed with the chaos on the future of Anatolia. Hellenic troops landed in Smyrna.

■ **1922**: Kemal attacked Smyrna, the Christian districts were burned to the ground. Start of political instability in Greece.

■ **1923**: Treaty of Lausanne, exchange of people based on religion. More than one million refugees headed for Greece.

■ **1940–41**: the Italian army attempted to invade Greece but was repelled on the Albanian border.

■ **1941–1944**: occupation of Greece by the Axis powers.

■ **1946–49**: civil war between the government (populist) and the Democratic Army (communist).

■ **1951**: Greece became a member of NATO.

■ **1960**: Cyprus, at the time a British colony, gained independence.

■ **1967–1974**: military dictatorship.

■ **1974**: a referendum sanctioned the Republic on a permanent basis. The Turks landed in Cyprus and occupied the north half of the island.

■ **1981**: Greece became the tenth member of the EEC.

1

ATHENS

The city area has been occupied since the Neolithic era, as demonstrated by the remains of huts, wells, and pottery on the southern and northwest slopes of the Acropolis, and in the area around the Klepsydra spring, though these were all small inhabited centers rather than extended settlements. The site's historical period began with the Mycenaean age: the many "heroic" myths of the royal period were supported by impressive buildings on the Acropolis itself (defended by solid walls known as the *Pelasgikon* in accordance with the tradition that the Pelasgi were the first inhabitants of the Acropolis itself), including a palace, the memory of which survived in the historical era in the cults of Zeus *Polieus* and Athena *Polias*. Evidence of a "lower city" complete with necropolis has also been found. Athens was the capital of a kingdom to which the myth of the synoecism (unification) of Theseus alluded. The Ionic resistance under King Codrus to the Doric invasion did not lead to a decline, but it was undoubtedly this situation that brought about the

sudden abandonment of the houses outside the walls on the north slope of the hill about the mid-12th century BC. However, reoccupation of much of the "lower city" (wells in the zone of the agora and to the west of the Areopagus) and large tombs with gigantic symbols in the Kerameis district demonstrate that a strong resurgence marked the post-Mycenaean phase that

lasted throughout the Geometric Age (1050-700 BC). Such vitality and splendor was the fruit of the Attic colonization led by the aristocrats (known as Eupatrids, "from illustrious stock") during the 9th century BC.

Athens experienced several forms of government: first monarchy, then oligarchy of nobles, next tyranny, and finally democracy. The key figure in the transition from the monarchy to the oligarchy was that of the archon. The king transformed himself into archon for life, then into archon with a mandate of 10 years, and finally only a single year as he lost power.

Moreover, his appointment was fragmented: the archonate became organized into a panel of nine members, while the Areopagus, a council of elders composed of former archons, seconded it. Increasing pressure from

those social classes excluded from power led to: important changes, and it was more by Draco than Solon (594-593 BC) that the innovation in institutions was created. This was to bring new life in Attica to the class of small landowners that was to form the base for economic and demographic development. The Timocratic constitution (or *censitaria*) introduced by Solon established the equal division of taxes based on

fundamental event for the layout of the city occurred: the creation of a new agora, as opposed to the old one at the foot of the Acropolis, with a series of new political buildings.

The rapid economic and social evolution resulting from Solon's reforms displeased the aristocracy as it saw its power eroded by the new rich. The tension and conflict between the landowning nobility on the one hand, and the classes of merchants and craftsmen

treatment of small farmers, craftsmen, and traders. He introduced *strategi* (generals with wider responsibilities) and paid close attention to the Straits area, gaining better control of the Aegean. The setting up of the Great Dionysia and the reorganization of the Great Panathenaea also gave his period of rule a cultural dimension. The period of tyranny was one of intense construction that changed the face of the city, in particular the Acropolis

41

ATHENS

four classes of income; it opened the way for a higher number of individuals to achieve the highest appointments; and it created a people's justice system that had its new tribunal in the Heliaea. In this period a

and on the other, led to the transitory form of government known as tyranny. After the failed attempt by Cliton in 636 BC, Athens was ruled by the tyrant Peisistratus from 560 BC, and contemporaries praised his favorable

and the agora; in addition the city received its first theater, the gigantic temple of the Olympieion, and the gymnasium in the Academy. Peisistratus' sons Hippias and Hipparchus were unable to live up to the prestige of their father and

tyranny was abolished in 510 BC. In 508 BC, Cleisthenes pushed through a reform to the constitution that created a new balance of power in the institutional: bodies by dividing up Attica on a different basis. In place of a by the people's assembly (*ekklesia*), the power of which had grown to the disadvantage of the Areopagus (old aristocratic council). Another innovation was the law of ostracism (from the word *ostrakon*, meaning the potsherds on creation of the Delian-Attic League in 478–77 BC. The political climate between the conservatives and the progressive democrats was also tense. Cimon, who led the conservatives, believed that Persia was the power to fear and wanted peace with

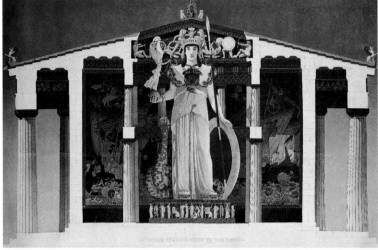

division based on kinship, i.e., the ancient 4 Ionian tribes based on kinship, he created 10 territorial tribes composed of 3 districts (*tryttes*, "tribal thirds")— one urban, one coastal and one internal—in an attempt to break up the alliances and special interests and render the civic body more homogeneous. Each tribe drew lots to choose 50 people to make up an annual council (*boulè*) of 500 members. Each group of 50 (*prytanea*)directed the council on a rotating basis. The task of the council was to prepare the political topics debated and voted on which members of the assembly wrote the name of those they wanted exiled). The newborn democracy continued its building program in the agora and on the Acropolis until it was interrupted by the Persian invasion of 480 BC. After the battle of Marathon the Athenians strengthened their institutions with the election of the archons. The outfitting of a large fleet under Themistocles brought Athens victory over the Persians, and it became the largest naval power Greece. This in turn allowed it to extend its hegemony in the Aegean Sea through the the other large Greek political force: Sparta and the Peloponnesian League. The progressives, led by Themistocles, were more open about the future and worried most by Sparta, the only competitor to Athens' hegemony over Greece. (As a result of this concern, the leader had new walls built that also enclosed the port of Piraeus.) Themistocles' successor, Ephialtes, managed to further weaken the power of the Areopagus by reducing its responsibilities to dealing only with violent crimes and passing its jurisdiction over civil offences to the

people's tribunal. On Ephialtes' death, Pericles took up leadership of the democratic party. He was elected *strategus* for many consecutive years with the support of the people. This is the portrait of Pericles given by Thucydides (II, 65, 8):. "Pericles, powerful on account of his dignity and sense, clearly incorruptible by money, dominated the people without limiting their freedom, and was no more led by them than he himself led them. . . .So in Athens there was democracy, but in fact [it was] power entrusted to the first citizen." Pericles immediately dedicated himself to the reconstruction of the symbol of the city, the Acropolis. This was the most demanding and certainly the most visible task in a structured program that affected almost all of the city and its surrounding area (Eleusis, Rhamnous, Acharnae, and so on.) with the goal of giving them an "imperial" appearance worthy of the role that Athens now played in Greece and the Mediterranean. In fact, Cimon had conceived a program for providing the agora and its surroundings with a new ideological and monumental face.

A series of events allowed the city to expend a new bout of energy in the 4th century: the Peloponnesian War, the oligarchic "putsch" after the collapse of Athens, the return to democracy, the surrender to Sparta in 404 BC, the government of the Thirty under Critias, and the final restoration of democracy by Thrasybulus. Launched by Conon, this new phase of development was a period of great splendor under Lycurgus between 350–330 BC, with the construction of many buildings and the completion of others. The theater was of particular importance. The early period of Hellenism was one of stagnation for the city, bound up as it was in the struggle against the growing power of Macedonia. In the 2nd century BC, the ancient cultural prestige of Athens returned once more and attracted the beneficence of eastern rulers, in particular those of the Attalids of Pergamum. In addition to their three huge donations to the Acropolis (near the Pinakotheke, on the south wall, and near the northeast corner of the Parthenon), they sponsored extensive work in the agora, which, in the 2nd century BC, took on an oriental appearance standardizing its sides with large porticoes. Following Sulla's sack of Athens in 86 BC, Augustus launched a program of moral and religious renewal of the city, centering on a conservative policy of architectural and urban development. He started a program of temple restoration in all of Attica. Even though he bore the title *Soter*, he was careful not to emphasize the extent of his power, and thus the impact of the building that symbolized this program— the *tholos* on the Acropolis, dedicated to Rome and the genius of the emperor—was contained. Also, the rebuilding work undertaken in both the Greek and Roman agoras was generally "commemorative." Hadrian's interest in Greece allowed Athens to again become a cultural capital and the home of philosophical and artistic schools. The crisis in the city during the late imperial era of Rome, following a period of new splendor then destruction by the Herulians in 267 AD, culminatedwith the invasion of Alaric and the Visigoths in 395. The 5th century AD, however, saw the resurgence of Athens and the construction of a large gymnasium in the center of the agora. The Byzantine Emperor Justinian's closure of Athen's schools of philosophy in 529 sparked the city's decline, and the Slav invasion in 582 marked the end of the history of the ancient city.

..

OPPOSITE: STATUE OF ATHENA PARTHENOS, 119TH-CENTURY ENGLISH PRINT.

THE MYTHS

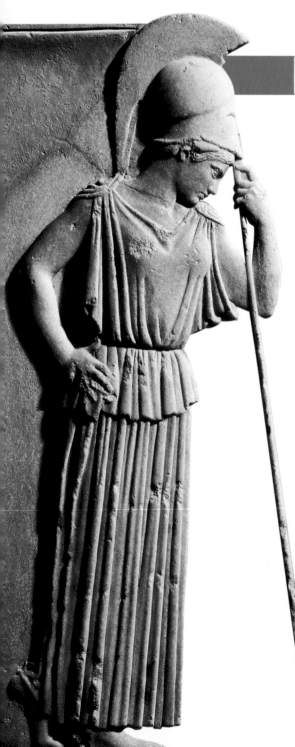

The greatness and prestige of Athens followed from the greatness of its people and, naturally, from the favor of the gods—in particular, Athena, after whom the city was named. Athena was the goddess of intelligence, creativity, and the value and strength of the spirit. As the Italian classical scholar Dario Dal Corno has emphasized, the beginnings of Athenian mythology were marked by the coexistence of man and the gods. According to St. Augustine, the decision to make the city the seat of Athena's cult was made by the people rather than by divine assembly as normally occurred. The myth told that Athena and Poseidon competed for the settlement, at that time still nameless , by placing gifts on the Acropolis. Poseidon's gift was the sea, but he was trumped by Athena's simple gift of an olive tree. The assembly of the people, called to decide by King Cecrops, chose Athena as their patron. The assembly was composed of more women than men, and the women voted en bloc for the wise

goddess. In anger, Poseidon caused a dreadful flood that covered all of Attica. To placate the offended god, the Athenians decided to exclude women from all future voting.

The relics of that myth, a fountain of brackish water and the olive tree, are still conserved in the Erechtheum on the Acropolis, as well as the commemoration of the first king, Cecrops, the serpent king. He was thus called because he was born from the earth—snakes live close to the land—and he always represented the city's link with the earth. The Athenians believed themselves autochthonous, unlike other Greeks who had all come from elsewhere.

The earth was also the mother of another great king Erechthonius. Athena was extracted from Zeus' brain by Hephaestus, the gods' smith, who then fell in love with the young girl. After the humiliation of his defeat in the contest for the city of Athens, Poseidon decided to avenge himself by encouraging Hephaestus to take the virginity of the young goddess by making a formal request for her hand in marriage to her father Zeus (according to one version of the myth), or by taking her by force (according to another). Athena succeeded in evading Hephaestus' embrace, but his ardor was such that some of his seed fell on the goddess's thigh. She cleaned herself with a wad of wool that she then threw on the ground, but the Earth was impregnated by it. This led to the birth of Erechthonius, the second part of whose name indicates his origins from the ground.

Abandoned, however, by the Earth, the baby boy was taken in hand by Athena who, unable to take care of the youngster, placed him in a basket and handed him over to the daughters of Cecrops with the instruction that they should not look inside—and that is exactly what they did. On seeing the contents— depending on the version of the myth, either a snake, a baby with a snake's tail, or a baby guarded by two snakes—the girls were so frightened that they threw him from the highest part of the Acropolis.

Erechthonius took shelter in the hollow of a shield belonging to Athena, and when he became king, he founded the goddess's first temple on the Acropolis and the festivities that honor her. And it was to him that the monument that contains the traces of the city's ancestral myths was dedicated—the Erechtheum. Another important chapter in Athenian mythology could be titled "Theseus, or democracy." This hero, a king of Athens, was the son of Aegeus and was involved in many famous exploits along the lines of those of Heracles. In a certain sense, the Athenian Theseus was a rival to the Doric Heracles, although they were in fact good friends and were both great-grandsons of Pelops. After Theseus had united the local communities of Attica into a single state under the aegis of Athens, enlarged to include its suburbs, he renounced his title as king in the name of the equality of all citizens, and reserved for himself only the command of the army and the role of the guardian of the law (Plutarch, *Life of Theseus*, 24–25).

45

ATHENS

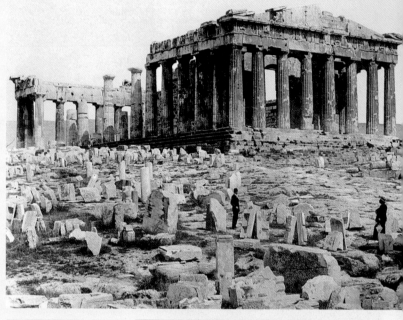

THE EXCAVATIONS

Excavation work in Athens has been highly unusual, almost unique. Unlike Rome, the past of which was consumed as the city grew larger, in Athens the Turkish occupation prevented any exploration of its antiquity until long after the European Middle Ages.

The artistic renaissance in Europe, closely linked to its Roman heredity, attempted to draw on the monumentality of classical Greece and of Athens in particular. It did not succeed (owing to the presence of the Turks) in going beyond the writings and collections that had been acquired in the Hellenic east. Thus throughout the Renaissance and Baroque periods, there existed a "myth" of the greatness of Greek art that was stronger than Europe's historical knowledge of it.

The almost four centuries of Turkish domination (1453–1832) marked a real distancing of Athens from Europe, exacerbated by the fact that the trading routes with Constantinople did not pass through the Greek city, instead touching on Crete, Rhodes, and Cyprus.

Letters from Constantinopolitans published in a volume by M. Kraus (*Turcograecia*, 1584) inform us that at the end of the 16th century Athens had about 1,200 inhabitants: some Christian, who lived in the lower city, and Turks, who lived in the Acropolis. However, the information is so vague that the Parthenon is referred to as the "Pantheon" and the "temple of the unknown god."

Around the middle of the 17th century, Britain and France began to establish contacts with Athens and

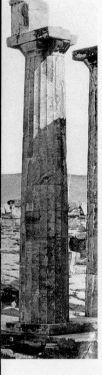

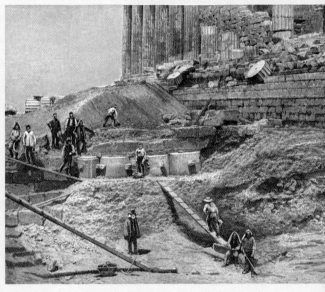

the Greek world, first in the form of political and commercial interests. In 1630 Baron Louis de Hayes, Louis XIII's ambassador to Constantinople, visited and described Athens in his *Voyage du Levant* (Paris, 1632) and was astounded by the Parthenon, which was then still fairly in tact, *"comme s'il venait que d'être fait"* ("as if it had just been made"). A French consulate was set up in the city in 1658, and in the same year, Capuchin monks founded a monastery around Lysicrates' monument and drew up the first modern plan of the city. The first

depiction of the Acropolis is dated 1670, probably the work of a Venetian artist. The French consul, Jean Giraud, acted as a guide to the few foreign visitors to Athens, one of whom was the Marquis de Nointel, the French ambassador to Constantinople (1674). Nointel commissioned from the painter Jacques Carrey a series of drawings of the Parthenon sculptures; the drawings are now in the Bibliothèque Nationale in Paris. Today these are extremely important documentation of the site (even with a little artistic license) before the bombardment underwent a few years later.

On September 26, 1687, the Parthenon (which the Turks had turned into a powder magazine after they had removed the Christian church set up inside it) was hit by gunfire. Canons were aimed at the Acropolis by Francesco Morosini during a siege of the city in the course of the Venetian attempt to reconquer Crete. The explosions destroyed about half of the temple. This destruction was compounded by Morosini's clumsy attempt to take down the stone quadrigas (four-horse chariots) on the west pediment to take back to Venice; instead, they fell and broke on the rocky

slopes of the Acropolis. Venetian officials collected the various fragments, which were then dispersed among collected by the Venetian various museums and collections in Europe (including Rome and Copenhagen, in addition to Venice). However, Morosini's venture also brought reports, plans, and views of the city that gave the rest of Europe, at the start of the 18th century, better knowledge of the city. In 1707 Francesco Fanelli published *Attic Athens*.

Some years earlier, in 1674, a young doctor from Lyons, Jacob Spon, published *The Current State of the City of Athens*, written on the basis of a letter received from the Jesuit J. P. Babin. Soon after Spon visited Athens in person with an English friend, George Wheeler. Together they published the first scientific topographical summary of Greece, as part of the book *Voyage d'Italie, de Dalmatie, de Grèce et du Levant* (Lyons, 1678). For the first time, a scholarly connection was made between ancient sources— principally the 2nd-century AD Pausanias (author of the invaluable *Description of Greece*)—and the monuments. The book was translated into various languages and widely by Europe's cultural elite. From that time on, the Grand Tour of Europe included Greece and, in

particular, Athens. During the last few decades of the 18th century, the French gained a monopoly on the flourishing market in antiquities in Athens. One particular individual in this activity was Louis-Sébastenti Fauvel, who succeeded in transporting to Paris a metope and a slab from the Parthenon frieze. The Society of Dilettanti was set up in London in 1733 with the aim of encouraging and financing cultural ventures related to the ancient arts. In mid-century the Society asked the painter James Stuart and architect Nicholas Revett to measure and draw the ancient buildings and sculptures of Athens, between 1751 and 1753. The first volume of *Antiquities of Athens* as published in 1762. Another three volumes followed in 1788, 1794, and 1816. Europeans gained a precise idea of Greek art and, in particular, its architecture through the very beautiful plates in these works. Another important figure in the diffusion of Greek inspiration into England was the Scot Sir Thomas Bruce, Earl of Elgin and Kincardine. His name is indissolubly linked to the "Elgin" marbles of the Parthenon and the current problem of their conservation. Lord Elgin managed to be appointed British ambassador to Constantinople. There he organized a team of Italian

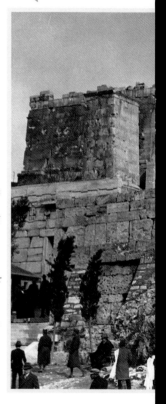

artists and engineers whom he had engaged during his trip to the Sultan's capital and sent them to the Acropolis in 1800. After initial refusal, Suleiman III signed a decree that opened the road to "the taking away of some pieces of stone with inscriptions and figures." It was this clause or provision that allowed the systematic looting of the Parthenon's

marbles and also led Lord Byron to pronounce his famous invective, "*Quod non fecerunt Goti fecerunt Scoti*" ("What the Goths did not do, the Scots did"), referring to Elgin's Scottish background. In 1803 all decided to purchase the entire collection for the British Museum. The Classicism of ancient Greece now definitively entered European culture. After the Greek nation's successful struggle for Klenze, private counselor to King Ludwig I of Bavaria, and the architects Schaubert and Kleanthes. Following removal of all Turkish constructions, thanks to the contribution of the new Greek

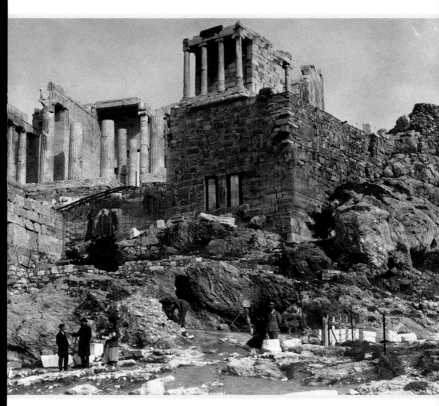

this material arrived in London (after an eventful journey, including a shipwreck), where Elgin rented a house in Mayfair to accommodate the 280 chests that had arrived from Athens. After long discussions and negotiations (partly caused by King Ludwig I of Bavaria's competing offer to buy the marbles), the House of Commons independence from Turkey, Otto of Wittelsbach (the Bavarian ruling dynasty) was chosen as the first king of Greec, in 1834. When he reached Athens and climbed the Acropolis, this site—one of the most important in the history of the Western world—had for two years been under restoration by the German archaeologist Ludwig Ross, with the supervision of Leo Archaeological Society (1837), it was finally possible to begin excavation of the Acropolis under the direction of Panagiotis Kavvadias. The visit to Athens described here begins from the Acropolis.

THE PROPYLAEA
IN 1925.

ITINERARIES

Athens was Classical,
Athens was (a little)
Byzantine, and then it
was chaos. The city is
indeed a blend of styles
in which it is possible

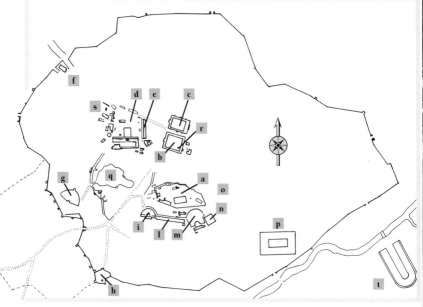

to recognize the many
periods of its tormented
history, even after the
end of the Turkish
occupation. The same
can be said of its
people's dress and
styles, especially the
cosmopolitanism of the
men's moustaches and
beards. And it is
perhaps just for this
reason that a foreigner
feels at home here, as
well as for the fact that
Athens represents the
roots of a civilization
common to the entire
West. Athens is an

obligatory stop on any
trip to Greece. Provided
here is a series of short
itineraries centering on
a place or site, or
focused on a historical
epoch; one route would
take too long and be
confusing and
exhausting. This series
of short visits will
together cover the
history of the city, or at
least its most important
phases. And, given that
much of the
centerprohibits:
vehicles, they are
pleasant walks that lead

to the discovery of a
phantasmagorical city.
However, do not forget
the new and very
convenient
underground train
system. The
construction project
allowed scientific
excavation from 1992
to 1997 of a surface
area of 750,000 square
feet in crucial sites of
the ancient city.
Ancient structures
stand *in situ* in stations
along with the most
important of the more
than 30,000 items

found; in other words the stations themselves are small museums complete with excellent and informative captions.

The most fascinating of the following itineraries is the tour of the **Acropolis (a)**, its southern slopes, and the Plaka district. Following a series of itineraries radiating out from the city center, you can reach the **Roman agora (b)** and **Hadrian's Library (c)**, which is itself an ideal base for an attractive tour of Athens' Byzantine churches. Not far away lies the **Classical agora (d)** with a museum housed in the rebuilt *stoa* of **Attalus (e)**; next door is the **Kerameis (f)** and its own museum. The walk to the **Pnyx (g)** and **Mouseion (h)** is one of the most pleasant in Athens; if you have time, visit Lycabettus Hill using the funicular railway from Leoforos Vassilissis Sofias, and the Zappion in the center of the National Garden next to Sintagma Square. Not far from the stadium, the square was rebuilt in 1895 on the site of its ancient equivalent. The **Olympieion (p)** and Hadrian's Gate are another obligatory stop among those that ring the Acropolis. And finally, a visit is necessary to some of the city's museums: (most important is the National Archaeological Museum, then the string of pearls composed of the Benaki Museum, the Museum of Cycladic Art, the Byzantine Museum, and the National Library, which all lie, more or less, along Leoforos Vassilissis Sofias. A possible detour is to the Museum of Popular Art.

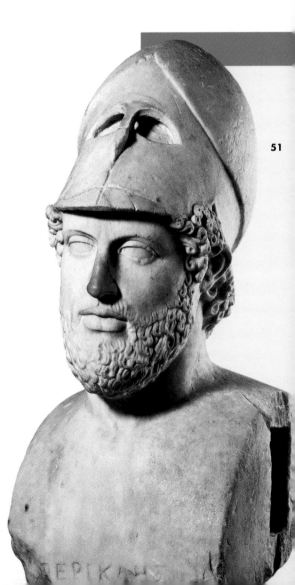

51

1.1

seen between the **Propylaea** (a) (monumental entrance) and the **temple of Athena Nike** (b), where the entrance to the Acropolis lies. Steps cut in the rock brought into the fold in either the 8th or 7th century BC) seems to offer greater support to the traditional hypothesis. Almost nothing is known of

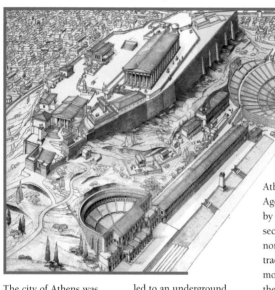

The city of Athens was founded beside the Acropolis in the same way, it might be said, that Athena was miraculously born from Zeus' head. This limestone platform, accessible only by the west side, was originally a Mycenaean fort. It seems that a palace was built here in the 13th century BC; terracing and cuts in the rock indicate its position to have been between the **Erechtheum** (c) and the **Parthenon** (e) and reveal that it had a *megaron* with a front court and secondary buildings (perhaps warehouses). A defensive wall (the *Pelasgikon*) protected the hill, and solid vestiges of this can still be led to an underground spring close to the north edge of the esplanade. Mycenaean materials found on the south slopes toward the Illissos River seem to confirm Thucydides' description (II, 15, 3) of the extension of the settlement. An attempt at finding parallels between the myth and discoveries tends to give Mycenaean Athens a predominant role over the other cities in the region and, therefore, to bring the "synoecism of Theseus" forward to the 13th century BC. However, the gradual nature with which administration was centralized (the final step was when Eleusis was

Athens in the Geometric Age. Occupation is proven by tombs in the southwest section and pottery on the north slopes, but there is no trace of buildings. Athens' most ancient cult – that of the mythical King Erechthonius, is positioned in the area of the Mycenaean palace with a 7th-century BC temple. What was to be the new religious use of the Acropolis was probably based on the form of open-air cults: the political and administrative functions were moved northwest outside the walls in what was later called the *archaia agora* or "agora of Theseus." At the end of the 7th century, following the economic and political revival stimulated by Solon, the monumental phase of the Acropolis was begun with the construction of a first large temple with

pedimental decoration in the area of the Parthenon. A *hekatòmpedon* with pediments made of *pòros* The east pediment: features 2 lions fighting a bull and

Heracles fighting the 3-bodied monster Nereus, with Triton; the west pediment has the lions on their haunches, and 2 serpents). New construction

of a public character was begun, probably in 566, in relation to the reorganization of the Panathenaic festivities; for example, a new temple in the area that later lay between the Parthenon and the Erechtheum, and the

OPPOSITE: ARTISTIC RECONSTRUCTION OF THE ACROPOLIS.

ABOVE: LIONS AT THE ENTRANCE L

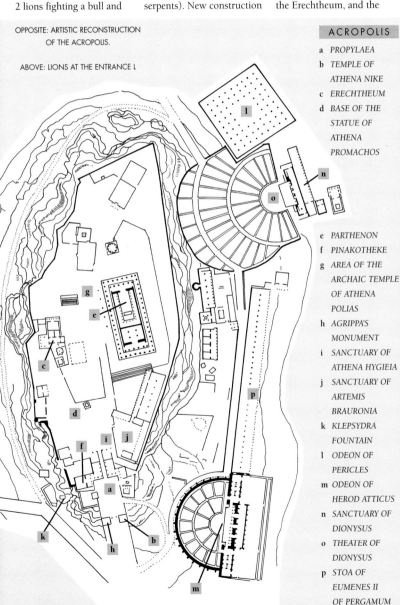

first layout of the sanctuary dedicated to Athena Nike. A number of less important schemes were carried out during the tyranny of Peisistratus, however, the exact location, size, or appearance of the various temples and small sacred enclosures from this period are unknown because of destruction under the Persians and extensive rebuilding in the Classical era. Many fragments have been found from the buildings or their sculptures. The reconstruction of the **Archaic temple of Athena Polias (g)** about 520 BC brought innovations in Athenian temple tradition. Most important were the high-relief sculptures on the pediment, marble acroters, and the introduction of metopes and guttering along the pediment. After various attempts to date the "old Parthenon" to the period in which Cimon was active, it now seems certain that this building was founded before the Persian destruction of the Acropolis: there are traces of fire inside the stereobate and on parts of the partially exposed raised section of the building in the north wall of the Acropolis.

The first Propylaeum should also fall within this chronology. After the Mycenaean entrance and the first "monumentalization" of the Acropolis circa 566, the "old Propylaeum" was built soon after the battle of

Marathon. The first small *poros* temple dedicated to Athena Nike (which lies beneath the Classical construction) dates to the same period. In the period between Themistocles and Cimon the city was mostly busy constructing defenses and bound by the vow not to rebuild the temples destroyed by the barbarians, so little construction was undertaken on the Acropolis. Under Cimon the long straight stretches of the south walls were marked out and built with the booty

won by the Athenian general Eurymedon, and the area around the **Klepsydra fountain (k)** was monumentalized. At this time the protracted execution of the colossal bronze statue of the *Promachos* was begun by the young PHIDIAS. It was commissioned as *anathema* for the victory over the Persians. Next came the "miraculous" period under Pericles, made possible by the enormous financial and intellectual resources available. Although formally

religious, the program was in fact political: the ideological background to the project is betrayed by the argumentative atmosphere in which it was being implemented, and the incomplete state of the program once the political conditions changed is proof of it.

In 449 BC the Peace of Callias confirmed Athens as the leading power in the Aegean. This followed from its dominant position within the Delian League. In 454 BC the League's treasury had been transferred to Athens, which the city soon made use of for purposes that were not purely defensive despite infringing the agreements by doing so. It was Pericles' intention to make the city that had guided Greece to freedom supreme, a supremacy that was not just military, but also economic, political, and cultural. An aspect of this plan was the construction of large monuments on a nearly deserted Acropolis. However, there was another contributory factor: the discovery at Sounion of silver mines during Themistocles' rule and the construction of a large fleet. In short, the conditions that made possible the new development were greater well-being and participation in political and social life.

Athena *Promachos*
The epithet *Promachos* refers to the colossal bronze statue made by PHIDIAS between 460–50 BC as *anathema* of the city for the victory at Marathon or, perhaps, after Eurydemon to celebrate the end of the Persian War.

The **base (d)** of this statue is identifiable, but its appearance can only be hypothesized. One theory, that it copied the colossal statue of Athena in Constantinople as described by Nicetas Choniates, which was melted down during the Fourth Crusade is debatable. A possibility is that the statue was a standing figure holding a spear and shield, perhaps with Nike to her right.

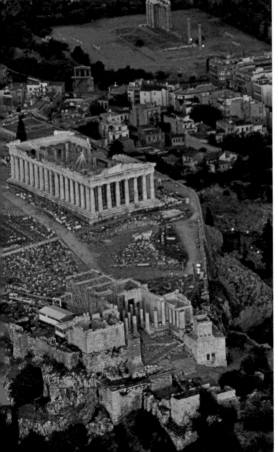

LEFT: THE ACROPOLIS SEEN FROM THE WEST.

ABOVE: IONIC CAPITAL ON THE ACROPOLIS.

PARTHENON

The chryselephantine (finished with gold and ivory) colossus of Athena *Parthenos* (41 feet high) was the starting point for construction of the famous is the small Varvakeion statue. In this the goddess stands, dressed in a Doric *peplos* with the aegis on her front, and holds a Nike on the palm of contrasts of Greek versus barbarian, intelligence versus force and *sophrosyne* versus *hybris*. The accounts relating to the execution of the statue (447–438 BC)

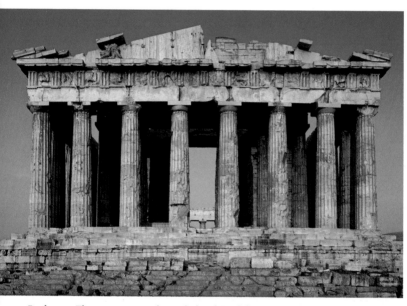

Parthenon. The greatest sculptor in Athens, PHIDIAS, was commissioned to produce the statue and to supervise the related activities, first and foremost the construction of the temple that was to house the statue. Whether *Anathema*, ex-voto, or not a cult statue (this last was the function of the wooden statue in the temple of Athena *Polias*), we have only a few copies of Phidias' work. Of them, the most her right hand. With her left she holds a shield that rests on the ground while her spear leans against her shoulder. On her head she wears a richly decorated Attic helmet with a triple crest; her shield has a gigantomachy painted on the inside and an amazonomachy sculpted on the outside; her sandals have a centauromachy on the edges of the soles. These scenes provide a constant reference to the and the epigraphic records of the regular controls made on the weight of the gold reveal the extraordinary accumulation of riches in the coffers of Athens. Although the work may not have excited modern sensibilities, it certainly had a great impact on contemporary society and even prompted a tradition of chryselephantine colossi. Construction is thought to have begun 448–47 BC. Conditions for the building

program were set by the remains of the earlier building destroyed by the Persians which provided a model to work from. The old Parthenon was a peripteral temple with 6 x 16 columns, and a central tetrastyle amphiprostyle **naos (b)** which was divided into 3 aisles to the east and a **quadrangular bay (d)** to the west. The new temple was constructed using the same material: Pentelic marble. Certain features were maintained: the same prostyle configuration of the pronaos (a) and **opisthodomus (e)** and the division of the naos and space on the west side. However, the need to create a setting for the colossus required a radical innovation in the naos itself.

The result was an enlargement of the internal façades of the pronaos and opisthodomus (which were prostyle with 6 columns) and of the external façades (with 8 columns). Consequently, the stylobate was increased considerably in width (from 77'3" to 101'3") and slightly in length (from 219'7" to 228'1") and given 17 columns down its longer sides. The axes of the entire peristasis incline toward the center of the building, and the 4 corner columns have a larger diameter to compensate the effect of tapering created by their position. The thickening of the elements is balanced by the lightening of the entire construction through the increase in length of the module of the shaft height, the stretching of the profile of the capitals, the 1:1 balance of the architrave/frieze ratio in the trabeation, and the reduction in weight of the *geison*. A series of optical corrections to the horizontal lines imbue the structure with a strong tension. The central nucleus of the temple is raised 2 steps from the walkway. The architraves of the pronaos and opisthodomus have a figural Ionic frieze that is continued on the side walls. Typical of Ionic tradition, the outside, featured opulent colonnades and, inside 4 Ionic columns supported the wooden ceiling of the chamber behind the naos. This was the true Parthenon, the name of which ("place of the Virgins") referred to the virgin weavers of the Panathenaic peplos (a specific shawl woven for a sepcific festival).

The naos measured 100 Doric feet (*hekatompedon*) and was laid out with colonnades in the shape of the symbol pi (10 x 5 columns) around the statue of the *Parthenos* to create a new dimension in the interior space of the temple. A basin (c) in front of the base held the oil used to ensure the ivory sections of the statue did not dry out.

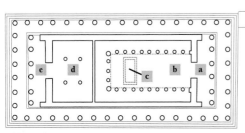

PARTHENON

a *PRONAOS*

b *NAOS*

c *BASIN*

d *PARTHENON*

e *OPISTHODOMUS*

ATHENS

The political and cultural significance of the statue was extended to the decorative cycles, the apex of art during the Periclean period. These were 92 relief metopes (unique in antiquity), roughly 175 yards of frieze, and the series of high-relief sculptures on the pediment. Ancient sources mention the names of the architects ICTINUS, CALLICRATES, and CARPION (perhaps only a treatise writer) but remain absolutely silent on the sculptors, or *megaloi technitai* as Plutarch called

of vast debate. The best artists of the time had come to Pericles' Athens to support those already working in the city (AGORACRITUS, ALCAMENES, CRESILAS, COLOTES, POLYCLITUS, and others). The first two were described as the pupils and assistants of PHIDIAS. Thanks to official documentation and the interpretation of technical and stylistic details, it has

temples, the stylistics of the metopes confirm they were the first stage of the decoration, as there are motifs that can be traced back to the Severe style. PHIDIAS' designs were first modeled and then carved in marble by various workshops. The subjects are the amazonomachy (west), the gigantomachy (east), the destruction of Troy (north), and the centauromachy (south).

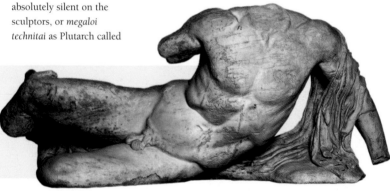

them. And Pausanias (I, 24, 5) only records the theme of the pediments.
The silence of these sources and the damage caused by both time and, the hand of man has meant that the marbles remain the object

been possible to reconstruct the chronology of the works: first the metopes (447–442), then the frieze (442–438) and the pediments (438–432).
In addition to the normal building process of Doric

In this last series (the best conserved), a splendid contrast is created between traditional motifs and the Phidian innovations in the bodies of the Lapiths and heads of the Centaurs.
With the great novelty of

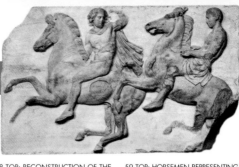

58 TOP: RECONSTRUCTION OF THE
WEST FRIEZE OF THE PARTHENON.

59 TOP: HORSEMEN REPRESENTING
THE TEN TRIBES ON THE WEST FRIEZE.

58 BOTTOM: SCULPTURE OF
CEPHISSUS FROM THE WEST FRIEZE.

59 BOTTOM: SACRIFICE OF A
HEIFER ON THE SOUTH FRIEZE.

the depiction of the Panathenaic procession, the frieze left less freedom of expression to the individual artists compared to the model, despite the direct intervention of the master (the group with the horse rearing in the west frieze) and the dedication of his closest collaborators (in various points on the east frieze). With regard to this last point, we see the pictorial tendency of AGORACRITUS in contrast with the more static, plastic and traditional approach of ALCAMENES. But what is most striking in the frieze—beyond the process and the participation of so many masters with their own workshops—is the novelty of the theme. The interpretation in Stuart and Revett's 18th-century drawings has been revised in more recent studies. For example, the procession has been described as a very early one at the time of the institution of the games by Erechthonius, the first procession after the destruction by the Persians. Then there is even the attractive suggestion that it represents the Panathenaic festival from the twin aspects of *pompe.* and *agony*, the representational unity of which is not given by the space itself but by its religious equivalent in the

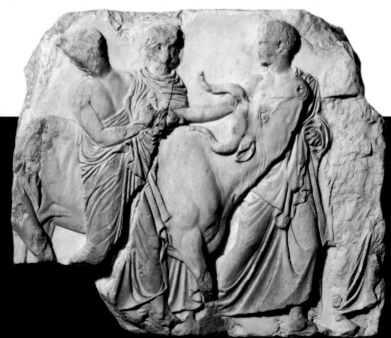

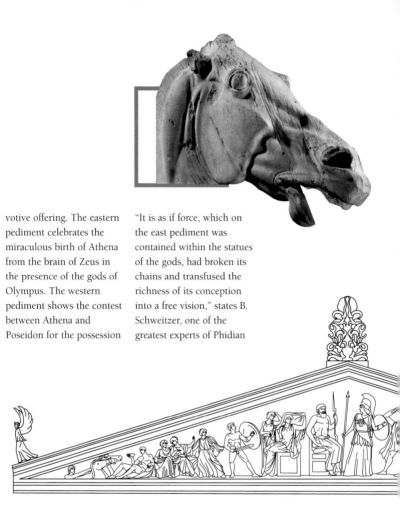

votive offering. The eastern pediment celebrates the miraculous birth of Athena from the brain of Zeus in the presence of the gods of Olympus. The western pediment shows the contest between Athena and Poseidon for the possession

"It is as if force, which on the east pediment was contained within the statues of the gods, had broken its chains and transfused the richness of its conception into a free vision," states B. Schweitzer, one of the greatest experts of Phidian

of Attica in the presence of local gods and heroes, including the personifications of the rivers Cephissus and Eridanus on the left, and Calliroë and Ilissos on the right. The east side was executed earlier than the west side, and its alternation of motion and stasis is one of its most successful motifs. The tension in the nudes and the richness of the drapery are even more complex and dynamic on the west side.

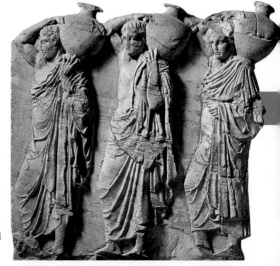

OPPOSITE TOP: HORSE'S HEAD FROM THE QUADRIGA OF THE MOON ON THE EASTERN FRIEZE OF THE PARTHENON.

OPPOSITE BOTTOM: BEARERS OF *HYDRIA* ON THE NORTH FRIEZE OF THE PARTHENON.

TOP: HESTIA, DION AND APHRODITE; EXCELLENT EXAMPLES OF THE "WET" DRAPERY BY PHIDIAS, ON THE EASTERN FRIEZE.

BOTTOM: SCENE RELATING TO THE ITEMS SACRED TO ATHENA ON THE EASTERNFRIEZE.

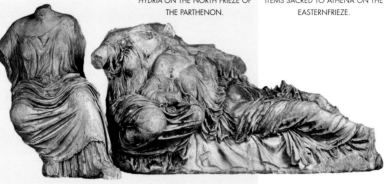

BELOW: RECONSTRUCTION OF THE EAST PEDIMENT OF THE PARTHENON.

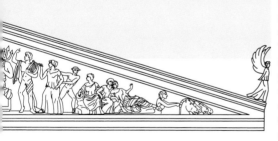

ITINERARY I

61

ATHENS

compared to the vibrancy of the personification of the River Cephissus (west side), as well as in the "wet" clothing of the "Sisters of the Dew" (east side) compared to the floating clothing of Iris (west side). When the sculpture is considered as a whole, the power of Phidias' composition comes through as strongly as the intensity of the developments of his style. At the same time, the participation of other masters in the decorative elements (though we do not know for sure who was responsible for what) was based and expressed in the idea of the project.

art. The sense of evolution, in addition to the fact that several artists were involved in its execution (more plastic on the east side, more pictorial on the west), is more easily recognized in the Classical composure of figures like Dionysus and Heracles (east side)

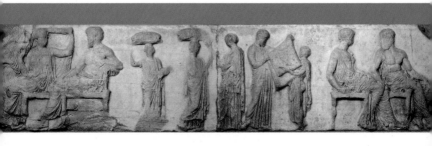

A T H E N S

PROPYLAEA

Once the Parthenon had been completed, it became necessary to give the Acropolis a worthy monumental entrance to

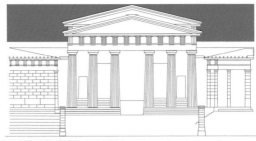

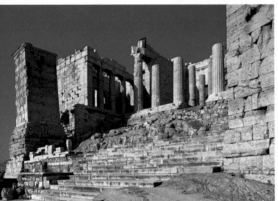

replace the old Propylaeum. The works began in 437–436 BC but were suddenly interrupted in 432–431 by political and military events. The architect was MNESICLES, a pupil of ICTINUS, whose distinct personality led him to search for new and original ideas. He had to take into consideration the irregularity of the terrain. In addition, many monuments donated by rich benefactors and sanctuaries already stood near the Parthenon. The resulting entrance was composed of a central nucleus (the Propylaea proper), which appears like a temple on its 2 Doric hexastyle prostyle façades. The problem of the difference in level of the ground was resolved by a different number of steps at the sides (4 on the western

front, 5 along the middle wall of the gates, and 1 on the east). The broad west vestibule is split into 3 aisles by 2 rows of Ionic columns. The chamber is separated from the east entrance by a wall in which 5 gates open with the same distance between the columns of the façades. Two wings connected to the central section symmetrically face the access ramp and its portico with 3 Doric columns; but, behind the line of the porticoes, there were various asymmetrical spaces created by the problems mentioned above. To the south, an atrium connects the Propylaea to the lower terrace of the temple of Athena Nike; to the north there is a room with a door and 2 windows used either as a *pinakotheke*, a banquet hall.

Mnesicles' design also took account of the slopes of the Acropolis: the slope was made regular by the construction of a ramp between two parallel walls; about halfway up, there was a terrace on the left side of the ramp where Agrippa's monument was built and, on the right, a retaining wall for the cult area of Athena Nike (an ancient structure that was incorporated into the general plan of the Propylaea). The structure is made from Pentelic marble but with a chromatic contrast that was new to Athenian architecture. A few bands of black stone from Eleusis underlined the monument's most important levels. The use of color was completed by the painting of the trabeations and barrel vaults. There was no sculptural decoration.

TOP: ARTIST'S IMPRESSION OF THE FRONT VIEW OF THE PROPYLAEUM.

CENTER AND BOTTOM: THE PROPYLAEUM SEEN FROM THE SOUTH.

ATHENS

TEMPLE OF ATHENA NIKE

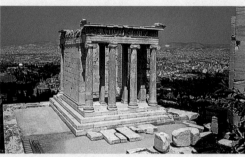

The Mycenaean rampart to the right of the Propylaea had been used for cult purposes since very ancient times. The presence of an inscribed altar attests the cult of Athena Nike from at least 566 BC, and between 490 and 480 BC a small sacellum was built. In

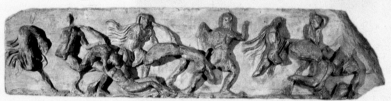

449–48 Hipponicus (the son of Callias and grandson of Cimon) proposed to the Assembly the construction of a new temple designed by CALLICRATES, but Pericles was completely against the idea, and the construction of the temple of Athena Nike only occurred toward 420 BC.

The temple is Ionic, amphiprostyle, with 4 columns and a platform with 3 steps, but it has no opisthodomus and only a "false" pronaos. The front wall of the naos has a large doorway and two side openings blocked by grilles to provide extra light as the Propylaea overshadows the south wing.

A figural frieze runs along the architrave. The heavier, Archaic, and rather squat order (compared to that of the Propylaea) suggests that the original design by CALLICRATES was used with certain additions: these were the architrave with three projecting bands and the post-Parthen character of the sculptures.

A gigantomachy and amazonomachy respectively decorated the east and west pediments, a few fragments of which can be seen in the museum.

An assembly of the gods was represented on the east frieze with scenes of combat between the Greeks and Persians (and also Greeks versus Greeks

in reference to the Peloponnesian War) on the remaining 3 sides (now in the British Museum). AGORACRITUS OF PAROS, a pupil of PHIDIAS, is credited with being the author of the frieze, on which many different sculptors worked.

Around 410 BC a balustrade was built to enclose the area of the rampart.

On each of the sides there was a seated figure of Athena watching Nike adorning trophies and leading victims to sacrifice. CALLIMACHUS has been attributed with this work, the dominating feature of which is its post-Phidian Mannerism.

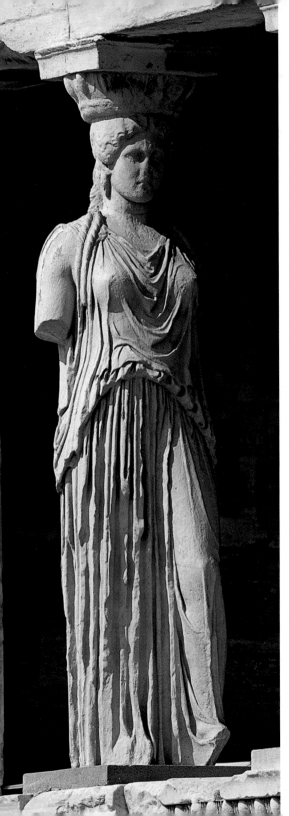

ERECHTHEUM

This temple was part of Pericles' program for rebuilding the Acropolis, but the project only got underway in 421 BC after the Peace of Nicias. Suspended at the time of the unsuccessful expedition to Sicily, the work was restarted in 409 and completed in 405.

It stands in the area of the oldest Attic cults, which, following destruction at the hands of the Persians, required a new and worthy face. A group of almost unknown architects (PHILOCLES and ARCHILOCHOS are known only through epigraphs) produced a building whose plan seems to have been the work of the great Callicrates. The complexity of the plan and above-ground sections and the importance of its decorations make the Erechtheum perhaps the first authentically baroque building in the world. The cause of this was the variety of cults and different ritual functions that took place in the building, which required a distribution of volumes of different size and type.

On the east side a portico with 6 Ionic columns stands in front of a naos with altars (a) that is wider than it is long. In this first section of the building stand the altar of Zeus *Hypatos* ("the most high") beneath the portico, an altar to Poseidon and

Erechthonius (mythical king of Attica killed by the god and then assimilated to him) on the back wall of the naos, and altars to Ephestus and Butes (another mythical king) on either side of the entrance.

To the west there is an almost square naos that some experts believe to have been the area of the temple dedicated to Athena *Polias* (as opposed to the traditional hypothesis that her temple lay in the east section). To the left of the entrance stood the *adyton* for the tomb of Erechtheus (b) and the den of the sacred serpent Erechthonius, son of the Earth and king of Attica. In line with the entrance was the *prostomiaion* (c), marked with the signs of the trident flung by Poseidon during the contest with Athena, and the fountain of brackish water made to flow by the god. At the back of the chamber was the *adyton* with the wooden statue of Athena *Polias* (d), supposed to have fallen from the sky,

and was given the peplos woven by the *ergastinai* during the Panathenaic festivities. The golden lamp that was permanently lit in the naos was made by CALLIMACHUS. The central section of the temple is on a much lower level and connected to the north by a portico with 4 x 2 columns. To the south a stairway leads to the loggia of the Caryatids (e). The west side of the naos gives access to the enclosure containing the tomb of Cecrops, the sacred olive tree (f) given by Athena, the altar of Zeus *Herkeios* ("of the enclosure"), and a small temple of Pandrosos, daughter of Cecrops.

Only the light, uncluttered Ionic forms were suited to the complexity of this building. The use of color is extensive: gilded bronze on the capitals, glass balls in the bases of the columns, and the high-relief, white marble figures in the frieze stand out against the blue-black stone from Eleusis. This was not purely for

decorative purposes because, as already seen in the Propylaea, the use of color created lines of force that temper the surfaces and exalt the volumes.

Not only do we not know the authors of the frieze but also its subject and the characters (though probably associated with the different cults). We can only assert that its rich mannerism is Phidian in nature, particularly where the drapery was concerned. ALCAMENES was probably

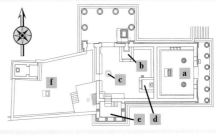

responsible for the *korai* in the famous loggia that faces toward the Parthenon. The 6 traditionally Ionic figures may represent the daughters of Cecrops on the tomb of their father, carrying sacrificial bowls for the libations.

ERECHTHEUM

a *NAOS WITH ALTARS*
b *ADYTON OF ERECHTHEUM*
c *PROSTOMIAION*
d *ADYTON OF ATHENA POLIAS*
e *LOGGIA OF THE CARYATIDS*
f *ATHENA'S OLIVE TREE*

A marble **portrait of Alexander the Great** by LEOCHARES (second half of the 4th century BC) welcomes the visitor with its striking beauty at the museum entrance.

Room 1. Among the many architectural and decorative elements in *poros* from the early 6th century BC is a reconstructed **pediment**, parts of which still show traces of its original coloring. It depicts Heracles against the Hydra: at the center, assisted by Iolaus, he battles the monster while a large crab sent by Hera threatens him. It is almost impossible to attribute the many surviving fragments of pediments to particular buildings, but this decoration undoubtedly comes from a minor building dating to 570–560 BC.

In form it is indicative of the most important innovations in Attic composition: the figures have been cleverly adapted to the triangular space without any sacrifice in narrative intensity. In the same room there is another **sculptural group from a pediment** showing the battle between a lion and a bull.

Room 2. On the left is the decoration from a **pediment** depicting the Apotheosis of Heracles (560–550 BC). Zeus is shown enthroned in profile with Hera, seen frontally, welcoming the hero (dressed in the skin of the Nemean lion) to Olympus. Depth in the **pediment** is created by the hierarchical graduation of the figures, which, from a stylistic standpoint, reveal an assimilation of Ionic characters in the modulation of the planes. The polychromy is intense. Another **pediment** shows Heracles battling the three-bodied Nereus and Triton in a very busy narrative rhythm. It was executed for the earliest temple

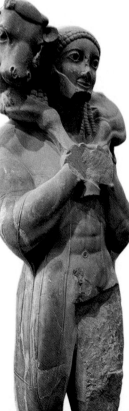

(570–560 BC) to have stood on the site of the Parthenon.

The iconography is Corinthian in origin but executed in Attic style, with the emphasis on plasticity. What is known as the **Olive pediment** (ca. 550 BC) shows a rare scene notable for its setting in a real landscape (a fountain and an olive tree behind a wall: the Erechtheum?) in which a young girl carries a *hydria*. It has been suggested that this is a reference to Peisistratus' policy in support of services, in particular the provision of water to the city.

Heracles appears in another **pediment** with Triton (570–560 BC).

A masterpiece of early 6th century BC statuary, the **Moschophoros** ("Calf Bearer") is a marble ex-voto of Mount Hymettus donated by a man named Rhombos, probably after a victory in the Panathenaic games of 566 BC. It represents the donor himself offering the animal to the goddess.

Room 3 contains 2 works in particular: the **statuary group** of a bull and lion in combat that was the central section of the pediment mentioned above with Heracles fighting Triton and Nereus, and a superb sphinx with complex iconography and heavily emphasized decoration on the head (575–550 BC).

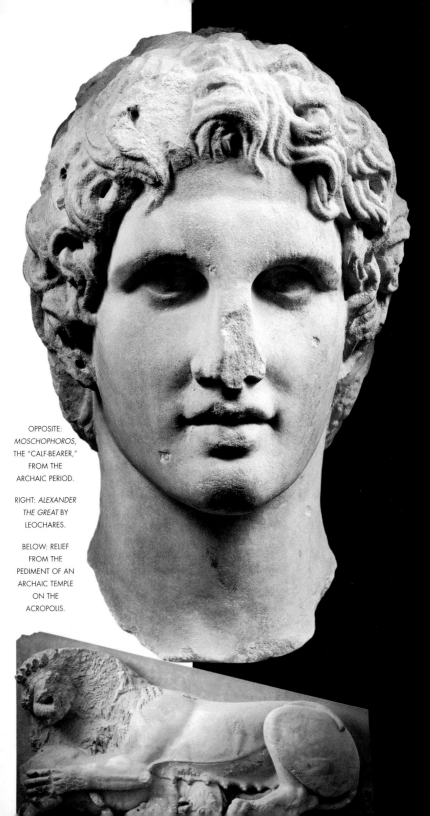

OPPOSITE:
MOSCHOPHOROS,
THE "CALF-BEARER,"
FROM THE
ARCHAIC PERIOD.

RIGHT: *ALEXANDER
THE GREAT* BY
LEOCHARES.

BELOW: RELIEF
FROM THE
PEDIMENT OF AN
ARCHAIC TEMPLE
ON THE
ACROPOLIS.

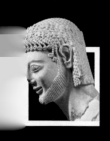

Room 4. This room contains an impressive creation from the era of Peisistratus known as the Rampin Horseman after the collector who donated the head of this work to the Louvre. Rampin had purchased it in Athens in 1877 and virtually "rebuilt" it making use of copies and using the fragment of the horseman found on the Acropolis in 1866,

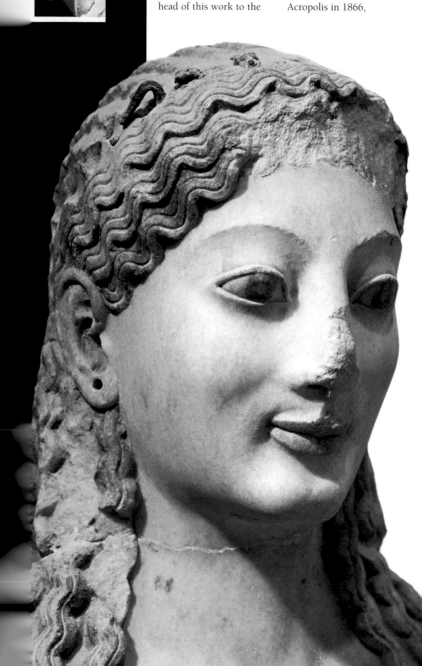

following H. Payne's brilliant intuition in 1935. Dated to 550, the sculpture represents a rider crowned with oak leaves in a possible reference to a victory in the Pythian or Nemean Games, which may have been matched with a second horseman (the two sons of Peisistratus?). The extraordinary control shown in the rider's anatomy tallies with the *chàris* (luminous grace) of the head, which is ornamented with calligraphic locks in the hair and beard.

Works in other museums (a discus thrower in the National Museum in Athens, a *kore* in the Museum of Lyon, and others) can be attributed to this unknown sculptor, and perhaps also the *Kore* wearing a peplos in this museum, in which the execution of the face shows the same sensibility. Another work to notice in this room is the *kouros* torso made from Parian marble during the second half of the 6th century BC. The last section of the room contains a "parade" of korai: "the girls of the Acropolis Museum." These mostly come from what is known as the "Persian landfill." The successful assimilation of Ionic iconography in *kore 593*, dated to roughly 560 BC (in the previous room), demonstrates an extensive degree of richness and invention in the series of

pieces exhibited here. *Room 5*. The most impressive piece is the group from the east pediment in the temple of Athena from the time of Peisistratus (529–515 BC). Made from island marble, it depicts an episode in the gigantomachy (on the west pediment, animals fighting) with Athena bringing down the giant Enkelados. Other fragments of giants, Zeus

and other gods, and probably Heracles, survive. The most remarkable point is the use of a constant module that, in combination with a well-distributed juxtaposition of poses and attitudes, ensures a harmonious use of color in the pediment space without breaks or discordance.

The Athenian sculptor ANTENOR, who carved the group of the Tyrannicides rescued from the Persians, was the creator of *kore* 681 dated to 525 BC. This very large statue was dedicated to the potter NEARCHOS. The figure wears a chiton and *himàtion* and holds his arm forward in a gesture of offering. Despite the damaged face, we know that the eyes were partly made using rock crystal.

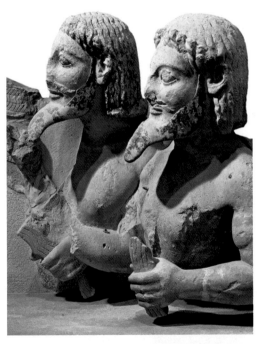

OPPOSITE TOP: THE RAMPIN HORSEMAN.

OPPOSITE BOTTOM: *KORE* BY PHAIDIMOS.

ABOVE: HERACLES AND TRITON.

RIGHT: SCULPTURE OF A HORSE MADE FROM PARIAN MARBLE.

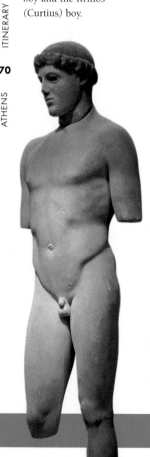

BELOW THE *KRITIOS BOY*.

OPPOSITE: THE *BLOND BOY*, SEVERE SCULPTURE.

Room 6. The famous relief of "Pensive Athena" in Severe style (c. 460 BC) welcomes the visitor on the left side of the room. But one's attention is immediately caught by the masterpieces of this stylistic period: the blond boy and the Kritios (Curtius) boy.

The compact, solemn yet also gentle head of the "blond ephebus" (it takes its name from the traces of gilded effects in the hair) is portrayed with chiaroscuro effects and expresses the ideal of the determined athlete. In the athlete's body, KRITIOS (the sculptor, with NESIOTES, of the new group of the Tyrannicides) breaks the rigidity of the Archaic *kouros* and, though retaining a degree of rigidity in the muscles of the figure's powerful shoulders and chest, this is relaxed in the effect created by gravity on the muscles of the hips and abdomen.

Two more *korai*, the Propylaeum *kore* (no. 688) and *kore* no. 686, also stand out, one for the quality of the drapery and the other for the face. Note also the lovely marble horse and a rare example of painting on a clay tablet, with the representation of a hoplite (infantryman), Megakles, from the Alcmeonid family.

Room 7. This room contains the fragments of the sculptural decoration of the Parthenon. The pieces that stand out are torso no. 885 of Poseidon on the west pediment and a metope with the abduction of a Lapith woman by a centaur.

Room 8. Here you will find 20 or so slabs from the Ionic frieze of the Parthenon with depictions of the Panathenaic procession. There are scenes of a cavalcade, chariots, musicians, and an assembly of the gods. Other exceptional items on display are the slabs from the balustrade of the temple of Athena Nike, with representations of winged Victories, including the famous one who is tying up her sandal.

Room 9. The room holds 4 of the 6 Caryatids from the south portico of the Erechtheum;. one is in London, and one is damaged and therefore not exhibited. Those currently in the temple are copies.

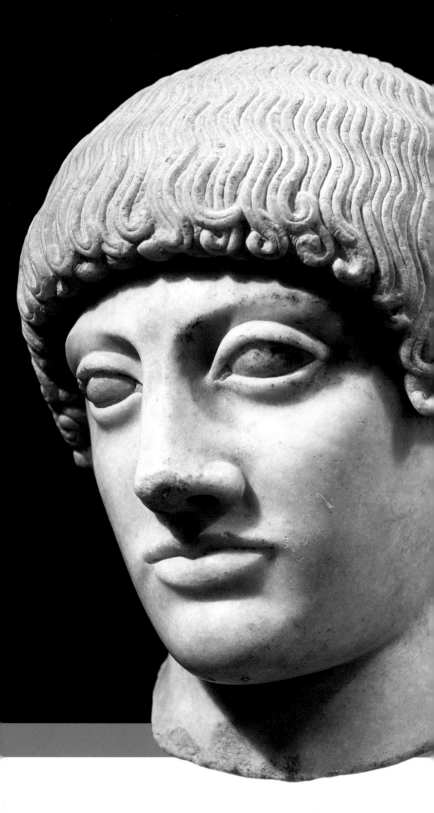

SOUTH SLOPES OF THE ACROPOLIS

The odeon of Pericles (l), built in 443 BC, was the first structure of this sort. Its single chamber was covered with a sloping roof (its beams were taken from captured Persian ships) supported by 9 rows of 10 columns each. The function of the room was to host music competitions.

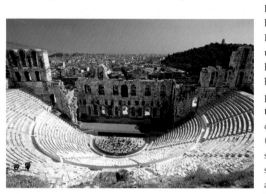

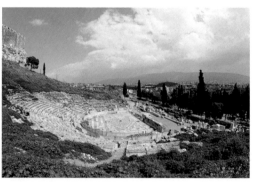

nearby odeon of Herod Atticus (m) was built. Little remains of the sanctuary of Dionysus (n) founded in the 6th century BC by Peisistratus. There was a small Doric distyle temple *in antis*, to the south of which are the more conspicuous ruins of a new 4th-century BC Doric

Ictinus and other architects who had worked on the Parthenon designed and constructed it using their experience garnered from the construction of the *Telesterion* in Eleusis. The building fell into disuse in the second half of the 2nd century AD when the

tetrastyle temple. With regard to the latter, Alcamenes made the cult statue using the chryselephantine technique. After a 4th-century BC Doric portico to the north, lies the theater of Dionysus (o), where the public gathered during the

Dionysian festivals. The first phase of construction, which occurred at the time as construction of the Archaic temple, regularized the rock but this was developed in the 5th century BC with a wooden structure on a rectilinear plan. This modification took place when the Great Dionysia were transferred here from the agora. Radical rebuilding was undertaken in the second half of the 4th century BC by Lycurgus to match the prescribed form of the theater, with a circular *orchestra*, a round altar (*thymele*) in the center, seats in the first row, a simple stage building, and a cavea capable of seating 15,000 spectators. Further alterations were made in the Hellenistic age when the people's assemblies were held here, which until then had met on the Pnyx. During Nero's reign in the 1st century AD, the *orchestra* was paved with marble and a tall stage front erected and integrated with a marble proscenium. The building was richly decorated with sculptural Dionysian scenes. In the 5th century AD, the stage building was transformed into a portico and in the 6th century, a church was created in the east *parodos*. Numerous choragic monuments (primarily Hellenistic) can be seen in

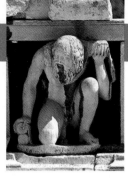

the upper area of the cavea and where Tripodi Street enters the western *pàrodos*. Those of note are the monument of Trasillus (271 BC) (a cave that 18th-century drawings show was fitted with a ship-shaped structure); the monument of Nicias (320 BC), a small Doric hexastyle temple in Pentelic marble (parts were reused in the fortifications of the Acropolis); and the most famous,: the monument of Lysicrates (334 BC) at the end of Lysicrates Street.

To the west of this is the large *stoa* of Eumenes II of Pergamum (p) (197–159 BC). It has 2 aisles and 2 floors, 64 columns in front and 31 inside. According to Vitruvius (1st century BC), it was used to protect spectators from the nearby

Pausanias praised its roofing made from extremely long Lebanese cedar trees, although some experts consider that the only part covered was the 3-level section of stage, which was adorned with columns and niches containing statues. The orchestra was paved with polychrome marble. Beneath the escarpment of the Acropolis, behind Eumenes' portico, the sanctuary of Asclepius was founded in 418 by the Athenian Telemachos. With the help of Sophocles, Telemachos

with a monumental altar and two-story portico (*enkoimetèrion*, where healing dreams were dreamt). In the northeast corner of this building was a well with 4 bases for columns or pillars to support a canopy that resembled the famous *thòlos* in Epidaurus. During the Roman period a portico was added south of the temple and, east of the spring, the *katagogion* was built. This was a portico with 4 banqueting rooms and a standard annex to an *asklepieion*. A propylaeum monumentalized the south entrance to the sanctuary. The place of worship survived the invasion of the Herulians but was replaced by a small church in the 6th century AD.

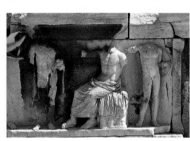

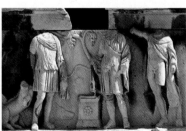

theater when bad weather occurred.

One of the best conserved monuments in Athens is the odeon of Herod Atticus, built in 160–170 AD in memory of Annia Regilla, the wife of the great tycoon. The building could hold 5,000 spectators, and

succeeded in transporting the cult of the god of health from Epidaurus to this place with a spring and sacred ancient traditions. Rebuilt in the 4th century BC, the sanctuary had a small Doric tetrastyle temple dedicated to Asclepius and Hygea,

OPPOSITE TOP: DETAIL OF A RELIEF IN THE ODEON.

OPPOSITE CENTER: THE ODEON OF HEROD ATTICUS.

OPPOSITE BOTTOM: THE THEATER OF DIONYSUS.

ABOVE: TELAMON AND RELIEFS FROM THE THEATER OF DIONYSUS.

BELOW: ROMAN AGORA,
COLONNADE OF THE
ROMAN PORTICO AND:
THE TOWER OF THE
WINDS (PICTURED AT
RIGHT).

ROMAN AGORA

1.2

This area was originally connected with the activities that took place in the agora, in particular, commerce.

During the Augustan period, following Aristotle's theories that the administrative center should be separated from the commercial center, a new agora was built next to the old one, although the old one had by then been deprived of all political importance and reduced to

connected to it functionally. Separated from it are three buildings: the Conqueror's Mosque, (the mosque of Mahomet II, conqueror of Constantinople (also called *Fetiye Dzami tou Staropazarou*), and the oldest mosque in Athens); a large public latrine built for the many people who visited the agora; and, above all, what is known as the **Tower of the Winds (a)**.

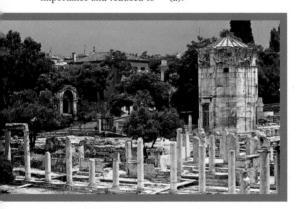

a purely cultural function. It was a sort of museum of past glories. The new agora was composed of a square plaza surrounded by Doric and Ionic porticoes and 2 entrances, an Ionic one to the east and a Doric one to the west.

Entry to the new agora from the east side allows the visitor to appreciate several monuments

The Tower was a water clock constructed around the middle of the 1st century BC (some say the end of the 2nd century BC) by Andronicus of Cyrrhus; it is still in good condition thanks to its being transformed into a chapel during the Byzantine era. During the Middle Ages it was referred to as "Socrates' tomb." The

octagonal tower is made from Pentelic marble and contained the machinery of a clock that was powered by the water from the Clessidra spring. The water was collected in a cylindrical container on the south side of the monument. The dome over the building (the building reveals Oriental and Syrian influences) was masked on the outside by sloping roofs with lion-headed eaves. On the roof a bronze weathervane in the shape of a Triton showed the direction of the wind. Personifications of the winds adorned the upper part of the monument by the ventilation points; their characters are distinguished by their attributes, clothes, and forms, but their names are also given.

A detailed description is given by Vitruvius in *De architectura* I, 6, 4:.

"According to some, there are but four winds, namely, Solanus, the east wind, Auster, the south wind, Favonius, the west wind, and Septentrio, the north wind. But those who are more curious in these matters reckon eight winds; among such was Andronicus Cyrrhestes, who, to exemplify the

RIGHT: A DETAIL FROM THE TOWER OF THE WINDS: THE PERSONIFICATION OF THE SOUTHWEST WIND.

BELOW HADRIAN'S LIBRARY, WEST SIDE.

ATHENS

theory, built at Athens an octagonal marble tower, upon each side of which was sculpted a figure representing the wind blowing from the quarter opposite thereto. On the top of the roof of this tower a brazen Triton holding a rod in its right hand moved on a pivot, and pointed to the figure of the quarter in which the wind lay.

The other winds not above named are Eurus, the southeast wind, Africus, the southwest wind, Caurus, by many called Corus, the northwest wind, and Aquilo the northeast wind."

Beside the tower and in line with the propylaeum stands a rectangular construction from the mid-2nd century AD that has a lovely marble front adorned with 3 small arches, and a dedication to Athena *Archegétis* ("founder") and the August Gods.

This was probably the **agoranomion (b)**, i.e., the building used by the magistrates that supervised the markets in the agora. On the east of the plaza there was a row of **shops (c)**. The south side was characterized by a double portico made of marble

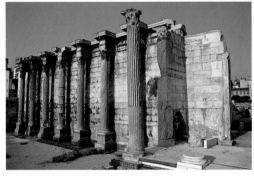

with a fountain at its center (the paving may have been laid down in 126 AD). The western side probably also had shops and boasted a second propylaeum built in 10 BC in honor of Athena *Archegétis*.

It was hung with a portrait of Lucius Caesar, one of Augustus' grandsons who died before he could be crowned emperor. From there you reach the Classical agora down a long street on which the library

of Pantainos was built around 100 AD.

Hadrian's Library (d) was built in perfect alignment with the agora on its north side. Identified by W. Leake in 1821 on the basis of descriptions furnished by Pausanias (I, 18, 9), it was excavated beginning in 1885 by the Greek Archaeological Society after a fire displaced the market that was held on the site. Even today, exploration of the area is only partial.

ROMAN AGORA

a TOWER OF THE WINDS
b AGORANOMION
c SHOPS
d HADRIAN'S LIBRARY

According to experts, the magnificent complex was dedicated in 132 AD and was inspired by Rome's Forum of the Peace. It may have also been used as an archive or land registry office, and, more generally, for legal and cult purposes. A monumental Corinthian propylaeum gave onto the agora on the west side. It stood in a *poros* wall and was characterized by a splendid and well-conserved external façade with Corinthian columns on plinths, and a trabeation (now broken) that was probably crowned by statues. At either end were 2 acroters of Nikai in flight.

A large garden and pool was surrounded by a superb polychrome portico with columns made from Phrygian marble and stylobates of white marble. On the long sides of the portico were 3 exedras, semicircular at the sides and rectangular in the center.

The library proper stood on the east side. It had a large room with 3 orders of niches on the walls to hold containers for papyrus rolls and parchment volumes. A series of landings allowed the various texts to be reached.

At the sides of the main room were 2 symmetrical service rooms, steps to reach the landings, 2 distyle exedras for

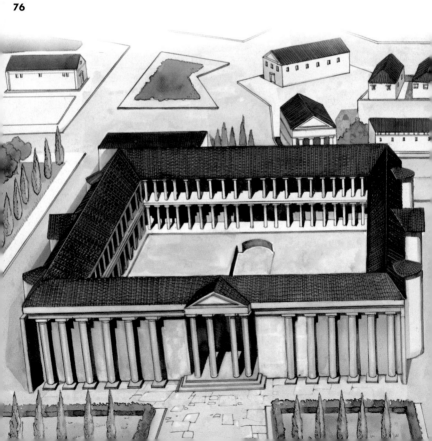

OPPOSITE TOP: ROMAN AGORA, LOWERED ARCH.

BOTTOM: ARTIST'S IMPRESSION OF THE ROMAN AGORA.

BELOW: GATE OF ATHENA *ARCHEGETIS*; ENTRANCE
TO THE ROMAN AGORA.

philosophical discussions,
and 2 *auditoria* for
declamations.

During the late ancient
period, a three-cornered
hall was built over the
place where the pool lay
to be used for "learned"
meetings.

In the 7th century AD it
was replaced by a church
and then another in the
12th century.

Not far away, but in a spot
that has yet to be identified,
stood a gymnasium.

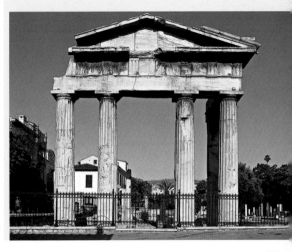

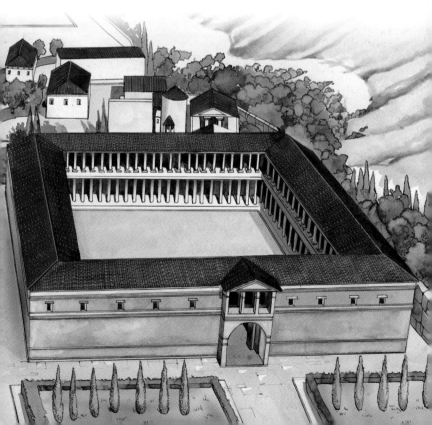

BYZANTINE CHURCHES

1.3

The tour begins in the heart of Classical Athens: the small church of the Holy Apostles stands in the shadow of the Acropolis, near the southeast corner of the agora.

This building is the only survivor of the densely inhabited district that featured Byzantine, Frankish, and Turkish additions that literally "disappeared" as a result of

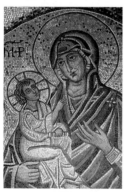

excavation of the agora itself.

Today the church is isolated, though this is not the case for the other small Byzantine churches in the city: Kapnikarea, Little Metropolitan, Aghii Theodori, and others. These are practically submerged by chaotic, suffocating, and, ugly buildings.

The extreme example is the chapel of Agia Dynamis, which is squashed beneath the portico of a modern building.

The church of the Holy Apostles, which was founded in the 11th century over the ruins of a 2nd-century AD fountain (built over one from the time of Peisistratus), has a rather unusual plan. At first glance it is the standard plan of a cross resting on four corner pillars; in fact, it is more of a four-apse plan with a dome.

Note too that the additional rooms fit perfectly onto the sinuous lobate plan of the interior. The influence is Eastern (Caucasian and, above all, Armenian), found among only a few early medieval buildings in the West, such as, San Satiro in Milan. Over the centuries the church has undergone substantial alterations, for example, the plan has been lengthened with the demolition of the western apse, a second narthex was added, and the aisles were removed to make a single nave.

In 1955 the church was completely renovated by the American School of Classical Studies, which was also responsible for excavation of the agora. The regrettable restoration has returned the church to its original style but left the atmosphere in the building distinctly chilly.

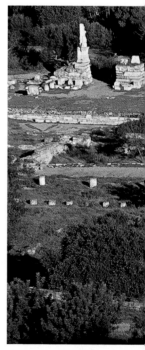

The interior is surprisingly unified and only slightly affected by the light framework of the low iconostasis. Frescoes once covered all the walls but only patches of these remain.

The 10th-century Pantanassa (church of the Great Monastery) lies on

OPPOSITE: CHURCH OF KAPNIKAREA,
METER THEOU, MOSAIC.

CENTER: CHURCH OF THE HOLY
APOSTLES.

LEFT CHURCH OF AGHII THEODORI.

BELOW, TOP CHURCH OF AGHII
THEODORI, INTERIOR.

BELOW, BOTTOM: CHURCH OF
KAPNIKAREA.

A T H E N S

the other side of Monastiraki and has been renovated on several occasions. From there, heading down Odos Ermou toward the Parliament building (built

Elou, the church of Aghii Theodori. The Classical period of middle Byzantine architecture (11th century), to which both churches belong, was remarkably somber.

In Mitropoleos Square, just south of Odos Ermou, next to the large Megali Mitropoli (the new cathedral built in neo-Byzantine style in 1840–55), there is another jewel from the end of the 12th century: the Mikri Mitropoli or Gorgoepikoos ("the most holy that

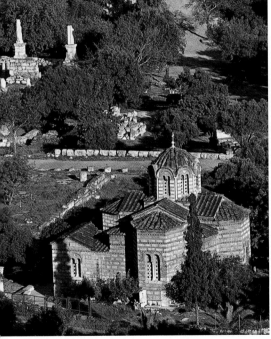

immediately fulfills [one's desires]").

Many ancient marbles have been used to build its walls, in particular an Attic "calendar" from the 4th century BC showing the months and signs of the zodiac. The interior was influenced by Constantinople and has 4 columns that support the dome above spandrels (also seen in the Kapnikarea).

in 1836–42 by F. von Gärtner as a residence for King Otto I), you will see two of the most interesting small Byzantine churches in the city: the Kapnikarea, which belongs to the university and is used for the institution's official ceremonies, and, with a short deviation down Odos

Nevertheless, repeated hounds-tooth bands and friezes of Kufic script (probably introduced after the middle of the 10th century following contact with the Islamic world with the reconquest of Crete) hark back to previous decorative traditions.

1.4

In addition to the city sanctuary on the Acropolis, the city has a second characterizing element, the agora. This lies at the center of the community's political, moral, and economic life.

The agora in Athens is the clearest and earliest example of the formation of a space of this nature inside a Greek city. Mention has been made of the existence of an *archaia agora*. We know from Apollodorus (in *Arpocration*) that it was

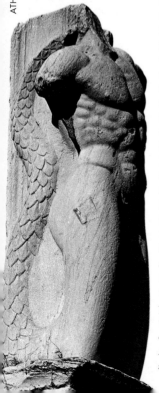

situated near the temple of Aphrodite *Pandemos,* which Pausanias referred to as on the southwest slopes of the Acropolis (?); excavation by Dontas has clearly identified it. The large monuments later built in this area prevent an objective check being made of an earlier space for public gatherings (that was the original meaning of the word *agora*).

The transfer of public functions to the Kerameis district occurred at the start of the 6th century BC and should probably be considered in relation to the outcome of Solon's reforms and the new self-governing system of the *polis*. In addition to this was the more favorable position that the Kerameis district offered for communications between the city and the countryside, and this function was soon indicated by the altar of the Twelve Gods, from which the roads fanned out into Attica.

Excavations in this part of the city have a long history. The Greek Archaeological Society began work in 1859 and continued for roughly 50 years, though a German team helped for a short period. In 1890–91, when the Greek government decided in to build the Athens-Piraeus railway line along the north edge of the

ancient square, the large trench that had to be dug (about 50 feet deep) caused great and irreparable damage. Thus, when at the start of the 20th century a city development plan was drawn up that encompassed the area, the American School of Classical Studies (able to count John D. Rockefeller's financial support) put forward a proposal for a large-scale "preventive" dig. The plan was approved, though on a smaller scale than requested. Work began in 1931 and continued until 1940 when the war interrupted it. Restarted in the postwar period, excavation is still continuing today. Since 1934, progress reports have been regularly published in the magazine *Hesperia*, and a multi-volume publication, *The Athenian agora*, has been in preparation since 1953; this features a monograph on the articles found. And thanks to the Rockefeller Foundation's financial support, the spectacular reconstruction of the Stoa of Attalus was undertaken between 1953 and 1956 to house a museum for the huge number of items found in the excavation works.

Under the supervision of A. Orlandos and J. Travlos, the building was reconstructed with stone and marble, cut

ATHENS

OPPOSITE: STATUE FROM ODEON.

RIGHT AND BOTTOM RIGHT:
PEDIMENT OF A SHRINE AND
REPLACED CAPITAL, GREEK AGORA.

BOTTOM LEFT: RELIEF FROM THE
GREEK AGORA OF A DANCING
WOMAN.

using the ancient techniques, and with tools similar to those used in the past. Though debatable in principle, and still an object of discussion, the project was highly rewarding in educational terms and matched the new demands posed by mass culture that archaeology soon had to satisfy.

Before the Archaic agora was laid out, the area was mostly occupied by necropolises, though a few traces of habitation have

been discovered (such as wells). In the course of the revival in the 7th and early 6th centuries BC in crafts, building, and urban development, an area in the new agora was set aside for the political functions of the *Boulè* of the 400, and Buildings C and D were constructed. Slightly to the south, Building E was replaced around 550 BC by Building F as the probably seat of the Pritaneion or, more probable, as the residence of the tyrant Peisistratus.

This was also the period of the construction of the temples of Apollo *Patroos* (the divine ancestor and protector of the Ionians) and Zeus, who, after 479 BC, was referred to as Zeus *Eleutherios* ("liberator"). The altar of Zeus *Agoraios*, at which the archons prayed, was built in front of the temple of Zeus *Eleutherios*. A little to the north lay the Stoà Basileios, which was where the laws were hung up, public banquets held, and where

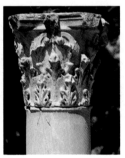

the archon-king based his operations.

The enclosure of the Heliaea, the people's court instituted by Solon, was probably located near the southwest corner of the large square. In relation to the reorganization of the Panathenaic festivities, the first monumentalization (adding of impressive buildings) took place of the: street where the procession was led. It crossed the area from northwest to southeast and was called *dromos,* because

this was where the games were held.

Peisistratus' sons built the altar of the Twelve Gods and the Enneakrounos (the first public fountain), though it is possible that this name referred not just to 1 but to a system of 9 fountains connected to the aqueduct built by the tyrants.

Further building was undertaken in the area at the foot of the *kolonos agoraios* during the period immediately after Cleisthenes' political reforms. Most important of these buildings were the new Bouleuterion of the 500 and the temple of the *Meter* that was connected to it. The sculptural group of the Tyrannicides of Antenor was erected in the center of the esplanade, and after the Persian destruction, a new work by KRITIOS and NESIOTES (477 BC) was dedicated there. The excavation has expanded our knowledge of the practice of ostracism, which entered Athenian politics in 488 BC. More than 1,000 *ostraka* (the shards on which the name of the person to be exiled was written) have been found, of which 190 bear the name Themistocles. Cimon and his family concentrated on the layout of the agora.

ITINERARY 4

81

ATHENS

On the site of Building F they erected the *Tholos*, which was where the prytanis operated. The north side of the square was the location of the Stoà Poikile ("painted portico"); its name derived from the tablets hung on its walls painted by the greatest artists of the period.
At the end of the 4th century BC, it became the seat of the famous school of the philosopher Zenon of Cyprus, which took the name Stoic.

(forebuildings) at the ends of the façade. These were used to hold the laws of the Athenian state inscribed on bronze plates. In the 4th century BC, a colossal statue of Themis—the personification of justice—was positioned in front of the stoa. The south stoa and the Mint closed off the south side of the square.
The monumentalization of the square's west side continued with a new *Bouleutèrion* behind the old

after the liberation of the country from the Turks, the building housed the city's antiquities until the completion of the National Museum in Athens. Dedicated to the god of craftsmen, the Hephaisteion stood near the inner Kerameis in the crafts' district. Athena, the goddess of *metis* ("wisdom") was also associated with the cult. The temple is a Doric peripteral building with 6 rows of 13 columns, an *in*

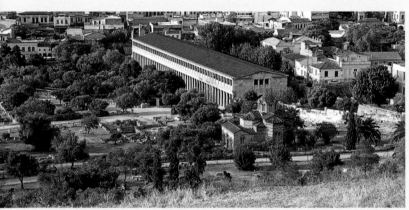

The discovery of numerous herms (base of a raised, bust-type statue) in this section of the agora suggested that this was the location of the Stoa of Hermes, mentioned in the sources as being on the site of an Archaic sanctuary of Hermes *Agoriaos*.
The Stoa of Zeus *Eleutherios* was added around 430 BC on the site of the Archaic sanctuary dedicated to the same god. Construction of this new building meant that the Stoà Basileios also acquired two avant-corps

one (which had been transformed into the new *Metroon*), the *Strategeion,* and the monument to the Eponymous Heroes of the 10 tribes of Attica.
The Hephaisteion was built during Pericles' rule on the *kolonos agoraios*, though this temple was not part of the overall Periclean program for Athens. It remains one of the best conserved temples in the Greek world, thanks partly to its transformation into a church, the Agios Georghios, in the 7th century. Deconsecrated

antis (in rear) distyle amphiprostyle naos, a two-story internal colonnade, and a cult statue of Hephaestus and Athena made by Alcamenes.
This temple was probably planned by Cimon before 450 BC, but was in fact only built in the 440s; it was completed most likely in the years between the Peace of Nicias (421 BC) and the Sicilian expedition (415 BC). Despite having certain original features (the spacious peristasis and a wide ambulacrum), the temple betrays a certain

dependence on the model of the Parthenon: the 9:4 ratio module, and the layout of the naos in the shape of the letter "pi" (Π).

A similar influence is evident in the sculptural

the *Parthenos* and Parthenon. This move would have been politically motivated by an anti-Pericles, pro-Cimon party. The west side of the square was further affected by works in the 4th century

OPPOSITE: THE STOA OF ATTALUS HOUSES THE MUSEUM OF THE AGORA; VIEW FROM THE AREOPAGUS.

ABOVE: RELIEF FROM THE HEPHAISTEION.

LEFT: HEPHAISTEION, SEEN FROM THE SOUTH.

BELOW THE REMAINS OF AN EXEDRA IN THE GREEK AGORA.

decoration. The metopes on the façade that looks toward the agora were carved with the labors of Heracles, while those that continue around onto the side walls (4 metopes each) were decorated with the exploits of Theseus. The Athenian hero is seen in the 2 Ionic friezes on the pronaos (myths related to Attica) and the opisthodomus (centauromachy of Theseus with his friend Pirithous). The few surviving fragments from the pediments allow us to hypothesize a theme that brought Heracles and Theseus together.

With the exception of the metopes, the execution of the cycles seems late, coeval with Alcamenes' cult statues; however the choice of subject seems to have been made at the time of the project to create a contrast between the Hephaisteion's Athenian program and the panhellenic ones seen in

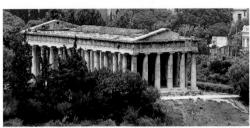

BC, with the construction after 338 BC of 2 altars to Zeus *Phratrios* and Athena *Phratria*; they were the guardian deities of the *phratries*, the basic units of the Athenian political organization. Another alteration on the west side was the addition to the temple of Apollo *Patroos*, which contained the famous statue by Euphranor.

Little building occurred during the Hellenistic period. The situation changed again in the 2nd century when the square was given an Eastern appearance with the regularization of

the south and east sides with large porticoes (respectively the southern *stoai* and Stoa of Attalus) and the new *Metroon* to the west.

After the devastation wrought by Sulla, the Augustan phase saw the central area of the agora (which no longer had any political significance) progressively invaded by new buildings. Next to a large odeon (141 x 167 feet) built by Agrippa, the Romans reassembled a temple that had been dedicated to Ares in the second half of the 5th century BC, after disassembling it in its original location (still unknown) and transporting the materials to the new site.

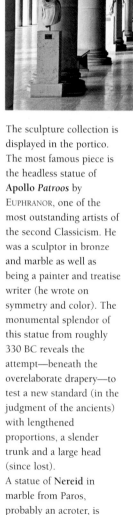

The sculpture collection is displayed in the portico. The most famous piece is the headless statue of **Apollo *Patroos*** by EUPHRANOR, one of the most outstanding artists of the second Classicism. He was a sculptor in bronze and marble as well as being a painter and treatise writer (he wrote on symmetry and color). The monumental splendor of this statue from roughly 330 BC reveals the attempt—beneath the overelaborate drapery—to test a new standard (in the judgment of the ancients) with lengthened proportions, a slender trunk and a large head (since lost).

A statue of **Nereid** in marble from Paros, probably an acroter, is indicative of the post-Phidian mannerism beginning in the early 4th century BC, as is the acroter statue of **Nike** from the portico of the temple of Zeus *Eleutherios*. The museum contains a variety of objects, but the majority are pottery from the Neolithic to the Roman era as well as: Byzantine and Turkish. These are descriptive of daily life in the heart of the ancient city. Note the samples of **weights and measures**, a **water clock**, and a **kleroterion** (a tool used in the balloting of public appointments such as magistrates, judges, etc.). Then there is a fine **bronze shield** taken in battle at Pylus in 425 BC against the Spartans. The red-figure vases include a **crater** by EXECHIAS (c. 530 BC) and a **cup** by EPIKTETOS (520 BC).

Of great interest are the *ostraka*, the pottery shards on which were written the names of those people for whom exile was sought. The most famous names among those found are

OPPOSITE TOP: STOA OF ATTALUS, ENTRANCE TO THE MUSEUM OF THE AGORA.

OPPOSITE BOTTOM: HEADLESS STATUE FROM THE CLASSICAL AGE.

Aristides and Themistocles. Interestingly, those bearing the name Themistocles have the same handwriting and suggest that they were previously fabricated by a political party or faction that opposed him.

A bronze **head of Nike** stands out wonderfully in the middle of the room. Originally covered with gold leaves, it is dated to c. 430 BC.

Before you arrive at the collection of **Roman oil-lamps**, take note of an **ivory statuette** from the Hellenistic period in the same manner as the **Apollo Lyceus** by PRAXITILES.

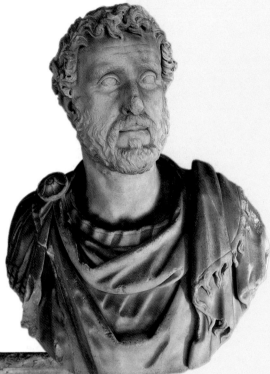

ABOVE: IMPERIAL ERA BUST.

LEFT: RACING QUADRIGA, RELIEF FROM A SARCOPHAGUS.

BELOW: TWO ROMAN-ERA REPORTS IN THE MUSEUM OF THE AGORA.

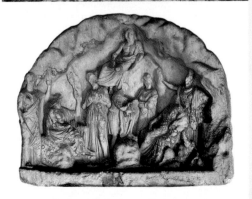

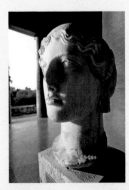

KERAMEIS, DIPYLON, AND ACADEMY

The entrance is from Odos Hermous; the visit, which includes the small but very important museum, can be made from Tuesday to Sunday, from 8:30am to 3pm, and requires about one and a half hours.

Just to the north of the agora lies one of the most attractive districts in Athens. This is the demos of *Keramèis*, seat of the cult of the hero Kèramos, who was the founder of pottery, the most widespread craft. It was the here that splendid artisans made the objects that we find spread across the whole of the Mediterranean basin from the 8th till the 5th centuries BC.

The district is divided into two parts—the outer and inner Kerameis—by the **Wall of Themistocles (a)**, raised after the battle of Platea (479–78 BC); it was

reworked by Conon in 394 BC and again by Lycurgus at the end of the same century. The most notable of the wall's 13 gates is the **Dipylon (b)** ("double gate"), which is connected to Athens' most famous necropolis, also known as the Dipylon, the use of which dates back to the 12th century BC. Nearby to the south is the Sacred Gate.

The excavation and recovery of huge quantities of materials began in 1862 and continued off and on until the early 1900s. Credit for the first attempt to survey and measure the site, in 1909, goes to A.

Brückner, who provided the basis for systematic excavation of the area by the German Archaeological Institute throughout nearly all of the 20th century. The burial method was initially inhumation in rectangular trenches, but, about 1000 BC this altered in favor of cremation. Then toward 800 BC inhumation was once more preferred, and from the 7th century BC onward the two practices coexisted. Mounds covered the graves and on them vases were placed for libations. These vases took on monumental dimensions beginning in the 8th century BC (up to

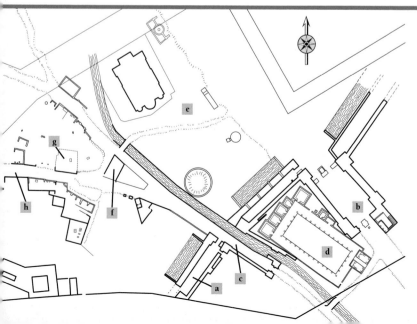

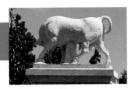

LEFT: FUNERARY MONUMENT
IN THE KERAMEIS.

BELOW: VIEW OF THE AREA
AROUND THE DIPYLON.

BOTTOM ARCH AND WALLS IN
OPERA ISODOMUM, DIPYLON.

ATHENS

5 feet high) and were decorated with beautiful geometric patterns: for this reason, we refer to the Geometric Age. At the end of the 7th century, statues of *kouroi*, and *korai*, and stelae appeared. The stelae were either pillar type or pseudo-shrines and symbolic in nature. The most important development was the agglomeration of graves in ever larger mounds that were probably inspired by Ionic models, and which seem to have been the burial places of large families (*genos*). In response to these large aristocratic monuments, Solon issued a decree against elaborate tombs, which was a policy also taken up later by Cleisthenes. The Classical period saw a slow revival of funerary stelae and the replacement of mounds by cube-shaped monuments made from unfired bricks and crowned by stone or,

at times, decorated with painted clay *pinakes* (tablets) to hold up the stelae. These were also given the appearance of simple columns, funerary tables (*trapeza*), marble vases (*loutrophoroi*),

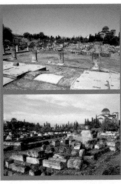

statues of animals, or actual shrines.
In the second half of the 4th century, a decree issued by Demetrius Phalereus struck once more against luxurious tombs, but in a more radical manner, and in doing so brought an end to this tradition of the nobility.

Later, however, "family enclosures" would come into being that gave the area an ordered appearance, organized along the lines of a city, and thus justified the Greek name *necropolis* ("city of the dead"). Under the force of the "heroizing" ideology and impressive Eastern models, the middle and late Hellenistic periods were characterized by tombs in the form of a sacellum that required a substantial architectural investment. After a new long period of "monumental crisis" marked also by the destructive invasion by Sulla in 86 BC (which led to the setting up in the area of many pottery and metals kilns), there was once more a decided revival in luxury tombs during the imperial age. The area is dominated by the stretch of walls with the Dipylon to the north and **Sacred Gate** (c) to the

KERAMEIS	
a WALL OF THEMISTOCLES	f SACRED AREA OF THE TRITOPATORES
b DYPILON	g TOMB OF THE FAMILY OF ALCIBIADES
c SACRED GATE	
d POMPEION	
e POLYANDRION	h WAY OF THE TOMBS

south. Between these two lies the **Pompeion (d)**, a building in which the Panathenaic processions were prepared.

Built in the late 5th century BC and renovated at the start of the 4th, it consisted of an Ionic *propylon*, a peristyle with a chariot in the form of a ship used to transport the sacred *peplos*, and a series of rooms for sacred banquets. The place was also used as a gymnasium. Destroyed by Sulla in 86 BC, it was rebuilt in the 2nd century AD with 3 aisles. It was destroyed once more by the Herulians in 267 AD. From the Academy, the *dromos* entered the district from the Dipylon. The *dromos* was a road about 140 feet wide along which the Panathenaic procession wound its way. Just after the ruins of a Hellenistic baths outside the gate, there lay the *demòsion sèma*, the "public graveyard," where the poor were buried at public expense. It may have been built during the

Cleisthenes period. This was where competitions were held to celebrate those considered heroes; it was there that Pericles made his famous commemoration speech of the first to die in the

Peloponnesian War; and it was there, in the first section, that the **polyandrion (e)** stood. This was the tomb of the Spartans who died in battle in 403 against the democratic Athenians who rose against the Thirty Tyrants.

Further south across the Eridanus River (which flowed through the Sacred Gate) lay the fork between the Sacred Way, which led

to the famous sanctuary of Eleusis, and the Way of the Tombs.

At the fork there was the **sacred area of the Tritopatores (f)**, the guardian deities of births who were often identified with the winds but who perhaps incarnated the ancestors. The **tomb of the family of Alcibiades (g)** lies opposite.

The **Way of the Tombs (h)** is the area that best conserves the appearance of the necropolis as it was in the Classical era, though some of the most famous funerary monuments have been taken to the museum and replaced with copies, such as the stele of Hegeso. The dominant stylistic influence in the lovely *semata* is Parthenonic or post-Parthenonica. This is revealed in the compositions and drapery of the stele of Dexileos (also in the museum), which depicts a young rider about to pierce his fallen enemy with his spear in the Corinthian War (394 BC).

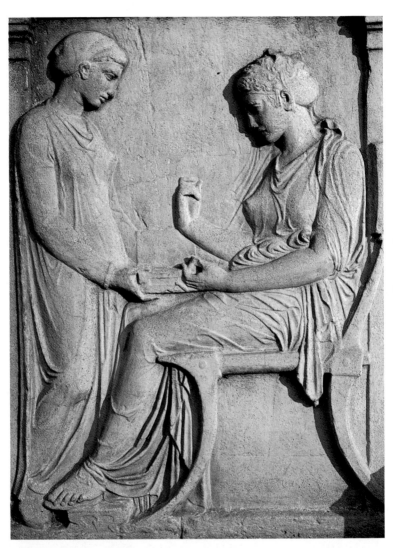

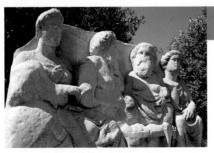

OPPOSITE TOP AND LEFT:
RELIEFS AND STATUES IN THE
DEMOSION SEMA (PUBLIC
GRAVEYARD).

ABOVE: STELE OF HEGESO.

This museum holds the most interesting finds from the necropolis. Certain important pieces, however, have gone to the National Archaeological Museum, including the stele of Hegeso and the Dipylon amphora.

As is to be expected, ceramics dominate the museum's exhibits and document the entire period of use of the necropolis itself. They span the proto-Geometric, the Geometric, and the Archaic periods with black and red figure vases.

Of the funerary stelae, the most outstanding is the **stele of Dexileos**.

It shows a young warrior who fell in the war against Corinth in 394 BC; here, from his saddle, he is about

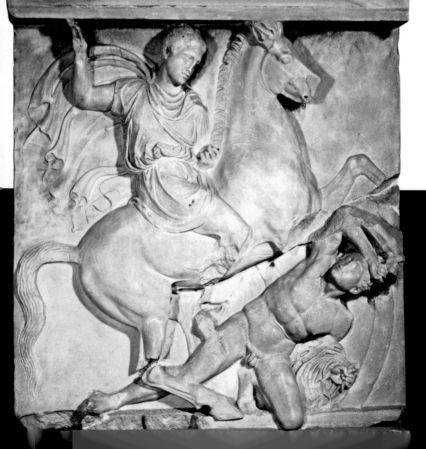

to run his enemy at his feet through with a spear. There is a clear reference to the Phidian frieze in a Parthenonic cavalcade, but also the figure of the fallen enemy has similarities with the frieze at Bassae.

The display is completed by a number of *kouroi*, the **bases of funerary monuments** decorated with reliefs, a lovely **Archaic sphinx**, and a **marble lion**. To reach the Academy from the Kerameis, take Odos Lenorman and then turn left into Odos Tripoleos. The area enclosed by a wall during the Peisistratid era has been turned into a garden. It gets its name from the hero Hekademos (Academy), whose cult was

celebrated here along with many other gods: Prometheus, Hephaestus, the Muses, Athena, Hermes, Heracles, Zeus and others. Its fame is above all linked to the school that Plato established here just to the northeast, in the surroundings. Traces of settlements from the Neolithic, Mycenaean, and Geometric periods have been identified beneath a large gymnasium from the Roman era; this site is open to visitors.

OPPOSITE: STELE OF DEXILEOS.

ABOVE: ARCHAIC SPHINX.

CENTER: VIEW OF A ROOM IN THE KERAMEIS MUSEUM.

BOTTOM: GEOMETRIC AND EARLY GEOMETRIC AGE AMPHORAS.

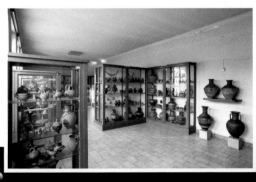

GREEK POTTERY

BELOW: EASTERN-INFLUENCED
RHODIAN *OINOCHOE*.

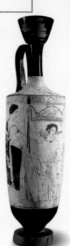

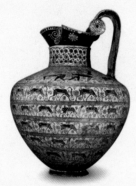

92 CENTER: FUNERARY
LEKYTHOS, ON A WHITE
GROUND.

92 RIGHT: ATTIC CRATER WITH
VOLUTE HANDLE.

Since remote times man has produced terracotta containers, especially for domestic use. The rapid evolution of forms and decoration, fostered by the generally short life of the pots (most often due to their fragility and low cost), made them a class of item that can bemake them easily classified by type, style, and chronology.

A huge quantity of pottery is found in almost any archaeological excavation, and it is clear that scholars accord much importance to it in terms of dating the strata of a site, reconstructing its history, and developing information on the economic
and social aspects of the life lived there.

Initially, terracotta vases were made by hand, then, with the introduction of the wheel (a simple machine consisting of two horizontal wheels linked vertically by a rod), they were modeled more quickly and uniformly. One

technique used was the matrix for vases in the shape of animal heads or "plastic" men, or those decorated in relief.

During the historical age, the surface was often left untreated except for slightly smoothing it with a thin layer of purified clay (referred to as "slip");. this was referred to as "common" pottery. Another finish was provided by painting though in fact the paint was simply the same clay heavily purified and added to urine.

The decoration process involved: (a) the slip, (b) the outline of the decorations with a stick or charcoal, (c) the painted outline of the shapes (in black-figure pottery) or the ground (in red-figure pottery), and (d) the application of added colors such as lime white, purple, yellow, etc. Then came the firing in the kiln.

The firing operation indicates of the high technological capacities the ceramists of the period. There were three phases of firing:

(1) in oxidizing conditions (i.e., in an abundance of oxygen) up to a temperature of 800°C; (2) in a reducing environment (i.e., with a lack of oxygen) between 800° and 945°C; and (3) firing at 900°C once more with oxygen available. After these three firings were completed, the object was allowed to cool slowly.

This procedure was responsible for creating the chromatic differentiation (red/black) of the surface of the vase.

The red was the outcome of simple slip, the black by the application of paint. In the earlier black-figure decoration (6th century BC), the decorative elements were applied in black on a red background and the internal details were given by the use of scratching and adding color. In the red-figure technique (c. 530 BC), the decorative elements were left untreated (and therefore came out red) on a ground painted black.

The internal details were rendered with black lines, brushstrokes of diluted paint or added colors. A special technique used in the 5th century BC is known as "white ground," obtained by treating the surface of the clay with whitewash onto which delicate colors were superimposed between fluid lines.

Types of vases

In general the ancient names attributed to Greek vases are agreed upon by convention, but in some cases they are used by ancient authors.

A first group includes large and medium-large containers used to hold water, wine and oil, such as the **amphora**: the **hydria** was used exclusively for water; the crater (vase) to mix wine with water and honey (the **stamnos**, **deinos**, **lebete**, and **psikter** had a similar function); in contrast, the **pithos** was used to store foodstuffs and was buried underground in storerooms or courtyards.

A second group includes smaller containers such as the **kylikes**, **kantharoi**, **skyphoi**, and **kotylai** (types of cups), **phialai** (bowls), and the **kyathos**, which is a sort of ladle for pouring wine into **oinochoai** or **olpai** (jugs).

Another group of containers was used for personal toilette and includes the *lèkythos* (a sort of pitcher, often used for funerary purposes), the **arybballos** and the **alabastron** (small, rounded containers for ointments and perfumes), the **askos** (small leather bags), **pyxides** and **lekanides** (lidded boxes for holding loose articles).

Most of the painted vases in museums around the world were found during excavations in necropolises, whereas crockery is, in general, found in excavated houses.

After a period of domestic use, household vases or containers, like those used for personal toilette, were often employed as grave goods, placed in the grave to accompany the deceased to the afterworld.

The monumental vases dating to the Geometric Age often had the function of marking the tomb and being the means of "conducting" the libations to the deceased. Vases also were sometimes used to hold the ashes of those cremated.

1.5

To enjoy one of the best views of the city, take the shady climb up to the Hill of the Muses from the junction between Dionysiou Areopaghitou and Apostolou Pavlou streets, where there at one time stood a very popular sanctuary, that of Heracles *alexikakos* ("who chases away evil"). There, among the bare rocks and the remains of a fortified

chamber. It is designed in the form of a slightly curved exedra and made in Pentelic marble with a high *poros* plinth, and the lower section has a relief of Philopappus in his role as consul, mounted on a quadriga and preceded by lictors (officers). The upper section is divided into 3 sections by 2 Corinthian columns: the central semicircular niche was to hold the seated statue of Philopappus in the role of a philosopher, and those rectangular niches on

dual nature of a "heroized" Hellenistic intellectual and Roman magistrate.
Return down the hill, then head north toward the Hill of the Nymphs to the Pnyx, the seat of the people's assembly (*ekklesia*) reformed by Cleisthenes. Almost nothing remains, but the exceptional position and historical interest are worthy of the climb.
A sort of theater-like **cavea** (**a**) facing the city was cut out of the hill, using earthworks held by a large retaining wall. A **rostrum** (**b**) (or *bèma*) was built on

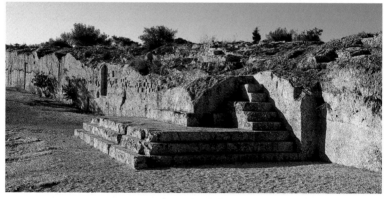

wall built by the Macedonians (3rd century BC), lies the tomb of Caius. Julius Antiochus Philopappus ("lover of the ancestors") of Commagene. He was a descendant of the princes of Syria and a Roman consul in 109 AD. Only the northeast façade of his funerary monument (114–116 AD) remains, the side that faces Athens, behind which lie the remains of the burial

either side contained an image of his grandfather Antiochus IV, king of Commagene, and one of Seleuchus Nicator, first king of Syria (this explains Philopappus' name). A bilingual inscription gave the *cursus honorum* of the nobleman in Latin (on the left) and his princely titles in Greek (on the right). All of which symbolizes, together with the "illustrated" section, the

the north side for use by the orators. A famous sundial designed by the astronomer Meton was installed in 433–32 BC in line with the rostrum. At the end of the 5th century BC, the site was radically altered: the cavea was turned around completely, and the *bèma* was moved to the south side. An altar to Zeus *agoraios* was installed on the rostrum but was transported to the agora

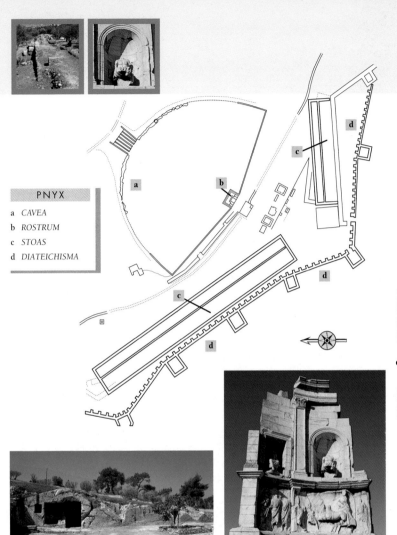

PNYX

a *CAVEA*
b *ROSTRUM*
c *STOAS*
d *DIATEICHISMA*

during the Roman era; construction began on two large **stoas** (c) behind the altar, but they were never completed. At the end of the 4th century BC the *diatèichisma* (d) ("intermediate wall") was erected with towers to defend the hills, and in the meantime, the assemblies were transferred to the theater.

The slopes of the nearby Areopagus—the "hill of Ares" and seat of the ancient aristocratic council of Athens until 461 BC and the blood-crimes court—are home to many remains of late Roman houses. Worthy of attention is the "Omega House," a high-quality residence with 2 peristyles and a private baths area; a fine sculpture collection was found here that covers a period from the 4th century BC to the 3rd century AD, including portraits of various emperors.

OPPOSITE: STEPS ON THE ROSTRUM.

TOP LEFT: ROAD ON PHILOPAPPUS HILL (THE HILL OF THE MUSES, OR MOUSEION).

TOP RIGHT AND ABOVE ABOVE RIGHT: BURIAL MONUMENT OF PHILOPAPPUS.

ABOVE LEFT: HOLLOWED ROCK, PHILOPAPPUS HILL.

To reach Hadrian's Gate, leave the Roman agora on Adrianou Street, cross the Plaka near the enormous foundations of a temple—Hadrian's *Pantheon*,

Greek-style trilithic structure with the central intercolumnar space marked by a sort of niche. The monument was erected in 131–132 AD to

side reads, "This is the Athens of Theseus, the original city."
Close by the gate is the *Olympeion*.
Excavation of this

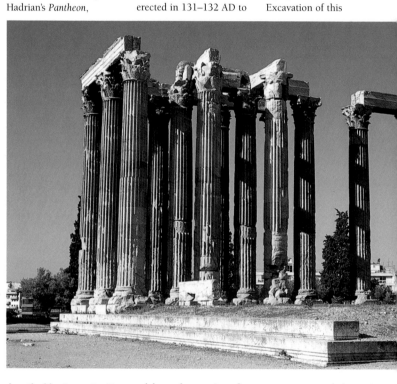

described by Pausanias (I, 18, 9)—and take Lyssikratou Street. The gate is an eclectic compromise, a sort of "bilingual" form of architecture: a Roman type of arch made from *opera quadrata* with slightly projecting side pilasters and isolated columns (now fallen), and a second order puts forward a light,

celebrate the opening of the nearby *Olympieion*. It came to mark what is presumed to be the Hadrianic district (though there are doubts about this). The inscription on the south side of the monument states, "This is the city of Hadrian and not the city of Theseus"; the inscription on the other

enormous temple began in 1883 by F. Penrose and was taken up again and completed by G. Welter in 1920–21. Drilling operations performed by J. Travlos in 1961 provided a better understanding of the nearby buildings. The temple was built during the Archaic Age for the Peisistratids in a gigantic

ABOVE: DORIC CAPITAL AND IONIC VOLUTE FROM THE *OLYMPIEION*.

BELOW: THE *OLYMPIEION* SEEN FROM THE NORTHEAST.

RIGHT: HADRIAN'S GATE.

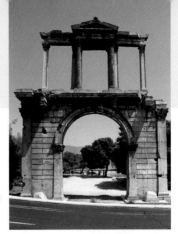

temenos. It is clear from the design that an attempt was made to introduce into Athens an example of macrotectonics (the art of making big structures) that recalled the large Ionic temples of the tyrannids of Asia Minor.

The architects of the Olympieion were ANTISTHENES, KALLAISCHROS and ANTIMACHIDES but construction was abandoned at an early phase when the tyranny stage fell. As a symbol of this form of government, the temple was taken up once again in the 2nd century BC by Antiochus IV Epiphanes, king of Syria, who pursued a policy of global Hellenization that had its fulcrum in the sacred building dedicated to the panhellenic gods.

The Seleucid king invited the Italic architect Cossutius to rebuild the temple, keeping the original dipteral, octastyle layout with a lengthened naos. Cossutius made a fundamental innovation by introducing a Corinthian order into the colonnade. The death of the king left the works incomplete once more, with only the roof missing.

The sack of the city at the hands of Sulla in 86 BC meant that the columns were appropriated to furnish the temple of Jove Capitoline in Rome. Later, a proposal was made to dedicate the temple to the Genius of Alexander but this brought no follow-up, and the building had to wait until Hadrian to be completed and restored. The temple, one of the largest in Greece, was finally inaugurated in 131–32 AD with the role of centralizing the religious attention of Greece on Athens. Concomitant with this event was the institution of the *Panellénion*, which was a body created by the emperor to reunite all the cities of Greek origin.

The double peristasis was made into a triple one along the façades with a total of 104 columns. The naos was very long and undivided and contained the chryselephantine statue of the god (Pausanias I, 18, 6). On the north side of the enclosure wall, with a spurred substructure, a small *propylon* called the Hippades Gate ("of the cavalry") stood on the site of a gateway in the walls built by Themistocles. Next to it was a late 2nd-century AD baths complex: and a paleo-Christian church.

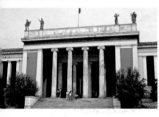

This exquisite neo-Classical building was begun in 1866 by the architect Ludwig Lange and completed by Ernst Ziller in 1889. It was designed to house the ancient pieces found in the capital or which had ended up there from the country's most important archaeological sites. Until that time, these items had been held, by royal decree in 1834, in the temple of Hephaestus in Kerameis and other places in the agora, but no more space was available. Between 1925 and 1939 a new wing to the museum was built. At the start of the WWII, all the objects were packed and hidden to avoid damage or destruction.

They were later returned to the museum in a layout organized by the archaeologist H. Karousos. The description below follows this layout, which, after the prehistoric section is organized by material: marble, bronze, pottery. Within each category, the ordering is generally chronological. The visit begins in *Room 4* (*Mycenaean*).

This room includes objects Schliemann found during his excavation of Mycenae in 1876. The most striking are: a **gold rython** with a bull's head and another with a lion's head made from gold leaf (16th century BC); a pure gold **funerary mask** (16th century BC) that Schliemann attributed incorrectly to Agamemnon; a **bronze dagger** with thin decorative inlays in gold and silver of armed men about to fight a lion and other felines (16th century BC); an **ivory statue** of 2 goddesses and a young boy (15th century BC); the famous "**warrior vase**" (13th century BC) with an illustration of Mycenaean military society; a **rock crystal vase** with a handle in the form of a duck's head; and a large collection of **coins** and **gold parures**.

There are many fragments of **frescoes**, one of which is known as the "**Mycenaea**"; this 13th-century BC piece was found in 1970 and depicts a female figure (probably a goddess) on a dark blue background. Then there are **seals** made from amethyst and gold, articles made of ivory, and a number of **tablets** from Pylos written in Linear B. There are many grave goods from Mycenae and other archaeological sites. Superb **gold cups** from Vaphio in Laconia are decorated with embossed scenes of the capture of a bull in a meadow (16th–15th century BC). *Room 5* (*Neolithic*). The

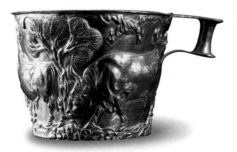

FIRST FLOOR

GROUND FLOOR

THE COLLECTIONS

OPPOSITE TOP: THE
ENTRANCE TO THE
NATIONAL
ARCHAEOLOGICAL
MUSEUM IS A
MODERN IONIC
PORTICO.

OPPOSITE BOTTOM
AND ABOVE (DETAILS):
GOLD CUP FROM THE
TOMB OF VAFIÒ
(LACONIA),
MYCENAEAN AGE.

MYCENAE

NEOLITHIC

CYCLADIC

GEOMETRIC-ARCHAIC

CLASSICAL

ORIGINALS AND COPIES

EPIDAURUS

FUNERARY MONUMENTS

VOTIVE RELIEFS

LATE-CLASSICAL FUNERARY ARTICLES

HELLENISTIC

ROMAN SCULPTURE

ROOM OF THE DIADUMENOS

BRONZES

EGYPTIAN ARTICLES

BYZANTINE ARTICLES

FRESCOES FROM THERA

CERAMICS

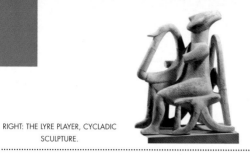

OPPOSITE TOP: AMPHORA BY DIPYLON, THE PAINTER, GEOMETRIC AGE.

BOTTOM LEFT: HEAD OF A CYCLADIC "IDOL."

RIGHT: THE LYRE PLAYER, CYCLADIC SCULPTURE.

BOTTOM RIGHT: "VIOLIN-SHAPED" IDOL FROM PAROS; AEGEAN ART.

items of major interest are the **clay idols** from Thessaly, in particular from Sesklo near Volos, (late 4th millennium BC). From the Bronze Age there is a fine "**sauce boat**" (15th–13th century BC) from Dimini, as well as gold coins and pottery. *Room 6 (Cyclades).* From the Neolithic to the Bronze Age there are **vases** and **idols** from the Cycladic archipelago, in particular the almost life-size idol of Amorgos, with his abstract, violin-shaped profile (2200–2000 BC). The unique culture of the archipelago was fueled by the sale of obsidian from Milos and fine white marble (especially from Paros and Naxos). Two of the statues made from the marble are the famous **lyre player** and the **twin-barreled flute player** from Keros (2400–2200 BC), which is arranged spatially with an interesting distribution of volumes (the face retains the traditional abstract style). *Rooms 7 to 13* contain Archaic sculpture. *Room 7.* This opens with

one of the most famous pieces of Greek pottery from the Geometric Age (mid-8th century BC), the magnificent **amphora** by the "Dipylon Painter" which shows scenes of the deceased on his burial bed harmoniously fitted into the geometric arrangement of the ornamental motifs. In the large collection of sculptures in this room, special attention should be given to the **marble statue** dedicated by Nikander of Naxos to Artemis (c. 660 BC), sculpted in elaborate monumental style, of a figure between parallel planes only broken by the slight jut of the breasts and the belt fastened around the waist. The damaged head was given an Egyptian klaft hairstyle. *Room 8.* This is where the collection of **Archaic kouroi** begins. First there is the round but fluid **Dipylon head** (c. 610 BC) with crystalline surfaces. The large oval of the face is framed by the curls of the hair and is characterized by slightly oblique eyes. This statue

is countered by the equally famous **kouros from Sounion** (c. 600 BC); this is decidedly square, the lower lid of the eyes horizontal and the upper one curved, "bobbin" style curls in the hair, and an ear in the abstract form of an Ionic capital. The most organic expression in this period of sculpture was represented by the body, of which the clean, square surfaces are brought to life by anatomical details that do not break the compactness of the work. *Room 9.* The **kouros of Milos** reaches a greater unity and more marked naturalism through its slimmed-down forms and delicate treatment of surfaces (mid-6th century BC). *Room 10.* The **kouros from Volomandra** in Attica (c. 550 BC) is similar to that of Milos, as is the **kouros of Merenda** (Attica, mid-6th century BC). Note also the fragment of **stele** with the head of a young discus thrower. The discus itself frames the face in profile almost like a halo (560–550 BC).

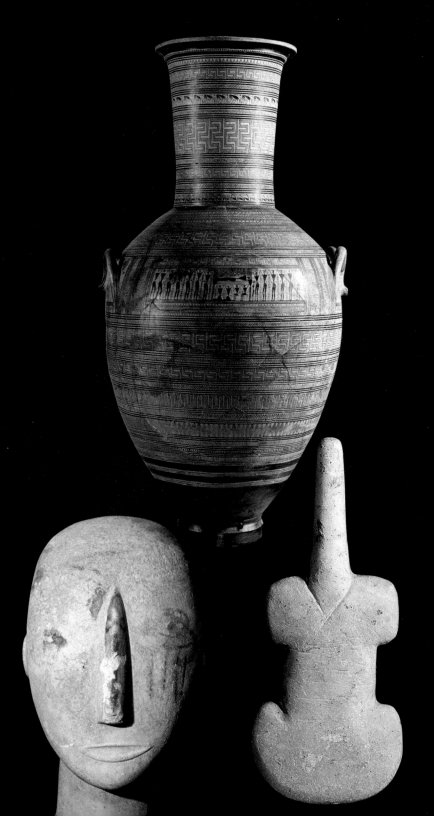

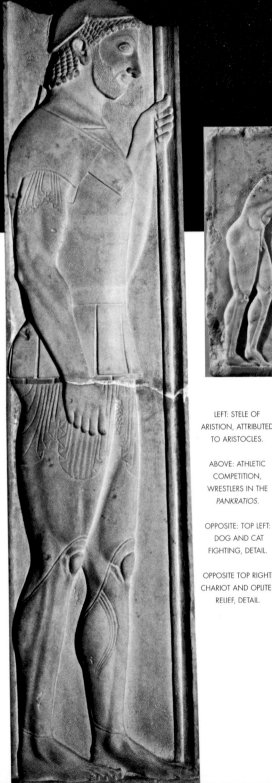

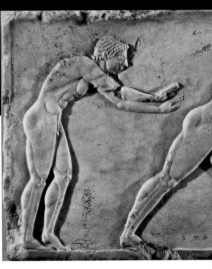

LEFT: STELE OF ARISTION, ATTRIBUTED TO ARISTOCLES.

ABOVE: ATHLETIC COMPETITION, WRESTLERS IN THE *PANKRATIOS*.

OPPOSITE: TOP LEFT: DOG AND CAT FIGHTING, DETAIL.

OPPOSITE TOP RIGHT: CHARIOT AND OPLITES RELIEF, DETAIL.

Room 11. The masterpiece in this room is the **stele of Aristion** by ARISTOCLES (which is written on the base). It shows the deceased as a hoplite with a short beard; he was therefore probably killed in battle (520–510 BC). The low relief has distinct outlines and was probably polychrome originally. Note also the "muscular" ***kouros* from Keos** (c. 530 BC).

Room 12. Here there is another masterpiece: the **relief of a hoplitodrome (runner)** in a "race in armor," with his head brutally facing backward. This last detail has suggested to some scholars that this scene is

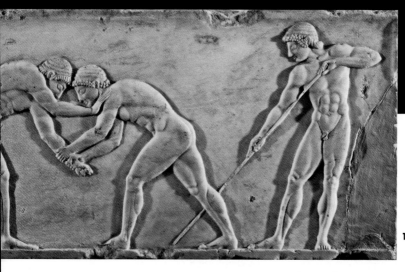

of a dance, in particular the "Pyrrhic" dance that was performed in armor (late 6th century BC). *Room 13.* The *kouros* of the Ptoion (sanctuary of Apollo near Thebes) has a finely rendered body combined with a "calligraphic" treatment of the hair (510–500 BC). The *kouros* of Aristodikos was one of the latest to be found in Attica. It was executed by an important master, perhaps a member of ANTENOR's circle, in about 500 BC or shortly thereafter. It is marvelously conserved (only the head is damaged) and is permeated with a new tension and elasticity that,

however, has not yet broken into movement. Another interesting statue is of **Croesus** from Anavysos in Attica (c. 530 BC). Its base is inscribed, ". . . halt and cry near the funerary monument of Croesus: furious, Ares killed him one day as he was fighting in the front line." The serene authority of the figure seems to endow him with self-knowledge, at the height of his strength and youth. **Base 3476** is carved with 3 low reliefs of scenes in the palaestra (c. 510 BC); on the front an athlete prepares for a race, two wrestle, and another prepares to throw the

javelin. On the left side 6 youths are playing ball, and on the right, 4 individuals watch a fight between a dog and a cat. Next to it a similar **base** mixes scenes of the militia with scenes of play (c. 500 BC). A bronze statue of **Apollo** from Piraeus (530–520 BC) extends his right hand that once held a cup (since lost) while his left hand clasps a bow (also lost). His advanced right leg breaks the schema of the *kouros*, but the forms of his body are still fully in harmony with the late Archaic tradition, whereas his head (especially the hair) seems to refer to ancient models. *Room 14.* This is

the start of the Classical sculptures, or rather, these are the most important sculptures in what is known as the "Severe" style (first half of the 5th century BC). First and foremost, the relief in Paros marble of **Ephebus crowning himself** (480–469 BC) from Sounion: the image is filled with restraint, the head bent, the body in three-quarter profile, the movements limited (the leaves of the crown were originally made from metal). A good depiction is given of the elderly deceased on a **funerary stele** from Orchomenos, signed by ALXENOR FROM NAXOS (who was so proud of his art that he invites the passer-by to take a closer look, "Turn your gaze hereupon"). The deceased wears the *himàtion* and rests on his staff as he offers his faithful dog a grasshopper.

Room 15. The visitor's attention is immediately won by a large bronze work attributed by some to CALAMIDES, by others to ONATAS. This is the **Poseidon** (or **Zeus**) **from**

POISEIDON (OR ZEUS).

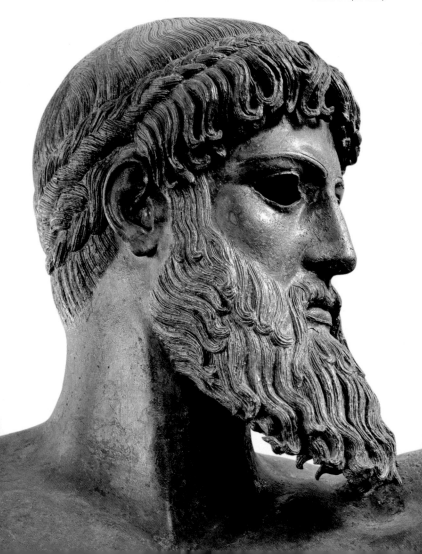

Cape Artemision with the god about to hurl his trident (or thunderbolt). Dated to around 460 BC, the statue shows that by then Classical statuary had achieved a structural relationship in the depiction of the limbs. Everything is tense, controlled power. The representation of the god's hair is extraordinary, and the locks of his beard flow. His eyes, eyebrows, and lips were rendered with the use of other materials. CALAMIDES is definitively credited with the **Apollo of the Omphalos** (470–460 BC), the power of which lies in the tension of the body, the powerful musculature and the intense psychological charge in the face.

A large **relief** discovered at Eleusis in 1859 shows Demeter with a scepter and Kore-Persephone with a torch as their poses offer protection to an adolescent in a worshipful attitude. The relief would have been part of an architectural set, probably from the Telesterion (rebuilt by Ictinus,) where initiation ceremonies were held. For this reason, some experts have identified the youth

as either King Triptolemus or Iacchus, the god associated with the procession of the mysteries, or Pluto, son of Persephone. According to the latest theories, the figure is simply that of an anonymous initiate. The artistry of this very shallow relief is excellent; it has many points in common with the frieze on the Parthenon, but this does not mean that PHIDIAS was necessarily its author.

Room 16. **Attic stelae** in the form of pseudo-shrines take up much of the display area. An important one is the **stele of Aegina**, which is topped by an elegant frieze of palmettes and lotus flowers. It shows the deceased in the main section in front of a small pillar on which a cat sits and against which a young slave leans. A small cage hangs above the head of the cat, and the deceased holds a small bird in her left hand. The main figure seems isolated from the world of the living.

An outstanding piece is the marble *lekythos* of **Myrrhyne** (410–400 BC) by a sculptor who seems to have studied with CALLIMACHUS. Hermes accompanies Myrrhyne— the deceased—whose name is written on the figure to the afterworld in the presence of his relatives.

Room 17 continues the display of the **reliefs**, including examples of **votive reliefs**. One of these, **no. 1500**, from Piraeus, shows banqueting

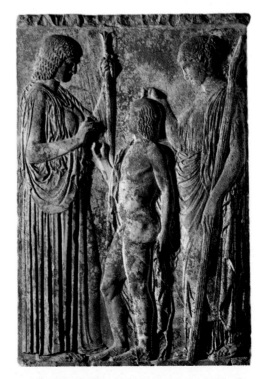

RELIEF FROM ELEUSIS.

OPPOSITE TOP: *DIADUMENOS*, ATHLETE TYING A BAND ROUND HIS HEAD; ROMAN COPY.

OPPOSITE BOTTOM: BOY ON HORSEBACK, BRONZE SCULPTURE FROM THE MATURE HELLENISTIC AGE.

scenes and **no. 1783**, of Cephissus, is carved on both sides (an assembly of the gods, and the hero Echelos and nymph Basilè on a chariot driven by Hermes), both from the last quarter of the 5th century BC. However, the most remarkable piece is unquestionably a **head of Hera** attributed to the circle of POLYCLITUS, and found in the Heriaon in Argos (late 5th century BC). *Room 18* is home to the famous **stele of Hegeso** (ca. 400 BC). The deceased sits dressed in a chiton and cloak and gives a melancholy glance at her jewel casket held by her maid. The scene has more than a simple domestic significance and alludes to her marriage with Hades. The perfection of the elegant lines and the structured rhythm of the composition contrast the inexorable and eternal world of death represented in the hard, bare architectural molding of the *naïskos*.

Rooms 19–20. These 2 rooms contain original 5th-century BC sculptures and also Roman copies, including the **Varvakeion Athena** (*Room 20*), a small and rather lifeless 2nd-century AD copy of the

chryselephantine statue by Phidias in the Parthenon. *Room 21* is also known as the Room of the *Diadumenos*, after the Roman copy from Delos of the bronze masterpiece by POLYCLITUS. This late work by the Argive master of an athlete tying the victory band around his head features a remarkable fusion of the limbs thanks to the use of gentle colorism comparable to the artist's mature period in Attica, when he was exposed to PHIDIAS' masterpieces. The difference between this piece and the other masterpiece in the room is extreme. The bronze statue of the **young boy on a horse** was found in the sea off Cape Artemision. Having finally confirmed that the horse was part of this same late 3rd-century BC monument, the focus of the statue is the explosive force that emanates from the centrifugal structure of the work and seen in the outstretched posture of the rider at the gallop. The result is one of great spatial freedom and naturalism. *Room 22* contains architectural sculptures and decorations taken from the sanctuary of Asclepius at Epidaurus, of which 2

acroters attributed to TIMOTHEUS stand out. One is a **personification of the wind on horseback** and the other a **Nike** characterized by flowing drapery, some of which is gathered, some skillfully stuck to the body, none of which conceals the grace and animation of the figures (370–365 BC). Working in the same workshop were HEKTORIDAS, a certain "THEO. . .," and another master, the last of whom was responsible for the 2 **pediments** (**Ilioupersis** to the east and an **amazonomachy** to the west). The **marble statuette of Hygeia** brings together the notions of the enude and drapery. *Rooms 23 and 24* return to the theme of funerary monuments with lovely examples from the 4th century BC. The **stele of the Ilissos** is very famous; some experts consider it to have been produced in the workshop of SCOPAS, but the influences of the other great masters of the century—PRAXITELES and LYSIPPUS—are unquestionable. *Rooms 25, 26, and 27* house the collections of Attic decrees and **votive reliefs**. *Room 28* has late classical **funerary monuments** and **sculptures.** In the center stands the **Ephebus of**

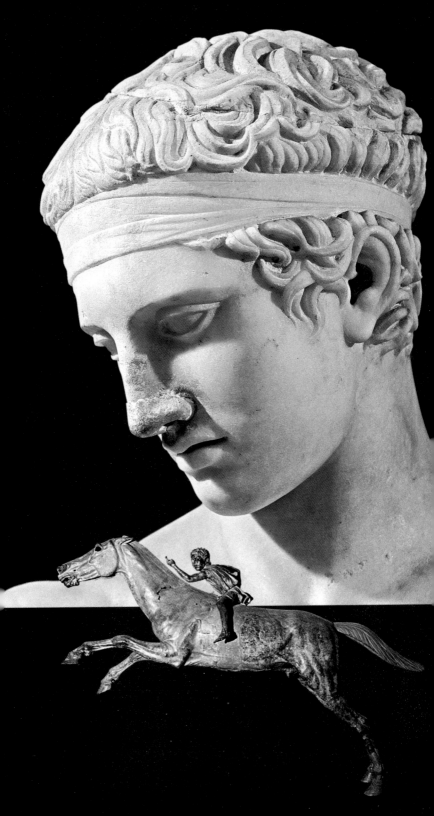

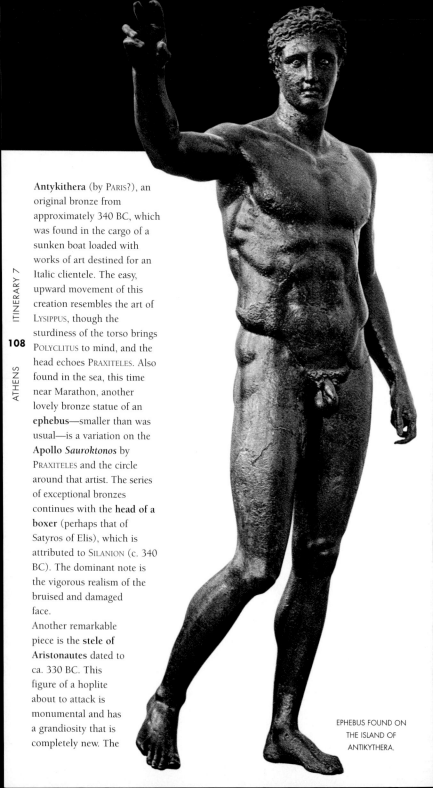

Antykithera (by PARIS?), an original bronze from approximately 340 BC, which was found in the cargo of a sunken boat loaded with works of art destined for an Italic clientele. The easy, upward movement of this creation resembles the art of LYSIPPUS, though the sturdiness of the torso brings POLYCLITUS to mind, and the head echoes PRAXITELES. Also found in the sea, this time near Marathon, another lovely bronze statue of an **ephebus**—smaller than was usual—is a variation on the **Apollo** *Sauroktonos* by PRAXITELES and the circle around that artist. The series of exceptional bronzes continues with the **head of a boxer** (perhaps that of Satyros of Elis), which is attributed to SILANION (c. 340 BC). The dominant note is the vigorous realism of the bruised and damaged face.

Another remarkable piece is the **stele of Aristonautes** dated to ca. 330 BC. This figure of a hoplite about to attack is monumental and has a grandiosity that is completely new. The

EPHEBUS FOUND ON THE ISLAND OF ANTIKYTHERA.

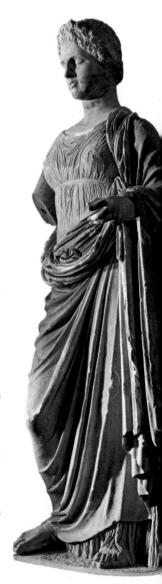

high-relief statue is separated from the dark ground of the *naìskos*, and depicts the wretched gaze of the hoplite in search of glory.

Room 29 marks the start of the Hellenistic sculpture with Chairestratos' monumental statue of **Themis** (Justice) from Rhamnous (early 3rd century BC).

The work brings together various motifs typical of PRAXITELES on a schema reminiscent of the Phidian school; what is most noticeable is the gentle face.

Room 30 contains 2 high quality 3rd-century BC busts of a **philosopher** and an **old man** that mark the end of Hellenism. A colossal statue of **Poseidon** from Milos (end of the 2nd century BC) stands in the center of the room in a powerful but also theatrical pose characterized by a heavily emphasized frontality. The group of **Pan and Aphrodite** from Delos (roughly 100 BC) is rich with contrasts even though the torsion of the figure of Pan is seen to be purely for the sake of appearance. The coquettishness of the goddess and jokey presence of the flying eros are notable.

Rooms 31, 32, and 33 hold the collection of Roman sculptures, which are principally portraits of the emperors. Worthy of attention is the upper half of a bronze **equestrian statue of Augustus** found in the sea in the Gulf of Euboea, and the "**pseudo-athlete**" from Delos (start of the 1st century BC), which is indicative of the Greek interpretation of a Roman portrait of an old man, with the superimposition of a realistic head on an athletic body characteristic of Polyclitus' school. The dividing line between the two approaches is evident in the workshop perfection that tends toward a slight idealization of the facial features.

After the votive reliefs in *Room 34*, a jump is recommended to *Room 36* where the bronze collection of the archaeologist K. Karapanos is displayed. Karapanos found these pieces at Dodona at the end of the 19th century. More

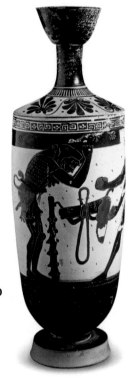

bronzes can be seen in *Rooms 37, 38, and 39. Rooms 40 and 41* contain one of the most important Egyptian collections in Europe, and *Room 42* holds a small collection of **Byzantine pieces**. Upstairs in *Room 48* opposite the top of the stairs you can see the famous **frescoes of Thera**, rightly considered one of the most important archaeological discoveries of the 20th century. With other very lovely finds from the site of Akrotiri (the "Aegean Pompeii") on the island of Santorini, you can see in all their splendor such frescoes as the brightly colored and impressionistic **Naval Expedition**; the **Lilies**, in which marvelous groups of 3 flowers each stand out against the volcanic rock

while swallows swoop overhead; the **Young Boxers** with their exquisitely rendered bodies; and the **Three Women**, the **Antelopes**, the **Blue Monkeys**, and many more. On the whole, they seem to hark back to Minoan painting, along the lines of the first naturalistic painting to have existed in European art; however, these frescoes boast much greater refinement and impressionistic power. Continuing on the upper floor, the **pottery collections** can be seen in *Rooms 49–56.*
This is unquestionably one of the greatest collections in the world, if only for the extraordinary quantity of pieces exhibited.
The arrangement of the pieces is chronological: it begins with the early

A T H E N S

ABOVE: *LEKYTHOS* WITH HERACLES.

BELOW: ATTIC CRATER WITH APOLLO'S CHARIOT.

OPPOSITE: BOXERS, FRAGMENTARY FRESCO FROM AKROTIRI (SANTORINI).

RIGHT: IONIC CRATER, DETAIL OF COMBAT OVER THE BODY OF PATROCLUS.

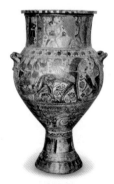

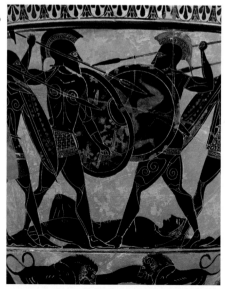

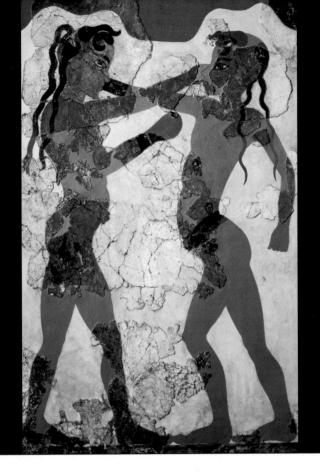

Geometric period, through the Geometric, then the Orientalizing era, and gradually to the production of black-figure, red-figure, and white-background vases, before ending with the Panathenaic amphoras of the 4th century BC. These black-figure pots were offered as prizes to the winners of the games organized to celebrate the Great Panathenaea.

These are the outstanding vases in the collection:

Room 49—**Diplyon amphora** showing a funereal scene (c. 750 BC);

Room 50—**Dipylon crater** with chariots and a funereal scene (c. 750 BC); the hydria by the PAINTER OF ANALATOS with a male and female chorus and heraldic lions (c. 700 BC);

Room 51—**amphora/crater** (?) found on Milos decorated with the epiphany of Apollo (c. mid-7th century BC); **amphora** by the PAINTER OF NESSUS with Heracles defeating the centaur Nessus (c. 615 BC);

Room 52—**fragment** from SOPHILOS with funerary games in honor of Patroclus (580–570 BC);

Room 53—**lèkythos** by the PAINTER OF AMASIS decorated with the abduction of Helen (c. 530 BC);

Room 54—**crater** by the PAINTER OF SYRISKOS with Theseus and the Minotaur (c. 480 BC);

Room 55—white-ground funerary **lèkythoi** by the PAINTER OF ACHILLES (470–450 BC), the PAINTER OF THANATOS, and the PAINTER OF CHARON;

Room 56—**cup** by the PAINTER OF PISTOXENOS with the death of Orpheus (470–460 BC); *epinetron* by the PAINTER OF ERETRIA with scenes in the gynaeceum (last 3rd of the 5th century BC);

Panathenaic amphoras (4th century BC).

On the corner of Leoforos Vassilissis Sofias and odos Koumbari.
Open every day except Tuesdays, 8:30am to 2pm.

The museum houses the important collection of ancient and modern decorative arts that belonged to the rich cotton trader Antónis Benaki (1873–1954), who lived in the Greek colony in Cairo.
First floor: Here you will see **gold jewelry** and objects, **bronzes**, pottery,

and **terracotta** from the Neolithic to Hellenistic periods, and a series of painted portraits from Fayum in Egypt.
The *Byzantine room* has **liturgical items**, **architectural elements**, and a series of **icons**. There is a reconstruction of a *Moslem room* containing pieces from different places (17h-century marble flooring from Cairo, 16th-and 17th-century faïences from Asia Minor).
Second floor: A collection of late Byzantine **cult**

objects, **woven fabrics** and **sacred goldwork** (17th and 18th centuries), a room filled with objects from Constantinople, and the reconstructions of rooms from a Macedonian house (early 18th century) and domestic interiors from different regions of Greece.
Third floor: Collections of **objects from modern history** (19th and 20th centuries) and collections of **oriental art** (fabrics and pottery from Asia Minor, Chinese porcelain, and Egyptian items).

A T H E N S

ABOVE: SACRED DOG'S HEAD, ICON.

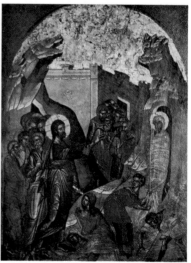

ABOVE: RESURRECTION OF LAZARUS, LATE BYZANTINE ICON.

BYZANTINE MUSEUM

LEFT: ENTRANCE TO THE BYZANTINE MUSEUM.

RIGHT: MARBLE PULPIT WITH MONOGRAMMATIC CROSSES.

BELOW: LION ATTACKING A DEER, RELIEF FROM AN ALTAR.

Leoforos Vassilissis Sofias, 22. Tel 721 10 27 – 723 21 78 Open: winter, Tuesday to Sunday, 8:30am to 3pm; summer, Tuesday to Sunday, 8:30am to 7pm.

This museum opened in 1914, but since 1930 it has been housed in a 19th-century building constructed for the Duchess of Piacenza, who was a fervent supporter of the Greek cause during the War for Independence from Turkish domination. Currently the display area is being expanded in a new section of the building. A visit to the museum gradually reveals an artistic and spiritual world as fascinating as it is little known.
First floor: Separate rooms contain **reconstructions of three sacred buildings**. The first is a small, early Christian basilica (5th to 7th centuries) assembled with pieces of different provenance (the altar from Eleusis, the gate from Thessalonica, etc.). The second is of a cross-shaped Byzantine church (11th century) with a marble iconostasis and beautiful

marble icon of the Virgin and the Child (from Thessalonica, 12th century); and the third is a small post-Byzantine chapel with a flat roof and fine painted wooden iconostasis.
Second floor: Here are collections of **icons** (9th to 18h centuries), **frescoes** (10th to 13th centuries), **furnishings, sacred**

vestments and **inscriptions**. Note the section dedicated to **Copt materials** (5th to 7th centuries). The wings of the museum contain a fine collection of **icons** from north Greece and Crete, and **frescoes, pottery,** and **parchments**. In the courtyard you can see architectural fragments including a lovely **6th-century mosaic**.

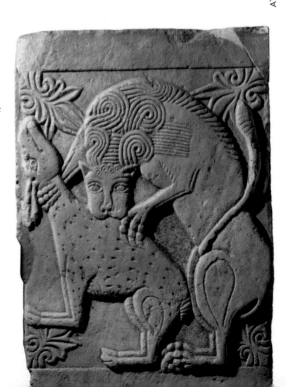

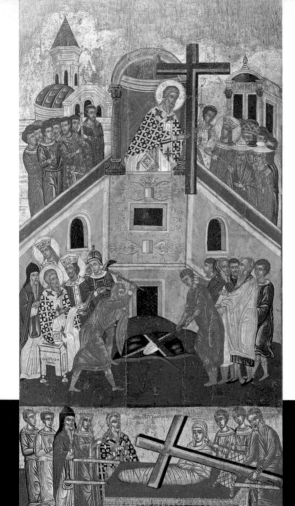

LEFT: THE INVENTION
OF THE HOLY CROSS,
PAINTING.

BELOW: CHRIST
ENTHRONED, ICON.

OPPOSITE TOP AND
BOTTOM RIGHT:
CHRIST AND THE
APOSTLES, DETAIL
FROM THE ICON.

OPPOSITE BOTTOM
LEFT: SAINT
CATHERINE OF
ALEXANDRIA, DETAIL
FROM AN ICON.

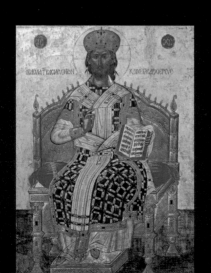

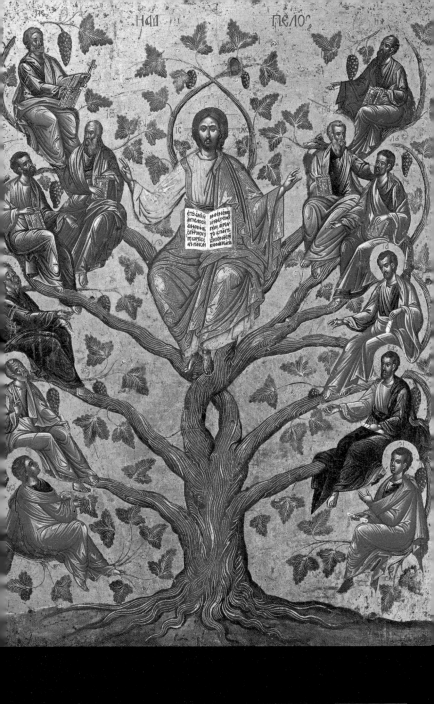

MUSEUM OF CYCLADIC ART AND ANCIENT GREEK ART

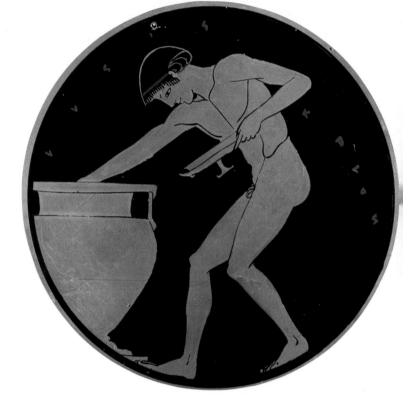

Odos Neofytou Douca, 4. Tel. 722 83 21. Open every day except Tuesdays and Sundays, 10am to 3pm.

This was the first museum in the world dedicated to the art of the Cyclades. It was opened in 1986 with the support of the Goulandris Foundation, which commemorates a businessman, sportsman, patron of the arts, and philanthropist. It is housed in a four-story building that has 14,000 square feet of display area designed by

Yannis Vikelas. Later a second building was added connected directly to the first. As previously seen, the Cyclades boasted a flourishing culture in the Neolithic and Eneolithic (Copper Age) periods based on the trade of obsidian from Milos. Another of the islands' assets was their abundant and good quality marble (particularly on Paros and Naxos). The large quantity available allowed **idols** to be carved that were placed in tombs to protect the deceased,

with representations of the nude goddess mother with her arms folded, sometimes with a small figure on her head, and figures of harp and twin-barreled flute players. The image— whether of a god, hero, or human—was executed in various ways in these idols. It was sometimes as an abstract, schematic, or flat outline as though "cut" in the marble, sometimes with a complete representation of the body (though still flat) and with only a slight swelling for the breasts and

OPPOSITE: CLASSICAL
CUP, DETAIL WITH
YOUNG MAN FILLING A
KYLIX WITH WINE.

BELOW: CLASSICAL
CUP, DETAIL OF AN
ATHLETE.

BOTTOM: ROOM IN
THE MUSEUM OF
CYCLADIC ART.

a cut to suggest the genitalia. At other times the movements, for example of the **musicians**, create a spatial requirement in which the limbs are rendered "tubular" and the general volumetric structure. However, the faces were always rendered in an abstract manner with the exception of the nose. The Museum of Cycladic Art includes more than 200 pieces from 3200 to 2000 BC. It is divided into 3 sections and presented chronologically for a better understanding of the evolution of the idols. The exhibits begins with the "**violin-shaped**" schematic models (3200–2800 BC, Ancient Cycladic I); it continues with those with "**crossed arms**" (2800–2300 BC Ancient Cycladic II); and it ends with the mature production (2300–2000 BC, Ancient Cycladic III) based on proper statues, for example, **idol no. 211**, which stands 55 inches tall. There are also some fine **marble vases** (plates and small cups). The collection of ancient Greek art includes Minoan and Mycenaean **pottery**, late-Roman **glassware**, 5th- and 4th-century BC **vases** (including a crater by the Painter of Cleophontes), elegant Hellenistic **jewelry**, Classical and Hellenistic **bronzes** and **weapons** (Eftaxias Collection), and terracotta figurines. (S.M.)

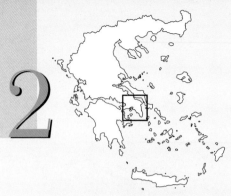

2

ATTICA

The changes that have affected this region, which today is industrialized, have not spoiled the appeal of some of the famous cult sites of antiquity, such as: Eleusis, the sanctuary of Amphiaraus in Oropos, or the monastery of Daphni. Many minor archaeological sites attest to the importance of the region. The road to Piraeus leaves from the Sacred Gate of the Dipylon (Odos Pireòs on the left). From the port (Perama) you can take a 15-minute boat ride to the island of Salamis (place of battle between the Greek fleet under Themistocles and the Persian fleet under Xerxes in 480 BC). Continue on the road as far as **Cape Sounion**, then continue to **Làvrio** (the ancient mineral district of Athens, with silver-lead mines from the end of the 6th to end of the 4th centuries BC), from where you can visit the archaeological park of **Thorikos** (Velatouri hill was occupied from the 3rd millennium to the end of the 4th century BC; there

are the ruins of a maritime fort on the peninsula of Aghios Nikolaos, late 5th-4th century BC). Return to the main road and head toward Keratea to reach Markòpoulon (necropolis of Myrrhinous in the locality of Merènda, 8th–6th centuries BC); after 1 mile turn right toward **Raftì**. Take the coast road toward **Brauron** (Vravrona); sanctuary of Artemis *Brauronia*), **Loutsa** (remains of the temple of Artemis *Tauropolos*, 4th century BC) and **Rafina** (ancient Araphèn; from here take ship for Euboea and the Cyclades). Continue toward Nea Màkri to visit **Marathon**, then head toward Rhamnous (sanctuary of Nemesis and fort). Return to Marathon and take the road to Kalamos, then, from there, to **Oropos**. Return to Athens on the freeway (E 75, Malakàsa interchange) that crosses the eastern pass of the Parnes, the highest mountain in the region, which was controlled in antiquity by the fort of

Decelea (5th century BC). Continuing to Menìdi, you can visit the remains of the fort of **Phylè** (turn left at Nea Lòsia). To reach **Eleusis**, after leaving from the Sacred Gate of the Dipylon, take the road on the right (Ierà Odos) that retraces the old Sacred Way. At **Daphni** you will see one of the oldest Byzantine monasteries in Attica (founded at the start of the 5th century AD over the remains of a temple dedicated to Apollo *Daphnaio*; the church of the Dormition of the Virgin has excellent mosaics, 11th century). Before you reach **Eleusis**, you will see a four-arch bridge built by Emperor Hadrian in 125 AD. On Aegina, which can be reached from Piraeus by ferry, after a visit to the sanctuary of Apollo at Kolona, if you take the road for the temple of Aphaia, it is possible to reach Palochora, which, until 1800 was the island's capital (in addition to its interesting houses, it has many 13th–17th-century churches and monasteries). (C.T.)

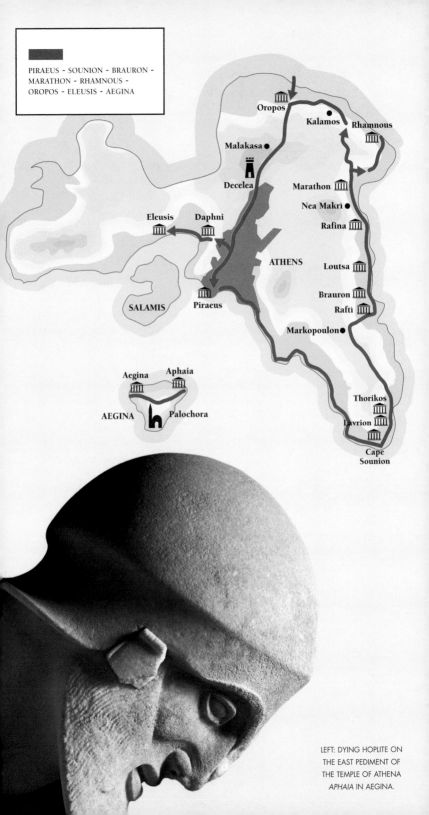

PIRAEUS ‑ SOUNION ‑ BRAURON ‑
MARATHON ‑ RHAMNOUS ‑
OROPOS ‑ ELEUSIS ‑ AEGINA

Oropos

Kalamos

Rhamnous

Malakasa

Decelea

Marathon

Nea Makrì

Eleusis

Daphni

Rafina

ATHENS

Loutsa

Brauron

Raftì

SALAMIS

Piraeus

Markopoulon

Aegina

Aphaia

AEGINA

Palochora

Thorikos

Lavrion

Cape
Sounion

LEFT: DYING HOPLITE ON
THE EAST PEDIMENT OF
THE TEMPLE OF ATHENA
APHAIA IN AEGINA.

PIRAEUS

This peninsula to the southwest of Athens is divided into 3 spurs (Ietonia to the northwest, Akti to the southwest, and Munychia to the east) and is connected to the mainland by a narrow strip with three bays of different size. In the 5th century BC it took over the role of Athens' main port from nearby Phaleron.

By the end of the 6th century BC, Hippias had already fortified the Bay of

were built, but the work was interrupted by the war against the Persians and not completed until 470 BC. The fortified ring was connected to Athens by two walls (the "Long Walls"), the north wall and the Phaleron wall. Later Pericles had raised another wall parallel to the north one to protect the road that led to the city. Pericles was also responsible for the city development plan (the only one) drawing by

port of Zea (today Passa Limani) and, separated the north and south areas allocated for private building.

Following the defeat of Athens in the Peloponnesian War, in 403 BC the Long Walls and fortifications were destroyed and port installations were sold off. Just eight years later, however, Conon restarted the port activities and rebuilt the walls. In the second half of the 4th century BC, the rivalry between Rhodes and Delos caused a decline in Athens' commercial activities, exacerbated by the defeat of the city in the Lamic War, and this marked the end of its naval power. Between 322 and 229 BC, Munychia was the site of a Macedonian military garrison, and its slow distancing from Athens coincided with a period of revival of commercial activities as a result of its connection with the heavy international traffic that made use of Delos. It became a Roman port but was destroyed in 86 BC by Sulla due to its alliance with Mithradates.

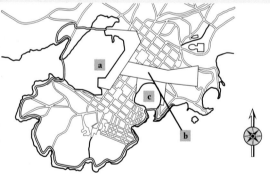

Munychia (today Mikrolimano) and established his residence there, but it was Themistocles who initiated the works that turned Piraeus into a commercial and military port. In 494 BC the peninsula was surrounded by walls inside which naval installations

Hippodamus of Miletus. It was based on a grid that can still be recognized in the modern layout and was applied to each district, with a careful functional division of the space. The agora at the center of the isthmus connected the commercial port of Kantharos and the military

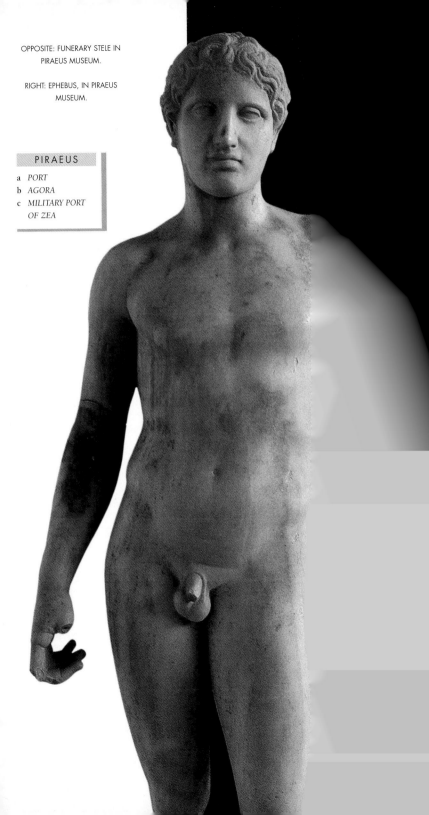

OPPOSITE: FUNERARY STELE IN
PIRAEUS MUSEUM.

RIGHT: EPHEBUS, IN PIRAEUS
MUSEUM.

PIRAEUS

a PORT
b AGORA
c MILITARY PORT
OF ZEA

Knowledge of ancient Piraeus' topography is very fragmentary as the modern city's presence does not permit systematic excavation to be carried out. The old fortifications still visible are stretches of wall built by Conon on the same course as Themistocles' earlier walls, on the south side of the peninsula. They consisted of a dual wall (built from dry parallelepiped blocks, with the space between the two

wall faces filled with rubble) and square and rectangular towers. On the inland side of the wall stood 6 gates (whereas only small, secret entrances led into the side that faced the sea). Of these gates, only 3 are known.

The largest inlet—Kantharos—was used for commercial purposes (though the southern end was fitted with 94 berths for military ships). On the east wharf stood the *Emporion* (**a**), a set of 5

porticoes (the ruins of the southernmost portico have been excavated in Odos Iasonos), while the north side was bordered by the long stoa built by Pericles and accommodated the corn market.

Near the portico in the northeast corner of the port stood the best known and most important sanctuary in Piraeus, that of Zeus *Soter* and Athena *Soteira* (many architectural fragments can be seen in the church of the **Aghia Triada**). Near the military sector on the southeast side. Pericles built the sanctuary of Aphrodite Euploia to celebrate the naval victory at Cnidus against the Spartans. (Some historians believe it was actually on the Ietionian peninsula)

The **military port of Zea** (**c**) had 196 berths for ships (submerged remains are visible in the southwest area) and the *skeuotheke*, the warehouse built in 346 BC by Philon of Eleusis to

house the ships' mobile equipment. The building was entered through a propylaeum on the nearby **agora** (**b**) and was composed of 3 long galleries divided by 35 columns or pillars. The side galleries were used to house the materials; the central one was a passageway.

In the south sector (near the archaeological museum) lie the remains (the orchestra and first rows of seats) of a small 2nd-century BC theater. A larger and earlier theater (4th century BC) mentioned by sources was discovered on the west slopes of the acropolis during 19th-century excavations, but today it is not visible.

The port of Munychia had 82 berths for military ships (still visible to the north and south of the inlet) overlooked by the sanctuary of Artemis Munychia (foundations of a temple or a portico, pottery from the Geometric and late Ancient ages).

At the tip of the peninsula (near the naval school) a *poros* column can be seen that, according to tradition, marked the burial place of Themistocles. Exiled from Athens, he died in Magnesia, on the River Maeander, but his family repatriated his bones.

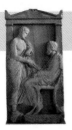
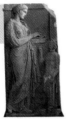

THE MUSEUM

Open every day except Mondays, 8:30 am to 3 pm. Payment required.

A series of very interesting 2nd-century AD reliefs were found in Piraeus in 1930–31 copied from PHIDIAS' Amazonomachy on the shield of Athena *Parthenos* (first floor, Rooms 1–2). Rooms 3 and 4 (second floor) contain bronze statues, found in 1952, that were probably being transported from Delos to Rome. (C.T.)

OPPOSITE: THE ARCHAEOLOGICAL PARK.

TOP LEFT: FUNERARY STELE OF HIPPOMACHOS.

TOP RIGHT: FUNERARY STELE IN PENTELIC MARBLE.

RIGHT: BRONZE STATUE OF ATHENA.

BOTTOM: ROOM WITH THE BRONZE STATUE OF "APOLLO OF PIRAEUS."

PIRAEUS

SOUNION

The promontory at the southeast tip of Attica was of strategic importance for control of navigation between the Saronic Gulf and Euboean canal and for protection of the nearby mining district of Laurion. The extreme tip of the promontory (called sacred by Homer, *Odyssey*, II, 28) was the seat of an ancient cult. Finds made there include Cycladic idols, Mycenaean seals, Geometric and Archaic pottery, objects imported from Egypt, and a series of monumental *kouroi* dating to the early 6th century BC.

VISIT

Open every day, 10 am to sunset. Payment required.

The sacred and inhabited areas were surrounded by **large fortifications (a)** that had small towers every 66 feet (11 remain). It was built using a mix of *poros*, conglomerate and marble and various techniques (polygonal blocks and isodomum) at the end of the 5th century BC. The

entrance **(b)** was located in the northwest section near a small bay; it had a double dock partly cut out of the rock that was accessible from above via steps (still surviving). The *tèmenos* of **Poseidon (c)** stretched across a terrace on a higher part of the cape and was bounded to the east and southeast by a peribolos built at the same time as the fortifications. On the north

and west sides, there were terracing walls. The **entrance (d)** was a Doric propylaeum with 3 aisles and a 2-column pronaos *in antis* that stood on the north side. To the west of the entrance were a **banquet room (e)** and a 2-aisle **portico (f)** (5th century BC) built using columns from the Archaic temple of Poseidon. A second **portico (g)** was constructed subsequently against the

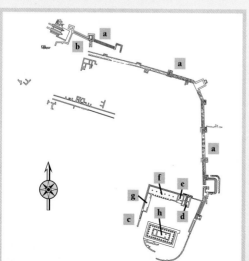

SANCTUARY
OF POSEIDON

a *DEFENSIVE WALL*
b *ENTRANCE*
c *TEMENOS OF POSEIDON*
d *DORIC PROPYLAEUM*
e *BANQUET ROOM*
f *PORTICO*
g *PORTICO*
h *TEMPLE*

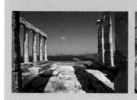

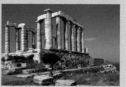

ATTICA

sanctuary's west peribolos. At the top of the promontory and visible from the sea was the **temple of Poseidon (h)**. It was a Doric amphiprostyle building, with a peristasis of 6 x 13 marble columns and smooth metopes. The Ionic frieze, made from Parian marble, on the architrave of the pronaos featured a gigantomachy, an amazonomachy and the labors of Theseus (14 slabs are in the National Museum, Athens). Only a single seated female statue remains from the decoration on the pediment. The temple was built between 444 and 440 BC by the same architect who designed 2 temples in Athens (dedicated to Hephaestus and Ares in the agora) and the temple of

Nemesis in Rhamnous. It had been built over a late 6th-century BC temple with a similar plan that had been destroyed by the Persians in 490 BC before it was completed. In a trench close to the temple, 2 statues of male figures (*kouroi*) 10 feet tall were found. Dating to 610 BC, they represent the first important examples of Attic sculpture known (National Archaeological Museum, Athens). Probably the sculptures were damaged during the Persian pillage and, as votive gifts to the god, were buried in the sanctuary. The *tèmenos* of **Athena Sounia (1)** lay on a terrace below surrounded by polygonal block walls. Inside it were the foundations of a **sacellum (2)** with 4 columns and the base for the cult

statue. It was built around 470 BC after the destruction of the previous building in the first half of the 6th century BC. After about 30 years a marble Ionic colonnade was built on the south and east sides, visible from the sea and the temple of Poseidon.

In the extreme north of the area are traces of an elliptical **enclosure (3)** composed of large stones, and in the immediate vicinity, the remains of a small **rectangular building (4)**, a base for a statue and an **altar (5)** between **2 votive bases (6)** on the façade. This would have been a place of worship for a hero and has been attributed to Phrontis, the commander of Menelaus, who died off the cape. (C.T.)

SANCTUARY OF ATHENA

1 TEMENOS OF ATHENA SOUNIA
2 SACELLUM
3 ENCLOSURE
4 RECTANGULAR BUILDING
5 ALTAR
6 VOTIVE BASES

OPPOSITE TOP: THE TEMPLE OF POSEIDON, SEEN FROM THE WEST.

TOP LEFT TO RIGHT: VIEW OF THE AREA OF THE NAOS, THE TEMPLE FROM THE SOUTH, AND FROM THE WEST.

BRAURON

The demos of Brauron was the seat of an important sanctuary dedicated to Artemis on the slope of a hill that had been inhabited since the Neolithic period.

The cult of Artemis *Brauronia* was connected to rites of passage of young girls because of her nature as guardian deity of the fertility of humans and animals. As can be deduced from a passage in Aristophanes (*Lysistrata*, vv. 641–46), at the Brauronion temple Athenian girls became an *arréphoros* ("she who transports mysterious things") at the age of 7, then an *aletris* (grinder) at 10, and an *arktos* (bear), which was the last phase before marrying. To mark the five-yearly festivities of the goddess, the young girls—either naked or dressed in saffron-colored gowns) danced, imitating the movements of the bear, the animal that was sacred to Artemis and a symbol of their temporary "wild" role.

We know that the cult existed in the Geometric Age from pottery materials found in the *favissa* (the place in a temple where votive objects were placed) in the southeast corner of the building.

However, the first temple was probably built on Peisistratus' wishes (he was from this demos), and the cult later taken to the acropolis in Athens. After the destruction of the sanctuary by the Persians, a distyle **temple *in antis* (a)** was built in the first half of the 5th century BC with an *adyton* (only the foundations remain) and a

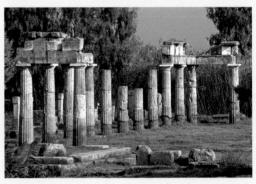

naos divided into 3 aisles by 2 rows of 2 columns. The entrance faced the road from Athens, which crossed the River Erasinos over a **large bridge (b)** made from blocks of *poros* (mid-5th century BC). To the east of the temple stood a **sacellum (c)** with 2 rooms (one with traces of a hearth) that may have been used for votive offerings. Next to the sacellum was a hollow space that is commonly identified as the

tomb of Iphigenia. In *Iphigenia in Tauris*, Euripides attributed the foundation of the sanctuary of Brauron to Iphigenia, the daughter of Agamemnon, whose destiny was to be sacrificed to propitiate the departure of the Greek expedition to Troy.

Saved by Artemis, Iphigenia became the priestess of the goddess in the distant land of the Taurians and later brought the cult and statue of Artemis *Taurica* to Brauron where she died.

Euripides' legend cannot be used as *aition* of the cults of the *Brauroneion* and, in this case, Iphigenia, rather than a heroine, seems to have been an ancient local goddess related to births, over which the cult of Artemis was laid.

In the last quarter of the

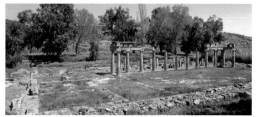

OPPOSITE TOP: AMPHORA FROM THE GEOMETRIC AGE, BRAURON MUSEUM.

BOTTOM AND LEFT: THE PORTICO OF THE SANCTUARY.

BELOW: THE TEMPLE BASE.

BOTTOM: THE NORTH SIDE OF THE STOA.

5th century BC, the sanctuary was radically altered with the construction of a large **Doric portico (d)** in the form of the letter "pi" (Π). On the north and west sides there was a series of square rooms with *poros* flooring in which holes can be seen used to fix the wooden *klinai*.

This clearly was the room used to hold the banquets sacred to the "bears" on the goddess's feast days. The portico was reached through a monumental **entrance (e)** in the middle of the west side. A narrow passageway through the rooms on the north side connected it to a **stoa (f)** that had monostyle propylaea on the east and west sides. The cult nature of this section is made clear by the discovery of numerous fragments of statuettes depicting the *arktoi* (bears) that were left here by the vestal virgins.

To the north of the sanctuary the ruins of a large early Christian basilica can be seen. Built with 2 side aisles, a dual narthex, and a baptistery on the south side, it dates from the 6th century but was destroyed in the 7th.

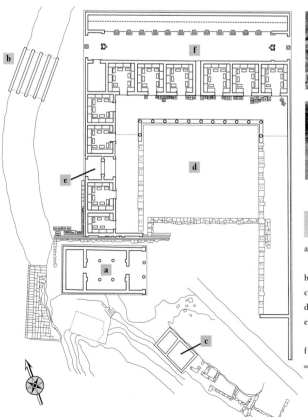

TEMPLE OF ARTEMIS

a *TEMPLE OF ARTEMIS*
b *BRIDGE*
c *SACELLUM:*
d *DORIC PORTICO*
e *MONUMENTAL ENTRANCE*
f *STOA*

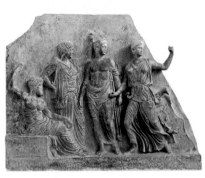

THE MUSEUM

Open every day except Mondays, 8:30 am to 3 pm. Payment required.

Rooms 1 to 3 display the finds made in the sanctuary, in particular the small craters found around the temple (6th and 5th centuries BC) with pictures of girls dancing around an altar. Statuettes of *arktoi* (4th and 3rd centuries BC) were also found near the stoa. *Room 4* contains objects discovered in the necropolis of Mèrenda (8th to 6th centuries BC). (C.T.)

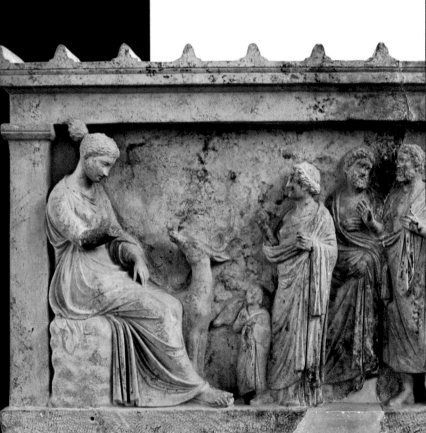

BRAURON

OPPOSITE TOP AND BELOW: RELIEFS OF THE BRAURONIA, A FESTIVAL IN HONOR OF ARTEMIS.

RIGHT: STATUE OF *ARKTOS*, A YOUNG GIRL CONSECRATED TO THE CULT OF ARTEMIS BRAURONIA.

BELOW RIGHT: A ROOM: WITH STATUES OF *ARKTOI* AND MARBLE RELIEFS.

MARATHON

130: THE *SORÒS*, BURIAL MOUND OF THE 192 DEAD ATHENIANS.

The name of Marathon is linked to one of the most famous battles of antiquity. In 490 BC the Persian fleet commanded by Datis and Artaphernes anchored in the roadstead of Marathon to allow a contingent of soldiers to disembark. The aim of the soldiers was to attack Athens from the mainland. Herodotus speaks of 100,000 footsoldiers and 10,000 cavalry. The Athenians (numbering 9000 hoplites), aided by a handful of 1000 Plataeans, occupied the position between the eastern flank of Agrieliki Hill and the sea, thus blocking the road to the city. After 8 days of waiting, the Persians decided to withdraw to their ships and sail away but they were attacked and defeated by the Athenians.

VISIT

When you arrive from Athens, about half a mile north of the village of Nea Makri you will see the ruins of a sanctuary dedicated to Isis. The cult building had a very unusual plan and was enclosed in a wide peribolos that could only be reached from the north side. Near the southeast corner of the defensive wall there stood a baths complex dated, like the sanctuary, to the 2nd century AD. It was probably part of one of the residences that Herod Atticus, born in the demos of Marathon, owned in this area. As is stated in inscriptions, the Gymnasium and the *tèmenos* of Heracles were both set around what is now Brexìza (Valaria). The Athenian camp in 490 BC would have been established near the sanctuary (also used for athletics competitions). Heading north and turning right toward **Aghios** Pantalèimon, you come to the "mound of the Athenians" where the ashes of 192 Athenian soldiers were placed after dying in battle to stop the Persians. Their names were recorded on a stele that originally crowned the tomb. Returning, follow the road toward the modern village of Marathon. Turning left toward the museum, you will see the tombs of the Early Helladic necropolis of Tsèpi (3rd millennium BC) beneath a canopy on the right. Next you will find the mound that contains the graves of the Plataeans who were killed in the battle. Past the museum on the right are 4 mounds from the Middle Helladic necropolis (2000–1580 BC) of Vranà. To the east of the building there is a Mycenaean chamber grave that contained the bodies of 2 individuals and a fine set of grave goods.

Open every day except Mondays, 8:30 am to 3 pm. Payment required.
The museum exhibits pottery from the Neolithic (*Room 1*), early Helladic, and Geometric ages (*Room 2*); black-figure pottery (*Room 3*), Hellenistic, Roman, and Byzantine sculptures (*Room 5*), and architectural elements from the villa (peristyle) belonging to Herod Atticus near Oinòe, 2 miles west of modern Marathon. (C.T.)

RHAMNOUS

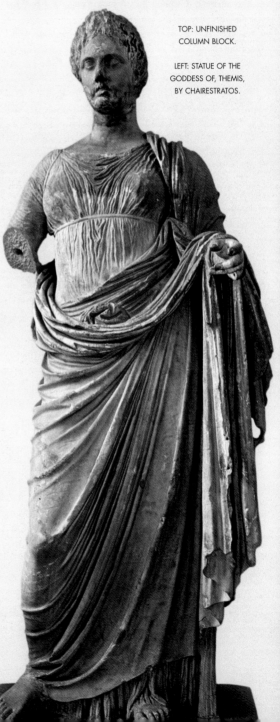

A massive fortress and a famous sanctuary dedicated to Nemesis, the goddess of justice, stood on a plateau overlooking the Euboean canal in the northeastern tip of Attica. **The Sanctuary (A)** included two temples, of which the foundations can be seen today, stood in the center of a terrace bolstered to the north and east by polygonal block walls. To the south stood a **small building (a)** (composed of a rectangular room and a vestibule with 2 Doric columns *in antis*) that dates to the early 5th century BC. This held the statue of Themis, the goddess of family behavior, carved by CHAIRESTRATOS, the son of CHAIREDEMOS, an Attic sculptor from the early 3rd century BC (National Archaeological Museum, Athens). On either side of the entrance to the pronaos stood 2 thrones (4th century BC) bearing a dedication to Themis and Nemesis by a certain SOSTRATOS.
Next to this on the north side stood a **temple (b)** (430–420 BC) with a peristasis of 6 x 12 Doric columns, a naos, a distyle pronaos, and opisthodomus *in antis*. The temple, however, remained

uncompleted as the columns were not fluted and the steps of the stylobate unfinished. The building had been preceded by 2 temples, one from the first half of the 6th century BC, the other from the end of the century, which were probably destroyed by the Persians in 480–479 BC. The naos held a statue of Nemesis sculpted by Agoracritus of Paros (a pupil of Phidias) and, in front of this, there stood an offerings table. As we can deduce from Pausanias' description and from images on coins and surviving material fragments, the goddess (both the protectress of law and good order and a deity of rural and chthonous nature) was represented holding a cup decorated with figures of Ethiopians in her right hand, and a branch of apple tree in her left. A crown decorated with deer and small

Victories rested on her head. The pediment of the temple, part of the statue, and the base of the statue decorated with reliefs of Leda and Helen have all been reconstructed and can be seen in a shed near the sanctuary.

During the Roman period the building was restored and dedicated to the deified Livia (45–46 AD), as the inscription on the central part of the architrave on the east side indicates.

A **rectangular building** (c) stood before the enclosure and is now thought to have been the seat of the *strategoi*, commanders of the demos. An inscription proves the existence of such a building, but this particular one may have been associated with cult activities.

The sanctuary stood on the **sacred way** (B) that arrived at the fort from the nearby demos of Tricorito.

Funerary monuments such

as stelae and gravestones, mostly commemorating illustrious citizens from the 4th century BC, lined the sides of the processional way.

Near the fort's port you can see the remains of a small **sanctuary** (d) originally dedicated to Aristomachus, a hero later associated with

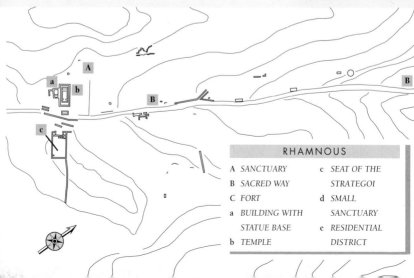

RHAMNOUS

A SANCTUARY	c SEAT OF THE
B SACRED WAY	STRATEGOI
C FORT	d SMALL
a BUILDING WITH	SANCTUARY
STATUE BASE	e RESIDENTIAL
b TEMPLE	DISTRICT

the cult of Amphiaraus, worshiped in nearby Oropos.

The fort (**C**) was built at the time of the Peloponnesian War to control the Euboean canal and protect transport ships to Athens, especially those carrying corn. Later enlargement and solidification of the walls made use of different materials and construction techniques and date to the Macedonian period (3rd century BC).

Accessible from the south end through a gate protected by 2 towers, it enclosed both military and civil buildings.

Protected by its own walls (4th century BC) on the upper terrace of the fort lay the **residential district** (**e**) of the garrison divided into many small areas facing courtyards. The remains of a small theater lie near the port, defended by a rectangular tower. (C.T.)

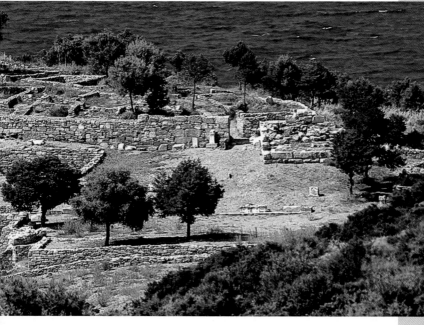

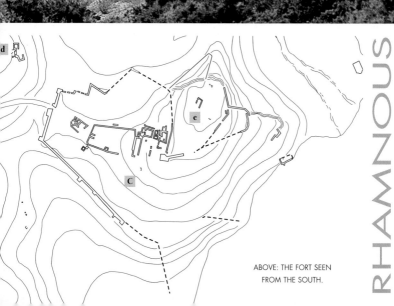

ABOVE: THE FORT SEEN FROM THE SOUTH.

RHAMNOUS

OROPOS

LEFT: CAVEA, *PROEDRIA*, AND PROSCENIUM
OF THE THEATER.

| VISIT | |

This attractive spot was the setting for a famous sanctuary dedicated to Amphiaraus, king of Argos. He inherited the gift of prophecy from his grandfather Melampus. The sanctuary was built in the last quarter of the 5th century BC and developed most notably during the 4th century when Amphiaraus was venerated as a god related to health and divination. Still renowned at the time of Pausanias' visit (I, 34, 2–5), the cult later rapidly declined.

Open every day except Mondays, 8:30 am to 3 pm. Payment required.

The entrance leads into the part where the earliest form of the cult was celebrated, at the sacred fountain. The area was limited northward by an open space with steps used by worshippers. In the 4th century BC, a large altar was built near the fountain. The **temple (a)** dates from the same era.

To the north of the temple stand the ruins of a small temple and a series of rooms dating to the earliest phases of the sanctuary. In front of the rooms are the bases of many votive offerings. Next to the complex toward the east stood a large Doric portico **(b)** (360 BC). This colonnade was used to host the faithful who, sleeping on the skins of specially sacrificed rams, awaited the dream in which Amphiaraus would appear to inform them of the cure they should take. One of the purification practices was to wash in the **baths building (c)**; a similar one stood in the central area. Behind the portico stood the 4th-century BC **theater (d)**; it was subsequently to undergo many renovations and improvements. Close to the stream you can see the ruins of a **water clock (e)** and, on the other side, administrative buildings and housing for the **sanctuary staff (f)**. (C.T.)

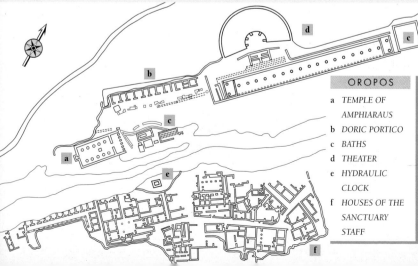

OROPOS

a TEMPLE OF AMPHIARAUS
b DORIC PORTICO
c BATHS
d THEATER
e HYDRAULIC CLOCK
f HOUSES OF THE SANCTUARY STAFF

2.1

ELEUSIS

LEFT: VOTIVE RELIEF OFFERED BY THE FAMILY OF THE PRIEST LAKRATEIDES.

BELOW: STELE OF DEMETRA AND HECATE.

The city and sanctuary stood near the coast on the Gulf of Eleusis about 13 miles from Athens. It was located in a strategically important position on the road that joins north Greece to the Peloponnesus.

THE MYTH

Homer's hymn to Demeter (7th century BC) recounts the oldest version of the myth. It tells the story of the foundation of the Eleusian rites in relation to the abduction of Persephone (or Kore, the young girl), the daughter of Demeter and Zeus, by Hades, god of the Underworld, on the plain of Eleusis. When Demeter found out from Helios what had happened, she left Olympus, disguised herself as an old woman and went wandering on the Earth until she came to Eleusis where she was welcomed into the house of Celeus, the son of Eleusis, the founder of the city. When she had found her daughter and obtained permission from Zeus to allow Persephone to return to Earth for nine months a year, she rewarded the lords of Eleusis, and Celeus in particular, by revealing to them the secrets (mysteries) of her rites.

THE CULT

As the cults celebrated at Eleusis were secret in nature, there is very little information about their rituals other than what Homer could tell us and what was handed down in late Christian texts. Persephone's nine months on Earth and the three winter months (when corn is absent from the fields) spent in the Underworld symbolized the death and rebirth of Nature and the resurrection of Man. Consecration at Eleusis promised initiates prosperity on Earth and a state of blessedness in the next world; what ensured this was simply the fulfillment of the ritual in itself, not the observance of an ethical standard. The rites were secret in that they were reserved only for initiates (mystai); however, anyone could be initiated, regardless of wealth or sex, as long they were not guilty of murder and agreed to be bound by secrecy. Anyone who broke this rule would be punished severely, not to mention suffer a divine curse.

The Great Mysteries were celebrated in Athens and Eleusis from the 13th to 16th days of Boedromione (at the end of September and start of October) to mark the epiphany of Persephone.

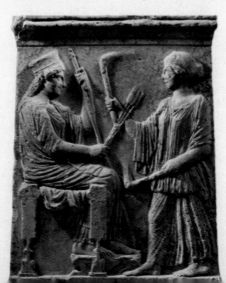

THE HISTORY

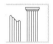

BRONZE AGE STATUE OF A
WOMAN, FROM ELEUSIS.

Our knowledge of the site derives solely from archaeological study as the literary sources do not left any mention of its monuments. This is for the same reason described by Pausanias (I, 38, 7): "a dream has forbidden me to describe what there is inside the sanctuary, and it is clear that the uninitiated are not allowed to know even indirectly those things that are hidden from their sight."

The area was inhabited as early as the middle and late Helladic periods, but it is not certain whether the cult of Demeter dates from the Mycenaean age, as tradition claims. The earliest buildings examined beneath the *Telesterion* are a peribolos and a small rectangular building with a vestibule reached from a platform flanked by steps; it dates from the 15th century BC and was enlarged in the 13th century BCwith the addition of 3 rooms on the north side. This building may not have been used for worship but instead have been part of a much larger palatial complex, as suggested by the widespread presence of buildings from the Mycenaean period.

On the other hand, we cannot be sure that the complex remained in use during later periods as data is lacking. Certain signs of building have been found in this area that date from the first half of the 8th century BC, when a curved retaining wall was built to support a terrace. The terrace was enlarged around the middle of the century and a new retaining wall constructed, and the sacred area was reached through a gate to the south that met a road arriving from the sea. These alterations were made as a result of the news that in 760 BC the oracle at Delphi—after being consulted regarding a serious famine—ordered the Athenians to make sacrifices to Demeter in the name of all Greeks before the plowing season.

From that moment the cult of Demeter grew in popularity and her sanctuary grew correspondingly. The principal construction phases were linked to the most important political figures in Athens, beginning with Solon. At the start of the 6th century BC, the first *Telesterion* (the building designed for the celebration of the Mysteries) was built with foundations in polygonal blue limestone from Eleusis, unfired bricks, and a terracotta crown of architectural features (now in the museum). Near the *Kallichoron*—the sacred well dug out of the rock of the terrace below—a ceremonial area was made with an altar and a podium with 3 steps from which the initiates could watch the sacred dances that honored the goddess. According to tradition, the *Kallichoron* was where Demeter met the daughters of Celeus and where, as Pausanias relates, the women had danced for the goddess for the first time. During the tyranny of Peisistratus in the second half of the 6th century BC, the cult of Demeter spread across Greece. It therefore became necessary to rebuild the sanctuary and make it more monumental. The *Telesterion* was rebuilt at double the size (83 x 89 feet) with foundations made of limestone from Kara and the raised section

made of *poros*. The ceiling was held up by 22 Ionic columns in 5 rows. The initiates present at the Mysteries stood on 9 steps that ran along the walls, and the *anaktoron* (the room reserved for the hierophant who showed the sacred objects during the Mystery rituals) occupied the west corner of the south side. The entrances on the east side were preceded by a portico of 10 Doric columns on the front and 2 at the sides (the guttering along the pediment was decorated with sheep heads, which can now be seen in the museum). In addition, a sacellum was built dedicated to Hades (later, the Roman Pluto) near the opening of the cave through which it was believed that the god had dragged Persephone into the Underworld. The expansion of the terrace of the *Telesterion* also led to the enlargement of the defensive wall. This was extended around the urban area and reinforced with square towers.

Finally, the main gate to the sanctuary was moved to the north side where the Sacred Way arrived from Athens.

RIGHT TOP: DETAIL FROM A SARCOPHAGUS, FROM ELEUSIS.

BELOW: HORSE'S HEAD WITH FRIEZE OF ACANTHUS LEAVES.

After destruction by the Persians (480–479 BC), who entered through a wide crack in the southeast stretch of the walls, Cimon built a new wall on the east side enclosing a large auxiliary area. The wall had 2 gates in points at which the most recent wall connected with the already existing one: the first was a secret entrance by the southeast tower, and the other a monumental propylaeum to the north. As construction of Peisistratus' *Telesterion* had determined the closure of the *Kallichoron*, the ceremonial area of the sacred well was moved outside the walls close to the propylaeum where it remained until the Roman period, despite later construction on the spot. A new and even larger *Telesterion* (165 x 230 feet) was begun, with 3 rows of 7 columns, 7 steps on each side, and an *anaktoron* in the middle of the south wall, but the work only reached the lowest sections of the shafts of the columns. After 445 BC, Pericles had the work passed to ICTINUS, the architect of the Parthenon, who designed a square building measuring 169 x 162 feet. It had 5 rows of 4 columns each, arranged so as to leave a wide space at the center for the *anaktòron*. Steps for the initiates ran along all of the walls, and there were 2 entrances on 3 of the 4 sides. However, the design was difficult to

BELOW TOP: HUNTING THE CALYDONIAN BOAR, DETAIL FROM A SARCOPHAGUS.

BELOW BOTTOM: VOTIVE RELIEF, ASCLEPIUS CURES A DOZING PATIENT.

OPPOSITE: A YOUNG RIDER ON AN ELEUSIAN SARCOPHAGUS.

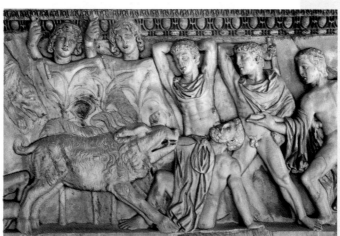

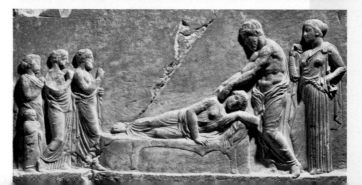

realize, particularly in relation to the building of the roof of the large room, and it was modified by KOROIBOS with the insertion of more columns (7 rows of 6). The material chosen was local black stone that was well suited to the character of the cults worshiped there. The building was completed by METAGENES (designer of the *diazoma*, the frieze above the architrave of the internal colonnade) and XENOKLES, who built the *opaion*, the opening above the *anaktoron* that provides the chamber with ventilation and light. The new expansion of the terrace toward the south and east required by the size of the building brought an extension of the wall. This was built in square blocks of Eleusis stone, rusticated at the base, and with smooth-faced *poros* blocks on the raised section. Two round towers were inserted into the extended walls. The north gate from Peisistratus' time was rebuilt and made into the entrance to the sacred

area reserved for the initiates (Propylaea of Demeter and Kore). Building was also constant in the 4th century BC. Between 370 and 360 the enclosure was once again extended on the southeast side to achieve its maximum length. A monumental portico with 12 columns was added on the east side of the *Telesterion* by PHILON, and the area of the *Ploutonion* was rearranged. Within the city further large scale works were implemented: this was the period of the construction of the theater and the stadium in the south zone and the *Dolichos* (horse-racing course) in the north. During the Roman period the sanctuary also underwent new construction, but exclusively in Pentelic marble as an expression of the esteem in which the cult was held by the republican aristocracy and the emperors, many of whom were initiates to the Mysteries. The largest projects were launched

under Hadrian but taken up again and completed following the sack of the sanctuary by the Costoboci people in 170 AD. In the middle of the 3rd century AD, Emperor Valerian repaired and strengthened the fortifications as a measure against the expected invasion of the Herulians (267 AD). The exterior of the front of the Great Propylaea was closed to leave just a small central passage. A large wall was raised between the propylaeum and the *Ploutonion* that left the northwest corner of the sanctuary outside of the wall, but the sacred well was incorporated to ensure water supplies. A new wall was erected on the acropolis with towers at the corners and the center of the sides. The sanctuary succeeded in surviving until the invasion of Alaric in 395 AD, when it was destroyed, and it was definitively abandoned after Emperor Theodosius' edict that closed all pagan cults.

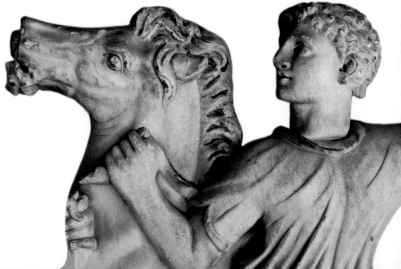

VISIT

Open every day except Mondays, 8:30 am to 3 pm. Payment required (ticket includes entry to the museum).

As in ancient times, the sanctuary is reached from the square where the Sacred Way arrives from Athens. Here the initiates performed the purification rites necessary to enter the sacred enclosure. In the center of the large area paved in marble stood the small tetrastyle amphiprostyle temple of Artemis *Propylaia* and **Poseidon** (a), built during the reign of Antoninus Pius, as related by Pausanias. On the east and north sides of the temple stand the altars of the two gods; on the northwest side is a small enclosure made of *poros* slabs that enclosed a four-sided brick building, in which a metal grid provided the base for the sacred fire (the grooves at the center of the sides remain).

The northeast sector of the square was closed by an L-shaped portico built on the earliest structures (6th century BC) while the northwest and southwest corners were the locations of 2 **triumphal arches** (b) dedicated to the Eleusian goddesses and Emperor Marcus Aurelius by the Panèllenes (the Greeks united in the *Panèllenion* created by Hadrian).

Both had a large fornex topped by a Corinthian niche and pediment in accordance with a model seen on Hadrian's Gate in Athens.

The first was used as the entrance to the city, the second to the service district spread along the road that flanked the eastern section of the walls. It led to the port and was lined by inns and taverns, baths and fountains.

Near the arches you can see the bases for the statues of the members of the emperor's family. Next

to the one on the south side was a fountain with a colonnaded façade.

The sanctuary was entered through the **Great Propylaeum (c)** that were originally connected to the walls (to the right the 6th-century BC walls, to the left those of the first half of the 5th century BC and restored a century later). These had been built on the model of those on the acropolis in Athens. Five steps led to a base on which there stood a double portico of 6 Doric columns separated by a wall with 5 doors that faced the spaces between the columns. The deeper external portico had a colonnade of 2 rows of 3 Ionic columns that stretched down the passage.

A clypeus (type of disk with an honorific inscription or image) of Antoninus Pius was attached to the façade and the interior epistyle was a dedication to this emperor and Marcus Aurelius.

ELEUSIS	
a	*TEMPLE OF ARTEMIS*
b	*TRIUMPHAL ARCHES*
c	*GREAT PROPYLAEUM*
d	*KALLICHORON*
e	*HOUSE OF THE KERYKES*
f	*HOUSES*
g	*SMALL PROPYLAEUM*
h	*PLOUTONION*
i	*IMPERIAL BUILDING*
j	*TELESTERION*
k	*BOULEUTERION*

ABOVE LEFT: THE SMALL PROPYLAEA SEEN FROM THE EAST AND DOMINATED BY THE ACROPOLIS.

The *Kallichoron* (**d**) can be seen at a very low level in the northeast corner of the Propylaeum. The well was dug in Cimon's era and inserted in an apsidal enclosure made of unfired bricks on a base of *poros* orthostats. The well's mouth (made from blocks of black stone and still visible) was from the same period. However, the low parapet that encloses it was built at the start of the 3rd century BC (at the time of the siege by Demetrius Poliorcetes), using blocks from the plinth of the original enclosure, which had collapsed.

Once past the entrance, you will see on the right (the auxiliary north area) a **large building** (**e**) from the Roman era built over a 6th-century BC structure (and in turn constructed on a granary from the time of Peististratus), which was in part destroyed by the late-ancient defense wall; the Roman building was the house where the family of the priest of the Kerykes met to celebrate cult rituals. In the adjacent area to the east stood the **houses** (**f**) where the sanctuary staff lived. The marble-paved Sacred Way led to the **Small Propylaeum** (**g**), the magnificent entrance reserved for the use of the initiates. The gate opened into a wide vestibule protected by a portico with 2 doors flanked by Corinthian columns with elegant capitals featuring winged lions and volutes, and, on the inside, by 2 caryatids. The cista (box holding sacred items) that hid the sacred items used in the Mysteries was positioned on the heads of the caryatids (now in the museum). Symbols of the cult of Demeter (ears of corn and *modioli* (*small amounts of grain offering*)) decorated the triglyphs on the Doric frieze, and pateras (small libation vessels) and bucranes (ox skulls decorated with wreaths) decorated the metopes. Two fountains were originally located on either side of the gate but were later replaced with passageways. The entrance was built in 54 BC by Appius Claudius Pulcrus after the demolition of the propylaeum of Demeter and Kore (a portico with 2 Doric columns in the center and pillars at the sides dating from the second half of the 5th century BC). The materials were reused in the propylaeum dedicated to Mitra.

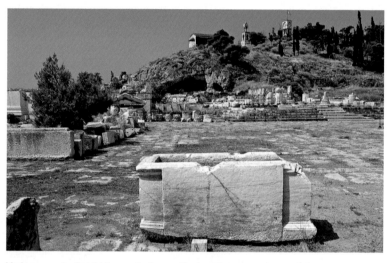

OPPOSITE TOP: FIGHT SCENE, DETAIL FROM A SARCOPHAGUS.

OPPOSITE BOTTOM: ENTRANCE AND GREAT PROPYLAEA IN THE BACKGROUND.
RIGHT: TYMPANUM REPLACED IN THE AREA OF THE GREAT PROPYLAEA.

BELOW: BUST OF ANTONINUS PIUS FROM THE PEDIMENT OF THE GREAT PROPYLAEA.

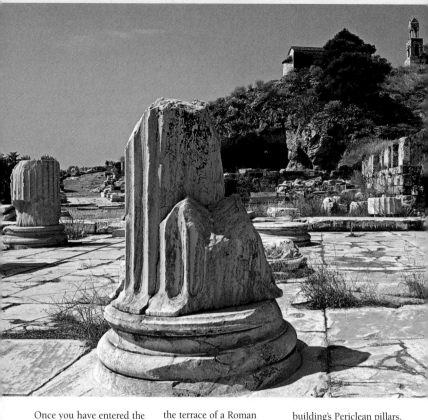

Once you have entered the sanctuary, on the right hand side you will see the *Ploutonion* (h). On a terrace higher than the road stood the small temple dedicated to Pluto (in the center of a triangular court enclosed by a wall) and a grotto in which there were 2 cavities of different size. In all probability the grotto was the setting for the annual epiphany of Persephone, who, according to tradition, was taken down into the Underworld through this cave. Continuing along the Sacred Way on the right you can see an exedra with steps cut in the rock and a small portico for the faithful present at the sacred processions. Then there is the terrace of a Roman temple that may have been dedicated to Sabina, the wife of Hadrian, and a flight of steps in the rock that led to another imperial **sacred building** (i), Ionic tetrastyle *in antis*, perhaps dedicated to Faustina, the wife of Antoninus Pius. As had happened to Sabina, Faustina was honored with the title of "new Demeter." At a lower level on the left side of the road, in the area incorporated with the extension of the walls by Cimon, lie the remains of a long building divided into 6 compartments that may have been a granary, but it was made unusable by the construction of Philon's portico. Some of the large building's Periclean pillars, originally underground, can also be seen. The Sacred Way ends on the north side of the *Telesterion* (j). Little remains of the luxurious building designed by Ictinus except the steps cut out of the rock that led to the west wall of the large room and the foundations of the portico on the east side. The remains of the earlier building have been excavated beneath the room itself.

The oblique foundations at the sides of the portico were laid in the 4th century BC, probably in preparation for an enlargement of the *Telesterion* that never occurred. The large sanctuary court spread open

semicircular exedra, was perhaps the **Bouleuterion** (k). On the other side of the gate stood another portico, and, between this and the south wall of the *Telesterion*, steps were cut out of the rock in the Roman period. These were the steps from which the initiates followed the cult rituals performed in the court.

Beyond the south gate lay the remains (today no longer visible) of what was known as the "sacred house." The first building (with 3 rooms preceded by a long vestibule that opened onto a paved courtyard) was built at the end of the 8th century BC and was an object of worship until it was destroyed roughly a century later. At the start of the 6th century BC, a small sacellum and altar, perhaps with peribolos, were built over the ruins. Perhaps a century later the complex was rebuilt with a polygonal stone enclosure and a *poros* temple. The decoration on the pediment is of a female figure made from Pentelic marble (now in the museum). Next to the small sanctuary stood a Mitreum from the late Roman period that was built using the

to the left and right in front of the portico. From here it is possible to see the well-preserved buildings of the Periclean walls with round towers and, to the south, the area enlarged in the 4th century BC. Further in, beneath a protective canopy, lies a stretch of the walls built by Peisistratus, equipped with square towers.

On the south side of the square by the walls there are several buildings: a portico: and a structure similar to an *odeon* that might have been used to hold meetings. It was built in the Roman period over a 4th-century BC building with 3 rooms, of which the central one, which concluded with a

BELOW: TIERS IN THE *TELESTERION*, WEST SIDE.

materials from the Small Propylaeum.

In the immediate area stood a set of buildings, perhaps the gymnasium, with a wide central peristyle onto which faced various rooms on 2 sides. The complex was entered from the north and south through two propylaeum.

145

ATTICA

BELOW: BOTTOM: BASE OF THE GREAT PROPYLAEA SEEN FROM THE EAST.

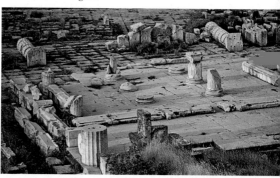

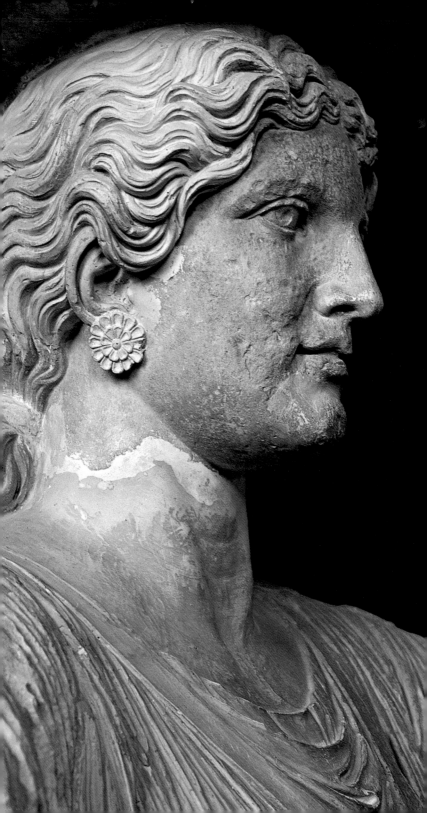

THE MUSEUM

In the entrance, note the large headless statue of Demeter (second half of the 5th century BC), which may be an original by AGORACRITUS, a pupil of PHIDIAS. Also note the large relief of the Eleusian gods (the original is in the National Archaeological Museum in Athens). Found in the flooring of the chapel of St. Zaccharias, it represents Demeter, in the presence of Persephone, giving Triptolemus corn seed so that agriculture can be spread around the world (445 BC. *Room 1* contains: an **early Attic amphora** by the PAINTER OF POLYPHEMUS (650 BC), decorated with a scene of the blinding of the Cyclops by Odysseus and his companions (on the top), and Perseus followed by the Gorgons (belly). The pediment statue of a girl in flight comes from the sanctuary of the "sacred house" (480 BC). Among the many works from the Roman era is the **caryatid** from the Small Propylaeum (*Room 5*). *Room 6* also contains vases from the Bronze Age to the late Ancient period. (C.T.)

OPPOSITE: HEAD OF A CARYATID FROM THE SMALL PROPYLAEA.

147

ABOVE: THE BLINDING OF POLYPHEMUS, AN EARLY ATTIC AMPHORA.

LEFT YOUNG GIRL RUNNING, PEDIMENT AT ELEUSIS, PROBABLY FROM THE "SACRED HOUSE."

ELEUSIS

ATTICA

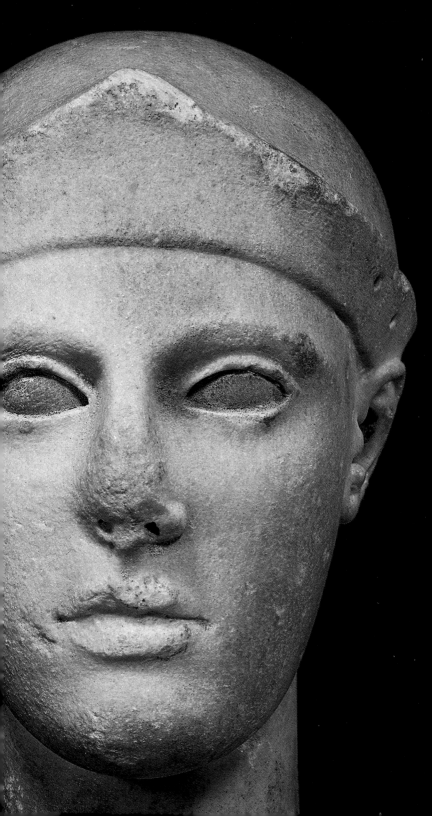

2.1

AEGINA

HISTORY

According to tradition, the island was uninhabited when Zeus took the nymph Aegina, the daughter of the River Asopus, there. This was the place where Aeacus was born, and when he grew up, asked his father for subjects to rule. Zeus made them grow from the earth, or, according to other versions, created them from ants (the Myrmidons, from *myrmex* meaning ant). The descendants of Aeacus—Peleus and Telamon—were guilty of killing Phocus, their brother and their father's favorite son, and were consequently exiled. Peleus went to Phthia in Thessaly and Telamon to Salamis. Their sons, Achilles and Ajax, respectively, fought together in the Trojan War.

Thanks to its position in the Saronic Gulf, Aegina could control communications between east and west and was one of the most important prehistoric settlements in the Aegean. After a period of abandonment between the 12th and 10th centuries BC, Aegina was colonized, perhaps by Epidaurus, c. 950 BC. It established itself as a naval and commercial

important as a center of arts. The local sculptors (CALLON, ONATAS, and ANAXAGORAS) were famous above all for their bronze works, of which, unfortunately, we know only what sources tell us. The importance of Aegina's role in maritime trade inevitably aroused the rivalry of Athens, and so, to counter the threat represented by its powerful neighbor, Aegina joined the

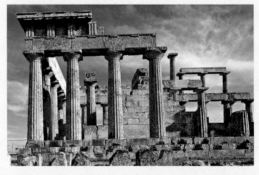

ATTICA

OPPOSITE: OF ATHENA, EAST PEDIMENT.

TOP: THE DORIC COLONNADE FROM THE TEMPLE OF ATHENA.

ABOVE RIGHT: PERISTASIS AND NAOS IN THE TEMPLE OF ATHENA, SEEN FROM THE SOUTH.

power during the 7th and 6th centuries BC, and it was the Aeginetans that introduced the first system of weights into Greece (656–650 BC). The island's coins were known as "turtles" because of the stamp they bore. Examples of them have been found around all of the Mediterranean. During this period the island became

Peloponnesian League at the start of the 5th century BC. Although victorious in 488 BC, it was defeated in 458 BC and again in 431, and the population was chased off the island. Later it passed under the control of Sparta, Thebes, Macedonia and Pergamum (210–133 BC), but continued to play a modest role even during the Roman era.

AEGINA

149

ATTICA

The hill of Cape Colonna (north of the port) was the city's acropolis and continuously inhabited from the Neolithic to the Byzantine age. Excavation on the hilltop has revealed a large settlement (2500–1600 BC) with 10 levels of occupation. Between 2200 and 2050 (level 5), fortifications were built that can only be compared to those of Troy. After the settlement was destroyed by a fire, a second wall (2050–2000 BC, level 6) was built close by, but thicker (13–16 feet) and with two entrances protected by towers.

In the center of the Bronze Age settlement, the foundations and a column (after which the cape is named) of the opisthodomus of the temple of **Apollo (a)** are visible.
Built between 520 and 510 BC in yellowish *poros*, it had a peristasis of 6 x 11 Doric columns, a distyle pronaos and opisthodomus, and a naos divided into 3 aisles by 2 rows of 5 columns. The decoration on the pediment was made from Parian marble, of which many fragments remain. On the east side were depicted the battle of

Heracles and Telamon against the Amazons (now in the museum).
Standing in front of the temple was a building from the second quarter of the 6th century BC that was destroyed by a fire. This had, in turn, replaced a building constructed at the start of the same century, of which fragments of large round terracotta acroters remain (also in the museum). Each of these buildings had an altar, remains of which can be seen on the east side of the temple.
Another element of the sanctuary was a small

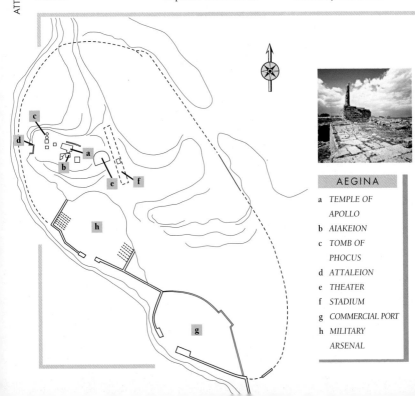

AEGINA

a *TEMPLE OF APOLLO*
b *AIAKEION*
c *TOMB OF PHOCUS*
d *ATTALEION*
e *THEATER*
f *STADIUM*
g *COMMERCIAL PORT*
h *MILITARY ARSENAL*

OPPOSITE BOTTOM: CAPE
COLONNA, RUINS OF THE TEMPLE
OF APOLLO AND THE BRONZE AGE
SETTLEMENT.

LEFT: FORTIFICATION OF COLUMN
HEAD.

BELOW: AERIAL VIEW OF THE
ACROPOLIS FROM THE NORTH.

temple dedicated to Artemis and built between 470 and 460 BC. The *Thearion*—the banqueting room—stood outside the peribolos. Its name derived from the *Thearoi*, the people sent to interrogate the oracle of Apollo about a serious drought that was affecting Greece as a whole. Formed by 2 rooms that opened onto a 5-column portico *in antis*, it was dismantled around the middle of the 3rd century AD so that the materials could be used to construct the fortification wall that protected the sanctuary and acropolis. The ruins of a quandrangular enclosure to the southwest of the temple are dated to 490 BC. This may have been the *Aiakeion* (**b**), the place of worship of Aeacus. According to Pausanias' description, it was decorated with reliefs (depicting Greek ambassadors to Aeacus asking Zeus to end the drought) and enclosed olive trees and a low altar that represented the hero's tomb.

The base of a mound (from the end of the 6th century BC) visible near the enclosure may have been another monument that Pausanias referred to

A E G I N A

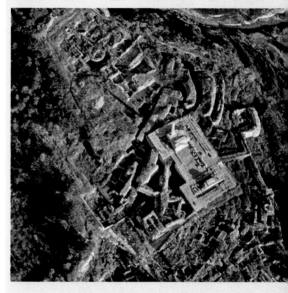

as linked to the myths of the city; if so, it could have been the **tomb of Phocus** (**c**), the son of Aeacus, who was killed by his brother Peleus with a stone during a gymnastic exercise (at that time stones were used instead of the discus).

The *Attaleion* (**d**), dedicated to the dynastic cult of Attalus II, stood at the foot of the hill.

Toward the east, depressions in the ground mark the site of the **theater** (**e**) and **stadium** (**f**), the materials of which were reused in the construction of the late ancient fortifications. The city and a large area were circled by walls with 2 gates: the **commercial gate** (**g**) to the southeast and the **military arsenal** (**h**) that Pausanias refers to as the "hidden gate."

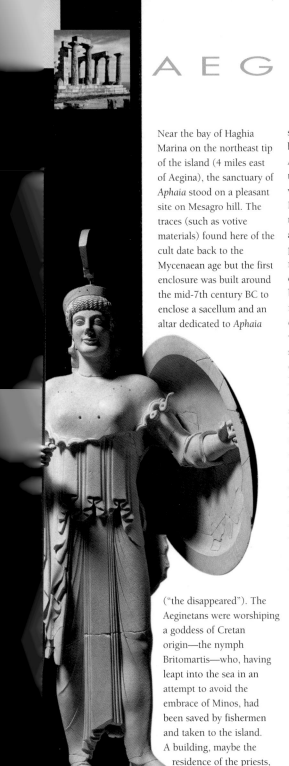

Near the bay of Haghia Marina on the northeast tip of the island (4 miles east of Aegina), the sanctuary of *Aphaia* stood on a pleasant site on Mesagro hill. The traces (such as votive materials) found here of the cult date back to the Mycenaean age but the first enclosure was built around the mid-7th century BC to enclose a sacellum and an altar dedicated to *Aphaia* ("the disappeared"). The Aeginetans were worshiping a goddess of Cretan origin—the nymph Britomartis—who, having leapt into the sea in an attempt to avoid the embrace of Minos, had been saved by fishermen and taken to the island. A building, maybe the residence of the priests,

stood close to the entrance but outside the enclosure. About 575–570 BC, a tetrastyle prostyle temple was built on the sacellum. It had a dual colonnade, two-part *adyton*, and a large altar. The entrance to the peribolos was monumentalized with a distyle propylaeum flanked by a portico. In the northeast corner of the enclosure, a votive column was raised crowned by a sphinx, fragments of which can be seen in the museum. Following a fire in the temple in 510 BC, the sanctuary was entirely rebuilt. Enlargement of the *tèmenos* required the construction of a new defensive wall, and this was given a **propylaeum (a)** with a *prodromos* and vestibule, both of which were distyle. A large **sacred building (b)** stood in the center of the area on a base with 3 steps, with a peristasis of 6 x 12 Doric columns, the naos divided into 3 aisles by 2 rows of 5 columns, and a distyle pronaos and opisthodomus *in antis*. The decoration of the local marble pediment and acroters represented a fine and almost unique example of the work of the Aeginetan school. The pediments (made in two stages) illustrated the first

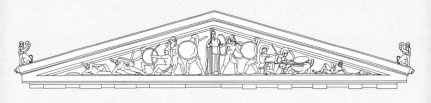

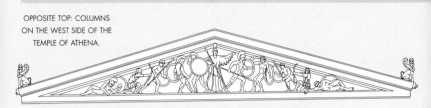

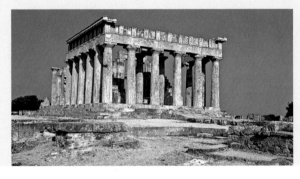

OPPOSITE BOTTOM:
STANDING EFFIGIES OF
ATHENA *APHAIA* ON
THE WEST PEDIMENT.

AEGINA

153

ABOVE: DRAWINGS OF
THE WEST, AND EAST,
PEDIMENTS OF THE
TEMPLE OF ATHENA:
FIGHT BETWEEN
GREEKS AND TROJANS.

ATTICA

ABOVE LEFT: EAST
PEDIMENT OF THE
TEMPLE OF ATHENA.

(east pediment, c. 480 BC)
and second (west
pediment, c. 490 BC) Greek
expeditions against Troy in
which the Aeginetan
heroes, Telamon and Ajax,
had participated. At the
center of the groups of
combatants, we see the
figure of Athena, whose
cult had been superimposed
on that of Aphaia.

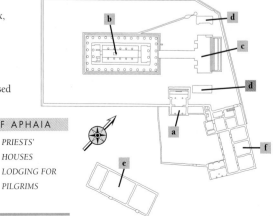

SANCTUARY OF APHAIA

a *PROPYLAEUM* e *PRIESTS'*
b *TEMPLE OF* *HOUSES*
 ATHENA APHAIA f *LODGING FOR*
c *ALTAR* *PILGRIMS*
d *BASES FOR STATUES*

AEGINA

The sculptures were discovered in 1811 by the English architect, R. Cockerell, who, with Haller von Hallerstein, was surveying the temple (which had been known of since 1675). In 1813 the sculptures were purchased by J. Martin Wagner for Prince Ludwig of Bavaria and sent to Rome to be restored. After Canova refused to work on them, Wagner performed his own restoration in contemporary taste with the help of the neo-Classical sculptor B. Thorvaldsen. This required an overall reworking of the sculptures so that it was impossible to tell which were the new parts and which the original. In 1828 they were exhibited in the Glyptotek in Munich, but the reconstruction of the pediment was based on non-scientific criteria. Only in 1962, when the new Glyptotek was being built, did D. Ohly remove the integrations (not without incurring criticism) and lay the sculptures out in a more correct arrangement.

The temple was connected by a ramp to a **large altar** (c) that had a dual flight of steps and a *bomos (altar)*. On one side, there was a **sculptural group (d)** of Heracles and Telamon against the Amazons, and on the other, of Zeus abducting the nymph Aegina. Most probably these were the first pediments made for the temple, but they were disassembled, perhaps for political reasons, when it was decided to replace them with images of the Aeginetan heroes fighting the Trojans.

The **priests' house (e)** and **buildings (f)** to accommodate

pilgrims stood outside of the enclosure.

Mount Oros (or St. Elias): from Aegina take the road toward Marathon; at the first junction turn left toward Lèfki and continue as far as Port Ràchi, then follow the path to the church of the Taxiàrches. The sides of this mountain were the site of the Hellenistic sanctuary of Zeus *Hellànios*, the earliest (13th century BC) and most important cult in Aegina, in which the god was worshiped as the giver of rain. A stepped road led to a terrace supported by polygonal walls. From here steps led to a building with 3 aisles (built over an Archaic building of which certain traces of polygonal walls remain) that was probably used to

accommodate worshipers (to the east there are the ruins of the Byzantine monastery). On a higher level there was a cistern carved out of the rock and connected to a smaller tank that held the water sacred to Zeus.

The oldest part (from the Geometric Age) of the sanctuary (a double semi-circular enclosure with an altar at the center) stood on the top of the hill where, according to tradition, Aeacus had built an altar to Zeus that brought an end to the drought that affected Greece.

Open every day except Mondays, 8:30-3 pm, winter and 8 am-2:30 pm, summer.

This museum has articles from the island's various sites; they include the votive sphinx from the sanctuary of Apollo made by an Aeginetan sculptor circa 460 BC and the reconstructed pediments of the temple of Aphaia, with original parts and molds of the figures held in the Glyptotek in Munich. (C.T.)

AEGINA

155

ATTICA

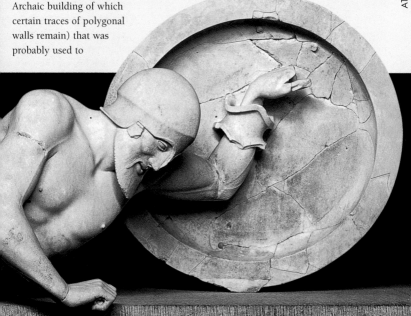

3

PELOPONNESUS

A journey to the Peloponnesus represents a return to the places where Greek civilization originated—Mycenae, Tiryns, Argos, Pylos—but also to the great sanctuaries of the Classical Age, such as Olympia, Epidaurus, and Tegea. The Peloponnesus is also a region of Byzantine monasteries and churches. In addition there are Frankish, Venetian, and Turkish forts and tiny villages far from bucolic regions like Arcadia. Above all there is the sea, so very alive that it lives on in memory long after you leave the peninsula.

ITINERARY 1

Leaving **Athens**, head for **Corinth** (60 miles) and go to **Isthmia** and **Perachora**. Then continue toward **Mycenae** (31 miles) with a stop in **Nemea**. From there go to **Argos** (6 miles), then **Tiryns** (4 miles) and **Nauplia** (3 miles). This is an ideal base for reaching **Epidaurus** (17 miles) and the Argolis peninsula (**Galatas, Ermioni, Kosta, Portocheli**).

ITINERARY 2

From **Nauplia** go to **Lerna** (6 miles) and from there continue to **Tripolis** (36 miles), which has an interesting museum. Going north to Levidi, after 6–7 miles you come to **Mantinea** (whic h has remains of a theater and *bouleutèrion*). Continuing toward Langadia, on the right you will find **Orchomenos** (5 miles), where there is a small but well preserved theater and remains of an Archaic temple. Southwest from Tripolis, you can visit **Megalopolis** (21 miles), capital of the Arcadian League, and 11 miles west, **Lycosura**, seat of a sanctuary dedicated to Despoina. To the south of Tripolis there lies **Tegea** (5 miles), famous for the temple of Athena *Alea*. From there you can reach **Sparta** (31 miles) and **Mistras**, the Byzantine "ghost" town. From Sparta, first heading south to Kania, then east, you come to **Monemvasía** (59 miles). Another trip from Sparta, toward the southeast, takes you to **Geraki** (24 miles); alternatively, head south to **Yithion** (29 miles, and 40 miles from Monemvasía), continue to **Areopolis** (16 miles) and the **Mani** peninsula.

ITINERARY 3

From Mani, take the coast road to **Kalamata** (50 miles), famous for its olives. Head for ancient **Messene** near Mavrommati (25 miles), then turn south to **Pylos** (39 miles) and **Nestor's palace** (10 miles). At **Khora** (3 miles) is a small archaeological museum. Then journey north to **Olympia** (23 miles) and **Andritsaina** (33 miles), which lies at the foot of Mount Likeos. This town is an ideal base to explore **Bassae** (9 miles), where you can admire the temple of Apollo *Epikourios*. From Andritsaina continue east to **Karitaina** (19 miles), once the capital of the Frankish barony. From Olympia, return to the coast and head north to **Killini** (27 miles) and the nearby **Hlemoutsi** castle. Then continue up the coast to **Patras** (39 miles). On the way to Corinth, turn off at Diakopton (37 miles) to visit the ravines of **Vouraïkos**, where the monastery of the *Megaspilaion* (Great Cave) stands (14 miles). Lying just before Corinth (20 miles west) is **Sicyon**. (C.T.)

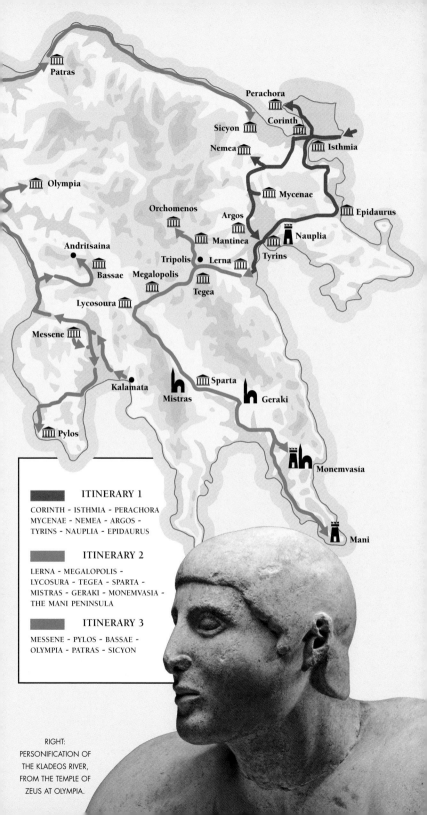

Patras

Perachora

Sicyon

Corinth

Nemea

Isthmia

Olympia

Mycenae

Epidaurus

Orchomenos

Argos

Andritsaina

Mantinea

Nauplia

Bassae

Tripolis

Lerna

Tyrins

Megalopolis

Lycosoura

Tegea

Messene

Sparta

Kalamata

Mistras

Geraki

Pylos

Monemvasía

Mani

ITINERARY 1

CORINTH - ISTHMIA - PERACHORA
MYCENAE - NEMEA - ARGOS -
TYRINS - NAUPLIA - EPIDAURUS

ITINERARY 2

LERNA - MEGALOPOLIS -
LYCOSOURA - TEGEA - SPARTA -
MISTRAS - GERAKI - MONEMVASIA -
THE MANI PENINSULA

ITINERARY 3

MESSENE - PYLOS - BASSAE -
OLYMPIA - PATRAS - SICYON

RIGHT:
PERSONIFICATION OF
THE KLADEOS RIVER,
FROM THE TEMPLE OF
ZEUS AT OLYMPIA.

ITINERARY 1
CORINTH

3.1

ABOVE: DETAIL OF CORINTHIAN *OINOCHOE* FROM THE ARCHAIC AGE.

LEFT: STATUE OF OCTAVIAN FROM CORINTH.

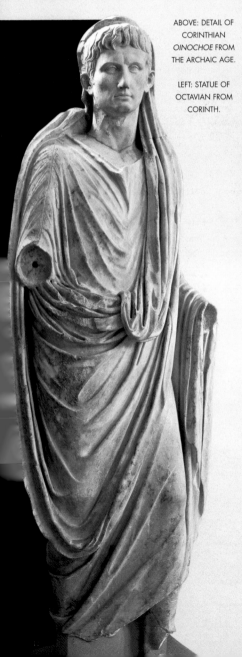

The ancient city of Corinth lay at the foot of the Acrocorinthus (its acropolis) about 4 miles southwest of the modern version founded in 1858. The city's geographical position close to the Isthmus of Corinth always ensured it economic prosperity and maritime expansion. It controlled the land routes between northern Greece and the Peloponnesus and, thanks to its two ports, Lechaeum (Gulf of Corinth) and Cenchreae (Saronic Gulf), also navigation between the Orient and Occident.

To avoid the long and dangerous journey around the Peloponnesus (185 miles), boats were hauled up onto wheeled platforms and pulled across the Diolkos (from *diélko*, to haul), which was the paved road built across the isthmus at the end of the 7th and early 6th centuries BC. It remained in use until the 12th century AD.

The project to lay out the road was begun by Periander in the Archaic Age and was taken up again by Demetrius Poliorcetes in the Hellenistic period. At later dates, under the Roman emperors Caesar, Caligula, and Nero, building works were continued but were interrupted on Nero's death. The modern canal (built 1882–85) follows the Neronian route.

The city was founded by Sisyphus, though his contemporaries only gave him the merit of having developed trade. For having dared to reveal the secret of Zeus, he was punished in an exemplary manne: by the judges of the Afterlife: he had to push an enormous boulder to the top of a hil, but every time it approached the summit, it rolled down to the bottom again. The vicissitudes of fortune experienced by Bellerophon, Sisyphus' grandson and Corinth's national hero, were much more complex. He abandoned the city after killing his brother and took refuge with Proetus, king of Tiryns. When Bellerophon turned down the attempt of Anteia (Proetus' wife) to seduce him, she falsely informed her husband that he had seduced her. Proetus sent Bellerophon to the king of Lycia with a sealed letter that contained instructions that the hero should be killed. However, the king of Lycia preferred to order Bellerophon to perform dangerous tasks, like the slaying of the Chimera that lived near the king of Caria. The Chimera had head of a lion, body of a goat, tail of a serpent, and breath of a dragon. Bellerophon succeeded in slaughtering the beast thanks to Pegasus. Bellerophon captured this winged horse, born from the blood of Medusa, while it drank at the spring dedicated to the nymph Pyrene at Corinth. To effect the capture, he used a golden bridle Athena had given him.

The site has been occupied since at least the second millennium BC, but foundation of the city occurred around 1000 BC. Having freed itself from the control of Argos in the eighth century, Corinth expanded rapidly. In the sixth century it entered the Peloponnesian League and allied itself with Sparta in the Peloponnesian War (431–404 BC), but it later switched sides and joined Athens, Argos, and Thebes against its former ally. It was chosen by Philip II as the seat for his anti-Persian coalition (League of Corinth, 338 BC), and united itself with the Achaean League in 243 BC. In the middle of the second century BC, the city participated in the insurrection against the Romans, but this ended in 146 BC with its destruction. In 44 BC, Caesar began reconstruction of the *Colonia Iulia Laus Corinthia,* which was completed by Augustus. In the second half of the second century AD, despite the earthquake of 77, Corinth was the richest city in Greece, but it was sacked by the Heruls and Goths in the third and fourth centuries and suffered earthquakes in 375 and 521. Justinian helped the city to recover from the second disaster and built a defensive wall across the isthmus.

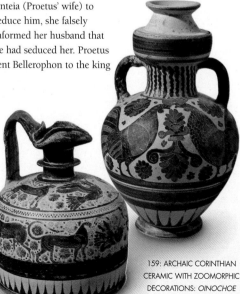

159: ARCHAIC CORINTHIAN CERAMIC WITH ZOOMORPHIC DECORATIONS: *OINOCHOE* (LEFT) AND AMPHORA.

Open every day, 8 am to 5 pm in winter, and 8 am to 7 pm in summer. Payment required.

The city, the Acrocorinthus, and Lechaeum (the west port) were defended by a single set of fortifications roughly 10 miles in length built during the Classical era. Their remains can still be seen at various points. The best known section of the ancient city is the agora district, thanks to the excavations that are still in progress. Studies have shown that the site of the Greek agora that was destroyed with the rest of the city in 146 BC does not coincide, as has always been believed, with that of the Roman forum. Instead, it lay along the north side of the ridge of the temple of Apollo in an area that has not yet been

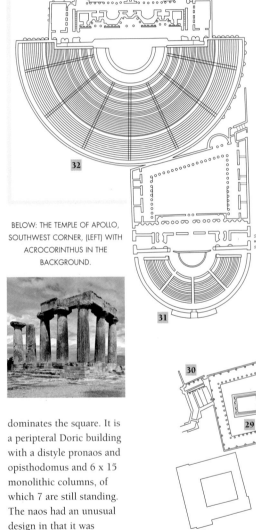

BELOW: THE TEMPLE OF APOLLO, SOUTHWEST CORNER, (LEFT) WITH ACROCORINTHUS IN THE BACKGROUND.

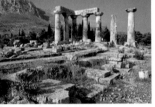

excavated.
Several buildings in the Greek town have been identified beneath the Roman forum, but the only monument still visible is the **temple of Apollo (1)** (70' 6" x 176' 6") which

dominates the square. It is a peripteral Doric building with a distyle pronaos and opisthodomus and 6 x 15 monolithic columns, of which 7 are still standing. The naos had an unusual design in that it was divided by a wall into 2 sections of different width. The temple was built by the Corinthian oligarchy between 560–40 BC, over a previous temple (675 BC), to celebrate the end of the tyranny.

LEFT: A DORIC CAPITAL IN THE TEMPLE.

AGORA

1 TEMPLE OF APOLLO
2 TEMPLE E
3 PORTICO
4 TEMPLE F
5 TEMPLE G
6 TEMPLE H
7 TEMPLE J
8 TEMPLE K
9 TEMPLE D
10 SMALL TEMPLE
11 SHOPS
12 BÈMA
13 HELLENISTIC PLINTH
14 PORTICO
15 CURIA
16 SOUTH BASILICA
17 JULIAN BASILICA
18 ARCHIVE
19 DROMOS
20 FOUNTAIN OF PYRENE
21 ARCH AT THE START OF THE ROAD TO LECHAEUM
22 "PRISONERS' FAÇADE"
23 UNDERGROUND SPRING
24 SHOPS
25 PORTICO
26 FOUNDATIONS FOR THE COLOSSUS OF MINERVA
27 LARGE ALTAR
28 ARCH WITH THREE FORNICES
29 TEMPLE C
30 GLAUKÈ SPRING
31 ODEON
32 THEATER
A BASILICA
B PERIBOLOS OF APOLLO
C BATHS
D MACELLUM

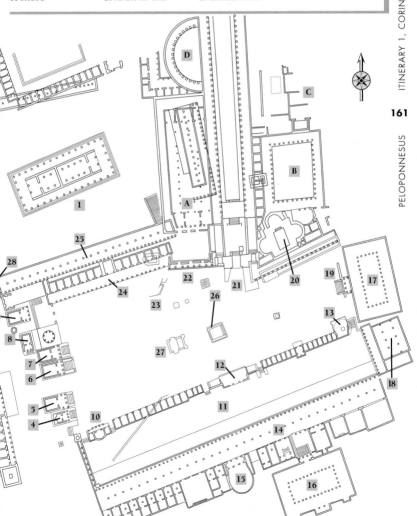

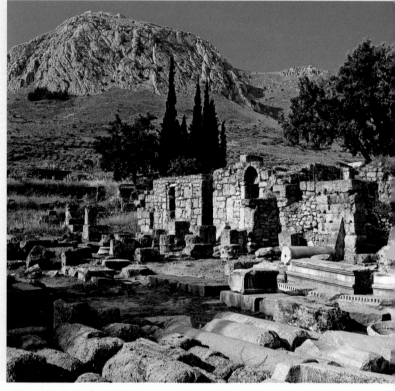

In the area to the north of the temple it is possible to see the ruins of a porticoed Roman square surrounded by shops (referred to as the "north agora") that was partly built over a Greek portico (4th century BC). The modern entrance to the archaeological zone leads to the western area of the Forum, where **temple E (2)** used to stand on a terrace lined on 3 sides by a double portico. The peripteral temple had 6 x 12 Corinthian columns and stood on a high platform. It is believed that the Julio-Claudian building was the one dedicated to Octavia, Augustus' sister, but its position might also have been that of the colony's Capitolium.

A flight of steps in front of the temple lay at the center of a **portico (3)**, with 6 shops on either side, and gave access to the square. On the west side stood a series of small temples (indicated by letters of the alphabet); the naos of each was preceded by a colonnaded pronaos on a tall platform. The Augustan **temples F (4)** and **G (5)** may have been dedicated respectively to Venus and Apollo, who were important gods to both the city and to Emperor Augustus.

Temples H and **J (6, 7)** were built at the time of Emperor Commodus and were perhaps dedicated to

was also due to Agrippa. **Temple K (8)** was also built during the Augustan era, perhaps for the cult of all the gods (Pantheon); **temple D (9)**, dedicated to Fortuna, was also Augustan.

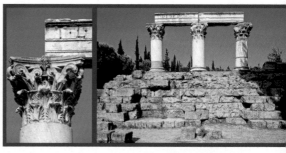

The south side of the square was on two levels. The lower level was endowed with cult buildings, civil buildings, and shops. An unusual **small temple (10)** stood on the west corner; it had an apse between two sacred enclosures and was preceded by a portico. It may have been used for the cult of Artemis (in the center) and of Dionysus *Lysios* and Bakchèios at the sides. There then follows a series of **shops (11)** interrupted at the center by what is known as the **Bèma (12)**. This was the high platform lined with marble and flanked on either side by seats that was used for public speaking by orators

and judges. It was from this platform that St. Paul, accused by the Jews in Corinth of infringing Mosaic Law, defended the Christian religion before Lucius Annaeus Novatus, the brother of Seneca and

proconsul of the province of Achaea (51–52 AD). Novatus' dismissal of the charges against Paul was decisive in the spreading of Christianity in Corinth. A small church with a nave and 2 aisles was built here during the Byzantine period, the remains of which can still be seen. The series of shops is closed off to the east by a tall, circular **Hellenistic plinth (13)**, used as a base for a monument to honor Agrippa and his sons Caius and Lucius, as is confirmed by coins of the period.

Heracles and Neptune. They stood where the notable Augustan consul Babbius Philinus had erected a fountain incorporating a statue of Poseidon (the remains are still visible) in honor of Agrippa, Augustus' son-in-law and collaborator, who played an important role in the reconstruction of Corinth. Construction of the adjacent **circular monument (13)**, whose function is still not certain,

CORINTH

TOP: ROMAN AGORA AND COLONNADE IN THE TEMPLE OF APOLLO IN THE BACKGROUND.

BOTTOM: THE RUINS SEEN FROM THE EAST: CENTER, THE ARCH AT THE START OF THE ROAD TO LECHAEUM.

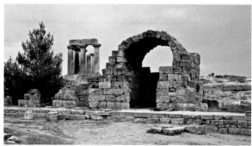

The upper level, which can be reached by steps, was bounded to the south by a large **portico** (14) with 71 Doric frontal columns and 34 Ionic columns in the center; the original plan (4th century BC) included 33 rooms perhaps used to host delegations from

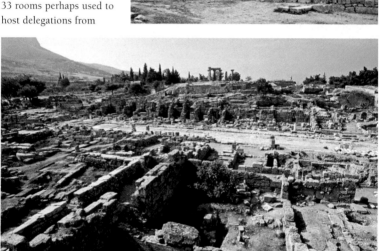

Greek cities belonging to the League of Corinth, but their commercial use cannot be ruled out. During the Roman period the building was rebuilt with larger rooms, though it maintained its external appearance, for use by the colony's administration. In this new layout it is possible to recognize **the curia** (15) from its horseshoe-shaped plan, preceded by a colonnaded but split atrium lined on either side by civil

buildings, perhaps the room of the duoviri (the colony's two most important judges) and their respective archives. The entrance to **the south basilica** (16) lay at the center of the eastern section of the portico, whereas the large rooms in the eastern half may have been the offices of guilds. On the east side of the square stood the **Julian basilica** (17), the layout of which was similar to the south basilica. It contained

a series of portraits of Augustus and his family (now in the local museum). The three-aisle building next to it, with an Ionic portico, was built around the mid-1st century BC by G. Babbius Philinus and rebuilt at the end of the century.

It may have been used as an **archive** (18) for public documents. The start line of the **dromos** (19)—the racetrack from the Greek era—still exists in front of the basilica.

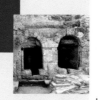

LEFT AND CENTER: THE AUGUSTAN AND HELLENISTIC FACES OF THE FOUNTAIN OF PYRENE.

BOTTOM: FOUNTAIN OF PYRENE, VIEW OF THE CENTRAL BASIN.

Continuing along the north side, you come to the building that houses the **fountain of Pyrene (20)**, famous in Corinthian myth. Pirene was the bride of Poseidon and mother of Leches and Cenchria (after whom the city's ports were named).

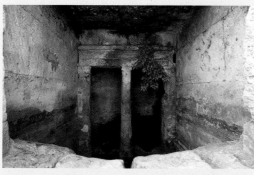

Cenchria was killed by accident by Artemis, and Pyrene wept for so long that she was turned into a fountain. The fountain we now see was created in the 2nd century AD by the munificent Herod Atticus; it has a four-sided court with apsidal exedras on 3 sides and a rectangular tank in the center that was originally lined with magnificent marble. The original design (6th century BC) was much simpler, with 6 openings for the water, each of which had its own tank. During the Hellenistic age the fountain was magnificently embellished with an arcaded façade,

Ionic pilasters, and during Augustus' reign, an Ionic front made of *poros*. Next to the fountain stood **the arch at the start of the road to Lechaeum (21)**. It originally had a single span but was rebuilt in 144 AD with a further two spans, reliefs of trophies and prisoners, and was crowned by the four-horse chariots of Helios and Phaeton.

Next to the arch lie the remains of what is known as the **"prisoners' façade" (22)**, which is a two-story architectural façade in Paros marble that acted as a monumental entrance to the basilica behind it and, at the same time, celebrated Septimius Severus' victories over the Parthians. At least 4 columns on the upper order were replaced by statues of Oriental prisoners, which rested on bases decorated with representations of Victories and Parthia subjected.

Below the façade, the remains of a cult complex dating from the Greek age can be seen, though the complex was already buried at the time of the destruction of Corinth. An **underground spring (23)**, which was a cult object from the Archaic Age to the 3rd century BC, can be reached down a flight of steps. The wall beside the steps that is decorated with triglyphs hid the entrance to an underground corridor that led to an apsidal temple (temple B, 5th century BC), probably used for oracular activity. The north side of the square was bounded on the west side by 16 **shops (24)**, behind which the remains of a Hellenistic **portico (25)** (3rd century BC) can be seen. In the center of the square (originally paved) you will see the **foundations for the colossus of Minerva (26)** and the foundations of a **large altar (27)**.

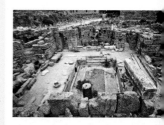

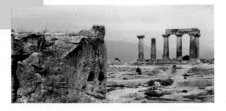

166 TOP: GLAUKÈ'S SPRING (TO THE LEFT) AND THE TEMPLE OF APOLLO.

166 BOTTOM: THE CAVEA AND THE REMAINS OF THE *SCAENA* OF THE ODEON.

AREA TO THE WEST OF THE TEMPLE OF APOLLO

Beyond the west side of the square lie the remains of an **arch with three openings** (28), which marked the start of the road to Sicyon. On the left of this road was a three-arch portico that housed the Ionic, tetrastyle **temple C** (29) that may have been dedicated to Mercury (Hermes). Behind the portico lie the remains of **Glaukè's spring** (30), which had a pilaster-decorated façade in front of three basins carved out of the rock. The spring was named after Jason's second wife, the daughter of Creon, the king of Corinth. The spring was given her name because she threw herself into it to relieve the pain of the burns inflicted on her body by the clothes poisoned by Medea, a witch and Jason's jealous first wife.

Continuing past the fountain, you reach the **odeon** (31) built during Nero's reign but rebuilt in marble in the mid-2nd century AD by the munificence of Herod Atticus. He also added a *porticus pone scaenam* (portico) to connect the odeon to the theater. After the fire of 225 AD, it was radically altered to provide a ring for gladiators and animal fights. Very little remains of **the theater** (32) as for centuries it was used as a quarry for building materials. Those sections that have best survived are the tiers of seats on the hill built by the Greeks, which were in part covered by those added during the period of Roman domination. Built in the 4th century BC, in the first half of the 3rd century BC the

koilon was enlarged and a permanent stage building added. The odeon was further modified under Augustus with the addition of a semi-circular orchestra, a colonnaded stage building and apses aligned with the three main doors. After the earthquake of 77 AD, the cavea had to be rebuilt. The stage building, which was begun under Hadrian and completed in the second half of the 2nd century AD, was fitted with statues and the front of the pulpit was decorated with reliefs of the amazonomachy, the centauromachy and the Labors of Hercules (in the local museum). At the start of the 3rd century AD, the orchestra was transformed into an arena for amphitheatrical games, in particular the *venationes* (animal hunts). And finally,

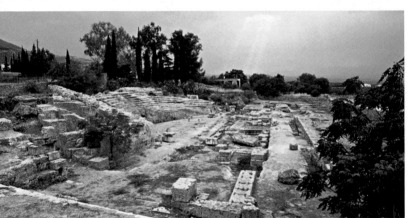

in the second half of the same century, a *columbetera* (large basin) was built to stage water spectacles (the *tetimimi*, mimed representations in honor of Tethys). The gymnasium was a vast building surrounded by porticoes; it has been excavated only in part. It stood to the north of the complex. Close to the northern edge of the city, is the **sanctuary of Asclepius** that communicated to the west with the Lerna fountain. This was a large building with a **central court** (1) surrounded by **porticoes** (2), 3 **banqueting rooms** (3) (to the east), and **pools** (4) (to the south). The temple

was built in the 4th century BC on the site of an older sanctuary (6th century BC) dedicated to Apollo. It stood in the center of a porticoed terrace on the west side of which the abaton (shrine) was located.

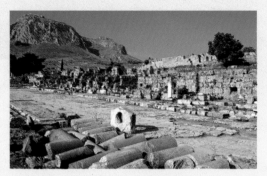

THE ROAD TO LECHAEUM

The wide colonnaded road that led to the port was the *carduus maximus* (main street) of the Roman city and, as such, lined with important monuments. To the left was a large **basilica** (A) built in the 1st century BC above the remains of a 5th-century BC market (the "fish agora") and rebuilt in marble in the 2nd century

AD. To the right of the road was the four-sided "**peribolos of Apollo**" (B) bordered by Ionic porticoes with an exedra for the statue in the middle of the south side. Next to it are the few remains of a **baths building** (C) in which the Baths of Euricles have been identified. Euricles was a rich Spartan who lived during the era of Hadrian.

It is possible, however, that Euricles' baths were in fact those in the magnificent complex that lies nearly 300 yards south and which have only in part been explored. The **Macellum** (meat center) (D) stood on the other side of the road, fronted by a hemicycle and shops on three sides.

ABOVE: BLOCKS OF COLUMNS AND ARCHITECTURAL ELEMENTS ALONG THE ROAD TO THE LECHAEUM.

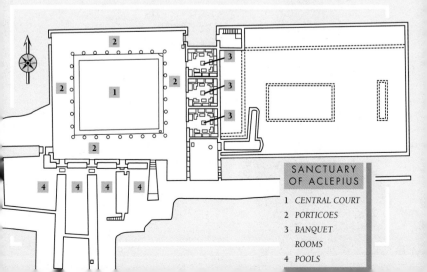

SANCTUARY OF ACLEPIUS

1 CENTRAL COURT
2 PORTICOES
3 BANQUET ROOMS
4 POOLS

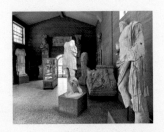

168 TOP: HEADLESS ROMAN STATUES AND SARCOPHAGI IN THE MUSEUM.

168 BOTTOM: ROMAN RELIEF WITH AMAZONOMACHY.

THE MUSEUM

Built by the American School of Classical Studies, the museum exhibits the finds from excavations in Corinth and its surroundings.

First room (on the left of the entrance): prehistoric and Mycenaean finds (pottery, tools, and personal objects).

Second room (to right of vestibule): finds from the Geometric and Classical Ages, in particular, painted vases, which, in the 7th and 6th centuries BC, were the city's most important crafts and were exported throughout the Mediterranean.

Third room (to left of vestibule): sculptures from the Roman era, including the **three statues of Augustus' family** from the Julian basilica, the **two colossal statues of barbarians** from the "prisoners' façade," a copy of the head of POLYCLITUS' **Doryphorus**, and the sarcophagus (2nd century AD) showing the death of Ophelte, who was strangled by a snake.

Fourth room: objects from the Asklepieion—temple dedicated to Asklepion (fragments of statues, votive offerings, and clay models of body parts offered by healed worshipers as offerings).

Under the porticoes: **amazonomachy**, **centauromachy**, and the **Labors of Hercules** (2nd century AD), taken from the theater. (C.T.)

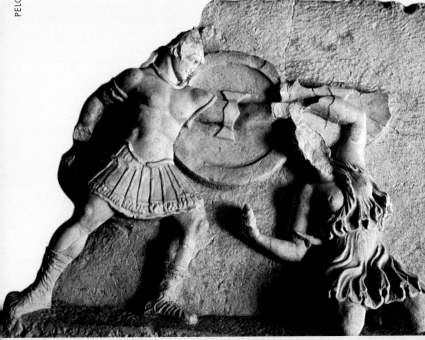

CORINTH

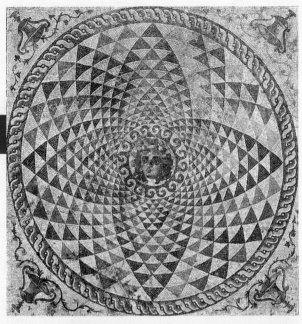

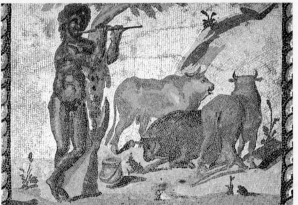

ABOVE (TOP): HEAD OF
DIONYSUS IN A GEOMETRIC
FRAME, (BOTTOM). MOSAIC
FROM A ROMAN VILLA.

RIGHT: BUCOLIC MOSAIC,
ROMAN COPY BY PAUSIAS OF
SICYON.

3.1

ISTHMIA

The sanctuary of Poseidon *Isthmios* stood in the modern village of Kyra Vryssi close to the east end of the isthmus near the road that joined Athens and the north of Greece to the Peloponnesus. Here, every two years, the Isthmian Games were celebrated with gymnastics and music contests and chariot and horse races. The winner was awarded a pine wreath from the sacred tree that grew close to the altar of the god. The legend is that either Poseidon or Helios instituted the games or, according to another tradition, Sisyphus, the first king of Corinth, in honor of the eastern hero Melikertes, the son of Io and grandson of Cadmus, who had been thrown into the sea by his crazed mother. His body was borne by a dolphin to the isthmus where he was buried. The Attic version of the legend, however, considered Theseus, the son of Poseidon, to have founded the games.

HISTORY

Historically, the foundation of the Isthmian Games is attributed to Cispelides (528 BC), but the cult had been important a century earlier, as shown by a temple dedicated to Poseidon from the mid-7th century BC and the richness of the votive offerings. During the Persian wars, the Archaic temple was destroyed by a fire and replaced by a new building c. 460 BC. The addition of monumental buildings to the site continued in the 4th century BC with the construction of a new **stadium (F)** and **theater (D)**. The destruction of Corinth (146 BC) by the Romans marked the end of the sanctuary, which had also had a political function as a meeting place for the representatives of the Greek cities. The games were probably transferred to Sicyon. The isthmus was once again visited during the Roman period (1st century AD), with the construction of an enclosure dedicated to Melikertes and extensive reconstruction in **the tèmenos of Poseidon (E)**. The building work initiated by Publius Licinius Priscus Juventianus, high priest of Poseidon, was particularly intense and widespread. Around the middle of the 6th century AD, after demolition of the monuments, Justinian used their materials to build a **defensive wall (A)** across the isthmus. The walls were known as Hexamili (meaning "six miles").

..

TOP: FLOOR MOSAICS FROM THE ROMAN BATHS.

CENTER: START LINE AND JUDGE'S STATION.

LEFT: ROMAN VOTIVE STELE.

OPPOSITE: VIEW OF THE BATHS AND THE *PALEMONION*.

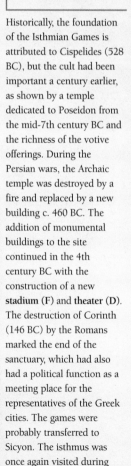

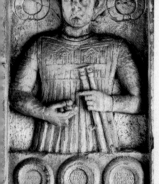

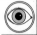

VISIT

Open every day, 8 am to 2:30 pm.

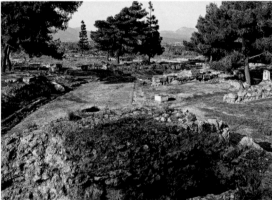

Entering the archaeological area, walk alongside the enclosure of Poseidon to reach the **Palemonion (a)**, the sanctuary of the hero Melikertes who was worshiped with the cult name of Palemon ("wrestler"). This is one of the few monuments in Isthmia referred to by Pausanias (II, 2, 1). The sanctuary was built at the start of the 1st century AD over the start line of the racetrack in the 5th-century BC **stadium (b)**. The northeast half of the isosceles triangle paving, with a circular depression at the top, can be seen; this was where the starting judge loosened the cords that allowed the barriers to

fall simultaneously and start the race. Initially the cult made use of three square depressions that contained ashes, animal bones, and pieces of pottery (vases and lamps) used in night sacrifices of black bulls in honor of Palemon. The first two depressions (A, Augustan age, 50 AD; B, Claudian age, 70 AD) lay within an irregularly shaped

enclosure, but the third (C, 70–150 AD) lay almost in the center of the east section of an enclosed area and divided by walls into three areas of different size. In the narrower central area it was later decided to build a semi-circular **propylaeum (c)** adorned with columns. This became the main entrance to the sanctuary and, at the same time,

ISTHMIA

A *ISTHMUS WALL*
B *BYZANTINE FORT*
C *ROMAN BATHS*
D *THEATER*
E *SANCTUARY OF*
 POSEIDON
F *STADIUM*

PALEMONION AND TEMPLE OF POSEIDON

a	*PALEMONION*	i	*ENCLOSURE*
b	*STADIUM*		*WALL*
c	*PROPYLAEUM*	j	*ALTAR*
d, e	*TEMPLE AND*	k	*IONIC ARCADES*
	TOMB OF	l	*SOUTHEAST*
	PALEMON		*PROPYLAEUM*
f	*TEMENOS*	m	*TEMPLE OF*
g	*NORTH ENTRANCE*		*POSEIDON*
h	*MAIN ENTRANCE*	n	*CLASSICAL ALTAR*

ISTHMIA

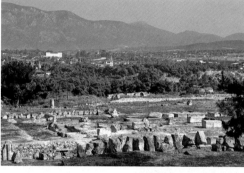

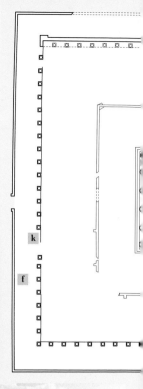

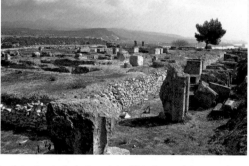

allowed communication between the sanctuaries of Palemon and Poseidon. During the reign of Hadrian, **a temple (d)** was built in the west area, which had to be enlarged westward. All that remains is the four-sided base; however, images on coins show us that it was a Corinthian monopteros that had a statue of Palemon lying on the back of a dolphin. During the late Antonine era, the temple platform was transformed into a *manteion* and the **tomb of the hero (e)** was transferred from the cave in the northeast corner of the peribolos of the temple of Poseidon to his new temple. The **tèmenos of Poseidon (f)** had been enclosed by a wall, of which very little remains,

back in the Archaic Age. An **entrance (g)** with distyle portico *in antis* has been identified on the north side while the **main entrance (h)** was on the east side; the latter is one of the few constructions of which we are unable to define the typology. A new **enclosure wall (i)** was erected about the mid-1st century AD and extended eastward under Emperor Claudius when the east gate and an **altar**

(j) in front of the temple were also built. In the 2nd century AD, the sanctuary was given a larger and more monumental enclosure with **Ionic arcades (k)** on 3 sides (the one on the north side was left unbuilt) and a **propylaeum in the southeast (l)**.
The **temple of Poseidon (m)** (460 BC) was a Doric peripteral building (6 x 13 columns) with a pronaos

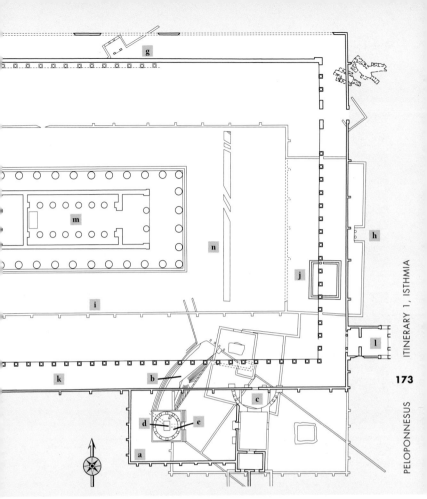

and opisthodomus. Originally, the naos was divided into 2 parts by a row of columns. After being gravely damaged by a fire at the start of the 4th century BC, it was rebuilt with the traditional three aisles created by two rows of 6 columns. Here Pausanias saw the chryselephantine statues of Poseidon and Amphitrite on a quadriga of seahorses, and the statue, donated by Herod Atticus, of Palemon on a dolphin.

On the north side of the temple lie the foundations of the long, rectangular

Archaic temple that had a peristyle of 7 x 19 Doric columns made from wood and a naos with a central colonnade. The foundations of the **Classical era temple (n)** lie in front of the temple.

OPPOSITE TOP: THE RUINS OF THE TEMPLE FROM THE SOUTHWEST, WITH THE BATHS IN THE BACKGROUND.

OPPOSITE BOTTOM: AREA OF THE *TEMENOS* OF POSEIDON.

BELOW: WHEEL TRACKS ALONG THE EAST SIDE OF THE TEMPLE.

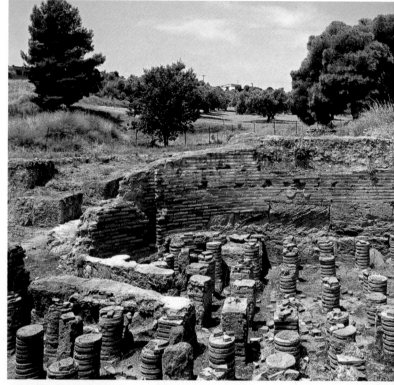

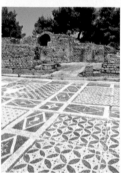

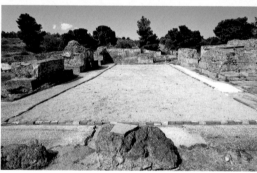

TOP: *SUSPENSURAE* IN THE *CALIDARIUM* OF THE ROMAN BATHS.

ABOVE AND BELOW: BATH MOSAICS; EROS RIDING A DOLPHIN.

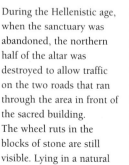

During the Hellenistic age, when the sanctuary was abandoned, the northern half of the altar was destroyed to allow traffic on the two roads that ran through the area in front of the sacred building. The wheel ruts in the blocks of stone are still visible. Lying in a natural hollow at the foot of Rachi hill to the south of the sanctuary, excavation work has revealed the start and finish lines of the **stadium** (**F**) that replaced the **Classical stadium** (**b**) near the temple of Poseidon at the start of the Hellenistic era. It was here that in 196 BC. Titus Quinctius Flamininus proclaimed the independence of the Greek cities. Very little remains of the **theater** (**D**) to the north

THE MUSEUM

Open every day except Monday, 8:30 am to 3 pm. Free.

The museum houses the finds made in Isthmia (pottery from prehistory to the Roman era,

and Plato), Egyptian subjects (lotus flowers, papyrus flowers, and water birds), views of ports and buildings by the sea, and fishing scenes. (C.T.)

of the sanctuary. During the earliest phase of the zone (late 5th to early 4th centuries BC) it had a rectilinear cavea that was rebuilt at the end of the 4th century BC in an unusual manner: the two central sections were curved and the side sections remained rectilinear. The radial pillars in the upper section of the cavea date from the Roman period, when an attempt was made to increase the seating capacity of the building. A grotto above the cavea was developed into a place of worship dedicated to Dionysus. It had two rooms where banquets were held until the 4th century BC, and the klinai (benches) can still be seen.

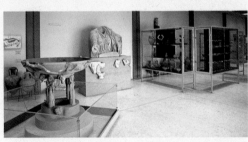

materials from the Archaic temple of Poseidon, collections of Roman oil lamps).
There are also finds from Cenchreae (pottery, ivories, and in particular, colored glass paste panels in *opus sectile* (mosaic) up till the 4th century AD showing figures (Homer

ABOVE: ROOM IN THE MUSEUM: LUSTRAL BASIN, OR *PERIRRANTERION*, FROM THE SANCTUARY.

OPPOSITE: CENTER HALL IN THE BATHS' BUILDING.

TOP: MOSAIC DETAILS: A DOLPHIN, AN OCTOPUS, AND A NEREID.

PERACHORA

This promontory divided the Bay of Corinth to the north from the Bay of Livadostros and was the site of an important sanctuary of Hera *Akraia* ("of the hill").

HISTORY

Cult activities, which were probably linked to the provision of an oracle, date to the first half of the 7th century BC, when an apsidal temple was built near the port. By the end of the same century, the temple had fallen into ruin. Until this period, the region had been under the hegemony of Megara. However, it was conquered by Corinth, which then took control of, and developed, the sanctuary. Votive deposits from the Archaic Age to Hera *Akraia* show that offerings were not just made locally but came from all across mainland and insular Greece.

Nonetheless, there does not appear to have been building here before the third quarter of the 6th century BC, when a new temple, an altar, and enclosed area were constructed, the last perhaps to accommodate pilgrims. Further important building works were carried out at the start of the 3rd century BC near the port and on terraces that overlooked it.

The site was abandoned at the time of the destruction of Corinth by the Romans in 146 BC.

CORINTIA

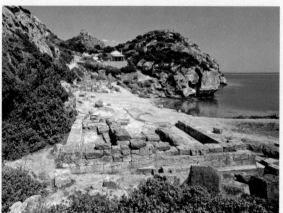

TOP: RUINS OF THE SANCTUARY OF HERA *LIMENIA*.

LEFT: VIEW FROM THE WEST, WITH THE TEMPLE OF HERA *AKRAIA*.

PERACHORA

a *TEMPLE OF HERA*
b *ALTAR*
c *AGORA*
d *L-SHAPED PORTICO*
e HESTIATORION
f CISTERN
g SANCTUARY OF HERA

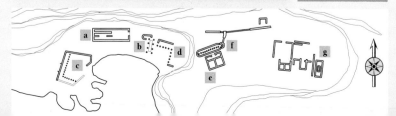

Near the little port can be seen the remains of the **temple of Hera (a)**; it had no peristasis but a naos with a double Doric colonnade. The temple stood over an earlier, Geometric Age building (remains exist to the north of the temple). An **altar (b)** adorned with triglyphs stood in front of the temple; in the 4th century BC the altar was

covered by a canopy, probably made of wood, supported by 4 (originally 8) columns of which the bases can be seen. The presence of a *bothros* (well) in the center of the altar demonstrates that chthonian cults were celebrated there. Worshipers at the services sat on a flight of steps cut in the rock. To the southwest of the temple lie the remains of what is referred to as the **agora (c)**; this was a pentagonal court enclosed by a wall along which runs a bench. On the south and west sides there was an arcade of wooden columns built in the 5th or early 4th century BC.

The foundations of an **L-shaped portico (d)** can be seen in front of the altar, with a double colonnade (Doric on the lower level and Ionic above) and a

bench along the back wall used by pilgrims to the sanctuary. Connected with the sanctuary from a functional viewpoint was the building on the hill slopes overlooking the port. Divided into two square sections each preceded by a vestibule, it has been identified as the *hestiatòrion* **(e)** (cult banquet room) as the walls in both rooms were lined by stone seats for the faithful. The building was constructed circa 300 BC over previous buildings that had the same function. On the north side of the *hestiatòrion* and connected to it, there was a large **cistern (f)** made during the same period with large blocks of *pòros* using the isodomum technique. It had apses on the shorter sides and a row of pillars along the major axis (this was a peristyle cistern).

Returning back up the valley you come to a series of terraces on which the ruins of walls still stand. The presence of storerooms for offerings with materials from the 7th and 6th centuries BC has suggested that a sanctuary dedicated to Hera Limenia ("of the port") once stood here, and would have replaced the

ruined cult building in the port. Though once identified with a **rectangular room (g)** with a central hearth, recent careful study of the topography indicates that this area was in fact an annex used to hold offerings and inscriptions for which there was no space in the lower sanctuary. This research holds that the rectangular room was more likely to have been used for banquets than to have been a temple. Extensive ruins of water-supply buildings on the top of the promontory have been found—Perachora had no springs—A fountain with a façade of 6 Ionic columns was fed by water piped into a triple cistern from underground water, and, in 300 BC, this substituted a round, 5th-century BC water tank that had been used to hold rainwater. The houses and a small temple (7th to 4th centuries BC) found in this area are less likely to have been residential than a settlement related to the cult activities or, even more probably, to have had a military or strategic function related to the promontory. (C.T.)

TOP: THE SANCTUARY OF HERA *LIMENIA*.

CENTER LEFT: ELLIPTICAL CISTERN AND *HESTIATORION*.

CENTER RIGHT: REMAINS OF L-SHAPED PORTICO.

MYCENAE

THE HISTORY

The existence of a settlement dating to the early Bronze Age (2500–1900 BC) is attested to by the presence of pottery shards, but the first significant finds are from the next period. The oldest tombs in grave circle B, at the extreme west of a vast burial area on the west slope of the acropolis, date to about 1600 BC. The humbleness of the grave goods—though they must have belonged to members of the royal family—indicate the modesty of the standard of living. A palace probably stood on the top of the hill, and it is to this hypothetical building that the ruins of walls found beneath various parts of the currently visible palace have been attributed. The more recent shaft

graves in circle B and those, more or less contemporaneous, in grave circle A (1580–1500 BC) at the east end of the same necropolis, contained very rich grave goods. These confirm the achievement of a very high standard of life in a short period, as well as cultural contacts with the Aegean, Asia Minor, and Egypt. The first chamber tombs appeared at the end of this period and were used for royalty.

Mycenae was at its largest circa 1400 BC; in 1350 BC the top of the acropolis was ringed by solid fortifications and a large palace constructed inside. Roughly 100 years later (1250 BC), the walls were enlarged on the west side to enclose grave circle A, and construction was

begun on the Lion Gate, the west bastion, and the North Gate.

ABout 1230 BC a fire destroyed the houses below the acropolis, and, at the end of the century, the same fate befell the palace and several houses in the citadel. A phase of reconstruction took place as well as the strengthening of the west side of the city walls. As occurred in other Mycenaean centers, the destruction of the city came at the end of the 12th century BC.

There are few signs of occupation during the following period. In the last quarter of the 7th century BC, a temple was built on the summit of the acropolis that was probably dedicated to Hera. Its framework was almost completely demolished when the building was reconstructed during the

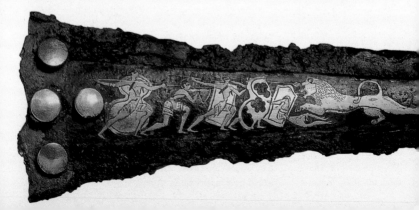

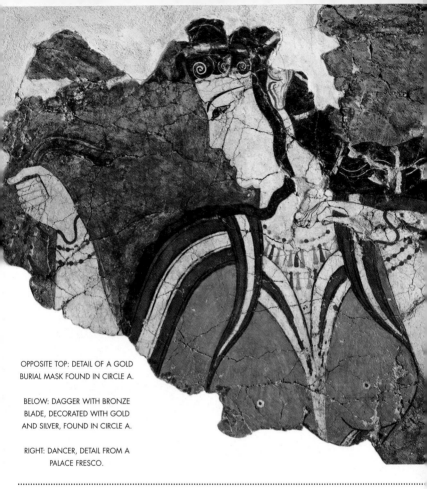

OPPOSITE TOP: DETAIL OF A GOLD BURIAL MASK FOUND IN CIRCLE A.

BELOW: DAGGER WITH BRONZE BLADE, DECORATED WITH GOLD AND SILVER, FOUND IN CIRCLE A.

RIGHT: DANCER, DETAIL FROM A PALACE FRESCO.

Hellenistic age.
Despite the fact that it was probably a small city, Mycenae entered the war against the Persians by sending a contingent of 400 men to fight under Leonidas at the battle of Thermopylae (480 BC) and at Plataea (479 BC). Like Tiryns, in 468 BC Mycenae fell under the control of Argos when he besieged latter Mycenae's acropolis and destroyed various sections of the fortifications. During the Hellenistic period (start of the 3rd century BC) a new settlement was built, the walls were restored (inserts of polygonal blocks), and the temple of Hera rebuilt. In the area below, a theater, gymnasium, and monumental fountain were also constructed. After the city's destruction in the second quarter of the 2nd century BC, it was abandoned. When Pausanias visited Mycenae in 160 AD, he found it desolate and ruined.

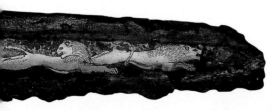

BELOW: HEINRICH
SCHLIEMANN
RIGHT: DRAWING OF THE
ACROPOLIS AT MYCENAE
BY SCHLIEMANN.

OPPOSITE TOP: DETAILS
OF THE DAGGER FOUND
IN CIRCLE A.

OPPOSITE BOTTOM: LION
GATE, AT THE END OF THE
19TH CENTURY.

ITINERARY 1, MYCENAE

180

PELOPONNESUS

EXCAVATION

Studies were begun in 1840 by the Greek Archaeological Society, above all to put an end to the removal of materials by European travelers for whom, from the 18th century on, the ruins of Mycenae were a popular destination.

The attention of scholars, though, was drawn by the excavation work carried out by Heinrich Schliemann. The German archaeologist visited Mycenae in 1874 and returned two years later

after he had discovered ancient Troy. His intention in Mycenae was to find the tomb of Agamemnon and all those who were killed with him, which Pausanias claims he saw (II, 16, 6–7) inside the city walls. The tombs of Aegisthus and Clytemnestra—the perpetrators of the crime—lay outside "a short distance from the wall." Relying on the accuracy of the topographical information provided by Pausanias' *Description*, Schliemann began his excavation near the Lion Gate. Here he found an enclosure with 5 tombs containing goods of extraordinary richness, which he believed to have been those of Agamemnon and his companions. Subsequent study of the

materials has established that they were in fact made about 350 years before Agamemnon's lifetime. Excavations continued under the direction of the Greek archaeologists P. Stamatàkis (1877–78) and C. Tsountas (1886–1902), and, at a later date, by the British School of Archaeology of Athens (Alan Wace, 1919–23). The results were not as striking as those of Schliemann but were certainly of equal importance providing knowledge of the site and, more generally, of the Mycenaean civilization. Investigations were continued by the British School after World War II (Alan Wace, 1950–57, and D. French and W. Taylor, 1957–67). In 1951, during restoration of Clytemnestra's tomb, another ring of royal tombs was found by chance and excavated by the Greek Archaeological Society (1952–55).

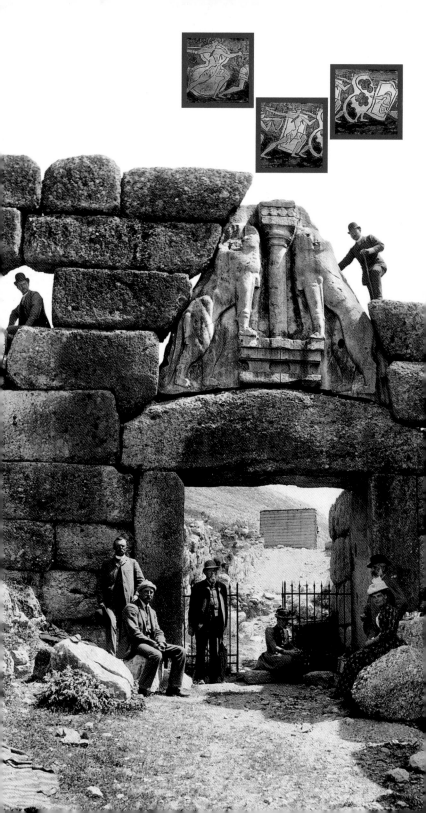

a

u

t

d

c

e

k

f

g

h

i

j

1350 B.C.

1250 B.C.

1200 B.C.

BELOW: THE CITADEL FROM THE
NORTHWEST DOMINATED, IN
THE BACKGROUND, BY MOUNT
HAGIOS ELIAS.

Open every day from 8am to 6pm in winter, and from 8am to 8pm in summer. Payment required.

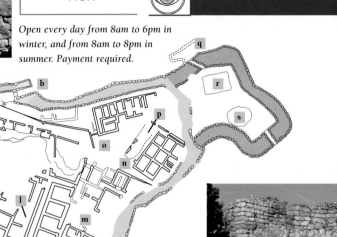

TOP: "CYCLOPIC" WALLS, NORTHWEST CORNER OF THE DEFENSIVE WALLS.

MYCENAE

a LION GATE
b NORTH GATE
c GREAT RAMP
d GRANARY
e GRAVE CIRCLE A
f RAMP HOUSE
g HOUSE OF THE
 WARRIOR VASE
h SOUTH HOUSE
i CULT CENTER
j HOUSE OF
 TSOUNTAS
k PALACE
l WORKSHOP
m HOUSE OF THE
 COLUMNS
n SQUARE
o,p STOREROOMS (?)
q UNDERGROUND
 CISTERN
r RESIDENCE (?)
s STOREROOM
t BUILDING M
u BUILDING N

The acropolis at the top of the hill was ringed by massive fortifications; it was the site of the king's palace, the houses of the dignitaries, buildings for the military garrison, the royal treasury, and storerooms for foodstuffs. Construction of the walls (1350–1340 BC) was traditionally attributed to the Cyclops due to the size of the blocks of stone. They are composed of two parallel walls made from large blocks of uncut stone (known as cyclopean masonry) with cavities filled by smaller stones. Later construction work (mid-13th century BC) to strengthen the southwest wall, the Lion Gate, the North Gate, and the tower-shaped projection on the southeast bastion was accomplished with the use of conglomerate blocks (used in important constructions) carefully cut and arranged horizontally. At the start of the 12th century BC, the walls were altered once again, in the northeast corner, to incorporate the underground cistern within the protected area. The walls had an overall length of 984 yards, an average thickness of 20 feet, and the original height would have been approximately 40 feet. There were two entrances in the walls: the North Gate (also known as the Postern Gate) and the Lion Gate. Two passages have also been discovered in the northeastern extension: the north passage allowed Mycenaean defenders to surprise attackers of the North Gate from behind, while the south passage led to a natural platform that overlooked the steep drop down to the Chavos stream; it also served as a lookout post.

ARGOLIS

The **Lion Gate (a)** stands at the top of the steps that arrive from the lower city and opens onto a narrow passage enclosed by steep rock on the left and an oblong bastion on the right. This arrangement forced attackers to be exposed from the right, that is to say, the side not protected by their shields. Built from four enormous conglomerate monoliths,

the strain onto the door jambs. The resulting triangular space was filled with a thin slab of carved limestone that is the oldest monumental relief in Greece. Two heraldic lions place their fore paws on two small altars, on which a column is carved holding up a ceiling. The lions have their faces turned toward the visitor who arrives at the walls of the city; their

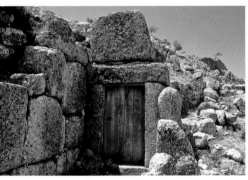

the gateway was originally closed by double wooden doors held shut by a large wooden beam. To relieve the lintel of the weight of the stones above, the gateway was designed with a triangular relief characteristic of late Mycenaean architecture. The blocks above the gateway progressively jut toward the center to form an empty triangular space below so as to discharge

faces (since lost) were made from a different material (perhaps steatite) and were then applied to the relief. The meaning of this representation is still debated: the column may allude to the royal palace that the lions—a symbol of Mycenaean power—are guarding. In that case, the representation would be a coat-of-arms of the Mycenaean rulers, which, according to tradition, was

the house of Atreus at the time the gate was built. The **North Gate (b)** was based on the model of the main gate. It opened at the end of a passage identical to the outer courtyard of the Lion Gate. It was built using 4 monoliths of conglomerate and was locked shut with the same wooden-beam method. Inside the Lion Gate there is a square courtyard that was originally covered.

OPPOSITE (LEFT): AREA OF THE
GRANARY WITH MILLSTONES,
RIGHT: BROKEN *PITHOS*
RECOMPOSED IN THE
GRANARY AREA.

BELOW AND OPPOSITE BOTTOM: THE
NORTH GATE AND LION GATE.

RIGHT: PASSAGE WITH A FALSE
ARCH IN THE EAST SECTION OF
THE WALLS.

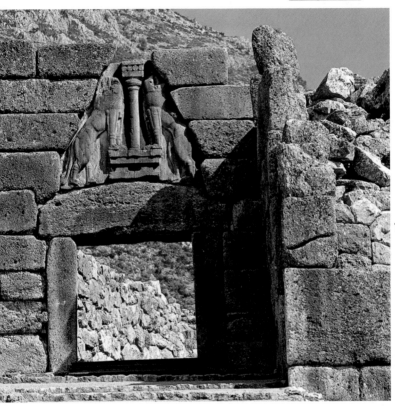

Ways to the Palace and **Great Ramp** (c) lead out of the courtyard. The current form of the steps dates to the last quarter of the 13th century BC.

Between the walls in the southwest sector and the Great Ramp, the remains of various houses are seen, but they are difficult to decipher as this area underwent notable building in the Hellenistic era.

Next to the Lion Gate lie the remains of the **Granary** (d), which got its name from the presence of pithoi (big jars) containing carbonized barley and wheat. More likely, given its size and position, the building was the quarters of the guard that protected the gate of the acropolis. The entrance to grave **circle A** (e) lies in front of this building. The circle is an enclosure of royal graves

(16th century BC) that was originally positioned away from the eastern end of the large prehistoric necropolis. In roughly 1250 BC the walls were extended to enclose the circle. As the enclosure lay lower than the height of the city walls, the Mycenaeans built solid walls around the grave circle to support an artificial platform; on this a new circular enclosure wall was constructed of two

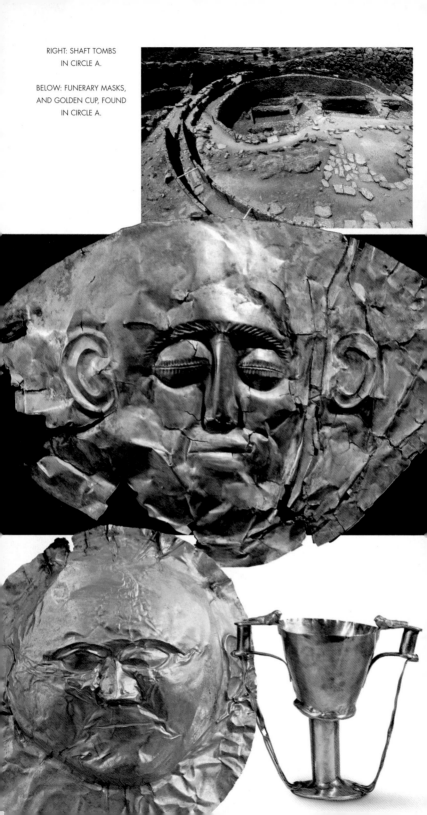

RIGHT: DETAIL OF THE RING OF THE FUNERARY CIRCLE.

BELOW: THE CIRCLE SEEN FROM THE AREA BELOW THE RAMP TO THE SOUTH.

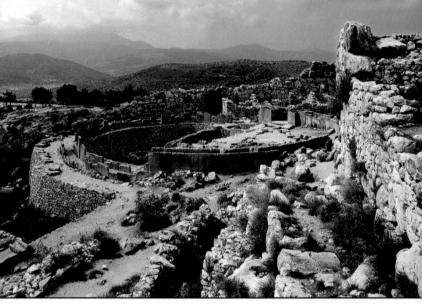

concentric rows of stone slabs planted in the ground about 4 feet apart, with the cavity between the slabs filled with small stones and covered with horizontal slabs. The positions of the ancient graves, which were left at their original level, were marked with stone stelae. Seventeen stelae have been found, 11 of which were decorated with reliefs of hunts, war scenes, or athletic games; it is therefore thought they may have been the graves of men. The large enclosure (90 feet in diameter) contained 6 shaft graves, each of which held the remains of several bodies (in total 19 people: 8 men, 9 women, and 2 children) accompanied by magnificent grave goods (now in the National Archaeological Museum, Athens). It is probable that this enclosure was reserved for members of the royal family, whereas circle B was for a cadet branch of the family. The greater importance of the individuals buried here is clear from the extraordinary quality of the grave goods and, above all, from the fact that this enclosure was later annexed to the citadel, probably because cults had grown up around the dead. Clay statuettes typical of funerary offerings that were found in the upper layers of the space indicate the existence of a cult of the ancestors.

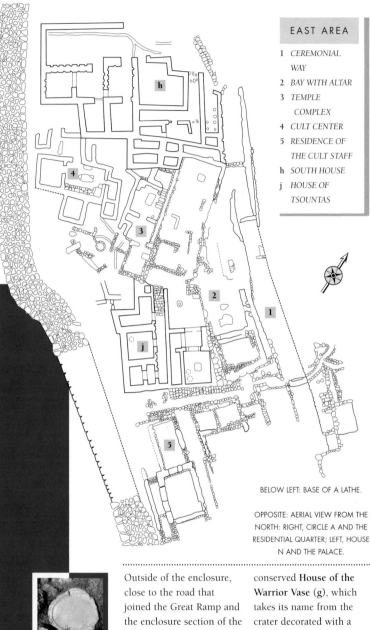

BELOW LEFT: BASE OF A LATHE.

OPPOSITE: AERIAL VIEW FROM THE
NORTH: RIGHT, CIRCLE A AND THE
RESIDENTIAL QUARTER; LEFT, HOUSE
N AND THE PALACE.

Outside of the enclosure, close to the road that joined the Great Ramp and the enclosure section of the city, is the location of the **Ramp House (f)**. Today the megaron (central hall of the house), vestibule and three small adjacent rooms (perhaps storerooms) can be seen. Five underground rooms remain in the partially conserved **House of the Warrior Vase (g)**, which takes its name from the crater decorated with a parade of armed men found on the plot. The set of buildings that stand next to the **South House (h)** has recently been identified as a **cult center (i)**. In the Mycenaean world, places of worship do not

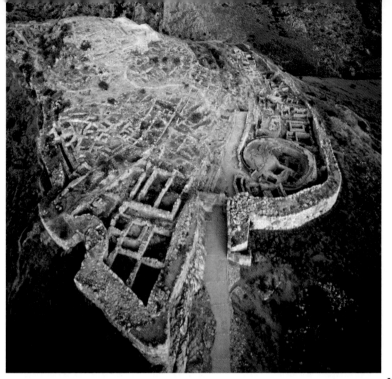

seem to have been based on any specific architectural model, with the result that they cannot be recognized so much by their layout but only by the presence of sacred objects (altar, offerings table, sacrificial stones, and so on.). On the basis of these characteristics a number of buildings previously thought to be houses have now been labeled as sacred places.

The center ran along a **ceremonial road** (1) that joined to the Great Ramp via steps and a monumental gateway. The road led to a **room** (2) that had an altar with a square base at its entrance and, inside, a horseshoe-shaped plaster hearth and a block of uncut stone.

This emerged from the earth floor by only 9 inches and was probably used for sacrifices. At the back of the room there was a small adyton.

This set of **buildings** (3) is now considered a temple. A vestibule led into a room with a rectangular hearth at the center and a series of benches at different heights along the north and northwest sides. In the small room on the north side, served by the stairway, a collection of terracotta figures was found (17 large idols, many smaller statuettes, and ten or so serpent rings), which is now in Nauplia Museum. Separated by a passage to the west there is another **cult center** (4), with a large room, a vestibule, a central hearth and a basin resting against the wall.

Part of a fresco (also in Nauplia Museum), probably of several deities, was found on the north wall.

Important fragments of frescoes that probably had: religious significance (the "Lady of Mycenae" and large bilobate shields) in Nauplia Museum come from a **building** (5) that may have been the residence of the administrators of the cult. Built against the city walls was the building referred to as the **House of Tsountas** (j).

What can be seen of the house today are its storerooms along a corridor and, at a higher level, the megaron with a square hearth at the center, and a vestibule that opens onto a courtyard.

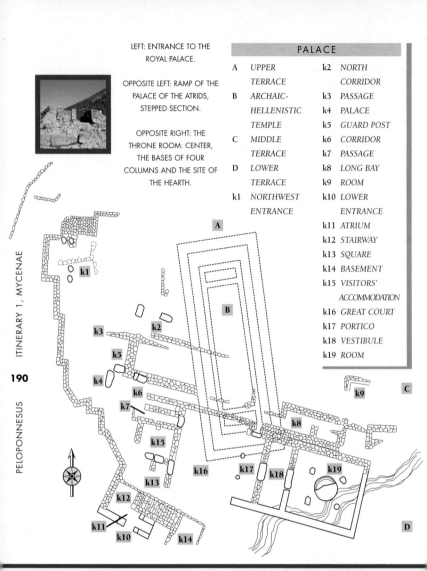

LEFT: ENTRANCE TO THE
ROYAL PALACE.

OPPOSITE LEFT: RAMP OF THE
PALACE OF THE ATRIDS,
STEPPED SECTION.

OPPOSITE RIGHT: THE
THRONE ROOM: CENTER,
THE BASES OF FOUR
COLUMNS AND THE SITE OF
THE HEARTH.

PALACE			
A	UPPER TERRACE	k2	NORTH CORRIDOR
B	ARCHAIC-HELLENISTIC TEMPLE	k3	PASSAGE
		k4	PALACE
C	MIDDLE TERRACE	k5	GUARD POST
		k6	CORRIDOR
D	LOWER TERRACE	k7	PASSAGE
		k8	LONG BAY
k1	NORTHWEST ENTRANCE	k9	ROOM
		k10	LOWER ENTRANCE
		k11	ATRIUM
		k12	STAIRWAY
		k13	SQUARE
		k14	BASEMENT
		k15	VISITORS' ACCOMMODATION
		k16	GREAT COURT
		k17	PORTICO
		k18	VESTIBULE
		k19	ROOM

Continuing along the Great Ramp you come to the **palace (k)**. This covered five vast artificial terraces supported by cyclopean walls. The buildings on the **highest level (A)** were probably the apartments of the royal family, but they have been almost completely obliterated by the **temple (B)** that was constructed in the Archaic period and rebuilt in the Hellenistic era. In the **terrace below (C)**, traces can be seen of two long corridors that connected the upper wing to the **lower terrace (D)** used for official receptions. The palace had two entrances: one on a level with the upper terrace where the northwest branch of the Great Ramp ended, and which gave access to the entire palace; the other of poorer quality, which was reserved for official visitors. It was possible to reach the rooms facing onto the **north corridor (k2)** in the highest section of the palace by passing through the **northwest entrance (k1)**—a double monostyle portico — and up steps in the northeast corner. A wide **passage (k3)** gave access to other parts of the palace. Heading south brings you to the **palace's (k4)** main entrance, which would have been protected by a **guard post (k5)**, and from here the **corridor (k6)**

on the middle terrace takes you to the domestic area and the official reception area on the lower terrace via a **passageway (k7)**. The **corridor (k6)** led to a long, **narrow room (k8)**, the function of which is uncertain. It has stone benches along the east and west walls, a hearth resting against the north wall, and unusual frescoes of curtains. The only remaining section of the domestic area of the palace is a **room (k9)** with the remains of a red stucco floor (northwest corner) and a drainage channel on the east and north sides. It was probably a bathroom, and consequently popular imagination has identified it as the place in which Agamemnon was killed. The **lower terrace (D)** led to

the palace could be reached. The oblique course of the great staircase compared to the perfectly axial layout of the nucleus of the Great Court and megaron reveals that it was a later addition, built during the final phase of the palace complex. The earlier entrance was an **open area (k14)**, partly below ground, with a central column. A small room on the north side of the square, originally with a stuccoed floor and frescoed walls, is connected on the west side to a small room that was used as a bathroom. It was probably a palace **guestroom (k15)** that, as was customary, gave no access to the royal apartments. Entrance to the **Great Court (k16)** from the east side of the square was through a

wooden columns (only the stone bases remain), plaster flooring imported from Crete, and walls decorated with the Mycenaean motif of triglyphs and rosettes. The portico led into a **vestibule (k18)** of which the floor was lined with plaster slabs and, in the central section, lined with stucco decorated with zigzags in blue, red, and yellow squares. The **room (k19)** was reached through a large opening (the threshold can still be seen). At the center lay a large hearth (11' 3" in diameter) formed by a ring of stones around a clay nucleus lined with painted stucco. The hearth area was bounded by 4 wooden columns (the stone bases remain) that supported the roof, which had an aperture to allow in air and provide

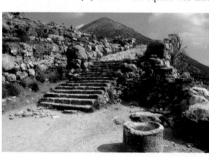
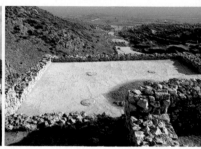

another branch of the Great Ramp that ended close to the **lower entrance (k10)**. From here, passing through an **atrium (k11)** that has benches on the north and west sides, you come to a monumental sandstone **stairway (k12)** that was originally lined with stucco. A second set of stairs, probably made of wood, led to an upper floor and a **small square (k13)** from which the reception area of

door of which only the threshold remains. The Court was a large, open yard closed on three sides by the walls of the surrounding buildings, but it was probably left open on the southwest side to provide a superb view over the Argos plain. The megaron lay off the east side, which was where the king and his court carried out their daily life. The megaron was preceded by a **portico (k17)** with two

some light. Fragments of wall frescoes can still be seen, with figures of warriors, horsemen, soldiers on chariots, and female figures in front of a palace. Probably the composition represented a battle before a fortified citadel. The throne must have been placed against the wall to the right as you enter, but this has collapsed following landslides (the eastern section has been restored).

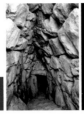

As recent excavation has shown, a number of buildings to the east of the complex were part of the palace, which was the largest royal residence in Greece during the Mycenaean age.

The **first building (l)** was organized around a courtyard lined by 2 corridors and a series of rooms. As the dross of smelted minerals containing bronze, which constituted the central section of the east wing of the palace, was damaged in a fire at the end of the 13th century BC, as was the workshop next door, but was only partially rebuilt.

A road that lies immediately to the east of this residence led to a **square (n)** faced onto by **buildings (o, p)** that were probably used as stores for the royal family's entrance, a **building (r)** may have been the residence of the superintendent of the cistern, and built against the wall was a **storeroom (s)**. Continuing along the north section of the walls, you pass the North Gate and reach a group of service buildings in the northwest corner; they are from the last phase of construction.

Building M (t) was

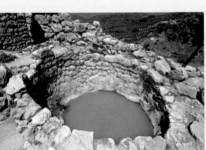

fragments of worked ivory, rock crystal, opal, green steatite, and white quartz was found in this building, it must have been the workshop where artistic pieces were produced for the king and his dignitaries. The adjacent **House of Columns (m)** was named for the large colonnaded court that formed the center of the residence and around which the rooms (including 2 megarons) and storerooms were arranged. The building, provisions and goods. They stood behind the eastern section of the walls that were extended at the end of the 13th century BC to incorporate the **underground cistern (q)**, one of the most surprising constructions in the acropolis.

Having a depth of 59 feet, it could be reached down three flights of steps and was connected to a spring roughly 300 yards from the acropolis by an underground terracotta pipe. Close by the probably the headquarters of Mycenae's military command; it was constructed over a series of corridors that led to stores for weapons and provisions within the walls themselves. The function of **Building N (u)**, however, is uncertain, though it may have been a barracks for the acropolis garrison.

In the zone below the citadel of some of the small inhabited areas have been excavatedn on the west and southwest slopes of the

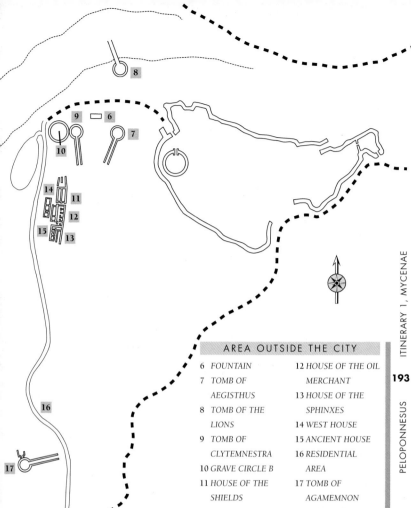

AREA OUTSIDE THE CITY	
6 *FOUNTAIN*	12 *HOUSE OF THE OIL*
7 *TOMB OF*	*MERCHANT*
AEGISTHUS	13 *HOUSE OF THE*
8 *TOMB OF THE*	*SPHINXES*
LIONS	14 *WEST HOUSE*
9 *TOMB OF*	15 *ANCIENT HOUSE*
CLYTEMNESTRA	16 *RESIDENTIAL*
10 *GRAVE CIRCLE B*	*AREA*
11 *HOUSE OF THE*	17 *TOMB OF*
SHIELDS	*AGAMEMNON*

acropolis. The houses were destroyed in a fire at the end of the 13th century BC and abandoned.

What remains of them are generally only the basements; however, their size—they originally had more than one floor—and what remains of the furnishings demonstrate the high quality of life of their inhabitants, who were merchants and craftsmen. We know these people could write as it was in these houses that the only tablets with inscriptions in Linear B have been found in Mycenae.

Among the houses, 9 royal chamber tombs have been found, which date from different chronological periods and represent the perfection of the chamber construction technique from its beginnings to its mature phase.

The tombs were looted of their grave goods in ancient times, and thus it is not possible to determine who was buried in them.

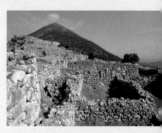

OPPOSITE BOTTOM: CISTERN (LEFT) AND WELL.

ABOVE: THE RISE OF THE PALACE SEEN FROM THE EASTERN SIDE OF THE CITADEL.

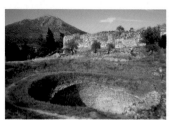

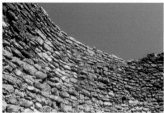

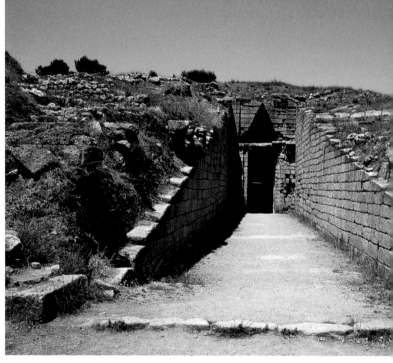

Having left the citadel and passed the foundations of a **fountain** (6) (3rd century BC) on the left, perhaps the "Fountain of Perseus" noted by Pausanias, you come to the **Tomb of Aegisthus (7)**. This is one of the earliest examples (1500–1460 BC) of the use of unfinished stone, the lack of facing on the corridor walls, and the absence of

the relieving triangle above the door lintel.

Typical features of this typology appear in the **Tomb of the Lions (8)** (1350 BC), which lies to the right of the Lion Gate, and in the **Tomb of Clytemnestra (9)**, which, with the Treasury of Atreus, represents the culmination of this type (1225 BC) of construction. Discovered by chance at the start of the 1800s, the

Tomb of Clytemnestra was looted by the Turkish governor of Nauplia who broke down the dome (today restored) to enter the tomb as the entrance corridor was impracticable. The monumental façade, which lies at the end of the corridor made of carefully cut blocks of conglomerate, was originally framed by half-columns of grooved plaster (the bases remain), lined with colored marble

theater was built over the top of it.

One row of seats from the theater can still be seen on either side of the tomb's corridor. In turn, the tomb was partly built over an enclosure of royal tombs—**circle B (10)**—which was made using large, uncut stones of different size; only a small section of the

goods such as undecorated vases. The other 14 tombs were shaft graves (first half of the 16th century BC) like those in circle A. They contained the remains of several individuals and were accompanied by high quality grave goods (today exhibited at the National Archaeological Museum, Athens).

and decorated with carved motifs (spirals, rosettes and triglyphs). In the burial chamber (44' 4" in diameter, 42' 6" in height), a large stone strip as high as the architrave forms the base of the dome; the dome itself is created by the progressive projection of the rows of stone that line the walls.

From the 3rd century BC, this tomb could no longer have been visible as a small

enclosure remains and can be seen on the north side. The circle contains 24 graves of different typology and chronology (they are identified by letters of the Greek alphabet), some of which were marked by decorated stelae.

The 10 earliest graves (end of the 16th century BC) were dug out of the earth or rock and used for inhumation. The dead were buried with modest grave

OPPOSITE TOP: *THOLOS*, WITHOUT ITS VAULT. VIEWS FROM ABOVE AND INSIDE.

ABOVE LEFT CORRIDOR AND ENTRANCE TO CLYTEMNESTRA'S *THOLOS*.

ABOVE: THE *DROMOS* OF AEGISTHUS' *THOLOS*, PARTIALLY EXCAVATED IN THE ROCK. NOTE THE MASSIVE ARCHITRAVE AND SMALL TRIANGLE TO RELIEVE THE DOWNWARD FORCE.

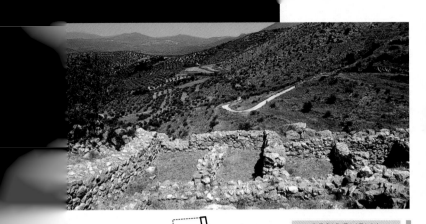

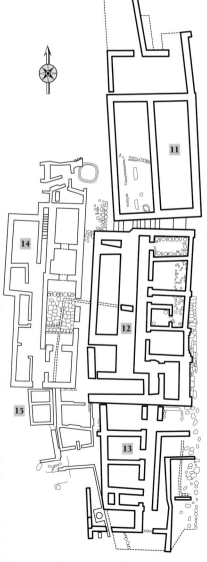

TOP AND CENTER: REMAINS OF HOUSES.

ABOVE AND 197 OPPOSITE: THE TREASURY OF ATREUS; THE DROMOS AND THE ENTRANCE.

OPPOSITE BOTTOM: FALSE DOME IN THE TREASURY OF ATREUS, SEEN FROM BELOW.

The remains of a residential area lie to the south of the funerary enclosure. The **House of the Shields (11)** has a very unusual layout and contained many fragments of finely worked ivory lions, dolphins, spirals, triglyphs, and shields in the form of a figure # 8 that were probably used to decorate furniture. In the basement smaller rooms that open onto a paved court; the discovery of Linear B tablets discussing aromas suggests that the building may have been used for making perfumes. To the south of the West House stood another **house (15)**, with a megaron, pronaos, and vestibule, which was built during the Mesohelladic period or early Mycenaean

the **residential district (16)** that was partially destroyed by an earthquake in the mid-13th century BC, stands the **Treasury of Atreus**, also called the **Tomb of Agamemnon (17)** (1250 BC), one of the masterpieces of Mycenaean architecture. The façade was originally elegantly decorated; the door was framed by 2 green marble

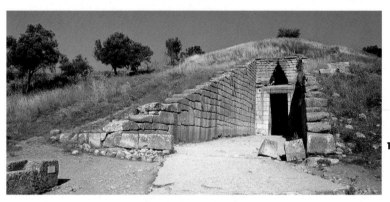

of the **House of the Oil Merchant (12)** at the northern end of the corridor were found 30 stirrup vases, perhaps used to transport the oil kept in the 11 pithoi discovered in room. The storerooms in the **House of the Sphinxes (13)** also contained numerous fragments of carved ivory, including the plaque with 2 sphinxes after which the house was named. The ivories most probably decorated the furniture, which fell from the upper floor during the fire.

Two other houses have been excavated at a higher level behind these buildings. One is the **West House (14)**, with a megaron and several

age (i.e., at the time of grave circle B). It is therefore the oldest of the known houses in Mycenae. "The carefully calculated dimensions, meticulous care, and capacity of the shaded areas, in which the light truly emanates, radiates toward the crown of the egg, as though from a tripod, together create one of the most marvelously created empty spaces known to architecture." (C. Brandi)
A little to the south, near

half-columns decorated with zigzags (of which some fragments are in the British Museum in London and the Archaeological Museum in Athens). Above the lintel, the relieving triangle was flanked by 2 half-columns and lined by polychrome marble adorned with horizontal bands of spirals and half-rosettes. The dome is created by 30 rows of blocks of stone and was decorated with metal pieces, fixed with nails (which we know from the holes). A smaller room lay on the north side of the chamber, the walls of which were originally faced with carved stone slabs. (C.T.)

NEMEA

The city in the Nemean valley that lay between the cities of Cleonae and Fliunte was the location of a famous sanctuary dedicated to Zeus, in honor of whom the Nemean Games were held every two years. The games were the fourth and last of the Panhellenic Games (the others being the Olympic, Pythian, and Isthmian Games), in which contests were held in athletics and music, as well as horse and chariot races.

THE HISTORY

The Nemean Games are believed to have been founded in 573 BC, but the tradition is much older in that games were held from the time of the expedition of the Seven against Thebes. During the journey, the seven heroes from Argos stopped in the valley to drink and came across Ophelte, the son of King Lycurgus, with his wet nurse. To show the Seven to a spring, the nurse left Ophelte on the ground, whereupon he was killed by a snake. In his honor, the Seven instituted the funerary games in which Ophelte was honored as Archemoros ("Start of Death"). To commemorate the death of Ophelte, the judges of the contests wore dark clothing and the winners were crowned with wreaths of parsley. In another version, the games were instituted in honor of Zeus *Soter* by Heracles to celebrate the slaying of the Nemean lion that lived in a cave on Mount Treto near the city. The killing of the lion— protected by Hera—was the

first of the 12 labors the hero was obliged to perform. After having shot the animal in vain with arrows and only stunned it with blows from his weapon, he strangled it in its lair, and from then on he wore its invulnerable skin (one of the hero's attributes). We know the site was used in the 7th century BC from the proto-Corinthian pottery found there, but cult activity only seems to have begun in the mid-6th century BC, with construction of the temple. After a period of abandonment following the transfer of the Nemean Games to Argos (430 BC), the sanctuary underwent another building phase in the second half of the 4th century BC (during which most of the buildings were constructed) when the Games returned to Nemea (330 BC). After another transfer to Argos in 270 BC and the unsuccessful attempt by Aratos of Sicyon to return them once more (235 BC), the site was abandoned. When Pausanias visited the site, the temple was in ruins and there were

no statues left (II, 15, 3). A small town and church were built on the ruins in the 6th century AD using materials from the temple of Zeus.

TOP: RUINS OF THE WELCOMING BUILDING *(XENON)*.

OPPOSITE TOP: BATHS ROOM.

OPPOSITE BELOW: VIEW FROM THE SOUTH. THE TEMPLE OF ZEUS CAN BE SEEN IN THE BACKGROUND.

NEMEA	
a	*ROAD*
b	*HOUSES OF THE HELLANODIKAI*
c	*XENON*
d	*BATHS*
e	*BASE OF THE DONARION*
f	*OIKÒI*
g	*TOMBSTONES*
h	*TEMPLE OF ZEUS*
i	*SACRED WOOD*

CORINTHIA

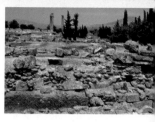

Open every day except Monday, 8 am to 2:30 pm in summer, 8 am to 3 pm in winter.

The south boundary of the sanctuary is marked by a **road (a)** along which **houses (b)** from the late 4th–mid-3rd centuries BC were inhabited by the *Hallanodikoi*, the priests who judged the races in the Games. On the other side of the road stood the **Xenon (c)**, a building from the second half of the 4th

century BC that offered accommodation to visitors. An early Christian basilica with 3 aisles, a narthex, and baptistery was later partially built over the Xenon. Constructed at the same time as the Xenon, the **baths (d)** had two large square sections. Continuing in the direction of the temple you come to the round **base for offerings (e)**, built in the second quarter of the 5th century BC with blocks from an earlier monument. You also see the foundations of 9

oikòi (**houses**) **(f)** (first half of the 5th century BC, rebuilt at the end of the 4th century BC), with a colonnaded façade, a kitchen, and banquet room. It probably had a similar function to the treasury rooms seen in Hellenic sanctuaries.

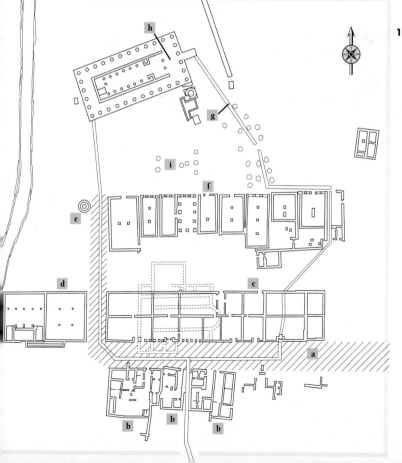

The sacred area (Epipola, "flat zone") was marked by **cippi (tombstones)(g)**; the **temple of Zeus (h)** stood at the center of the **sacred wood (i)** of cypress trees where, according to tradition, Ophelte was the back of the naos, 4 columns parallel to the wall marked out a sort of adyton with a crypt that was probably used by the oracle. The foundations of the south side of the earlier Archaic temple can be seen and many votive offerings (today in the local museum) were found, suggesting that this was the site of the *heròon* of Ophelte, where Pausanias (II, 15, 3) saw the tombs of the hero and his father

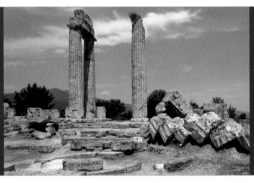

killed by a snake. Remains of the wood have been found in the area to the southeast of the building and study of the traces left by the roots has dated it to the 5th–4th century BC, but we know an earlier wood existed there as it was recorded by Pindar. The peripteral building (330–320 BC) had 6 x 12 Doric columns and was approached up a ramp. It was necessary to pass through a two-column pronaos (that had no opisthodomus) to reach the naos, which was divided into 3 aisles by 2 rows of columns in 2 orders (Corinthian and Ionic). At on the west side of the crypt. A very long altar stood in front of the temple. The Archaic, northern part (4th century BC), was lengthened in a southerly direction and covered by a sort of canopy to celebrate sacrifices in honor of the hero Ophelte. The bases for 2 statues, perhaps dedicated to Zeus and Ophelte, still stand to the south of the altar.

Beyond the river there is a trapezoidal enclosure built at the start of the Hellenistic era over an earlier building (second half of the 4th century) with a plan of the same shape. Inside the enclosure, small stone altars Lycurgus. Returning toward the museum on the paved road to the east, the stadium was built in the late 4th century BC, and it is probable that the original Archaic stadium was constructed close to the temple of Zeus. It was 600 Greek feet in length (195 yards) and had a track lined with clay; at the sides there are still the blocks that marked the distance every 100 feet between the *aphesis* (start line) and finish line. The depressions for the athletes' feet on the start line and the holes for the stakes that divided the track into 13 lanes also remain. The judges' platform stood

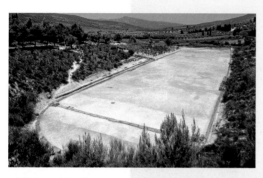

LEFT: THE STADIUM OF NEMEA.

BELOW: THE ENTRANCE TUNNEL TO THE STADIUM.

BOTTOM: THE ENTRANCE TUNNEL TO THE STADIUM, ON THE OUTER SIDE OF THE STADIUM.

on the east side, whereas a vaulted gallery built in 320 BC on the west side joined the Via Sacra with the stadium. The tunnel is marked with many examples of graffiti left by athletes as they passed through it to the racetrack.

THE MUSEUM

The museum exhibits finds made during excavation and architectural elements from the temple of Zeus. (C.T.)

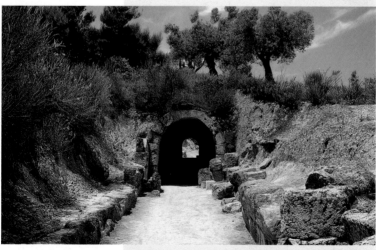

OPPOSITE LEFT: THE THREE SURVIVING COLUMNS IN THE TEMPLE OF ZEUS.

OPPOSITE: RIGHT BLOCKS OF TEMPLE COLUMNS.

ARGOS

Argos, part of which stood in the zone occupied by the modern city, was considered by the Greeks to be the most ancient city in Hellas. The area has a rise (the Làrisa, today referred to as the Kastro) on which the acropolis was built, and the hill of the Prophet Elijah that used to be known as the ancient Aspìs (shield), both of which are separate from the Deiras (mountain ridge).

THE HISTORY

The site of an important Mesohelladic settlement (on the Aspìs), and of a Mycenaean town (on the Làrisa, with a necropolis on the Deiras), Argos began to play an important role among the plain communities from the era of the Geometric style. From the 7th century BC on, its political history was marked by constant military opposition to Sparta, which was only interrupted by short periods of truce. In 450 BC, the signing of a peace treaty with the Laconian city and a closer relationship with Athens (whose influence resulted in a change from a monarchic to democratic regime) led to the construction of a monumental agora (the political and religious center of the city). Pausanias describes the prosperity of Argos under Roman domination, but the city was later violently sacked twice by the Herulians (267 AD) and the Goths (395 AD).

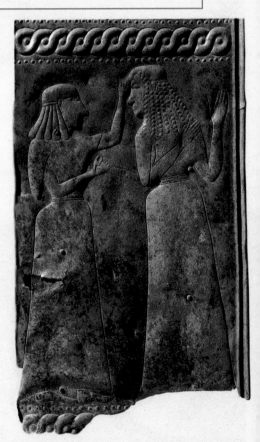

TOP: DETAIL OF A LATE GEOMETRIC CRATER IN THE MUSEUM.

ABOVE: CLYTEMNESTRA KILLING CASSANDRA, ENGRAVED AND EMBOSSED BRONZE ARCHAIC PLAQUE.

OPPOSITE TOP: HEAD OF HERA, FROM THE SANCTUARY.

OPPOSITE BOTTOM: HERCULES OF ARGOS, ROMAN COPY OF THE ORIGINAL BY LYSIPPUS.

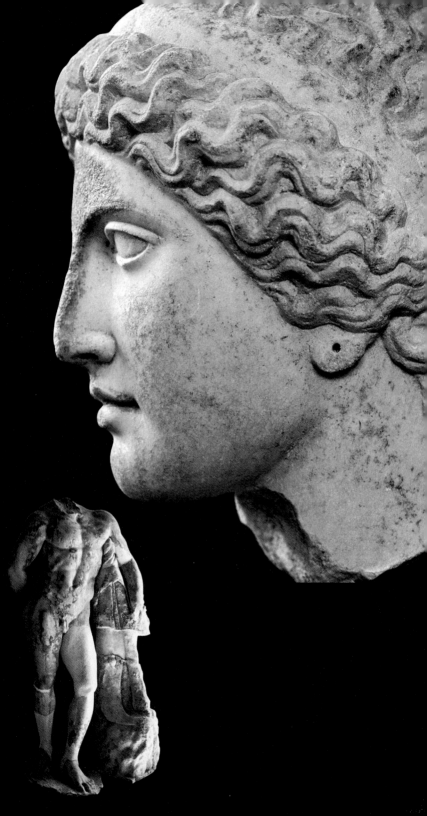

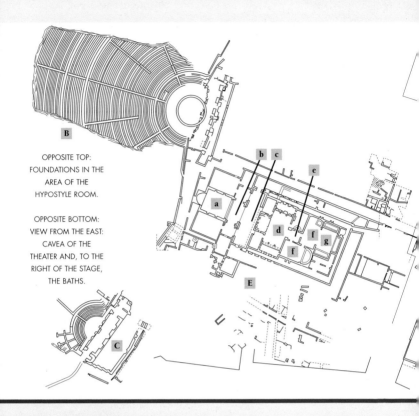

B

OPPOSITE TOP:
FOUNDATIONS IN THE
AREA OF THE
HYPOSTYLE ROOM.

OPPOSITE BOTTOM:
VIEW FROM THE EAST:
CAVEA OF THE
THEATER AND, TO THE
RIGHT OF THE STAGE,
THE BATHS.

C

E

VISIT

The presence of the modern city has prevented wide-scale excavation and allowed only limited research on a site that is archaeologically very complex—it has been inhabited continuously since prehistoric times. The largest monumental remains can be seen in the theater district (100 yards from the main square) and in the agora (where the road to Tripolis leaves the city).

Several authors have commented on the layout of the agora: Thucydides, Sophocles, Strabo, and, most important, Pausanias, who left us a long and detailed

description (II, 5, 19, 3–23,). However, our knowledge of the topography of the area, in which there were many monuments (Paunsanias' *Description* names 18 temples alone!), is only fragmentary. The agora extended in the plain as far as the foot of the Làrisa and its southeastern offshoots known as the Prôn (promontory), which was recorded in the sources as the steep place where the inhabitants of Argos gathered for political and judicial assemblies. This was the site where, about 460

BC, a theater was built with rectilinear tiers cut out of the rock. It was the city's first theater and also used as the meeting place for the people's assembly in the democratic city. The ruins can still be seen in the upper part of the seating section of the Roman odeon. To the south of the theater stood the temple of Aphrodite (430–420 BC), built with a naos and pronaos. The foundations incorporated the bottom section of two walls that had belonged to a small building constructed at the end of the 7th century BC.

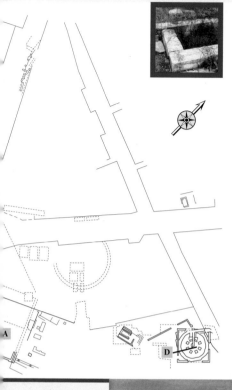

Licius (wolf-killer), which played an important political role as the place where the city's public documents were displayed. The temple has not been identified, but the presence of stone blocks from a portico and altar in the late walls of the hypostyle room and numerous inscriptions that mention the sanctuary of Apollo in which they were exhibited, suggest that it must have stood to the west of the room on a terrace of which, at present, only the east and west limits have been excavated. The sanctuary of Apollo was paired in the center of the square by the tèmenos of Zeus, inside which, besides the sanctuary of Zeus Nemeo, stood a functionally

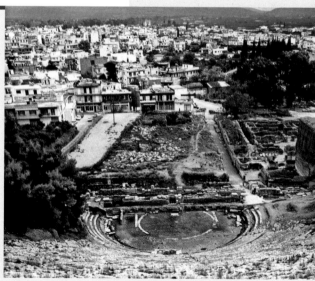

ARGOS

a ENTRANCE ROOM
b TRANSVERSAL CORRIDOR
c CHANGING ROOM
d COLD BATHS ROOM
e CORRIDOR
f, g HOT BATHS
A HYPOSTYLE ROOM
B THEATER
C ODEON
D THOLOS
E BATHS A

In front of this building, an altar was built in the second half of the 6th century, of which the base of the foundation can still be seen. The sanctuary remained in use until the end of the 4th century AD when it was destroyed and plundered of its construction materials. The nucleus of the agora was the sanctuary of Apollo unitary group of buildings. These were the **hypostyle room** (A), the south portico with gymnasium-palaestra, the dromos, the orchestra, and the nymphaeum. The

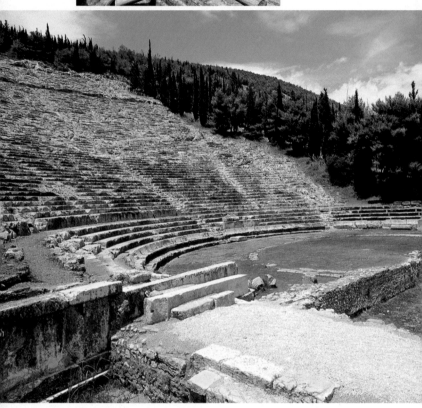

presence of these buildings can be linked to the games instituted (according to tradition) by Danaus, king of Argos, for the suitors of his fifty daughters, the Danaïds. The young girls of Argos were present at the games and formed a chorus in the orchestra (the space used by the chorus dancers), which lay immediately next to the start line of the dromos (the race track roughly 200 yards long). The nymphaeum,

which was, the fountain used for ritual bathing (the buildings that still stand are from the Roman era but are built over an earlier one), was an essential feature of life for both young athletes and young girls waiting to be married. The dromos was the square hypostyle room divided into three aisles by two rows of columns, which, in all probability, was the monument that

commemorated Danaus. At the start of the 3rd century BC a **theater (B)** was built, used for dramatic contests during the Nemean Games and for political meetings. The central section of the koilon (81 tiers) was cut out of the rock, while the wings were built on top of earthworks. Only the foundations remain of the original stage building; as it was rebuilt in the 2nd

ABOVE: BASE OF COLUMN IN THE BATHS.

BELOW: GALLERY THAT CONNECTED THE BATHS TO THE THEATER (VISIBLE BEHIND).

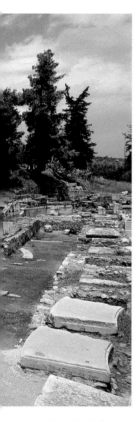

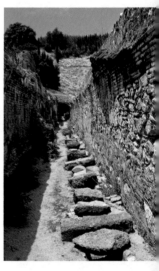

perimeter wall but was enlarged in the second half of the 3rd century by a dual system of radial rooms. The stage had three niches originally lined with marble slabs, of which many fragments have been found. The orchestra, the access corridors, and the corridors of the cavea were richly decorated with polychrome mosaics. A Serapeion (a temple or shrine to Srapis) was built to the east of the theater, which was transformed into public baths (baths A) at the start of the 2nd century AD and was restored after it was pillaged by the barbarians. The splendor of the site is still apparent, even if the buildings have lost their magnificent polychrome marble decoration, floor mosaics, painted stucco vaults, and many statues. A monumental nymphaeum with two pools and a vault on the slopes of the Làrisa marked the point of arrival of the aqueduct built by Emperor Hadrian. In the second half of the 2nd century AD, the palaestra connected to the south portico was also turned into baths (baths B). The portico was extended as far as the hypostyle room and shops were set up in the new section. The transformation

century AD using hollow bricks and marble facings, with the front of the stage adorned with niches. During the Roman age, there was a progressive transformation of the square that led to a radical change in its use. In the first half of the 2nd century AD the **odeon (C)** was built over the rectilinear theater for musical performances; the seating was initially enclosed by a rectangular

of the ancient religious heart of the agora into a market was concluded with the construction of a square fountain near the start line of the dromos, which indicates that the racetrack was no longer used. In the same period, the remaining two structures in the ancient agora were also modified: these were the orchestra, which was turned into a pool, and the nymphaeum, which became a simple monumental fountain.

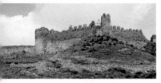

THE HILL OF THE LÀRISA

The top of the hill of the **Làrisa (A)** hosts a fort that was built in the 10th century AD using materials from the fortifications from the 6th and 5th centuries BC (in particular on the north and northeast sides). Later work was undertaken by the French overlords (corner towers), Venetians (south and southwest bastions), and the Turks. The elliptical outer **walls (a)** enclose a hexagonal **fort (b)**, inside which lie the foundations of two temples dedicated, according to Pausanias, to Zeus Larisaios and Athena Poliàs.

ABOVE AND BELOW: MEDIEVAL FORTIFICATIONS ON LARISA HILL, NORTHEAST AND SOUTH SIDES.

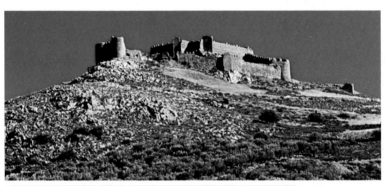

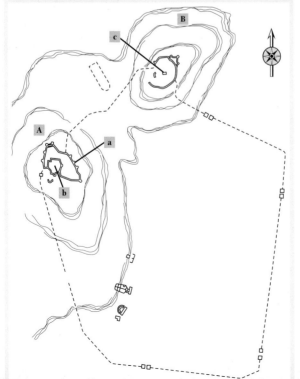

OPPOSITE LEFT: LATE GEOMETRIC CRATER.

OPPOSITE RIGHT: HELMET WITH CREST, LATE GEOMETRIC AGE.

LARISA AND PROPHET ELIJAH

A *LARISA*
B *PROPHET ELIJAH*
a *EXTERNAL WALLS*
b *HEXAGONAL FORT*
c *POLYGONAL BLOCK FORTIFICATIONS (SIXTH CENTURY BC)*

THE HILL OF THE PROPHET ELIJAH

The ruins of polygonal fortifications (4th century BC) can be seen on top of the hill of the **Prophet Elijah (B)**, with towers where the fortifications meet the city walls. According to Pausanias, the hill was the site of the temple of Hera Akràia ("of the hill") and sanctuaries dedicated to Apollo Pythios (meaning "of Pytho") and Athena Oxyderkés ("with sharp eyesight"), over which

an early Christian basilica was partly built (5th century AD). The sanctuary of Apollo covered two terraces on the western slopes of the hill. On the lower terrace a large altar, originally lined with marble, can be seen cut out of the rock, as well as traces of bases used for votive offerings; on the north side are ruins of a porticoed building that was probably a propylaeum. Behind this, a

large flight of steps cut in the rock led to the second terrace where there stood the temple (destroyed to build the church) and the oracle (a square construction made from brick on a stone plinth). To the east there were two more terraces, probably those of the sanctuary of Athena, where remains exist of a building demolished for the construction of a hypostyle cistern and a thòlos.

THE MUSEUM

The museum is close to the church, 100 yards from the main square, in Vas. Olga Street. It is open from 8:30 am to 3 pm every day except Monday. Payment required.

The room to the right of the entrance hall displays objects found in the city in chronological order from the Middle Helladic and Recent Helladic eras, the Geometric Age and Archaic Age. They are mostly ceramics, of which Argos was an important center of production (note the large **Geometric Age vases**). In the center of the room stands the **armor** found in a

tomb east of the odeon; made at the end of the 8th century BC, it is composed of a shell in two parts, and a helmet with side protections. The rest of the goods (in particular two iron firedogs in the shape of warships) are in window no. 8. Also on the ground floor are Roman era sculptures from Baths A. Finds from Lerna are displayed in the "Kallergeion" room.

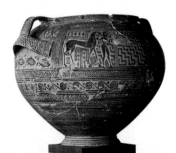

THE HERAION

The sanctuary dedicated to Hera is one of the most ancient and famous places of worship in the Greek world. It stands nearly 6 miles east of Argos on the slopes of Mount Euboea.

VISIT

Open from 8:30 am to 3 pm every day except Monday. Free.

A monumental flight of **steps (a)** leads to the **lower terrace (A)**, which is supported on three sides by a solid wall. The wall is in the form of steps where

420 and 410 BC, but little remains. The temple was in peripteral Doric style (6 x 12 columns) and was made from local stone. It had roof tiles and decorative sculptures made from Paros marble. It had a pronaos and opisthodomus *in antis* and a three-aisle naos.

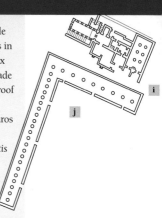

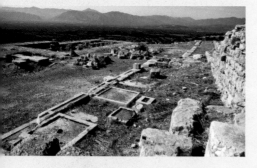

ABOVE AND OPPOSITE: DORIC COLUMNS IN THE PORTICO TO THE SOUTH OF THE TEMPLE.

LEFT: THE FOUNDATIONS OF THE TEMPLE OF HERA SEEN FROM THE PORT.

worshipers could watch as the procession arrived from Argos guided by the high priestess of Hera. Seated on a cart drawn by oxen, she went before the one hundred animals destined for sacrifice. At the top of the steps on the left, there was a **portico (b)** with 19 Doric columns at the front and 9 Ionic columns inside. The terrace of the **temple (c)** lay to the right. The temple was built by the Argive architect EUPOLEMUS between

The pediments were decorated with the birth of Zeus (on the east side), and the taking of Troy (west), and the metopes featured a gigantomachy and an amazonomachy. The clear influence of Attic architecture, as represented by the Parthenon, was the result of the political alliance created by Argos with Athens in opposition to Sparta. The naos housed the gold and ivory statue of Hera enthroned (420–417

BC) by the Argive sculptor POLYCLITUS. Hera is portrayed wearing a crown and holding a scepter and pomegranate in her hands. At her side was another chryselephantine statue of Hebe by the sculptor NAUCIDES, the brother of POLYCLITUS. In addition there were also two very ancient images of the goddess, one perhaps belonging to the old temple, the other a pear-wood image (*xoànon*) that the Argives had removed from the temple of

Hera when the city of Tiryns was destroyed.

The **katagògeion (d)** (the official banquet room) lay to the west of the temple with a large peristyle court on the north side of which there were three rooms with brick klinai built against the walls. Behind the banquet room, but on a lower level, stood

supported by a large wall built at the end of the 8th century BC with conglomerate blocks. The remains of two **porticoes (g)** are visible at the foot of the terrace; they were built in the late 7th to early 6th centuries BC (a smaller one to the east and a much larger one to the west) between which the access

activities ocurred and probably led to the transfer of the festivities in honor of Hera to Argos. During the Roman era, the sanctuary once more came to prominence when **baths (i)** and a **gymnasium (j)** were built for users of the temple on the western side of the area. (C.T.)

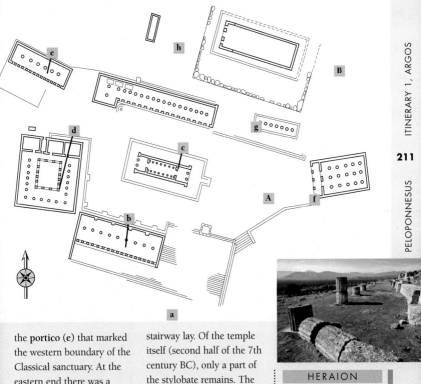

the **portico (e)** that marked the western boundary of the Classical sanctuary. At the eastern end there was a **rectangular building (f)** divided into three aisles by columns and with a portico in front. The function of the building is unknown, but it may have been used for ceremonies related to the mysteries (Telestèrion). The oldest section of the set of buildings is on the **upper terrace (B)**; it is partly cut out of the rock and partly

stairway lay. Of the temple itself (second half of the 7th century BC), only a part of the stylobate remains. The temple was peripteral with a very long plan (6 x 14 wooden columns), with a pronaos and opisthodomus *in antis*, but it was destroyed in a fire resulting from the negligence of the priestess Chryseid. The remains of the **altar (h)** lie behind the building; it was built during the Hellenistic era, but a decline in cult

HERAION

A	UPPER TERRACE
B	LOWER TERRACE
a	STAIRWAY
b	PORTICO
c	TEMPLE
d	KATAGOGEION
e	PORTICO
f	TELESTERION (?)
g	PORTICOES
h	ALTAR
i	BATHS
j	GYMNASIUM

TIRYNS

Tiryns used to stand to the southeast of the plain of Argos on a low rocky spur that sloped down from south to north. In ancient times the town was close to the sea, and it was an entry port for maritime goods.

THE HISTORY

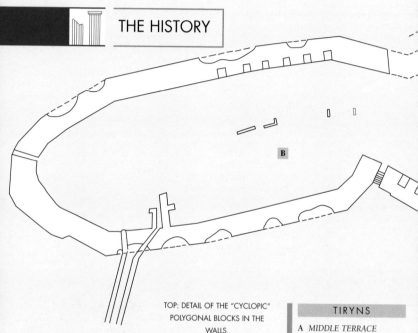

B

TOP: DETAIL OF THE "CYCLOPIC" POLYGONAL BLOCKS IN THE WALLS.

TIRYNS	
A	MIDDLE TERRACE
B	LOWER TERRACE
a	RAMP
b	ENTRANCE
c	EAST ENTRANCE
d	ENTRANCE
e, h, p	COURTYARD
f	CASEMATE
g	LARGE PROPYLAEUM
i	SOUTH BASTION
j	PROPYLAEUM
k	GUARD UNIT
l	LARGE COURTYARD
m	MEGARON
n	BATHROOM
o	CORRIDORS
q	SMALL MEGARON
r	MEGARON APARTMENT

The earliest vestiges of the settlement have been found beneath the palace megaron and date to the early Bronze Age (2500 BC). They are the remains of a large round, two-story building (92 feet in diameter) with a tiled roof. It was probably a granary for the people who owned large houses on the lower terrace.

Little information is available for the Mesohelladic era, when a very simple village occupied the hilltop, but we know there was a palatial residence there during the early stages of the Late Helladic period. A palace (of which walls and fragments of frescoes remain) and the defensive walls were built: c. 1400 BC A century later, the latter were extended to include the middle terrace. In the mid-13th century BC, the palace was destroyed by a fire and

replaced by a new and more imposing building; at the same time, the walls were further expanded to enclose the lower terrace. Tiryns was destroyed at the end of the 12th century BC but it was not completely abandoned. During the Geometric Age a temple was built over the site of the large megaron, and like Mycenae, the city sent a contingent of men to fight under Leonidas against the Persians in 479 BC. However, after the sacking of the city by the Argives in 468 BC, the inhabitants moved to Halieis on the coast of the Argolis peninsula.

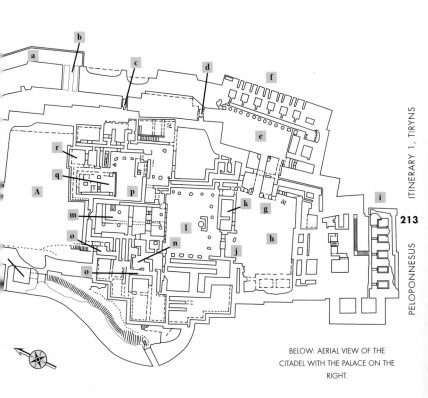

BELOW: AERIAL VIEW OF THE CITADEL WITH THE PALACE ON THE RIGHT.

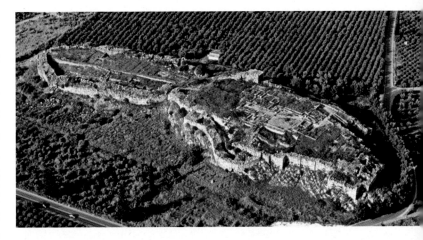

Open every day from 8 am to 5 pm in winter, and 8 am to 8 pm in summer.

The legend is that the walls were raised by seven Cyclops that Proetus, the founder of the city, invited especially from Lycia, and who were later asked by Perseus to build the fortifications of Mycenae. Tiryns' fame has remained linked to its walls ever since: Homer called it the "wall-girt city," Euripides described it as "the

the palace. The entrance was on the east side where the large propylaeum of the next palace was built. The subsequent enlargement of the walls, with the construction of a long wall to the north and east, permitted the enclosure of the **middle terrace (A)**, which was probably the location of craftsmen's workshops and storehouses. At the same time, the **south rampart (i)** was strengthened and the east entrance was given a

broad flight of stone steps led to a small passageway and exit in the walls that, in the event of a siege, assured the inhabitants of Tiryns of water supplies from a stream nearby and allowed soldiers to make sorties against the enemy. However, if the enemy attempted to enter the city through the passageway, they would find themselves exposed on all sides to the defenders' fire; they reached the top of the steps, they would fall into the deep shaft that lay at the

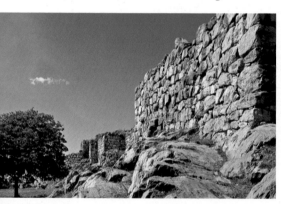

cyclopean city," and in the 2nd century AD, Pausanias recounted that its walls were more admired than the Pyramids of Egypt.
Built using the cyclopean technique with gigantic blocks carefully arranged in horizontal rows, the walls are massive, varying from 14' 8" to 57' 3" in thickness and with a standard height of 24' 7" (originally 42' 8"). The length of the perimeter is just under 800 yards. The first wall enclosed only

narrow passageway between 2 long bastions. Shortly before 1200 BC, the **lower terrace (B)** was also enclosed by walls, and the **east entrance (c)** was redesigned to match the layout of the Lion Gate in Mycenae, thereby making it unassailable. On the west side in front of the wall, a solid curving rampart and tower were built that comprise one of the most impressive defensive structures of that period. A

foot of the tower. The southeastern and southern **sections** of the walls were also strengthened.
The **lower terrace (B)** could be reached via the approach ramp down a narrow passageway. Two additional secret doorways and two passages in the walls led to galleries that were used as water cisterns.
Excavations are underway on this terrace to reveal the ruins of the residential area.

THE PALACE

A large **ramp (a)** led to an **opening (b)** in the outer wall from where a narrow corridor (that ran between the third-phase wall on the left and the second-phase wall on the right) led northward to the acropolis's **main gate (c)**. After passing over the threshold of the previous **entrance (d)**, you enter a **courtyard (e)** flanked on the east side by a portico. In the walls beneath this there is a small corbel-vaulted gallery that communicates with several **square casemates (f)**. This arrangement is one of the most characteristic features of Tiryns' last period. Passing through the **porticoed propylaeum (g)**, you come into another **court (h)** that is closed off to the south by a **fortified rampart (i)** built in several stages. During the city's last phase a gallery was built in the wall (here 56 feet thick), which can be reached by ladder, and which led to a number of small storerooms. On the north side another propylaeum **(j)**, similar to the previous one but smaller, was flanked by two rooms that were perhaps used by the **guard unit (k)**. From here one reached the **large court (l)** that was lined on three sides by porticoes and formed the center of the palace area. On the north side lay the large **megaron (m)**, laid out in the customary manner. From the two-columned

portico, 3 doors opened into the vestibule whose walls were frescoed and lined with an alabaster baseboard decorated with half-rosettes and triglyphs (now in the National Archaeological Museum, Athens). A door in the vestibule led into the throne room, in which the throne stood against the right-hand wall with a square hearth in the center. The floor was lined with painted stucco decorated with octopi and dolphins in rectangles. The wall, which cuts down the length of the room, originally belonged to the

temple of Hera that had been built in the Geometric Age over the ruins of the palace and which was destroyed by the Argives in 468 BC. The nucleus of the private apartments near the western section of the walls was connected to both the porticoed court and the megaron's vestibule. One of the rooms in this nucleus was a small **bathroom (n)**, the floor of which is lined with a single stone slab that

weighs more than 20 tons. It is inclined so that water flows away through an opening in the wall to an underground conduit. Fragments of a terracotta vase painted with spiral motifs were found in this bathroom.

The **corridor (o)** that separated this nucleus from the rooms built against the west rampart continued behind the large megaron to reach another **court (p)** on which a **small megaron (q)** faced. The **corridor (o)** gave access to a **megaron-type apartment (r)**. Only a few fragments of the original wall paintings

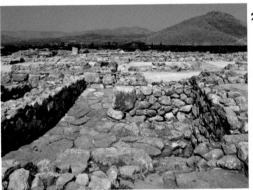

remain: dogs chasing a wounded boar, female figures on a chariot and in procession, and male figures with spears, all of which can now be seen in the National Archaeological Museum, Athens. (C.T.)

OPPOSITE LEFT: OUTER RING OF THE WALLS.

OPPOSITE RIGHT: SOUTH SIDE OF THE BASTION.

ABOVE: MIDDLE TERRACE AND RUINS OF HOUSES.

3.1

NAUPLIA

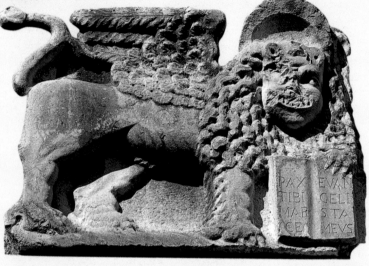

Modern Nauplia is a small port with Venetian and Turkish influences. It lies at the feet of Mount Palamid and the rocky peninsula of Itsh Kaleh (Acronauplia) on the east coast of the Gulf of Argolis. At one time the peninsula was linked to the mainland by an isthmus. Very little remains of the ancient settlement, which according to tradition, was founded by Nauplius (son of Poseidon and Amimone), who came to Argolis from Euboea, and he fortified the city with cyclopean walls. His descendant was Palamid, who is remembered as a great inventor; one of his achievements was to entertain his companions with games he made up during the long siege beneath the walls of Troy. There is little recorded history of Nauplia, which, fell to Argos in 628 BC and became its port. In the 7th century BC, it was a member of the league of Greek cities that participated in the cult of Poseidon on the island of Calauria. In the 3rd century BC, the summit of Acronauplia was fortified. The city was abandoned in the Roman era: Pausanias (II, 38, 2) mentions only the ruins of its walls, ports, and sanctuary of Neptune. The Byzantines occupied it the 5th century and rebuilt the fortifications on Acronauplia over the foundations of the Hellenistic constructions, creating the Castle of the Greeks. Next to this stood the fort built by the Franks (1210–1377) and, later, the fort built by the Venetians (Castel Toro). In 1450 the Venetians also built the lower city to accommodate the refugees from Chalcis, which had been conquered by the Turks. Ceded to the Turks in 1540, Nauplia was retaken in 1686 by Francesco Morosini after a month-long siege and became the capital of Venice's eastern possessions, with the name Napoli di Romania. During the second phase of their occupation, the Venetians built a rectangular rampart (Baluardo Grimani) to link Acronauplia to the city

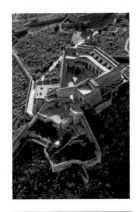

walls and to the approach to Mt. Palamid. They also built an imposing fortress of eight communicating forts surrounded by defensive walls on Mt. Palamid. Retaken by the Turks in 1715 after a long siege followed by massacres and looting, Nauplia was liberated in 1822 and made the first capital of the newly independent state of Greece. It held this role until 1833.

OPPOSITE TOP: VENETIAN FORT ON THE ISLAND OF BOURZI.

OPPOSITE BOTTOM: SAINT MARK'S LION; MARBLE RELIEF IN ACRONAUPLIA FORT.

LEFT TOP: AERIAL VIEW OF MOUNT PALAMIS, WITH ONE OF THE EIGHT REDOUBTS OF THE FORT.

THE MUSEUM

Plateia Sintagma. Open every day except Monday from 8 am to 2:30 pm. Payment required.

The museum is located in a section of the military arsenal that dates to the period of the second Venetian domination (1713). Its collections are of finds from the main sites in the region (Mycenae, Tiryns, Asine, and Midea), especially pottery.
First floor: Neolithic items from the grotto of Franchthi, pottery and stele from the tombs in grave circle B in Mycenae, idols and fragments of frescoes

from the 13th-century BC cult center in Mycenae, fragments of frescoes from the palace in Tiryns, and bronze objects from tombs in Midea, including 15th-century BC **bronze armor**—a rare example of a complete suit, with leg guards, and a reconstructed leather helmet decorated with boars' teeth.
Second floor: collections from the proto-Geometric to Hellenistic Ages. (C.T.)

BELOW LEATHER HELMET REINFORCED WITH BONE AND ARMOR, MYCENAEAN ERA.

217

PELOPONNESUS

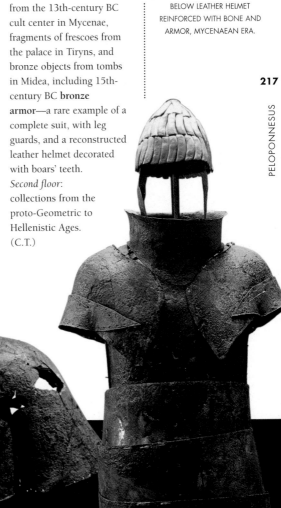

3.1

EPIDAURUS

The ancient city stood on the Akté peninsula (today Nisi) in the Epidaurus gulf to the southeast of the modern village of Paléia Epidavros. The sanctuary of Asclepius was built 6 miles southwest of the city in a valley surrounded by mountains and streams.

218 TOP DECORATION ON THE CEILING OF THE *THOLOS*.

219 *EPION HOLDING A GOOSE*, ATTRIBUTED TO TIMOTHY.

THE MYTH

Asclepius was a god whose cult originated in Thessaly. He was the son of Apollo and the nymph Coronis, but Apollo killed **218** his mother for her infidelity. Removed from the maternal womb before Coronis was cremated, Asclepius was entrusted to the centaur Chiron, who instructed the boy in medicine. Asclepius became a skilled healer and dared to bring the dead back to life; for this, Zeus struck him with a thunderbolt, but Asclepius was able to rise to join the gods on Olympus. According to Pausanias, Asclepius was weaned by a she-goat at Epidaurus and protected by a dog.

THE HISTORY

From very ancient times, Mount Kynortion was the location of the cult of Maleàs, who was a pre-Greek hero and god connected with the celebration of spring festivals for the rebirth of nature. About the mid-7th century BC, the cult was assimilated to that of Apollo, given the epithet *Maleàtas* and associated with an oracle.
The cult of Asclepius existed from the end of the 6th century BC, though Asclepius himself was known in Greece at the end of the 2nd millennium BC. It was during that period that the earliest known dedications were made to the god of healing; these were found on a terrace northwest of the sanctuary of Apollo *Maleàtas,* where a building (building E), associated with worship and healing, formed the original nucleus of the temple of Asclepius. The serious outbreak of the plague during the Peloponnesus War (429 BC) was probably decisive for the diffusion of the cult, which spread to all the Greek cities and acquired enormous prestige internationally. In the 4th century BC, the sanctuary became one of the most important sacred places in the Greek world, and it underwent intense building activity starting in 380 BC, when the temple was constructed. Other cult and service buildings continued to be constructed throughout the rest of the century. The sanctuary was also of great importance during the Roman era, but with the closure of pagan cults ordered by Emperor Theodosius in 395 BC, it was abandoned. Thereafter it was used to provide building materials for the church to the east of the north propylaeum (in which therapeutic cures continued to be practiced).

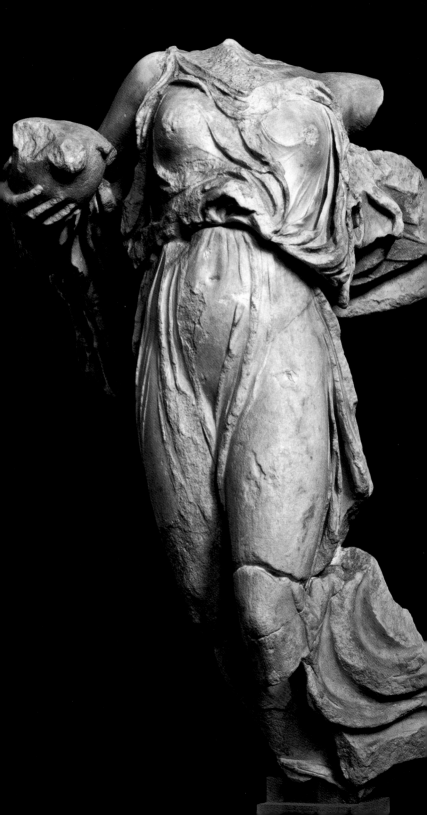

EPIDAURUS

VISIT

*Open every day from 8 am
to 6 pm in winter and 8 am
to 8 pm in summer.
Payment required.*

The current entrance leads
to the south part of the site
where the **theater** (a) stands
on Mount Kynortion.
Pausanias (II, 27, 5) praised
its harmony and beauty and
attributed its construction to
POLYCLITUS THE YOUNGER,

220

who also designed the
thòlos. The building is from
the mid-4th century and
could seat a total of 12,000
spectators. Moving toward
the center of the sanctuary,
you find the **Katagògeion**
(b), which offered
accommodation to pilgrims
(early 3rd century BC). It is
formed by four symmetrical

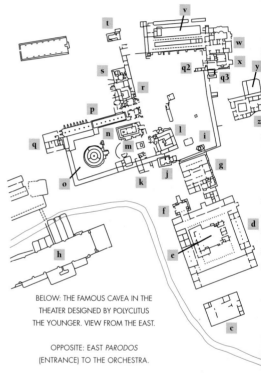

BELOW: THE FAMOUS CAVEA IN THE
THEATER DESIGNED BY POLYCLITUS
THE YOUNGER. VIEW FROM THE EAST.

OPPOSITE: EAST *PARODOS*
(ENTRANCE) TO THE ORCHESTRA.

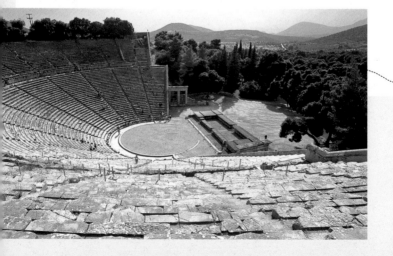

sections with independent entrances but which intercommunicate via corridors and a courtyard. Beyond the ruins of a Greek **bath (c)** stood a square building with internal Doric peristyle and hypostyle rooms along the sides (late 4th—early 3rd centuries BC); this is usually referred to as the **Gymnasium (d)**. It may in reality have been used for cult banquets, as is indicated by the discovery of stone supports for the klinai (banqueting beds) in the colonnaded rooms on the east and south sides. Cult use of the building would explain the transformation during the Roman era of the central peristyle, in which an **odeon (e)** was built with curved steps in rectilinear walls. The odeon may have been used for mystery-related performances that were previously given in the peristyle. On the north side of the site the remains of a late 4th-century BC **propylaeum (f)** can be seen that was originally used as the south entrance to the temple. During the Roman period it was connected to the banqueting room, probably to provide the latter with an impressive link to the sacred area. When the odeon was built, the building lost its function and was turned into a small temple dedicated to Hygeia. In addition, a **palaestra (g)** was built on the north side with a large central room divided into three aisles and flanked to the east and west by smaller rooms. To the west of these structures was the **stadium (h)**, built in the second half of the 4th century BC but probably over a similar earlier structure. It was connected with the gymnasium by a vaulted passage. Four-sided (overall measurements 643 x 144 feet, with the track 594 x 98 feet) without curved ends, it was ringed by stone seats on all sides. To the right of the sanctuary entrance lie the ruins of an unusual construction referred to as the **Temple of Themis (i)** (end of the 4th century BC). It was in fact a roofless rectangular enclosure divided into two sections accessible from east and west, both of which contained an altar. On the left lie the foundations of the **temple of Artemis (j)**, with a Doric hexastyle prostyle made from pòros (stone), with

b

a

221

PELOPONNESUS

SANCTUARY OF ASCLEPIUS			
a THEATER	j TEMPLE OF	q FOUNTAIN	v "PORTICO OF
b KATAGOGEION	ARTEMIS	q2 FOUNTAIN	COTYS"
c BATHROOM	k THRASYMEDES'	q3 FOUNTAIN	w BATHS
d GYMNASIUM	WORKSHOP (?)	r BATHS	BUILDING
e ODEON	l BUILDING E	COMPLEX	x SANCTUARY
f PROPYLAEUM	m ALTAR	s LIBRARY	OF THE
g PALAESTRA	n TEMPLE OF	t TEMPLE OF	EPIDOTAI
h STADIUM	ASCLEPIUS	APHRODITE	y SACELLUM
i "TEMPLE OF	o THOLOS	u NORTH	z "ROMAN
THEMIS"	p DUAL ARCADE	PROPYLAEUM	HOUSE"

guttering (decorated with images of dogs and boar, now in the local museum), roof and acroteria in Paros marble. To the west of the temple the foundations of the rectangular building are still visible, preceded by an 8-column portico, which may have been the **workshop (k)** of Thrasymedes of Paros, who produced the chryselephantine statue of Asclepius. The sanctuary was ringed by a peribolos wall of cippi (the wall visible today dates to the Byzantine era) and was accessible from the south and through an entrance on the north side where the Epidaurus road passes. The sanctuary was crossed north-south by the Sacred Way, along which stelae, official inscriptions, tables of offerings, and statues were placed.

The ruins of **building E (l)** stand near the peribolos wall, which was probably the sanctuary's original abaton (end of the 6th century BC). The purpose of this building was to treat the sick who, once they had performed the purification rites, spent the night here. The abaton is U-shaped with the open end facing west toward an **altar (m)** that is connected to a paved road. Pilgrims would perform sacrifices in the large court before the *incubatio*.

Immediately to the east stood the peripteral **temple of Asclepius (n)**. It had 6 x 11 Doric columns made of pòros (stone). The naos was paved with white and black stone slabs and had a wooden coffered ceiling decorated with astragals, rosettes, and acanthus leaves. The statement of costs for

the building tells us that it was built between 380-370 BC by the architect Theodotus in four years and eight months at a cost of 100,000 drachmas. The Pentelic marble decoration was entirely designed by the

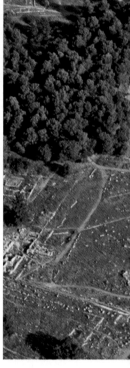

sculptor Timotheus, who, as the statement indicates, also prepared the typoi (models); the production work was shared between various artists, as is clearly demonstrated by the different styles involved. The east pediment of the destruction of Troy was by Hektoridas, whereas the acroters were the work of a sculptor whose name began The (...). The artist of the west pediment remains unknown, his name lost in the lacuna of the

LEFT: DRAWING OF THE THOLOS, PLAN AND VIEW.

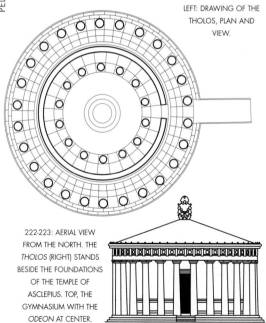

222-223: AERIAL VIEW FROM THE NORTH. THE *THOLOS* (RIGHT) STANDS BESIDE THE FOUNDATIONS OF THE TEMPLE OF ASCLEPIUS. TOP, THE GYMNASIUM WITH THE ODEON AT CENTER.

inscription, however his scene was of an amazonomachy. The acroters were the work of Timotheus and feature a Nike in the center and two female figures on horseback at the two sides. The chryselephantine

foundations only remain, was built on the western edge of the terrace in the mid-4th century BC by POLYCLITUS THE YOUNGER. The foundations are of 6 concentric circular walls, of which the 3 outer ones form

evaluated in relation to the function of the entire building. However, it must have had an important role in the cult of Asclepius owing to its large size (71' 2 inches in diameter), the richness of its materials

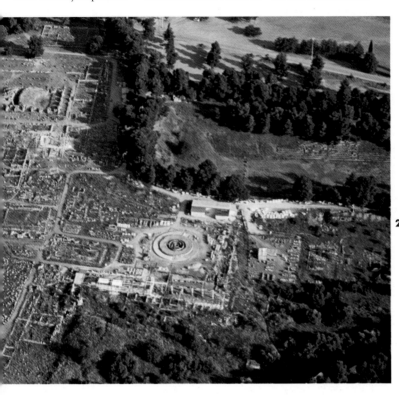

statue of the god, as Pausanias reminds us, had been produced by Thrasymedes of Paros. As we know from Pausanias' *Description*, as well as from images on the coins of Epidaurus and votive reliefs, the base also tells us that the statue represented Asclepius accompanied by a dog and seated with his right hand holding a scepter and his left resting on the head of a snake.
The **tholos** (o), of which the

the connection to the peristasis, naos wall, and internal colonnade. The other 3 can be reached from the floor of the naos by means of a wooden ladder; they are closed off by transversal walls and communicate through small connecting arched passageways. This arrangement has given rise to several hypotheses —for example, that sacred serpents were housed there—but its significance has to be

compared to those in the other monuments, and the refinement and exuberance of its ornamentation. Pausanias does not mention the building, but the term *thyméle* (sacrificial place) with which the building is cited in the inscriptions suggests the thòlos was used for a heroic cult dedicated to Asclepius (mentioned in the 3rd-century BC inscriptions), who was worshiped as a god in the temple.

The area of the sanctuary was closed on the north side by an Ionic, **dual arcade (p)**. The single-story western section was built in the 4th century BC, and to this was added a two-story portico a century later. Probably this building offered some or all of the functions of the original abaton (building E), but it became insufficient for

Corinthian columns to support the roof. Having returned to the sanctuary's large square, on the north side stand the various structures of what is referred to as "**portico of Cotys**" (**v**). This large building has Doric porticoes down the long sides and a central courtyard flanked by a peristyle where shops were

the growing number of pilgrims. A large **fountain (q)** was built in the 3rd century BC to meet the needs of these worshipers at the west end of the arcade. To the north there are a **baths complex (r)** and a **library (s)** constructed during the Roman imperial age. Heading toward the northernmost end of the sanctuary, one comes across the foundations of the **temple of Aphrodite (t)** built around 320 BC. The **north propylaeum (u)** was the main entrance to the sanctuary and built in the second half of the 4th century BC. It consisted of a rectangular platform reached up flights of steps to the north and south that led to a front with 6 Ionic columns. The passage was closed by lateral walls and had an internal peristyle of 14

situated. Built in the Hellenistic age, it was restored by Cotys—king of Thrace and vassal of the Roman Empire at the start of the 1st century AD—and then by the senator Sextus Julius Major Antoninus Pitodorus.
A **fountain (q2)** of ritual nature stood beside the wall of the southern portico but needed to be rebuilt at the time of the restoration of the complex by senator Antoninus. Another **fountain (q3)** was situated to the southeast but was ornamental and utilitarian rather than ritual; it was, however, restored by Antoninus, as was the sumptuous **baths building (w)** in the northeast corner of the square. The **sanctuary of the Epidòtai (x)** (dispensers, i.e., Apollo

Maleàtas and Asclepius) was built during the Roman period at the south end of the baths using materials from an earlier building. It consisted of a vestibule that opened southward onto a court and a semi-circular exedra with bases for cult statues. The ruins of two buildings stand to the west of the baths complex. One was a small **square enclosure (y)** composed of a portico of 4 Doric columns that communicated through 3 doors with a roofless bay, and the other was a construction known as the "**Roman house**," (**z**) whose function is not clear. Return to the theater, then take the partially paved road to the left, which leads to the top of Mount Kynortion, where the ruins of the sanctuary of Apollo Maleàtas can be visited.

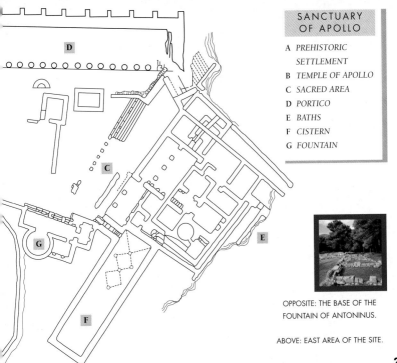

SANCTUARY OF APOLLO

A PREHISTORIC SETTLEMENT
B TEMPLE OF APOLLO
C SACRED AREA
D PORTICO
E BATHS
F CISTERN
G FOUNTAIN

OPPOSITE: THE BASE OF THE FOUNTAIN OF ANTONINUS.

ABOVE: EAST AREA OF THE SITE.

THE SANCTUARY OF APOLLO MALEÀTAS

About halfway, on the left, you will see the remains of a **temple** that may have been dedicated to Aphrodite and dates to between the end of the 4th and first half of the 3rd century BC. The Ionic tetrastyle prostyle building stands on a platform of three steps reached by a ramp and is an unusual type in the Peloponnesus owing to its pseudo-peripteral form. Its ornamental façade is one of the oldest extant.

The **hill top** (A) was inhabited in prehistory and was the site of a sanctuary during the Mycenaean period. The importance of the Mycenaean cult is demonstrated by the pottery, seals, terracotta idols, bronze spear tips and axes, and the materials found in the sacrificial deposits.

The **sanctuary of Apollo Maleàtas** was spread over three terraces, with the first cult building dating to the Archaic Age. The low remains of two walls were incorporated in the foundations of the building constructed during the Classical era; the monumentalization of the sanctuary occurred in the 4th century BC when a new distyle *in antis* **temple** was built for **Apollo** (B) over the previous one, with an adyton and, later, an altar and a small peribolos, perhaps dedicated to Asclepius. An **area sacred to the god and the Muses** (C) was laid out in the eastern section of the complex, which was bounded on three sides by stones and on the fourth by a lattice supported by seven pillars. Construction of the site was concluded at the end of the 4th century or early 3rd century BC with the erection of a solid terracing wall at the northern end of the area and of a **portico** (D). Following serious damage to the sanctuary during the Mithradatic war, widespread restoration was carried out, initiated by senator Antoninus. He had the northern supporting wall repaired and built a **baths complex** (E), a large **cistern** (F), and a **fountain** (G).

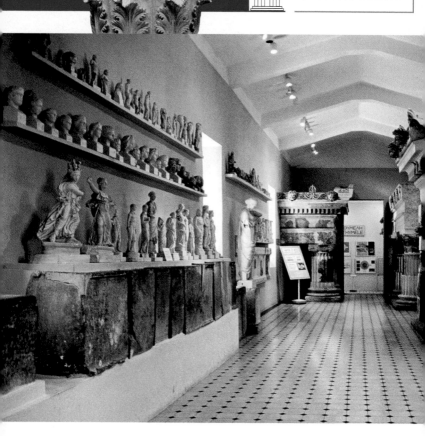

LEFT: PERFECTLY CONSERVED CAPITAL FROM THE *THYMELE* BY POLYCLITUS.

The museum has a collection of the materials found during excavation of the site, with the exception of the sculptures from the temple of Asclepius which are displayed in the National Archaeological Museum, Athens.

First room: collections of medical instruments and inscriptions, including the list of costs of construction of the temple of Asclepius and the stelae giving miraculous cures.

Second room: architectural elements from the north propylaeum and gymnasium.

Third room: the most important items. Sculptures from the temple of Artemis, a partial reconstruction of the temple of Asclepius and of the thòlos. (C.T.)

ABOVE: STATUES, SCULPTURAL FRAGMENTS OF THE PROPYLAEA AND GYMNASIUM.

RIGHT: MALE FIGURE, HELLENISTIC RELIEF SCULPTURE.

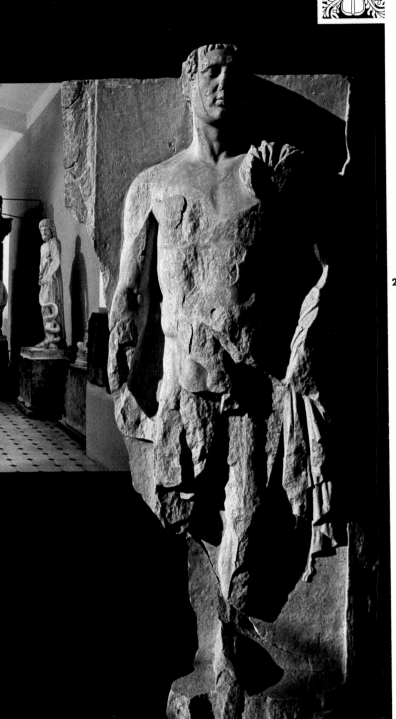

ITINERARY 2
LERNA

3.2

VISIT

The site was inhabited from the early Neolithic period until the Roman period.

The erosion of the upper levels of the hill, however, has resulted in the loss of the layers that were created after the late Mycenaean era.

Between the 6th and 1st millennia BC, seven phases of occupation of the site occurred (Lerna I–VII).

Open every day from 8:30 am to 3 pm. Payment required. A **rectangular room (a)** (5th–4th millennium BC) was demolished by construction of the **fortifications (b)** (mid-3rd millennium BC) that surrounded the settlement. **Two houses (c, d)** from the same period are inside the walls. The **House of the Tiles (e)** was built over the 2 houses and had been preceded by another **palatial building (f)**, the ruins of

which are beneath the northeast corner. The House of the Tiles was destroyed by a fire while it was being built. A low mound was built over the rubble and surrounded by a **ring (g)**. After a very long period a **house (h)** was built on the north side, and, in the 16th century BC, two **shaft graves (i)** were dug. The ruins of **absidal houses (j, k, l)** from Lerna IV are visible to the east of the House of the Tiles. (C.T.)

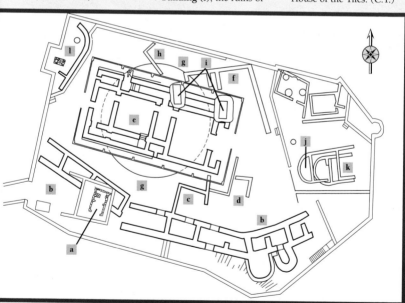

LERNA			
a	ROOM	g	RING OF ROUND STONES
b	FORTIFICATIONS		
c,d	HOUSES	h	HOUSE
e	HOUSE OF THE TILES	i	SHAFT GRAVES
f	PALATIAL BUILDING	j, k, l	ABSIDAL HOUSES

TOP LEFT: BRICK FOUNDATIONS ON STONE, MYCENAEAN AGE.

3.2 MEGALOPOLIS

The "great city"—together with Messene and Mantinea—was founded by Epaminondas as part of a political move against the Spartans following the Battle of Leuctra (271 BC). Forty villages were united, and within just four years, a logically planned urban organization was created as an independent city and federal capital of the Arcadian *koinon* (community). The territory

classical era, it was named the *Thersilion* after its builder. Its monumental façade, with a Doric portico in front of it (added later), was also used as a stage set. Thus, when theatrical works were staged, temporary wooden installations were simply mounted between the *Thersilion* and the orchestra. A stone **scene** was built toward the middle of the 2nd century BC, long after the *Thersilion* had

already lay in ruins. During the Augustan period, Strabo (*Geography*, VIII, 388) reported the biting comment of a comic poet, according to whom the "great city" had become an *eremia megale*, a "great solitude." Of the ruins, little more than the foundations remain, discovered by the British School of Athens at the end of the 19th century. Aside from the theater, the best-preserved sections are the

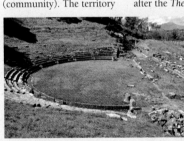

was enclosed by enormous city walls and was divided by the River Helisson, with the city located in the northern sector and the federal center known as *Oresteia* in the southern part. The main structure in the southern sector was a large theater—one of the largest in Greece—that was associated with an equally impressive meeting hall for the "Assembly of Ten Thousand," the body responsible for electing the executive government of the League. The legacy of the great columned halls of the

fallen into ruin. In effect, the Theban league was short-lived. Megalopolis joined the Achaean League in 235 BC, but it was sacked shortly thereafter (223) by Sparta, which had never been defeated. The great hall was destroyed and never rebuilt. The advent of Rome put a final end to this utopian dream after a brief revival led by political figures such as Philopoemen, Lycortas, and Polybius. When Pausanias visited Megalopolis, many monuments—including those of the city itself—

buildings of the agora: the *Philippeion*, named in honor of Philip II of Macedon, a large Doric portico with three aisles, located on the north side of the square; the stoa, dubbed *Myropolis* because perfumes were sold there, located on the east side; and the sanctuary of Zeus *Soter* on the south end, eroded by the river. (S.M.)

..

TOP AND BOTTOM LEFT THE THEATER.

BOTTOM RIGHT: COLONNADES AND BASE OF THE STOA MYROPOLIS.

3.2 LYCOSURA

The small town of Lycosura was located about 5 miles west of Megalopolis, and it was one of the many towns united to establish the "great city." As opposed to the others, however, it continued to be inhabited because of its famous sanctuary dedicated to

ceremonies of the mystery cult. This was the site of the Doric hexastyle prostyle temple (of which little more than the foundations remain). To the east is a **portico (a)** with three **altars** in front of it, dedicated to **Demeter (b)**, **Despoena (c)**, and the **Great Mother (d)**.

fragments from a group of cult statues were found in the naos. These statues represent some of the finest extant examples of Hellenistic sculpture. They were sculpted by Damophon of Messene following the terrible earthquake of 183 BC.

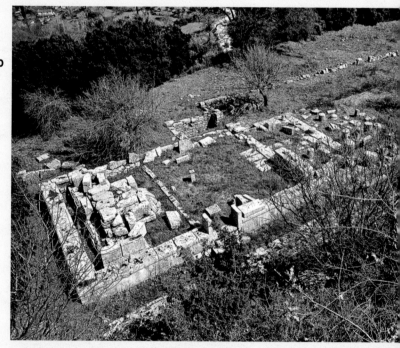

Despoena, the "Lady," an Arcadian deity equivalent to Persephone. Little remains of the town described by Pausanias (VIII, 37–38), but the ruins are fascinating. Set on a hill is a terrace with stairs on the uphill side for participants to observe the

A. K. Orlandos and P. Kavvadias excavated the **temple of Despoena (e)** in the late 19th century, dating it to the 4th century BC. The additions and the restoration work on the temple date from the 2nd century BC. Numerous

Our knowledge of the complex is based on the image on a coin minted in Megalopolis during the mid-life of Julia Domna, the wife of Emperor Septimius Severus (late 2nd century–early 3rd century AD). She oversaw the

OPPOSITE TOP AND BOTTOM: THE
TEMPLE OF DESPOENA SEEN FROM
THE SOUTH AND EAST.

RIGHT AND BELOW: THE ALTARS
AND PORTICO IN THE AREA IN
FRONT OF THE TEMPLE.

A R C A D Y

recomposition—not terminated yet—of the fragments that are now at the National Archaeological Museum, Athens (only a small part is deposited with the small local museum). Set on a platform in the middle of the base were the figures of Demeter with a torch on the right, and to the left, Despoena bearing a scepter and seated on a throne. Artemis (in this region considered to be Demeter's daughter) and Anitus (the Titan who raised Despoena) were portrayed on a smaller scale, standing to the sides and set slightly behind the main figures. The sensitive modeling of their faces and hair is particularly striking, as is the elegant chiaroscuro that can be noted particularly around the eyes. According to art historians, the enlarged eyes and the softness of the eyelids reflect an Alexandrian influence. (S.M.)

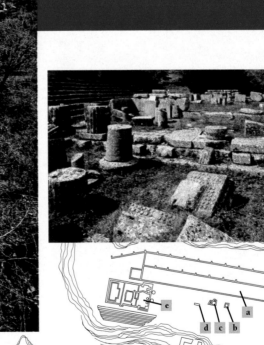

LYCOSURA

a PORTICO

b ALTAR OF DEMETER

c ALTAR OF DESPOENA

d ALTAR OF THE GREAT MOTHER

e TEMPLE OF DESPOENA

TEGEA

According to legend, Aleus founded this city when he initiated the synoecism (urban growth by fusion of small cities) of nine villages and the construction of the Geometric Age (demonstrated by the altar near a stream) and later. The name Tegea means "heat" and/or "refuge" and is linked to the chthonian power of fertility, after his death, but his bones were dug up secretly and taken to Sparta. This is a myth that suggests the historic rivalry between democratic Tegea and

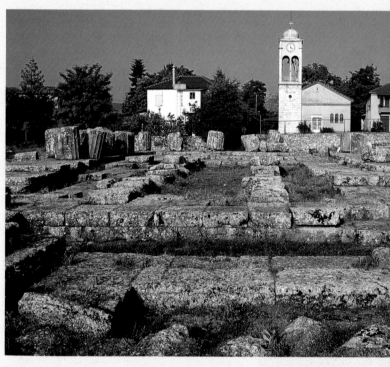

famous sanctuary of Athena *Alea* about the 9th century BC. Though today the date of the synoecism tends to be put around the start of the 5th century, an earlier date for the sanctuary is irrefutable as votive figurines and brooches attest the existence of a cult here since the 12th century BC. It remained rooted for all of the the detainer of the warmth that renders the land fruitful and which enabled the drainage of the marshy land of Tegea and its cultivation. The name gives the place a protective connotation, and, according to legend, the place was used as a refuge by Orestes, after he killed his mother Clytemnestra. Tegea was where he was buried aristocratic Sparta. Tegea, in fact, long suffered the Lacedaemonian hegemony: overrun in the middle of the 6th century BC, it rebelled on several occasions but was always defeated. The city declined in the 4th century, due to the foundation of Megalopolis and Mantinea. Conquered in 316 BC by Cassander of Macedon, it

A R C A D I A

VISIT

then enjoyed a period of prosperity. It was one of the most powerful cities in Morea and the seat of an important barony. Today it is a village.

What remains of the city is the late 4th-century BC theater, refurbished two centuries later and again in the Roman era. There are only clues as to the location of the agora visited by Pausanias. But the object of major interest is the temple

built in the Archaic Age and rebuilt in the Classical period. The large first version was built in marble in the 7th century BC. It was a Doric, peripteral building with 6 x 18 columns, a naos

with a double colonnade, a pronaos, an *adyton* rather than an opisthodomus, and unfired brick walls with a wooden frame and stone uprights. It was very similar to the *Heraion* at Olympia, the first *Heriaon* at Argos, and the temple of Artemis *Orthia* in Sparta. At the start of the 4th century a fire destroyed the temple completely and its reconstruction was commissioned from SCOPAS OF PAROS. This was in 350–340 BC, after the artist's return from Halicarnassus. On that occasion the Arcadian goddess was assimilated to Athena, whereas Athena *Polias* ("of the city") was probably worshiped in the agora.

ITINERARY 2, TEGEA

233

PELOPONNESUS

TEMPLE OF ATHENA ALEA

a *PRONAOS*

b *OPISTHODOMUS*

c *NAOS*

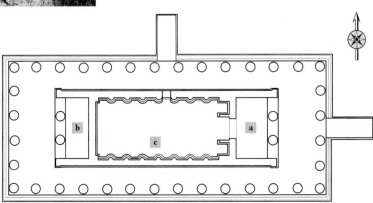

The temple was identified for the first time in 1819 by E. Dodwell near the church of Aghios Nikolas in the village of Pialì. The first excavation was carried out by A. Milchöfer in 1879, who discovered the dimensions of the building unearthed and various sculptural fragments, in particular, 2 male stone heads and a head of a boar, all from the pediment, which were taken to Athens. Following an inspection by W. Dörpfeld, research restarted in 1889 with the French School, and was later taken up by the Greeks.

The only parts of the

naos. The last had Corinthian half-columns set against the side and back walls joined by a cornice of interwoven acanthus leaves that practically swathed the space in which the cult statue stood. The Archaic ivory statue was made by Endoios and, saved from the fire, it was taken to Rome by Augustus. An upper order completed the decoration of the naos with the grace of the Ionic order (according to Pausanias). In this case the delicacy of an architect who was also a sculptor went much further than at Bassae. Dynamism was the principal characteristic of this

other local heroes to the east; and the struggle between Telephus (the son of Heracles and Auge, the priestess of the temple) and Achilles in the plain of the River Caicus to the west. On the basis of the few but high quality fragments that have reached us, we have an idea of the tension and dramatic nature of the busy composition and, most important, of the essential characteristics of SCOPAS' artistic language.

Whether a female torso made from Parian marble is from the pediments is still open to question (the other sculptures were made from marble from Dolianà):

BELOW: DRAWINGS OF THE EAST PEDIMENT (TOP) AND WEST PEDIMENT FROM THE TEMPLE OF ATHENA *ALEA*.

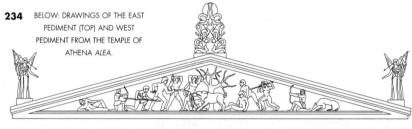

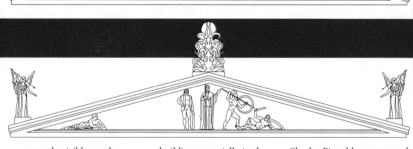

temple visible are the conglomerate foundations (the raised section was made of lovely local marble). It had an elegant Doric peristasis of 6 x 14 very slender columns but with no *entasis* (bulge in the middle of the column). A wide portico cut through the deep pronaos, the short opisthodomus and the long

building, especially in the changing chiaroscuro of the closed naos, which is almost baroque.

The pronaos and the opisthodomus featured sculpted metopes of local myths, as did the decorations on the pediments: the hunting of the Calydonian boar by Meleager, Atalanta, and

Charles Picard has suggested it comes from the altar, which Pausanias described as adorned with statues (it is thought SATYROS, Scopas' assistant, was the author). However, A. Giuliano considers that the torso is from an acroter, as this figure and that of Nike from another acroter are both shown in intense movement.

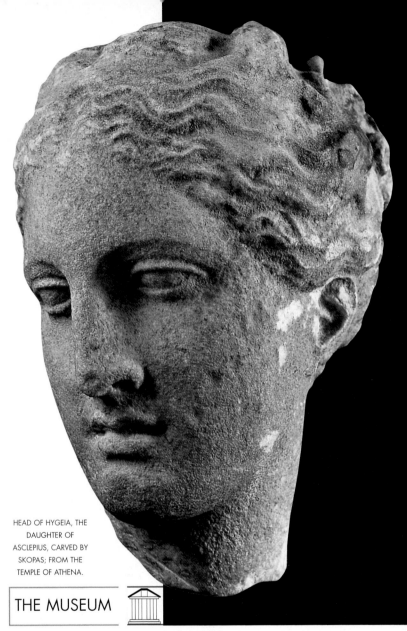

HEAD OF HYGEIA, THE DAUGHTER OF ASCLEPIUS, CARVED BY SKOPAS; FROM THE TEMPLE OF ATHENA.

THE MUSEUM

Open every day except Mondays, from 8:30 am to 3 pm.

Pieces to see are the **head of Telephus** with lionskin; the **head of Achilles** wearing a helmet; the bearded **head of** an elderly **Heracles**; the **torso of** "**Atalanta**"; and the **torso** of **Nike**. Critics consider the sculptures at Tegea to represent the height of SCOPAS' art. The dominant note is one of tension, expressed through heavy chiaroscuro that, however, does not distort the form or physical substance; on the contrary, it exalts them. In the dramatically composed heads, the *pathos* is concentrated in and around the deeply set eyes. The ruffled hair contrasts with the tense and elastic skin. The forceful movement of the torsos is revealed by the spare depiction of the bodies and the agitated heavy drapery. (S.M.)

SPARTA

Just as it remained throughout its history until the mid-imperial era, the Sparta described by Pausanias (III, 11, 2 ff.) was a normal city: defensive walls, an agora, a theater, several gymnasia, porticoes, and 64 temples. This is something very different from the image we get reading the words of the great historian Thucydides (I, 10, 2) who recounts the Peloponnesian War (431–404 BC) as a contemporary of the events, and says about the city:

"... if [modern Sparta] were reduced to a dead city and only the temples and foundations of the buildings were to survive—it is unlikely that posterity would attribute to it the military power of which tradition harbors the memory. Yet the Spartans occupied two-fifths of the Peleponnesus and dominated the entire region as well as many allies beyond: however, Sparta would seem less great than it was effectively since it was not a city rich with temples and magnificent buildings, but a

settlement formed of villages in accordance with the archaic norm of the Greek world."
Almost a prophecy! There is little that remains of ancient Sparta today. Those remains that have been brought to light since 1906 by the British School of Athens are only a pale reflection of what was one of the most famous cities of antiquity.
Even during the lifetime of Thucydides, Sparta's urban layout had "primitive" features: divided into 5 *obai* (village communities)

without the element that to the ancient most characterized the "image of a city," its fortifications, it was said that the only buffer Sparta had was the valor of its citizens. The layout of the city was a product of the Hellenistic and, even more so, the Roman renovation. Of this there are remains in the area of the acropolis and the lower "wheel-shaped" city (or better, "fan"), as Polybius describes it (V, 22, 1), just north of the modern city.

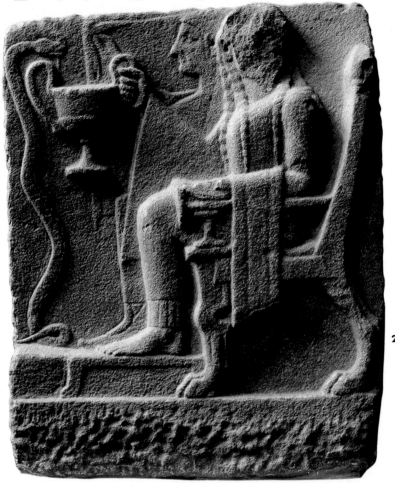

OPPOSITE TOP: DETAIL OF A POLYCHROME CUP.

ABOVE AND OPPOSITE BOTTOM: "LACONIC"-STYLE STELE
(MENELAUS AND CLYTEMNESTRA, LEFT) IN SPARTA MUSEUM.

THE MYTH

There are traces of Mycenaean presence, enough to account for the principal legend of Spartan mythology: the love of Zeus for Leda, the wife of King Tindarus. In order to make love to her, the god took the form of a swan, and Leda, who also made love to her husband that night, laid two eggs from which hatched four children: two boys, Castor and Pollux, and two girls, Helen and Clytemnestra. The *Dioskouroi* (the "sons of Zeus") were to be involved in the most famous Panhellenic myths—the expedition of the Argonauts, the hunting of the Calydonian boar, the abduction of the Leucippids, and others—and the names of the women were indissolubly linked to the greatest myth of all (to us moderns), the Trojan War. Helen married Menelaus and Clytemnestra married Agamemnon; the first was the reason that the war was fought, and the second gave rise to one of the most tragic episodes on the return of the heroes from Troy.

The organization of the Spartan state was not the work of a single legislator (Lycurgus) but was formed in the 8th and 7th centuries BC. The foundations were contained in what was the most ancient document in Greek history, the *Rhetra*, which dates to the 7th century. The Spartan state was composed of the system of two monarchs (the *archagetai*), the Council of the Elders (*gerusia*), and the assembly of the citizen-soldiers (*apella*). In early BC. The document makes no mention of the five *ephoroi* (ephors (spartan magistrate)), who were initially priests ("watchers of the skies"), and it was only with the democratization of the state that they were transformed into a political magistracy under the power of the monarchs. By the end of the 6th century BC, however, this body had usurped the power of the monarchs, whose only remaining responsibility was the army. In addition to the practice of life for the benefit of the community, the lack of a private dimension, and the military nature of society made Sparta unique in ancient history. The *oliganthropia* ("lack of men") was its downfall and, after two centuries of dominion over the Peloponnesus (and several decades over Greece) led to defeat at the battle of Leuctra.

Sparta's renaissance under Rome was interrupted again by Alaric and the Goths in 396 AD and by the Slav

Spartan history all the most important decisions were taken following the collaboration and agreement of these three governing bodies. The *Rhetra* established the organization of the *phylai* and *obai*, the tribes and villages that together formed the "open city" when five villages unified in the synoecism (urban growth by fusion of small cities) no later than 800 Spartiates (the caste of full citizens), there were the *perioeci* and the *helots*. The perioeci were also Dorians who lived in Laconia and made up most of the army, but they were not members of the *apella*. The lowest level was represented by the helots (Messenes and pre-Dorian inhabitants of Laconia), who were simply state-owned serfs obliged to pay taxes to maintain the Spartiates. This invasions of the 9th century. The city was abandoned—to the advantage of Mistras—and a new city appropriated its name, though not its glory, in the 1830s.

This new city was the Sparta founded by King Otto in 1834 after Greece had won independence from the Turks. The new Sparta has roughly 12,000 inhabitants and has no particular attractions but is an ideal base for visiting Mistras.

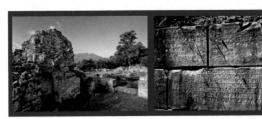

S P A R T A

OPPOSITE: THE ACROPOLIS.

ABOVE: CHRISTIAN RUINS
AND BLOCKS OF
ISODOMUM WORK.

BELOW: RUINS OF THE
BASILICA OF HAGIOS
NIKOS; ACROPOLIS.

BOTTOM: FRAGMENTARY
STATUE FROM THE
CLASSICAL AGE.

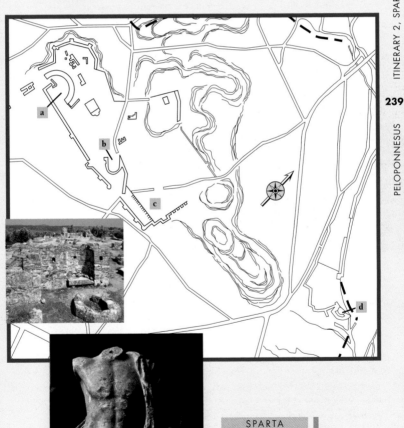

a

b

c

d

SPARTA

a *THEATER*
b *HEROON OF*
 BRASIDAS
c *ROMAN AGORA*
d *SANCTUARY OF*
 ARTEMIS ORTHIA

Further to the east is a large semi-circular brick structure more than 132 feet in diameter. It is made of stone blocks without binder, stands on a platform 3 steps high, and is believed to be (thanks once more to Pausanias, III, 14, 1) the *heròon* of **Brasidas (b)**, the general in the Peloponnesian War.

A **theatrical building (a)** has been unearthed on the southwestern slopes of the acropolis, which, judging by its appearance today, seems to date to the 2nd century BC. It was restored later in the Augustan period. The excavations undertaken by the Greek Archaeological Service between 1970 and 1991 led to discovery of the remains of a **Roman "stoa" (c)** east of the acropolis, is dating to 125–150 AD. The south face of this enormous building (its maximum length verges on 600 feet) incorporated a monumental fountain and has a series of enclosed areas that were probably filled with shops. One hypothesis is that it could have been built in place of the famous "Persian stoa" (Pausanias, III, 11, 3) built with the booty won from the Persians. However, some experts believe that it formed no more than the substructure of the agora above. The sight would have been a powerful one: a square lying on a large terrace supported by a large stoa, with two temples of the imperial cult (Caesar and Augustus) in a central position, and the "Persian stoa" closing it all off on the side of the hill. The *Limnaion* (from *limne*, "marsh") on the River Eurota's right bank was where the **sanctuary of Artemis *Orthia* (d)** stood. However, the paucity of the ruins matches the abundance of the votive objects found there, which are extremely useful in dating the chronological phases of this very ancient cult. The site seems to have been frequented from the 10th century BC; in the 9th, an altar was erected and in the mid-8th a small sacellum. In the 6th century a temple of a certain monumentality was added in the enclosure that was extended southward, and this building was completely rebuilt in the 2nd century AD. On this occasion a sort of theatrical cavea was built around the altar to allow worshipers to be present at the rite of the *diamastigosis*—the ritual flogging of the youths of the place.

Many of the finds are forms of pottery, including a particular item that was long believed to be Cyrenaic for its decorative work, but it was recognized by J. P. Droop as being of local production. Also famous is a black-figure cup by the PAINTER OF ARKESILAS (from the name of the king of Cyrene depicted) with a scene showing the

weighing of silphium, a precious medicinal plant (now at the Paris, Bibliothèque Nationale, Paris). With this and other forms of pots, in the 6th century BC the craftsmen of Sparta finally cracked open a large market for themselves that stretched from Italy to the Aegean coasts of Asia Minor.

The *Menelaion* (a sacellum consecrated to the heroic cult of Menelaus and his wife Helen) stood in the locality of Therapne a short distance southeast of the city. The ruins of the

century BC. First there was a simple *tèmenos* with an altar; in the late 7th or early 6th centuries a stone sacellum was built, but this was dismantled at the start of the 5th century and replaced with the building whose remains we see today. This may have been a part of a construction program to celebrate victory over the Persians, who identified the legendary hero Leonidas with the Spartan hero of Thermopylae of the same name.

A few miles south of the

first is not certain (probably near the church of Aghia Paraskevi), the second was discovered on the hill of Aghia Kyriaki by C. Tsountas back in 1890 and then excavated systematically in the 1920s by the German Archaeological Institute. Very little can be seen of the colossal and enigmatic monument referred to as the "Throne of Amyclae" by Pausanias (III, 18, 10–19, 5). It was designed and built by Bathycles of Magnesia between 540 and 520 BC and was not just a simple seat or platform decorated with ivory and gold suitable to accommodate the cult statue of the god Apollo, but a proper building suitably elaborate to be a *heròon* for Hyacinthus.

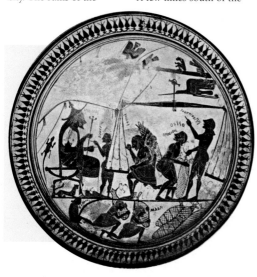

monument were recognized by Ludwig Ross in 1833 and immediately stimulated the attention of Heinrich Schliemann. Excavations by the British School of Athens have led to a detailed understanding of the sanctuary. Mycenaean remains provided the foundations for the cult, which became established at the end of the 8th

city lay the ancient center of **Amyklai**, the capital of the Laconian Achaeans, where 2 sanctuaries were built: the *heròon* of **Agamemnon and Cassandra** and, the *Amyklaion*, the altar-cum-tomb of Hyacinthus, the beautiful son of king Amyclae and the beloved of Apollo.

Though the location of the

LEFY: POLYCHROME CUP BY THE PAINTER OF ARKESILAS DEPICTING THE WEIGHING OF THE AROMATIC AND MEDICINAL PLANT SILPHIUM

BELOW: *KANTHAROS* WITH RELIEF DECORATION.

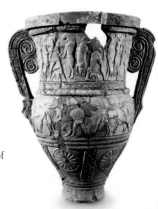

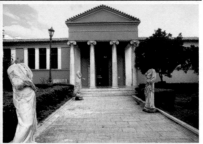

Open every day except Mondays, 8:30 am to 3 pm. Tel. (0731) 28575.

The Neoclassical building stands in a garden. The visit requires only half an hour and is based around items from the Archaic Age that form the largest collection in the museum.

Atrium: several votive stelae adorned with a sickle and dedicated to Artemis *Orthia*.

First room on right: fine **Roman mosaics** and a large **kantharos** (vase) produced between the late 7th and early 6th centuries with relief decorations of hunting scenes, battle scenes and parades of chariots.

Room 2 (right): a pyramidal **stele** from the Archaic era decorated with the couples Agamemnon and Clytemnestra, and Menelaus and Helen, and 2 snakes representing the Dioskoroi.

Room 3 (right): the main piece here is the famous **torso of "Leonidas"** in Severe style.

First room on the left: this room contains the most interesting exhibits. A number of small **bronzes** that achieved levels of excellence in the naturalism and grace of its subjects from the second half of the 6th century BC. They are mostly **korai**,

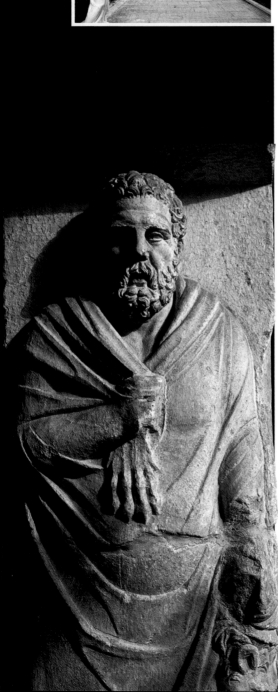

SPARTA

musicians and warriors in the form of mirror handles. The art of casting and embossing bronze must have flourished from the start of the century. Sources mention the names of certain artists from the period: GITIADAS, DONTAS, DORYKLEIDAS, and GORGIAS, the last of whom is mentioned by Pliny as being active in Athens around 530 BC. There are also interesting **clay masks** from the sanctuary of Artemis that were worn during religious ceremonies, probably to exorcise the monsters depicted by the masks themselves in forms assimilated from the Orient. In fact, some of them are from Phoenicia, but in the 7th century BC, they were manufactured in Sparta and achieved superior quality thanks to the interpretation in more humanized forms of the anguished oriental monsters. There are also many oriental **ivories**. Also from the Archaic era there are several **votive** **plaques** made of limestone, clay tablets with representations of Artemis as Potnia theron (the Mistress of wild animals) and 2 clay **metopes** that still retain traces of polychromy (armed figures).

Room 2 (left): votive reliefs and lovely Hellenistic mosaics, note especially a **clay model of a Roman boat** (late 1st century BC to early 1st century AD).

Room upstairs: Mycenaean objects from the region, including fine weapons. (S.M.)

BROKEN STATUES CONSIDERED TO
HAVE BEEN PORTRAITS OF
LEONIDAS.

MISTRAS

In 1249, William II de Villehardouin, prince of Achaea, had a virtually impregnable fortress built approximately three and a half miles northwest of Sparta, on a rocky outcropping of the main massif of the Taygetus. The construction of the fortress sealed the Frankish conquest of Laconia, following the fall of Constantinople and the partition of the territories of the Byzantine empire among those who had participated in the Fourth Crusade. The place was known as Myzithras (the name of a cheese that was produced there); the prince named the fortress Mistras (which means "mistress" in the local patois). The settlement that developed during this period at the foot of the citadel was protected by city walls, with the Monemvasía Gate to the east and the Nauplia Gate to the west, and it included houses and a palace. No trace remains of previous settlements. The ancient marble recovered here comes from the medieval city of Sparta, which in turn obtained it from Classical Sparta.

Shortly thereafter, William was defeated by the Byzantines at Palagonia and was forced to give up the fortified town, which became the strategic stronghold for the Byzantines' move to reconquer the Peloponnesus. The town thus became the administrative center for the region, and the bishopric was moved there from Sparta.

Mistras was transformed

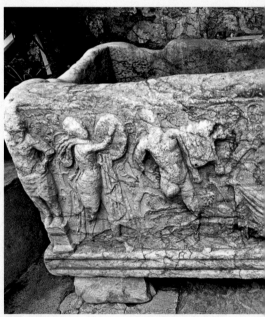

into a true city. Despite rather poor conditions for building a settlement, the town developed nonetheless, with irregular roads and houses set either parallel or perpendicular to the slope. Mistras entered one of its most prosperous periods, both economically and culturally. Toward the end of the 13th century, the erudite prelates Nicephorus Moschopoulos and Pachomius promoted extensive construction work, completing the metropolitan church of Aghios Dimitrios (started in about 1270) and building the churches of Panagia Odigitria and Aghii Teodori, incorporated in the Vrontochion monastery. This area was soon enclosed within a second set of city walls that marked off the intensely urbanized "lower city."

Emperor John VI Cantacuzene made Mistras the capital of the Despotate

of Morea, and his son Manuel became the first despot (1349). Manuel had the governor's palace enlarged (referred to henceforth as the Despot's Palace) and founded the palatine church of Aghia Sophia, as well as the Peribleptos monastery. At the end of the 14th

The Despot's Palace was again enlarged, the Evanghelistria church was built, and the Mitropolis basilica was restructured. The great residences of the aristocratic families (Laskaris, Phrangopoulos) were built during this period, and the foundation of the Pantanassa is linked

Turks, without even a struggle Mistras was handed over to the Sultan Mohammed II. The year was 1460, and this was the beginning of the city's decline and ruin. At the end of the 17th century, during a brief period of Venetian rule, Mistras thrived once again thanks to the soy trade (its population grew to over 40,000). Nevertheless, by 1715 the Turks had already regained control of Morea. Burned in 1770 during the Albanian revolt, it was virtually abandoned, and the foundation of new Sparta in 1831 sealed its fate.

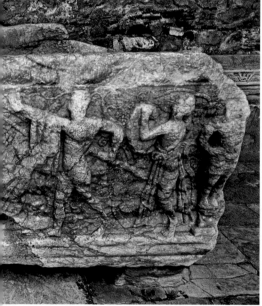

century, the Palaeologian dynasty gained control over the Peloponnesus, strengthening the Despotate's power over the area. Mistras developed into a metropolis, and the residential area expanded into the flat area to the southeast, outside the walls.

to these families. The city enjoyed an intense cultural life, attracting artists and men of letters. One of the most distinguished was George Gemistus Plethon, who founded a famous school of philosophy. Nevertheless, owing to the growing power of the Ottoman

OPPOSITE TOP: CLOVERLEAF CROSS ON THE FAÇADE OF AGHIOS NIKOLAOS (SOUTHEAST OF THE METROPOLIS).

ABOVE LEFT: SARCOPHAGUS IN THE CLOISTER OF THE METROPOLIS.

ABOVE: *CHRIST WITH STIGMATA* (AGHIOS NIKOLAOS).

TOP: VIEW OF THE CLOISTER.

VISIT

Tours daily: winter, 8:30 am–3 pm; summer, 8 am–7 pm. The museum is closed on Monday. Tel. (0731) 93377.

The complete tour takes at least 4 hours.

Given the terrain, we recommend the shorter tour. After going through the main entrance to the "lower city," turn right and head toward the Mitropolis and the annexed museum. From there, go to the Vrontochion monastery and then climb to the Evanghelistria, proceeding to the Despot's Palace and the nearby church of Aghia Sophia. From here, after visiting the Pantanassa, go down to the Peribleptos monastery and from there to the exit. You can then go by car to the castle (which is also accessible on foot from Aghia Sophia).

The **castle (a)**, which dominates the entire landscape, was actually the original center of Mistras. The fortress built by William II de Villehardouin, protected behind a double row of defensive walls, still has the features of the original layout, despite restructuring work and changes made in various stages by the Byzantines and the Turks. The main entrance is protected by a massive quadrangular tower. The housing for the garrison, a large cistern, and a lookout tower are located inside the first set of walls. The fortress itself, dominated by the large donjon (tower) (now in ruins), was built by the Franks over a large cistern, and it included a chapel (partially destroyed) and a sentry point at the western end.

The **Mitropolis (b)**, which is one of the city's oldest structures (13th century), was designed as a simple basilica with a nave and 2 aisles. However, it was renovated during the 15th century, borrowing the concept used for the Aphendiko (see later). As a result, the Greek cross plan was superimposed on the aisles of the basilica, with the pillars of the central

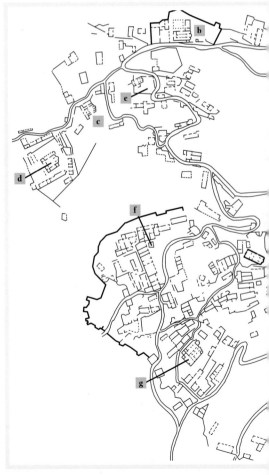

MISTRAS

cupola resting on the gallery floor. Naturally, the pictorial decoration does not show iconographic or stylistic unity.

The oldest parts of the church (the eastern sector of the building, diakonicon, the vault of the south aisle, and the wall of the north aisle were created in about 1270–1285) are the most conservative ones and they are linked to the capital. The decorations executed the first quarter of the 14th century are more lively and dynamic and feature complex landscapes, architectural backgrounds, and more elegant figures.

ABOVE: FORTIFIED GATE IN A FRANKISH CASTLE.

BELOW TOP: *MARTYRDOM*, FRESCOED SHRINE IN THE METROPOLIS.

BELOW CENTER: THE NAVE AND (BOTTOM) EXTERIOR OF THE METROPOLIS.

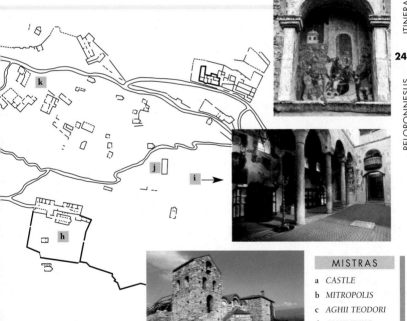

MISTRAS

a *CASTLE*

b *MITROPOLIS*

c *AGHII TEODORI*

d *APHENDIKO*

e *EVANGHELISTRIA*

f *PALACE*

g *AGHIA SOPHIA*

h *PANTANASSA*

i *PERIBLEPTOS MONASTERY*

j, k *PHRANGOPOULOS AND LASKARIS PALACES*

The **church of Aghii Teodori (c)** (built before 1296) has a complex Greek cross plan. Only a few fragments remain of the frescoes, done in a simple and archaizing style.

"church of the master," by the energetic Archimandrite Pachomius, who commissioned it). Its unique feature is its combination of two types of overlaid plans, the

cycle done in about 1320 is extremely rich and is perfectly suited to the architectural form of the church. Though tied to tradition, it shows innovative trends in the

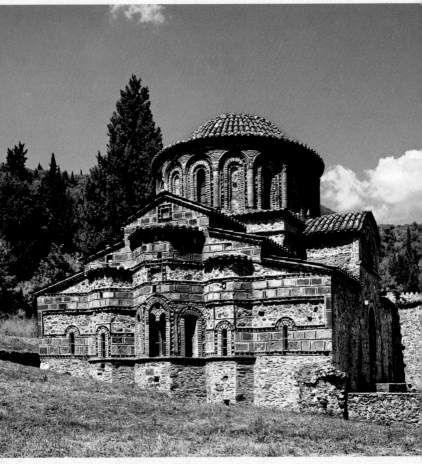

The **Aphendiko (d)** is indubitably Mistras' most unique structure. Built between 1310 and 1322, it was devoted to the Panagia Odigitria, "the Virgin who guides" (commonly referred to as Aphendiko for aphendicos naos, the

basilica with a nave and two aisles, and the Greek cross. Although it is quite small, this architectural gem replicates a magnificent model inspired by the capital's stately past (St. Irene of Byzantium is one example). The pictorial

use of color, applied with thick, fast brushstrokes using only a few colors, in a style that calls to mind Impressionism. The backgrounds are notable, with complex perspectives and exquisite modeling of the elongated and elegant

MISTRAS

figures. The frescoes in the funerary chapel of Pachomius, on the north side of the narthex, are also excellent.

The **Evanghelistria (e)**, built at the end of the 14th

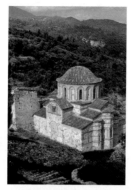

OPPOSITE: THE CHURCH OF AGHII TEODORI SEEN FROM THE EAST.

LEFT: APHENDIKO, DEDICATED TO THE PANAGIA ODIGITRIA ("VIRGIN WHO GUIDES").

BELOW AND BOTTOM: *MIRACLES* AND THE *WEDDING AT CANAA*, FRESCOES IN THE APHENDIKO.

century, has a simple Greek cross plan. The few extant frescoes were done in the early 15th century.

Every aspect of the **palace (f)** reflects Western construction, particularly the general structure, a rectangular block laid out on several floors with vaults and ogival(pointed arch) windows on the ground floor (and underground cisterns). The section added in the 14th century by the Cantacuzenes, as well as the facing one with a portico overlooking the valley, also show Western influence, whereas the one built by the Paleologians (first half of the 15th century) on the west side was inspired by the architecture of Constantinople.

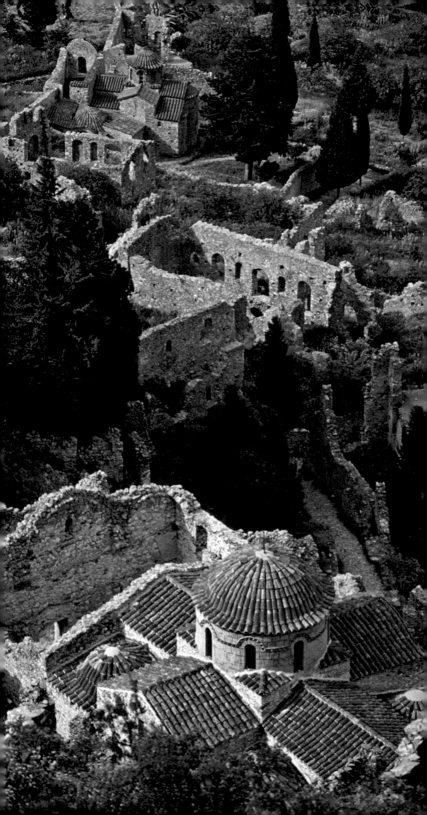

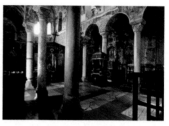

OPPOSITE: SACRED BUILDINGS AND RUINS
INSIDE THE FORTIFIED WALLS.

LEFT: THE DOME IN AGHIA SOPHIA AND THE
APSE WITH *CHRIST BLESSING.*

BELOW: LEFT EXTERIOR OF THE PANTANASSA
AND NAVE.

BOTTOM: THE LASKARIS PALACE.

The church of **Aghia Sophia** (g), with a simple inscribed Greek cross plan, was founded in 1350 by the first Despot, Manuel, as the palatine chapel and his burial place. Few frescoes survive.

The architectural language changes in the **Pantanassa** (h) (built by John Phrangopoulos in 1428): the layout of the building was drawn directly from the one used for the Aphendiko. However, an open portico with columns runs along the north side, and there is a gallery on the east side. Above all, with the exception of the central dome, the cupolas are hidden by a continuous roof, and there is a bell tower next to the body of the church.

The entire complex clearly shows the influence of southern Italy. Its construction technique and decoration are replete with elements that can be found in Salerno, Ravello, and Palermo: ribbing with a rectangular cross-section, three-light lancet windows, blind arches supported by slender columns and surmounted by plumed leaves that fan out, and festoons crowned with lilies.

The fanciful and hybrid appearance of the exterior is matched by the almost visionary treatment of the frescoes inside, with crowded spatiality that tends to burst onto the foreground and voluminous, almost statuary draping that uses mannered white highlighting.

The **Peribleptos monastery** (i), built in the

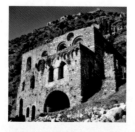

mid-15th century, also uses a simple inscribed Greek cross plan, and it has some of the best-preserved examples of late Byzantine painting. The style follows of the trends the capital city, not only in its accentuated linearism and attention to detailing but also in the use of illumination. The continual use of a blue ground—also inspired by the artwork in Constantinople—manages to make this rather small church look spacious.

The numerous smaller palaces in Mistras and the solidly built common houses reflect a style popular in the West: the ground floor—generally dark—with a vaulted ceiling, and the upper floor with a long and well-lit hall, preceded in some cases by a terrace. The **Phrangopoulos** (j) and **Laskaris** (k) palaces are excellent examples of this style. (S.M.)

GERAKI

Open daily except Monday from 8:30 am to 3:00 pm. Tel. (7310) 71329.

Ancient sources refer to Geraki by the name of *Geronthrae*, citing it as an important city during the Classical era. Pausanias (III, 22, 6–7) admired two temples there, dedicated to Apollo and Ares. British excavations confirmed that the area has been settled continuously since the Mycenaean age. Agriculture is now the main source of revenue for this little medieval-looking town, one of the 12 independent cities of the Peloponnesus. Geraki is not part of the major tourist circuit, and this means an enjoyable and peaceful visit to see the gems of rural sacred architecture from the Byzantine period. In 1995, the University of Amsterdam set up a research project on the Byzantine antiquities in the area. The 12th-century Evanghelistria has an inscribed-cross plan in its simplest and most widespread form. Its frescoes—Christ Pantokrator in the cupola, and the Virgin with the bishops and saints in the apse—reflect the Mannerist style of

Constantinople. The church of St. Athanasius, dating from the 13th century, was also built in the form of an inscribed cross, but its 14th-

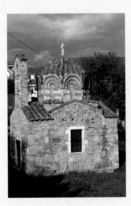

century frescoes were done in a decidedly more popular style. Just outside town are the church of St. John Chrysostom, with a single nave and lovely frescoes from the early 14th century, and the double-nave church of St. Nicholas, which was built in the 13th century. In the fields, there is a chapel with frescoes dating from the early 13th century. *To contact the custodian with the keys to all the churches, go to the Evanghelistria.* In about 1250, Guy de Nevelet built a fortress on

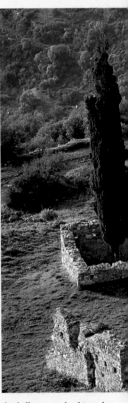

the hilltop overlooking the town. The church of St. George, in a basilica layout with a nave and two aisles, is located inside the walls of the fortress, and it has an iconostasis and a lovely icon of the saint. There are several small frescoed chapels outside the walls. (S.M.)

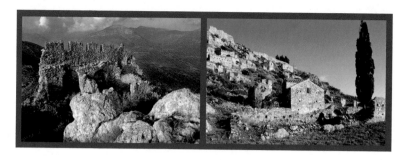

MESSENIA

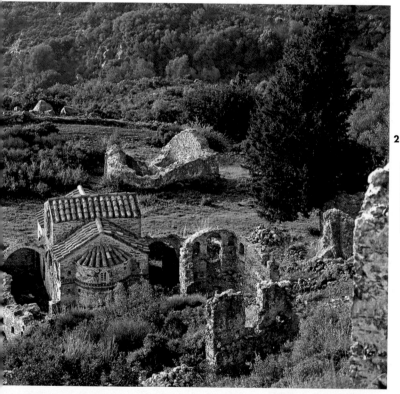

OPPOSITE TOP: GREEK CROSS AND LITURGICAL SYMBOLS, CARVING IN SOFT STONE.

OPPOSITE BOTTOM: EVANGELISTRIA, LATERAL VIEW.

ABOVE: RUINS OF CULT BUILDINGS AND A GREEK-CROSS CHURCH.

TOP: FORT, CRENELLATIONS AND BASTIONS.

RIGHT: ARCADE OF THE MODERN TOWN.

MONEMVASÍA

Open summer, Monday, 8:30 am–3 pm, Tuesday to Sunday, 8 am–7 pm; winter, Tuesday to Sunday, 8:30 am–3 pm

The history of this site essentially replicates that of the Morea's ancient capital. It was initially settled in the 6th century AD by Laconians fleeing the menace of the Avars. However, the extensive fortifications of the "upper city" were built by William de Villehardouin. Like Mistras, the prince ceded it to the Byzantines following the battle of Palagonia (1262). Under the

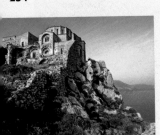

Paleologian dynasty, it enjoyed a period of great cultural and economic prosperity. The city used its port to trade a famous dessert wine, Malmsey—which has since disappeared from the Peloponnesus. The city continued to thrive during the Venetian

occupation (1464–1540), a period in which it was known as Napoli di Malvasia. It was subsequently held by the Turks, once more by the Venetians, and then once again by the Turks. This marked one of its grimmest periods. Many members of the leading local families were either barbarously executed or forced to emigrate. However, it was one of the first fortresses to regain its independence during the revolts of 1821, and the first National Assembly met here. Today, it revels in its memories, attracting droves of tourists who arrive every summer, also creating problems in reaching the town. *Moni envasis* means "single approach," and the rocky promontory, transformed into an island, can only be reached via a causeway with stone arches. The "Gibraltar of Greece"—as it was named by poet Iannis Ritsos, Monemvasía's most famous figure—boasts a charming medieval town protected by 16th-century walls. Its appearance reflects a blend of different rulers and cultures. For example, a Venetian church built over a Byzantine one overlooks the same square as the Turkish mosque, the **Paleo Dzami**.

The small **Panagia Myrtidiotissa** dates from the Frankish period (13th century), whereas the **Panagia Hrissafitissa**, with an exquisite Venetian façade, was built in the 17th century.

A steep path leads to the citadel. The ruins of the fortifications are impressive, but the main point of interest here is the church of **Aghia Sophia**. Founded in the middle of the 12th century, it has a domed cruciform layout, referred to as "octagonal" because its cupola is set on eight small triangles resting on the calotte. The church was the inspiration for the Aghii Teodori in Mistras. A number of art historians are convinced that this perfect architectural creation reflects foreign influence from Constantinople or, according to others, from Armenia. More simply, however, the model could well be the one from Daphni, transposed into more compact and less complex forms.

The Fifth Directorate of Byzantine Antiquities, which restored the monuments, also established a small museum (inside the mosque). Inaugurated in 1999, the museum houses artifacts that cover the entire history of the site. (S.M.)

THE MANI PENINSULA

In an Ottoman house-fortress, there is a small museum about the history of Mani (open every day from 9 am to 5 pm).

Mani is one of the most arid, barren, windswept, steep, and inhospitable lands of the Peloponnesus, and, paradoxically, this is what makes it so fascinating. The people of Mani consider themselves to be the direct descendants of the ancient

tower houses are being restored as part of a government program to provide tourist accommodation. The Maniots were independent spirits who managed to hold their own against the Byzantines and Turks, and

OPPOSITE TOP: FRANKISH ERA RELIEF IN AGHIA SOPHIA.

OPPOSITE CENTER: AGHIA SOPHIA ON THE GULF OF EPIDAURUS LIMERA.

OPPOSITE BOTTOM: PLUTEO AND CLAY OBJECTS IN THE MUSEUM.

ABOVE LEFT TOWER-HOUSE (BELOW) THE VILLAGE OF VATHI.

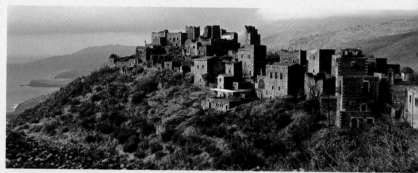

Spartans. The best way to reach this area is by going through Gythion, a beach resort with several attractions that was once the port of the great Lacedaemonian city. When you reach Areopolis, you venture into unusual and splendid countryside not yet fully equipped for tourism. The area is characterized by random abandoned villages, little churches and secluded chapels, and it stretches as far as Cape Matapan. The visit takes at least half a day. Tower houses symbolize this land. They were built by Laconian refugees fleeing the Slavic raids that began in the 7th century. Today, these

were at the forefront in the fight for liberation. (However, they assassinated the Greek Republic's first president, Ioannis Kapodistrias, when faced with the possibility of losing their independence.) Until the turn of the 20th century—when emigration became the only way to escape poverty—the Maniots were organized into clans, each of which would build a tower to symbolize their territorial power and defend against dangers as well as feuds and vendettas. The residential part, stalls, wells, and church were set around the tower, often protected by fences. There are about 800

of these squat, gray stone buildings, whose corners are made using blocks in a lighter color, dotting the countryside or grouped in villages. They have a square layout and can be as high as 80 feet. They contain several stories (the upper floors were added later) and were accessed through trapdoors and ladders. The best-preserved examples are in the villages of Kita and Vathia, divided into quarters that belong to different clans. The fascinating complex of Slavoumakos in Pyrgos has a sturdy fence, a massive tower, a church with a cemetery, an area for animals, and a two-story house. (S.M.)

The ruins of the ancient city are near Mavromati, a village that looks as though it were from a bygone era. Here, the local farmers often invite travelers to their homes to taste figs, bread, and cheese, washed down with hearty rosé.

systematic study of the local topography can be credited to Abel Blouet, as part of the monumental publication entitled *Expédition Scientifique du Morée* (Paris, 1831–1838). The first work by local scholars dates from the late 19th century, and in 1895

peninsula–which was isolated until just recently, without any roads or railways—played a significant role in the official disinterest in the area.

Research in this region was greatly stimulated by the Swedish scholar N. Valmin,

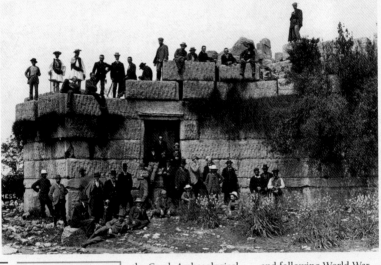

THE EXCAVATIONS

During the 19th century, numerous European travelers visited the site of ancient Messene. Some of them wrote fascinating reports complete with drawings: at the National Library in Strasbourg, for example, there is extensive material by Haller von Hallerstein. However, the first attempt to conduct a

the Greek Archaeological Society started excavation work, supervised initially by T. Sophoulis and then by G. P. Oikonomos. Until the 1920s and 1930s, however, Messene and all of Messenia were only of marginal interest to critics, who were involved in exploring and studying the sensational Peloponnesian discoveries from the Bronze Age. The position of this remote corner of the

and following World War II, this led to an important project conducted by the University of Minnesota. This project had considerable methodological interest, as this marked the first use of aerial photography in Greece.

Moreover, archaeological studies were done not only on the larger sites but throughout the territory (division of cultivated land

This is how Pausanias described Messenia (IV, 1, 1–2):
"This region was once deserted and so, I am told, the first inhabitants settled here: following the death of Lelex, who ruled in what is now Laconia, . . . power went to Myles, his eldest son, while Polycaon, being the youngest, remained there as a private citizen until he wed Messene, daughter of Triopa, from Argos. . . . Proud of her father, who during the era was one of the leading Greek figures in power and prestige, Messene had no desire to be the wife of an ordinary citizen. Gathering together an army from Argos and Lacedaemon, the two came to this region, which was given the general name of Messene. . . ."

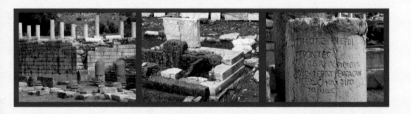

and related infrastructures, such as points for water supply, irrigation ditches, etc.). Enormous attention was devoted to the quantitative study of pottery from surface investigations, used as a criterion that—when there were no evident structures—could be applied to identify rural settlements, their size, and their chronology.

Thus, it was a program of "new archaeology," with an emphasis on anthropology. The studies done by A. K. Orlandos around the city (starting in 1957), followed by those of G. Themelis, have contributed decisively to sketching out a background of information.

OPPOSITE: GATE OF ARCADIA; DETAIL (TOP) AND PHOTOGRAPH, TAKEN IN 1891.

ABOVE LEFT TO RIGHT: PROPYLAEUM, DETAIL OF THE FACING, AND INSCRIBED COLUMN.

THE HISTORY

Messene has few remains from the Mycenaean Age and few traces remain of the Dorian occupation that, after 1200 BC, culminated with the peaceful coexistence of the Achaeans and the newcomers (led, Pausanias claims, by Cresphontes). In historic times, toward the end of the 8th century, Mount Ithome—which dominates the city—became the center of the Messenian resistance against Sparta during the Messenian War. During the first half of the 7th century, the Second Messenian War led to the complete enslavement of the inhabitants of the region, who were reduced to the status of helots (serfs), with the exception of a few towns. A number of the Messenians refused to bend to Spartan domination. A large group fled to Italy,

reestablishing the Chalcidian colony of Zancle and naming it Messane (modern-day Messina in Sicily) and another group based in the mountains of Arcadia took part in the struggle for freedom under the command of Aristomenes. This resistance led to the Third Messenian War in 464 BC. Nevertheless, the region was not liberated until after the Battle of Leuctra (371 BC), and the city itself was founded by Epaminondas in 369 BC. Messene established a democratic form of government at the end of the 3rd century BC. This was the city's golden age, thanks partly to its participation in the Achaean League. Its decline began when it left the league, and by the Roman era it was a "provincial" area attached to its past.

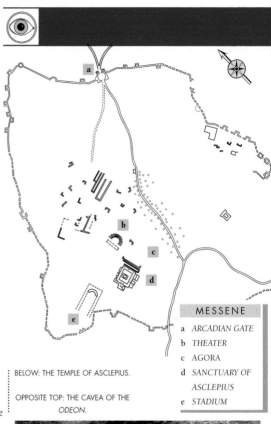

VISIT

The excavations surround
the village of Mavromati.
Admission is free
(admission to the small
Antiquarium, which
recently opened to the
public, is also free). The
visit takes 2 to 3 hours.
The city walls, built after
the city was founded, are
remarkable. The walls are
faced with beautiful opus
quadratum, with intricate
battlements and towers at
regular intervals. They are
over 5.5 miles long and
enclose the area of the
acropolis, including the
foundations of the
sanctuary of Zeus
Ithomatas. This cult dates
from at least the 9th–8th
centuries BC. Of the extant
city gates, the north one,
known as the **Arcadian Gate**
(**a**) is a masterpiece of
military engineering. It has a
dipylon or "double-gate"
form with a circular court
and two side towers facing
the countryside. Nearby,
there are several funerary
monuments from the
Roman era. Inside the
fortified area, the orthogonal
city layout is located in the
most favorable area of the
terrain, along the southern
slopes of Mount Ithome.
This area required terracing
and extensive work to make
the land even. Two
complexes still characterize
the urban landscape: the
agora and the Asklepieion,
which are connected to each
other. The area is reached
through the Arcadian Gate,

MESSENE

a ARCADIAN GATE
b THEATER
c AGORA
d SANCTUARY OF
 ASCLEPIUS
e STADIUM

BELOW: THE TEMPLE OF ASCLEPIUS.

OPPOSITE TOP: THE CAVEA OF THE
ODEON.

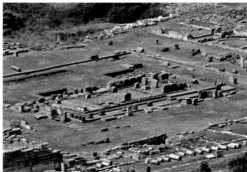

along a road that crosses an
area dotted with numerous
remains of monumental
buildings. With the
exception of the badly
preserved Greek **theater** (**b**),
these ruins are difficult to
interpret as there is still
much to be excavated.
Little has been uncovered in
the **public square** (**c**), the

identity of which was long
subject to debate. The parts
that have been excavated are
the south portico (not built
until the 4th century AD),
the north portico, and, at
the western end of this
portico, a monumental
fountain. The fountain,
dedicated to the local
heroine Arsinoë according

to Pausanias, made it possible to identify the agora. The cults of Zeus Soter ("savior"), Poseidon, Artemis Laphria/Limnatis, Eileithyia, Demeter, and the Dioskoursi were located here. Nearly all of these figures were tied in some way to the "mythical" history of the city, and they were thus "political" cults. The best-preserved public complex, the **sanctuary of Asclepius (d)**, is located immediately to the south. Messenian tradition gave the god a different origin than the one indicated at the main sanctuary of Epidaurus, citing him as the son of Arsinoë, the sister of the Leucippides who married the Dioskiursi. Thus, here Asclepius was more of a political figure than a therapeutic one. This **temple (A)**, a Doric peripteral building with 6 x 12 columns built in the 4th century BC, has a large altar and is positioned east of the center of the enclosure. In his description of the city, Pausanias never actually mentioned a temple devoted to Asclepius and thus, many historians were convinced that the sacred building was dedicated to the heroine Messene. However, the large number of votive bases with a characteristic exedra form and the inscriptions recovered there confirm that it was devoted to the god of health. The porticos around the square (Ionic order on the exterior and Corinthian in the interior, with figures

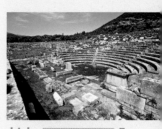

MESSENE

SANCTUARY OF ASCLEPIUS

A TEMPLE
B PROPYLAEUM
C ODEON
D HYPOSTYLE ROOM
E SEBASTEION
F SMALL TEMPLE OF MESSENE (?)
G BATHS
H HEROON OF SAITIDA AND GLAUCUS
I APOLLO
J HERACLES AND THE MUSES
K POLIS OF THEBES
L TYCHE
M ARTEMIS

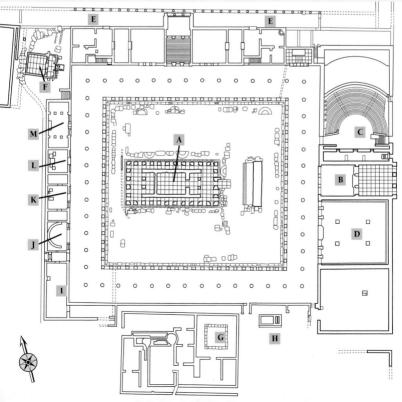

of Nike inserted in the acanthus of the capitals) "conceal" a series of highly significant rooms. On the east side, a small **propylaeum (B)** divides an **odeon (C)** or perhaps a theater (because the presence of roofing has not been confirmed) with a **colonnaded hall (D)**. It is characterized by a stone balcony with an elegant back along three sides, and as a result, it has been interpreted as the synedrion, where the city council met.

On the north side, there is a staircase with a propylaeum leading to the agora. Because of its "strategic" position linking two of the most important places in the city, during the Augustan era it was transformed into a **sebasteion (E)** (a building used for the imperial cult). The western side has revealed a rather complex arrangement, with various rooms used for sacred purposes. Based on Pausanias' description, we can identify the figures to whom the sacella were devoted. Starting from the south were the **sanctuaries of Apollo (I)** (the provenance of a lovely sculpted head, attributed to a local artist, DAMOPHON, who was active at the beginning of the 2nd century BC; now at the Antiquarium), **Heracles and the Muses (J)**, the **Polis of Thebes (K)** (with statues of Heracles and Epaminondas), **Tyche (L)**,

and **Artemis (M)** (venerated here as the kourotrophos, "protectress of youth," akin to Sparta's Orthia, as cited in a number of inscriptions). In the northwest corner, as already noted, there is a small Doric tetrastyle **temple (F)** in an elevated position and set back. It was probably dedicated to Messene, the first mythical queen of this area. The different orientation of the small building seems to indicate that it was "respected" when the major work responsible for the current appearance of the complex was done at the end of the 3rd century BC. Further proof that this must have been an important building comes from the fact that the official city

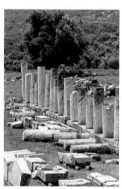

LEFT: FALSE VAULT, PASSAGE IN THE WALLS.

BELOW AND OPPOSITE: PORTICO AND CAVEA OF THE HELLENISTIC THEATER.

BOTTOM: "ASHLAR" BASE IN THE *BOULEUTERION.*

documents were displayed there (some of those found are exhibited at the small Antiquarium). The proximity of the building, reserved for the cult of Demeter, the Dioskoursi and the Leucippides—all figures linked to the mythical queen—seem to back this theory.

Despite the uncertainties involved, this kind of arrangement in the heart of the city seems to point toward interpreting the complex as a "state sanctuary" or "sacred agora" (alongside the "civil agora").

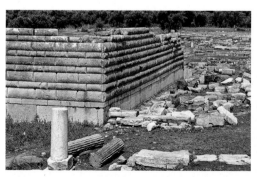

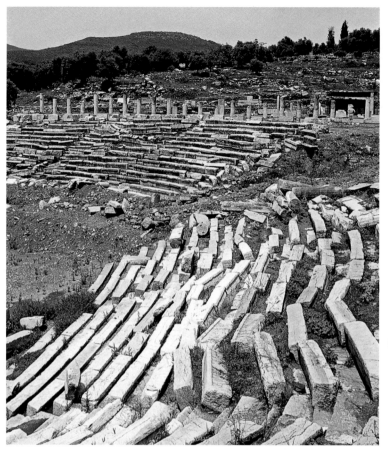

As is the case at other sites, toward the end of the Classical Age and the beginning of Hellenism, there was an evolutionary process characterized by the progressive unification of the cults tied to the local history. Although it seems undeniable that the architectural complex was devoted to Asclepius, it is essentially devoid of the elements typical of the therapeutic activities normally conducted in such settings. Instead, everything seems to show a political function, one of "self-representation" for the recently founded city anxious to give itself a genealogy of kings, heroes, and heroines. This has also been viewed as a possible model for the forums of imperial Rome.

The south side appears to reinforce this idea. There is a proto-Hellenistic **baths building (G)**, restructured during the Roman period, which was also used to worship some of the city's foremost heroic figures, **Saitida and Glaucus (H)**. To the south was the hierothysion (sanctuary), where the cult of the city founder, Epaminondas, was celebrated.

The more recently excavated monuments (some of which are still being restored) can be seen further south (and downhill): the gymnasium and the monumental **stadium (e)** from the late Hellenistic period. Inside the latter there were still signs of the cult for national heroes, the most important of whom was Aristomenes.

Thus, anyone entering the city from below climbing to the center experienced a powerful physical and emotional crescendo. (S.M.)

PYLOS
NESTOR'S PALACE

"But as the sun was rising from the fair sea into the firmament of heaven to
shed light on mortals and immortals, they reached Pylos the city of Neleus.
. . . they reached the place where the guilds of the Pylian people were
assembled. There they found Nestor sitting with his sons,
while his company round him were busy getting dinner ready,
and putting pieces of meat onto the spits while other pieces were cooking."
Homer, *Odyssey*, III, 1ff (translated by Samuel Butler)

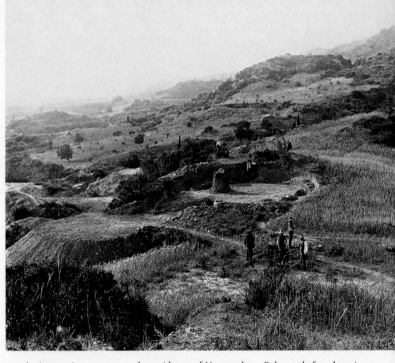

An impressive
Mycenaean palace has been
uncovered on the hill of
Epàno Eglaniòs, 2.5 miles
south of Chora and 10
miles north of the modern
village of Pylos.
It is believed to have been
the residence of Nestor, the
king of Pylos, the oldest of
the Greeks reunited at Troy.
All trace of the site was lost
in antiquity, and this quote
from Aristophanes' *The
Horsemen* is significant:
"There is a Pylos before
Pylos and after there is
another Pylos"; the only
topographic indications to
find the site were those
given by Homer when he
said that Nestor's city was
"sandy" and a single night's
journey from the land of

MESSENIA

the Eleans or Pherae (Gulf of Messenia).

However, Pylos had to be close to the sea because Nestor participated in the expedition against Troy with a fleet of 90 ships. Strabo (1st century BC)

mentioned 3 cities with the name Pylos—in north Elis, in Messenia, and in Triphylia (southern Elis)—and believed the last was where Nestor had his palace. On the other hand, Pausanias thought that

Homer's Pylos was the one on the Koryphasion promontory in Messenia, where he had seen the house of Nestor, the cave where his flocks were kept and the tomb of his son Thrasymedes (see Pausanias, *Description*, IV, 36, 1).

Having accepted Strabo's claims, W. Dörpfeld began investigating a site near the village of Kakovaton in Triphylia, where, between 1903 and 1907, he excavated several chamber graves and the remains of a citadel, but without finding any trace of the palace. In 1912 and 1926, the Greek archaeologist K. Kouroniotis found several tombs of the same kind in the region north of the Bay of Navarino, all built along the line of the modern road that joined the village of Pylos to Chora. For that reason, the Greek Archaeological Service, with the help of Cincinnati University, started an investigation into the region.

In 1939, northeast of the Bay of Navarino, the remains of a large palace were found: they were excavated by Carl Blegen and S. Marinatos between 1952 and 1966.

THE HISTORY

During the Mesohelladic period, the top of the hill was occupied by a settlement ringed with walls at the start of the Mycenaean age (1580–1400 BC). It is probable that between 1400 and 1330, a palace was built there, to which belonged the remains of walls found at various points beneath the currently visible building. Unlike other Mycenaean residences, the palace was built without fortifications on the leveled ruins of previous constructions in about 1300 BC. The slopes of the hill, from southwest to northeast, were occupied

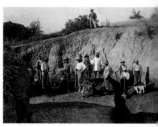

by an extensive settlement. The palace was destroyed by fire circa 1200 BC and the site abandoned until the 7th century BC, when a small oil press was built on the northeast side of the complex.

The residence covered a vast area (roughly 16 acres according to the most recent surveys) and was composed of a **nucleus (A)** and the palace itself, which had both ceremonial and public functions. Alongside the palace was the **southwest sector (B)**, which was probably the oldest part because the plan is less organized. The **service buildings (C)** (workshop and wine store): on the northeast side probably belonged to the later phase. All the sectors faced onto a wide **court (1)** with a stuccoed floor.

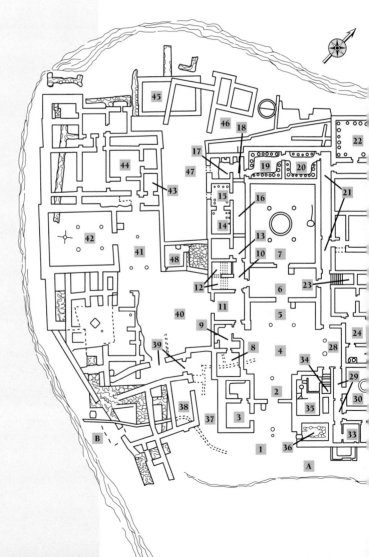

The **central complex (A)** was reached through a **propylaeum (2)** and a double portico supported by a wooden column (the bases and the stucco cincture with traces of 64 grooves remain). From the outer portico one entered the **archive (3)** where 1,000 clay tablets bearing Linear B records were stored. The inner portico had rich wall decorations of which fragments of yellow and blue nautilus mollusks, an architectural façade, seated female figures, lions, and heraldic griffins survive. This portico led into a large **central court (4)** around which all the various sections of the residence revolved. A **portico (5)** with 2 columns and a **vestibule (6)** on the north side preceded the **megaron** (central hall of the house) **(7)**, which had side passages to the private section of the palace where the stairs led to the upper floor. Four columns in the middle of a room bounded a space where the large circular hearth lay. This was lined with stucco and decorated with flame motifs on the sides and spirals on the edge; to the right of the entrance, halfway between the wall and the door, stood the throne.

Two hollows about 6' 6" apart can be seen in the floor connected by a conduit for cult libations which the king performed from his throne.

P Y L O S

NESTOR'S PALACE

A *CENTRAL NUCLEUS*	21 *CORRIDOR*	42 *HYPOSTYLE ROOM*
B *SOUTHWEST SECTOR*	22 *STOREROOM WITH JARS*	43 *BAY WITH VASES*
C *SERVICE BUILDINGS*	23 *STAIRS*	44 *STOREROOM (?) BATHROOM (?)*
1 *COURT*	24 *PARLOR*	45 *PROTO-PALATIAL ROOM*
2 *PROPYLAEUM*	25 *PORTAL*	46 *BAYS*
3 *ARCHIVE*	26 *BATHROOM WITH TUB*	47 *COURT*
4 *CENTRAL COURTYARD*	27 *COURT*	48 *OIL-PRODUCTION ROOMS*
5 *PORTICO*	28 *PORTICO*	49 *RAMP*
6 *VESTIBULE*	29 *CORRIDOR*	50 *PORTICOED COURT*
7 *MEGARON*	30 *MEGARON*	51 *CULT AREA (?)*
8, 9 *COMMUNICATING ROOMS*	31 *COURT*	52 *ALTAR (?)*
10 *CORRIDOR*	32 *FRESCOED BAY*	53, 54 *WORKSHOPS*
11 *CONNECTION ROOM*	33 *BATHROOM*	55 *CISTERN*
12 *STAIRS*	34 *STAIRWAY*	56 *SLAVES' BUILDING (?)*
13 *STOREROOM (?)*	35, 36 *TOWER*	57 *WINE STORE*
14–20 *STOREROOMS*	37 *RAMP*	
	38 *STOREROOM*	
	39 *DOUBLE ENTRANCE*	
	40 *GREAT COURT*	
	41 *VESTIBULE*	

Fragments of frescoes with a sacrificial procession can be seen in the vestibule, as well as traces of the floor decoration of squares with multicolored linear designs. The floor of the throne room was decorated with linear motifs in squares of different colors (red,

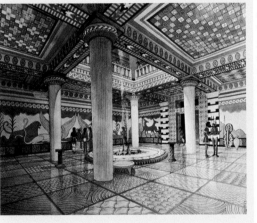

yellow, blue, white, and black), and there is a large octopus in a square in front of the throne. Frescoes originally covered all of the walls of the room, but only fragments remain: they are of a pair of griffins in heraldic pose (originally on either side of the throne), and a lyre player dressed in a long tunic and seated on a rock. In front of him is a bird flying and male figures seated at a table (perhaps a banquet scene) and large animals.

The **court** (4) leads through 2 passages on the east and west sides to the private sectors of the residence. On the southwest side were 2 **communicating rooms** (8, 9); the first contained 500 to 600 cups for serving the wine that was probably conserved in the large jars in the room next door. In the second, a bench lined with decorated stucco (west corner) and a support with 2 large jars (south corner) suggest the room was a sort of waiting room for the king's guests. The passage led into a long **corridor** (10) that originally flanked all of the west side of the megaron, but, in the later phases of the palace, it was partially closed off by walls to create **storerooms** (16, 18).
After crossing the **room**

(11), the corridor that connected the central section of the palace with the **large court** (40) continued in front of the **stairs** (12) and ended in what was probably a **storeroom** (13).
A large number of vases (roughly 6,000) were found in the stores in the westernmost part of this section. The **room** (15), which could be accessed from the **court** (47) of the adjacent southwest wing, was found to contain fragments of approximately 500 vases that originally stood on wooden shelves supported by poles (the holes in the floor remain). The same is true of the **next room** (14), where 2,853 wine cups were found, and of another **small room** (16) in which fragments of 474 vases and an offerings table were found. The table was surrounded by small cult vases, which like the table, may have fallen from the floor above as a result of the palace fire.
Pots and vases were also stored in **rooms** (17, 18) that did not communicate with the previous ones but which were still accessible from the **court** (47). The first contained 2,146 drinking cups and glasses, the second 601

OPPOSITE: ARTIST'S IMPRESSION OF
THE *MEGARON*.

BELOW (LEFT): THE HEARTH, THE
CENTER OF THE *MEGARON*, AND
(RIGHT) THE BASIN.

..

items, mostly very large jars that were probably used to conserve oil in the 2 large **storerooms (19, 20)**; here numerous jars were found standing in stucco-lined benches. The northeast side of palace was also served by a long **corridor (21)**. This provided access to another **storeroom (22)** that contained 16 oil jars, and to a series of 5 small rooms of uncertain

casing and 2 large jars placed in a clay bench. This room was found to contain many fragments of frescoes with hunting scenes (hunters armed with spears, dogs, deer, lions, and boar) that probably fell from rooms on the floor above. It is probable that the royal family's apartments were located in the southeast sector of this wing of the palace. The

reach a **court (31)** in the floor of which there are many holes of unknown function.

A door on the south side of the megaron led into a wide corridor, from which 2 rooms could be reached. The first **room (32)** was frescoed but only fragments of the decoration of the floor have been conserved (east corner); they are of linear motifs, fish, dolphins, and

267

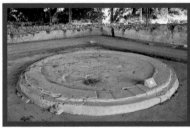
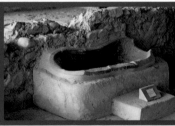

function.
Beyond the **stairway (23)**, the corridor led to a **parlor (24)** (judging by the fragments of jars, amphoras, and stirrup vases), then through a large **portal (25)** that was originally the northeast gateway of the palace to another **court (27)** laid out, like the previous one **(31)**, during the last phases of the palace.
From **the parlor** it was possible to reach a suite of 2 rooms heading north, and a small **bathroom (26)** on the south side. The bathroom had a terracotta tub set in a stuccoed clay

greater importance of this nucleus is demonstrated by the fact that access from the large court was made through a two-column **portico (28)** (with stone bases and a stucco cincture that has conserved the traces of 60 grooves), which led into the north-south **corridor (21)** and to the **megaron (30)** via another **corridor (29)**. The room had a central hearth lined with stucco and decorated with flames, zigzags, and spirals, and the walls were frescoed with friezes of griffins and lions. From here it was possible to

octopi in square panels. It is thought that the other **room (33)** may have been a bathroom due to the presence of a drainage channel and a number of stirrup vases, plus the fact that it was somewhat separate and could only be entered from the end of the **corridor (29)**.
A **stairway (34)** (of which 3 steps remain) from the **portico (28)** led to a **tower-like building (35, 36)** of uncertain use. The location of a **room (36)** next to and joined to the entrance propylaeum suggests it could have been a guardroom.

The **northeast section (B)** could be reached by a **ramp (37)**, which started in the large **court (1)**. A **storeroom (38)** on the ramp contained 850 vases that originally stood on wooden shelves supported by poles (the holes in the floors are still present). At the end of the ramp, **2 entrances (39)** separated by a corridor led into a **large court (40)** and wide **vestibule (41)**. The vestibule had 2 columns at the front and another inside (the stone bases and stucco cinctures with the marks of 44 grooves remain). The walls were frescoed above the plinth with linear motifs in multicolored panels and with a frieze of hunting dogs and battle scenes. A **large room (42)** lay on the west side on an axis marked by an internal column. In the room there were 4 columns in an unusual arrangement (1 stone base and the circular foundations of the other 3) as the room was divided asymmetrically. No trace of a central hearth has been found, probably because of the erosion that has led to the loss of the upper floors in this section of the hill, nor of the frescoes that undoubtedly lined the walls.

A small door led from the vestibule into a set of rooms whose use is not clear. In the **small room (43)** roughly 300 vases were found, mostly for use in the kitchen. The fragments of at least 6 large jars and a basin with painted decoration were found in a nearby **room (44)**, which was probably a store for oil or wine, but the possibility that it was a bathroom cannot be ruled out.

The structures to the northeast of the building were certainly a part of it

and with all probability were used for storing oil or wine. Another **room (45)**, dating to the initial phase of the palace, was substituted by a complex of 3 or 4 **rooms (46)** which in part overlay it. In the south section of the **court (47)** that separated this wing from the central one, 2 **rooms (48)** used for oil processing were built, probably in the late Geometric Age, utilizing reused materials.

The **northeast wing (C)**, separated from the central complex by a **ramp (49)**, consisted of a rectangular building, of which there remain a **porticoed court (50)** (the bases of 2 columns on the northeast side survive) and 6 rooms of various size (the south part has been destroyed by erosion). Another **room (51)** opened directly onto the court and was probably used for cult purposes; a stuccoed and decorated rectangular stone opposite the façade looks as though it may have been an **altar (52)**. The largest room was found to contain many fragments of bronze, 17 seal stamps, and 56 inscribed tablets, of which some discuss leather and metal repairs, and others mention parts of carts or refer to orders and supplies of leather and bronze. This was clearly a **workshop (53)** for making and repairing metal objects and weapons.

In the room next door, hundreds of tiny

large room. It contained 35 big jars arranged along the south wall and in part in the center of the room. There were also 60 seal stamps impressed in clay blocks that were used to close the containers. Excavation in the northeast section of the acropolis has revealed a Mycenaean settlement, which was destroyed before the palace was constructed. A series of houses was aligned along a road and the settlement as a whole was enclosed by walls. A gate remains from which a road paved with flagstones ran to a chamber grave (now accessible from the car park).

A small but interesting museum in Chora displays part of the finds from the palace (in particular, fragments of frescoes) and the grave goods from a chamber grave in Peristeria (gold cups, jewelry, and seals).

arrowheads and fragments of ivory, some engraved, suggest that this area of the **workshop** (54) was used for more delicate materials. In the area to the north of the workshop at the end of the ramp, a **cistern** (55) was built during the last phases of the palace. The adjacent **rectangular building** (56) was built partly before construction of the palace with 4 variously sized rooms that could have been used for the king's slaves.

The **wine store** (57) could be entered through a small vestibule that led into a

BAY OF NAVARINO

The bay is lined on the north by the promontory of Koriphasion where a city stood in the Classical era (5th century BC). The city was called Pylos by the Athenians and Koriphasion by the Spartans. Many remains of the city have been found. In 1278 the Franks built the Paliokastro that also enclosed the remains of the ancient wall. Beneath the hill, on which the church of the Prophet Elijah stands, it is possible to see the chamber grave of Thrasymedes (the son of Nestor) at the center of a funerary enclosure dating to the Late Helladic period. Sphacteria lies off the promontory; it was where the Athenians captured a body of Spartan soldiers in the hostilities of 425 BC. At the extreme end of the bay you can visit the modern village of Pylos, overlooked by the Neokastro fort built in 1573 by the Turks.

THE MUSEUM

Open every day except Mondays, 8:30 am to 3 pm. Payment required.
The museum's main display is pottery from Kyparissa, the Mycenaean necropolis of Koukounara, and the Hellenistic-Roman necropolis in Divari.

THE TABLETS OF PYLOS

When Carl Blegen found Nestor's palace archives in 1939, containing roughly a thousand terracotta tablets, it was thought that the script with which they were engraved—Linear B—was a form of Minoan writing. According to Sir Arthur Evans, who in 1900 had discovered the first examples of this type of script in the palace of Knossos, Linear B was an advanced form of Linear A, which was used in Crete between the 18th and 15th centuries BC, and which it replaced in 1450 BC. Both, however, were unrelated to Greek and therefore could not be deciphered.

Given this assumption, the discovery of the Linear B tablets at Mycenae, Tiryns, Thebes, and Pylos was considered proof of the extension of Minoan control over the Mycenaean kingdoms. Then, in 1952, Michael Ventris (an architect with experience in cryptography gained during World War II) deciphered Linear B.It was revealed that the language used was a very archaic form of Greek. This meant that the Mycenaeans were of Greek lineage and that it was they who had conquered Crete, rather than vice versa.

The Mycenaeans learned the use of writing from the Minoans and adapted Linear A to the requirements of their

language.
The tablets were created by writing on damp clay with a sharpened stylus and then leaving the tablets in the sun.
They were then placed in baskets of wooden chests (as attested by the discovery of hinges) and aligned on shelves on the archive walls. We owe the survival of the tablets to fires that broke out in the palace—the flames baked (fired) the tablets.
Unfortunately, as at other Mycenaean sites, the

tablets found at Pylos contained documents referring only to the administration of the palace just before it was destroyed by the fire.
They are inventories of land properties, goods in the storerooms, and military and naval equipment.
They also list the professions of the settlement's subjects, their relations with central power, and state their offerings to the gods (cited are Zeus, Hera, Athena, Poseidon, and

maybe Dionysus).
In general, the tablets have provided a great deal of information on different aspects of the economy and organization of the palace and Mycenae as a whole, and point to an economically complex and specialized society.
(S.M.)

TABLET FROM NESTOR'S PALACE,
INSCRIPTION IN LINEAR B.

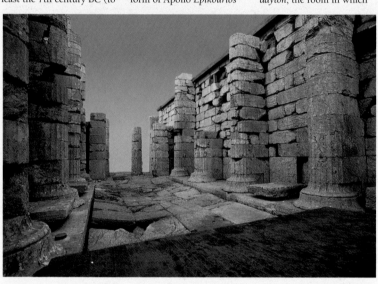

BASSAE

Like stranded ice when
freshets die
These shattered marbles tumbled lie:
They trouble me.
Herman Melville

Near Andritsaina on Mount Kotilios (ancient *Kotilon*), at a height of more than 3,300 feet, where the oaks give way to rock, there are visible signs of an ancient cult that dates to at least the 7th century BC (to

to Apollo that rebuilt on several occasions and is today one of the most important and best preserved temples in Greece. In its present condition, it is dedicated to the god in the form of Apollo *Epikourios*

marble roof tiles. The plan of the temple seems to imitate that of the temple of Apollo in Delphi, having a peristasis of 6 x 15 columns and a width to length ratio of 2:5. There was also an *adyton*, the room in which

judge by the votive offerings found). The site was related to the city of Phigalia, which lay about 6 miles away, and is divided between two enclosures at different levels on the mountain. The upper enclosure has the remains of a **small temple dedicated to Aphrodite** and of a larger one—with a pronaos and naos but no peristasis— **dedicated to Artemis Orthia**. The lower site has a similar building **dedicated**

("helper"), which, according to Pausanias (*Description*, VIII, 41, 8) is an epithet linked to the end of the terrible "black plague" that struck during the Peloponnesian War. Others, however, think there may be a warrior connection due to the many ex-voto bronzes that have been found. Built from local gray limestone, it had capitals, an internal frieze, a coffered ceiling in the vestibule, and

the oracle was consulted. The discovery and survey in 1765 of this jewel of ancient architecture was the work of the French architect Joachim Bocher, who was murdered while attempting to carry out a closer examination. His preliminary drawings are held in the Victoria and Albert Museum in London, but it was not until the start of the 19th century that excavation began, sparked by the interest of the Britons

OPPOSITE TOP AND RIGHT:
AMAZONOMACHY AND CENTAUROMACHY;
DETAILS FROM THE FRIEZE.

OPPOSITE BOTTOM: INSIDE THE NAOS;
IONIC HALF-COLUMNS AGAINST THE
WALLS.

A R C A D I A

C. R. Cockerell and J. Forster and the German architect K. Haller von Hallerstein. The work soon suffered the serious and mysterious disappearance (a theft, of course) of the Corinthian capital positioned at the back of the naos, which was a great novelty in debatable one). Pausanias (VIII, 41, 9) attributes its construction to ICTINUS, but modern experts agree on the latter's collaboration with CALLICRATES (not the first time they had worked together). In fact, the temple was built in two stages in the

TEMPLE OF APOLLO

a *PRONAOS*
b *OPISTHODOMUS*
c *NAOS*

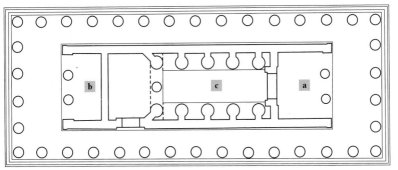

the design of a sacred space (discussed in greater detail later later). The Greek Archaeological Society carried out excavation work and anastylosis (reassembling of ancient buildings) at Bassae between 1902 and 08, directed by P. Kavvadias. After being forgotten for a long period, the temple of Apollo at Bassae was declared a World Heritage site by UNESCO. Interest in the monument was rekindled, particularly in its conservation (even if the decision made some years ago to shelter it beneath a tensile covering is a

first, the lengthened plan, style of the external capitals, and small internal transversal walls are related to the Peloponnesian style of the years 450–440 BC. Then, during the last quarter of the century, the building was modified by the Attic school. According to others, the building was constructed circa 425 B. C. reusing materials taken from a late 4th-century temple that was completely dismantled for the purpose. ICTINUS and CALLICRATES produced a sort of prototype that was to have enduring repercussions on building in the 6th century

and even on Hellenistic architecture, above all on how the internal space was organized. This very long peripteral building runs, unusually, north-south which, to our minds, can only be explained for cult reasons. It has 6 x 15 Doric columns free of optical corrections, and a very deep pronaos and opisthodomus, but significant differences with the architectural canons of the day were reserved for the naos. Here the decorative effects seem to have been given more importance than the architecture; though the

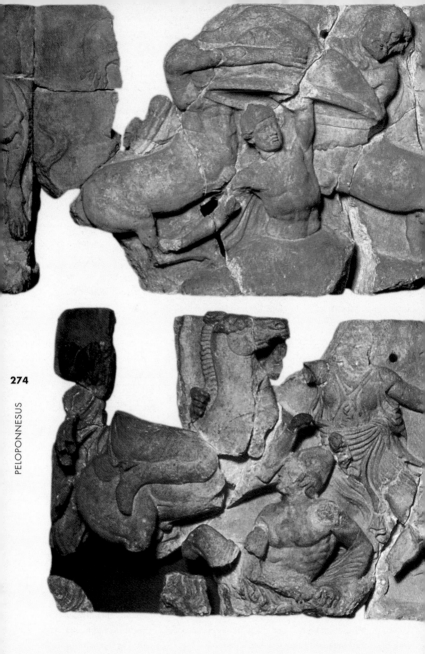

plan and the (ritually obligatory) distinction between the naos and *adyton* have been maintained, the small transversal walls inside have been given Ionic half-columns to create a series of niches, and there is an order decorated with a frieze featuring an amazonomachy (east and south sides) and a centauromachy (west and north sides). Then, and this is the innovation, a Corinthian order is used to close off the back of the naos from the *adyton* with a chromatically powerful column. Overall, the unity of the space is created more by the pictorial effect than by an architectural one in a development that marks a break with Classical style and the advent of the Baroque. The wall is given a sense of movement through

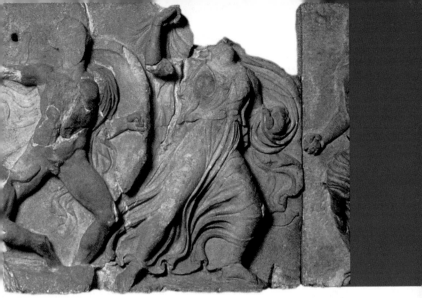

BASSAE

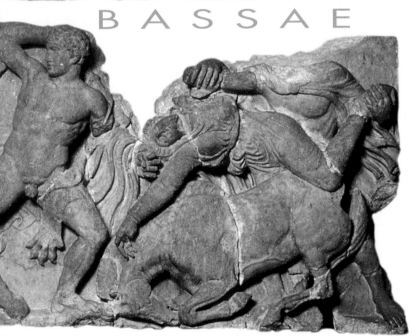

a series of projecting elements that modify the volumes, and the decorative aspect of these projections has been elaborated to the point that their functional relationships are overshadowed. This new approach to the internal space eliminates the aisles and frees columns and trabeations of architectural functions, but, in doing so, violates the fundamental law of Classicismthe architectural order becomes decorative, and therefore pseudo-functional. (S.M.)

TOP: CENTAURS BURY CENAEOS (LEFT); TAKEN FROM THE WEST FRIEZE.

BOTTOM: HERACLES, AT THE CENTER OF THE EAST FRIEZE, FIGHTS THE AMAZONS.

OLYMPIA

When, at the end of the 19th century, Pierre de Coubertin stated his ideal of Olympia and the Olympic Games, the place had not long been returned to the awareness of the world. After the Roman Emperor Theodosius banned games in general in 394 AD, and thus also the Olympic Games, which he considered "pagan," the sanctuary was literally wiped away by a series of natural events such as earthquakes, floods and landslides. During the Byzantine era, a small village, Andilano, grew up in the *Altis* (the small grove that tradition says Heracles enclosed in honor of his father, Zeus, near the grave of the hero Pelops) and knowledge of the real location of one of ancient Greece's most famous and impressive monumental sites was lost.

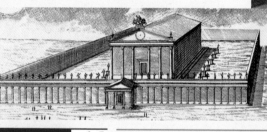

THE EXCAVATIONS

After the city had disappeared for centuries—aided by Turkish occupation—one of the founders of modern Greek historiography, Bernard de Montfaucon, was seized by the wish to rediscover Olympia. The famous Benedictine monk wrote to the archbishop of Corfu, Cardinal Querini, in 1723 requesting that excavation be organized in Elis, but in vain. Some decades later, J. J. Winckelmann obtained permission from the Sultan to excavate the stadium in Olympia, but he died and, the project was never carried out.

In those years the infrequent travelers to the valley of Olympia experienced a vague sentiment, an almost bucolic utopia, without having the faintest idea where the ancient sanctuary used to lie. The name of Olympia became a symbol to the young philo-Hellenes who traveled to Greece from all over Europe to help in the Greeks in their struggle for independence against Turkey.

As often happens, it was pure intuition that enabled the Englishman Richard Chandler to discover the

In 1787 Louis François Sebastien Fauvel was the first to draw the ruins, on the orders of Count Choiseul-Gouffier, the French ambassador to the court of the Sultan. The road had been opened, and finding and, above all, transportation of several figured metopes to the Louvre sparked a furious protest by the Greek government, which threatened to suspend the excavation.

exact location of the ancient city and provide us with its first description. In his *Travels in Greece* (1778), he tells how quite by chance he had learned some years previous of the existence of large ruins near the river Alfios, which he immediately connected with the great pan-Hellenic city. After visiting them, with enormous trouble but immeasurable satisfaction, he saw, among other things, the ruins of a great Doric temple, probably the temple of Zeus.

many scholars concentrated their interest on Olympia, two of whom were 1827 W. M. Leake and E. Dodwell, who made valuable drawings and annotations.

Following the battle of Navarino (1827), which was so decisive to Greek independence, and the expedition to Morea by General Marais, a French archaeologist, J. J. Dubois, opened a Byzantine church that had been built over PHIDIAS' workshop and in the area of the temple of Zeus. The

OPPOSITE TOP: THE FACE OF ANTINOUS.

OPPOSITE BOTTOM: INTERPRETATION OF THE TEMPLE OF ZEUS; SEVENTEENTH CENTURY.

ABOVE: THE PLAIN OF OLYMPIA, FROM *VIEWS OF GREECE* BY JOHN BAILEY, 1820.

TOP: PORTRAIT OF JOHANN JOACHIN WINCKELMANN, SEVENTEENTH CENTURY.

The decisive year for the fate of Olympia was 1874 when an agreement was signed between Wilhelm I of Germany and the new kingdom of Greece for excavation of the site. The great German historian and archaeologist Ernst Curtius began a major project that, over six stages (1875–81) systematically explored the central area of the sanctuary. With the help of

number of objects were discovered and classified: 130 sculptures, 400 inscriptions, 6,000 coins, more than 1,000 gold items, etc.

As early as 1852, in a conference in Berlin, Curtius had aired the idea of excavating Olympia, evoking an idealistic picture of Greece and the Greeks that included the themes—at the time very

topical in Germany—of patriotism and national unity. And, as it happened, the work begun in 1875 represented an act of national prestige. Certainly the name of Olympia, which now was to be heard in all manner of cultural and other circles, had awoken similar sentiments in Greece, and thus the agreement between the two countries was in the first

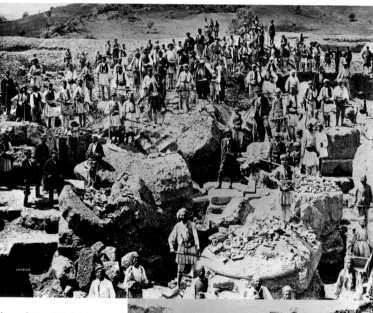

the architect Friedrich Adler, almost all the buildings in the *Altis* were uncovered, though no attempts at reconstruction were made, and the exact positions of buildings and objects were mapped. The accounts of the excavation report that a very high

TOP: GERMAN EXCAVATIONS IN THE TEMPLE OF ZEUS, 1876.

BOTTOM: VISIT TO THE REMAINS OF PHIDIAS'S WORKSHOP, 1891.

instance rejected by the Greek parliament. The document in question is of major importance in the history of ideas: for the first time, all materials found were declared the property of Greece and were to remain *in loco*; they were placed in a specially built museum with the "modern" intention of not separating the archaeological finds from their original context. Naturally, this raised a stir and much criticism in Germany, and Chancellor Bismarck, among others, never accepted Greece's renunciation of the original agreement.

A praiseworthy aspect of the German expedition was its rapid publication of the results of the project: between 1890 and 1897 the team released 5 volumes (plus 4 more of plates) edited by Curtius and Adler, allowing the great discovery to enter the realm of the scientific community. In 1894 Adler's drawings were published, followed shortly afterwards by model reconstructions. And the same meticulous care and an analogous attempt to shorten publication times marked the excavation work carried out by W. Dörpfeld between 1921 and 1930. More large-scale work was undertaken in 1936–41. Since 1952 until ttoday, periods of excavation have alternated with periods of study and systematic revision of the discoveries.

TOP: THE EXCAVATION OF THE STADIUM WITH THE HELP OF A TIP WAGON, 1958.

BOTTOM: DORPFELD POSES WITH COLLEAGUES ON THE SOUTH SIDE OF THE *HERAION*.

THE MYTH

To understand the history of the site, it is best to begin with the myth of the site. Pausanias provided a summary of the intricate traditions. The start of the games is associated with the infancy of Zeus: they were promoted by the Curetes brothers, whose duty was to look after the young god on Crete. When they moved to Elis, the games were unofficially begun when the brothers competed for fun in races. An alternative to this version is that Zeus beat his father Cronus at Elis. In the many myths that surround Olympia, two figures stand out: Pelops

and Heracles. This pair represent two layers in the historical understanding of the Greeks: the Mycenaean age of the Achaeans, and the age of the Dorians. Pindar and Apollodorus furnish the most valuable sources for the first of the two legends, i.e., the one that provides the more ominous version of the origins of the first Olympic race. In this, Oenomaus, the king of Pisa, wished to avoid his daughter Hippodamia getting married as an oracle had predicted Oenomaus' death by the hand of his future son-in-law. For this reason he had proclaimed a challenge with any suitors

that wished to present themselves: this was a chariot race with the prize being the hand of Hippodamia and death if the suitor should lose. The king felt certain of victory as his father, the god Ares, had given him a team of horses as fast as the wind and a highly skilled chariot driver—by fate, Myrtilus, the son of Hermes. But he wished to make it more difficult for the suitor by having him carry Hippodamia on his chariot. In the races the unfortunate suitor was always overtaken and killed. The heads of 13 young men had already been impaled in front of the palace when a prince from the East presented himself: this was Pelops, the son of Tantalus, lord of Lydia. Pelops was attracted by Hippodamia's beauty and the allure of the challenge. He therefore obtained winged horses from his divine lover Poseidon and succeeded in defeating Oenomaus.

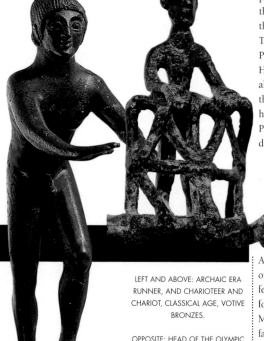

LEFT AND ABOVE: ARCHAIC ERA RUNNER, AND CHARIOTEER AND CHARIOT, CLASSICAL AGE, VOTIVE BRONZES.

OPPOSITE: HEAD OF THE OLYMPIC BOXER SATYROS, BRONZE PORTRAIT IN SEVERE STYLE.

According to another version of the myth, Hippodamia fell in love with the foreigner and convinced Myrtilus to sabotage her father's chariot; and, in another, it was Pelops who corrupted Myrtilus.

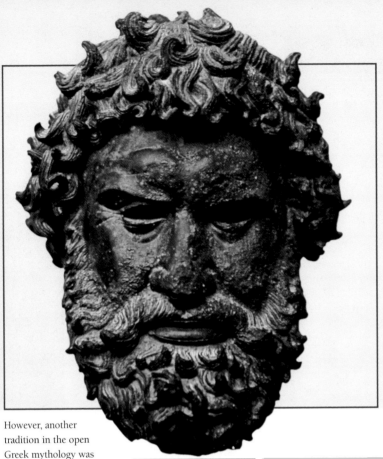

However, another tradition in the open Greek mythology was that Heracles was the founder of the games following his fifth, and least heroic labor: the cleaning of the Augean stables, which he did by diverting the courses of the Alpheus and Peneus rivers, but for which he was expelled from Elis. Heracles got his revenge by killing the king and founding the Olympic Games in honor of Pelops. As the place lacked trees to provide shade, Heracles returned to the country of the Hyperboreans where he took a wild olive tree from the springs of the Danube. And it was with a branch of this tree that the winners were crowned.

THE HISTORY

The existence of games, discussed even in antiquity, in 776 as part of the famous Panhellenic Games, is today considered inexact. The first phase of the sanctuary's history seems linked to the oracle of Zeus, which specialized in questions of war, —the valuable offerings found there were mainly weapons from the 10th to 8th centuries BC. However, even if the traditional date (776 BC) for the start of the Olympic Games is the result of *a posteriori* calculations, that period was one of the consolidation and increase in the prestige of the sanctuary.

As exists in other Hellenic sanctuaries, there was no preordained plan that could explain the establishment and gradual development of the cult's center. It appears to be the result of successive, unordered and unrelated architectural additions.

It was only in the Hellenistic age that an overall plan was introduced that gave the site a unitary appearance.

The proposed route centers on the historical development
of the buildings in the sanctuary and therefore starts from
the heart of the Altis. A visit to the excavations and
museum requires an entire day (or at least 4 hours).

Open 8 am–7 pm summer, 8 am–5 pm winter
(8:30 am–3 pm on Sundays).

OLIYMPIA

a *ALTAR OF ZEUS*
b PELOPION
c *TEMPLE OF HERA*
d *STADIUM*
e BOULEUTERION
f PRITANEION
g THESAUROI
h *TEMPLE OF ZEUS*
i *PHIDIAS'S
 WORKSHOP*
j *ENCLOSURE OF
 THE ALTIS*
k HEROON
l *"GREEK BATH"*
m *KLADEUS BATHS*
n THEOKOLEION
o METROON
p *SOUTHEAST
 BUILDING*
q STOA OF ECHO
r LEONIDAION
s *GYMNASIUM*
t PALAESTRA
u PHILIPPEION
v *NYMPHAEUM OF
 HEROD ATTICUS*

RIGHT: AERIAL VIEW
OF THE SITE.
COMPARE TO THE
MAP BELOW.

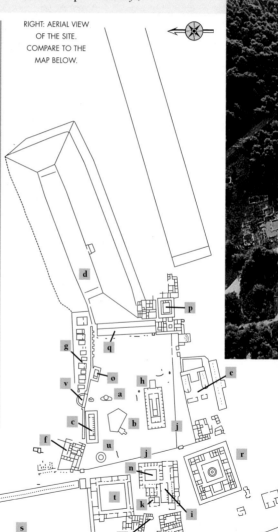

For a long period the *Altis* maintained a decidedly rural appearance. Until the first half of the 5th century BC Zeus had no "house" at all. A very ancient sacrificial **altar** (**a**) was dedicated to him that, according to at Olympia), and therefore the origin of the race was linked to the cult of Zeus associated with the heroic cult of Pelops. Indeed, the *Pelopion* (**b**) was in the immediate vicinity. In the area where the remains of an Early- and Middle- the Archaic age that was monumentalized into a prostyle tetrastyle structure at the start of the 4th century BC, at the time that the enclosure was reorganized on a polygonal plan typical of a *heròon*. The interior of the

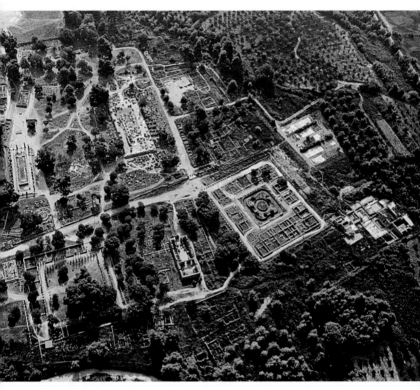

tradition, was built by Heracles. Every year the remains of the sacrifices were covered by ashes and thereby increased the height of the heap (in Pausanias' time its circumference was 125 feet and its height 22). The altar marked the finish line of the race in the stadium (initially the most important of the various competitions held Helladic village have been discovered, there is a small hill crowned by a circle of stones with a paved floor. This was probably a place of worship and the site of consultations to the oracle to whom the fortune of the sanctuary was owed in its earliest phase. Considered historically to be Pelops' tomb, a propylaeum was built in circle, where trees grew and statues were erected, was the site of the sacrifice of a black ram. In the 8th century BC, the presence not just of local people but those from neighboring regions is recorded, and a century later, the games had been opened to the entire Greek and colonial world. At this time the sanctuary had very few buildings.

The first monumental construction (toward the middle of the 7th century) was the **temple of Hera (c)**, which is considered to have represented the political influence of Argos. Our limited knowledge suggests that the temple was one of the precursors of the prescribed Doric order and a clear example of the builders' attempts to develop the monumentality of sacred buildings and to reconcile aestheticism with the technical problems posed by the roof. The foundations and remains of the aboveground structure were brought to light in 19th-century excavations that prompted an extended critical debate. The long peripteral temple is Doric in style, with 6 x 16 columns, and a distyle pronaos and opisthodomus *in antis*. The naos has an original layout in that the lack of a central row of columns to support the central beam of the roof benefits the cult statue; to achieve this, the central row was substituted by 2 series of 8 columns on 2 levels along the side walls. Almost all the columns of the peristasis have been preserved. They show clear differences in the materials

used, in the diameter of the shafts and in the form of the capitals: these evidently were inserted at later times to replace the earlier columns. These, according to the sources, must have had wooden shafts (Pausanias saw one made from oak in the opisthodomus) and wooden capitals lined with

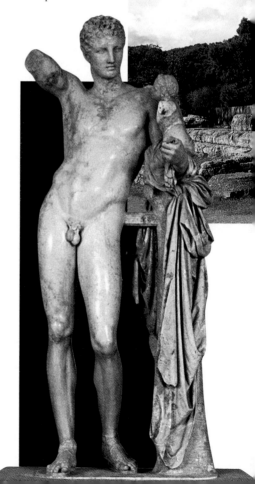

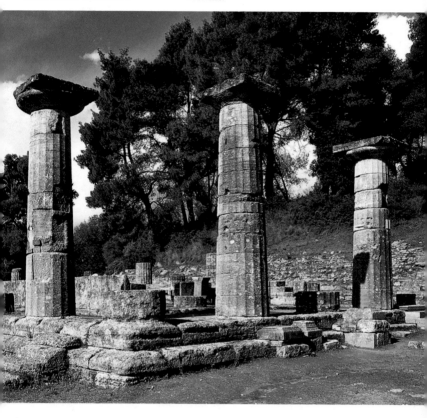

bronze. The transition from a wood to stone trabeation was related to the new layout of the naos mentioned above that gave better distribution of the loads. The roof was made from clay with flat and curved tiles typical of Laconia. Pausanias' description gives us to understand that the temple was a sort of museum. The walls of the naos had a series of "niches" to contain votive offerings, including PRAXITELES' very famous statue of **Hermes carrying the young Dionysus**. In addition to the cult statue, a simulacrum of Zeus was contained in the same naos. The opisthodomus was the location of the "chest of Cypselus," the tyrant of Corinth: this was a very valuable cedar chest decorated with ivory reliefs and gold leaf of mythological scenes related to Olympia. Another of the Cypselidis' (tyrant's) gifts was an image of Zeus made from embossed gold leaf and kept in the opisthodomus. But the most important piece was the bronze disk inscribed with the names of Iphitus of Elis and Lycurgus that document the institution of the Olympic Games and on which the regulations to which the *hellanodikai* (chief judges) had to adhere were inscribed.

"architectural" development that took advantage of the slope of Mount Cronios (phase 1). At the start of the 5th century BC, the track was closed off on the south side by earthworks topped by

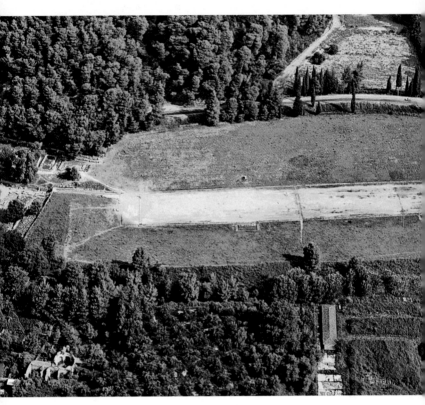

Substantial building related to the games took place in the 6th century BC. This was the period of the construction of the stadium, the *Bouleuterion* (the seat of the Olympic council), the *Pritaneion* (the place from which the sanctuary was administered) and many *thesauroi* (small temple-shaped buildings used to hold the votive offerings made by various cities).

Given the massive influx of the public, the temple of Hera no longer had space available.

We are able to see today that the **stadium (d)** was the product of successive building phases. Originally the racetrack was farther west by the altar of Zeus, in homage to the games' religious origin. The move of the race eastward coincided in the 6th century with a modest

numerous bronze votive offerings that had been displayed beside the track in the Archaic period (phase 2). In the 4th century BC, the stadium took on its present form with the addition of seats for the judges (phase 3a) and, circa 330–20 BC, a sidewalk alongside the track (phase 3b). The monumental entrance was a long, vaulted corridor built about 200 BC and an

elegant portal was added in 100 BC. Then, in the 1st century AD, the earthworks were redone and the altar dedicated to Demeter *Chamyne* was built.

Little is left of the

Bouleuterion (e) in which, in front of the judges, the athletes had to swear to observe the rules. Located to the south of the sacred area, its many rebuilding works and renovations eventually produced a square building (according to some, a simple court with a central altar) preceded by an Ionic portico (4th century BC) and flanked by two long apsidal sections (the north

one was 6th century BC, the other probably 5th century). The *Bouleuterion* had a central colonnade and a final room that was functionally similar to the *thalamus* (bed) in an Archaic house, but its use remains obscure.

The *Pritaneion* (f) was the official seat of the sanctuary's administrators and where the winners of the races and important guests were welcomed. It had a large central hypostyle reception room, a series of rooms for offering hospitality and kitchens. Deep excavation revealed the location of an altar that (with the aid of Strabo's writings) has been

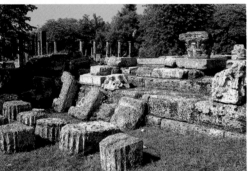

interpreted as dedicated to Hestia, and where the perpetual flame was kept burning.

At the start of the 6th century BC, a terrace was prepared between the stadium and temple of Hera for the *thesauroi* (g) (treasuries). Running from west to east we find those of Sicyon, Syracuse, Epidamnus, Byzantium, Sybaris, an anonymous one, Cyrene, another

anonymous one, Selinunte, Metapontus, Megara Iblea, and Gela. The oldest are those of Gela, Metapontus and Sybaris (first half of the 6th century BC) and the most recent are those of Syracuse and Byzantium. The treasury of 5th-century BC Sicyon was also rebuilt. As the architectural decoration was peculiar to each city, we are able to date the buildings by comparing the materials with those used in their respective homelands. Because of its sanctuary, Olympia was generally considered a center that imported works of art rather than a center of production, with the

exception of common objects or "minor" offerings that were produced locally, as was the case for large sites of popular devotion.

The first dedications on offerings and votive statues of athletes appeared at the end of the 6th century BC. A century later, the Greeks' resounding victories over the Persians to the east and the Carthaginians to the west provided the

opportunity for the continental and colonial *poleis* to demonstrate their pride. These donors made offerings that included the colossus of Zeus, given by the cities that participated in the battle of Platea; the bull made by the Eretrians to thank the god for saving their city from the wrath of the Persians; and an offering made by Phormis, a Syracusan general in the service of Gelon and Hieron. However, the major structure completed during the 5th century was the **temple of Zeus (h)**. It was built during the second quarter of the century in the center of the sacred grove (the *Altis*) in an area filled

Construction was completed in 456 when the Spartans placed a golden shield on the apex of the east pediment in commemoration of the battle of Tanagra. It was also inscribed with the name of the temple architect: Libon of Elis.

The temple marked the limits of religious architecture at the start of the Classical period. Its vigorous and solid proportions were faithful to an appearance of strength that was at that time characteristic of the Peloponnesus, and this is one of the reasons why the material used was a rather coarse local shell

the period. The base module was given by the measurement of the space between the columns in the peristyle (equal to 16 Doric feet [17'1"]). The measurements of the entire building—plan, raised section and details—were given by multiples and submultiples, for example, the overall measurements were 80 x 192 Doric feet, i.e., 5 x 12 modules, and the naos measured 48 x 144 feet (3 x 9 modules). In the same manner, the

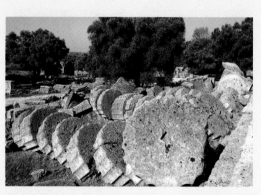

with votive monuments that were dismantled and buried beneath it. Some of them, which have been dated fairly accurately, confirm the written sources on the start of the work, which indicate that the temple was begun immediately after the military campaigns against Triphylia in 472–471 BC.

conglomerate. Another is that the rough surface provided a suitable base for stucco lining that was painted to emphasize the most important architectural features. The temple is a systematic representation of the modular principles that inspired the architects of

ABOVE: GROOVED BLOCKS FROM THE DORIC COLONNADE IN THE FIELD OF RUINS OF THE TEMPLE OF ZEUS.

RIGHT: ARTIST'S MPRESSION OF THE *ALTIS*, WITH THE TEMPLE OF ZEUS AT THE CENTER.

length of the metope-triglyph block, the eaves, and the parapet tiles is equivalent to given fractions of 1 module. The peristasis had 6 rows of 13 fairly massive columns that marked the first attempts at creating optical corrections by inclining the long sides and corner columns slightly inward in contrast to the perfect verticality of the front columns. This was to create a sort of upward thrust that was furthered by the particularly high platform created by an earth bank roughly 10 feet high. The platform had three steps, the last of which (the highest) was slightly curved horizontally.

The naos had a pronaos and distyle opisthodomus *in antis* and was raised compared to the side porticoes. It was divided into a nave and 2 aisles by 2 rows of 7 columns arranged in 2 stories, and with the central nave double the width of the aisles in conformity with the canons of the period. The naos was built to hold the statue of Zeus, and this is another problem posed by the temple. PHIDIAS was invited to sculpt the statue more than 20 years after the temple had been completed. Experts tend to consider that the artist was offered the prestigious commission after producing the *Parthenos*; in other words, after the year 438 BC.

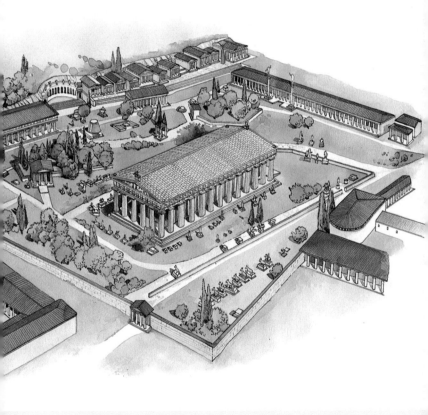

O L Y M P I A

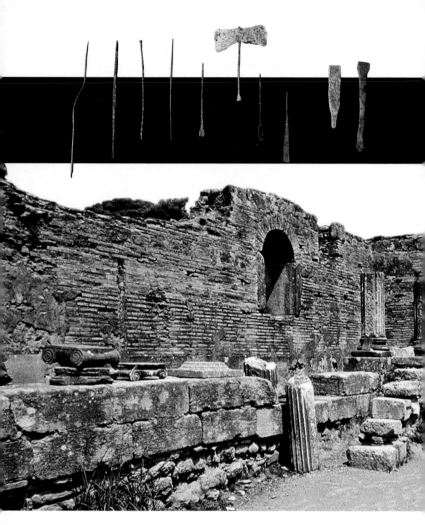

So that the master could work more easily (as well as to check the costly materials with which the statue had to be made), a **workshop (i)** was prepared with the same dimensions and orientation as the naos. The workshop was transformed into a church during the Byzantine period, and its true nature was only recognized in 1958 by E. Kunze. Research showed that below the walls were solid 5th-century BC stone foundations, and also work tools, including a small hammer, a small anvil, bone tools, fragments of ivory and other work materials, and glass ornaments. There were dyes for melting parts in gold and lead sheets to fix worked parts to the wooden support structure, and also objects in common use, for example a small pot on which was written *pheidio eimi* ("I belong to Phidias"). These objects and their forms and decorations together provide evidence for the dating of the workshop activity, which of course must have continued for some years.

The sources and certain coins minted in Elis during Emperor Hadrian's reign provide the only assistance in creating a picture of what was one of the seven wonders of the ancient world. (The others were the temple of Artemis in Ephesus, the Mausoleum of Halicarnassus, the Colossus of Rhodes, the Pharos of Alexandria, the Pyramids of Giza, and the Hanging

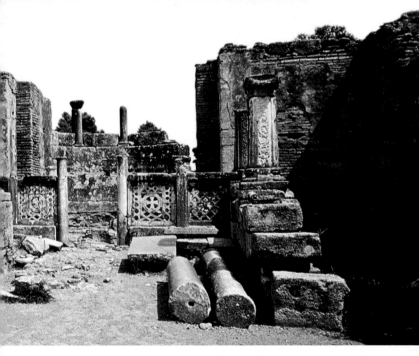

Gardens of Babylon). Strabo's opinion of PHIDIAS' statue was highly critical: "It was so large that, though the temple was of considerable size, the artist does not seem to have respected the proportions; he showed the god seated, but almost touching the roof with his head, so as to give the impression that if Zeus were to stand up straight, he would have lifted the roof off the temple" (Strabo: *Geography*, VIII, 3, 30).

To house the chryselephantine statue in a worthy manner, the naos was given a black marble floor from the third column from the entrance and the columns were linked by light walls from the second column so as to isolate the space that held the god. The base of the statue was placed at the back of the naos. The colossus was 42 Doric feet high (41 feet) and formed by gold leaf (*chrysos*) and ivory strips (*elephas*) over a wooden frame.

TOP ROW: CHISELS, A HATCHET, AND A BRACKET FROM PHIDIAS'S WORKSHOP.

BOTTOM PHIDIAS'S WORKSHOP; COLUMNS AND PARAPETS OF THE CHRISTIAN BASILICA THAT OCCUPIED THE BUILDING.

Pausanias provides a detailed description of the simulacrum (V, 11): "The god sits on a throne and he is made out of gold and ivory. On his head he wears a crown made to look as if it were made from an olive branch. In his right hand he holds a statue of Victory which is made of ivory and gold too; she wears a ribbon and on her head is a crown. In the god's left hand is a scepter, decorated with every kind of metal. The bird on the end of the scepter is an eagle. The god's sandals are also made of gold and so is his robe; animals and lilies are represented on his robe." He continues with a detailed description of the throne that gives us an enlightening view of the approach that the ancients took to works of art in general, which is much different from the modern view. Pausanias goes into a highly detailed description of the complex depictions of painted and sculpted mythological subjects, generally associated with the myths of the Peloponnesus—but no mention is made of their quality.

On this score it seems suitable to bear in mind an Olympia-related episode in the Greek trip of Lucius Aemilius Paullus after the victory over Perseus of Macedonia in 168 BC. Livy (*Histories*, XLV, 28) tells us that, having entered the temple of Zeus, the consul: ". . . turning his gaze upon the statue of Jove, as though he were in front of the god himself, he was strongly impressed. And so, as though he were preparing to sacrifice in the Capitol, he had a more magnificent sacrifice than usual prepared."

More than an example of aesthetic sensitivity, this episode seems to fall within the realm of devoutness; the prevalent approach to the piece of art is unquestionably of a religious nature, and is particularly justified given the importance of the artist. The vision of the god is the primary experience, and the reaction – a large sacrifice – a religious one.

Whereas in modern cultural tourism a certain utopian sentiment exists of wishing to experience a site from the standpoint of the art that was associated with that site, it was very different in the ancient world. For the ancients, the experience of the countryside was above all closely bound up with mythology, in both a religious and (pseudo) historical sense. The countryside was marked by sacredness: a mountain, cave, river, spring, wood or even a tree were inhabited by the gods; and then there were the features of the landscape considered associated with heroes: the tomb of one, walls built by another, etc.

And so the most notable works of art were found in sanctuaries where they had their original religious function. To the visitors to these sanctuaries, the function of the form of the works of art—when they were of interest or relevance—was to exalt their content. Therefore ancient descriptions of statues, reliefs, paintings, and so on. almost always focused exclusively on the myth. Consider, for instance, what Pausanias tells us of the sculptures that decorate the temple, and which fortunately have survived to the modern day:

RIGHT ARTIST'S IMPRESSION OF THE NAOS IN THE TEMPLE OF ZEUS, WITH THE CHRYSELEPHANTINE STATUE OF THE GOD BY PHIDIAS.

OPPOSITE BOTTOM DORIC CAPITAL IN THE TEMPLE OF ZEUS.

he does not say a word about the artistic quality of what to us moderns is one of the most important sculptural cycles of antiquity, but gives a description only of what the works represent.

The main pediment—the east one—was illustrated with preparation for the race between Oenomaus and Pelops in the presence of

the capture of the wild horses of Diomedes, Geryon, the apples of the Hesperides, Cerberus, and the Augean stables. What was important was to account for the origin of the cult.

Although we have the name of the architect, we know nothing of the men who conceived and built the extraordinary complex. In

however, connected with the temple in one way, for it was Paeonius who sculpted, on the east side of the sacred building, the famous Nike dedicated by inhabitants of Messenia and Naupactus to mark the victory over the Spartans in 425 BC at Sphacteria. And, as the inscriptions tell us, Paeonius was also responsible for the acroters on the temple itself.

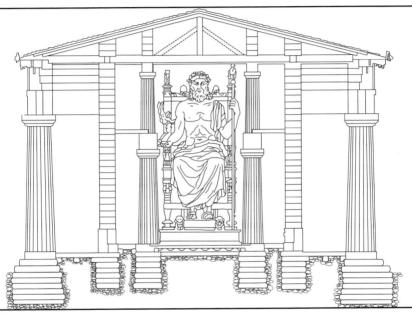

Zeus, and the west pediment represents the centauromachy of Theseus. The metopes of the pronaos and opisthodomus (the only ones decorated) show the 12 labors of Heracles: to the west, the Nemean lion, the Hydra, the man-eating birds of the Stymphalian marshes, the Cretan bull, the elusive hind of Arcadia, and the taking of the girdle of the Amazon queen, Hippolyte; on the east pediment there are: the boar of Erymanthus,

spite of heated debate, experts have not succeeded in attributing the sculptures to a known artist. The names cited by Pausanias— Paeonius of Mendes for the east pediment and the Attic sculptor Alcamenes, a pupil and collaborator of PHIDIAS, for the west one—are certainly incorrect due to misdating by a generation. Both were active later in the century than the period in which the workshop operated. Both were,

Alcamenes, on the other hand, was probably responsible for restoration of the west pediment, as three statues there are carved from Pentelic marble (which comes from Attica)where as all of the ot statues are of marble from Paros.

The moment immediately before the race between Pelops and Oenomaus is represented on the east pediment. In a space clearly in between the personifications of the rivers Alpheus and Cladeus, the chariots of the contestants are shown with drivers, stable boys, and affairs. At the sides stand the contenders: on the right (the side of victory) we see Pelops with Hippodamia, on the left, the cruel king with his wife Sterope. The theme on the other pediment is the struggle between the Lapiths and the Centaurs at the wedding of Perithous and Deidamia. holds a Lapith woman. To the left Perithous, clutching a club, attempts to free his wife from the clasp of the centaur Eurytion. Groups of fighters follow one another into the angles of the gable where figures of Lapith women attempt to contribute to the battle half-lying down.

two elderly figures, who have been interpreted as soothsayers. In the center the figure of Zeus is invisibly present in human Apollo occupies the center of the composition, with Theseus on the right, who, with a double-bladed axe, challenges a centaur that

ABOVE THE LABORS OF HERACLES IN THE METOPE IN THE TEMPLE OF ZEUS. (LEFT), THE APPLES OF THE HESPERIDES,(RIGHT) THE AUGEAN STABLES.

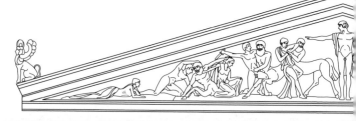

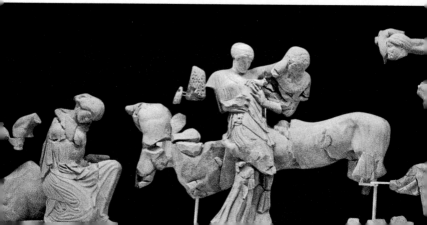

The harmony of the sculptures is apparent in the iconography, style, and composition, though, in the last case, the figures on the east side are more static than those on the west; however, this is justified by the scene being represented. Attempts to recognize the hand of different artists in the conception of the project have always been unsuccessful, and the idea of a single master (first proposed by E. Loewy in 1914, then supported and improved by E. Langlotz in 1934 and G. Becatti in 1939) is today pretty much accepted. On the other hand, it is possible, nay necessary, that more than one executor worked on the carvings as a single sculptor could not have produced

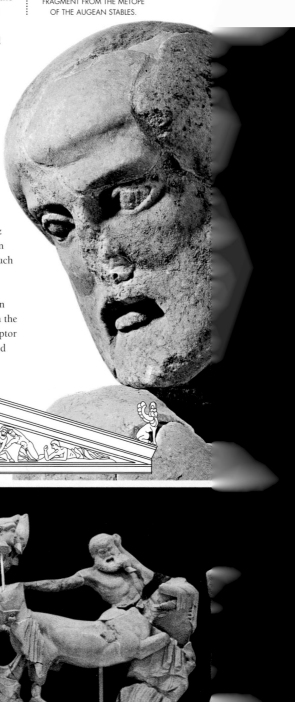

all the figures involved. The likelihood is that the entire cycle was conceived by a single person: a master whose responsibility it was to run the workshop and provide the sketches for others to work from. No doubt he would also have collaborated on the creation of the figures. It is difficult to believe that such an important and prestigious work could have been awarded to an artist who was not already established on the international scene as a creative personality, and who could also manage a workshop team.

Today it is recognized that the sculptural works' stylistics are not related to any of the other known workshops that produced pediment statuary in Parian marble: not the one that carved the east pediment of the temple of Athena *Polias* in Athens, nor that of the temple of Apollo *Daphnephoros* in Eretria, nor that of the east pediment in the temple of Apollo of the Alcmaeonids in Delphi. In consequence, the title "the Master of Olympia" has been given to the unknown artist. Of all the hypotheses, the most dwelt upon is the one that sees a link with the painting of Polygnotus and Micon.

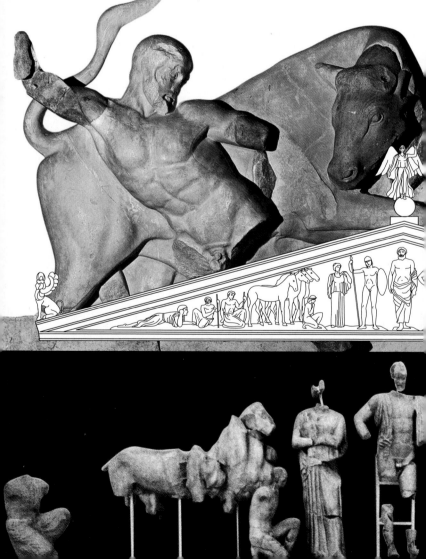

Olympia's "golden age" was the 5th century. After Triphylia was conquered, the synoecism of Elis promoted, democracy adopted (under the influence of Athens), the festivals extended to 5 days, and the *hellanodikai* increased in number from 2 to 10, a period of intense building and dedications of votive monuments began for the sanctuary.

RIGHT: HERACLES AND THE CRETAN BULL, FROM A METOPE IN THE TEMPLE OF ZEUS.

BELOW: HERACLES FIGHTS THE CRETAN BULL (LEFT) AND RECEIVES THE CASTANETS WITH WHICH TO FRIGHTEN AWAY THE STYMPHALIAN BIRDS (RIGHT).

LEFT: CENTAUROMACHY: RECONSTRUCTION OF THE WEST PEDIMENT (BELOW) AND FRAGMENTS.

OPPOSITE: HERACLES DEFEATS THE NEMEAN LION, RECONSTRUCTION OF A METOPE.

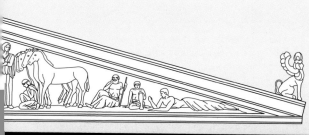

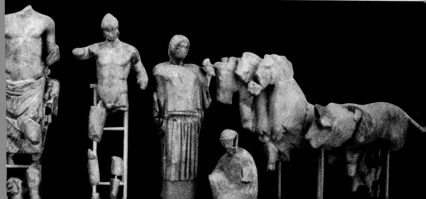

The construction of the temple of Zeus has been discussed above. Now came the first wall of the peribolos of the sacred grove, the *Altis* (**j**). The constructions were grouped together in the area just west of the enclosure. One of these was the so-called *heròon* (**k**), an enigmatic building featuring a portico that led to a rectangular area and a room containing a ring of orthostats: a number of dedications to an unspecified "hero" were found in this room, whom some experts consider to have been PHIDIAS. In this case the dedications would have been made by a body of people responsible for the maintenance of the colossus of Zeus, the *phaidyntai* ("polishers"). Next to this

room was the "Greek bath" (**l**), which was replaced in the Roman era by the so called **Cladeus baths** (**m**). The baths were composed of a single room for individual baths and a large communal pool. Another building was the *theokoleion* (**n**), which is traditionally considered to have been the official seat of the high priests, though it was actually a gymnasium or building for the temporary residence of less important sanctuary staff linked to the sports

activities. Between approximately the end of the 5th to the start of the 4th century BC, in addition to the fitting out of the *Pelopion* already mentioned, construction of the **Metroon** (**o**) took place. This was a peripteral Doric building of 6 x 11 columns, and the third largest temple in the sanctuary. Dedicated to the chthonic cult of Rhea, it was transformed during the Roman era into a place of worship dedicated to an imperial cult. Another building that is difficult to decipher is what is known as the "**southeast building**" (**p**): this has four square rooms preceded by a Doric portico and court that functions like the sanctuary of Hestia. Enlarged to the east and south in the 2nd century BC, it was transformed in the 1st century AD into an ordinary house traditionally referred to as Nero's residence. In the 3rd century AD, it underwent further work to turn it into a baths building. An earthquake in 374 BC and devastation following the conflict between the Arcadians and Elidians in 364 made new building work necessary, during which an attempt was made to give the sanctuary a unified appearance by defining the central space with the construction of porticoes. The result was the South Stoa—or Proedria, which gave the approach to the *Altis* a solemn backdrop—and the **Stoa of Echo** (**q**) or *heptaphonon* ("of the seven voices") also

known as the stoa *poikile* ("painted stoa").

The *Leonidaion* (**r**), named after its donor, Leonidas of Nassus, was a gigantic rectangular structure with a central peristyle used to accommodate distinguished athletes participating in the games. The function was maintained into the Roman era when, owing to the progressively smaller numbers of noble participants, the building housed the governor of Achaea. The famous *Zanes* (from *Zan*, Archaic for Zeus) were life-size bronze statues of Zeus that stood on the east side of the central area. They were funded by the fines paid by athletes who broke the sporting regulations.

Few but significant alterations were made during the Hellenistic era. The **gymnasium** (**s**) was built outside the enclosure; this was used to train for running races, jumping, and discus and javelin throwing. It was fitted with a *xystus* (a covered track a conventional stade long (629 feet)), and an elegant propylaeum represented the passage to the sanctuary. There was also a **palaestra** (**t**) that was reserved for wrestling and boxing practice.

The *Philippeion* (**u**) was a fairly important building constructed by Philip II of Macedonia after the battle of Chaeronea in 338 BC. It was a *thòlos* of roughly 50 feet in diameter, with 18 Ionic columns in the peristasis and 9 Corinthian half-columns inside the naos. It harked back to monuments typical

of heroic cults and marked the start of the celebration of the dynasty that was becoming common in the sanctuary: already located there were chryselephantine statues (all by Leochares) of Philip, his wife, his parents, and his son Alexander. Soon there was to be a series of equestrian statues honoring the Diadochs (the successors of Alexander the Great) and, in the Roman era, the most important locations in the sanctuary

Rome, everything at Olympia returned to normal under Augustus. In general the imperial era brought restoration of the site and few changes. However, the most important were the enlargement of the enclosure, construction of monumental gates, transformation of the *Metroon* into a place for the imperial cult, and construction of the **nymphaeum of Herod Atticus (v)** (roughly 160

four baths complexes were erected during the imperial age. The invasion of the Herulians in 267 AD was a sharp blow to the sanctuary's splendor. The result was the construction of fortifications at the expense of the buildings around the temple of Zeus and the *Bouleuterion*, but little else. As mentioned, the edict of the Christian Emperor Theodosius against the pagan games brought a sudden end to the life of the sanctuary, which was,

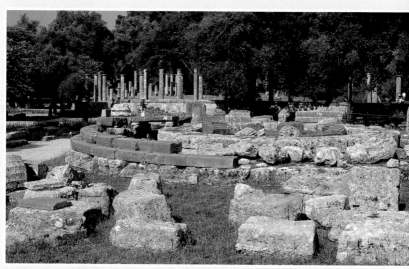

were to be occupied by the images of the new conquerors.

In 146 BC, CA. Mummius placed 21 gold shields in the temple of Zeus representing the peoples defeated by the Achaean League and, at the same time, the Elidians offered an equestrian statue. After the sanctuary was looted by Sulla (to subsidize the war against Mithradates VI Eupator, king of Pontus) and the "sacrilege" Sulla perpetrated when he transferred the games to

AD) with the aim of putting an end to the chronic lack of water during the season of the games. The building was simply a monumental exhibit of the water conveyed to Olympia by a long aqueduct. The exedra contained the statues of Herod, his wife Regilla and the imperial family. Houses were gradually built around the sanctuary for rich Romans visiting the games, and, with the increase in the visiting public, the services offered were also increased:

however, already in decline. The transfer of PHIDIAS' colossal statue of Zeus to Constantinople did not ensure its survival: it was destroyed by a fire in 475. The temple of Zeus collapsed after an earthquake in the 6th century AD.

......................................

OPPOSITE: CORINTHIAN CAPITAL FROM THE "SOUTH PORTICO," TO THE SOUTH OF THE *BOULEUTERION*.

ABOVE: THE CIRCULAR BASE IN THE *PHILIPPEION* AND, IN THE BACKGROUND, THE COLONNADE OF THE *PALAESTRA*.

THE MUSEUM

The museum has the same opening hours as the excavations except for Mondays: 12 pm–7 pm summer; 11 am–5 pm winter. Tel. (0624) 22 517 / 22 529.

The museum is a vast, modern building with a collection of the materials found during the enormous excavation of the site. The pieces are displayed chronologically and thematically. The *vestibule* has two models of the sanctuary as it appeared when complete. The visit then continues in *Room 1* on the left; here there are objects from the Mycenaean and Geometric Ages, including the two most important items in the museum: a **bronze horse** and a "**Homeric**" **helmet** decorated with boars' teeth. *Room 2* has a fine collection of votive **bronzes** dating from the end of the Geometric Age through all of the Archaic. It includes armor, helmets, chestplates, shinguards, shields and

...

ABOVE: BRONZE GRIFFIN; METAL BOSS OF AN ORNAMENTAL SHIELD.

LEFT: BRONZE HORSE, ORIGINALLY ONE OF A FOURSOME. ARGIVE STATUETTE.

OPPOSITE TOP LEFT COLOSSAL HEAD OF THE CULT STATUE OF HERA, TAKEN FROM THE *HERAION*.

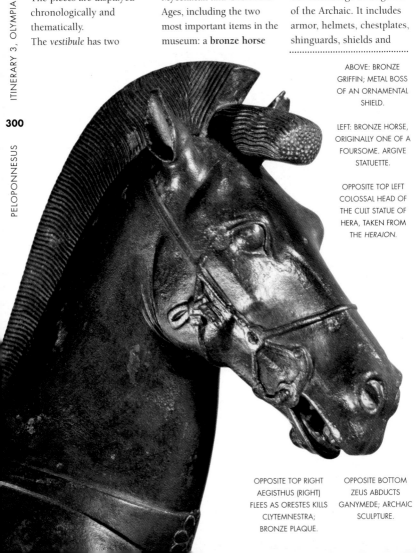

OPPOSITE TOP RIGHT AEGISTHUS (RIGHT) FLEES AS ORESTES KILLS CLYTEMNESTRA; BRONZE PLAQUE.

OPPOSITE BOTTOM ZEUS ABDUCTS GANYMEDE; ARCHAIC SCULPTURE.

many weapons made in Corinth, Chalcidea, and Crete. Some are engraved with mythological scenes, for example, a mid-7th-century BC back plate shows Apollo playing the lyre accompanied by two

containers adorned with the heads of griffins or lions. Fragments of stone statues lie at the back of the room, including the famous **head of Hera** (roughly 560 BC) from the temple of the goddess.

pediment of the Treasury of Megara (500 BC) made from stone. In addition there are pots from Attica, Corinth, and Lacedaemonia, and a number of bronzes, including a lovely horse's head.

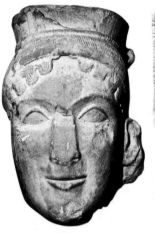

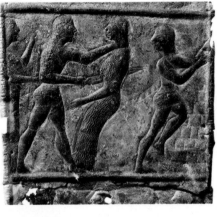

Hyperborean girls in the presence of Zeus and two youths (maybe spirits). One of the helmets was offered by Miltiades, the victor in the battle of Marathon. Worthy of note is a rare example of a **statue of a winged female** (early 6th century BC) made of hammered bronze. Interesting pieces incude the **bronze reliefs** decorated with heroic scenes (the gifts of dynasties or cities), one with the Lapith Kaineos struggling against Centaurs (mid-7th century BC), one with a female griffin suckling her young (approximately 625 BC), one of Heracles and the *Potnia theron* (roughly 600 BC), and large oriental

Room 3 contains reconstruction of the first version of the **pediment of the Treasury of Gela** (c. 560 BC) made from polychrome terracotta, and the reconstruction of the

Room 4 has fine examples of clay statuary from the late Archaic and Severe periods, including a **head of Athena** wearing a diadem of flowers (c. 490 BC) and one of the masterpieces of Severe style: the **clay group of Zeus and Ganymede** (470-65 BC). The god is shown abducting the youth, who has made a gift of a cock. The sculpture has strong formal analogies with figures on the pediment of the temple of Zeus. The strength of the composition lies in the contrast between the stately majesty of the cloaked god and the delicate grace of the youth (who childishly holds onto his gift at this dramatic moment). A window on the right-hand side displays objects found in PHIDIAS' workshop.

An exedra in line with the entrance holds the famous statue of **Nike** by PAEONIUS OF MENDE (c. 425 BC). The sculptor, originally from Thrace, here takes to the extreme the expressive possibilities offered by PHIDIAS' stylistic element of "wet" drapery. By asking us to imagine the wind blowing down onto the goddess's body, the artist makes his representation of her clothing a demonstration of his technical skill: parts of it are diaphanously transparent, others bunched into whirls of folds, transformed almost into a veil, the only limitation on his depiction being the material with which he was working. Continuing to *Room 5*, we find sculptures from the Classical Age, including a lovely marble **head of Aphrodite** attributed to PRAXITELES, a **head of an athlete**, and another of **Alexander the Great**. Another interesting exhibit is the clay guttering from the *Leonidaion* (c. 350–25 BC c.). A small detour is to the statue of **Hermes carrying the young Dionysus**, displayed in its own room. This is a masterpiece from the mature period of PRAXITELES' art that was found in the naos of the temple of Hera. The attribution to PRAXITELES has long been controversial. The PRAXITELES to whom Pausanias refers (V, 17, 3–6) was been identified by some as an artist of the 2nd century BC; however, today

the tendency is toward the master of the 4th century BC. In this sculputure PRAXITELES carries to the extreme his sensibility for the nude. The face of the god is portrayed with an expressive use of color that is almost Manneristic. The subtlety of the shading displays masterly skill and the polishing of the surfaces an intense contrast to the rough modeling of the drapery and hair (perhaps originally gilded). The statue has as its theme the intellectual understanding between an adult and a child created by PRAXITELES' father, CEPHISODOTOS, in his "Eirene and Ploutos." *Room 6* holds sculptures from the

Roman period. The most impressive are the **imperial** ones from the *Metroon*: there is a lovely **Antinous** and **statues** from the Nymphaeum of Herod Atticus.
Room 7 is dedicated to the Olympic Games, with inscribed Archaic bases, small bronzes, terracottas, and accessories related to the games and sport in general, including *halteres* and strigils (curved instruments for cleaning athletes' bodies after the competition).

ABOVE: HEAD OF A MACEDONIAN STATUE.

LEFT: RECOMPOSED FRAGMENTS OF THE NIKE DONATED BY THE MESSENIANS AND NAUPACTIANS; WORK BY PAEONIUS OF MENDES.

OPPOSITE FACE OF ANTINOÒS.

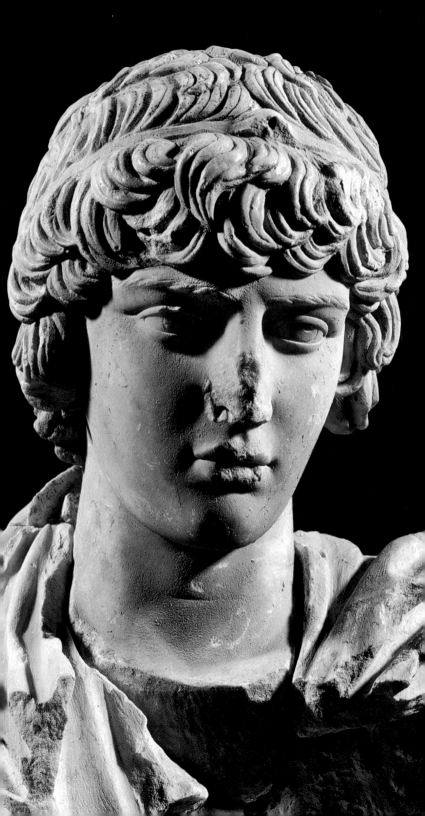

The museum's major *central room* is dedicated to the temple of Zeus. A still unresolved problem is the arrangement of the figures, particularly those on the east pediment. The order of the sculptures on the pediment given by G. Treu in volume III of his *Excavations at Olympia* has often been contested. In one of the most important publications on this subject, edited by B.

groups. As for the **east pediment figures**, opinions diverge concerning the position of Pelops and Oenomaus. It is uncertain whether their placement to the right or left of the god

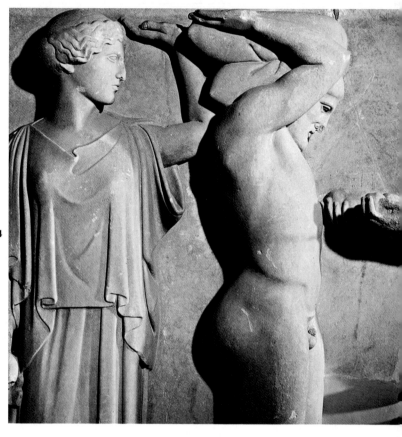

ABOVE: METOPE FROM THE TEMPLE OF ZEUS; ATLAS GIVES THE APPLES OF THE HESPERIDES TO HERACLES, SUPPORTED BY ATHENA.

OPPOSITE LEFT: THE "SOOTHSAYER," FROM THE EAST PEDIMENT.

OPPOSITE RIGHT: DETAIL OF THE STATUE OF APOLLO, THE CENTRAL FIGURE IN THE WEST PEDIMENT.

Ashmole and N. Yalouris in 1967, both scholars proposed different arrangements of the statues, particularly those on the east pediment. The current layout of the **west pediment figures** has greater balance with the two heroes of the centauromachy—Theseus and Pirithous—to the right and left of the central figure of Apollo and with the inversion of the two-figure

respectively, as Pausanias has described, relates to the figure of Zeus or the viewpoint of the observer (in the current arrangement in the museum, Pelops has been placed on the viewer's left).

Also unresolved is the identification of the **two female figures**. The one with the belted peplos who raises the end of her garment with her right hand

seems more inexperienced and youthful, even within the Severe interpretation put upon her portrayal, and would therefore represent Hippodamia. The other appears more gentle and is

shown with crossed arms in the characteristic pose denoting mourning; she would therefore more logically seem to be Sterope. Nor is it certain whether Zeus had his head turned to the right or left. As with the drapery, the nude figures on the pediments share considerable unity in the manner in which they have been depicted, some being vigorous and natural, others

compact and physical. The wide, squashed folds are indicative of an approach typical of the clay figure modeler (and therefore of a bronze sculptor) rather than of a sculptor in marble. This hypothesis is supported by the use of the burin, a technique we see in the surprising details which, despite the tendency to wide and simple surfaces, appear in the rendering of the hair and beards. Also use of the modeling stick can be ascertained in places in the distribution of volumes, the extreme simplicity of the fall of the peplos, in the "eye-shaped" folds and in the waves of bent or moving figures. In combination with the bold schema that creates interaction between the

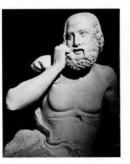

figures and the foreshortened views that typify the busy and elaborate composition of the west pediment, the whole is therefore more reminiscent of a two- rather than three-dimensional approach, which suggests the conception was by a painter. The figures on the east pediment were portrayed with a balanced stillness to refer to the solemn and

tragic composure of the athletes while waiting for the race. The **figure of Zeus** is the most stylistically evolved of those on the pediments, whereas that of Apollo is the most conservative and still linked to the Severe style.

The lack of details in certain unified masses, for instance in several caps worn by the men and women, suggests heavy use was made of color.

All the comments made about the pediments would also seem to pertain to the metopes, the theme of which is the twelve labors of Heracles. As one of the greatest experts on Greek art, Giovanni Becatti, has stressed, "a new human sense chooses [in the

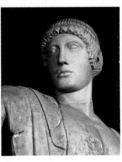

labors] the most moving moment of Heracles' various deeds …, not so much illustrating the culminating moment of the feat as the hero's state of mind in relation to the effort expended and to the confident support of Athena." In these metopes Heracles is the personification of the last aristocratic Archaism, of the ethics that Pindar described in his odes.

THE OLYMPIC GAMES

The official document that instituted the Olympic Games is a bronze discus that Pausanias claims to have seen in the temple of Hera (Aristotle had already considered it the most important "monument" in the history of the Peloponnesus). It was inscribed with the regulations of the *ekecheiria*—the sacred truce established by Iphitus of Elis and Lycurgus of Sparta—in keeping with the wishes of the oracle of Delphi. It represented a sort of international law accepted by all the Greek cities that recognized the region of Olympia as being sacred and inviolable during the period of the games. It prohibited the passage of armed forces through its territory and guaranteed safe conduct to all participants at the festivities. The punishments for offenders were very severe. The full moon following the summer solstice marked the start of the month-long *ekecheiria* (the training and qualification rounds having been held in the period running up to the games). The four-yearly cadence of the games formed the basis of the Hellenic calendar.

Initially the games consisted of a single race: *stadion*, a running race over the distance of the stadium, i.e., 600 Doric feet, equal to approximately 210 yards. Other competitions were added in this order:

1st Olympiad, 776 BC: *stadium*
14th Olympiad, 724 BC: *diaulos* (race double the distance of the stadium)
15th Olympiad, 720 BC: *dolicos* (endurance race)
18th Olympiad, 708 BC: *pentathlon* (five contests: discus, long jump, javelin, running race, wrestling), *pale* (wrestling)
23rd Olympiad, 688 BC: *pygme* (boxing)
25th Olympiad, 680 BC: *tetrhippon* (chariot race with four horses)
28th Olympiad, 648 BC: *pankration* (wrestling), *keles* (horse race)
66th Olympiad, 520 BC: *hoplites dromos* (race in armor)
93rd Olympiad, 408 BC: *synoris* (chariot race with two horses)
96th Olympiad, 396 BC: musical contest for heralds and trumpeters.

Some of these races (*stadium, pale, pentathlon,* and others) also existed for boys. The routine was as follows: the athletes were informed of the rules by a

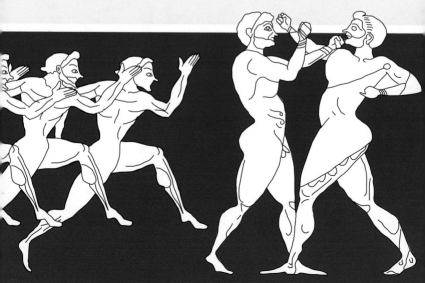

"panel" of 10 *hellanodikai*; they then took an oath before the *Boule*. A palm leaf was presented to the winners, who, on the last day, would also receive the wreath of wild olive branches called the *kallistephanos*. However, a progressive decline in the games' ethical and religious values led to an increase in professionalism during the Hellenistic and Roman eras, with consequent prizes of valuable objects and money. Pausanias remains our most reliable source of information relating to the competitions.

The first list of winners was drawn up by Hippias of Elis at the end of the 5th century BC, but was later revised by Aristotle; however, both versions have been lost. The list we have today, updated in 217 AD, was by the Christian chronographer Sextus Julius Africanus. Despite being somewhat unreliable, it demonstrates how the fame of the sanctuary and games progressively grew: the first winners were all from Elis, then Peloponnesians were recorded, then Attic athletes, then Greeks from Asia Minor, and finally also from the western colonies. The cities from which the winners came erected statues in their honor, and great poets, such as Simonides, Bacchylides, and Pindar drew inspiration from the games to write odes in honor of the Olympic champions. (S.M.)

BELOW: DRAWINGS OF DECORATIONS ON POTTERY WORKS AND STATUES FROM THE ARCHAIC AND CLASSICAL ERAS. LEFT, SPRINTERS; CENTER, BOXERS; RIGHT, DISCUS THROWERS WRESTLERS, AND SPRINTERS.

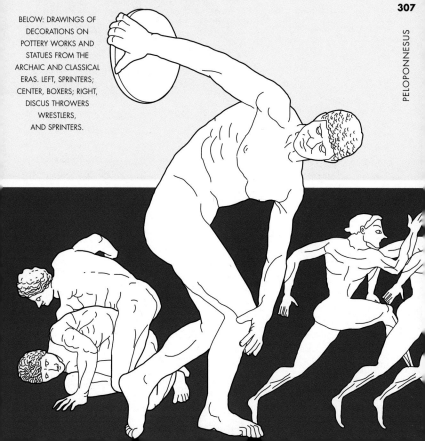

3.3

PATRAS

that Triptolemus once fell asleep, and that then Antheias, the son of Eumelus, yoked the dragons to the car of Triptolemus and tried to sow the seed himself. But Antheias fell off the car and was killed, and so Triptolemus and Eumelus together founded a city, and called it Antheia after the son of Eumelus. Between Antheia

The capital of Achaea, Greece's second port, and its third largest city, Patras appears to the visitor as though it had no past. Its modern, chaotic, and in places, graceless appearance is due to its recent history. Though it can boast origins far back in history, it was very active in the struggle for independence and suffered violent retaliation at the hands of the Turks, who

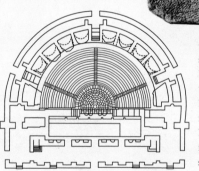

burned it to the ground. The unorganized industrial growth of the 20th century did the rest, wiping out the neo-Hellenic stamp of its rectilinear street system, squares, and dignified townhouses, which had been rebuilt during the administration of President Capodistria around 1830.

"About eighty stades from the River Peirus is the city of Patrae. Not far from Patrae the River Glaucus flows into the sea. The historians of ancient Patrae say that it was an aboriginal, Eumelus, who first settled in the land, and that he was king over but a few subjects. But when Triptolemus came from Attica, he received from him cultivated corn, and, learning how to found a city, named it Aroe from the tilling of the soil. It is said

and Aroe was founded a third city, called Mesatis. . . When afterward the Achaeans had driven out the Ionians, Patreus, the son of Preugenes, the son of Agenor, forbade the Achaeans to settle in Antheia and Mesatis, but built at Aroe a wall of greater circumference so as to include Aroe within it, and named the city Patrae after himself." That is how Pausanias (VII, 18, 2–5) described the origins of the synoecism (urban growth by fusion of small cities) that brought the city into being. In the Archaic Age the villages of the area were sparsely populated. The importance of Patras

increased in the 3rd century BC as a result of its pre-eminent position in the Achaean League. After the conquest of Greece, Rome's interest in the city gave a stimulus to the economy and subsequently the layout of the city. Augustus brought about the definitive centralization of the parts of the city in a colony whose

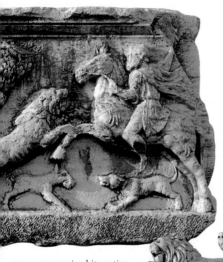

name summarized its entire history: *Colonia Augusta Aroe Patrensis*. Various public buildings stood inside the acropolis whose materials were reused to build the walls of the Frankish (later Turkish, then Venetian) fort, one of the largest in all Morea. The **agora** with the main sanctuary dedicated to Zeus stood in the "lower city"; the site of the sanctuary is now occupied by the church of the Pantokrator. The ruins of the Roman city are more extensive. The **odeon** is the only ancient monument still entirely visible. Standing close to the agora, it was, according to Pausanias, "the

most beautiful of those in Greece." Built in brick at the time of Pausanias' visit (2nd century AD), this covered theater for musical and poetic performances had a cavea lined with marble and a stage decorated with niches. The *scaena frons* had the usual three doors and niches for statues. Today it is known that an amphitheater once existed in the city (end of 1st – start of 2nd century AD). Recent excavations have confirmed Pausanias'

description of Patras as a flourishing city (owing to its trade in cotton and fine linen); a number of houses have been discovered, with good quality mosaics and services (basins for collecting water, small hot water systems, gardens, etc.). St. Andrew preached in Patras and the head of the saint—as well as a relic of the cross on which he was martyred—is kept in the neo-Byzantine church dedicated to him. (S.M.)

SICYON

> "… Sicyon was long the homeland of painting. But later all the paintings belonging to the public domain were put up for auction to pay off the city's debt and Scaurus had them taken to Rome during his magistracy."
> [58 or 56 BC]
> Pliny, *Natural History*, XXXV, 127.

THE HISTORY

The 7th and 6th centuries BC were a sort of golden age for this ancient city (of Mycenaean origin?). The tyranny of the Orthagorids made it one of the first artistic centers in Greece, as Greek literature attests, in particular painting. Craton, a contemporary of the Corinthian Creanthes (end of 8th–start of 7th centuries BC), is considered to have invented colored drawing when he drew the outlines of a man and woman on a clay tablet and painted the inside of the figures with a technique different to that he had employed in the background. Telephanes, on the other hand (early 7th century BC) is considered to have invented the use of lined details within figures. Today, however, experts tend to attribute the famous painted wooden tablets found in the cave of Pitsà (close to Sicyon) to Corinthian workshops

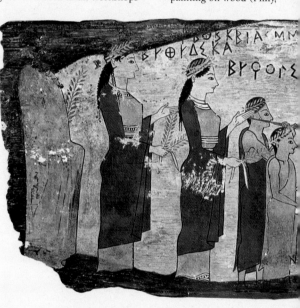

(second half of the 6th century BC; now in the National Museum in Athens). Certainly the city was the seat of a very important school of painting, as Pliny tells us, at which masters such as Eupompos, Pamphilos, Pausias and Apelles

studied. In the 4th century BC the first thing the children of good family learned was *graphikè*, i.e., painting on wood (Pliny,

NH, XXXV, 77). Sculpture also flourished in Sicyon. Butades is reputed to have been the first to model clay (mid-7th century BC), and two Cretans—Dipoinos and Skyllis, "pupils of Daedalus"—are also said to have worked long in the

city. The two are considered the founders of the Peloponnesian school of marble sculpture (NH, XXXVI, 9, The Olympiad, 580-577 BC), and the figured metopes in the Treasury of the Sicyons at Delphi (c. 560 BC) are held to be evidence of the originality of Sicyonian compositions.

XXXIV, 75), the god was depicted naked with his left leg advanced, holding a bow in his left hand and a deer in his right. It is to Kanakos that a number of similar bronze statuettes of Hermes Criophoros ("bringer of the lamb") have been attributed (the one in the Museum of Fine Arts, Boston,

a new tyranny following the battle of Leuctra, Demetrius Poliorcetes conquered the city (303 BC). He transferred the settlement on the hill where the Archaic acropolis had been. In the middle of the 3rd century BC, Sicyon entered the Achaean League and was initially favored by the Romans over Corinth after 146 BC, but the city faded to relative unimportance politically and culturally, as recounted by Pliny (NH, XXXVI, 9).

Almost nothing is known of the Archaic and Classical city, though work carried out to build the motorway from Athens to Patras confirmed its location on the coast. Apart from a necropolis from the 5th–4th centuries BC, a number of houses have been found with pebble mosaic floors like those in Olinthos and Pella.

More information has been forthcoming about the Hellenistic city: American excavation work at the end of the 19th century and more recent work by the Greek Archaeological Society have recovered some of the many public buildings recorded by Pausanias.

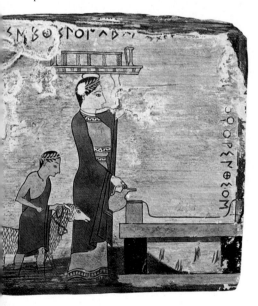

Another figure in the second half of the 6th century BC was Kanakos, a skilled worker of wood, marble and bronze, who produced a famous Apollo Philesios ("benevolent") for the Milesians. On the basis of the description offered by Pliny (NH,

Massachusetts is splendid). The 4th century BC also saw the rise of Lysippus , Hellenism, and a new city. After Sparta overturned the Orthagorid tyranny at the end of the 6th century BC, and following Sicyon's entry into the Peloponnesian League and

A visit to the excavations and small but interesting museum requires about 1 hour. (Open every day except Monday from 8:30 am to 3 pm. Tel. (0741) 31207.)

VISIT

The most outstanding building is the **theater (a)** from the start of the 3rd century BC. Standing on the slopes of the acropolis, all that remains are the 9 lower tiers of the cavea but a large capacity is indicated. Rebuilt several times, the stage building was added to in the Roman era with several backrooms and a portico that faces onto the plain. Slightly to the west, in a hollow, stands the **stadium (b)** (not mentioned by Pausanias), the recently begun exploration of which has already revealed interesting engineering techniques relating to the problem of containment of the hill slope. The agora lies to the east of the theater and has a **temple (c)** on its north side, though only the foundations have survived.

The long plan indicates it was from the Archaic Age but it was certainly rebuilt in the 2nd century BC. It was first thought to have been dedicated to Artemis but it has now been assigned by X. Roux to Apollo (others thought it may have been given the dedication Peithò ("the Persuasion") following

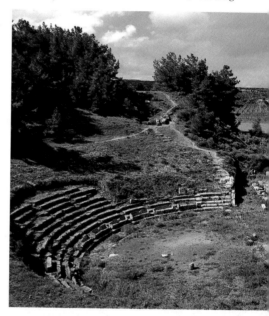

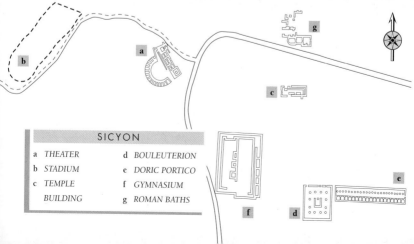

SICYON	
a THEATER	d BOULEUTERION
b STADIUM	e DORIC PORTICO
c TEMPLE	f GYMNASIUM
BUILDING	g ROMAN BATHS

BELOW AND RIGHT: THE CAVEA
SEEN FROM THE SOUTHEAST AND
THE FOUNDATIONS OF THE SCAENA.

OPPOSITE LEFT THE RUINS OF THE
TEMPLE BUILDING.

BELOW, TOP AND BOTTOM AND
BOTTOM THE GYMNASIUM AND
FOUNTAIN.

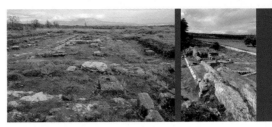

Pausanias' mention that it stood at the entrance to the agora as he entered it from the direction of the theater. On the south side of the square stood the

sykyonia, footwear that were famous for their elegance and softness, and still celebrated at the time of Cicero [De Oratore, I, 231]). The **gymnasium (f)** (3rd century BC) was a building, with two porticoed terraces enhanced by fountains that stood between the agora and the acropolis. Pausanias (II, 10, 1) wrote that this was the site of the famous statue of Heracles by SCOPAS (the same type as the "Lansdowne" Heracles shown on the city's coins)

and of other sculptures. A Heracles by LYSIPPUS stood in the agora (II, 9, 6). A visit to the museum at the end of the tour—in a **Roman baths complex (g)** from the 2nd century AD—allows you to admire the most important pieces found during the excavations. The most striking are the pebble mosaics, a head of Apollo from the late Classical period, and a Hellenistic portrait, perhaps of DEMETRIUS POLIORCETES. (S.M.)

313

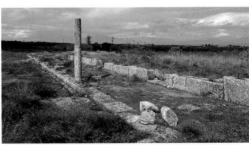

bouleuterion (d), which was a hypostyle room for the local senate, with 4 x 4 columns that supported the roof. It was later transformed into a baths building. Next to it is a long **Doric portico (e)** over 110 yards long with Ionic columns on the inside; the far side of the portico is lined with 20 rooms, which suggests that it was built for commercial reasons (à propos of which we should perhaps recall the upodemata

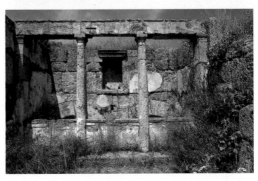

S I C Y O N

MAINLAND GREECE

During the millennia that have passed since prehistoric times, man's interventions have changed mainland Greece's landscape, making it ever more varied. Mountainous Thessaly, with the Meteora area, differs from Phocis, with its Delphi site. Then there is Mount Pelion, and the Kastorian region, not far from the Macedonian splendors of Verghina. The peace of the sanctuary of Dodona in Epirus contrasts with the exuberant colors of the "Levantine" city of Salonica. And then the plains of the north that face onto the ever-changing sea . . . and everywhere, in chapel, church and tomb, is the glittering decoration so loved by the Byzantines.

ITINERARY 1

Igumenitsa-Ioànnina

From Igumenitsa take the E 55 in the direction of Preveza to visit the **Nekromanteion** in the locality of Mesopotamo. Continue on route 19 to find the ruins of **Kassope**, then head for the coast to reach **Nicopolis**. Next take route 21

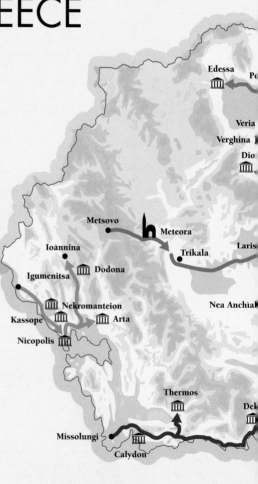

OPPOSITE: GOLD STUD, THESSALONICA MUSEUM.

FOLLOWING PAGE, RIGHT: FRAGMENT OF THE SOUTH FRIEZE IN THE TREASURY OF SIPHNIS AT DELPHI.

Philippi

Amphipolis

Kavàla

Tessalonica

Olynthus Ierissos

Potidea

Mount
Athos

olos

omenos
evadia

Hosios
Loukas Tebe

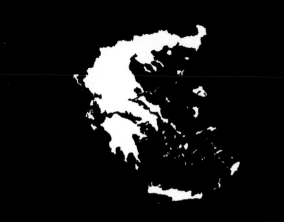

toward Arta, then the E 951 for **Dodona** and, lastly, **Ioànnina**, (Archaeological Museum, Avéroff Street, Municipal Park, open from 8.30am to 3pm, payment required. Note the finds from the sanctuary of Dodona. Byzantine Museum in Kastro, open Tuesday to Sunday, from 8am to 7pm, and Monday from 12pm to 7pm. Payment required.)

ITINERARY 2
Thessalonica—Olynthus— Mount Athos Leave Thessalonica in the direction of Nea Moudanìa, continue toward the peninsula of Kassandra (ancient Pallène), which is the first of the three arms of the Chalcidicean peninsula. On the isthmus near Nea Potìdia, you find what remains of **Potidea.** (The colony founded, c. 600 BC, by the Corinthians in this region; the remains of the Archaic and Classical city have not yet been found. A house and two sections of the wall are the only remains from the Hellenistic city founded by Cassander in 316 BC). Continuing the tour of this first arm of the peninsula

(47 miles), you will come to **Mende**; this was a colony founded by Eretria ca. mid-8th century BC. (South of the hill on which the city stood, sections of the walls built to contain the sandy terrain can be seen on the beach of Kalandras, where 6th-century BC houses were enclosed. Excavation of a sanctuary dedicated to Poseidon is taking place on the promontory to the west; it has 3 temples side by side, built between the 7th century BC and 480 BC.) Return to Nea Moudanìa and head for **Olynthus**, then continue toward Jerakini to visit the central arm of the peninsula (Sithonìa, tour 68 miles long). As you come down the west side, you will reach Porto Kouphòs, the site of the Euboean colony of **Toròne** (the vestiges of a prehistoric settlement of 3000-2500 BC have been found on the promontory, and, on a hill separate from the isthmus, the walls of the colony founded in the 7th century BC. The Classical city was built at the foot of the hill where a necropolis has also been found dated to

the 11th to 9th centuries BC; i.e., the site was also inhabited before the colony was settled). Continue on the west side to reach Route 16 to Paleochorion, passing through Pyrgadikà. From there, to visit the third arm of the peninsula, continue to **Stagira** (colony of Andros and the birthplace of Aristotle) and then on to **Ierissos** (on the site of ancient Akanthos, another colony of Andros, with a necropolis on the coast in which 5,500 tombs have been found dated to between the 6th century BC and the Roman epoch). In antiquity this was called Aktè and since the 9th century BC it has been the setting for the monasteries known as the monasteries of **Mount Athos**.

ITINERARY 3
Amphipolis – Philippi
From Thessalonica take the E 90 towards Kavala (which follows the course of the old Via Egnatia, 146 BC). After Nea Kerdylia, turn left to visit the excavations of ancient **Amphipolis**. Then continue on the coast road where Thasos founded a number of colonies (Galepsòs and Loutra Eleftheròn, and Osyme north of Nea Peramos) till you reach

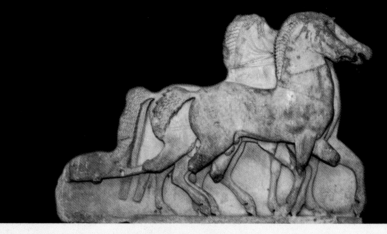

Kavàla. (Archaeological Museum on Erithrou Stavou Street. *Open Monday from 12 pm–7 pm, and every other day 8 am–7 pm. Payment required.*) Leave the town on Route 12 toward Drama and after 7 miles you will reach **Philippi.**

ITINERARY 4

Pella – Verghina – Dion

From Thessalonica take the E 86 towards Edessa. After 24 miles turn right toward the city of **Pella,** from where you reach the excavations of the ancient capital of Macedonia. After visiting **Edessa** (the ruins of the ancient city walls are c. 1 mile from the city), turn back to Skidra and turn right toward Veria to visit the Macedonian tombs of **Lefkadia** about 2 miles before the Naussa junction. Then, less than a mile from the village of Kopanos, the nymphaeum of **Mieza.** From here go to **Veria.** (Archaeological Museum: *open every day except Mondays, from 8am to 3pm. Payment required.*) The site of **Verghina** lies 3 miles northeast of Veria. In the area of Kypseli on the same road you will come to the junction

with the road from Jannitza; turn right here toward Katerini to reach **Dion,** at the foot of Mount Olympus.

ITINERARY 5

Thessaly – Leave from Epirus, cross the Pindus Mountains at **Metsovo** (3,800 feet), an ancient town populated by peoples originally from Wallachia (part of modern Romania), and descend the mountains for 40 miles to **Kalambaka** in the region of **Meteora.** From there go to **Trikala** (13 miles), which is the capital of Thessaly.

From Trikala, pass through **Larisa** to reach **Volos** (68 miles), which makes a good base for a quick trip to the sites of **Demetriade** and **Pagasai** (3 miles). A tour of the **Pelio** is recommended (125 miles all round) which lies off the beaten tourist track. Particularly worthy of note are the villages of **Milies,** with the church of the Taxiarchs, **Tsangarada** and **Zagora** with their beaches. From Volos, Giorgio De Chirico's home town, take the road for Lamia to reach **Nea Anchìalos** (16 miles).

ITINERARY 6

Boeotia – From **Levadia** you can reach interesting places: **Orchomenos** (9 miles northeast), and **Thebes** (28 miles southeast. Thebes makes a good base to visit **Ptoion** (9 miles), **Gla** (12 miles), a Mycenaean town with walls, a palace and *megaron* buildings, and **Arachova** (22 miles west). This last town offers the possibility of a side trip to the monastery of **Hosios Lukas** (6 miles).

Phocis – At the foot of Mount Parnassus, **Arachova** is ideal for an excursion to **Delphi** (7 miles). From there pass through **Amphissa** on your way to **Thermopylae** (55 miles).

Aetolia and Acarnania – From Delphi drive down to **Naupactos** (55 miles) where you can admire the Venetian citadel, and then to **Calydon** (20 miles), site of a famous sanctuary. Continue to **Missolonghi** (7 miles), the "holy place" of Greek independence. Once you reach **Agrinio** (22 miles) along Lake Trihonida, you come to the famous sanctuary of **Thermum** (17 miles). (C.T.)

MAINLAND GREECE

LEFT: CRYPT IN THE ORACLE BUILDING.

BELOW: *THE EVANGELIST*; A FRESCO IN THE CHURCH OF SAINT JOHN PRODROMOS.

ITINERARY 1
NEKROMANTEION

After that of Dodona, the oracular sanctuary dedicated to Pluto and Persephone was the most famous oracle in Epirus, and was where the living could speak to the souls of the dead. It stood on a low hill where the rivers Acheron and Cocitus came together, and looked over Lake Acherusio (now drained). The site is surprisingly like Circe's description (*Odyssey*, Book X) of the entrance to Hades, where Ulysses was sent to consult Tiresias. She says "You will find it near the place where the rivers Pyriphlegethon and Cocytus (which is a branch

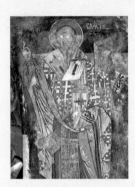

of the river Styx) flow into Acheron, and you will see a rock near it, just where the two roaring rivers run into one another." The second river is identified by some as the Vouvos, the modern tributary of the Cocitus. Others say that it was the Kakavas, a tributary of the

lake, which only flowed in winter. Currently there is no information on the earliest phases of the oracle, but undoubtedly it was operational in the 7th century BC, as Periander, the tyrant of Corinth (627–585 BC), sent a delegation to ask the spirit of his wife where she had hidden some treasure. The oracle was very famous in the 3rd and 2nd centuries BC, but the site was destroyed in 167 BC, like many other centers in Epirus, by the Romans for the support offered by the Epirote League to King Perseus of Macedonia.

 VISIT

The buildings used by the oracle that are extant today date to the early 3rd century BC. In the 18th century, the monastery of St. John Prodromos was built over the site, making extensive use of the ancient materials. Today only the small church of the monastery remains.

The plan of the complex is almost rectangular and enclosed by a thick wall of polygonal blocks. The entrance lies on the north side and led into a **court (a)** in which the storerooms, priests' houses and visitors' waiting rooms once stood. These buildings were in

great part destroyed during the construction of a **Roman building (b)** and a **fortified palace (c)** during the Ottoman period. At the bottom of the court a Mycenaean **cist grave (d)** (14th century BC) has been uncovered.
The entrance to the central

BELOW, LEFT AND MIDDLET: THE
FRONT OF THE CHURCH AND A
VIEW OVER THE ACHERON VALLEY.

BELOW RIGHT: *PITHOS* USED TO
HOLD THE OFFERINGS OF THE
FAITHFUL.

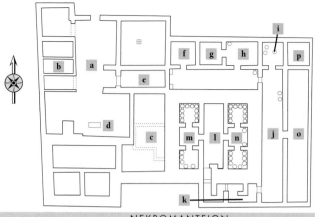

NEKROMANTEION

a COURT
b ROMAN ERA
 CONSTRUCTION
c FORTIFIED PALACE
d CIST GRAVE

e CORRIDORS
f,g HESTIATORIA
h BATHROOM
i SACRIFICIAL
 ROOM

j CORRIDOR
k LABYRINTH
l ORACLE
 ROOM
m, n STOREROOMS

o EXTERNAL
 CORRIDOR
p PURIFICATION
 ROOM

319

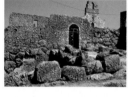

section of the sanctuary lay on the east side and was originally closed by two doors. This is where the journey to the kingdom of the dead began: first, down a dark **corridor (e)** on either side of which lay a number of rooms. In the first two **rooms (f, g,)**, pilgrims ate the food served in funerary banquets (pork, broad beans, barley flour and shellfish) and drank water, and milk and honey. They would then **bathe (h)** to purify themselves. Next the pilgrims threw a stone against the right upright of a narrow door to avoid

coming to a bad end, and paused in a **small room (i)** to sacrifice a ram. Then came a **long corridor (j)** at the end of which they turned right and entered the **labyrinth (k)**; this was a twisting passage with three iron doors that represented the gates to the Underworld. By now confused and helpless, the pilgrims entered the **room of the oracle (l)** where the souls of the dead appeared to them with the use of machinery; counterweights and toothed wheels have been found. Two **rooms (m, n)**, each divided into 3

sections, lay at the sides of the oracle room and contained huge jars to take the offerings of the visitors. After receiving their response, the pilgrims would return down the **outer corridor (o)**, then remain for three days in another **room (p)** to purify themselves before leaving the realm of the oracle. A crypt was cut out of the rock beneath the central room in the sacred area, probably inside the cave in which the cult had been practiced in prehistoric times. The ceiling of the crypt was supported by 15 stone arches. (C.T.)

KASSOPE

The city was built as the capital of the Cassiopeans at the end of the 5th or in the early decades of the 4th century BC following the synoecism (urban growth by fusion of small cities) of the inhabitants of the region who, until that time, had lived in clusters of small villages.

The site was chosen because of its ability to control the roads leading north and south as well as access to the ports of Michalitsi (on the Gulf of Ambracia) and Kastrosykia (on the Ionian Sea).
Another factor was that the site was naturally protected on the south side by a sheer drop to the plain

below, and on the north side by a series of hills that acted as an acropolis.
The city was destroyed by the Romans after the battle of Pydna (167 BC) and was rebuilt.
In 30 BC, the inhabitants moved to Nicopolis, founded by Octavian after his victory over Mark Antony at the battle of Actium.

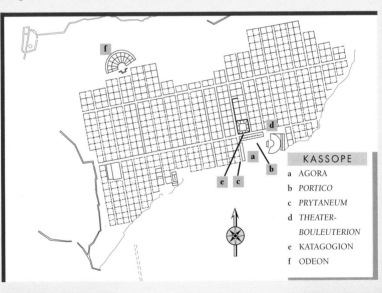

KASSOPE

a AGORA
b PORTICO
c PRYTANEUM
d THEATER-BOULEUTERION
e KATAGOGION
f ODEON

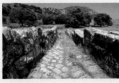

320 TOP: THE RUINS OF THE NORTH STOA SEEN FROM THE AGORA.

320 BOTTOM: PAVING OF THE STRAIGHT CITY STREET THAT LEADS TO THE PUBLIC SQUARE.

VISIT

Open every day from 8:30 am to 3 pm. Payment required.
The city was built on a grid pattern created by 2 large roads running east-west. This layout created 60 rectangular blocks. The blocks were then divided

lengthways into 2 rows of houses by a passageway and canal down the center. At the end of each block a brick cloaca (sewer) collected the waste from the latrines. The houses were all the same size (47' 3" x 52' 6" = 2,480 sq.

feet) to reflect the democratic nature of the city in which everyone had the same rights. Close to the entrance, the **court (c1)** was lined by the men's banqueting room, or *andron* **(c2)**, the **stable, or** *hippon* **(c3)**, and the **kitchen (c4)**. The most important room, the *oikos* **(c5)**, had a hearth at the center and stood at the bottom of the courtyard where it communicated with the owner's **cubicle (c6)** and **bathroom-cum-latrine (c7)**. The upper floor, the location of the men's and women's quarters, could be reached from the courtyard up a flight of brick stairs.: You enter the site following *plateia* A to reach the **agora (a)**; on the north side stood a **large portico (b)** with two aisles, 27 Doric columns on the façade and 13 square pillars inside. It was built at the end of the 3rd century BC over a late 4th–early 3rd-century BC building, long and narrow, that may have been used as an archive. In front of the portico there were 20 pedestals for honorary bronze statues that inscriptions date to after the destruction of 167 BC. The west side of the agora was occupied by the 4th-century BC *Prytaneum* **(c)**, in which a number of rooms were arranged around a peristyle court as destroyed in 167 BC, the *Prytaneum* was rebuilt and remained in use until the city was abandoned. In the 2nd century BC, a portico was built on the front of the complex to connect it to a paved enclosure on the east side surrounded by low orthostats. A series of pedestals with limestone bases has been found in front of the enclosure, which would have been used to support an unknown monument. There were also 4 altars, one of which was dedicated to Zeus *Soter*. The north side of the agora was the location of the **theater (d)**, which was also used as a *bouleuterion*. It had a portico

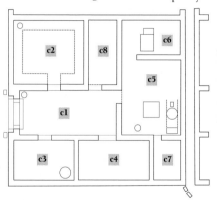

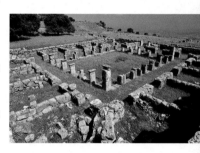

RIGHT: PERISTYLE AND SURROUNDING ROOMS IN THE *PRYTANEUM*.

the rooms used for banquets by the archons (7 *klinai* in the first room, 10 in the second) and perhaps the public archive. The rectangular exedra with 3 columns on the front, was reserved for the cult of Hestia in which a flame was kept burning on a permanent basis. The archons sat on the benches in the semi-circular exedra during the religious ceremonies celebrated in the agora. When the site was with a double row of rectangular pillars on the east façade and a room at either end. No information exists as to what lay at the south end of the agora, which has slipped down into the valley. To the west of the agora was the *katagogion* **(e)**, built during the period of the Epirote League (233-168 BC) over a previous building (mid-4th to early-3rd century BC) that probably had the same function. (C.T.)

NICOPOLIS

"Victory City" was founded by Octavian to celebrate his defeat of Mark Antony at the battle of Actium (31 BC). Populated by Roman veterans and the inhabitants of various cities in the region, it was both a Roman city (*Colonia Augusta Actium*) and a Greek one (*Civitas Libera Nicopolitana*). As capital of the province of Epirus from 67 AD, Nicopolis was prosperous throughout the imperial epoch. It suffered heavy damage from the earthquake in 375 and from the invasions of the Goths, but remained important in the early Christian period, as demonstrated by the number of basilicas (6 in all, of which 2 are still to be studied).

VISIT

Open every day except Mondays, from 8.30am to 5pm. Payment required.

The visit can begin from **Michalitsi hill (a)**, where Octavian located his headquarters and where, after his victory, he had a magnificent celebratory monument built: a terrace with a portico at the north end and a retaining wall at the other; the terrace was used to display the ship-piercing rams captured from Antony's fleet.

The foot of the hill was the site of the **theater (b)** (Augustinian, with restorations in the 2nd century) and the **stadium (c)** where, every four years, the *Aktia* (gymnastic and musical contests) were held. Heading towards the ancient city, on the right you see the ruins of a **baths building (d)**. Excavations in the inhabited area of the city, still in progress, are revealing many of the monuments depicted on the coins minted in Nicopolis.

Entering the city through the **north gate (e)** (second half of the 5th century or early 6th century, restored by Justinian in 540) you see on the left **Basilica C (f)** (late 6th–early 7th century). This has a nave and two aisles, a semicircular *synthronon*, a strongly projecting narthex but no atrium. Next comes **Basilica B (g)**, built in the first half of the 6th century by bishop Alkyson; preceded by a porticoed atrium, it has a nave and 4

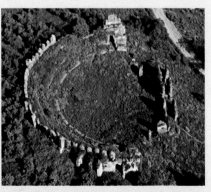

ABOVE: SUBSTRUCTURES INSIDE THE CAVEA OF THE ROMAN ERA *ODEON-BOULEUTERION*.

RIGHT: THE THEATER SEEN FROM THE NORTH.

OPPOSITE, TOP: PORTICO AND OF THE NARTHEX IN BASILICA B.

OPPOSITE, BOTTOM: THE STRUCTURE OF THE WELL-CONSERVED *ODEON*.

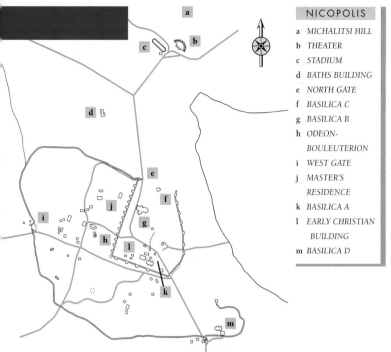

NICOPOLIS

a *MICHALITSI HILL*

b *THEATER*

c *STADIUM*

d *BATHS BUILDING*

e *NORTH GATE*

f *BASILICA C*

g *BASILICA B*

h *ODEON-*
 BOULEUTERION

i *WEST GATE*

j *MASTER'S*
 RESIDENCE

k *BASILICA A*

l *EARLY CHRISTIAN*
 BUILDING

m *BASILICA D*

aisles, a 3-part transept, and a narthex with a *diakonikon* at the south end (mosaics). The apse of the nave still has the ∏-shaped *synthronon*, the base of the altar with 9 supports and the base of the ciborium. (canopy)

Take the path on the left toward the west door in the Byzantine walls to reach the *odeon-bouleuterion* (**h**) (Augustan period, with restorations in the 2nd century). From the top of this building you have a general view of the city and **west gate** (**i**) in the Roman walls. The inside of the gate appears like a grandiose nymphaeum, with marble walls and statues in niches (2nd century).

To the north of the *odeon* lie the remains of a **luxury house** (**j**) (2nd century, with restorations in the 3rd

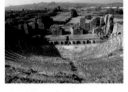

and 4th centuries), with marble floors, mosaics and walls lined with marble. Returning inside the Byzantine walls, continue toward the south gate. On the right you will see the remains of a Roman building that was the seat of the governor of Epirus. On the other side, **Basilica A** (**k**) was built by Bishop Dimitrios in the second quarter of the 6th century. It has a nave and two aisles,

a 3-part transept, a porticoed atrium and a narthex. To the west of the atrium an early **Christian building** (**l**) has been uncovered; it has rooms ranged round a peristyle court and may have been the residence of the bishop. Leaving through the south gate, you will find **Basilica D** (**m**) on Karaouli hill. From the first half of the 6th century, it has a nave and two aisles, a 3-part transept, a rectangular *synthronon* and a narthex ending in a *diakonikon* to the south (mosaic floors from the mid-6th century).

Museum *Summer: Monday, 12 pm–7 pm; Tuesday to Sunday, 8 am–7 pm; winter, from 8:30 am–3 pm. Payment required.* Collections of marble sculptures and inscriptions. (C.T.)

ARTA

VISIT

The modern city stands on the site of ancient Ambracia, founded in 645 BC by colonists from Corinth. The major developmental phase coincided with the ascent of Pyrrhus (297–272 BC) to the throne when, owing to its strategic position, the city became the capital of Epirus. At the time, it was one of the most beautiful cities in Greece. As a result of Ambracia's alliance with Antiochus III against Rome, in 189 BC the Roman consul Marcus Fulvius Nobilior destroyed the city and also plundered it of a large number of works of art. In 30 BC, the population was obliged to transfer to Nicopolis, and abandoned the site. At the end of the 11th century AD, a new city was founded with the name of Arta, which, after the occupation of Constantinople by the Latins, became the capital of the independent Greek state (the despotate of Epirus, 1204–1479) founded by Michael I Angelus Comnenus Ducas. Until the Turkish occupation, Arta was an important cultural center that had a deep influence on the other cities in the despotate.

The remains of the Greek city are limited to certain tracts of the fortifications (nearly 3 miles long) built in the second quarter of the 4th century BC. Inside the irregularly laid-out town (end of 5th century BC), 2 late 4th-century BC theaters have been found, a small one in

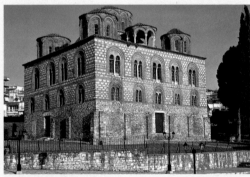

Odos Konstantinou and a larger one in Odos Tsakalof. The foundations of a Doric temple (500 BC) dedicated to Apollo *Pythios* (the protector of the city) have also been found in Odos Pirrou, close to the site of the agora.

The remains of the Byzantine city are more extensive. The largest and most famous church is the Panagia Parigoritissa

(*open every day except Mondays, 8:30 am to 3 pm*) built 1282–89 for the despot Nicephorus and his wife Anna Paleologus. From the outside it looks like a massive cube crowned with 5 domes and a lantern above the narthex. Large twin-light windows are crowned by large, wide-collared arches. The interior blends a domed, central, octagonal span with a raised section built on a Greek cross; the pendentives of the dome are supported by an attractive but unusual combination of 3 orders overlaid by small columns. These stand on progressively projecting brackets formed by pairs

of columns embedded horizontally in the walls (all reused materials). The sculpted reliefs on the upper part of the naos are Romanesque in style (perhaps by Italian artists) and express Nicephorus's preference for Western art. The mosaic decoration of the dome, however, is typically Byzantine (Christ Pantokrator surrounded by angels and cherubims, and the 12 prophets in the drum) and reflects on Anna Paleologus' pro-Byzantine policy.

OPPOSITE, TOP: THE MONASTERY OF VLACHERNE.

OPPOSITE, BOTTOM: PANAGIA PARIGORITISSA, DOMES AND THE LANTERN.

ABOVE: HELLENISTIC AND BYZANTINE OBJECTS IN A ROOM IN THE LOCAL MUSEUM.

BELOW: *CHRIST IN GLORY*; DOME AND TYMPANUM OF THE PANAGIA PARIGORITISSA.

A R T A

The basilica of Aghia Theodora was built as the *katholikon* of the monastery of St. George (only the front façade remains) constructed in the 13th century by Theodora, the wife of Michael II, who was buried here (her magnificent carved sarcophagus stands in the narthex). A characteristic of the basilica is that the pediment walls rise above the slopes of the roof. Inside, 2 rows of 2 columns divide the space into a nave and 2 aisles; the (reused) capitals of the columns are 5th- or 6th-century AD with Byzantine leaf decoration mixed with traditional motifs (volute cornices) and images of Christ.

The façades of the church of Aghios Vasileos (14th century) also have the pediments raised above the height of the roof. Extensive use is made of decorative brickwork (typical of the despotate) with inserts of enameled plates. The interior was originally just a nave and apse but two rooms were added on either side separated by passages covered with barrel vaults (17th and 18th-century frescoes).

Four miles northeast of the city (head for Ioànnina, turn right after the bridge), you can visit the 12th-century monastery of the Vlachairnon where the Comnenian dynasty rulers of the despotate were buried.

The church has a nave and 2 aisles with a vaulted ceiling. Around the middle of the 13th century, the ceiling was raised, given 3 domes and decorated with superb frescoes and marble reliefs.

At the end of the century, a narthex was added with a fresco illustrating the procession of the icon of Theotokos Odighitria ("she who guides") of Constantinople, the only one of its kind. The famous icon, said to have been painted by St. Luke, disappeared from the monastery in 1453 when Constantinople fell into the hands of the Turks. (C.T.)

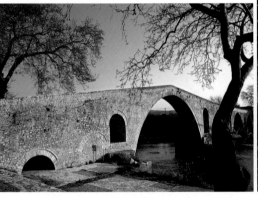

OPPOSITE TOP: ARCHANGELS
GABRIEL AND MICHAEL; MARBLE
RELIEFS ON THE FAÇADE OF THE
MONASTERY OF VLACHERNE.

OPPOSITE BOTTOM: BRIDGE OVER
THE ARACHTHOS RIVER; MEDIEVAL
STRUCTURE ON EARLY-CHRISTIAN-
ERA FOUNDATIONS.

BELOW: APSES AND CUPOLA
OF THE CHURCH IN VLACHERNE
MONASTERY.

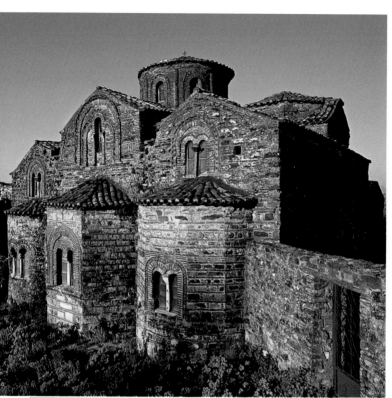

BELOW: CAPITAL
OF THE INNER COLONNADE
OF AGHIA THEODORA.

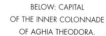

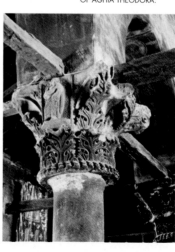

ABOVE: FAÇADE OF
THE CHURCH OF
AGHIOS VASILEOS

DODONA

The oracle of Dodona was considered one of most ancient in the Greek world. According to Herodotus, it was founded by one of the two priestesses that the Phoenicians had taken from Thebes in Egypt. The other, sold in Libya, had founded the oracle of Ammon in Siwa oasis, which was also consulted by Alexander. According to another version, two doves had left from Thebes: the black one flew to Siwa and the white one to Dodona, where, from the top of an oak tree, with a human voice it had told the inhabitants to build a sanctuary to Zeus. Originally (2nd millennium BC), the oracle–sanctuary was dedicated to a pre-Hellenic deity, perhaps Gaia (Ge, the Earth), which would explain the character of the divinatory procedures followed in the later oracular sanctuary. This was dedicated to Zeus *Naios* ("inhabitant") flanked by a triad of goddesses: his wife Dion, their daughter Aphrodite, and Themis. The first evidence of the sanctuary in the area dates to the 14th century BC (remains of huts and pottery beneath the portico of the *bouleuterion*) but it was consulted with frequency in the 8th and 7th centuries BC (tripods, small

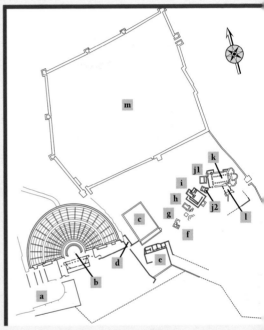

DODONA	
a *STADIUM*	h *TEMPLE OF*
b *THEATER*	*THEMIS*
c *PRIESTS' HOUSE*	i *TEMENOS OF ZEUS*
d *BOULEUTERION*	j *TEMPLES*
e *PRYTANEUM*	k *EARLY CHRISTIAN*
f *TEMPLE OF*	*BASILICA*
APHRODITE	l *TEMPLE*
g *ROMAN*	m *RESIDENTIAL*
BUILDINGS	*AREA*

TOP: WEST SUBSTRUCTURES OF THE THEATER.

OPPOSITE, LEFT: THE CAVEA, ORCHESTRA AND STAGE OF THE THEATER SEEN FROM THE NORTH-NORTHEAST.

bronzes and weapons). After a period of decline, the sanctuary acquired fame in the first half of the 4th century BC when it became the religious center of, first, the League of Molossians (which brought together the

tribes of Epirote shepherds), then of the Epirote Alliance (340–234 BC) and, after the installation of the democratic regime in 234, of the Epirote League. Rebuilt on a monumental scale during the reign of Pyrrhus (297–272

BC), it was reconstructed after being sacked by the Aetolians (219 BC). In 168 BC, together with 70 other Epirote centers, the sanctuary was destroyed by Lucius Aemilius Paullus as punishment for the Epirotes having supported Perseus. It was sacked by Mithradates in 86 BC and remained abandoned until Rome's imperial age, when it took on a new life: the *Naia* were celebrated until the 3rd century AD.

Open every day from 8am to 7pm. Payment required.

You reach the **stadium (a)** (early 3rd century BC) from the entrance. The **theater (b)** was from the same period though it was destroyed and rebuilt on two occasions (219 and 169 BC). The lower part of the *koilon* rests against the slope while the upper part is supported by 2 walls strengthened by 6 tower-shaped buttresses. Once past the theater you enter the sanctuary area and see the **House of the Priests (c)** and the *Bouleuterion* **(d)** where the meetings of the Epirote Senate were held (early 3rd century BC) and the *Prytaneum* **(e)**. Several temples stood in the area that separated the official section from the enclosure of Zeus: the Ionic distyle *in antis*

temple of Aphrodite **(f)** (late 4th–early 3rd centuries BC), a **building (g)** from the Roman era and the Ionic, tetrastyle, prostyle **temple of Themis (h)** (late 4th century BC). The *temenos* of Zeus **(i)** originally contained a sacred oak (*phegos*) in the roots of which the god lived. The tree was ringed by bronze cauldrons on tripods that produced a sound when they were struck by animal bones in the wind. The sounds were considered to be an expression of divine will and interpreted by the priests, the *Selloi* or *Helloi*, as answers to questions posed to the god. The questions were engraved on bronze plates, some of which can be seen in Ioànnina Museum. A building with a pronaos and naos was constructed in the

4th century BC, with the probable function of holding the votive offerings made by worshipers. A low enclosure wall was built around the building and sacred oak (350–325 BC). During the reign of Pyrrhus, the enclosure was enlarged and given porticoes on the north, west and south sides. After 218 BC a monumental propylaeum and an Ionic tetrastyle, prostyle temple with 4 Ionic columns on the front were built. Two temples were dedicated to Dion on the east side of the sanctuary. The first **temple (j1)** was Ionic and tetrastyle and built between the end of the 4th–start of the 3rd century

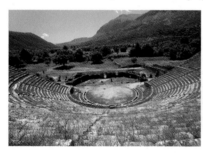
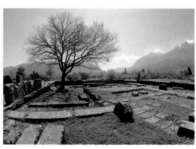

and 169 BC). The lower part BC, but this was replaced after 218 BC by a new Ionic tetrastyle, prostyle building **(j2)**. Next to the large **Christian basilica (k)** (5th–6th centuries AD) stood the Doric tetrastyle, prostyle **temple (l)** built in honor of Heracles at the start of the 3rd century BC. The **settlement (m)** (not yet excavated) stood on the hill to the north of the sanctuary. (C.T.)

ABOVE RIGHT: THE RUINS OF THE TEMPLE OF ZEUS DOMINATED BY THE SNOWS OF PINDOS OROS.

4.2

The city was founded in 316 BC by Cassander. It united the inhabitants of 26 villages on the Gulf of Thermai into a single settlement which he named after his wife, Thessalonica, the sister of Alexander the Great.

Thanks to its position at the center of the land connections between East and West it soon took on a role of prime commercial and military importance that it maintained after the Roman conquest. Crossed by the Via Egnatia (148 BC), the road that connected Durazzo and Byzantium, in 146 BC it became the capital of the province of Macedonia. During the Augustan era it was the most prosperous city on the peninsula and, under Emperor Decius (249-251 AD), it became a Roman colony. However, it was with the Tetrarchy that the city assumed a role of prime importance. Emperor Galerius (293–311 AD) chose Thessalonica as his residence and made it one of the capitals of the empire. The next boost to the city's development resulted from its proximity to Byzantium, the capital of the Eastern empire beginning in 330, as a result of which it enjoyed a substantial construction phase. The city was raided by barbarians on many occasions: by the Ostrogoths in 473, the Huns in 540, the Slavs in the 5th and 6th centuries, and the Saracens of Leo Tripoli (904). In 1185 Thessalonica was conquered by the Normans of Sicily and in 1204 by the Franks who held it as a fief of Boniface de Montferrat until 1224. Taken back by the Byzantines during the reign of Theodore Dukas Angelus, despot of Epirus, it experienced a period of prosperity reflected in notable artistic development. Reintegrated with the Byzantine empire that Michael VIII Paleologus had regained in 1261, between 1321 and 1328 Thessalonica was involved in the dynastic struggles between Andronicus II and his grandson Andronicus III. In 1387 Thessalonica became part of the Ottoman Empire and remained as such (except for a short period of Venetian occupation between 1423 and 1430) until 1912. Thanks to the railway line that connected it to Belgrade, and therefore to all central Europe, from the end of the 19th century the city was an important commercial center visited by businessmen of many nationalities.

..

ABOVE: SACRIFICIAL SCENE; DETAIL FROM THE ARCH OF GALERIUS.

LEFT: GOLD STUD, THESSALONICA MUSEUM.

OPPOSITE: GOLD MEDALLION WITH PROFILE OF OLYMPIA, MOTHER OF ALEXANDER THE GREAT.

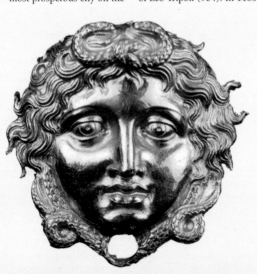

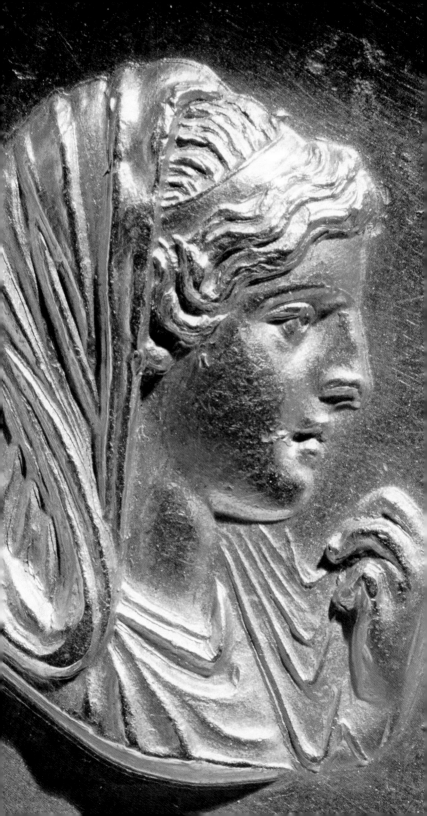

VISIT

The first part of the visit is to the **lower city**, which has conserved buildings from its Greek and Roman periods and also has many Byzantine churches. During the Ottoman period the lower city was home to the Greek population; at the end of the 15th century, this was joined by a large community of Jews expelled from Spain. The Turks preferred to live on the hills overlooking the bay as the lower city was unhealthy and overcrowded. It was only in 1866 when the walls

over the remains of the Hellenistic walls (some sections can be seen between the gate of Eski Delik and the tower of Manuel Paleologus). Access to the upper city is near the tower of Andronicus Paleologus, where a maze of narrow streets and flights of stairs is lined with typically Turkish houses with projecting upper floors. From here you can reach the Hellenistic *Heptapyrgon* fort that was rebuilt in the 14th century and used as a prison until 1989.

temple from c. 500 BC have been found (belonging to the settlement that existed before Cassander founded the city, and which may have been ancient Thermae, referred to by ancient writers). The remains of a *Serapeum* have also been discovered in the southwest area of the city. The Hellenistic city was surrounded by thick walls that provided the course for the fortifications rebuilt around the middle of the 5th century AD; some stretches have been found

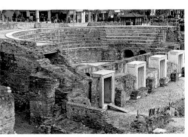

that ringed the city from the sea were knocked down that it became possible to clean up the area. The entire zone was almost completely destroyed in 1917 by a large fire which only a few areas escaped (the Ladakika district).
The walls that today encircle the upper city date back to the Paleologan emperors of Byzantium. In the 14th century, these emperors rebuilt the fortifications first raised in the mid-5th century AD

THE HELLENISTIC AND ROMAN PERIODS
Little remains of the Hellenistic city, but it was laid out on a regular grid of which the 2 main east-west streets still exist in the modern Egnatias Street and Dimitriou Street. There was probably an agora at the center. The stadium and gymnasium were located north of the agora, as we know from ancient writers. An area was reserved for cult buildings in the western section of the city, where the foundations of a

on the west of the city beneath those still visible. The most extensive ruins are from the Roman city; they date above all to the era of the Tetrarchy (284–311). The city plan was based on a north-south street (the *cardus maximus*) that is today Venizelos Street, and an east-west street (the *decumanus maximus*), today's Egnatias Street. The **Roman forum (a)** was built on the site of the Greek agora with two porticoed squares on different levels.

Excavations in 1966 uncovered part of the upper (north) square; it was paved with marble and lined by a double quadriportico with floor mosaics. On the east side there was an **odeon** (**b**). The south side of the portico rested on a **cryptoportico** (**c**) that also acted as a terrace for the upper square and as a popularly known as *Las Incantadas* (**f**) ("the Enchanted Ones"), which attracted travelers in the 17th and 18th centuries. The name is derived from a story that, the monument was dedicated by a royal couple from Thrace who had been turned to stone by a spell. The monument had a façade with two orders: the lower one had 5 It extended 1.9 million square feet. Although excavations were carried out, its topography is still not clear. The only known part of the palace is a four-sided, porticoed court lined by many small rooms and surrounded by a wide corridor. On the east side of the corridor there was a long rectangular room divided

OPPOSITE LEFT: SECTIONS OF THEODOSIUS' CITY WALLS.

OPPOSITE RIGHT: NICHES AND SEATING IN THE *ODEON* OF THE FORUM.

ABOVE: SUBSTRUCTURE ARCH IN THE PALACE OF GALERIUS.

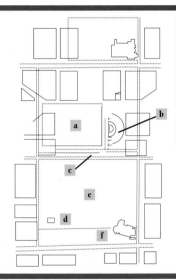

AGORA

a FORUM/AGORA
b ODEON
c CRYPTOPORTICO
d PANAGIA TON KALKEON
e MEGALOPHÒROS
f LAS INCANTADAS

portico for the lower one. The lower square has not yet been excavated but extended over the area now occupied by **the church of Panaghia Chalkeon** (**d**) and its grounds. The lower square was known in the Byzantine period as the *Megalophòros* (**e**). During that time its west portico was reused as *Chalkeutikè stoà* (the "portico of the bronze workers"), a name which has remained with the church. Undoubtedly connected to the forum was the monument

columns made from cipollino, the upper one had square pillars (4 remain). The monument was decorated on either side by high relief figures. The monument was probably built in the Severe era at the time the forum was being rebuilt. The structure was disassembled in 1865, and the sculptures were shipped to the Louvre.

The most important construction was Emperor **Galerius' palatial complex** in the southeast of the city.

into 4 vaulted areas and with an apse at the south end. A circular building has been found to the north of the court while a mysterious octagonal building (throne room?) on the south side looked onto an elliptical vestibule on its south side. In Odos Isàvron, very close to the foundations of the arcade in front of the vestibule, excavators have found the remains of a small arch that is richly carved with ornamental motifs and medallions.

A colonnaded street led from the palace to a large rectangular vestibule paved with mosaics that opened onto Galerius' arch. This was built on the Via Regia between 297 and 305 to celebrate the emperor's victories over the Persians.

decorated with scenes of the Adiabene campaign, and the southwest fornex with the Armenian campaign. In the last one, Galerius' victory was sealed by the surrender of the enemy.

The reliefs are one of the

arched windows above rectangular niches. A deep well lay in the middle of the room, probably below an oculus in the dome. Originally built for the cult of the deified emperor, Emperor Theodosius later transformed the building

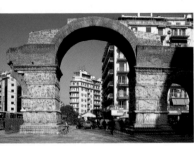
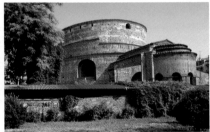

ABOVE: SOUTHEAST SIDE OF THE ARCH OF GALERIUS.

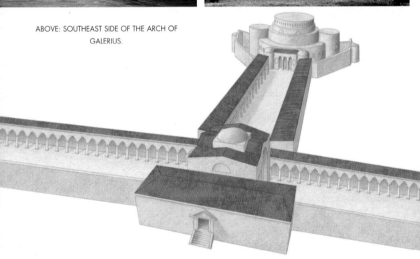

The initial project was for a four-sided archway with a dome, but 2 lateral fornices were later added to connect the arch to the palace on one side and to the Rotonda on the other. The widest fornex, the central one, was flanked by 4 pillars decorated with reliefs that illustrated Galerius' military campaigns against Narsetes, the king of the Persians. The northeast fornex was

most important examples of Tetrarchic art; in style they draw upon the columns Trajan and Antoninus Pius raised in Rome.

On the other side of the arch, the porticoed street (100 yards long) led to the **Rotonda**. This was a large circular room covered by a hemispherical dome (79' 3" in diameter). The cylindrical walls are punctuated by 8 large

into a church dedicated to St. George; he also commissioned a circular external nave, a deep apse on the east side and a vestibule on the west side. The interior was lined with marble and the dome given three registers of polychrome mosaics on a gold background: these show Christ triumphant in a mandorla supported by four angels (not conserved),

angels and apostles below, but only their feet have survived. **In the lower section** are eight panels with complex representations of buildings; these adopt techniques used in the Hellenistic period in theatrical sets and public buildings, and, in the foreground, very realistic figures of people praying. The undersides of the arches of the niches are decorated with geometric motifs, flowers, fruit and birds. Closely connected to the palace physically and functionally, the **hippodrome** was based on the model in Rome in which the emperor used to watch the races in the Circus Maximus from the top of his palace, where he could be seen by the public.

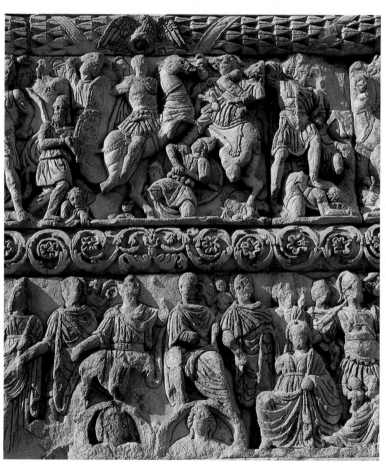

OPPOSITE RIGHT: THE ROTONDA SEEN FROM THE SOUTHEAST, WITH THE APSE OF THE THEODOSIAN CHURCH ON THE RIGHT.

OPPOSITE BOTTOM: ARTIST'S IMPRESSION OF THE ROTONDA, PORTICO AND ARCH OF GALERIUS.

ABOVE: *VICTORY OVER THE PERSIANS* AND THE *TRIUMPH OF THE TETRARCHS*; ARCH OF GALERIUS, SOUTH PYLON.

RIGHT: SOLDIER WEARING ARMOR; DETAIL FROM THE *BATTLE AGAINST THE PERSIANS*.

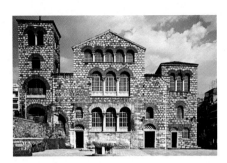

LEFT: FAÇADE OF THE CHURCH OF AGHIOS DIMITRIOS SEEN FROM THE NORTHWEST.

BELOW: THE NAVE AND APSE OF AGHIOS DIMITRIOS.

BYZANTINE PERIOD

Thessalonica has many examples of religious buildings from the early Byzantine period on through to the Turkish conquest. Unfortunately, the fire of 1917 seriously damaged many of these buildings and others have suffered as a result of neglect or transformation into mosques. The

336

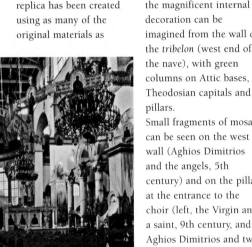

churches are presented in chronological order.

The oldest of the Christian churches is **Aghios Dimitrios**, dedicated to the patron saint of the city who was martyred in 304 in the baths close to the Forum. A *martyrion* was built on the spot on which he was executed, and over

that a basilica was constructed in 411. After being seriously damaged by a fire in the first half of the 7th century, it was rebuilt on the same plan, also reusing many of the stone and mosaic materials. Destroyed again by the 1917 fire, today a replica has been created using as many of the original materials as

possible (column shafts mostly from the 7th century, capitals mostly from the 5th, and marble linings and fragments of mosaics). The building is evidence of the most mature form of a basilica with a cross-shaped transept, a form that spread from this zone to

surrounding areas. Preceded by a narthex, the nave in the basilica is separated from the aisles by a double order of arches on groups of 4 columns; there is also a narthex and an apse with 5 wide openings.

The original appearance of the magnificent internal decoration can be imagined from the wall of the *tribelon* (west end of the nave), with green columns on Attic bases, Theodosian capitals and pillars.

Small fragments of mosaic can be seen on the west wall (Aghios Dimitrios and the angels, 5th century) and on the pillars at the entrance to the choir (left, the Virgin and a saint, 9th century, and Aghios Dimitrios and two children, 7th century; right, Aghios Dimitrios with a bishop and a state administrator, Aghios Dimitrios praying and with a deacon, all 7th century).

There are also very few frescoes remaining. The one on the south wall is historical in nature, with Justinian II returning to the city after fighting the Slavs.

The crypt fills the east section of the Roman baths. Originally it was at street level but was pushed underground by the construction of the basilica. The stairs to the right of the choir lead down to a room from the baths that has been transformed into a chapel with the addition of an apse with 5 openings; at one time it may have been possible to see the remains of the martyr through these. A niche encloses a marble shrine with 7 columns (capitals from the era of Theodosius): this is the *hagìasma*, which poured oil onto the tomb of the saint so that it could be blessed.

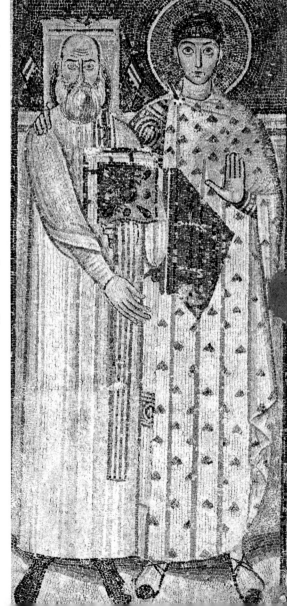

TOP, LEFT TO RIGHT: MOSAICS IN AGHIOS DIMITRIOS: THE HOLY SCRIPTURES, THE FACE OF A SAINT, AND A FUNCTIONARY.

RIGHT: SAINT DIMITRIOS WITH A DEACON; A MOSAIC ON THE PILLAR TO THE RIGHT OF THE ENTRANCE TO THE CHOIR.

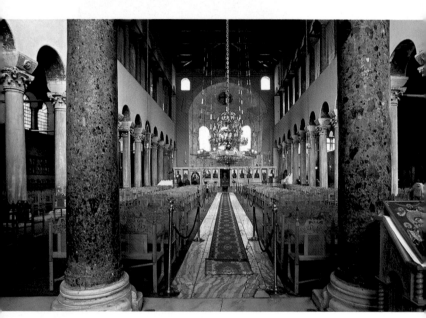

Set against the southeast corner of the church stands the small basilica of St. Eutymius (10th–11th centuries) with frescoes from 1303 (scenes of the 12 liturgical festivals, the life and miracles of Christ, the life of the saint).

The church of **Theotokos Achiropoietos** is dedicated to the mother of God and dates from the second half of the 5th century. The epithet means "made without hands" and refers to the presence of a miraculous icon that is said to have fallen from heaven.

The church is typical of a basilica with a gallery. It has an exonarthex connected to the corner rooms of the aisles. Inside there are two arcades on two levels, joined at the bottom by low transennas (screens) to isolate the nave. In the Orthodox Church, the nave, like the presbytery, was reserved for the clergy while the congregation used the aisles and galleries.

The superb internal decoration has been reduced to just the mosaics of flowers, fruit and birds (5th and 6th centuries) that adorned the

as the *katholikon* of the
monastery of Latomou
(named after the *latomie*,
"stone quarries"), the apse
still has wonderful mosaics
(6th century) of a beardless
Christ on a rainbow
surrounded by two
prophets and symbols of
the evangelists. The
frescoes of the Nativity and

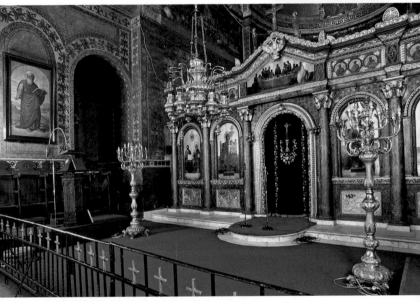

intradoses (arches) of the
arches. Large sections of
the marble floor can be
seen in the nave where
there are also splendid
"Theodosian" capitals
decorated with double
rows of deeply carved
acanthus leaves.
The small church of **Hosios
David** is considered one of
the prototypes of the cross-
plan with a central dome
(now substituted by a
roof), which was the
fundamental model of early
Byzantine architecture.
Built around the year 500

Baptism of Christ (second
half of the 12th century)
are the only example of the
art of this period in
Thessalonica.
Hagia Sophia is one of the
few authentic Greek-cross
churches with a dome that
has survived to the
modern day. It is even in a
good state of conservation.
Dedicated to Divine
Wisdom, it was built at the
start of the 8th century
over the ruins of a large
basilica (5th–6th
centuries) to which the
remains of a small apsidal

hall with *synthronon* and
episcopal throne
(northeast corner) belong.
The dome is decorated
with late 11th-century
mosaics with the
Pantokrator surrounded by
the twelve apostles, and
the Virgin between two
angels. In the apse, the
Virgin and Child (12th
century) replaced the
image of a cross from the
Iconoclastic period. A
mosaic with crosses and
plant motifs (late 8th
century) decorates the
vault.

THESSALONICA

From the period in which Hagia Sophia was built until the first half of the 11th century, no examples of architecture exist in Thessalonica. The next instance is provided by the **Panaghia ton Kalkeon** (Our Lady of the Bronze Workers), dedicated in 1028 by a high dignitary in the imperial court. This is another cross inscribed in a square, with a dome on spandrels supported by four arches on columns. Even the exonarthex has a gallery and two domes, and is terminated at either end by semi-circular motifs. The arms of the cross both end in a triangular pediment. The simple interior is decorated with fine frescoes (11th century) by Constantinopolitan artists. The apse has an image of the Virgin in prayer with bishops and saints below; the Ascension is in the dome and on the high part of the walls there are scenes from the life of Christ. The Last Judgment is shown in the narthex. The church of **Aghia Aikaterini** was built in the last 20 years of the 13th century and

represented the start of late Byzantine architecture. The Greek cross plan inscribed in a square was traditional; what was new, however, was the stress placed on the verticality of the central dome, the barrel vaults and the apse. Fragments of frescoes remain in the apse (bishops officiating and the communion of the apostles) and in the

central area (the miracles of Christ and figures of saints).

The same plan was used in 1327 for the church of **Aghii Apostoli**, in which the verticality is even more developed and more strongly emphasized by the lower height of the narthex and greater slenderness of the corner drums that together give the building a new profile.

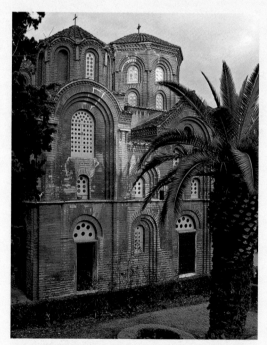

TOP: ICONOSTASIS OF THE CHURCH OF THE AGHII APOSTOLI.

ABOVE: PANAGHIA TON KALKEON; THE FAÇADE SEEN FROM THE NORTH.

OPPOSITE BELOW: CORNER DRUMS AND ESONARTHEX OF THE AGHII APOSTOLI.

The external walls are richly decorated with monochrome tiles, and alternating use of white stone and groups of 3-4 red bricks.

Inside, the mosaics covering the dome depict Christ and the prophets; those in the vaults and on the high part of the main chamber walls show festivals in Jerusalem and the descent to Limbo, represent a rare variation of the type of Greek cross, in which the dome rests on the walls of the presbytery and two pillars on the west side (frescoes).

In the first half of the 14th century a pair of small basilical buildings were constructed with wooden roofs: the **church of the Taxiarchs**, built over a crypt used as a burial

The large **church of the Prophet Elijah**, datable to 1360–85, has a plan with three apses, typical of Mount Athos, with tiny domed chapels in the four corners between the apses, and a very broad central dome. The external walls are made from regular stone blocks alternated horizontally with bricks. It also has extensive tile decoration with triangles,

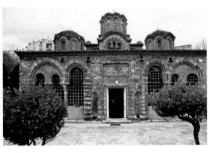

while the fresco cycle depicts the life of St. John the Baptist and the childhood of the Virgin. All the work was executed by a workshop from Constantinople.

A design similar to that of the Aghii Apostoli church is seen in several 14th-century churches – the **Aghios Pantaleimon** and the *katholikon* of the **Vlatadi monastery**, dedicated to the Transfiguration of the Savior. The design

place for monks, and the church of **Aghios Nikolaos Orphanos**, which was the *katholikon* of the monastery founded by the Serbian king Stefan Uros. The monastery is the Milutin and was used to accommodate orphans; it has a notable complex of frescoes that include the Dodecaorton, the miracles and Passion of Christ, scenes from the life of St. Nicholas and St. Gerasius, illustrations of the *akathistos* hymn, and saints.

patterns of interwoven osiers, and key patterns.

OTTOMAN PERIOD

Few buildings from this period survived the 1917 fire. With the exception of some public baths in the area of Kendrikì Agorà— the picturesque and lively oriental commercial district – you can visit the **Bèzestani**, a rectangular building with eight domes, built in the 15th century and used as a covered market.

Citadel of Museums at the White Tower (1535), the symbol of Thessalonica.

ARCHAEOLOGICAL MUSEUM

Monday, 12:30 pm–7 pm; Tuesday to Friday and Sunday, 8 am–7 pm; Saturday, 8:30 am–3 pm. Payment required.
Entrance room: finds from the Macedonian tombs of Hagìa Paraskevi and Potidea (marble *klinai* with painted decorations).
Room opposite the entrance: materials from Sindos necropolis (8 miles west of the city), discovered in 1980, dated to 550–480 BC

(**Attic red- and black-figure pottery, weapons, jewelry**).
Rooms 1–3: Archaic (7th–6th centuries BC) and Classical (5th–4th centuries BC) sculpture from the region.
Room 4: items from the Hellenistic and Roman eras (**marbles, mosaics and statues**).
Rooms 5–6: Roman sculpture from the city (**imperial portraits, sarcophagi**).
Room 7: finds from the necropolis of Derveni (6 miles east of the city), discovered by chance during construction of the road to Kavala in 1962. In particular, **6 monumental**

tombs in chests made of stone slabs (roughly 6' 6" high and 7' to 10' long) from the second half of the 4th century BC. The grave goods are of excellent quality, particularly those in Tomb B: **gilded bronze and silver vases, bronze and iron weapons, gold jewelry**, and a **fragment of papyrus** (the first found in Greece) with 18 lines of an Orphic poem. Note a high-quality **crater in gilded bronze** containing the burned bones of the deceased (whose name is given on the inscription on the rim) and decorated with reliefs of Dionysus and

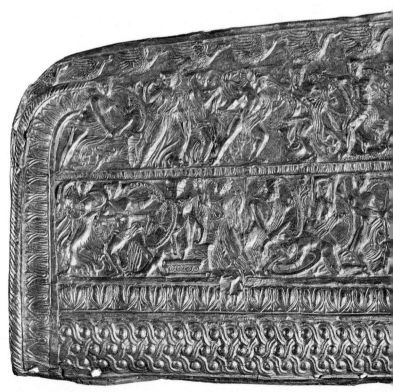

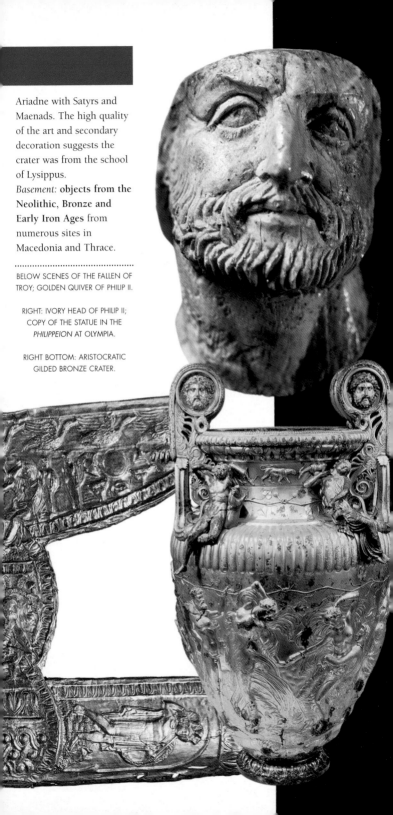

Ariadne with Satyrs and Maenads. The high quality of the art and secondary decoration suggests the crater was from the school of Lysippus.

Basement: **objects from the Neolithic, Bronze and Early Iron Ages** from numerous sites in Macedonia and Thrace.

BELOW SCENES OF THE FALLEN OF TROY; GOLDEN QUIVER OF PHILIP II.

RIGHT: IVORY HEAD OF PHILIP II; COPY OF THE STATUE IN THE *PHILIPPEION* AT OLYMPIA.

RIGHT BOTTOM: ARISTOCRATIC GILDED BRONZE CRATER.

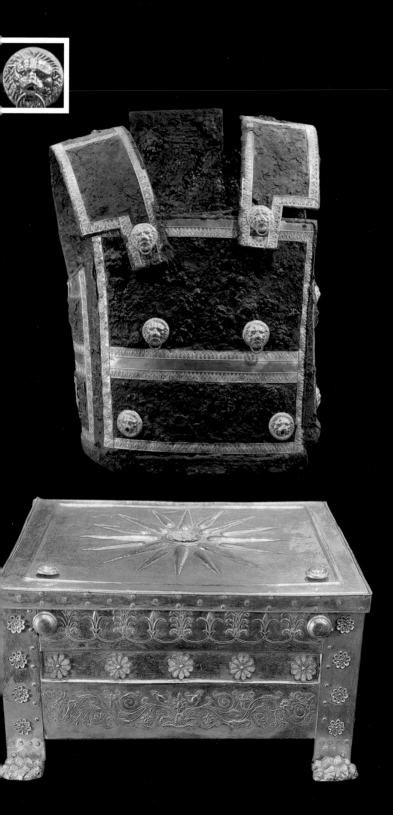

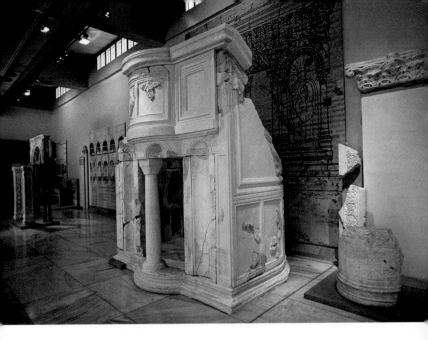

MUSEUM OF BYZANTINE CIVILIZATION

Monday, 12:30 pm–7 pm; Tuesday to Sunday, 8 am–7 pm. Payment required.
Section I: monumental early Byzantine painting and sculpture.
Section II: objects from everyday life.
Section III: funerary rites from the early Christian and Byzantine eras through funerary painting. There is also a museum of early Christian and Byzantine art in the White Tower (*open every day except Mondays, from 8.30am to 3pm. Free*) but parts of the collections have been taken to the new museum. (C.T.)

OPPOSITE TOP: PHILIP II'S ARMOR, MADE FROM IRON WITH GOLD TRIMMINGS.

OPPOSITE BOTTOM: GOLD BOX (*LARNAX*) FROM PHILIP II'S GRAVE GOODS.

ABOVE: MUSEUM OF BYZANTINE CIVILIZATION; RECOMPOSED ARCHITECTURAL ELEMENTS.

LEFT: CAPITALS AND RECONSTRUCTED SHRINE WITH THE REMAINS OF A WALL PAINTING IN THE MUSEUM.

THESSALONICA

OLYNTHUS

4.2

The first historical notice of this short-lived city dates to 479 BC when the Persians, having chased out the ancient Thracian inhabitants (the Bottieans) repopulated the city with Chalkidikian colonists who had strong commercial ties with the East. Around the middle of the 5th century BC, Olynthus was a member of the Delian-Attic League, but in 432 BC Perdiccas of Macedonia convinced the city to form the Chalkidikian League with other peoples of the zone. A new city was founded to the north of the existing one to which the inhabitants of a number of nearby sites moved. After being subjected by Sparta in 379 BC, Olynthus was obliged to ally itself with Philip II of Macedonia in 356. Then, fearing the Macedonian king's expansionist policy (Philip was determined to conquer all of Chalkidiki), the city attempted to reconcile with Athens. However, this gave Philip a pretext for declaring war, and in 349 BC he completely destroyed the city and sold its inhabitants as slaves.

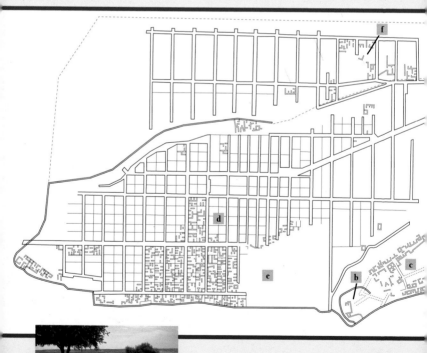

TOP: SARCOPHAGI, FUNERARY STELAE AND STONE BLOCKS LINE THE ENTRANCE AVENUE TO THE SITE.

LEFT FOUNDATIONS IN THE RESIDENTIAL AREA ON THE NORTH RISE.

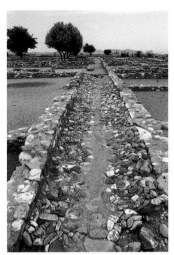

OLYNTHUS

a *NEOLITHIC SETTLEMENT*

b *BOULEUTERION*

c *FIRST CITY LAYOUT*

d *NEW CITY*

e *AGORA*

f *VILLA OF GOOD FORTUNE*

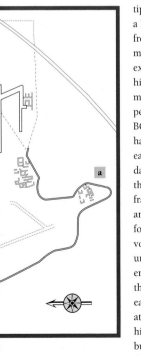

VISIT

We start from the southern tip of the south hill, where a **Neolithic settlement (a)** from the first half of the 3rd millennium BC has been excavated. After a long hiatus, the site was once more occupied by Thracian peoples in the 8th century BC, whose pottery materials have been found. The earliest architectural work dates from the middle of the 6th century BC: it is a fragment of Doric capital and stucco decoration found in a waste pile of votive materials from an unknown sanctuary. At the end of the 6th century, or at the start of the 5th, on the east side of an open space at the northern tip of the hill, a three-part rectangular building was constructed that may have been a *Bouleuterion* **(b)**. This is where the Chalkidikian colonists located their agora

(479 BC) when they laid out the first city on a **regular plan (c)** around two longitudinal arteries that ran along the east and west margins of the hill; these were cut transversally by three or four smaller streets.

The **new city (d)** (432 BC) grew across the open land on the north hill based on a grid of 7 north-south running streets (*plateiai*, A-G) cut every 125 feet by 24 orthogonal streets (*stenopoi*). All the axes measured 16 feet wide except for Plateia D (23 feet). The city blocks created measured 283'3" x 113'3" (equal to 300 x 200 Attic-Euboean feet) and were cut east-west by an alley that separated 2 rows of 5 houses. The **agora (e)** lay at the southern end of the hill with the *Bouleterion* on the east side. This was a rectangular building divided internally by a row of 7 columns in which materials from the older assembly building were reused. On the north side there was a portico and a fountain with a monumental façade.

TOP: RESIDENTIAL QUARTERS ALONG THE MAIN STREET AND (RIGHT) MILL STONE, ENTRANCE AVENUE.

With regard to the houses, the most common type had a small entrance **vestibule (a1)** that led to the **courtyard (a2)** onto which there usually, but not always, faced the *andron* **(a3)**, the men's banqueting room.

The far end of the the interiors. A distinctive feature of a house was the *andron*, as it represented a practice—the men's banquet—that typified the aristocracy.

The basic elements in the *pastas* type of house are seen in a more luxurious form in the large suburban of fortune. The incomplete inscription in the top left corner ("*Dikaio*") may have referred to the owner of the house. In the next room the words "*Eutykia kalè*" (Good fortune is wonderful) were written in front of the entrance and "*Aphrodite kalè*" (Love is

BLOCK

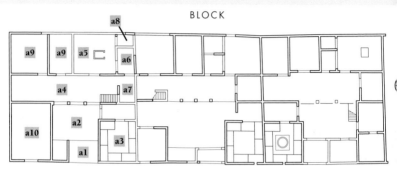

courtyard was occupied by the *pastas* **(a4)**, which was a portico of wooden pillars with stone bases and capitals. The private rooms of the houses looked out onto this portico. The **room (a5)** in which the family would gather to eat was flanked by the **kitchen (a6)**, the **pantry (a7)**, and the **bathroom (a8)**, often with a bathtub, and by the owners' **bedroom (a9)**. The bedrooms of the rest of the family and servants were distributed on the upper floor. Next to the entrance a **shop (a10)** opened directly onto the road. Though the layouts of the houses were very similar and reveal substantial social uniformity of their middle-class inhabitants, the different owners' aspirations are disclosed in the mosaic floors and painted wall decorations of

residences, like the **Villa of Good Fortune (f)** on the east side of the city. In addition to the wide *pastas* **(v2)**, the **courtyard (v1)** had a **peristyle (v3)** in the center, and the *andron* **(v4)** and its **vestibule (v5)** were decorated with high-quality mosaic floors made from black and white pebbles. The scenes illustrated were fully expressive of aristocratic values: the triumph of Dionysus in his chariot, in the first, and the handing over of weapons to Achilles in the second. Beyond the **kitchen (v6)** and **bathroom (v7)** on the east side of the house there were two communicating private rooms paved with pebble mosaics containing symbols and well-wishing inscriptions. In the **vestibule (v8)**, the words "Good luck" were accompanied by the wheel

beautiful) in a box in the center. Around these you can see symbols such as the double-bladed axe, the swastika, and a motif similar to a hand. (C.T.)

OPPOSITE AND RIGHT: AXONOMETRIC CROSS-SECTION; (BELOW) RECONSTRUCTION OF A TWO-STORY HOUSE BASED ON ARCHAEOLOGICAL DATA FOUND AT OLYNTHUS.

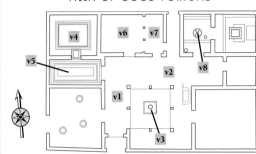

VILLA OF GOOD FORTUNE

OLYNTHUS

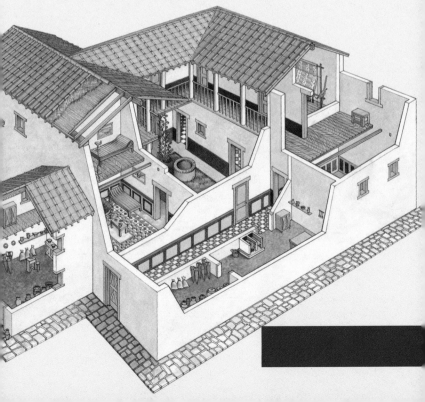

MOUNT ATHOS

The third peninsula in Chalkidiki is the narrow, mountainous finger that extends 28 miles into the sea and ends in the majestic bulk of Haghion Oros (Mount Athos), the "Holy Mountain." In this almost deserted and forested zone, from the 9th century AD onward hermits and monks attempted to find refuge after fleeing the various Byzantine cities the booty, founded a *Lavra* (a small community of anchorites). With the support and protection of Nicephorus (who became emperor) the *Lavra* was transformed into a large and rich monastery (963) with a community of 80 monks and extensive lands. Although the foundation of the monastery had aroused the hostility of monks that lived as hermits on the allowed fast sea communications with Thessalonica and Byzantium.

With the ascent to the throne of Andronicus II Paleologus (1282–1328), who supported the monks who opposed the unification of the Orthodox and Catholic churches, a period of profound spiritual and artistic renewal began. During this time Mount

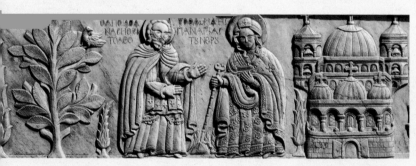

thrown into confusion by the iconoclastic struggles. Typical were the ascetics Peter the Athonite and St.Euthymius, who lived in caves.

The organization and rules of the monastic community were set down by St. Athanasius the Athonite who, in 957, had retired here as a hermit. However, he followed his friend the Nicephorus Phocas into the war against Candia (Crete's largest city, now called Iraklion) and, with part of peninsula and refused the new monastic lifestyle, the monasteries of Iviron (978) and Vatopedi (985) were also established.

Monasteries soon were flourishing throughout the whole peninsula. Emperors and members of the imperial court founded some; most received support from the Byzantine rulers and also from the substantial commercial activities undertaken by the monks since the peninsula's geographical position Athos became a center of religious and cultural attraction in the Byzantine world, which was a role that it was to maintain throughout its history. During the 14th century, the monasteries suffered raids by pirates, the damage of the civil war (1341–47), and occupation by first the Serbs (1345–71) and then the Turks. In 1424 the Ottoman Turks made them subject to the Ottoman state, though they maintained a degree of

CHALKIDIKI

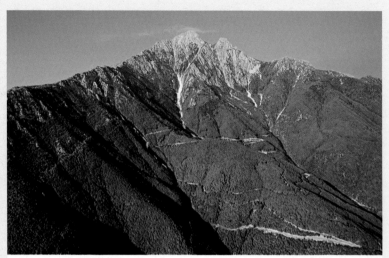

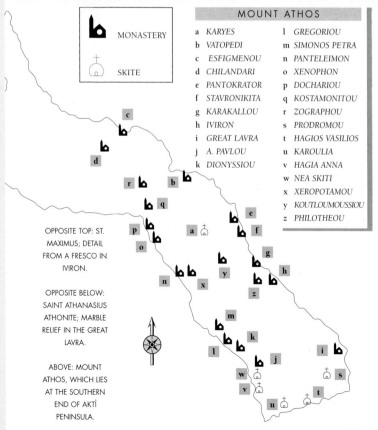

MONASTERY

SKITE

MOUNT ATHOS

a KARYES
b VATOPEDI
c ESFIGMENOU
d CHILANDARI
e PANTOKRATOR
f STAVRONIKITA
g KARAKALLOU
h IVIRON
i GREAT LAVRA
j A. PAVLOU
k DIONYSSIOU

l GREGORIOU
m SIMONOS PETRA
n PANTELEIMON
o XENOPHON
p DOCHARIOU
q KOSTAMONITOU
r ZOGRAPHOU
s PRODROMOU
t HAGIOS VASILIOS
u KAROULIA
v HAGIA ANNA
w NEA SKITI
x XEROPOTAMOU
y KOUTLOUMOUSSIOU
z PHILOTHEOU

OPPOSITE TOP: ST. MAXIMUS; DETAIL FROM A FRESCO IN IVIRON.

OPPOSITE BELOW: SAINT ATHANASIUS ATHONITE; MARBLE RELIEF IN THE GREAT LAVRA.

ABOVE: MOUNT ATHOS, WHICH LIES AT THE SOUTHERN END OF AKTÌ PENINSULA.

political and administrative autonomy, and retained their extensive possessions. Owing to the participation of the monks in insurrection movements against the Ottomans, in 1821 the Turks occupied the Athonite community for 9 years, and irreparable damage was done to the buildings, works of art and libraries.

The 1927 constitution of Greece established the peninsula as a theocratic and fully autonomous republic that is part of the state and represented by a prefect employed by the Ministry of Foreign Affairs. It is administered by the Epistasia, which sits in Karyes; it is composed of 20 representatives, one for each monastery, who are

elected in January of each year.

In addition to the 20 large monasteries on or close to the coast, the peninsula also has 12 *skite* (smaller monastic communities) that are often grouped in modest buildings. Sometimes the monks, in groups of two or three, live in scattered settlements (*kellia, kathismata*); hermits live in caves and ravines, particularly in the

southern area of the peninsula.

Monastic life is organized on one of two different systems. In the cenobitic system the monks share a common life under the guidance of the Igoumenos (abbot), whereas the idiorrhythmic system ("to one's own rhythm") introduced in the 18th century offers the monks greater independence; for example, each one has his own cell and can own personal belongings; the group as a whole meets only for prayer.

Architecturally, the monasteries are very varied as they date from different periods and, in consequence, are built in different styles. Each one, therefore, has a unique character. They were constructed as fortified enclosures, with towers, patrol walkways, bastions, slit windows and a single entrance closed by massive nailed metal gates. Built against the walls on the inside are the *kordes* (like the "cords" of a ring around the *katholikon*). These are multistory buildings, with loggias at the top, that house the cells of monks, the administrative center, the oven, the cellar, the hospital, the guesthouse, the hospice, the library and a number of small chapels. The *katholikon* stands at the center of the court, usually on the plan of a Constantinopolitan Greek cross, but with the later

additions (perhaps for liturgical reasons) of two apses to create the plan peculiar to Mount Athos of three apses in all. The large narthex (the *liti*) that stands in front of the *katholikon* for particular

liturgical purposes is characteristic of the monasteries. It is divided into 6 bays with 2 isolated columns at the center, and is covered by a central vault and two lateral cupolas. In front of the church stand the purification fountain (*phiala*) and the refectory (*trapeza*). The latter is essential to monastic life as the collective meal is the last act in the celebration of mass.

OPPOSITE, RIGHT, AND BOTTOM: SCENES OF MONASTIC LIFE. AUTONOMOUS IN EVERYTHING, THE MONKS OF THE "SACRED MOUNTAIN" WERE EXCELLENT CRAFTSMEN.

BELOW: AERIAL VIEW OF MONI PHILOTHEOU: THE KATHOLIKON (CENTER) SURROUNDED BY THE KORDES.

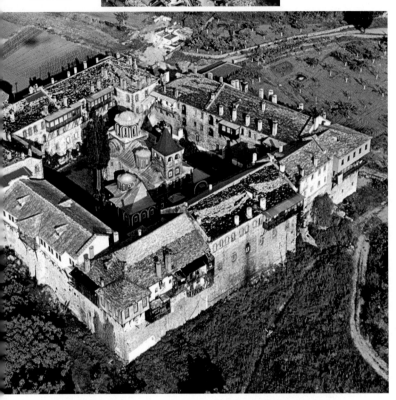

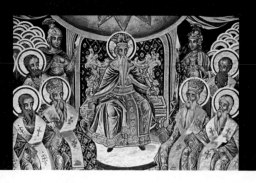

The monasteries were decorated with cycles of frescoes that have been repainted several times over the centuries. Few paintings remain from the 12th century, but those that do are among the finest examples of Byzantine painting from that period. The most important phase was the one that coincided with the reign of Andronicus II Paleologus, the great supporter of the Athonite monks. The frescoes from this period were painted by MANUEL PANSELINOS of Thessalonica (late 13th century), an exponent of the Macedonian school. His works are characterized by

elaborate architecture, figures with realistic faces, and bright, shiny colors. Cretan painters were active in the 15th and 16th centuries, when Crete was one of the most important artistic centers in the Orthodox world, with a long tradition of portable icons. One of these painters was THEOPHANES STRELITZAS, who worked on the Great Lavra in 1535; his elegant, balanced compositions and rich figurative program were particularly appreciated for their impeccable Orthodox character. Apart from the Cretan school, there was also the Theban painter

FRANGOS KATELANOS (1560), who favored freer scenes featuring movement and spatiality. In the 18th century Athonite painting developed its own local style, permeated by a strong retrospective tendency typical of PANSELINOS. It fell within a more general movement that harked back to the era of the artistic renaissance that occurred under Andronicus II Paleologus. The monasteries also have many works of art (icons, goldwork, fabrics, vestments and altar furnishings) and rare, religious books (including about 11,500 illuminated manuscripts).

MOUNT ATHOS

ABOVE AND RIGHT: ECUMENICAL COUNCIL, SAINT JOHN DAMASCENE AND SAINT GABRIEL IN IVIRON MONASTERY.

OPPOSITE: *CHRIST BLESSING* IN THE CHURCH OF THE PROTATON IN KARYES.

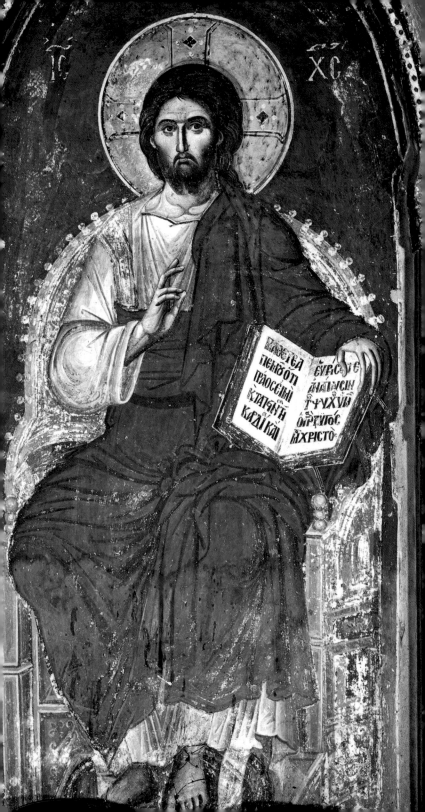

Only men over the age of 21 are allowed to visit Mount Athos. To obtain a permit that will allow you to stay a maximum of four nights, you must write a letter of request to your consulate in Athens (or in another Greek city where your country has a consulate). Or you may apply to the *Ministry of Foreign Affairs, Religious Administration, Zalokosta e Vassilissis Sophia Street, Athens (tel. 01 362 6894), or to Room 218, Office of Political Affairs, Ministry of Macedonia and Thrace, Dikitiriou Square, Thessalonica.*

Daily embarkation is at 9.45am at Ouranopolis for Daphni, the entry point to Mount Athos. To obtain permission to stay (*diamonitirion*), you must present your permit to the Ephistasia in Karyes, which can be reached by bus or on foot (about 3 hours) from Daphni.

On the road from Daphni to Karyes, you can visit the monasteries of **Xeropotamou (x)** (10th century but rebuilt and given new frescoes in the second half of the 18th century) and **Koutloumoussiou (y)** (founded in the 13th century and very prosperous in the second half of the 14th because of the influence of its Romanian monks; The frescoes are from the Cretan school and date to 1540 but have recently been repainted).

356

LEFT: THE MAIN CHURCH OF KOUTLOUMOUSSIOU, SOUTHEAST OF KARYES.

BELOW LEFT: *THE HOLY MARTYRS*; FRESCO IN THE MONASTERY OF KOUTLOUMOUSSIOU.

BELOW RIGHT AND OPPOSITE TOP: *THE PIOUS WOMEN*; FRESCO IN THE CHURCH OF PROTATON.

OPPOSITE BOTTOM: ANCIENT CHURCH OF THE PROTATON IN KARYES, SEEN FROM THE SOUTH.

KARYES

In the **capital (a)** you can visit the **Church of the Protaton**, one of the earliest, and those of the **Great Lavra (i)**, **Vatopedi (b)** and **Iviron (g)**. The marble *templum*, one of the oldest (second half of the 10th century) and the frescoes (*Canti* and Life of the Virgin), painted at the end of the 13th century by MANUEL PANSELINOS, are all exceptional. From Karyes, the monasteries are visited on foot. To be offered accommodation in a monastery, you must arrive before dusk.

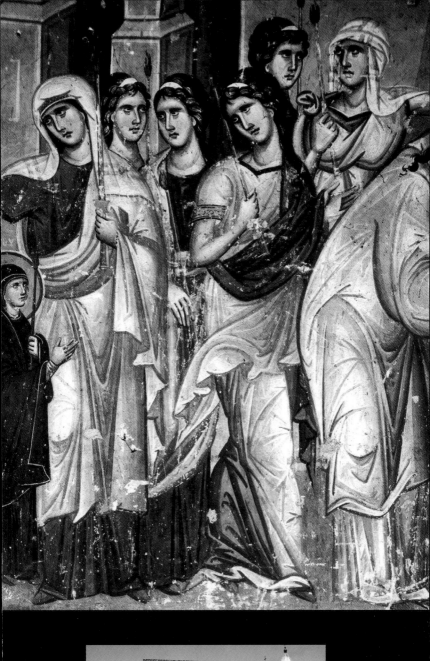
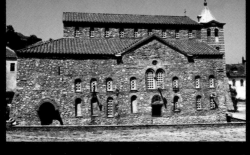

BELOW TOP: AN ILLUMINATED
MANUSCRIPT IN VATOPEDI.

BELOW CENTER: MONI VATOPEDI,
SECOND IN IMPORTANCE AFTER THE
GREAT LAVRA.

TOWARD THE NORTHEAST

MONASTERY OF VATOPEDI (b) (roughly 1.5 hours from Karyes) Founded around the end of the 10th century by three monks from Hadrianopolis and dedicated to the Annunciation of the Virgin, Vatopedi has always been one of the most important monasteries on Mount Athos owing to the support it was offered by the Byzantine emperors. Vatopedi has remarkable

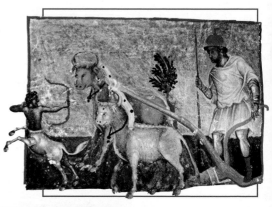

bronze doors (15th century, from the church of St. Sophia of Thessalonica) and mosaics (the only ones still existing on Mount Athos) on the tympanum of the door that leads to the endonarthex (of the Virgin and the Baptist praying before Christ, mid-11th century), and also a coeval mosaic on the walls that divide the presbytery from the prothesis and diaconicon (Annunciation). The frescoes are by the Macedonian school (1312), but have been repainted several times.

MONASTERY OF ESFIGMENOU (c)

(roughly 3h30 from Vatopedi) Founded at the end of the 10th or early 11th century, the katholikon was rebuilt 1806-10. The carved wood templum inside (1813) and a rare icon made from mosaic (12th century) are worthy of attention.

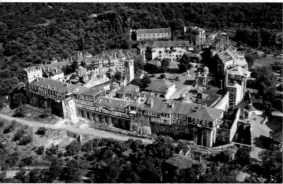

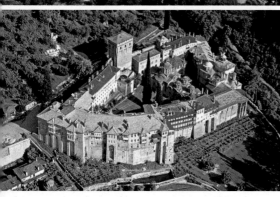

ABOVE: AERIAL VIEW OF MONI CHILANDARI.

OPPOSITE TOP: MONI PANTOKRATOR SEEN FROM THE SOUTHEAST.

OPPOSITE BOTTOM: MONASTERY OF STAVRONIKITA, DONJON AND TERRACING SEEN FROM THE NORTH.

MONASTERY OF CHILANDARI (d) (50 yards southwest of Esfigmenou)

This was built in a lush valley around 1192 by the Serb prince Stefan Nemanja, who retired here with the name of Simeon. His son, Rastko (St. Sava) was the founder and first patriarch of the Serb Orthodox Church (1219). The monastery was rebuilt in 1299 by his descendant, Stefan VI Milutin, king of Serbia. The katholikon is preceded by a large narthex covered by a cross vault and 2 cupolas. This was the first example of this type of construction and was taken up by other monasteries. A second narthex was added during later times. Inside there are Macedonian frescoes from the 13th–early 14th centuries, repainted in 1803.

TOWARD THE SOUTH
MONASTERY OF THE PANTOKRATOR (e) (2 hours south of Vatopedi)

Tradition has it that this monastery was founded by Alexis Stratigopoulos, the commander for Michael VIII Paleologus, when he won Constantinople back from the Crusaders in 1261. The katholikon dates to 1363 and the large tower on the west side of the wall to 1536. The Macedonian frescoes are 14th century and were repainted in 1854.

MONASTERY OF STRATONIKITA (f) (1 hour south of the Pantokrator)

This stands on a rocky outcrop dominated by a tall defense tower overlooking the sea. It is provided with water by an arched aqueduct from the slopes above. It was rebuilt over a previous monastery (last quarter of the 10th century) by the Patriarch of Constantinople, Jeremiah the Elder, in 1541 and dedicated to Haghios Nicolaos Stridas. Owing to space restrictions, the church has no side choirs or holy water font. Inside the frescoes are by the Cretan painter THEOPHANES and his son SIMON (1546).

MONASTERY OF KARAKALLOU (g) (2.5 hours from Iviron)

Founded in the 12th century and abandoned in the 13th, it was restored by Andronicus II Paleologus. The large tower that dominates the monastery is remarkable. The paintings in the katholikon date to the 18th century.

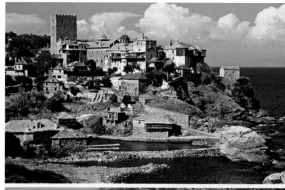

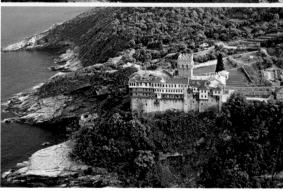

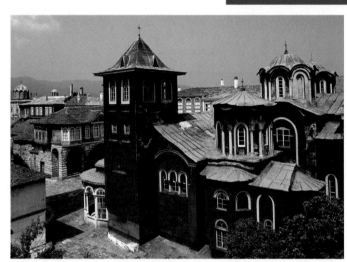

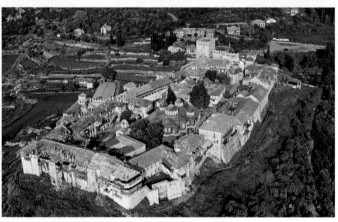

MONASTERY OF IVIRON (h) (2 hours from Karyes) Founded in the last quarter of the 10th century by the rich dignitary John Tornikios (originally from Georgia, also called Iberia, from which the name of the monastery is derived), this complex is dedicated to the Dormition of the Virgin. The katholikon was rebuilt in 1513 but conserves flooring from

the mid-11th century. The paintings date to the 15th and 16th centuries. One chapel contains the miraculous 10th-century icon of Panhaghia Portaitissa that was recovered from the sea by a monk named Gabriel.

GREAT LAVRA (i) (4 hours from Karakallou) This is the most magnificent monastery on the peninsula. It was

founded at the foot of Mount Athos in 963 by St. Athanasius. In appearance it seems a fortified hamlet with crenellated towers entered through a triple gateway. The court is dominated by the katholikon (concluded 1004) with its large central dome that is supported internally by 4 massive pillars. The large narthex is flanked by 2 chapels that form 2 small

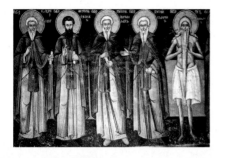

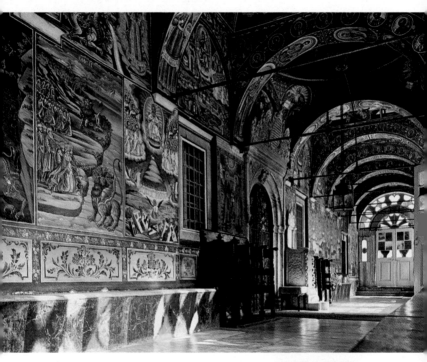

churches (St. Nicholas is adorned by frescoes by FRANGOS KATELANOS, 1560, and the Forty Martyrs contains the tomb of the founder). The frescoes in the katholikon are the work of the Cretan painter THEOPHANES (1535), who probably reworked an earlier cycle by PANSELINOS (14th century). The cross-plan refectory stands in front of the church and has an apse on the west side. The walls are decorated with a famous cycle of frescoes by THEOPHANES (c. 1535). Starting from the Great Lavra, you can visit several *skite* on the tip of the peninsula (**Prodromou**, founded by the princes of Moldavia, and **Kavsokalyvia**) and the **hermitages of Haghios Vassilios** and **Katounakia**.

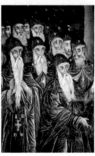

ABOVE: A GROUP OF
MONKS IN A FRESCO IN
THE GREAT LAVRA.

MOUNT ATHOS

BELOW: MONI DIONYSSIOU,
AEREA VIEW.

BOTTOM LEFT: THE REFECTORY IN
THE MONASTERY OF DIONYSSIOU
WITH FRESCOES BY ZORZIS.

BOTTOM RIGHT: MONASTERY OF
GREGORIOU SEEN FROM
THE SOUTH.

OPPOSITE TOP LEFT: THE MODERN
ARCHITECTURE OF HAGIOS
PANTELEIMON.

OPPOSITE TOP RIGHT: THE
MONASTERY OF XENOPHON WITH
THE KATHOLIKON AND DONJON
IN THE FOREGROUND.

OPPOSITE BELOW: MONI
DOCHARIOU.

ITINERARY 2, MOUNT ATHOS

362

MAINLAND GREECE

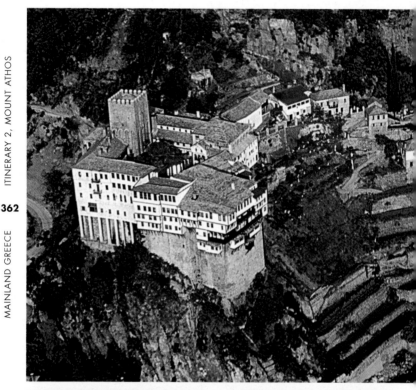

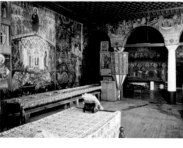

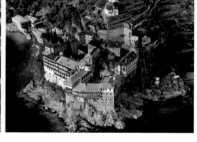

Returning up the **west coast**, after the *skite* of Haghia Anna and Nea Skiti, you can visit the **MONASTERY OF ST. PAUL (j)**, which stands in a magnificent position on the side of the mountain. This was built on the site of a hermitage in the second half of the 10th century and enlarged by the Serb prince Georges Bankovic with a new katholikon (restored in the 19th century). The chapel of St. George is decorated with frescoes from the Cretan school (1555).

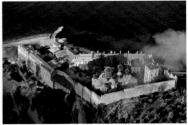

MONASTERY OF DIONYSSIOU (k) (35 yards from the Great Lavra) Founded around 1370 in a dominant position over the sea, it was destroyed by a fire in 1535. The katholikon was frescoed by the Cretan painter ZORZIS (1546–47) and has a lovely carved and gilded wooden templum (18th century). Note also the carved wooden ambon, the frescoes in the refectory (1603) and those in the entrance porch (1568).

MONASTERY OF GREGORIOU (l) (1h30 from Dionyssiou) Founded in the 14th century, the katholikon was rebuilt in the 18th and frescoed by GABRIEL and GREGORY OF KASTORIA (1779).

MONASTERY OF SIMONOS-PETRA (m) (1h30 from Gregoriou) Founded by the hermit Simon in the 14th century in a site of exceptional beauty on the top of a rock; it can be reached only from an unusual bridge composed of 3 levels of arcades.

North of Daphni (1h30 from Simonos-Petra) Here you can visit the **MONASTERY OF S. PANTELEIMON (n)** (2h from Daphni) founded by Russian monks (1830–90) in an attempt to exploit the centrality of Mount Athos in the Orthodox world to extend its influence in the Balkans by building numerous buildings on the peninsula. Rebuilt at the

end of the 19th century, it was largely destroyed by a fire in 1968.

MONASTERY OF XENOPHON (o) (1h30 from S. Panteleimon) According to tradition, it was founded in the 10th century by Xenophon, a contemporary of St. Athanasius. It is dedicated to St. George. The old katholikon (the new one was built in 1890) is decorated with frescoes by the Cretan painter ANTONIOS (mid 16th century).

MONASTERY OF DOCHIARIOU (p) (1h from Xenophon) The plan dates to the second half of the 10th century. The katholikon was rebuilt in the 16th century and has frescoes by the Cretan painter ZORZIS (1568).

MONASTERY OF COSTAMONITOU (q) (1h30 from Dochiariou) Founded in the 11th century, it was destroyed by Catalan pirates and rebuilt in the 14th century.

MONASTERY OF ZOGRAPHOU (r) (1h from Costamonitou) Built in the 13th century; rebuilt in the 14th. (C.T.)

ITINERARY 3
AMPHIPOLIS

The city of Amphipolis occupied a strategic position at the mouth of the River Strimone, which allowed easy access to inland Thrace. The region's interior offered resources of timber and deposits of gold and silver. For this reason the site was uninterruptedly occupied from prehistory to the middle of the 6th century BC by a settlement with the significant name of *Ennea Odòi* (Nine Roads) that excavation has recently identified on hill 133. At the end of the 6th century BC, an attempt by the Parians to occupy the settlement failed, as did one by the Miletans in 498 BC; however, in 476 BC Athens succeeded in gaining Eiòn, the last Persian bulwark at the mouth of the river, and then Ennea Odòi. However, when the Athenians tried to penetrate inland, they were massacred by Thracians at the village of Drabescos. The Athenians only succeeded in their attempt in 437 BC and concluded by founding Amphipolis. A few years later, during the Peloponnesian War, the city was taken by Sparta (423 BC), which they succeeded in holding against several Athenian attacks. Annexed to the

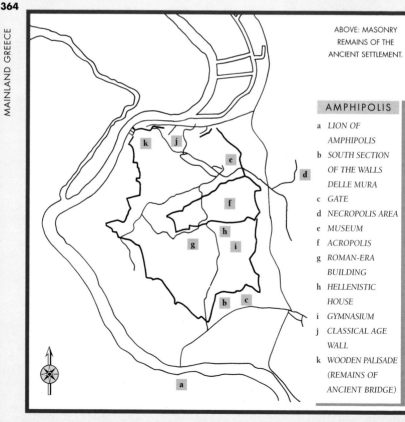

ABOVE: MASONRY REMAINS OF THE ANCIENT SETTLEMENT.

AMPHIPOLIS

a *LION OF AMPHIPOLIS*

b *SOUTH SECTION OF THE WALLS DELLE MURA*

c *GATE*

d *NECROPOLIS AREA*

e *MUSEUM*

f *ACROPOLIS*

g *ROMAN-ERA BUILDING*

h *HELLENISTIC HOUSE*

i *GYMNASIUM*

j *CLASSICAL AGE WALL*

k *WOODEN PALISADE (REMAINS OF ANCIENT BRIDGE)*

T H R A C E

Macedonian kingdom by Philip II, Amphipolis continued to have great importance even after the battle of Pydna when it became the capital of the first of the four districts into which the Romans divided Macedonia.

Damaged during the Thracian revolt against the Romans, Amphipolis, which may have been refounded by Augustus, enjoyed great prosperity in the late imperial age.

Open every day 8 am to 7 pm. Payment required.

You enter the archaeological area from the south where you will find the **Lion of Amphipolis (a)** before you cross the River Strymon. The Lion of Amphipolis is a late 4th-century BC funerary monument probably built for Laomedon, an admiral of Alexander the Great's fleet. You continue alongside the **south section of the walls**

(b) which, thanks to the excavations now in progress, are the better known part of the Greek city. Carefully constructed at the end of the 5th century BC using the isodomum (building technique in various courses of stones of the same height) technique, and partially rebuilt in the 3rd and 2nd centuries BC (in very irregular pseudo-isodomum technique), the fortifications reflected the city's preoccupation with defense and the strength of the community that had founded the colony. The walls were 4.6 miles long and reinforced by round or four-sided towers. There were several **fortified gates (c)**, one of which can be seen in this stretch. At the sides of the gate there are two bases for statues, one of Augustus (mentioned in the inscription as the founder of the city) and the other for L. Calpurnius Pison, referred to as a "patron and benefactor of the city." The two statues were probably raised when

ITINERARY 3, AMPHIPOLIS

365

MAINLAND GREECE

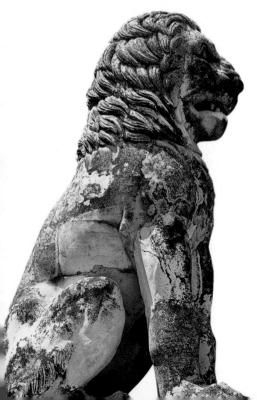

THE LION OF AMPHIPOLIS, PROBABLY A FUNERARY MONUMENT OF THE ADMIRAL LAOMEDON.

extensive restoration work was being carried out on the city wall. Continue until you meet the road to Serres on the right that runs alongside the **necropolis (d)**; here you turn left toward the modern village of Amphipolis, and pass a section of Byzantine fortifications built over the ruins of the walls of the Greek acropolis.

Then continue on to the **museum (e)**, in front of which you can see a cist tomb (early 6th century BC) that contained a silver chest with the burned bones of a high-ranking individual and a gold crown (now in Amphipolis Museum). The tomb is thought to be that of Brasidas who, according to Thucydides, died in 423 BC fighting the Athenians and was buried as a hero close to the agora inside the walls. Go past the museum and, 220 yards on, turn right from where you can climb to the **acropolis (f)**. At the top excavations have revealed a set of basilicas built between 450 and 550 AD reusing many ancient building materials.

On the left of the path, which crosses the area east-west, stood Basilica C, with a nave, two aisles, an apse with a *synthronon*, a transept and an atrium on one side. To the right of the path was Basilica A, also with a nave and two aisles, and an atrium (with fine Ionic capitals), and the baptistery and *diakonikon* to the north and south of the atrium respectively. Southeast of the Basilica A lay Basilica D, with a nave, two aisles, and an atrium with a peristyle. On the eastern edge of the area you can see the remains of Basilica E, built on an unusual horseshoe plan, and with a peristyle court in front of it. Finally, to the south of this stood Basilica B.

Descending from the flat, a path heading southwest will take you to a **building (g)** from the Roman age that has elegant mosaic floors (Europa abducted by Zeus, Poseidon and Aminon, and Hylas abducted by the Nymphs, all in Kavala Museum). It may have been a villa or part of a larger complex that was the gymnasium during the imperial era.

To the southwest of this building a **Hellenistic house (h)** has been excavated (3rd and 2nd centuries BC) that has interesting wall decorations (an imitation of pseudo-isodomum created with stucco; and a composition made with rectangular panels of fake marble behind a row of *trompe l'oeil* columns, with an architrave made of stucco). A path leads to the **gymnasium (i)** below which dates to the 5th century BC, but the ruins seen today are from a renovation carried out in the 3rd and 2nd centuries BC. (At this point you can return by car taking the road for Serres and turning right and right again after 100 yards.) A monumental stairway led to a large

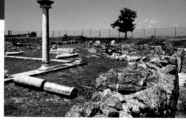

ABOVE LEFT: CAPITALS, BASES AND COLUMN SHAFTS IN THE AREA OF THE BASILICAS AND ACROPOLIS.

ABOVE RIGHT: A REPLACED COLUMN AND THE AREA OF THE GYMNASIUM.

OPPOSITE: ZOOMORPHIC FIGURES; DETAILS OF RELIGIOUS FLOOR MOSAICS IN THE BASILICA AREA.

palaestra arranged round a peristyle court with rooms on three sides. At the sides of an Ionic propylaeum (Augustan) on the north arm were a bathroom, in which the supports for the ablution basins can still be seen on the ground, and, on the right, two communicating rooms used for rubbing on body oils. The rooms on the other side were where men engaged in physical training, while those on the west side were used by the public: the long room was for official competitions, the office of the gymnasiarch (the public official responsible for supervising the games and athletes) and, beyond that are a secondary entrance and a sacellum dedicated to Hermes, with three statue bases and an offerings table.

To the north of the palaestra lay a wide court with a large altar (two sides were lined a double row of four bases with iron rings to which sacrificial animals were tied), a long cistern connected with the baths on the west side, and, in the northeast corner, the track covered by a Doric portico for winter athletics training. A row of 20 holes in front of the south wall was used for placement of the poles that separated the running lanes from the outdoor track.

The court was crossed diagonally by a stairway that climbed from the monumental steps to the north entrance of the complex.

Return to the Serres road, turn left and pass the intersection that allows you to go to the village; then, turn left again about 900 yards on to visit the north arm of the **Classical-era wall (j)**. The northeast section (183 yards) rises at its highest to 24' 6" and has a remarkable water evacuation system comprising large triangular or trapezoidal pillars that vertically cut the wall on either side of a gate flanked by two towers.

Continuing west past a Byzantine tower, you come to the ruins of a second stretch of wall (118 yards); the third section (218 yards) has a fortified gateway built in the Hellenistic era. A little farther ahead, past a round tower that was rebuilt on a rectangular plan in the Hellenistic era, you will see the remains of a **wooden palisade (k)** beneath a canopy that supported the only bridge built over the river. This was therefore the weakest point in the entire defense system. When the colony was founded, it had not been incorporated inside the walls and the Spartans used it in 423 BC to get beneath the walls of the city. In the two successive years, the walls in this section were reinforced to defend the bridge adequately with the most heavily fortified gateway in the entire circuit. (C.T.)

THE MUSEUM

Every day except Mondays, 8:30 am to 3 pm. Payment required.
The **silver chest** containing the bones of the Spartan general Brasidas is in the *entrance*. The *downstairs floor* has objects found on the site from the Paleolithic to Byzantine periods (pottery, jewelry, statues, inscriptions, coins, glassware and mosaics). (C.T.)

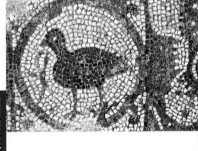

PHILIPPI

The original name of the city was Krenides after the many springs in the area. It was founded in the 6th century BC by colonists from the island of Thasos, who were attracted by the fertility of the plain and the possibility of controlling access to the gold deposits in the Pangaeus district. Conquered by local tribes, the city was newly colonized by the Athenian Callistratus in 361 BC. Five years later Philip II of Macedonia captured it and renamed it after himself, celebrating the event by minting a series of coins that showed the head of Heracles with the Nemean lion skin and, on the other side, the tripod of Apollo and the caption "*Philippon.*"

The name of Philippi is linked to the battle that took place here in 42 BC when Mark Antony and Octavian fought Brutus and Cassius, the assassins of Julius Caesar. The victory of the two triumvirs (three men sharing public administration or civil authority in ancient Rome) marked the end of the republican regime in Rome. The battle was followed by the foundation of a colony (*Colonia Victrix Philippensium*), renamed

Colonia Julia Philippensis by Octavian, who transferred the partisans from the ancient alliance in 30 BC whose property he had confiscated in Italy. All the plain was divided up into "centuriae" (agricultural plots) and occupied by rural settlements (one, Aulòn, has been identified with Kipia near Eleptheroùpolis). The colony, which was named *Augusta Julia Philippi* after the battle of Actium, enjoyed great prosperity, particularly in the late Antonine period, owing to its location on the Via Egnatia. It was an important Christian center after St. Paul founded the first European Christian community here in 50 AD, but the city's decline began

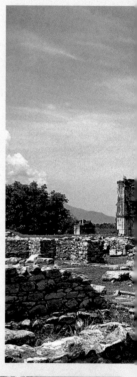

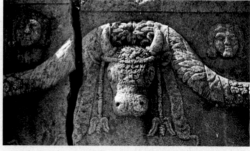

with the invasion of the Goths in 473 AD. During the Byzantine period the city moved completely within the Macedonian walls over which new ones were built.

Further problems occurred with the destruction an earthquake caused around the middle of the 7th century, but the city continued to be inhabited.

OPPOSITE TOP: DETAIL OF CAPITAL, BASILICA B.

OPPOSITE BOTTOM: RELIEF FROM THE THEATER.

BELOW: FORUM AREA, THE PORTAL OF THE LIBRARY AND, IN THE BACKGROUND, THE RUINS OF BASILICA B.

VISIT

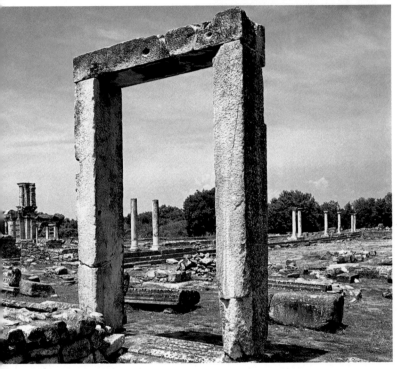

Winter, every day except Mondays, 8 am–5 pm; summer, every day, 8 am–7 pm. Payment required.

The ruins visible today date to the second half of the 2nd century AD and the early Christian period. Currently the Greek phase of the settlement has not been investigated (it lies beneath the Forum and a residential area to the east of the Macellum) though some sections of the walls and square towers are known. After you enter the excavation site, you will see the **Forum (a)** on the right of the Kavala-Drama road. This road traces the path of the *decumanus maximus*, which was the city section of the Via Egnatia.

The square was given a monumental facelift at the time of Marcus Aurelius (161–175) which, as far as can be seen, did not substantially alter the preceding layout created during the Claudian age. The square was bounded on three sides (east, south and west) by raised porticoes with two aisles, behind which lay various rooms.

The eastern section was reserved for buildings constructed in honor of the imperial family and colony by important public officials.

In the northeast corner was a distyle Corinthian temple *in antis*, dedicated to the cult of the emperor (*Sebasteion*). This had been commissioned by C. Modius Laetus Rufinianus, the quaestor (ancient Roman officials concerned chiefly with financial administration) of Macedonia (his name appears on two statue bases that stand on either side of the entrance to the naos). The temple replaced a smaller building used for the cult of the family of Augustus. In front of the temple is the plinth originally for the seven statues of the priestesses of Livia, the wife of Augustus. When the new and larger temple was built, the plinth had to be shortened and the statues reduced to five. Next to this were four large rooms and a library that opened onto the portico with three granite columns *in antis*.

The west side of the square was where the colony's political and administrative buildings of the colony stood. The Curia (the senate's meeting place and seat of the duovirs (two men sharing public administration or civil authority in ancient Rome)) stood in the northwest corner; like the building in the opposite corner, this too was distyle Corinthian *in antis*. Then came the Basilica, a long rectangular room with an entrance with

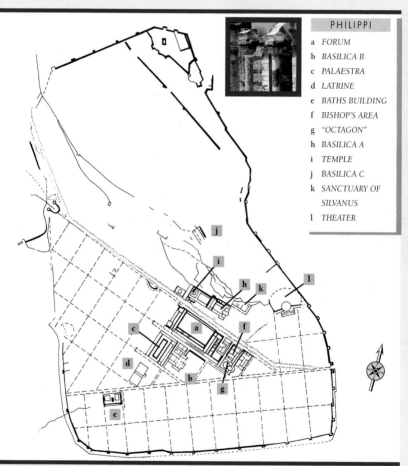

PHILIPPI

a *FORUM*
b *BASILICA B*
c *PALAESTRA*
d *LATRINE*
e *BATHS BUILDING*
f *BISHOP'S AREA*
g *"OCTAGON"*
h *BASILICA A*
i *TEMPLE*
j *BASILICA C*
k *SANCTUARY OF SILVANUS*
l *THEATER*

5 columns *in antis*, and a shrine on the north wall. Right at the south end of the Forum stood the Tabularium, the public archive and seat of the *aedili* (magistrates responsible for monitoring public places, markets and prices). The north side of the square was flanked by the twin buildings of the Curia and temple of the imperial cult, and formed a sort of architectural backdrop. Its

building with a peristyle and was used as the atrium of the church.

Heading farther south you can see a large **latrine (d)** and a **baths building (e)** built in 250 AD on the ruins of a sanctuary dedicated to *Liber*, *Libera* and *Hercules*. Now, go back to the Forum to visit the **episcopal quarter (f)** on the east side. This is one of the best preserved in Greece. The southern part of the first

mosaic floor, now in the museum. Above the basilica a church with an octagonal plan was built during the reign of Emperor Arcadius (395–408). It has a central chamber surrounded by a deambulatorium and crowned by a dome. In the first half of the 6th century, however, it was necessary to insert it in a square with projecting apses at the corners. A corridor on the north side of the Octagon

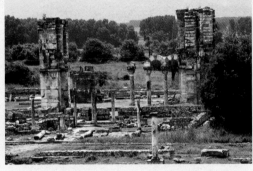

decorative buildings were arranged symmetrically at the sides of the orators' rostrum: there were 2 rectangular courts, 2 large fountains and 2 arched ramps that led to the *decumanus*.

Lastly, the Forum's south side was used for commerce, with 21 two-story shops that faced onto a road that ran south. On the other side of the road stood the Macellum (food market). In the 6th century AD, the ruins of the Macellum were built over by **Basilica B (b)**. The basilica's narthex was built over the *odeon* of a **palaestra (c)** from the Antonine period. The palaestra was a rectangular

two is occupied by the "**Octagon" (g)**, an exceptional basilica with an octagonal plan within a square; it has an atrium and narthex and was built around 500. The entrance was on the *decumanus* through a magnificent triple portal with a gable and colonnaded way that led to the narthex.

The basilica of St. Paul (the first place of worship for the city's Christian community) has been found beneath the north part of the church. It was built in the first half of the 4th century against a late-Hellenistic *heroon*-tomb (2nd century BC) by Bishop Porphyrius, as is indicated by the inscription in the

leads to the court with the *phiale* (northwest corner) and the five rooms in the Baptistery that used hot water from the baths complex next door. Built in the Augustan period, the baths were rebuilt in the second half of the 6th century. The next block in an easterly direction was where the bishop's residence stood. He had a house with an atrium and a double rectangular storeroom. Another house that has been excavated stands in block 4. The house (second half of the 5th century) had a triclinium paved with marine mosaics, an atrium, and a series of storerooms on the south side.

Excavation of block 5 is still in progress. On the other side of the main road, you can visit the north section of the site. The terrace that lay at the foot of the acropolis and overlooked the Forum is lined with the remains of **Basilica A (h)**. This was constructed in the 5th century using materials from at least three earlier buildings and has almost completely erased the remains of older constructions in the area. Only in the northern part of stood the *Capitolium* dedicated to the Capitoline triad. The upper terrace terminated in an arcade similar to the one in the square and closed off the political area in a remarkably scenographic manner.

The ruin of **Basilica C (j)** can be seen close to the museum. Built in the first half of the 6th century to replace a smaller one from the late 5th century, it has a nave, two aisles and a transept that was added ruins of the basilica were then used as a graveyard (11th and 12th centuries). Heading toward the theater, a turn to the left after Basilica A will take you to the rock **sanctuary of Silvanus (k)**, three large shrines and a bench. Latin inscriptions (2nd and 3rd centuries) to the right of the bench list the members of a religious body related to burials and another that had contributed to the construction of the sanctuary.

BASILICA A

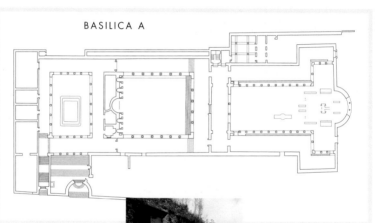

the complex has it been possible to recognize the structures of a **temple (i)** with a pronaos and naos that was transformed into a cistern when the basilica was constructed. The temple and its western wing looked toward the Forum below to which it was connected by a monumental stairway that ended at the arched ramp of the west entrance. There was probably a similar building at the eastern end, while in the center, aligned with the Forum rostrum, around 550. The basilica was badly damaged by an earthquake and, in the 10th century, a new church was built in the area of the northern annexes. The The **theater (l)** dates to the period of Philip II but it underwent various modifications in the Roman era. In the second half of the 2nd century the lower steps were removed, the vaults of the side corridors built, the orchestra paved and the stage decorated. In the 3rd century AD, the

TOP: PLAN OF BASILICA A.

BOTTOM: MARBLE FLOORING AND RIBBING IN BASILICA A.

orchestra was turned into a circular arena to allow gladiatorial and animal games, the *frons scaenae* was removed and underground corridors built.

On the south and southwest slopes of the acropolis you can see various rock carvings (187 in total), many of Diana hunting deer (but also Jove, Minerva, Cybele and a Thracian horseman) shown inside squares topped by gables and accompanied by Latin inscriptions (2nd and 3rd

Basilica A, begun before 337 and destroyed during the invasion of the Goths in 473. It was rebuilt with a nave and two aisles during the reign of Justinian but was once more destroyed during raids by the Bulgars (821 or 837). On the east side of the nave a small church was built with an apse and figured mosaic floor (animals, plants and geometric patterns).

Lying 420 yards south of this stood the extramural Basilica B, with a nave, 2

aisles and a narthex. The nave has a geometric mosaic floor (late 4th–early 5th centuries).

Beside the church there is an underground burial complex (3rd century) with a vestibule that communicates with two chambers through sliding marble doors. The chambers were divided into two parts by a transenna (screens) patterned with diamond perforations, and the deceased had been placed in lead sarcophagi.

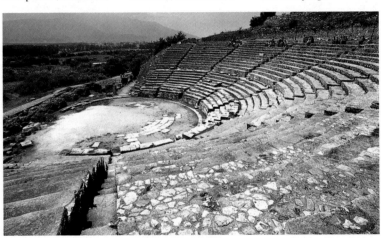

centuries AD). The smallest shrines, with female figures at the center, may refer to the people who made the dedications.

Along the path that leads to the top of the acropolis lie the remains on two terraces of a 2nd-century AD sanctuary dedicated to Egyptian gods. On the upper one there were five square cells originally lined with marble, the second of which was dedicated to Isis. In the village of Krenides, you can visit the ruins of

TOP: THE CAVEA OF THE HELLENISTIC THEATER THAT WAS HEAVILY REBUILT IN THE ROMAN ERA.

BOTTOM: PILLAR AND COLUMN IN THE SANCTUARY OF SILVANUS.

THE MUSEUM

Open every day except Mondays, from 8:30 am to 3 pm.

Hellenistic, Roman and early Christian objects found on the site. Prehistoric objects from Dikili-Tach and Sitagri. (C.T.)

At the end of the 5th century BC, the small settlement on the shores of Lake Ludios became the new capital of the Macedonian kingdom, probably because the short distance to the sea could be easily traveled by river. The city (the name of which means "stone") stretched between the lakeshore and the two rises of the acropolis (the one occupied today by the village Palai Pella and the hill to the west). The fort of Faco used to stand in the middle of the lake—since drained—where, Livy wrote, the Macedonian kings kept their treasure. The city's design was laid down at the time of Archelaus (413–399 BC) or Amyntas (393–371 BC), but it was built over a series of construction phases of which Cassander's seems to have been of particular importance. Construction was completed in the 3rd century BC. A prosperous and refined city, Pella maintained its importance even after the Roman conquest and was probably the seat of the provincial governor. Seriously damaged by the earthquake in 90 BC, it began to decline when the governorship was moved to Thessalonica. Under Caesar (or Mark Antony) Pella became a colony, which was refounded by Augustus with the name *Julia Augusta Pella*. The information provided by sources, which refer to the city as depopulated and rundown in the 1st and 2nd centuries AD, contrasts with the presence of a mint in the 2nd and early 3rd centuries AD. Probably the Roman settlement was built on a site different to that of the Greek city, and it was the latter, perhaps abandoned, that the sources described.

TOP: IONIC CAPITAL IN THE PERISTYLE OF THE HOUSE OF DIONYSUS.

BOTTOM AND 374-375: HUNTING LION MOSAIC, DETAILS FROM THE HOUSE OF DIONYSUS (IN THE MUSEUM).

OPPOSITE: MOSAIC DETAILS FROM THE HOUSE OF THE ABDUCTION OF HELEN.

Open every day except Mondays, 8:30 am–3 pm, winter, and 8:30 am–7 pm, summer. Payment required.

The city was built on a unified development plan with a grid of north-south roads between 19' 8" and 20' 4" wide, and east-west roads each 29' 6" wide. These created a series of rectangular blocks of varying length in which the houses were built. The acropolis and its palace fitted harmoniously into the city fabric as they were bounded on the east and west sides by two larger north-south roads (29' 6" wide) that marked the limits of the agora in the center of the city.

The extension of the city is not known exactly. Sections of the walls, made from unfired brick on a stone base and reinforced with square towers, have been excavated to the south of the residential district and along the east side of the city as far as the acropolis. Here they curve northward along the northern boundary of the palace.

The visit sets out from the city's southern section where blocks of luxury houses from the last quarter of the 4th century BC have been uncovered; it is from these houses that the most important group of Macedonian pebble mosaics come.

The **House of Dionysus** (a) has a double peristyle, one Ionic to the north and a larger one, Doric, to the south. The latter was lined with triclinia and resting rooms with elegant floor mosaics. On the west side a small triclinium was decorated with an *emblema* of Dionysus on a panther (in the museum), and an antechamber with a mosaic of inscribed squares (*in situ*). Of the 3 rooms that lie between the 2 peristyles, the floor of the central and largest one is decorated with black and white diamonds; at the center of the triclinium, there was an *emblema* showing a

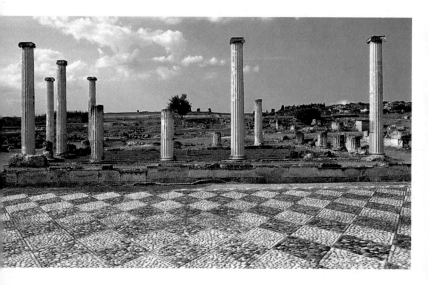

MOSAIC FLOOR AND IONIC PERISTYLE IN THE HOUSE OF DIONYSUS.

OPPOSITE TOP: HOUSE OF THE ABDUCTION OF HELEN: ALEXANDER AND HEPHAESTION HUNT DEER.

OPPOSITE BOTTOM: DETAIL FROM THE HOUSE OF THE ABDUCTION OF HELEN (IN THE MUSEUM).

lion hunt (in the Pella Museum).

Another series of exceptional mosaics was found in the **House of the Abduction of Helen (b)**; the house is named after the subject of the mosaic located in the triclinium at the center of the north side of the peristyle in the north section of the residence. The mosaic in the room next door, signed by Gnosis, is also exceptional; it depicts a deer hunt with Alexander and Hephaestion, while the amazonomachy in the triclinium in the middle of the east side is of lesser importance in terms of both composition and execution.

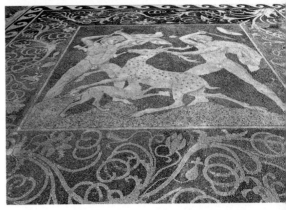

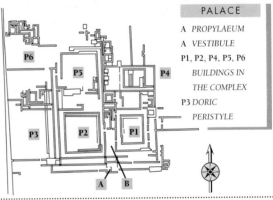

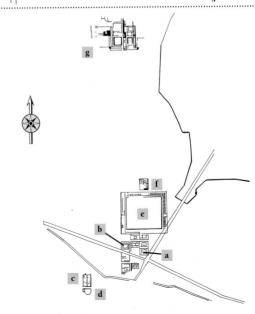

To the south of the quarter (380 yards beyond the museum), you can see the ruins, which cover an entire block, of a **sanctuary** (c) outside the wall dedicated to Darron, a Macedonian hero possessing therapeutic gifts. To the south of this lie the remains of a large **circular building (d)** (115 feet in diameter) unique in Greek architecture not just for its

north, you come to the **agora (e)**, which covered an area equal to 5 blocks in width and 2 in length. Lined with porticoes, it could be entered through pedestrian passageways on the north and south sides, while a monumental gate on the east side marked the entrance to the greater *plateia* (49' 2") that crossed it east-west and divided it into 2 unequal sections.

presence of bases for statues on the right hand side, and fragments of inscriptions bearing the names of magistrates. In this section the monotonous series of shops was interrupted by a semi-circular fountain, originally adorned with statues, while the left-hand side had an area with a semi-circular exedra that may have been used for political meetings.

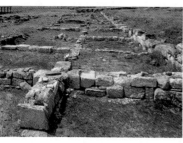 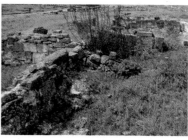

huge size but also for its 3 smaller circular rooms, two of which open directly into it, and the third that may have been connected via a corridor. The complex was built at the end of the 4th century BC over a *megaron*-type structure from the Archaic era used for cult purposes. The new building was decorated with wall paintings and floor mosaics (only those in the smaller room in the northwest have survived and are now in the museum) and may have been dedicated to the cult of Heracles. This hero was considered the mythical ancestor of the Macedonians and was worshipped as the protector of the city and regal dynasty. If you continue

What we see today is the rebuilt square from the late-2nd and early-1st centuries BC, built to a plan by Philip V. Destruction by an earthquake at the end of the 1st century BC has led to the discovery of objects in the rooms behind the porticoes that identify the uses of the porticoes. The east portico was found to contain crafts-related objects associated with terracotta modeling and ceramics; the south portico was lined with food shops and the west one with two metal workshops and a perfume shop. The square was, therefore, prevalently commercial in character. Only the north side seems to have been official; we know this from the

The building in the southwest corner—a quadriportico with a peristyle court—could also have had an official use, perhaps as the city archive. The *Metròon* (f), the city's main sanctuary, lay immediately to the north of the agora. Dedicated to the Great Mother Cybele, it was used between the mid-3rd and first centuries BC. The sanctuary covers about the same area as a city block and has a rectangular court divided into two sections by a portico. The south part contained a sacellum *in antis* with an offerings table in the naos and a series of service rooms. The north section had a room for symposia and, beyond it, two small

areas ranged around courtyards, the purpose of which we do not know. From there you come to the **palace (g)** that dominates the city on the acropolis. It was formed by at least three architectural units (excavation is still in progress) arranged from east to west on parallel longitudinal axes and covering an area of roughly 15 acres. Each unit contained two buildings. A grandiose Doric portico gave the complex a unitary feel and formed the south face of the palace (the side that looked toward the city). The entrance was a monumental **propylaeum (A)** that led into a wide **vestibule (B)** between the east and central buildings.

The **east building (P1)** was probably used for receptions and lay around a peristyle; the north side of the peristyle was lined by a long room with apses at the east and west ends and, beyond this, a vast room with 2 smaller rooms on either side. The **building (P4)** to the north of the east building was one level higher but it has not been sufficiently investigated for us to know its plan. The central section was entirely filled by two **buildings (P2, P5)** with large peristyle courts measuring 55 yards square. These were surrounded by Doric arcades and separated by a covered room. The north court may have been used as the

palaestra and was joined to the baths buildings in the northeast corner (the "Large Baths"). The west wing too was divided into two buildings: the south building had an immense **Doric peristyle (P3)** measuring 77 x 87 yards but was never completed. In the northeast corner of the **building adjacent (P6)** there was another baths complex (the "Small Baths"). The degree of complexity of the layout and the size of the palace are very different to those of the residence at Verghina, a fact undoubtedly determined by the fact that this was not just the seat of the royal court, but also of the administrative and political bodies of the kingdom.

ITINERARY 4, PELLA

379

MAINLAND GREECE

OPPOSITE LEFT: REMAINS OF SHOPS, WEST END OF THE AGORÀ.

OPPOSITE RIGHT: REMAINS OF CIRCULAR BUILDING, PERHAPS CONSECRATED TO HERACLES, PROTECTOR OF THE CITY.

PAIR OF UNBROKEN *PITHOI* FROM THE WEST SIDE OF THE AGORA.

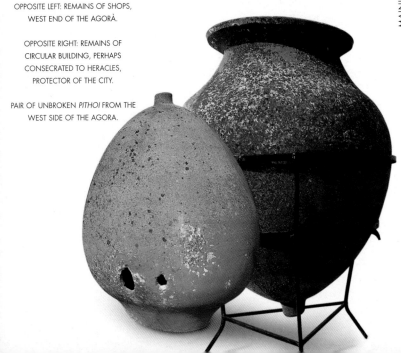

THE MUSEUM

Open every day except Mondays, from 8:30 am–3 pm, winter; in summer, Monday from 12 pm–7 pm, other days 8 am–7 pm. Payment required.

The museum contains all the finds made on the site, including a collection of sculptures (funerary stelae, late 5th century BC; a dog and headless rider, mid-4th century BC; and a head of Alexander, late 4th century BC) and mosaics (**Dionysus on a panther**, **Alexander hunting lion**, and a round mosaic from the *thòlos*). (C.T.)

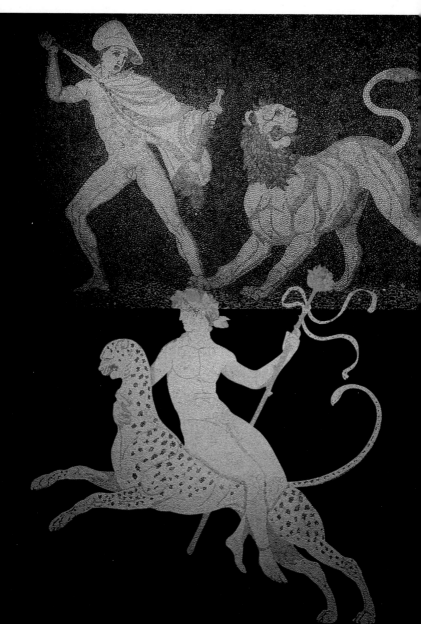

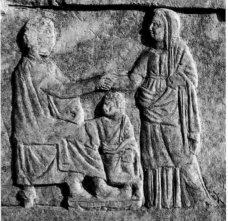

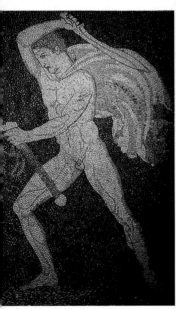

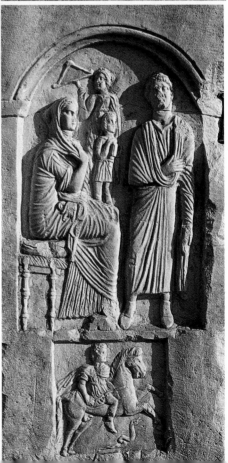

ABOVE: ALEXANDER (LEFT) HUNTING LION WITH CRATERUS; FLOOR MOSAIC IN THE HOUSE OF DIONYSUS.

LEFT BOTTOM: THE GOD WITH HIS KNOTTED CLUB RIDES A PANTHER; FLOOR MOSAIC IN THE HOUSE OF DIONYSUS.

RIGHT TOP AND BOTTOM: FUNERARY STELAE FROM THE CLASSICAL ERA.

VERGHINA

The extraordinary discovery made in 1977 of a group of royal tombs has resulted in confirmation that Verghina was Aigai (proposed in 1968 by N. Hammond), the ancient capital of the Macedonian kingdom.

As indicated by the ancient tombs in the vast necropolis, the first settlement dates to the early 10th century BC and the grave goods (in particular, weapons and jewels) are suggestive of the high quality of life.

In the first half of the 7th century BC, the Macedonian dynasty of the Argeads from the high valley of Haliàkmon conquered the region and founded Aigai ("goats") as its capital.

At the end of the 5th century BC, Archelaus transferred the court to Pella, but the kings and nobility continued to marry and be buried here. The city maintained a high level of prosperity, in particular from favor

shown to it by Philip II, who had a palace built here with a theater and sanctuary.

In 274 BC, Pyrrhus—at war against Antigonus Gonatas—occupied the city and his mercenaries sacked the necropolises (Plutarch, *Life of Pyrrhus*, 26, 11). Little information has survived from the Roman period, but excavations still in progress suggest the city was an important center that was inhabited until at least the early Christian era.

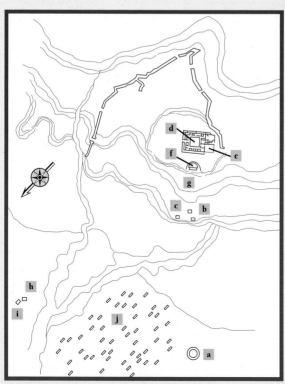

VERGHINA

a *TUMULUS OF THE ROYAL TOMBS*

b *RHOMAIOS' TOMB*

c *EURYDICE'S TOMB*

d *PALACE*

e *STAFF RESIDENCE (?)*

f *THEATER*

g *SACRED AREA*

h *HEUZEY TUMULUS*

i *BELLA TUMULUS*

j *NECROPOLIS OF THE TUMULI*

ABOVE: DETAIL FROM THE FLOOR MOSAIC.

OPPOSITE: GOLD STATER WITH PORTRAIT OF PHILIP II.

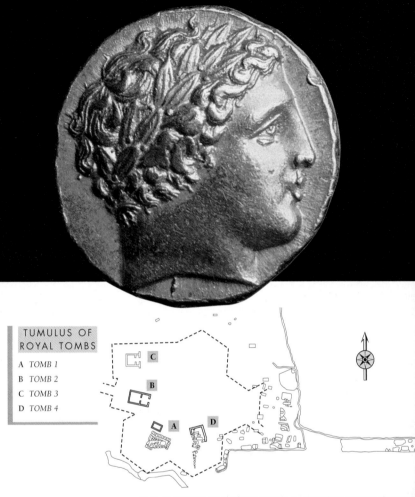

VISIT

The visit begins at the **tumulus of the royal tombs (a)** (360 feet in diameter, 39 feet high) in which M. Andronicus from Thessalonica University found four graves and the foundations of a building used for funerary purposes. The tombs were covered by two mounds, one on top of the other. After looting by the Galatians, Antigonus Gonatas had a new tumulus built over the original one to protect those tombs that were still intact from further depredation. Consequently, two tombs survived to the modern day unviolated. Having entered the large crypt, you will see painted funerary stelae (4th century BC) on either side of the door and a nother 7—painted or sculpted during the same era—on the left. Before you there are windows with other materials (7th–4th centuries BC). Like the fragments of stelae, these were found mixed with the earth of the tumulus. **Tomb 4 (D)** has a façade decorated with 4 Doric half-columns (the window contains the few items that were not looted: earthenware, and 2 small ivory heads that decorated a *kline*). The foundations of a building thought to be a *heroon* (second half of the 4th century BC) lie beside the tomb.

The chamber **Tomb 1 (A)**

with a horizontal covering contained no grave goods. Though small, the walls were decorated with a fine fresco of Hades abducting Persephone (north side), Demeter (east side) and the Moirai ("Fates") (south side) that it is thought was painted by Nicomachus. Dated to the first half of the 4th century BC, the tomb may have been built for Amyntas III, the great-grandfather of Alexander the Great.

A stairway leads down to **Tomb 2 (B)** at the center of the tumulus. In the temple-shaped façade the large, gray marble door is framed by two Doric half-columns that support the architrave and Doric frieze (with original polychromy). Above runs a remarkable painted frieze, perhaps by the Athenian Nicias, of a royal hunt featuring 10 people. The horseman about to run the lion through with his spear is probably Philip II, to whom the tomb has been attributed. Philip was killed in the theater in 336 BC. The young horseman in the center would therefore be Alexander, his successor. Inside the tomb are two rooms, in each of which a set of extraordinary grave goods was found (see the windows in the crypt). Inside a marble sarcophagus in the antechamber (probably built for one of Philip's wives), was a gold chest containing the burned bones of a woman (aged

23–27) wrapped in a purple and gold cloth, and a splendid gold diadem. In addition there were a gold myrtle, a gold quiver with scenes of the *Iliupersis* and two shin guards.

In the main chamber there was another sarcophagus containing a larger and richly decorated gold chest that contained the bones of the deceased. They too were wrapped and laid beside a gold oak-leaf crown. Weapons lay on the floor (pieces of iron armor with decorations in gold, a helmet, lances, a sword, a dagger and shin guards) and a silver banqueting service. In a corner was a set of bronzeware for the bathroom, a superb gold

and ivory ceremonial shield, and ivory decorations from a *kline* including a series of small heads (Philip, his wife Olympia, and son Alexander).

The front of **Tomb 3 (C)**, enclosed between two corner half-pillars, has at the sides of the door two large shields that were originally painted. The painted frieze above the Doric frieze (with original polychromy) has not survived, perhaps because it was painted on a perishable material.

The walls of the antechamber were lined with white stucco and decorated with a painted frieze of a chariot race. At

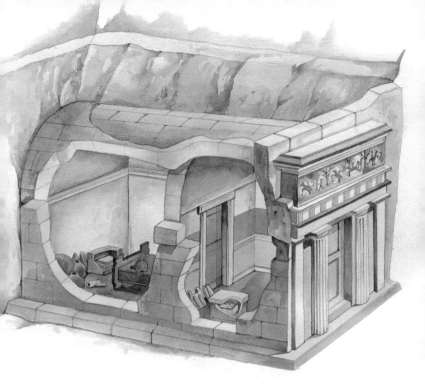

the back of the burial chamber was a marble table with a hole in the center in which a silver hydria stood. The hydria contained the burned bones of a young boy, aged 13–14. Gilded ivory elements from a *kline* showed a drunken Dionysus accompanied by Pan and a young woman. The young boy may have been the son of Alexander the Great and Roxanne, Alex IV, killed by Cassander, along with his mother, in 311 BC. Returning to the village, you come to two Macedonian tombs. The **Rhomaios tomb (b)** dates from the first half of the 3rd century BC and is one of the best known for the elegance of its architecture.

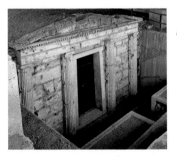

Inside the chamber (looted in antiquity) all that remains is a marble throne and stone *kline*. Another **large tomb (c)** was found to the east of this in 1987. It dates to around the mid-4th century BC and may have been the burial place of Eurydice, the mother of Philip II. The architectural decoration of the back wall of the burial chamber is like the façade of a building with four Ionic half-columns that frame a door and two windows. Only a large marble throne remains in the tomb, but this is unique for both its size and its magnificent decoration. The backrest is framed by an elegant polychrome low relief of volutes; at the center is a fine painting of Hades and Persephone on a quadriga, certainly the work of a master.

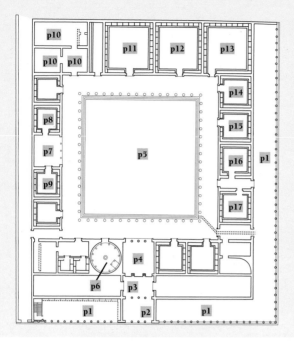

p1 TWO-LEVEL
PORTICO
p2-4 VESTIBULES
p5 PERISTYLE
p6 "THOLOS"
p7 CENTRAL ROOM ON
THE SOUTH SIDE
p8-9 SIDE ROOMS
p10 STOREROOMS
p11-13 LARGE
ROOMS ON THE
WEST SIDE
p14-17 ROOMS ON
THE NORTH SIDE

OPPOSITE: BLOCKS OF
GROOVED COLUMNS IN
THE PALACE AREA, SEEN
FROM THE NORTH.

386 Continue on the road that leads to the **palace** (d); this is a rectangular complex built around the end of the 4th century BC and measuring 115 x 97 yards. The entrance lies on the east side and is preceded by an **arcade on two levels** (p1) (Doric and Ionic). This continues on the north side to form a sort of veranda that looks down onto the plain below. The entrance has **3 vestibules** (p2-p4), that lie one after the other and are separated by colonnaded passages that led into the **peristyle** (p5). This had 16 Doric columns on each side and lay at the center of the palace; the rooms of the 4 wings of the palace were ranged around the peristyle.

Immediately to the left of the entrance lies the *Tholos* (p6), the most distinctive room in the entire building. Square on the exterior, inside it is circular with niches and a seat base set into the wall. An inscription with a dedication to Heracles (the mythical ancestor of the Argeads) identifies the room as a place of worship and may have been used as a throne room.

A suite at the center of the south side was formed by a **central room** (p7) that opened onto the peristyle through 3 double columns, and by **lateral rooms** (p8, p9) connected to the central room. The pebble mosaic of the peristyle floor still exists; a round floral motif is inscribed in a square at the center and female figures on a calyx lie in the corners. With all probability this was the

official banqueting room. The west side of the peristyle was lined by **3 storerooms** (p10) and **3 large rooms** (p11-p13) perhaps used for the meals of the palace guards. The north wing had 4 rooms, 2 of which opened onto the peristyle and 2 onto a passage that led to the veranda.

The foundations of a **large building** (e) have been found to the west of the palace. It was built in the first half of the 3rd century BC and arranged around a peristyle; it may have been used by the palace staff. The **theater** (f) stood on the slopes below the north wing and was functionally connected to the royal residence. The palace and theater would have been built during the same period according to the

Hellenistic city model seen in other great capitals. It was here that in 336 BC Philip II was assassinated by a certain Pausanias while he was watching the procession of the statues of the Twelve Gods. The young Alexander was immediately proclaimed

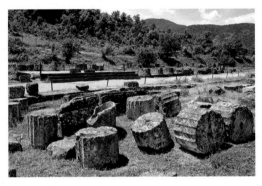

king. A **sacred area (g)** has been uncovered near the theater, inside which stood a small Doric temple with a pronaos and naos. On the west side of the sacellum were three statue bases, one of which was inscribed with a dedication to Eukleia (goddess of Good Fame) by Eurydice, the daughter of Serra. Eurydice was the wife of Amyntas III and the mother of Philip II. The north part of the sanctuary was the site of the Doric temple *in antis*, with an *eschara* at the center of the naos where Zeus *Melichios* may have been worshiped.

The foundations of large public buildings have been uncovered to the west of the sacred complex. The buildings lined the agora, with the sanctuary of the *Megale Meter* found to the

northwest of the theater. The **Heuzey tumulus (h)** can be seen on the road from Verghina to Palatitsa. It dates to the last quarter of the 4th century BC. The side walls of the burial chamber were lined with limestone *klinai* coated with stucco and carved to look like a wooden bed. The nearby **Bella tumulus (i)** (named for the family it contained) had three tombs. The façade of the biggest (second half of the 3rd century BC) had 4 Ionic half-columns that supported the architrave, Doric frieze and pediment. The burial chamber contained a stone sarcophagus carved to look like a wooden bed and was decorated with reliefs of palmettes, rosettes and spirals on the legs. A frieze of yellow griffins on a red background was painted in the central section. The façade of the second tomb (early 3rd century BC) had no architectural elements with the exception of the door. Above this three figures were painted: a young warrior at the center who

undoubtedly represented the deceased; to the right a tall female figure in profile who holds out a gold crown toward the warrior; and on the left a young man may be the personification of war or the god Ares. Inside there was a single chamber that contained a marble throne of which the back was painted on the wall behind.

A third tomb (end of the 3rd century BC) had a sarcophagus in the burial chamber.

The Tumulus Necropolis (j) lies between Aigai and Palatistia and contains more than 300 tumuli, most of which are still to be explored. The earliest tombs (1000-700 BC) lie in the north part of the necropolis. The new interments gradually spread south towards the city, from which the site was separated by a stream. Each tumulus contained several graves for both male and female members of a family and was used over a long period. Most of the tombs found date from the ninth and eighth centuries BC, while for the moment there is an absence of those between 650 and 400 BC though these may lie in a part of the site not yet investigated. Many of the graves are from the fourth and third centuries BC, whose grave goods reveal that the dead were from a rather low social class. (C.T.)

DION

The city was sacred to Zeus *Olympios* (as the name Dion attests) and the center of a famous sanctuary dedicated to him, in honor of whom (and the Muses who were worshipped in the region) Archelaus, the king of Macedonia, instituted important festivals with athletic and dramatic competitions. Here the successors of Achelaus celebrated their victories; Alexander performed large sacrifices before his expedition to Asia Minor and placed bronze statues of 25 horsemen by Lysippus here to commemorate his companions who fell in the battle of Granicus in 334 BC. In 219 BC the Aetolians sacked sanctuary and city, but after the battle of Pydna (168 BC), they passed under Roman control. Shortly afterwards, Quintus Caecilius Metellus definitively conquered Macedonia and removed the bronze horsemen and sent them to Rome where they graced the magnificent quadriportico (the *porticus Metelli*) that he had built in the Campus Martius. Under Augustus, Dion was made a colony (*Colonia Julia Augusta Diensis*) and flourished in the imperial era until the invasion of the Ostrogoths in 473 AD. The city was probably abandoned in the 5th century as a result of the damage caused by earthquakes and floods.

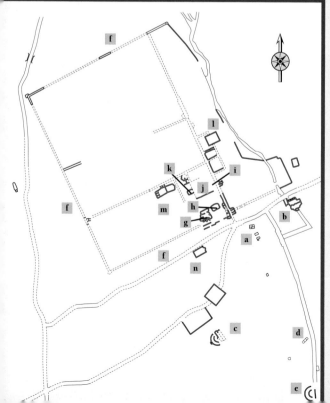

DION

a SANCTUARY OF DEMETER
b SANCTUARY OF ISIS
c HELLENISTIC THEATER
d SANCTUARY OF ZEUS
e ROMAN THEATER
f FORTIFICATIONS
g BATHS BUILDING
h ODEON
i WALLS WITH RELIEF OF SHIELDS AND ARMOR
j FORUM
k TEMPLE OF THE IMPERIAL CULT
l VILLA OF DIONYSUS
m EARLY-CHRISTIAN BASILICA
n CEMETERY BASILICA

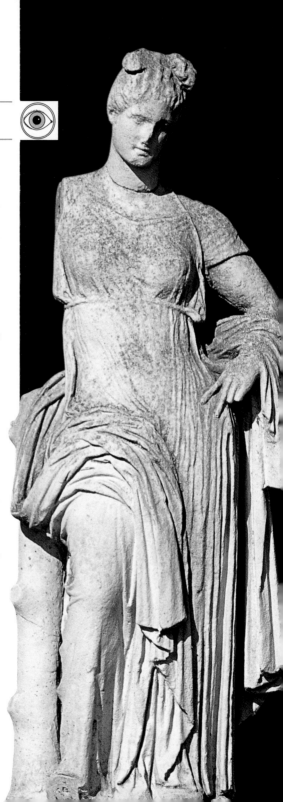

Open every day from 8 am to 7 pm. Payment required.

From the entrance the path leads to the **sanctuary of Demeter (a)** in an area that was frequented as early as the Mycenaean age (15th century BC). In the 6th century BC, two small cult buildings (a, b) were constructed but at the end of the 4th century BC these were replaced by two small Doric temples *in antis*. A marble head of Demeter from the cult statue in one of the temples suggests the building was probably dedicated to the goddess. Next to the temple was a well surrounded by an enclosure, similar to the sacred well (*Kallichoron*) in Eleusis. To the north of the sacellae was a series of *oikoi*, in one of which early fruit and vegetable produce was placed on a table in front of a statue base.

OPPOSITE: DETAIL FROM A MOSAIC IN THE VILLA OF DIONYSUS.

STATUE OF APHRODITE *HYPOLIMPÌDIA*, SANCTUARY OF ISIS.

Next comes the **sanctuary of Isis (b)**, which lay in an area made marshy by the River Baphyras; today it runs farther east than it did in antiquity.

The cult of the waters favored the foundation of a sanctuary dedicated to Artemis, the goddess worshiped as the protectress of births. In the Late Classical period the sanctuary of Isis *Lochia* was built on top of that of Demeter but retained Artemis' function. Rebuilt completely at the end of

had a pool fed by a spring. To the left was another small temple, perhaps dedicated to Poseidon, as we know from a dedication and the statue of the god found in the central temple. In front of this and slightly south stood the sacellum of Isis *Tyche*, the tutelary goddess of seafarers, with an apse for the cult statue in front of the entrance, a shrine on either side and a pool at the center.

A secondary entrance on the north side of the

orchestra was connected to the proscenium by an underground passage that was used when it was necessary to make the spirits of the Afterlife appear in a performance. The sanctuary of Dionysus has been identified near to this area.

The road flanks the area of the **sanctuary of Zeus (d)** where excavation has revealed fragments of Doric columns, sculptures and inscriptions, and a wall roughly 110 yards long that may have been part of

 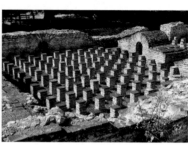

the 2nd century AD, the sanctuary was frequented until the end of the 4th century when it was destroyed by an earthquake. Surrounded by a wall, the sacred complex had its main entrance on the east side, from where a processional way led to the altar. This stood in front of an Ionic portico, beyond which the temple of the goddess stood on a tall platform reached by a stairway.

To the right of the building stood the sacellum of Aphrodite *Hypolympìdia* ("on the slopes of Olympus") in which, instead of a floor, the naos

entrance separated a square room from a tripartite portico. In front of one of these the dedicatory inscription was found of P. Anthestius Amphios, a rich and generous freedman who became one of the duoviri of the colony, and his wife Anthestia Maxima. This couple underwrote the reconstruction of the sanctuary in about 200 AD. Return to the main path and turn left toward the Roman theater. Along the way you will see on your right the ruins of the **Hellenistic theater (c)** (200 BC), with a *koilon* resting on an artificial rise and brick steps. The

the peribolos.

The second-century AD **Roman theater (e)** lies a few yards south. Its cavea is supported by wedge vaults and the stage building was decorated with statues (in the museum).

Return north to visit the city. The Greek town was ringed by rectangular **fortifications (f)** (end of 4th century BC) (1.6 miles long) with towers every 35 yards and gateways, of which 6 have been found, at the ends of the main city streets. The best conserved is the west gate in the north wall; it is flanked by a tower on each side and

has a double internal courtyard. After the city was sacked by the Aetolians, the walls were restored but were neglected during the Roman period. In the 3rd century AD they were rebuilt once more when threats of barbarian invasions arose. Many of the materials were taken between a series of shops (on the right) and latrines (on the left), then through a large square to reach the entrance. Standing in front of the entrance was the vestibule that led into all the different areas of the baths. On the west was the *frigidarium*, which was decorated with a mosaic probably used for political meetings, given its proximity to the legal section.

If you continue up the *cardus maximus*, you will see a **wall** on your left (40 yards long) **adorned with reliefs of shields and armor (i)** that were originally painted (end of

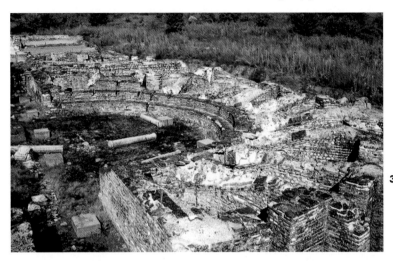

from existing buildings, including the nearby necropolis, and a modification was made to their course so that they followed the line of the river on the west side. The last renovation was made in the early Christian era when the area the walls surrounded was lessened by exclusion of the city's north and east sections. The paved *cardus maximus* of the Roman city, which left from the south gate, had already been one of the Greek city's main streets. The large **baths complex (g)** was reached on the left of the street by passing through a passageway

floor of Nereids and Tritons, plus two baths and a large swimming pool. To the south lay, the *calidarium* (hot rooms) and the two *tepidaria* (medium-heat rooms), where the *suspensurae* (supports) in the hypocaust can still be seen. A room on the north side may have been used for cult purposes as statues of Asclepius and his family were found here (in the museum).

The *odeon* **(h)** lay to the north of the square, with a cavea supported by wedge vaults and adorned by an Ionic arcade. Built, like the baths, at the end of the 2nd century AD, it was

OPPOSITE LEFT: SANCTUARY OF ISIS, THE PROCESSIONAL WAY AND THE ALTAR.

OPPOSITE RIGHT: *SUSPENSURAE* IN THE *CALIDARIUM* IN THE CITY BATHS.

TOP ROMAN *ODEON*.

BELOW: DETAIL FROM A MOSAIC IN THE ROMAN BATHS.

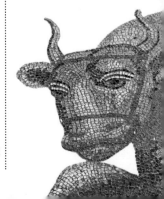

the 4th century BC). The wall may have been the basement of a monument or a public building. This was the area of the **Forum (j)**. Beneath it, buildings from the Hellenistic agora have been found, but of the buildings that normally stood in the political and religious center of Roman cities, here only the **temple dedicated to the imperial cult (k)** has been found so

columns and a well, to a large **atrium (3)** where the *tablinum* **(4)** lay. The *tablinum* was connected to a suite of two rooms and to a **long room (5)** with an apse at the end. The fact that this room was the residence's private shrine is indicated by a statue of the god and the floor mosaic of Dionysus, crowned with ivy, holding his knurled staff and seated on a throne. The

at the center, accompanied by an old Silenus, emerging from the waves on a chariot drawn by two marine panthers whose reins are held by a pair of centaurs at the sides of the chariot. The scene is framed by two rows of three small panels showing the head of the god between theatrical masks. The room was found to contain four statues of headless philosophers that

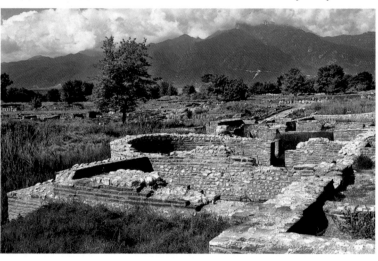

far (in the middle on the west side).

Farther ahead on the right side stood a luxury residence referred to as the **Villa of Dionysus (l)**. The central nucleus of the residence has a **baths building (A)** to the south and two large peristyles on the north side. There were **two large entrances (1, 6)**, the first led in through a **vestibule (2)**, with 4 Ionic

second entrance (6) led into a larger and more sumptuous **atrium (7)** joined to the first entrance by a **corridor (8)**. On the west side of the atrium lay a **room (9) with an elegant mosaic** of black and white squares, and, on the east side, a splendid **triclinium (10)** measuring slightly over 1,000 square feet. The floor mosaic is of high quality and shows Dionysus

had been brought from the atrium (where the heads had been removed), probably after the earthquake that seriously damaged the house.

A **marble shrine (11)** on the left of the room was dedicated to the cult of Heracles.

Returning to the city gate, you can turn right to visit the remains of a large early **Christian basilica (m)** built

in the second half of the 4th century AD. It was destroyed shortly after by an earthquake and rebuilt on the same plan. Along the street you will see the ruins of 3rd- and 4th-century AD houses on the left. As you leave the city, the remains of the **graveyard basilica (n)** (5th century AD) can be seen on the right.

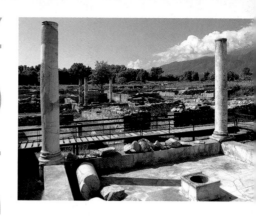

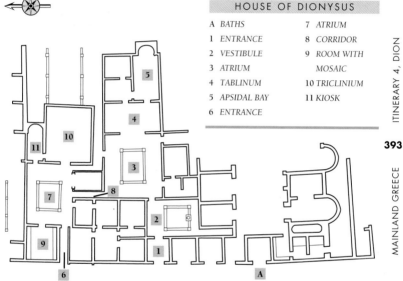

HOUSE OF DIONYSUS

A BATHS
1 ENTRANCE
2 VESTIBULE
3 ATRIUM
4 TABLINUM
5 APSIDAL BAY
6 ENTRANCE
7 ATRIUM
8 CORRIDOR
9 ROOM WITH MOSAIC
10 TRICLINIUM
11 KIOSK

THE MUSEUM

Open Monday from 12:30 pm–7 pm; Tuesday to Friday, 8 am–7 pm; Saturday, Sunday and holidays, 8 am–2:30 pm. Payment required.

Ground floor: pieces from the sanctuaries of Isis and Demeter, and the baths (in particular the **statues of Asclepius and his family**, excellent 2nd-century AD copies and originals from the early Hellenistic period).

First floor: a *hydraulis* (hydraulic organ) invented by Ktesibios in the 3rd century BC and very popular in the Hellenistic and Roman periods. It was also used at the court of Byzantium. The organ found in Dion dates to the 1st century BC and is the oldest known. Articles found in the Villa of Dionysus are of interest. (C.T.)

TOP: CENTRAL WELL AND COLUMNS IN THE VESTIBULE.

BELOW: DETAILS OF AN IONIC CAPITAL; FRAGMENT FROM THE *DOMUS*.

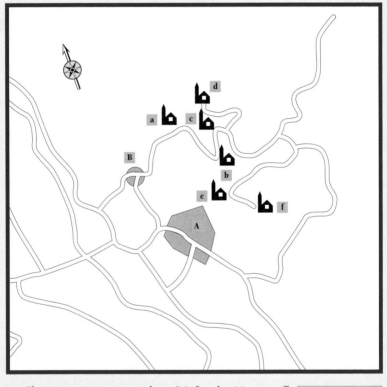

The monasteries "suspended in the air" cling to the peaks of magical obelisks. The impetuous River Pinios created these towers of sandstone in ancient prehistory as it rushed through the last spurs of the Pindus Mountains. In 1834, R. Monckton Milnes (a British aesthete) termed the area, "A marvelous combination of Nature and Art, of the strange humors of geology and man." At first the visitor is astonished. Some of the groups of rocks appear like slivers, others like huge rock masses, some are so pale and thin that they can be confused with the cypresses beside them, others are square and as solid as cathedrals, and yet others shapeless in their immensity. These prodigies of nature are the setting for the works of men who wished to retreat here to meditate.

METEORA

A TOWN OF
 KALAMBAKA
B KASTRAKÌ
a HAGIOS
 NIKOLAOS
 ANAPAUSAS
b HAGIA ROSSANOU
c VARLAAM
d MEGÀLO
 METÈORO
e HAGIA TRIÀDA
f HAGIOS
 STEPHANOS

THE HISTORY

The sources for the history of the Meteora ("high places") are essentially given by the lives of the founding saints (*Syggramma Istorikon*) and the inscriptions found in the monasteries themselves. It is not known with certainty when the site became a monastic settlement. However, it is probable that a number of hermits lived here from the 12th century on, in small cells with rudimentary chapels concentrated in the area of Dhoupiani. In the second half of that century, a "monastic village" with a central church (*kyriakon*) and refectory is recorded as having existed under the dependence of the Bishop of Stagoi (today Kalambaka). Another indication of the early existence of the community is given by the foundation around 1200 of the Church of the Theotokos ("Mother of God") in Dhoupiani.

The evidence became more detailed and reliable in the 14th century when large monasteries were built by founder-monks from noble families, for example, the Serb prince John Uros Paleologos (Megàlo Metèoro, end of the 14th century), and Antony, the brother of the Byzantine Emperor John IV Cantacazune (Hagios Stephanos, end of 14th century), and the children of the Apsarades family (Varlaam, early 16th century). That was the period in which Stefan Dushan and his successors ruled over a vast and powerful Serbian kingdom that included Thessaly. The support that this dynasty gave to the Meteora region allowed the monasteries to become the owners of large properties and consequently they flourished. (Those that survived were confiscated by the Greek dictator Eleuthérios Venizélos in 1922.) In the 16th century, the monasteries experienced a second period of splendor and many developed their present-day appearance. As in the area of Mount Athos, each religious complex is composed of a *katholikon*, chapels, refectory, kitchens, cells, a library and an infirmary. In the middle of the century, a gradual decline set in resulting from the heavy-handed control of the Turkish authorities. The monasteries were progressively abandoned: the *scriptoria* (copying rooms) that had brought fame to Meteora disappeared, and, from the 18th century, the monasteries lost a great many of their precious manuscripts to private collectors and libraries across Europe. During more recent centuries, the monks were supported financially by the lords of Moldavia and Wallachia, many of whom were of Greek stock. However, it was only after World War II and the cruel events of the Greek Civil War that monastic life began to take a turn for the better. Even today, however, very few of the monasteries are inhabited by religious communities.

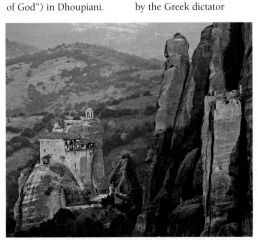

OPPOSITE AND LEFT: THE MONASTERY OF HAGIOS NIKOLAOS, FAMOUS FOR THE PAINTINGS BY THE CRETAN PAINTER THEOPHANES.

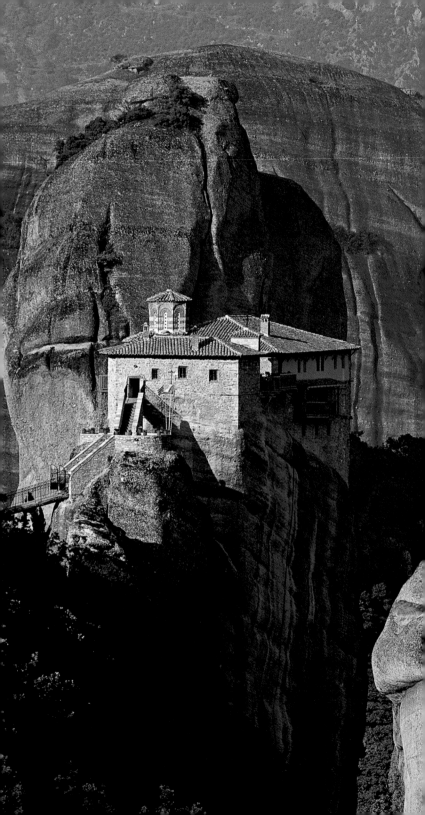

OPPOSITE: HAGIA ROSSANOU, WITH THE WALKWAY THAT CONNECTS THE MONASTERY TO THE ROAD.

LEFT: PAINTINGS OF THE CRETAN SCHOOL IN THE HAGIA ROSSANOU.

BELOW LEFT: VARLAAM: A STEEP FLIGHT OF STEPS CLIMBS TO THE CENOBITE.

BELOW RIGHT: THE VILLAGE OF KASTRAKI WITH THE CLIFFS.

VISIT

From **Kalambaka (A)** go to the village of **Kastraki (B)** (near the *Aeginium* of ancient sources). On the road that goes up to the Meteora you come to the **monastery of Dhoupiani**, which is in fact a small 12th-century church with a barrel vault.

THE MONASTERY OF HAGIOS NIKOLAOS ANAPAUSAS (a)

(*open 9 am–4 pm summer; 9 am–1 pm and 3 pm–5 pm winter; tel. (0432) 22 375)* Was built in the late-13th and early-14th centuries; it has a *katholikon* frescoed in 1527 by THEOPHANES, the greatest painter in the Cretan school. His name appears on the composition of the **Last Judgment** in the narthex. Other frescoes in the *katholikon* are the **Dormition of Saint Ephrem**, the **Virgin and Child**, and **Adam in Earthly Paradise** (probably by a pupil); in the nave the **Dodekaorton** (the 12 festivals that mark the major events in the life of Christ); and in the choir **Jonah and the Whale**. The ruins of the **monastery of Hagia Moni** lie on the left.

THE MONASTERY OF HAGIA ROUSSANOU (b)

(*open 9am-6pm summer; 9am-1pm and 3.30pm-5pm winter; tel. (0432) 22 649)*. (Also known as the monastery of St. Barbara because her head was long kept here, but is now in Trikala) is one of the loveliest examples of the "stylite" Meteora. This one dates from the 14th century but it only took on its current appearance in the middle of the 16th century at the instigation of the two monks, Maximos and Josaphat. This monastery's *katholikon* was also frescoed by artists of the Cretan school, with the **Last Judgment** in the narthex, the **Dodekaorton** in the nave, **Christ in Glory** in the dome, and the **Transfiguration** and the **Resurrection** in the side domes. At this point the road forks. If you take the left fork, you come to **Varlaam monastery**.

VARLAAM MONASTERY (c)

(*open 9am-1pm and 3pm-6pm, closed on Tuesdays; tel. (0432) 22 277)*. Varlaam was the name of the first occupant of the site, who built a chapel and a cell in the mid-14th century. Then, in 1518, Nectarios and Theophanis from Ioànnina contributed large sums of money that allowed the *katholikon* dedicated to All Saints to be built. The frescoes were the work of F. KASTELANOS and were inspired by later Paleologan peinture and Italian painting; the monastery also has a carved iconostasis. Varlaam became one of the most flourishing of the Meteora monasteries; at the end of the 16th century it had the most organized *scriptorium* in this region; some of its manuscripts are in the refectory. The 16th-century chapel of the Three Hierarchies is worthy of a visit.

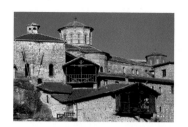

M E T E O R A

THE MEGÀLO METÈORO (d)
(*open 9 am–1 pm and 3:30 pm–6 pm, closed on Tuesdays; tel. (0432) 22 278*).
Founded by St. Anastasius in 1365, is a

dedicated to the Transfiguration, was rebuilt in the 16th century in accordance with models found on Mount Athos; the fresco cycle was painted by artists from THEOPHANES'

HAGIA TRIADA (Holy Trinity) (e)
(*open 9 am–5 pm, closed on Thursdays; tel. (0432) 22 220*).
Founded on a very high rock column at an unknown date, and one

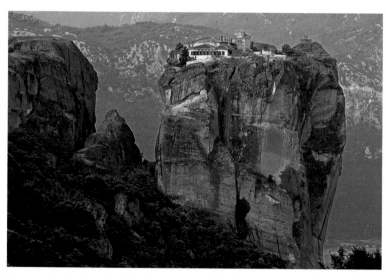

fine example of a late-Byzantine monastery. Typical features are the long refectory with a projecting apse, the square kitchen with domed fireplace, and the infirmary with 9 bays, of which the central one rests on 4 columns and opens into a domed fireplace. The *katholikon*,

SCHOOL in the second half of the same century. The late 18th-century carved wood iconostasis is particularly beautiful. North of the Megàlo Metèoro is the **monastery of Ypapandis**, abandoned in the 19th century. Return to the fork and take the right-hand road to the monastery of

of the richest of Meteora's monasteries, its treasure was looted during World War II. It has a 15th-century *katholikon* decorated two centuries later in post-Byzantine style. The round chapel of St. John the Baptist is unusual for having been carved out of the rock.

THE MONASTERY OF HAGIOS STEPHANOS (f) (*open 9 am–1 pm and 3:30 pm–6 pm, closed on Mondays; tel. (0432) 22 279)* It stands on the site of a 12th-century hermitage. In the 16th century it received

the 18th century (note the splendid early 19th-century iconostasis). Much older is the chapel of St. Stephen (15th century) but it is in very poor condition. Icons, manuscripts and vestments can be seen in the former

refectory.
As mentioned, important *scriptoria* were active in the 16th and 17th centuries in particular. The icons they produced are of great interest, including those of a group of anonymous

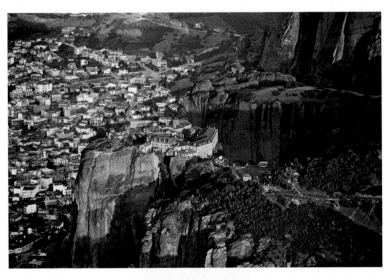

a large donation from the Byzantine Emperor Andronicus II Paleologus (1282-1328) – which is why it is referred to as a "royal monastery"; it suffered serious damage in World War II. Of its two churches, the first you see in the large court is consecrated to St. Charalambos and dates to

artists from Ioànnina in the Megàlo Metèoro at the end of the 14th century. An embroidery workshop has long been active in the monastery of Varlaam and specializes in the use of gold thread. Also to be appreciated are the high-quality wood carvings, produced by craftsmen from Epirus. (S.M.)

VOLOS

Volos is Greece's third largest port. With the two exceptions of the Archaeological Museum and the Theophilos Museum it does not offer great artistic attractions. The former is famous for its important collection of more than 200 painted funerary stele (*just over a mile from the city center on the road towards Tsangarada; open every day except Mondays from 8.30am-3pm. Tel. (0421) 25 281*) and the latter was the lovely early 20th-century frescoed house of the naïve painter Theophilos, whose inspiration for its decorative cycle was taken from Greek history (*take the road for Mount Pelion, then, at the Ano Volos sign, turn left. The museum is about 300 yards up on the left. Open every day except Mondays from 8.30am-3pm*). However, the city's surroundings offer several interesting discoveries.

On the northern side of the gulf, dominated by Mount Pelion (the mountain of the Centaurs), the coast is characterized by a number of brackish springs near the Ligarorema stream. In the Archaic and Classical periods this was the site of *Pagasai*, the successor of the Mycenaean *Iolkos*. According to Strabo, the city was founded in the 8th century BC in the place where the mythical ship of the Argonauts was beached. The period of Volos' greatest success was linked to the hegemony of the nearby *Pherae* (today the town of Velestinòn), where Greek and French excavations have discovered a number of Classical and Hellenistic finds. The period of *Pherae's* tyranny under Alexander and Lycophron terminated at the start of the 3rd

century BC, more or less when *Pagasai* was abandoned. The city may have flourished once more under the name of Demetriades, which was founded at the instigation of Demetrius I Poliorcetes, king of Macedonia, around 290 BC, less than a mile north-northeast of the earlier city. Of the 175 towers that were built along the double **circuit of walls**

(a), more than 70 can still be seen. On the plateau of the acropolis stand the ruins of Basilica A (**Basilica of Damokratìa (b)**, who sponsored its construction) from the Byzantine period. It was completed over five building phases between the late 4th and late 5th centuries AD. The '**Antigonid palace**' (c) designed by Demetrius was built by his son Antigonus Gonatas and reconstructed by the latter's grandson, Philip V, at the end of the 3rd century BC. Currently, it is closed to visitors. The palace served as a royal residence and administrative center and was laid out around two large courts. One had a peristyle fortified by four corner towers; the other, which stood on a lower level to the west, was lined by galleries. A third open area lay to the west of the complex.

OPPOSITE: RUINS OF THE
FORTIFICATIONS BUILT BY
DEMETRIUS POLIORCETES.

OPPOSITE AND BELOW: NECKLACE
WITH PENDANTS IN THE FORM OF
AMPHORAS.

THESSALY

To the south of the palace lay the **agora (d)** with the temple of Artemis *Iolkia*. All around, the city was laid out on a grid pattern. An early 3rd-century BC theater stood against the buttress that ran parallel to the acropolis. A building thought to be the *heroon* **(f)** of the founder Demetrius stood at the top of the theater **(e)**; a more recent (and probably more correct) interpretation is that it was a mausoleum for Demetrius

in the form of a ship. The city flourished under Philip V of Macedon but its period of decline began when it was occupied by the Romans in 197 BC. (S.M.)

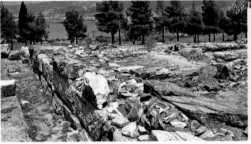

401

MAINLAND GREECE

TOP: GOLD CROWN WITH OAK
AND LAUREL LEAVES; VOLOS
MUSEUM.

CENTER: REMAINS OF THE GRID
PLAN OF THE HELLENISTIC CITY.

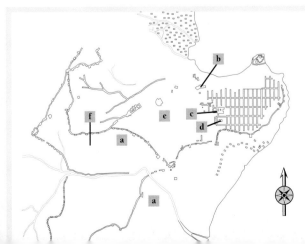

DEMETRIAS

a FORTIFICATIONS
b BASILICA OF DAMOKRATÌA
c ANTIGONID PALACE
d AGORA
e THEATER
f *HEROON*

NEA ANCHÌALOS

The ruins of ancient Thebes Phthia, capital of Phthiotis (the village of Mikrothives on the Lamia-Volos road) lie near the modern town built in 1906-07 to house Bulgarian refugees. In the 19th century W. M. Leake recognized the ruins of the ancient town and in 1907 excavations led by A. S. Arvantinopoullos began. The name Thebes Phthia was first recorded in the 4th century BC but the site's earliest settlement dates to the Neolithic period. Destroyed by Philip V of Macedonia in 217 BC, it grew up again farther east between the hill of Pyrasos (the Pyrasos of Homer, *Iliad*, II, 695), one of the three cities in the kingdom of Protesilaus) and the sea, where it had a port. Thebes Phthia flourished greatly during the early Christian period, and numerous buildings including many basilicas were constructed.

The Greek Archaeological Society is still carrying out studies of them. The city's existence was brought to an end in the 7th-8th centuries by invading barbarians. **Basilica A (a)** (dedicated to Hagios Dimitrios) stands in the town's center. It had a nave and two aisles, a large apse, a narthex and a large atrium with a curved the west side. To the north of the atrium is a room used as a baptistery (mosaic with inscription of St. Dimitrios),

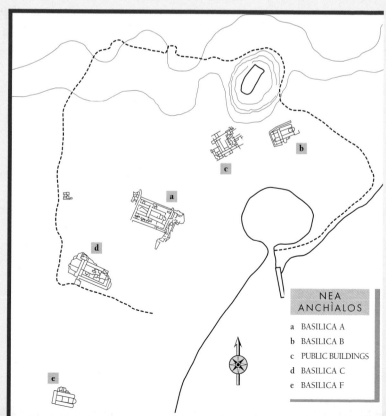

NEA ANCHÌALOS

a BASILICA A
b BASILICA B
c PUBLIC BUILDINGS
d BASILICA C
e BASILICA F

OPPOSITE AND TOP LEFT:
ARCHITECTURAL FRAGMENTS FROM
THE AREA OF BASILICA A.

TOP RIGHT: REMAINS OF THE
CALIDARIUM IN THE BATHS.

BELOW: RESTORED COLONNADE IN
BASILICA C.

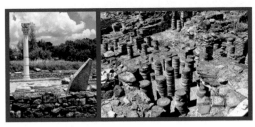

and to the south a *skeuophylakèion* (sacristy). Abundant decorative work found in the ruins (including a very fine ambo (pulpit) from which the sermon was read) allows the building to be dated to the 5th century AD. Near the northwest corner of the basilica lie the ruins of the baths associated with the basilica. Farther north are the remains of a 5th-century AD villa, and to the east a portico and a necropolis;

Volos-Almyros road. This also had a nave and two aisles, a lovely semi-circular *synthronon* with steps around the episcopal chair, a narthex, atrium, baptistery to the west, and a propylaeum and *skeuophylakèion* to the south. This basilica was constructed slightly later than Basilica A (late 5th century, restorations in the 6th century) and made use of earlier architectural materials.

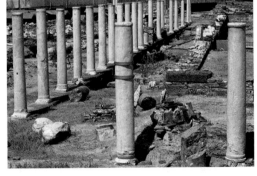

the necropolis was used in two periods, the first contemporaneous with the basilica, the second later when architectural elements were reused. A second baths complex stood to the south on the site of a 3rd-to 4th-century gymnasium. The bishop's palace (the bishop's *megaron*) stood a hundred or so yards to the west. **Basilica B (b)** stood at the foot of Pyrasos hill near the

Excavation carried out since 1960 in the area between the two basilicas has revealed several **public buildings (c)** that stood in the agora of the ancient city (and even dating back to the Mycenaean period), including a 3rd-century BC baths complex.
Basilica C (d) (dedicated to Archpriest Petros as indicated by mosaic inscription in the south

aisle) stood to the southwest of Basilica A and was the largest paleo-Christian building in Thebes Phthia. Three phases of this building's history have been documented: the first, in the second half of the 4th century AD, the second in the mid-5th century, and the third during the reign of Justinian (c. 530). The early version had a nave and two aisles, a double narthex, an octagonal ambo, and a large square atrium. The second version was moved slightly eastward and was given a smaller apse. The final version of the basilica was moved even farther eastward and given a large apse and *bema*. It had splendid mosaic floors featuring the animal and plant worlds. The baptistery was built to the south of the atrium at the same time as the first version of the basilica. A 4th-century baths complex to the north shows evident signs of rebuilding. Other basilicas have been identified: Basilicas D and E (5th-6th centuries) toward Almyros; **Basilica F (e)** (basilica of the Martyrios, first half of 5th century) near the sea to the south of the town; and Basilica H in the town (mid-5th century). (S.M.)

ITINERARY 6
THEBES

Thebes perhaps does not merit a visit as the old city is buried beneath the modern one. But its myths have lasted vigorously to the modern day, with, according to Freud, the force of destiny: "There must be something inside of us that makes us immediately understand the constrictive force of destiny in the myth of Oedipus…"
(Sigmund Freud, *The Interpretation of Dreams*).

THE HISTORY

THE MYTH

The city's history is concentrated in the supremacy it achieved over Greece during the middle of the 4th century BC. After the Peloponnesian War and the replacement of Athenian imperialism by Spartan supremacy, the Lacedaemon city's belligerence prompted the reconstitution of a naval league headed by Athens. This was a new version of the Delian-Attic League. The experiment was short-lived, however, due to the rebellion of the allies. In the ensuing crisis, Thebes successfully expanded its sphere of influence to Tanagra, **Thespiae, and Platea** until it came into confrontation with Sparta. At Leuctra in 371 BC, the troops led by Epaminondas defeated those of the Spartan general Cleombrotus and marked the start of Theban hegemony. It was to be a short episode because it was linked to the fortunes of its leaders Epaminondas and Pelopidas, both of whom were supporters of an oligarchy (and therefore

opposed internally). While the military activity of the former was engaged in supporting the anti-Spartan forces in the Peloponnesus, that of the latter was busy in Macedonia and Thessaly. The death of both leaders – Pelopidas at Cynocephalae in 364 BC against the Thessalian tyrant Alexander of Pherae, and Epaminondas at Mantinea in 362 BC – marked the end of Thebes rule. As is known, this was the period in which the Macedonian monarchy stamped its authority on the Greek world, with devastating effects on the Boeotian city, which was razed to the ground by Alexander. Rebuilt by Cassander of Macedon in 316 BC, it fell into a decline during the Roman era. However, few people are aware of the eminent role it had played during the Mycenaean period. Indicative of this is the series of myths set in Thebes and reflected in the drama of Aeschylus, Sophocles and Euripides.

It all began with Cadmus, the Phoenician hero who arrived in Greece looking for his sister Europa who had been abducted by Zeus. On Apollo's advice, Cadmus abandoned his mission to found a city (Thebes) after having overcome severe tests: the slaying of a dragon and the struggle against giants born from the teeth of the dragon as they fell to the ground. Known as the Sparti ("sown"), the great families of Thebes claimed descent from the survivors. Autonoë, one of Cadmus's daughters by Harmony, married Aristaeus; it was their son Atheon who, during a hunt, caught sight of Artemis naked and was turned into a deer to be ripped to pieces by his own hounds. Another of Cadmus's daughters, Semele, was raped by Zeus and gave birth to Dionysus. Cadmus was succeeded by his son Pentaeus, who ended up torn apart by the Maenads. Then came Nitteo, the father of Antiope, who in turn was ravished by Zeus and gave birth to the twins

Amphyon and Zetus (who condemned the cruel queen Dirce to be dragged to death by the bull). Amphyon was responsible for building the walls and the city's even famous gates of the city. He married Niobe and together they had a great many sons, but the mother's arrogance and pride were punished with the darts of Apollo and Artemis (the slaughter of the Niobids was one of the favorite subjects of Archaic and Classical art).

But unquestionably the best known myth of all was about Oedipus, the son of Laius, who defeated the Sphinx. Oedipus became the unwitting murderer of his own father and husband of his own mother. Even his children, Heteocles and Polynices, came to bad ends, as did his daughter Antigone. Heteocles sent his brother into exile, but Polynices returned with six Argive warriors to exact revenge. The two brothers ended up by shooting arrows into one another beneath the walls of the city, and the sister died for having buried the traitor.

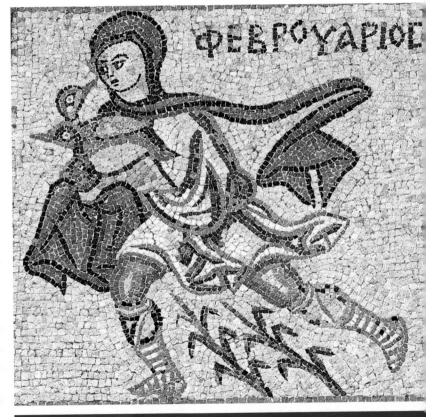

OPPOSITE: CORINTHIAN CAPITAL IN THE MUSEUM.

THE MONTH OF FEBRUARY; BYZANTINE MOSAIC.

Recent archaeological research in Boeotia's ancient capital of Thebes has mostly concentrated on the upper city, whereas the finds in the lower city, where settlement was more sporadic, are fewer and mostly date to the Byzantine and medieval periods, though those were periods of prosperity for Thebes. The emergency

excavations that took place after the 1981 earthquakes and investigations made in relation to the plans for reconstruction of the modern city helped to give a clearer idea of the topography of the **Kadmeia (A)**, the ancient acropolis. However, the new excavations are not yet open to the public.

On the north side of the Megalo Kastelli, on the left-hand side of the Athens-Thebes road, lie the "**twin tombs** (**a**)" of the sons of Oedipus, Heteocles and Polynices. In reality the chamber tombs (united to form a rectangle with

separate entrances) are from different eras, the larger of the two being from the Mycenaean Age IIIa (c. 1350 BC) and the other from the Mycenaean IIIb (c. 1250 BC).

Not far from the museum lies a tumulus over a stepped pyramid with a cist tomb (called the **tomb of Amphyon and Zetus (c)**) from the Ancient Helladic period though it contains more recent materials that date back as far as the Mycenaean. In the enclosure of the museum stands a **tower (b)** from the Frankish period (c. 1210 AD) built using materials taken from the Mycenaean walls of the acropolis. Though a Meso-Helladic settlement existed across all the hills of the Kadmeia (it was one of the largest settlements in the Aegean and Near East, containing hundreds of houses and tombs that were found during the emergency excavations), the Mycenaean palatial period

(ca. 1400-1200 BC) was without doubt the most glorious and splendid in the history of Thebes. Not surprisingly, this was the period to which most of the Theban myths quoted in ancient sources are linked.

The great palatial center was one of the largest in the Mycenaean world. It stood on the hill behind massive walls and controlled almost all of Boeotia; its influence stretched over Euboea, Attica and Aegina, and objects found in the area indicate the city had strong contacts with the East. Discovered in 1906 by A. Keramopoullos, the so-called **palace of Cadmus (d)** was a princely residence with a plan influenced by the Minoan culture. It was decorated with paintings dated to the Mycenaean IIIa very similar to those in Mycenae and Tiryns (a procession of women can be seen in the museum). Almost nothing is currently visible (only a wing with storerooms destroyed by fire at the end of the 14th century BC, behind the modern market). Just to the south was the "new palace" that was destroyed around 1250 BC, and of which a few remains can be seen in the basement of the Commercial Bank. Various buildings from the era

seem to have been shops or storerooms, others provided housing for the palace staff, and yet others were workshops for the production of pottery and working of ivory, gold and wool. Many Linear B tablets have been recovered, which are mainly statements of cereals, wine and olives received from votive offerings to the gods in the local sanctuaries.

A few remains of the walls that in the Classical era ringed the city at the foot of the acropolis can be seen at the end of Odos Amphìonos and the so-called **Gate of Electra (e)**. The gate has two round towers, tapered at the base, and a circular internal court.

To see a more extensive example of Boeotian architecture, one needs to visit some of the famous sanctuaries at Thebes: the

Ismenion, *Amphiaraion* and above all the *Kabirion* and *Ptoion*. The *Ptoion* lies away from the city in the mountains.

The **Ismenion (f)** is named for Ismenos, the river god, with whom Apollo was later identified. The seat of an oracular cult, it stood outside the "Gate of Electra." It was a Doric temple with 6 x 12 columns, a distyle pronaos and opisthodomus *in antis*; the foundations of a phase from the fourth century BC can still be seen. The building was preceded by a seventh- or sixth-century BC *poros* temple lined with terracotta, which in turn stood over a small Geometric Age temple. The Byzantine city developed in this area, using the excellent building materials provided by the large works from antiquity. The three-apse church of

Aghios Dimitrios has numerous fragments of Classical reliefs in its external walls.

The *Amphiaraion* was dedicated to the Argive soothsayer Amphiaraos, who had dissuaded (in vain) his brother-in-law Adrastos and Polynices from attemting their expedition against Thebes, and may be seen among the ruins that lie alongside the road to Tachy. Destroyed in the fifth century BC, it was substituted by the more famous sanctuary of Oropos.

ITINERARY 6, THEBES

407

MAINLAND GREECE

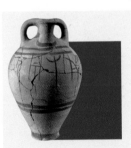

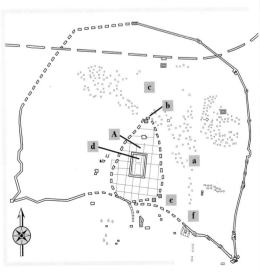

The *Kabirion* (the Cabiri were demons who served the Great Mother; like their father Hephaestus, they were smiths as well as the protectors of sailors) lay on the road to Livadia (in the direction of Thespies). This sanctuary was the site of the ancient ceremonies of male initiation, at the center of which were *Kàbiros-Prometheus* (the son of Demeter) who held the secret of fire, and *Pais*, his son, to whom the secret was told during the ceremonies. Frequented in the ninth and eighth centuries BC, the *Kabirion* reached its greatest monumental splendor in the first imperial age when the **initiation building (a)** took the form of a temple preceded by a *prostoon* (portico), with a central room and court with two rectangular wells. A fifth-century BC building with an apsidal plan followed, and then a fourth-century BC building. The most ancient *telesterion* (b) (this is the name of the building where the initiation ritual was held in the form of a theatrical representation) was a rectangular construction with seats along the inner walls that stood just to the south of the previous building. It was complemented by two **circular chambers (c)** where sacred symposia were held. The hill that closes off the east side of the sanctuary was laid out in the Julio-Claudian era with a **theater cavea (d)** for the ritual dances. Two **porticoes** were built to bound the areas to the south (e) and west (f) (first century BC).

This is where Cabiric vases come from: they are usually black-figure *skyphoi* decorated with witty and realistic scenes of sacred processions, banqueting scenes or mythic episodes interpreted in a popular vein that edged on parody.

The *Ptoion* was dedicated to Apollo, who took as an epithet the name of the local hero Ptoios. Apollo-Ptoios had a cult at the spring of Perdiko Vrisi not far from the ancient city of *Akraiphia*

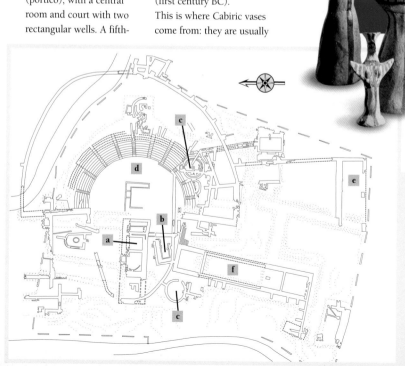

(today Kardìtsa) and he continued to be worshiped on the nearby hill of Kastràki. The fame of the oracle was widespread and important, as is attested by the many dedications, for example, at least 11 *kouroi* datable to the early sixth–late fifth century BC (these were made by various schools of archaic sculpture, first local, later Attic and Cycladic). The Athenian Alcmeonids were responsible for a statue of Apollo (mid-sixth century BC) placed, according to the sources, in the square in front of the temple (the base in the form of a Doric capital remains).

Having become one of the centers of the Boeotian League, it was affected by the destruction of Thebes but was to receive a new, monumental and dramatic layout under Cassander in 316 BC. This was the period to which the version visible today seems to refer (though with restoration and integrations made under the Romans). The *temenos* filled three terraces; the upper one, on which the temple of Apollo stood, can be visited. In the fourth-century BC version, it was peripteral with 8 x 13 Doric columns in stucco-lined *poros*. It had a distyle *in antis* pronaos, and a naos with wooden columns and trabeations. There was an altar on the east side circled by a number of dedications. To the west there was a ramp that led to the oracle's cave and the sacred spring. The second terrace had two parallel *stoai* that were built at the same time as the temple, and a rectangular *katagogion* (accommodation provided for pilgrims)of which traces are still visible. The third and lowest terrace was the site of a divided cistern, of which a similar earlier version also existed.

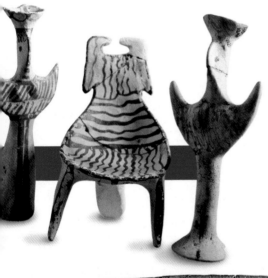

KABIRION	
a INITIATION BUILDING (*TELESTERION*)	c CIRCULAR CHAMBERS
b ANCIENT *TELESTERION*	d CAVEA OF THE THEATER
	e SOUTH PORTICO
	f WEST PORTICO

ABOVE: ANTHROPOMORPHIC STATUETTES AND SEAT; MYCENAEAN TERRACOTTAS FROM THEBES.

BELOW: TABLET WITH INSCRIPTION IN LINEAR B FROM THEBES ARSENAL.

THE MUSEUM

The museum opened in 1962 and holds some
of the most important materials found in the various
sites of Boeotia.

*Open every day except Mondays from 8:30 am to 3 pm,
winter; and every day from 8 am to 7 pm (Monday 12 pm to
7 pm), summer - Tel. (0262) 27 913*

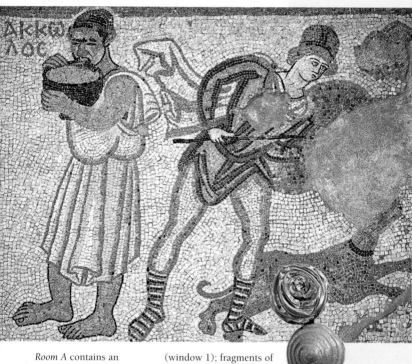

Room A contains an interesting series of **mosaics** depicting the months, and famous archaic **kouroi** from the *Ptoion* and Classical funerary stelae.

Room B has various objects from across the region that cover a period from the Mycenaean to Classical periods, including some objects of personal toiletry from Orchomenos dating from the sixteenth to thirteenth centuries BC (window 1); fragments of **frescoes** from Cadmus's palace (window 23); oriental cylindrical lapis lazuli seals from the "new palace," and small decorated ivory plaques (window 15); an ivory cosmetics container, also from Mycenaean Thebes, with figures of sphinxes that face one another (window 16); black- and red-figure vases (windows 4-8); and Cabiric vases (window 20).

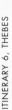

Room C has examples of funerary sculpture, for example, lovely stelae of warriors with overpainting, from the late fifth–early fourth centuries BC. *Room D* contains a fine collection of painted clay sarcophagi (*larnakes*) found in a Mycenaean age necropolis at Tanagra. (S.M.)

BELOW: MYCENAEAN GOLD JEWELRY, FROM THE "PALACE OF CADMUS."

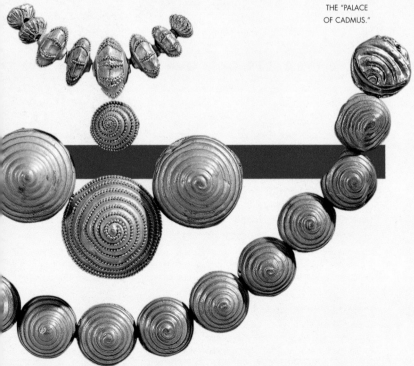

HOSIOS LUKAS

In the greenery of the olive groves near the ancient city of Stiris in the region of Phocis, 23 miles from Delphi, lies one of the most famous monastic complexes in Greece. UNESCO has listed it as a World Heritage site. According to *The Life of Luke*, a 10th-century account of the life of a local hermit and saint written on the wishes of Luke himself, a church dedicated to St. Barbara was built in 946 with the financial assistance of the military leader Krinites. After the death of the saint in 953, and the completion of the church, several monks undertook the construction of a cross-shaped building over Luke's grave equipped with rooms suited to monastic life. Another tradition says that the monastery was founded by the Byzantine Emperor Romanus II in homage to St. Luke, who had correctly predicted the liberation of Crete from the Arabs during his reign; this event occurred in 961. The origins of this historically and artistically important monastery present a problem, however, as its monumental splendor is in great contrast to the rather

unimpressive image that these sources furnish. Of the three large buildings that characterize the monastery within the solid defensive walls—the church of the *Theotokos*, the *Katholikon* and the refectory—recent

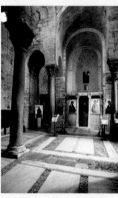

excavations indicate the two main ones date respectively to the original construction phase and the one immediately following it. The *Theotokos* is identified with the mid-10th-century church of St. Barbara, and the *Katholikon* is thought to have replaced the cross-shaped building over the saint's grave at the start of the 11th century. The church of the *Theotokos* (Mother of God), also known as the church of the *Panaghia* (Madonna), is in the shape of an inscribed Greek

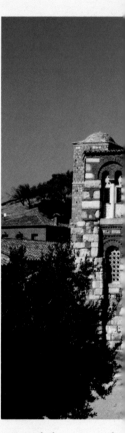

cross, with three apses and a wide, six-bay narthex supported by two columns. It is the first important example in Greece of the model typical of Constantinople though the six-bay narthex represents a variation. The cloisonné masonry is enriched with pseudo-Kufic motifs and other Islamic influences can be seen in the encrusted ornamentation of

OPPOSITE TOP: DETAIL OF THE
PORTICO OF THE
KATHOLIKON.

OPPOSITE BOTTOM: INTERIOR
OF THE KATHOLIKON;
ICONOSTASIS.

LEFT AND BELOW: APSES IN THE
KATHOLIKON, AND THE
THEOTOKOS.

PHOCIS

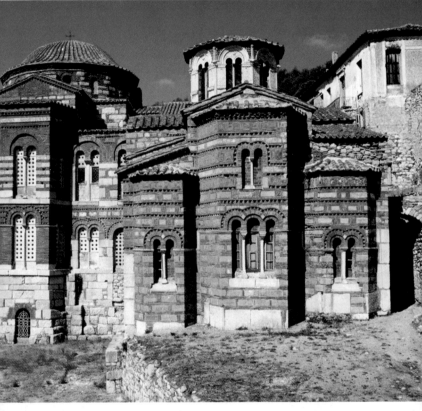

the octagonal drum. An orientalizing influence is apparent in the decorative sculpture. Of the original pictorial decoration, only a fragment remains of a fresco of *Joshua and the Angel*. The narthex and the naos are embellished with a lovely *opus sectile* floor.

The *Katholikon* is a large domed church on an octagonal base with upper corner structures for a dome and a cross-shaped crypt. A series of secondary rooms crowned by galleries is arranged around the central area and aids in supporting the weight of the roof. To the east there is a large apse. Here the masonry differs in the cloisonné as the blocks are larger, more irregular and separated by horizontal rows of bricks. The sculptural decoration on the outside is of particular interest as it harks back to and reinterprets earlier conventions from the 4th and 5th centuries. The interior also has high-quality elements, such as the iconostasis's very beautiful capitals, decorated with bands of knots, reliefs of rosettes, and figures of griffins.

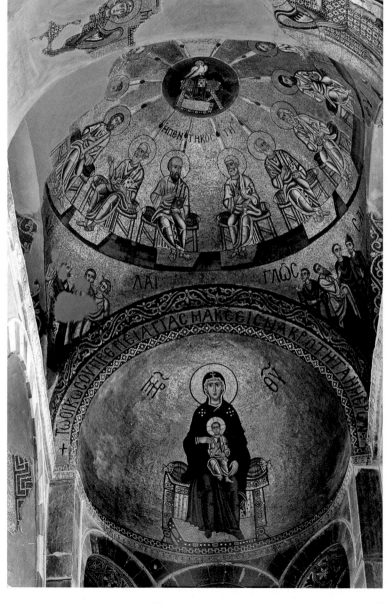

Open every day 8:30 am–5 pm winter, 8 am–9 pm summer.
Tel. (0267) 22 797

OPPOSITE TOP FROM LEFT TO RIGHT: THE KATHOLIKON AND FRESCOES IN THE ENTRANCE, PANEL WITH LIONS DEVOURING PREY.

OPPOSITE BELOW: APSE; VIRGIN ENTHRONED WITH CHILD.

TOP: ARCHANGEL GABRIEL; INTRADOS OF THE ARCH THAT LEADS TO THE CHANCEL.

BOTTOM LEFT AND RIGHT: KATHOLIKON; MOTHER OF GOD AND SAINT PETER.

Recent restoration has returned the mosaic and pictorial decorations to their ancient splendor; the building contains the most significant examples of Byzantine painting in the Macedonian era (around the mid-11th century), and the mosaics are typical of the post-Iconoclast phase. The **Virgin Enthroned with Child** fills the apse, and the

the **Crucifixion**, the **Anastasis**, the **Incredulity of Saint Thomas** and the enormous, monumental bust of **Christ Pantokrator**. Experts consider these decorations in the narthex to be those of the highest quality owing to their simplicity, symmetry, at times irrational proportions, and the spirituality of the faces dominated by large

functions of the rooms themselves, however, what those functions might have been is not clear. The current opinion is that the paintings were from the same period as the mosaics. The crypt is the setting for the cycle in 7 parts of the **Passion** and **Resurrection**, then there are the **Dormition of the Virgin**, and images of apostles,

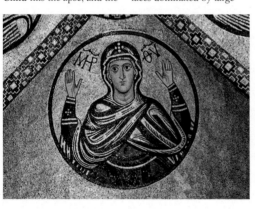

Pentecost the dome of the *bema*. Three of the upper corner structures (the decoration of the fourth has been lost) are adorned with scenes of the **Annunciation**, the **Presentation in the Temple**, and the **Baptism**. In the cupola and drum, 19th-century frescoes have replaced **Christ Pantokrator** and the **Prophets** and, in the narthex, there are the **Washing of Christ's feet**,

eyes. At one time considered an expression of "provincial monastic art," today they are attributed to masters from Constantinople, which therefore argues that even in the metropolis a variety of trends and stylistic levels existed. The pictorial decoration is less easy to decipher: in the subsidiary rooms the saints and angels are perhaps related to the

warriors and sanctified monks. Dating is considered to be the same as that of the *Katholikon* as a whole. To the south of the two large religious buildings stands the monumental refectory (*trapeza*). This was built in the customary style of an aisleless nave and an apse (polygonal externally). The fortified perimeter contains service and living areas. (S.M.)

DELPHI

"The sun blows" down from Parnassus and disrupts
the center of the world. Castalia drips
warm on the lips of the tourist
and the water-seller laughs
close to the fountain with two votive
statuettes moist with mold. . . .
(Salvatore Quasimodo, *Delphi*)

THE TEMPLE OF
APOLLO FROM THE
CAVEA OF THE
THEATER.

THE EXCAVATIONS

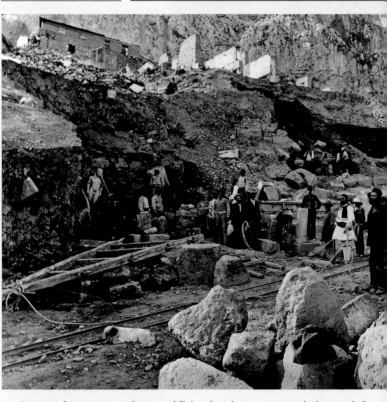

Cyriacus of Ancona (1391-1452) was the first westerner to "rediscover" Delphi. This happened in 1456, before the Turks occupied Greece. He admired the stadium – still well conserved – beneath the steep cliffs but thought it was a hippodrome (horse racing course), and he copied down some inscriptions. More than 200 years later the site was visited by J. Spon and G. Wheeler (1675), but much more time had to pass before Delphi earned the respect that its literary tradition deserves. The first attempt at understanding the layout of the site, made by H. Ulrich in 1838, was substantially based on the information

Pausanias gave us in his *Description of Greece* rather than on the ruins that stood between the houses in the village of Kastrì. In 1840, the first object of interest to the international scientific community was the large wall that bounds the terrace of the temple of Apollo, first studied by the German O. Müller, then by the Frenchmen P. Foucart and Ch. Wescher. Given the large number of inscriptions that could be read on it, the wall was to all intents and purposes an archive. The investigations and excavation by the Frenchmen led, in 1865, to the publication of the first archaeological study of the site. It became clear that for the ancient sanctuary to be excavated properly a large increase in resources was needed, and, in particular, a radical change in approach. An early French project supported by Napoleon III got nowhere following the abdication of the king of Greece, Otto I, in 1862. In 1882 an agreement was signed between Greece and France that entrusted the study of the site to the French Archaeological School of Athens, but bureaucratic and diplomatic shackles brought the project to a standstill.

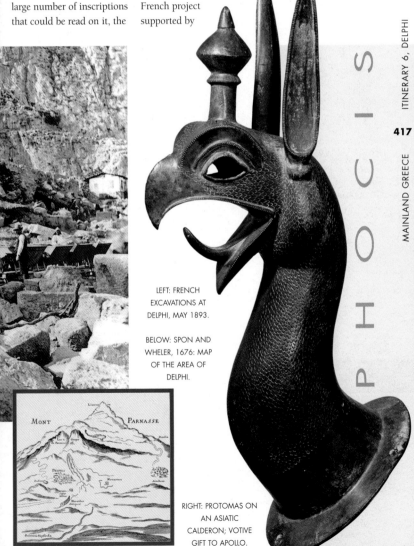

LEFT: FRENCH EXCAVATIONS AT DELPHI, MAY 1893.

BELOW: SPON AND WHELER, 1676: MAP OF THE AREA OF DELPHI.

RIGHT: PROTOMAS ON AN ASIATIC CALDERON; VOTIVE GIFT TO APOLLO.

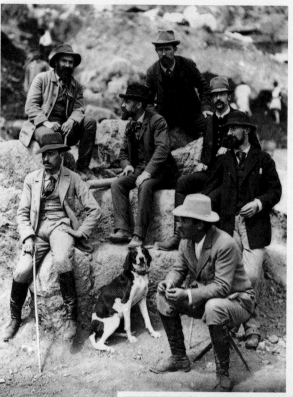

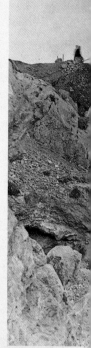

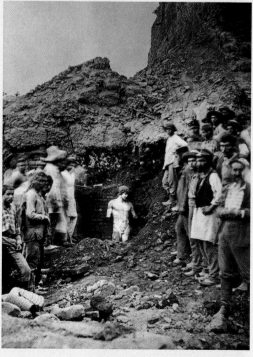

DELPHI

ABOVE THEOPHILE HOMOLLE,
CENTER, WITH MEMBERS OF THE
EXPEDITION.

RIGHT: THE ANTINOOS FROM THE
REIGN OF HADRIAN, NOW IN THE
LOCAL MUSEUM.

OPPOSITE: SLIDE FOR THE DETRITUS
IN THE VALLEY OF PLEISTOS, 1893.

So limited excavation and partial exploration continued until 1891 when Théophile Homolle became the director of the French School. His appointment led to a clear and definitive agreement similar to the one the Greeks had signed with the Germans for the site of Olympia. This agreement stated that the guest country bore the costs of excavation and organization of the site, while the host country retained ownership of all the materials found. The large French project, supported by substantial backing for the time, planned to "dismantle" the village of Kastrì and rebuild it outside the archaeological zone! This resulted in a vehement protest by the inhabitants and their occupation of the archaeological site. For this reason excavation proper did not get started until spring 1893, under the protection of the Greek army!

The findings were immediately exceptional. The general topography of the sanctuary, distributed over three large terraces on the side of Mount Parnassus, was finally understood. By 1897, the entire site had been mapped; identification of the monuments was made easier by Pausanias' descriptions.

Between 1898 and 1902 work concentrated on the Marmarià zone ("the marbles") in which the sanctuary of Athena *Pronaia* was uncovered. In 1902, publication of the results of the excavations began in a series of *Fouilles de Delphes*. In 1902–03 a museum was built, sponsored by the Greek art patron A. Syngros, to house the many objects found during the works. The museum was rebuilt in 1937-38 and has since been modified and enlarged several times.

THE MYTH

The "prehistory" of Delphi goes back to the beginning of the world. The oracle resided here from the time in which the gods emerged from the chaos and Gaiai (Ge), the Earth goddess, was the first deity to occupy the site and be the first prophet.

killed the creature and left it to rot in that place, from which comes the epithet *Pythios* as the name given to the monster was Python (from *pythesthai*, "to rot"). To celebrate his victory, Apollo composed an anthem on the cithara, and it was

the secret rites of poetry, music and dance. The god's first house was a hut made from laurel branches taken from the valley of Tempe in Thessaly. This was followed by a small house built by the bees using a mixture of beeswax with feathers

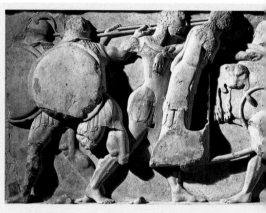

According to another version, a shepherd named Coreta discovered the oracular properties of the site when he noticed his flock's agitation every time the sheep moved toward a certain crevice; when he came close to it, he too began to prophesy.

The Homeric hymn to Apollo tells us that after the birth of the god on Delos and his ascension to Olympus, he returned to Earth to search for a place to establish the oracle. After wandering far and wide, he came to Delphi at the foot of the snow-capped Mount Parnassus where a spring was guarded by a serpent (or female dragon). Apollo

from this that the contest for cithara players developed as the first competition at Delphi in 582 BC. This was followed at later dates by athletic and equestrian events, held every four years on the model of the Olympiad, which became known as the Pythian Games. Apollo left Delphi in the winter months to visit the country of the Hyperboreans, the people devoted to him in the far north. During that period Dionysus oversaw the sanctuary, but the territory of Delphi belonged more properly to Apollo, and with it Mount Parnassus. There the god would withdraw with the Muses to celebrate

(Apollo later transferred this small temple to the country of the Hyperboreans). A third temple made of bronze was destroyed by the gods because—Pindar tells us— the figures on the pediment bewitched the mortals with their song. With later constructions, we enter the realm of history. A fourth temple (the first from stone) was built by Apollo with the help of the architects Triphonius and Agamedes, and this has actually been found in the excavations. Its remains – fragments of columns and orthostats – may be from the 7th century BC. Herodotus tells us that it burned down in 548-547 BC.

In the Mycenaean period a large settlement occupied the northeast area of the sacred enclosure. In the Geometric Age we find the first traces of the settlement and the presence of one or more sanctuaries. The importance and popularity of the oracle had developed by the 8th building *thesauroi*. A fire destroyed the temple of Apollo in 548 but it was rebuilt with the help of the Alcmaeonids, a noble Athenian family that had been exiled by Peisistratus. The great artist ANTENOR was commissioned to produce the sculptural decoration, entry into the Amphictyony of Philip II of Macedonia. A fourth Sacred War ended with the Macedonian hegemony over Greece following the battle of Chaeronea in 338 BC. The propaganda that Delphi offered was exploited during the Hellenistic period,

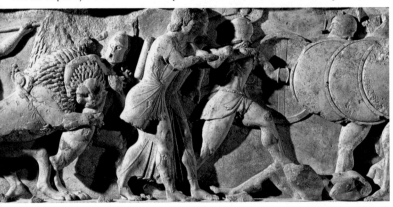

century, in regard to the role it played in colonization. Many votive offerings of the highest quality have been found, from the 7th century BC, when objects influenced by oriental styles became common. The sanctuary came to be administrated by an Amphictyony (association) of 12 tribes but this soon entered on a collision course with the local Phocians and led to the first Sacred War (600-590 BC). This, however, did not prevent the fame of the sanctuary from extending throughout the Mediterranean, and powers like the Etruscans and Lydians asked the advice of the oracle, bringing valuable gifts, raising statues and and the god rewarded this gift by convincing the Spartans to destroy the tyranny in Athens! However, Apollo seemed more prudent during the Persian invasion of 480 BC; his position was not hostile to the eastern aggressors. Tradition attributes the saving of the sanctuary from the Persians to intervention by the god together with the local hero Phylakos, when a landslide closed off access to the site. Votive thanks from the Greek world were received at Delphi following the two Greek victories of 480 at Salamis and at Himera. A second Sacred War (448 BC) broke out between Sparta and the Athenians, then a third in 356 BC marked the particularly by the Attalids. The Aetolian League saved the sanctuary from the Galatian danger in 279, but it came under the Roman sphere of influence after the battle of Pydna in 168 BC. Delphi's decline began with the institution of the Roman province. The reforms of the Amphictyony that followed Sulla's sack of the site in 86 BC were not enough to revitalize the center, even though they had the backing of Augustus. Neither did the support of Hadrian bring change in the situation. Delphi's decline led to the institution of a bishopric in 380 AD. A village, Kastrì, then hid the site until new life was brought following the French excavations.

VISIT

Open every day except Mondays, 8:30 am to 3 pm, winter; and 8 am to 7 pm, summer.
Tel. (0265) 82 966

What has rightly been called the Pantheon of Hellenic glory enjoys a spectacular location on the slopes of Mount Parnassus overlooking the rolling, olive-green plateau of Krissa that stretches eight miles to the sea. The rocks and ruins, in their exquisite shades of gray, make Delphi a place that exists outside of time. From afar the faceless multitude of monuments blends into the indifferent mountain, then, as you reach the walls and stones

of the buildings, the rocks turn into geometrical constructions and you suddenly become aware of the life that the forms still

harbor.
Two very tall rocks dominate Apollo's sanctuary opposite the narrow valley of Pleistos on the south flank of Mount Parnassus: these are the Phaedriades ("shining"); one Phlemboukos, the "flaming," and the other Rhodini, the "red." A spring, the Castalia, flows from the gorge between the two rocks,

and to the west there used to be a crack from which vapors gushed that would inebriate and render unconscious both men and animals. It was beside this crack that the temple of Apollo was built.
After entering the sacred enclosure from what is known as the Roman Agora, and before reaching the heart of the sanctuary, you will find yourself following the Sacred Way, lined on both sides by gifts of thanks of every sort, all built in a spirit of rivalry to exalt the names of their donor cities. It was a competition that only ceased at the temple of Apollo, where the Greek world united to celebrate its common victories over the barbarians.
The beginning of the Sacred Way illustrates the clash that in the 5th and 4th centuries BC characterized

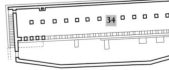

TOP: TREASURY OF SIPHNUS.

CENTER AND BELOW: THE SACRED WAY.

THESAUROI

T1 TREASURY OF SICYON	ATHENS	CAERE (?)
T2 TREASURY OF SIPHNUS	T6 TREASURY OF POTIDAEA	T10 TREASURY OF CNIDUS (?)
T3 TREASURY OF BOEOIEA	T7 SMALL TREASURY OF POTIDAEA	T11 ANONYMOUS TREASURY
T4 TREASURY OF THEBES	T8 TREASURY OF SPINA (?)	T12 ANONYMOUS TREASURY
T5 TREASURY OF	T9 TREASURY OF	T13 TREASURY OF CORINTH

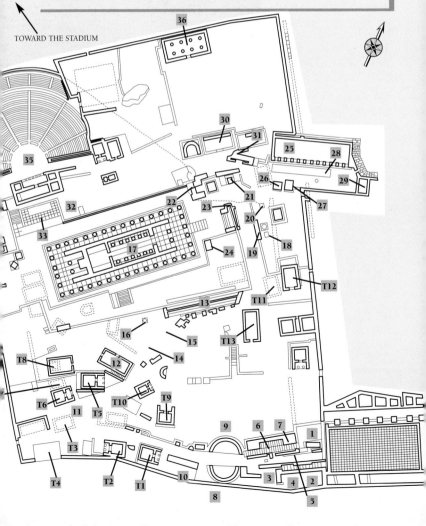

DELPHI

SANCTUARY OF APOLLO

1. BASE OF THE BULL
2. MONUMENT OF THE NAVARCHOS
3. MARATHON GIFT
4. TROJAN HORSE
5. GIFT OF THE ARCADIANS
6. PHILOPOEMEN'S STATUE
7. ANONYMOUS MONUMENT
8. MONUMENT OF THE HEROES OF ARGOS
9. MONUMENT OF THE KINGS OF ARGOS
10. GIFT OF THE TARANTINES
11. SECOND MARATHON GIFT
12. BOULEUTERION
13. PORTICO OF THE ATHENIANS
14. "ROCK OF THE SIBYL"
15. ROCK OF LETO
16. COLUMN OF THE NAXIOTS
17. TEMPLE OF APOLLO
18. GOLD TRIPOD OF PLATAEA
18. SECOND GIFT OF THE TARANTINES
20. COLOSSUS OF APOLLO
21. GOLD TRIPODS OF THE TYRANTS OF SYRACUSE
22. PILLAR OF PRUSIA
23. PILLAR OF EUMENES II
24. PILLAR OF AEMILIUS PAULUS
25. PORTICO OF ATTALUS I
26. STATUE OF ATTALUS I
27. STATUE OF EUMENES II
28. RECTANGULAR
 BASE OF THE ALTAR OF NEOPTOLEMUS
29. OIKÒS
30. EXEDRA OF DAOCHOS
31. COLUMN OF THE DANCERS
32. STATUE OF THE AURIGA
33. GIFT OF CRATERUS
34. PORTICO OF THE AETOLIANS
35. THEATER
36. HALL OF THE CNIDIANS

TOWARD THE STADIUM

the history of the Greek mainland: the democratic ideal of Athens and Argos against the oligarchy of Sparta. After the **base of the bull (1)** dedicated to Apollo c. 480 BC by the inhabitants of Corcyra in thanks for a miraculous catch of tuna (indicated by a bull on the beach), you will see on the left the foundations of the **monument of the Navarchos (2)**. This commemorated Sparta's naval victory over Athens in 405 BC at Hegospotamis, at the end of the Peloponnesian War. A line of 39 bronze statues represent the gods of Sparta crowning Lysander, the admiral of the fleet; a second row and a higher level represent the Lacedaemon admirals and their allies. Sparta's purpose in the memorial was to annul, hide, or at least overshadow, the Athenians' **Marathon gift (3)** that they raised following their victory over the Persians at the battle of the Eurymedon (467 BC). This gift was meant as a retrospective celebration of the Athenian victory at Marathon (490 BC) under their general Miltiades, father of Cimon. According to Pausanias, even PHIDIAS worked on the group of 16 bronze statues. Two of the statues (claimed by some scholars to be PHIDIAS' own work) are the famous Riace bronzes found

in the sea: the figures of Miltiades and a king-hero, probably Codrus, Cecrops or Erechtheus. The Spartans' gift was also aimed at diminishing the prestige of the **Trojan horse (4)**, a gift from the Argives for their

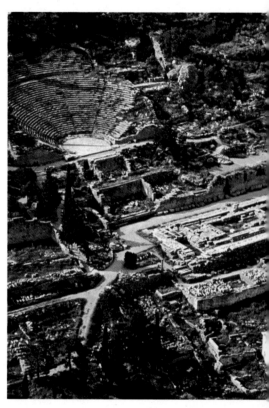

victory over the Spartans in 414 BC in the Tyreatis. The gift of another rival stood opposite the monument of the Navarchos: this was the **gift of the Arcadians (5)**, who had freed themselves from the Spartan hegemony after the battles of Leuctra and Mantineia (371 and 362

BC). Next to this was **Philopoemen's statue (6)**, the gift of the general of the Achaean League who defeated the Spartan forces at the end of the 3rd century BC. Just behind this are the few remains of an

anonymous monument (7) and a large base, identified as the place where two gigantic gold stars were dedicated in 405 BC by Lysander to the Dioscuri. The two symmetrical exedras of the glories of Argos – which finally give the Sacred Way a little respite from the cities'

rivalry – almost constitute a second entrance. On the left are the foundations of the **monument of the heroes of Argos (8)**, with the "Seven against Thebes" and the "Epigoni" in commemoration of the battle of Oinoe in 456 BC when the Argives defeated the Spartans for the first time. The **monument of the kings of Argos (9)** on the right, erected after the battle of Leuctra in 371 BC, records a period after that conflict. It held the statues of the mythical dynasty of Danaus and established the descent

of the Argives from Heracles, who, it was claimed, was born in Thebes, the son of Zeus and Alcmene. Further ahead on the left was the first **gift of the Tarantines (10)**, which celebrated a victory over the Messapii in 473 BC. Then begins a series of *thesauroi*. One of the earliest of these small, elegant temple-like buildings, in which each city placed its gifts to Apollo, was that of **Sicyon (T1)** from the end of the 6th century BC, though today only a few elements of

its foundations are to be seen. Several curved stone blocks belonged to an earlier rectangular portico built by the tyrant of Sicyon, Cleisthenes, the winner in 582 BC of a chariot race at the Pythian Games (the metope is in the Delphi museum). Next comes the **treasury of Siphnus (T2)**, a jewel of Archaic Ionic architecture (ca. 525 BC), financed by a tenth of the income provided by the famous gold and silver mines on the island in the Cyclades. You can see the tall platform on which the small temple stood, with a distyle pronaos and naos *in antis* (in fact, there were caryatids rather than columns, one of which can be seen in the museum). There is a lovely frieze with the Judgment of Paris on the west side, the rape of the Leucippids to the south, the duel between Achilles and Memnon and an assembly of gods to the east, and a gigantomachy to the north (also in the museum). Then the east pediment was decorated with the contest between Apollo and Heracles for the Delphic tripod.

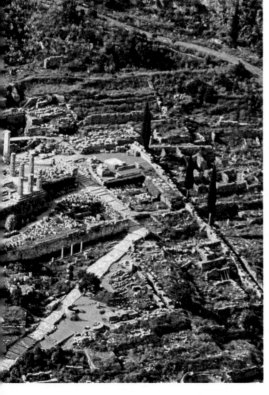

TOP: VIEW OF THE SITE.
BELOW: VIEW OF
THE SACRED WAY.

D E L P H I

The terrace of the Megarisians was built on the other side of the road in the third quarter of the 5th century BC to take the place of an earlier *thesauros* (500-475 BC).

At this point the Sacred Way makes a sharp turn, to the west of which were the treasuries of the **Boeotians** (T3) and the **Thebans** (T4). A conical block of limestone nearby represents an *omphalos*, which is an aniconic (not human or animal form) representation of Gaia (Ge; Earth) and a symbol of the center of the earth (but we do not know its original position).

The **treasury of the Athenians** (T5) was the first to be discovered, back in 1893, and was rebuilt in 1903-06 by the Commune of Athens. Pausanias says it was made of Parian marble with the tithes of the booty won in the battle of Marathon in 490 BC. Both architecturally and sculpturally it seems to represent the transition from the Archaic era to Severe style, whereas the

style of the metope – still late Archaic – suggests that Pausanias was misled by the **second gift of Marathon** (11), of which the dedication remains on the southern side of the

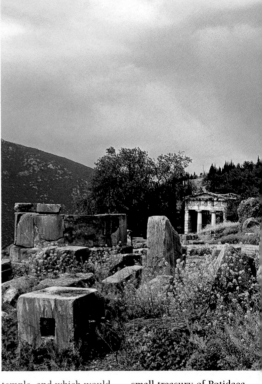

temple, and which would therefore be somewhat older (510-500 BC). The subjects of the 30 metopes are the labors of Heracles (north and west sides), and the amazonomachy of Theseus (south and east sides). These are now in the museum and copies

have been put in their place. Very little remains of the pediments.

Behind this there are two more *thesauroi*, the **treasury of Potidaea** (T6) (530-520 BC) and the

small treasury of Potidaea (T7). A little above this is another *thesauros* (T8) (mid-4th century BC), attributed to an Etruscan city, perhaps Spina (one *thesauros* (T9) is attributed to Caere). It is possible that another *thesauros* (T10) (mid-6th century BC) was

built by Cnidus; in this case too the columns on the façade were replaced by caryatids. Now you come to the area that tradition considers to have been the location of the earliest

"**rock of the Sybil**" (14) stands in a field of rocks and springs and is thought to have been the place where the first prophetess (a hypostasis of Gaia?) gave her responses. Another

crowned by a sphinx is in the museum), and supposedly marks the mythical killing place of the Python. The *Halos* – the monster's lair – stood right opposite the portico of the Athenians. The portico of the city of Athens has been defined the "manifesto" of the city's maritime power. Though linked by Pausanias to the Athenians' naval victory over Sparta at Phocis in 429, it was more probably related to their success over the Persians in 478, as the *hopla* (cables) referred to in the inscription is most likely a reference to the cables used in the pontoon that Xerxes threw over the Hellespont. Another reference is to the bows of the enemy ships made as an offering "in the sanctuaries of the gods," as Herodotus assures us. When the Delian-Attic League was created, the portico, with seven Ionic columns in the façade, became the tangible sign of growing Ionic cultural imperialism.

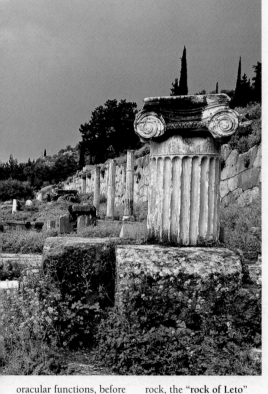

oracular functions, before they became linked to Apollo. The **sanctuary of Gaia** (closed to visitors) stood in the triangular area between the road, the *Bouleuterion* (12) (the meeting place of the Council) and the **portico of the Athenians (13)**. The

rock, the "**rock of Leto**" (15) is supposed to be where Apollo's mother was present at the killing of the serpent Python. A third rock, further north, was monumentalized with the **column of the Naxiots (16)** around 570-550 BC (the famous Ionic capital

OPPOSITE: THE TREASURY OF THE ATHENIANS SEEN FROM THE NORTH ALONG THE SACRED WAY.

CENTER: THE STOA OF THE ATHENIANS, RIGHT, OVERLOOKS THE TREASURY OF THE CITY.

TOP: IONIC CAPITAL IN THE STOA OF THE ATHENIANS.

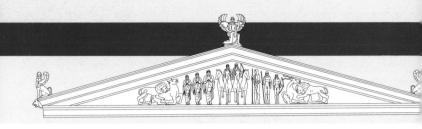

The last *thesauroi* include **two anonymous** ones (**T11 and T12**) and the oldest, built by the **Corinthians** (**T13**) in the 7th century BC, which was rededicated in 540 BC to the expulsion of the tyrant Cypselus. You then climb a stepped ramp

slaves between the 2nd century BC and the 1st century AD.

The **temple of Apollo** (**17**) was rebuilt after 548 BC (fifth temple). The costs involved were partly defrayed by the Alcmaeonids, whom

of Apollo at Delphi from the land of the Hyperboreans, and those on the west pediment depict a gigantomachy (perhaps the work of Antenor). Built in the Doric order, it would have been constructed using the same orientation and

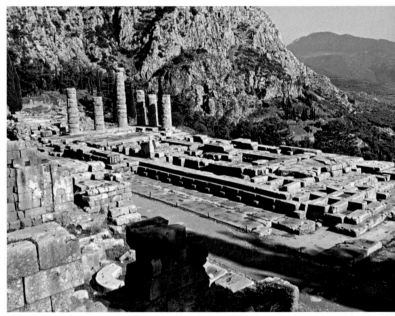

to arrive at the esplanade of the temple of Apollo. This has a retaining wall of polygonal blocks built after the fire of the fourth temple with the contribution of many Greek cities. It is covered with hundreds of inscriptions, many of which relate to the liberation of

Peisistratus exiled from Athens, but what we see today are the ruins of the sixth temple, rebuilt after an earthquake (or a fire or a landslide) destroyed the previous building in 373 BC. Some sculptures were saved; those on the east pediment depict the arrival

proportions as the fifth temple; i.e., peripteral, 6 x 15 columns, with a distyle opisthodomus and pronaos *in antis*, with a passageway at the back of the naos that led to the underground space (an *adyton* or *manteion*) where the oracle was consulted. The *chasma*

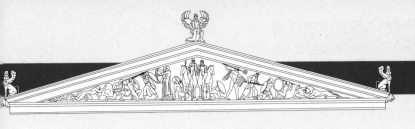
ges ("crack of the earth") lay beneath a wooden canopy next to the *omphalos*, the gilded statue of Apollo and the stone of the "tomb of Dionysus." This was where the vapors came out of the earth, which, together with the

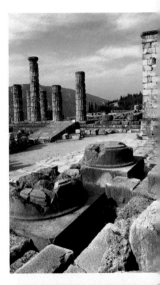

laurel leaves chewed by the priestess, induced the Pythia seated on a three-legged stool into a trance.

The decoration of the pediments (fragments in the museum) referred to the oracular and orgiastic aspects of the Delphic, Apollonian and Dionysiac cults. The east pediment shows Apollo with a cithara seated on the *omphalos* with his sister (Artemis), mother (Leto), the Muses and Helios; the west pediment depicts Dionysus and the *thiasos* of the orgiastic Thyiads.

The antagonism and rivalry between the various *poleis* seen on the Sacred Way were set aside in front of the temple in favor of the panhellenic celebrations of victory over the barbarians. Or rather, the desire to stand out from the others took the form of grand gifts that avoided reference to internal conflicts. There was the **gold tripod of Plataea (18)**, a common gift from the Greek League to commemorate the panhellenic victory over the Persians at Plataea in 479 BC (some scholars think that the base visible today relates to another tripod dedicated by the Crotonians sometime between the end of the 6th and start of the 5th centuries BC). The real tripod, however, related to the battle of Plataea and fused by the Phocians during the second Sacred War, would have stood beside it. Then there was the **second gift of the**

Tarantines (19) for a victory over the Peucetii and Iapodes, "barbarians" of Magna Graecia. And a **colossal statue of Apollo (20)** donated by all Greeks for the victory over the Persians at Salamis. The two

OPPOSITE TOP AND TOP: ARTIST'S IMPRESSION OF THE EAST (LEFT) AND WEST PEDIMENTS OF THE TEMPLE OF APOLLO.

LEFT: OVERALL VIEW OF THE TEMPLE OF APOLLO.

ABOVE: THE BASES OF THE STATUES OF THE TYRANTS OF SYRACUSE AND, IN THE BACKGROUND, THE COLUMNS OF THE TEMPLE OF APOLLO.

gold tripods (21) offered by the tyrants of Syracuse – Gelon and Hieron – for their respective victories against the "barbarians of the west" (the Carthaginians at Himera in 480 BC, and the Etruscans at Cuma in 474 BC). Next there were the pillars offered by Prusia (22), the king of Bythinia, and Eumenes II (23), the king of Pergamum, which were dedicated in 184 BC by the Aetolians to the new defenders of the Greek world against the Galatians. Another truly impressive gift was that of the Cnidians of Lipari for a naval victory over the Etruscans at the start of the 5th century: on a base measuring roughly 200 feet, there were a total of 20 colossal statues of

Apollo, one for each ship captured in battle! Finally, the pillar of Lucius Aemilius Paullus (24) stood at the southeast corner of the temple. This was a monument begun by Perseus – the last king of Macedonia – who was defeated at Pydna in 168 BC by the Roman general. Paullus completed the monument with an equestrian statue of himself. The inscription was the first in Latin on an official monument on Greek territory.

Overlooking the east terrace of the temple is the terrace on which, at the end of the 3rd century BC, the portico of Attalus I (25) of Pergamum was built with statues (26) of the king and

of his son Eumenes II (27). A large rectangular foundation (28) is thought by some to be the base for the monument that celebrated victory over the Galatians in 241 BC, and, by others, to be an altar to Neoptolemus, the son of Achilles, from whom the Attalids claimed descent. An oikos (29) completes the complex. This has been interpreted as a place where gifts were exhibited or perhaps the site of the cult of Dionysus *Sphaleòtas* ("who makes mistakes and redeems"), associated with Telephus, the mythical founder of Pergamum. Then comes a series of ruins, including the exedra of Daochos (30). Next came one of Delphi's most famous

OPPOSITE: COMBAT, FRIEZE OF THE
MONUMENT OF AEMILIUS PAULUS.

BELOW LEFT:
THE STADIUM.

LEFTP: THE STOA OF THE
AETOLIANS, THE LARGEST AT DELPHI.

BELOW RIGHT: *KOILON* AND
SCAENA OF THE THEATER.

monuments, the "**column of the dancers**" (**31**) (in the museum). At a little over 50 feet high, it was visible from every point in the sanctuary and is characterized by a high base, a marble column

tripod. Certain scholars consider this monument to be the allegorical representation of the city of Acanthus and its ally and protector Sparta, which liberated Acanthus from

owners of the sanctuary. The theater was the setting every four years for the Pythian Games. It was built in the 4th century BC and restored 200 years later and again in the Roman epoch.

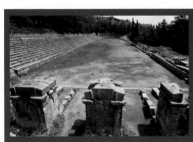

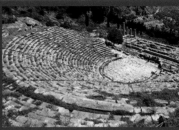

with a shaft encircled by acanthus leaves. It was topped by three dancing girls, each with a *kalathiskos* (a basket made from reed leaves) on her head, though they were originally supposed to support a

Athens in 422 BC and defended it from Olynthus in 382-379 BC (the period the column was made). Others prefer the hypothesis that the column was dedicated by the Athenians at the end of the 4th century BC.

After passing the famous bronze **auriga statue** (**32**) dedicated by the Syracusan Polyzalus, winner of the 4-horse chariot race in 475 BC, you come to **Craterus' gift** (**33**) where the bronze statue by Lysippus and Loechares once stood. It represented the lion-hunt during which Craterus saved the life of Alexander the Great (320-300 BC). From there, on your way to the **theater** (**35**), you pass the **portico of the Aetolians** (**34**) on your left outside the enclosure; this was built to hold the weapons captured from the Galatians in 278 BC by the new

The cavea lies in a square and is divided into two orders: the lower with 7 divisions, the upper with 6. Only the foundations, on two levels, remain of the stage building, and the stage itself had two projecting wings. The **hall of the Cnidians** (**36**) stood to the east of the theater on the highest terrace in the sanctuary. This was a meeting and banqueting room built around 475-460 BC that was famous for its frescoes by POLYGNOTUS OF THASOS depicting the conquest of Troy and the descent of Ulysses to the underworld. To the west of the theater, a path leads to the stadium. This stands on solid, 5th-century BC substructures, but its current appearance was the result of a radical restoration carried out during the reign of Herod Atticus.

TEMENOS* OF ATHENA *PRONAIA ("SHE WHO PRECEDES THE TEMPLE [OF APOLLO]").

The visit begins at the **temple of Athena Pronaia (a)**. This is a Doric peripteral building (6 x 12 columns) from the 6th century BC. It has a platform of just two steps, a wide and very deep naos, and a distyle pronaos *in antis*. Restored after the

temples were dedicated to Athena and Artemis). Two *thesauroi* (**g**, **h**) stood to the west, the second of which has recently been identified as the treasury of Marseilles. The building was dedicated in 535-500 BC and probably transformed into a place for the imperial cult during the reign of Emperor Claudius. The **Doric treasury (g)** next to it

the architecture as a whole. Internally, however, the new trends are apparent: the 10 elegant Corinthian columns that touch the internal wall of the naos introduce a pictorial and coloristic element, and the waterleaf cornice around the outer base of the naos and the diamond-shaped coffers in the ceiling of the portico are filled with a dynamic tension.

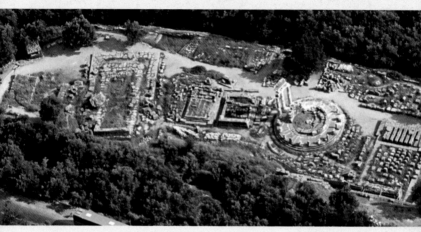

landslide of 480 BC, it was built over a 7th-century BC building of which only a few remains have come to light, in the area in front of the temple. The **altar (b)** stood on the right close to an earlier **temple (c)**. The original altar was probably nearby **(d)**. **Two small buildings (e, f)** stood on a small terrace to the east. They were also 6th-century BC and have been interpreted as temples from a sanctuary dedicated to Phylakos, the local hero who saved Delphi from the Persians in 480 BC (another suggestion is that the

(c. 475 BC) was probably related to the 480 BC victory over the Persians, as was the **base (i)** dedicated by the Delphians. The large *tholos* (**j**) stood at the center of the terrace. The great architct-engineer Vitruvius (1st century BC) attributed this architectural masterpiece to Theodoros of Phocaea, and is dated to 380–370 BC. Though considered a "Classical" monument, its classicism is all external, seen in the Doric peristasis (20 columns) and trabeation (40 metopes), and in the proportions and harmony of

The contrast between the white of the Pentelic marble and the dark tones of the Eleusian stone does not spoil the purity of the architectural lines but it emphasizes their balanced distribution. The purpose of the building is still uncertain. One hypothesis is that it was a *heroon* for Phylakos. Further west lie the ruins of a Doric, prostyle, hexastyle limestone **temple (k)** with pronaos. The naos has a triple-entrance underscored by Ionic half-columns (built c. 365-360 BC). Next to it lie traces of a building partially

obliterated by the temple that may have been the 5th-century BC *oplothèke* (l). From the refreshments area, you can reach the 4th-century BC gymnasium. The open track (*paradromis*) and covered gallery (*xystòs*) used for training and races in the event of bad weather lay on the upper of the two terraces; the *palaestra* (to the south) and a round swimming pool (*loutròn*, to the north) on the lower one. Next to the gymnasium stood a small Roman baths building. After returning to the modern road, you will see the fountain of Castalia that collects the water that gurgles out from the Phaedriades. There are three fountains visible today: one with a paved courtyard was Archaic with Hellenistic restoration, one is modern, and the third was Hellenistic, with a rectangular courtyard, and a tank adorned with half-pillars and 6 water outlets. The last of these fountains stands where the ancient cult of Gaia (Ge) and Python was practiced; it was referred to as the *lalon hydor* ("speaking water") with which the Pythia washed her hair before giving her oracular responses.

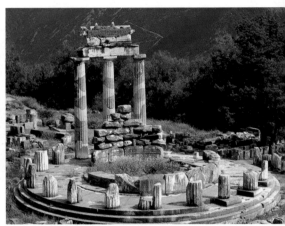

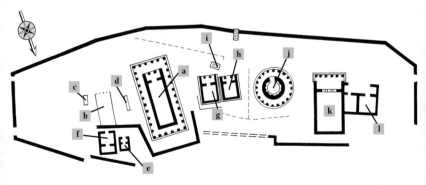

ABOVE LEFT: AREA OF THE MARMARIÀ, WITH THE *THOLOS*, CENTER, AND THE TEMPLE OF ATHENA *PRONAIA*, LEFT.

ABOVE RIGHT: THREE DORIC COLUMNS ON THE BASE OF THE *THOLOS*.

SANCTUARY OF ATHENA PRONAIA

a	*TEMPLE OF ATHENA PRONAIA*	g, h	THESAUROI
b-d	*ALTARS*	i	*BASE OF TROPHY*
e, f	*CULT BUILDINGS* (?)	j	THOLOS
		k	*DORIC TEMPLE*
		l	OPLOTHEKE (?)

THE MUSEUM

Open 8:30 am to 3 pm, winter; and 8 am to 7 pm (Mondays 12 pm to 7 pm), summer. Tel. (0265) 82 312
Sculpture is the museum's strong point. Like the museum at the Acropolis (rather than the National Archaeological Museum in Athens) the Delphi Museum offers a spectacular cross-

historians Amandry and Martinez posits that this marble representation of the center of the world was part of the column of the dancers.
Room 2: **bronze shields.** There is a series of bronze shields from the 7th century BC, and of decorations in the form of griffin heads used on caldrons.

Abduction of the Leucippids) created distinct volumes with figures that stand out clearly from the ground. The master who produced the north and east sides (**gigantomachy** and **Greeks fighting the Trojans in the presence of the gods**) makes more use of color and prefers a high relief, with

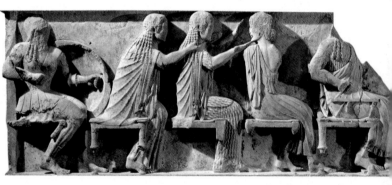

section of Archaic and Severe style sculpture, and this will be the thread followed in the presentation of the rooms, which of course have many other excellent exhibits.
Room 1: the *omphalos.* A recent hypothesis put forward by the French

Room 3: from the **Treasury of Siphnus.** This is one of the most important rooms in the museum; it exhibits the **frieze** and **east pediment** of the famous monument built in c. 525 BC. The master who carved the west and south sides of the frieze (**the Judgment of Paris** and the

complex background action and a more distributed narration (some experts suggest the artist may have been ENDOIOS). The small pediment (**contest between Apollo and Heracles for the Delphic tripod**) has figures detached from the background wall but in the

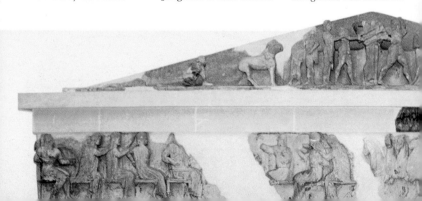

OPPOSITE TOP: THE TREASURY OF
SIPHNUS, AN ASSEMBLY OF THE GODS.

OPPOSITE BELOW: FRIEZE FROM THE
TREASURY OF THE SIPHNIANS.

TOP: ROMAN COPY OF THE
OMPHALOS.

CENTER: SPHINX FROM THE
COLUMN OF THE NAXIOTS.

form of cut-outs, therefore without volume, grace or refinement. This room also contains one of the two **caryatids** from the *thesauros* and the head of another

vigorously modeled **caryatid** datable to c. 530 BC. The **sphinx** that crowned the column of the Naxiots (c. 550 BC) has a certain magnificence: the vibrating

slenderness of the emaciated body stands out against the large wings embellished with their calligraphic feathers, and the face of this apotropaic monster expresses a watchful confidence.

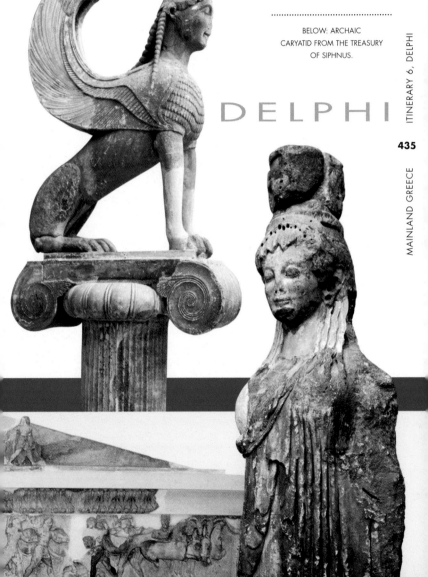

DELPHI

ITINERARY 6, DELPHI

435

MAINLAND GREECE

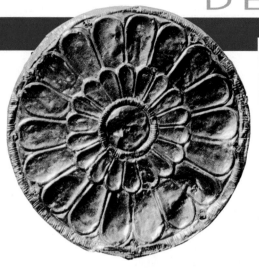

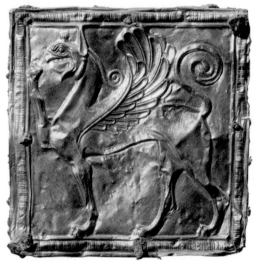

under the Sacred Way in 1939 in front of the portico of the Athenians. The foremost piece is a votive offering in the form of a **silver plated bull** from the first half of the 4th century BC. Also admirable are the **bronze and ivory**

Room 4: the **kouroi**. The outstanding pieces are the **twin kouroi**, thought to be Cleobis and Biton who drove their mother (the priestess of Hera) on a chariot for 45 *stadi* from the city of Argos to the sanctuary of the goddess. The works are attributed to the Argive sculptor (POLY)MEDES at the start of the 6th century BC. The two figures' powerful bodies are represented with just a few essential lines to illustrate the anatomical divisions. The heads still have an almost geometrical solidity and the faces are flattened.

The room also displays the **four metopes from the treasury of the Sicyonians** (**Europa and the bull**, the **Argonauts**, the **Dioscuri**, and **the Calydonian boar**).

The works are not easy to interpret as they are rather unusual in Peloponnesian art, being extremely compact and solid (c. 560 BC).

Room 5: the **Bull**. The contents of this room were found in two trenches dug

statuettes. Note also the fragments of **three life-size chryselephantine statues** (mid-4th century BC). A real masterpiece of 5th-century BC bronze-working is the **incense burner** with relief decorations.

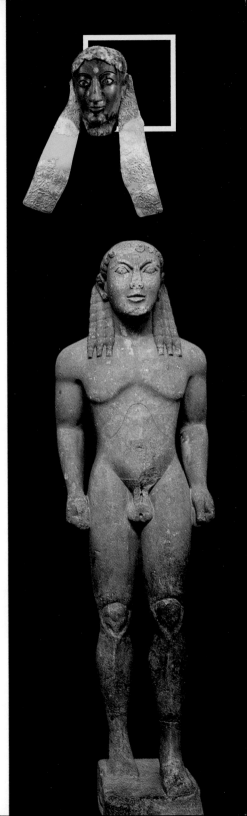

OPPOSITE TOP LEFT: GOLD BUTTON FROM A CEREMONIAL GARMENT.

OPPOSITE TOP RIGHT: FRAGMENT OF A SILVER VOTIVE BULL.

OPPOSITE BOTTOM: ARCHAIC GOLD PLAQUE WITH GRIFFIN.

TOP: IVORY MALE HEAD (A GOD?) WITH GOLD HEADDRESS; VOTIVE GIFT.

BELOW: TWIN KOUROI, PERHAPS OF CLEOBIS AND BITON.

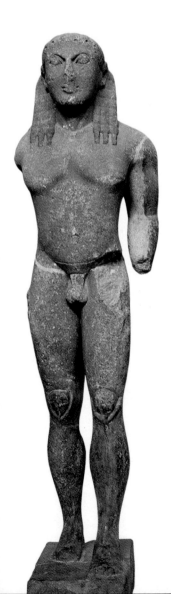

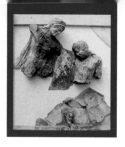

Room 6: from the **Treasury of the Athenians**. The building was a landmark in the evolution of late Archaic architectural decoration. Although the lack of surviving pieces in the **pediments** (combat scenes that probably glorified Heracles and Theseus) prevents judgment being passed on the work's stylistic qualities, the relatively good conservation of the **metopes** (**amazonomachy** to the east, **exploits of Theseus** to the south, **labors of Heracles** to the north and west) provides an appreciation of the unified nature of the scenes, even though they were produced by different sculptors. Sculpted in high relief, some parts (the heads in particular) are completely detached from the ground, and the desire to render the action is clear although the bodies are represented in a conventional and somewhat conservative manner (c. 500 BC; others, basing their judgment on Pausanias, say after 490 BC). *Rooms 7 and 8:* from the **temple of Apollo**. The pieces exhibited are from the 6th-century "Temple of the Alcmaeonids." Most important are the **fragments from the sculptures of a gigantomachy** (west pediment) and of the **arrival of Apollo at Delphi** (east pediment). The colossal cycle must have taken the workshop a long time to produce, and it is possible to note (end of the 6th century BC) a few compositional uncertainties, though the individual figures of both humans and animals display exceptional creativity, e.g., the figure of **Nike** on the acroter, alive with movement.

Parts of the reworking of the temple during the 4th century BC are exhibited in this room.

The series of **decrees** relating to the history of Delphi is of great importance.

Room 10: **funerary stelae**. The most outstanding stele is the **Apoxyomenos** (athlete cleaning himself with the strigil) from c. 470 BC. There are also **bronze objects** and weapons that were votive gifts to Pan and the Nymphs.

Room 11: from the *Tholos*. The room displays surviving sections of the architectural decoration of the famous *tholos* of Marmarià. Unfortunately, little survives of the **two Doric friezes** (the external one of the **amazonomachy** and **centauromachy**; the internal one of the **deeds of Heracles and Theseus**); the situation is the same for the acroters as a result of the repeated reuse of the building's materials from the end of antiquity. Consequently, only **4 metopes** in poor condition are mounted in a reconstruction. However, the state of the pieces does not conceal the exceptional quality of the execution, which is close to that of the frieze at Bassae. Next to the metopes is a **female figure** (perhaps a Nike) that probably formed an acroter on the *tholos*.

OPPOSITE TOP: FIGHT SCENE FROM THE FRIEZE OF THE TREASURY OF THE ATHENIANS.

OPPOSITE BOTTOM: NIKE; SCULPTURE FROM THE ACROTER OF THE TEMPLE OF APOLLO.

TOP: EAST PEDIMENT OF THE TEMPLE "OF THE ALCMAEONIDS".

BELOW: HERACLES CATCHES THE CERYNITE HIND; METOPE FROM THE TREASURY OF THE ATHENIANS.

BOTTOM: REARING HORSE AND RIDER; METOPE FROM THE *THOLOS* OF THE SANCTUARY OF ATHENA *PRONAIA*.

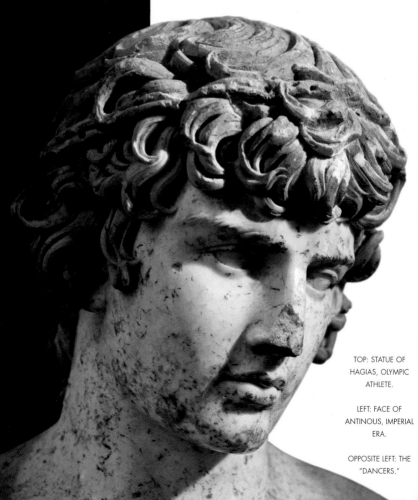

Room 11: "**The Dancing Girls**." The room presents the three dancing girls that crowned the column encircled with acanthus leaves in the portico of the Attalids, one of the most unusual and difficult monuments to understand at Delphi. Debate on the subject is still ongoing. The dates considered for the work range from c. 380 BC (based on an unknown, possibly Spartan, dedication) to 335-325 BC (based on a dedication from Athens that was attempting to restore its influence following its defeat at Chaeronea). If the latter case, then rather than the simple figures of Thyiads or the Three Graces, the girls could be the three daughters of Erechtheus. The dancers are dressed in light chitons and betray a degree of uncertainty in the Attic or Peloponnesian training of the sculptor (the "**Spartan dancing girls**" by CALLIMACHUS are the most commonly mentioned reference).

TOP: STATUE OF HAGIAS, OLYMPIC ATHLETE.

LEFT: FACE OF ANTINOUS, IMPERIAL ERA.

OPPOSITE LEFT: THE "DANCERS."

The room contains other importance items, e.g., the statue considered by the French archaeologists to be of the Roman consul Titus Quinctius Flamininus, who in 196 BC proclaimed the freedom of Greece from Macedonia, and also the **statues from the donation of Daochos II**, the Thessalian tetrarch of the Delphic League for several years from 337 BC. Of the 9 original statues, 6 have been found entire plus the base of the seventh. The individual statues celebrated the prince's dynasty and provided a series of dynamic and fluent images of the man in a strongly pictorial style. The approximations of the details suggest that the portraits were supposed to represent views from a distance. Authorship of the statues remains unknown: attribution to EUTHYCRATES, the son of LYSIPPUS, is purely hypothetical. The suggestion that several artists, prevalently Peloponnesian, were involved needs to be investigated further; there are many affinities with the Polyclitan school.

The **statues of Agelaos** and **Aghias** seem to fall within the artistic vision of LYSIPPUS, and it is clear that the great sculptor from Sicyon produced at least the second for the **bronze donation from Pharsalus**, which he replicated in marble at Delphi. It is unanimously considered one of LYSIPPUS' most important works for understanding the master's personality. The room also contains an excellent statue of Antinous (Hadrianic era). *Room 12*: from the **Auriga**. Part of a group (chariot, horses, young boy holding the horses) dedicated by Polyzalus after a chariot victory in 478 BC. He repeated the work four years later. This famous bronze statue incorporates all the Severe style's salient characteristics, e.g., the rounded head, the taut facial surfaces (the brilliance of the boy's gaze is exceptional), the tight curls of the hair, the architectural simplicity of the chiton, and the stark anatomical forms of the arms and feet. The base appears to bear the sculptor's signature (SOTHADES OF THESPIA); however, this is not certain as the style seems to be less Attic than Peloponnesian or, possibly, is from Magna Graecia. The name of PYTHAGORAS OF REGGIO has been put forward; he was long active for the tyrants of Sicily. Especially noteworthy is an **Attic cup** in a window against the wall. It has a white ground with **Apollo holding a cithara** in his left hand and pouring a libation from a bowl with his right (c. 470 BC). (S.M.)

..
BELOW: THE "AURIGA OF DELPHI"; A CELEBRATORY BRONZE STATUE IN SEVERE STYLE.

THERMUM

*Timetable of the excavations: every day
except Mondays, 8:30 am to 3 pm. Free.
Tel. (0641) 27 377.*

Thermum, which lies in Aetolia, is not one of the most spectacular sites in Greece, but it is one of the most important for understanding the origins of the Doric temple. Inhabited since the Mycenaean age, the site acquired importance in the late Classical period when it became the seat of the Aetolian League's federal sanctuary (367 BC). The presence of the League's treasure was the cause of looting and destruction of the city in 218 BC and again 10 years later by Philip V of Macedonia. The cult of Apollo *Thermios* was practiced there; in this guise Apollo was the god of fire and heat and the guardian deity of herds and transhumant (migrating) herders. Digs have revealed the 3rd-century BC Hellenistic appearance of the sanctuary. A large wall protected three sides of the site; the fourth, to the east, was protected by Mount Mega Lakkos. The wall was composed of huge blocks of limestone with sun-baked brick in the upper section.

Two round towers protected the southwest gate and square towers were built around the wall. The **temple of Apollo (a)** stood inside the walls. Today little more than the stylobate is visible but on the temple site it is possible to trace a succession of buildings. Lying north-south, the last version of the temple dates to the end of the 3rd century BC or start of the 2nd (after the destruction of the city in 208) but retained the very long Archaic plan of a building previously

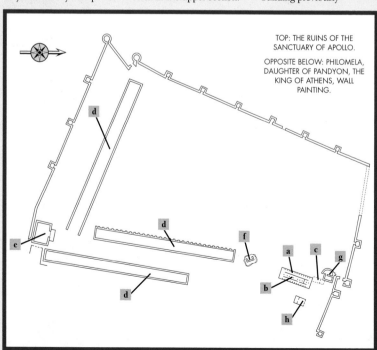

TOP: THE RUINS OF THE SANCTUARY OF APOLLO.

OPPOSITE BELOW: PHILOMELA, DAUGHTER OF PANDYON, THE KING OF ATHENS, WALL PAINTING.

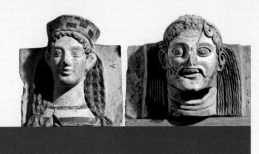

constructed around 630–20 BC. (A group of scholars argue that the temple was built for the first time after the Macedonian expedition of 208.) As in the first phase,

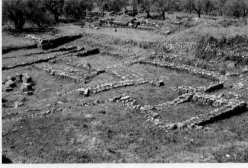

the temple had a peristasis of 5 x 15 columns, and a naos without a pronaos but with an opisthodomus. The nave was divided into two halves by a row of 10 columns that

AETOLIA

THERMUM

a TEMPLE OF APOLLO
b MEGARON B
c MEGARON A
d STOAS
e BOULEUTERION
f FOUNTAIN
g TEMPLE OF ARTEMIS
h TEMPLE OF APOLLO LYSIOS

supported a sloping roof. All the beams and supporting ribs of the structure were made from wood. The Archaic building had a series of painted metopes that represent the oldest known example of a trabeation. Whether the Archaic metopes were reused or not in the Hellenistic building is still subject to debate. Recently the hypothesis was put forward that copies were made at the end of the 3rd century BC or at the start of the 2nd. An earlier building – from the 9th century BC – has been discovered beneath the foundations of the temple. This was the so-called *megaron* B (b) characterized by a deep

pronaos, naos and *adyton*. This building was part of a proto-historic village that had at least 10 apsidal houses, including the 13th or 12th-century BC *megaron* A (c). A series of slabs arranged in an ellipse around the *megaron*, like a sort of peristasis, was initially attributed to this building but they were in fact added during a later epoch following the destruction of the *megaron* B. What their function was is not known. In the agora **two long *stoai* (d)** marked the boundaries of a strip of land closed on the north side by the temple and, on the south side, by a *bouleuterion* (e). A monumental **fountain (g)** stood in the northwest corner. The layout may have been planned in the 3rd century BC. The sanctuary also contained two small sacred buildings: the **small temple dedicated to Artemis (g)** west of *megaron* A, and another **temple, dedicated to Apollo *Lysios* (h)**, just to the east of the large temple. Traces of other buildings found in the sacred enclosure include a trophy that celebrated the victory of the Aetolian League over the Galatians at Kallion in 278 BC. (S.M.)

EUBOEA

Euboea is separated from the mainland by a long narrow channel (the Euripus) that is affected by strong alternating currents. The island has been uninterruptedly inhabited since the Paleolithic period when it may still have been connected to the mainland. **Chalcis** and **Eretria**, the two main cities on the island, were the first to begin the process of colonization of the western Mediterranean in the eighth century BC, founding Pithecusa (Ischia) and Cuma (756 BC), which represented the center of irradiation of the Greek culture to Rome (the Latin alphabet is derived from the alphabet of Chalcis). Sicily was also colonized by Chalcis (Zancle, Naxos, Lentini and Catania) and also Reggio on the Italian mainland. No less important was the colony on the peninsula of Sithonìa, which took its name (Chalcidice) from the city.

From **Khalkis** (*Archæological Museum, open 8:30 am to 3 pm, Tuesday–Sunday, but 8:30 am to 7 pm from 1 July–31 October. Payment required*) go north to **Mantoùdi** (ruins of a Meso-Helladic settlement and the city of Kerinthos, seventh–third centuries BC). Continue to **Loutra Edipsou** (sanctuary of Heracles and Roman baths) and return via **Elymnion** and **Strophilia**. In a southerly direction, leave Chalkis to visit **Lefkandì** (important settlement with 2 phases of habitation: the first from 2100 BC to the Mycenaean Age, the next from the second half of the eleventh century BC to circa 700 BC when the city was

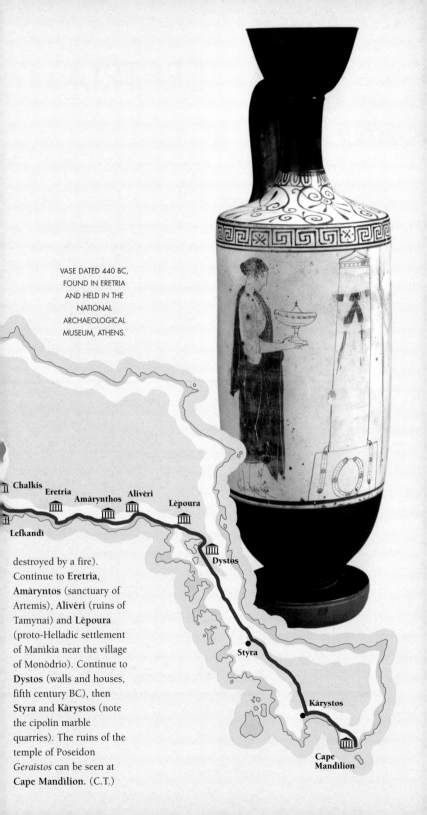

VASE DATED 440 BC,
FOUND IN ERETRIA
AND HELD IN THE
NATIONAL
ARCHAEOLOGICAL
MUSEUM, ATHENS.

Chalkis
Eretria
Amàrynthos
Alivèri
Lèpoura
Lefkandì
Dystos
Styra
Kàrystos
Cape
Mandìlion

destroyed by a fire).
Continue to **Eretria**,
Amàrynthos (sanctuary of
Artemis), **Alivèri** (ruins of
Tamynai) and **Lèpoura**
(proto-Helladic settlement
of Manìkia near the village
of Monòdrio). Continue to
Dystos (walls and houses,
fifth century BC), then
Styra and **Kàrystos** (note
the cipolin marble
quarries). The ruins of the
temple of Poseidon
Geraistos can be seen at
Cape Mandìlion. (C.T.)

ERETRIA

The city was named for the Greek word for oars (*eretmoi*) and flourished as a result of its maritime trade from the Early Geometric period.

Eretria was founded when the population of Xeropolis (perhaps the settlement discovered on Lefkandì hill) abandoned its settlement at the end of the 8th or beginning

Eretria was severely punished by the Persians in 490 BC for the support it offered to the Ionic revolt (499 BC); the city was destroyed and the inhabitants deported to Ecbatana. Like other Euboean cities, it later entered the Delian-Attic League but in 446 BC rebelled against Athens' hegemony, for which it

until the arrival of the Romans.

In 198 BC it was sacked and destroyed by Lucius Quintius Flamininus. Rebuilt with the help of Antiochus III, in 87 BC it was once more razed by Sulla for having supported Mithridates VI Eupator, king of Pontus, in the war against Rome.

HOUSE OF THE MOSAICS

A PERISTYLE COURT
B MAIN ANDRON
C VESTIBULE
D ROOM
E BANQUETING ROOM
F SOUTH ROOMS
G COURT-GARDEN
H ROOMS
I VESTIBULE
J SERVICE ROOMS

of the 7th century BC, following its defeat in the war against Chalkis for possession of the Lelas river plain.

was punished heavily. In the middle of the 4th century BC it passed to the Macedonians, to whom it remained linked

TOP: *PITHOS* IN THE ARCHAEOLOGICAL MUSEUM.

OPPOSITE: VIEW OF THE SITE.

The archaeological area lies at the foot of the acropolis hill, on the left of the Chalkis-Karistos road. The monumental ruins are almost exclusively from the reconstruction of the city after 198 BC as all remains of previous versions of the city were completely leveled. The visit begins from the **House of Mosaics (a)** (same opening hours and ticket as the museum).

The house stood on the road between the west and east gates at the junction with the north-south road on the north side. The **main** *andron* **(B)** contained 11 *klinai*, the walls were lined with polychrome stuccoes and decorated with clay appliqués of a Gorgon, satyrs and serpents. A **vestibule (C)**—with a pebble mosaic of sphinxes and panthers facing one another in a cornice of palmettes and lotus flowers—led into the **next room (D)** that had 7 *klinai* and a pebble mosaic floor with a Macedonian star at the center surrounded by palmettes and lotus of the entrance there was a panel of a Nereid carrying weapons to Achilles.

Another **banqueting room (E)** on the east side of the peristyle has 3 *klinai* and a mosaic floor patterned with plants.

The use to which the **rooms (F)** on the south side were put is unknown. The private section of the house was on the east side, where a **court-garden (G)** lay in the center. To the north of this were **2 rooms (H)** that opened onto a wide **vestibule (I)**

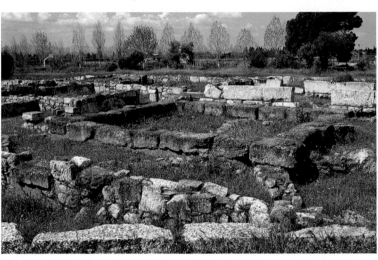

that led to the agora. Almost square in plan (roughly 6,300 square feet), it was composed of 2 sections: the public one was organized around a **peristyle court (A)** which had the most important rooms (the men's banqueting rooms) on the flowers, all within a square decorated with bucranes (bovine skulls) and birds with spread wings at the corners. A frieze ran around the room with a representation of the Arimaspi between 2 griffins and a horse attacked by a lion. In front to the south of the **kitchen and bathrooms (J)**. The house was built around 375 BC and destroyed by a powerful fire a century later. A monumental tomb with 2 sarcophagi was built at the end of the 2nd century BC above the banqueting room.

From the **House of the Mosaics (a)**, take the road to the right toward the acropolis. On the left you will see the remains of the **stadium (b)** and **gymnasium (c)**, both from the Classical age (4th century BC) but rebuilt in the 2nd century BC after the city was destroyed by the Roman consul Lucius Quintius Flamininus. The large peristyle court had a series of rooms on the north side: a round room with 3 rooms to the west (the one with the white mosaic floor was used for private worship) and a bathroom to the east (the baths remain).

The ruins of the Hellenistic *Thesmophòrion* (d) lie on the northeast side of the gymnasium. It was dedicated to Demeter and Kore and had a square naos reached up a central flight of steps. Nearby stood the **sanctuary of Artemis** *Olympia* (e); it had a sacellum from the 6th or 5th century BC that was destroyed in 198 BC.

One of the best preserved monuments is the **theater** (f). It was built in the 5th century BC and renovated at the end of the 4th. The cavea was built against an artificial slope, and an underground corridor covered with a vault joined the orchestra to the lower part of the stage. The nearby **temple of Dionysus (g)** dates to the same period; it was a peripteral building with 6 x 11 Doric columns, a deep naos, and a distyle pronaos *in antis*. There was no opisthodomus. You then come to the edge of the ancient city and the remains of the **west gate (h)**. Excavation has shown that there were 5 building phases to the gate and, therefore, also to the city walls.

Construction of the gate

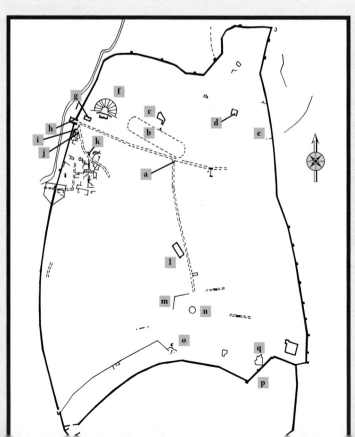

dates to the start of the 7th century BC. On this occasion the course of the torrent that ran through this area was diverted to the east into the city. The next stage occurred in the mid-6th century BC when the stream was returned to its original course and a bridge built over it. At the same time a gate with 2 oblique bastions was constructed. Both the bridge and gate (with 2 square bastions) were rebuilt (450-400 BC); first after being destroyed by the Persians and again after its destruction at the hands of the Romans in 198 BC. During this last phase, the gate was transformed into a bastion with an entrance each on the north and south sides. The bridge was demolished after the torrent was diverted to the west.

To the south of the road that led to the gate stood a large building referred to as **Palace 1 (i)**. It had an unusual trapezoidal plan with many rooms set around 2 peristyle courts. The north section of the building was residential; *andrones* faced onto the court on the north and west sides that communicated with the bedrooms. A similar layout was seen in the central section where the large peristyle was surrounded by a banqueting room, 2 bedrooms at the back and a second *andron* on the south side preceded by a vestibule. The storerooms and baths area were located in the south section.

The ruins visible today date to the 2nd century BC but the building had a history from the earliest phases of the city. Between 725 and 680 BC this area was used to build a group of tombs for the oligarchy of rich landowners (*hippobotai*, "those that graze horses"). When the walls were built, around 680 BC, a triangular *heroon* was raised over the tombs that represented the establishment of a cult of ancestors. To the southwest of this, a small temple was built around 600 BC flanked by an *oikoi* structure, a series of 5 rooms used for funerary banquets. Around 550 BC the complex was rebuilt in a similar form but moved eastwards. After the Persians sacked the city, a rectangular building was constructed, with a central room and 2 bipartite lateral sections, that resembled the previous *oikoi* structure. The new version built after 411 BC maintained the same layout.

The palace built in the 2nd century BC is thought to have been the residence of 3 families that were the custodians of the cult of the ancestors, in honor of whom funerary banquets were celebrated in the *andrones*.

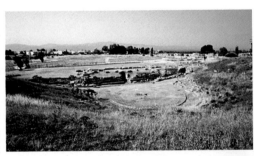

OPPOSITE TOP: *PARADOS* OF THE THEATER.

ABOVE: VIEW OF THE THEATER.

ERETRIA			
a	HOUSE OF THE MOSAICS	i	PALACE 1
b	STADIUM	j	TRAPEZOIDAL BUILDING
c	GYMNASIUM	k	RESIDENTIAL QUARTER
d	THESMOPHORION	l	TEMPLE OF APOLLO
e	SANCTUARY OF ARTEMIS	m	AGORA
f	THEATER	n	ALTAR OF APOLLO
g	TEMPLE OF DIONYSUS	o	BATHS BUILDING
h	WEST GATE	p	BASTION
		q	ISEION

To the south of the building lie the remains of another **trapezoidal building (j)**, constructed in the late 5th or early 4th century BC. It was restored in the middle of the 2nd century BC and destroyed in 198 BC by Lucius Quintius Flamininus. The plan is fairly close to that of the previous construction.

To the south of these 2 residences—between the city wall and a north-south road—a **residential district (k)** has been uncovered with 4 large houses (4th century BC). The public section of these buildings has the customary layout around a central peristyle court, and the private and service sections around a court garden.

Having returned to the House of the Mosaics, turn

Doric persistasis of 6 x 14 columns, and a naos with pronaos and opisthodomus *in antis* divided into 3 aisles by 2 rows of columns. Many fragments have been found of the sculptures from the west pediment, which represented an Amazonomachy (in the museum).

The pediment of an amazonomachy with Heracles and Theseus probably belonged to the temple rebuilt, perhaps in the second half of the 5th century, after the Persian invasion. After Sulla's destruction of the city, the pediment was taken to Rome and inserted in the temple of Apollo Sosianus. Examination beneath the building has enabled the long history of the temple to be understood. The

plan with stone walls flanked by 11 pairs of clay bases for the poles that supported the roof. These were aided by 3 internal bases set out in a triangle. The north-south orientation, repeated in all the successive buildings, evoked the place where the god spent the winter months in the country of the Hyperboreans.

Just north of the hut was a building of similar size with an oval interior and polygonal exterior. Its honeycomb appearance resembled the second of the mythical temples at Delphi (the walls can be seen beneath the northeast corner of the temple). Around 800 BC a temple stood on these structures measuring 100 feet, *hekatòmpedon* A (**d2**). It had a very long apsidal plan preceded by a *bothros*, which, around 700 BC was replaced by a peripteral temple of 6 x 19 wooden columns, *hekatòmpedon* B (**d3**), that was incorporated in the late-Archaic building.

The temple stood in the immediate proximity of the **agora (m)** which was lined on the north and east sides by porticoes. The east portico was built in the 4th century BC over a similar Archaic structure and had a series of shops at the rear. The foundations of a round building (5th century BC with restorations in the 4th and 3rd centuries BC) can be seen at the south end. Ringed by 62 wooden poles

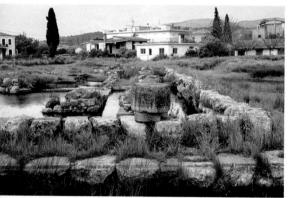

right toward the center of the ancient city where the **temple of Apollo (l)** *Daphnephoros* ("laurel bearer") stood. The remains currently visible are of the **building (d4)** from 520-490 BC, with a

earliest building, the *Daphnephòreion* (**d1**), imitated the hut made of laurel branches that Pausanias identifies with the first of the mythical temples of the god at Delphi. It had an apsidal

TEMPLE OF APOLLO

d1 DAPHNEPHOREION
d2 HEKATOMPEDON A
d3 HEKATOMPEDON B

d4 *LATE ARCHAIC*
BUILDING

OPPOSITE: BASE OF THE TEMPLE
OF APOLLO.

BELOW: THESEUS AND ANTIOPE
FROM THE PEDIMENT OF THE
TEMPLE OF APOLLO.

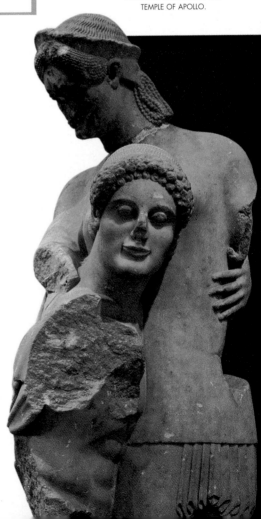

standing on stone bases, it had a round *bothros* at the center and has been identified as the **altar of Apollo *Daphnephòros* (n)** where the god was worshiped as the tutelary deity of sailors. Recent examination of the area between the temple of Apollo and the ancient port have revealed remains of the Early Bronze Age settlement, including a workshop for treating obsidian imported from Melos and a kiln for pottery. The continuity of habitation on the site seems to contradict Strabo's claim in his *Geography* that the ancient city stood on a different site.

Findings have also been made relating to the Geometric settlement, for example, districts with oval or apsidal houses.

To the south of the agora are the remains of a **baths building (o)** (3rd century BC, rebuilt after 198 BC) that may have been related to the port gymnasium. Continuing east you will pass the east arm of the **bastion (p)** raised in the 4th century BC parallel to the walls; it has round and rectangular towers and at one time ringed the ancient port.

The *Iseion* (**q**) was built around 300 BC due to the generosity of the sailors of Alexandria; it was rebuilt after 198 BC and finally abandoned after 87 BC. The north section of the sanctuary contained 15 rooms that may have been used for purification rituals, while the area dedicated to the cult – with the distyle *in antis* temple of Isis – stood in the south of the zone.

Heading to the east section of the walls, you come to the lower gymnasium (**18**) from the Archaic era, but it was rebuilt on several occasions up until the early 2nd century BC. It had a large court, a portico with 2 aisles on the north side, and an L-shaped portico on the south and west sides.

THE MUSEUM

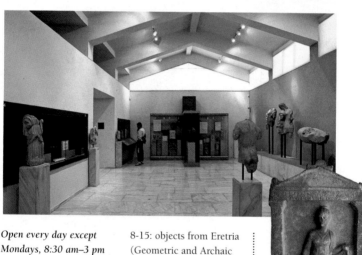

Open every day except Mondays, 8:30 am–3 pm from November through March; from 8:30 am–7 pm from July through October. Payment required.

The museum displays finds from the excavations that have taken place since 1885 in the various sites in Euboea.

First room: articles from the necropolis of Lefkandi (2100-700 BC); windows 8-15: objects from Eretria (Geometric and Archaic eras).

Second room: contains one of the museum's best pieces, a masterpiece of Late Archaic sculpture, the broken pediment of the temple of Apollo featuring an **amazonomachy. Athena is at the** center; to her right Theseus abducts Antiope, the queen of the Amazons. (C.T.)

TOP: ROOM IN THE MUSEUM, WITH PEDIMENT AND FRAGMENTARY SCULPTURES.

ABOVE AND OPPOSITE: FUNERARY STELAE.

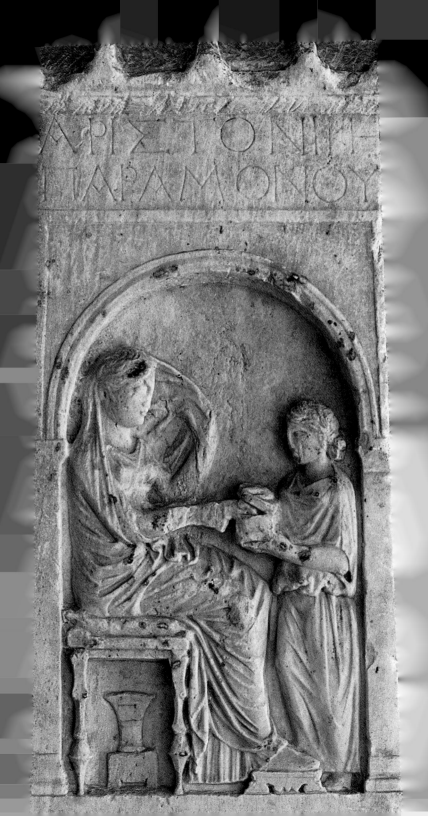

6

IONIAN ISLANDS

GORGON, ANTEFIX, KERKYRA
MUSEUM.

Of the seven islands in
the Ionian archipelago, six
face the Greece's west coast;
the seventh, Cythera, lies off
the southern tip of the
Peloponnesus. Though the
many earthquakes in the
region have destroyed the
ancient monuments, the
presence of the Venetian
Republic is still strong. The
trading city-state dominated
the islands between the 14th
and 18th centuries and
impressed a Venetian
"atmosphere" on many of the
towns and villages.
From **Kerkyra**, make a short
stop on the island of **Paxos**
and continue to **Levkas**. The
island retains a few traces of
its past, for example, the ruins
of the ancient city of **Leucas**,
which was founded by the
Corinthians in 640 BC at the
northern end of the island, 1.5
miles from the modern city.
Objects found here, like those
from other sites on the island,
are exhibited in Lefkada
(*Archaeological Museum, 21
Phanèromènis Street*).
Ithaca, the island made famous
by Homer as the homeland of
Odysseus, does not offer any

important archaeological sites. The ancient capital from the time of Odysseus was recently identified with the ruins discovered in the bay of **Porto Polis** on Pelikata hill (less than a mile from Stravos). These belonged to a small settlement that existed between 2200 and 1200 BC (*see the local museum for finds, open from 9am to 3pm, Tuesday–Sunday*). Other Homeric sites have been identified near **Vathy**, the modern capital, such as the **Cave of the Naiads** (or Marmarospilia, 2 miles to the east), in which Odysseus is supposed to have hidden the gifts of the Phaeacians on his return to Ithaca. More difficult to reach (down a 2-mile path) is the **spring of Arethusa** in the bay of Pera Pighadi, dominated by a tall rock wall (the Rock of the Crows). Two miles south of Vathy are the ruins of what was the island's capital until the 16th century. The buildings seen on Mount Aetos (4 miles west of Vathy) are those of the **city of Alalcomenàai** (8th and 7th centuries BC).

On the island of **Cephalonia**, setting out from the capital Argostoli (*Archaeological Museum, open 8:30 am to 3 pm, Tuesday–Sunday*), you can reach **Peratata** to visit the church of the monastery of Aghios Andrea (17th century) and the remains at **Krane**

(sections of 4th- and 3rd-century BC walls). At **Sami** (the site of the ancient Same) on the island's east coast, you can see the remains of the fortifications of the acropolis, houses and a Roman baths complex. **Zante**, capital of the island of **Zacynthus**, was destroyed by the earthquake in 1953. Besides seeing the few Byzantine and Venetian monuments that have survived, you can visit the Byzantine Museum (*open from 8:30 am to 2:30 pm, Tuesday–Sunday*). Other important Byzantine remains can be seen in the south of the island at **Machairado** (church of Aghios Mavra, 14th century) and in the north at **Anaphonitria** (15th-century monastery). The capital of **Cythera** is home to Venetian residences and white-plastered houses typical of the Cyclades (*Archaeological Museum, open 9:30 am to 2:30 pm, Tuesday–Sunday*). The medieval quarter of **Mesa Vourgo** has important Byzantine churches. If you

pass through **Mylopotamos**, one of the island's loveliest villages, you will find the 12-century Byzantine monastery of Aghios Theodoros, which is well worth a visit. (C.T.)

KERKYRA

6.1

Even in antiquity Kerkyra was identified with Scherìa, the island of Phaeacia where Odysseus was taken in by the court of Alcinous. Inhabited by the Liburni people from Illyria, in the first half of the 8th century BC it was occupied by colonists from Eretria, who seem to have given the island its original name: *Drepàne* ("scythe"). In 734 BC the Eretrians were chased out by colonists from Corinth led by Chersicrates, who founded the city of Corcyra on the isthmus that

separated the military port Hyllaico to the west from the commercial port of Alcinous on the east (today buried). Kerkyra's position made it an obligatory stop on the trading routes to the Ionian, Tyrrhenian and Adriatic seas, thanks to which the Corinthian colony rapidly prospered and then entered into conflict with its mother city. In 664 BC, after having defeated Corinth in what was recorded by Thucydides as the first naval battle in the Greek world, Corcyra declared itself

independent, but, at the end of the century, Periander brought it back under the control of Corinth. After having completed several colonial exploits, in 435 BC Corcyra once more defeated the Corinthian fleet at Cape Leukimme, and again in 433 at Sybota with the aid of Athens. A long period followed, roughly 80 years, of civil war between the philo-Spartan nobility and philo-Athenian democrats. At the start of the 3rd century BC, the island supported the attempts by Agathocles of Syracuse and Pyrrhus to unite Greece and Magna Grecia in a single kingdom. In 229 BC, Corcyra passed under the control of Rome so as to ward off the threat posed by the Illyrians and, later, Demetrius of Pharos. In the Roman and early Christian era Kerkyra experienced great prosperity, but it was destroyed by the Goths in the middle of the 6th century. To be able to defend itself better, the population moved to the small isthmus to the north where the Venetians built a fort in the 11th century. In the 13th century, Corcyra passed under the control of the Venetians (1204) and then that of the Despots of

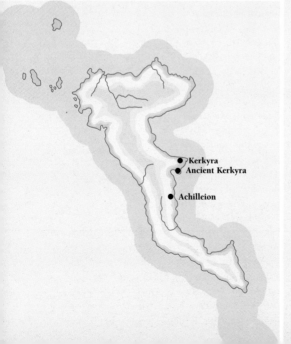

Kerkyra
Ancient Kerkyra
Achilleion

Epirus (1210). Once back in Venetian hands, it remained under the Serenissima's control for four centuries (1388-1797) and provided a bulwark against Ottoman expansion in the West. Following Napoleon's occupation of Venice, the island was controlled first by the Russians, then the French (1807-15). The Congress of Venice placed Kerkyra under the British protectorate, which created the United States of the Ionian Islands. In 1864 these were assigned to Prince George of Denmark, who in that same year was invited to become the king of Greece.

OPPOSITE TOP: DETAIL OF THE PEDIMENT SCULPTURE FROM THE TEMPLE OF ARTEMIS.

BELOW: GORGON; PEDIMENT FROM THE TEMPLE OF ARTEMIS.

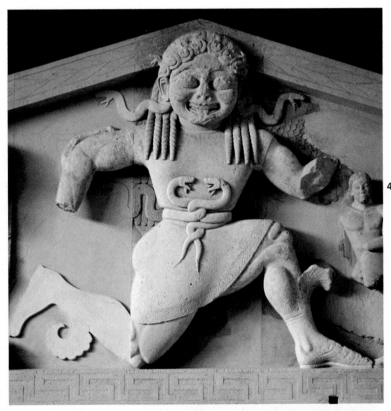

VISIT

Although badly damaged by Italian and German bombardments in 1940, the city of Corcyra still has many examples of the different architectural phases of its history, which are pleasingly and harmoniously mixed.
The *Spianada* was once an exercise and parade ground for the Venetian troops. It lies between the Old Fort and the center of the modern city.
The Old Fort (*Tuesday-Friday 8 am–6:30 pm; Saturday-Sunday 8.30am-3pm. Payment required*) was built over 2 hills (from which the modern name of the island is derived: *polis tôn Koryfôn*); the fortifications were built by the Byzantines and later strengthened by the Venetians. A fort was built by the latter in 1550 and separated from the mainland by a large dike

that could be crossed on a mobile wooden bridge, which was protected by 2 bastions.

The Old Fort is connected to the New Fort by two arcaded houses built during the French occupation by Matthieu de Lesseps, who designed the Rue de Rivoli in Paris. On the north side stands since 1913, the Municipal Library (it also houses a museum of Chinese and Japanese art, mosaics from early Christian buildings and Byzantine

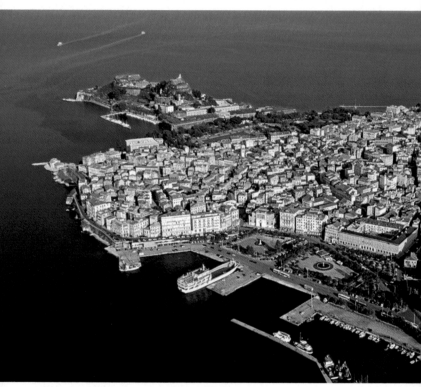

sets of walls that also protect the inhabited area. These solid defenses enabled the city was able to resist the attacks of the Turks, in particular the assault launched by Suleiman the Magnificent in 1571.

The west side of the *Spianada* is bounded by the Liston, a street of the imposing Palace of St. Michael and St. George (*Tuesday-Saturday 8am-3pm; Sunday 9.30am-2.30pm. Payment required.*), which was built between 1819-23 by the English architect G. Whitmore as a residence for the British governor. In 1864 it became one of the royal palaces and, icons).

A walk through the city should take in the City Hall (one of the most distinguished Venetian buildings) built between 1661-93 for the meetings of the nobility (Loggia Nobilei), and the church of the Hagios Spyridon, built in 1590 with a characteristic bell-tower.

THE MUSEUM

Open Tuesday–Saturday 8:30 am–3 pm; Sunday 9:30 am–2:30 pm. Payment required.

The museum has many and important exhibits ranging from prehistory to the Roman period. Those from the Archaic Age are of

particular interest as they represent the period of major economic and cultural development on the island. The **pediment** from the west façade of the **temple of Artemis** (*Room 6*) is the oldest stone pediment conserved. The depiction of the **monstrous Gorgon** in the center was supposed to ward off evil.

Next to her is **Pegasus** (to the observer's left) and **Chrysaor** (right), who were generated from the Gorgon's blood when she was decapitated by Perseus. The group is framed by **2 panthers**, both of which had a protective function for the sacred building; the corners of the pediment are filled with 2 mythical scenes: to the right a beardless **Zeus strikes a Titan** with a lightning bolt; to the left the enthroned **Priam is attacked by Neoptolemus** (other opinions are Rhea or Cronos threatened by Poseidon). It is in all probability the work of an artist from Corinth (to whom ancient sources attribute the invention of pediment decoration); this is suggested by certain iconographic details such as the type of Gorgon and panthers, and the very elegant decorative treatment of the surfaces, which were accentuated with colors. Another interesting piece is the **fragment of pediment** (*Room 8*), datable to

roughly 500 BC, found in the Figarettou area. It shows **Dionysus and a young man** lying on a *kline* and facing toward the missing half of the gable. In front of the *kline* is a small table beneath which a lion is stretched out; toward the corner there is a large dog and a crater (drinking cup).

Materials from the cult area of Mon Repos are exhibited in the same room, some of which date to the period of the founding of the colony.

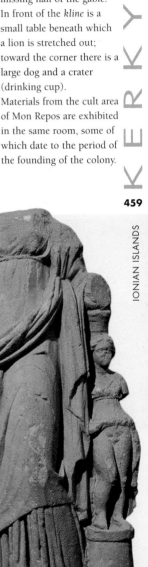

KERKYRA

IONIAN ISLANDS

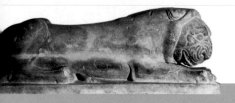

KANONI PENINSULA

The ancient town of Kerkyra has stood on the peninsula since the Archaic Age. The town center developed around the port of Alcinous (the modern Paleopolis) while the residential areas stood in the western part of the peninsula. The east side was reserved for sanctuaries. The northwest section of the city was reserved for traders and craftsmen, as is demonstrated by the workshops, shops, and of bronze and pottery workers at Stratià. **Menekrates, cenotaph (a)** is a funerary monument from 600 BC. The dedication "for Menekrates, son of Tlsìas, proxenos of the Corcyrians" is inscribed on the round base and is one of the earliest of its kind. A stone lion (now in the museum) was found nearby and, if it were part of the funerary monument, would be the oldest animal figure placed on a tomb. Continuing along the sea, you come to the district of Anemòmilos (named after windmills) where a **tower (b)** remains from the walls that protected the east jetty of the port of Alcinous (now underground).

You then come to Paleopolis where the ruins of the **agora (c)** lie. In the first half of the 5th century AD, a basilica with a nave and 4 aisles stood in this area. It was rebuilt in the 8th century with just 2 aisles and then again in the twelfth with only the nave. The north wall has 121 marble lions'-head gutters that originally came from an ancient temple. The double narthex communicated with the nave via a tribelon. An inscription on the architrave of the tribelon recorded how the basilica was built by Bishop Jovianus "after the temples and altars of the Hellenes were destroyed." And indeed, the basilica stands on an *odeon-Bouleuterion* dating to the 2nd or 1st century BC

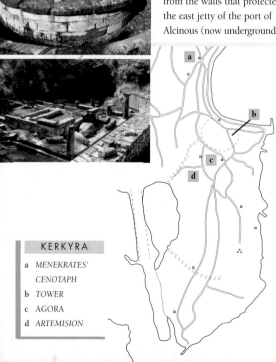

KERKYRA

a *MENEKRATES'
 CENOTAPH*
b *TOWER*
c *AGORA*
d *ARTEMISION*

but rebuilt during the Severe era; it is the only public building found in the agora. Nearby there stood a Roman baths building that remained in use until the 6th century AD; this was constructed over Hellenistic houses and an Archaic pottery workshop. The *Artemision* (d) stood to the west of Paleopolis. It was built between 590 and 580 BC and was the first great stone construction of the Archaic Age; even at this early date it had all the elements of Doric architecture fully expressed. The temple had a naos with pronaos and opisthodomus, and was divided into a nave with 2 aisles by 2 rows of 10 columns. The naos was surrounded by a peristyle of 8 x 17 columns. The gallery around the naos was wide and was more typical of a large Ionic dipteral naos. The enlargement of the façade to 8 columns was an innovation introduced by Corcyrian architects that allowed a wide pediment to be built, into which sculpted decoration was inserted for the first time (pediment of the Gorgon in the museum).

A large rectangular altar stood in front of the temple and was joined to it by a paved road. It was decorated with orthostats decorated with metopes and triglyphs.

ACHILLEION
(7 miles south of Kerkyra; 8.45am-3.30pm. Payment required.)
This villa was built for Empress Elizabeth of Austria in 1890-91 by the Neapolitan architects Raffaele Cardita and Antonio Landi. The empress named it after her favorite hero, Achilles. (C.T.)

7

EASTERN AEGEAN ISLANDS

Due to their geographical location, the seven islands are closely tied to the mainland that faces them, a fact that has affected their political, economic and cultural histories. The most northerly islands, **Thasos** and **Samothrace**, are administered respectively by Macedonia and Thrace while the others lie at a short distance from the Anatolian coast. Due to its position in front of the Dardanelles, **Lemnos** was already important in the Aegean world during the early Bronze Age. On the site of **Poliochni** (*open 9 am to 3:30 pm, Tuesday–Sunday*) a settlement flourished between 2900 and 2100 BC thanks to the treatment of metals imported from the Caucasus. In **Chloi** (*open 9 am to 3 pm, Tuesday–Sunday*) there was a sanctuary dedicated to the Cabiri (the sons of Hephaestus), who were gods of metallurgy and the guardians of sailors.

Another sanctuary that has been discovered is at **Hephaistìa** (7th to late 6th centuries BC). Archaeological finds made on the island are displayed in the museum at Myrina (*open 8:30 am to 3 pm, Tuesday–Sunday*). On **Lesbos**, after visiting **Mytilene**, continue down the east coast to **Thermì** (remains of a settlement founded around 3400 BC by Anatolic peoples). **Molyvos**, on the north side of the island, is the site of ancient Methymna (2800 BC–Roman era; *Archaeological Museum open from 8.30am to 3pm, Tuesday–Sunday*). From **Antissa**, you can reach the ruins of the ancient city of the same name (7th century–167 BC) and the petrified forest (*open from 9am to 5pm, every day; tree trunks buried by volcanic ash during the Tertiary era*). On the south coast at **Skala Eressou** are the ruins of ancient Eressos, the birthplace of Sappho, and a

small museum (*open 8am to 3pm, Tuesday–Sunday*). From here you can make an excursion to **Kalloni** to visit ancient Arìsbe (near Arìsvi), the ruins of the sanctuary of Apollo Napaios (530 BC), and then continue to **Mèssa**, which was the seat of the confederal sanctuary of the Lesbians (remains of a 4th-century BC temple). In the local capital of Ikarìa, **Hagios Kyrikos**, you can visit the small archaeological museum (*open 9 am to 2:30 pm, Tuesday–Sunday*). At **Kataphyghion**, not far from the therapeutic springs of Terma, are the ruins of the acropolis of ancient Thermai. On the west coast, **Kampos** (ancient Oinoe) retains traces from the Middle Ages (*Museum, open 9 am to 3 pm, Tuesday–Sunday*). Near **Armenistis**, the sanctuary of Artemis Tauropolos can be seen in the inlet of Nas (remains of the temple and altar, 7th to 5th centuries BC). (C.T.)

THASOS

SAMOTHRACE

LEMNOS

HAGHIOS
EUSTRATIOS

LESBOS

PSARA

CHIOS

THASOS - SAMOTHRACE - LESBOS
CHIOS - SAMOS

SAMOS

IKARIA

FOURNOI

THASOS

*"An ass's backbone crowned with wild wood;
it is not a lovely, friendly landscape
like where the Siri quickly flows"*
Archilocus

Thasos was originally inhabited by Thracians, but at the start of the 7th century BC it was colonized by peoples from Paros. In the 6th century BC, given its many resources of metal, semi-precious stones, marble, wood and wine, Thasos experienced a rapid and extraordinary development. In 463 BC the island was overrun by Athens: the city was interested in the gold deposits that lay in the Pangaeus region on the coast of Thrace, opposite the island.

Thasos next became involved in the civil war which ended in 405 BC with the massacre of the pro-Athenian democrats by Lysander. The island then enjoyed a certain independence from the 4th century BC and, above all, it enjoyed economic well-being thanks to its trade in marble and wine. It continued to flourish under the Romans and became an important episcopal center. In 618 AD Thasos was overwhelmed by invasions of Slavs.

VISIT

The ancient city was ringed by a solid wall about 2.5 miles long, built in the late 6th and early 7th centuries BC. It also protected the military port (the modern fishing port) and the adjacent commercial port. Rebuilt several times during the 5th century BC, it was reinforced with towers at the start of the 3rd century BC. The gates were the only ones in Greece to have the posts decorated with reliefs of gods for protective reasons.

The visit begins at the commercial port, where the gate of Hermes and the Charites (Three Graces) stood. Behind the gate lay the **north section of the town** (a). Blocks I and II, to the right of the road, were built in the 6th century BC and rebuilt at the start of the 5th when blocks III and IV were added on the left side of the road.

Going west, you come to the gate of either Artemis or Hera *Epilimenia* standing on a chariot drawn by 2 horses and perhaps driven by Hermes. This gate was the main entrance to the military port.

TOP: GENOESE FORT.

OPPOSITE: HEAD FROM THE SANCTUARY OF DIONYSUS.

Taso

Potamia

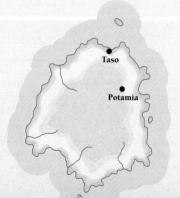

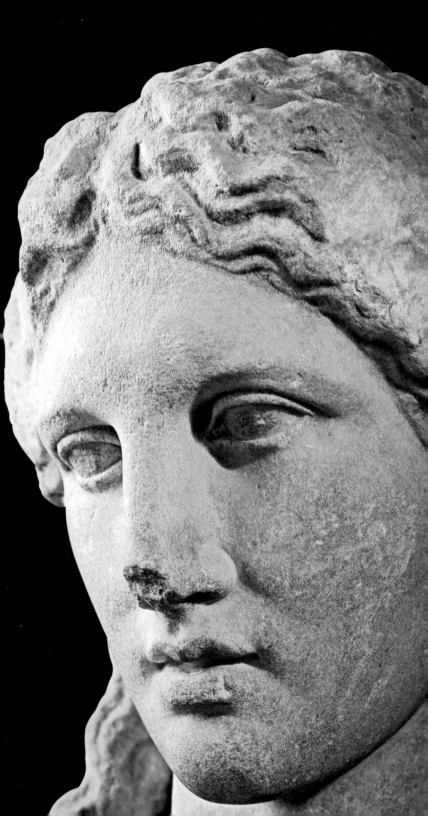

A road connected the gate to the 4th-century BC **sanctuary of Poseidon (b)**, built by Xenophànes, the son of Myllos (2 dedications are inscribed on bases at the sides of the south gate in the double entrance). A circular altar, perhaps dedicated to Amphitrite, another in a Π shape and a small temple dedicated to the god were aligned inside the court. On the north side of the enclosure stood a portico and, on the other side, 6 rooms used for the banquets of the *Poseidoniastài*, the shipowners.

Heading toward the agora you come to the **sanctuary of Dionysus (c)** at the foot of the road that led to the theater and acropolis. The enclosure dates from the 4th century BC and surrounded 2 more ancient altars (to the left of the steps); the first, with a semi-circular *eschara*,

was dedicated to *Agathòs Dàimon* (6th century BC); the other to *Agathè Tyche* (late 5th century BC). From the same period, the Doric choragic monument—prostyle tetrastyle—stood on a high platform reached up a flight of steps. At the center of the back of the platform was a semi-circular base for the statues of Dionysus, and personifications of various forms of literature: Tragedy, Comedy, the Dithyramb and *Nykterinos* (in the Thasos Museum).

The modern entrance to the **agora (d)** stands in front of

the museum. Continuing along the ancient road that connected the port to the square, you will see on the right the remains of an early Christian district built over warehouses from the Roman period. On the left is a 1st-century AD **court (A)** containing an exedra dedicated to Livia, the deified wife of Augustus. The version of the large square seen today dates from the early 3rd century BC with alterations made during the Julio-Claudian era. A distyle **propylaeum (B)** with a 6-step platform (1st century AD) led into a

THASOS		
a NORTH DISTRICT	f COURTYARD OF THE HUNDRED FLAGSTONES	k THERSILOCHEION
b SANCTUARY OF POSEIDON	g EXEDRA OF LIMENDAS	l SANCTUARY OF ARKOUDA
c SANCTUARY OF DIONYSUS	h ODEON	m TEMPLE OF ATHENA POLIOUCHOS
d AGORA	i ARCH	n CAVE
e ARTEMISION	j SANCTUARY OF HERACLES	o SANCTUARY OF APOLLO
		p THEATER

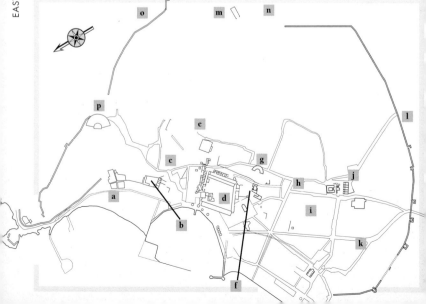

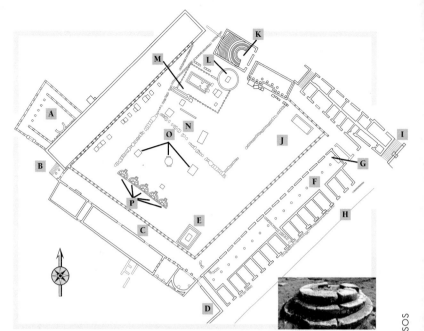

portico (C) with 33 Doric columns (1st century AD). Behind this were a rectangular room, a propylaeum that let the square communicate with a rectangular court, the **Courtyard of the 100 Flagstones (f)**, and an **apsidal room (D)** dedicated to Hadrian. This room was probably built to celebrate the emperor's visit to Thasos town in 124 AD; a statue of the emperor is exhibited in the museum.

Aligned with the **propylaeum (C)** was a 3rd-century BC **marble altar (E)**, the largest in the square. The east side of the square was shut off by

a portico with 31 Doric columns (1st century BC) that stood in front of a **hypostyle gallery (F)** divided into 2 aisles by 16 tufa (porous rock) columns. The northeast end of the portico had enclosed the base of the **monument dedicated to Glaukos (G)**, the general and friend of Archilocus, who died c. 650 BC while fighting in Thrace (dedicatory inscription in the museum). This was the oldest monument in the square (7th century BC); the long base originally supported a stele around which heroic cults were celebrated.

AGORA

A *COURTYARD*
B *PROPYLAEUM*
C *PORTICO*
D *APSIDAL ROOM*
E *MARBLE ALTAR*
F *HYPOSTYLE GALLERY*
G *MONUMENT OF GLAUCUS*
H *SHOPS*
I *PASSAGE OF THE THEOROI*
J *STERN-SHAPED BASE*
K *BOULEUTERION*
L *THOLOS*
M *ZEUS AGORAIOS THASIOS*
N *SANCTUARY OF THEOGENES*
O *ALTAR*
P *EXEDRAS*

ABOVE: BASE IN THE AGORA.

LEFT: AGORA, VIEW OF THE SOUTH.

RIGHT: DETAIL OF A FRIEZE IN THE AGORA.

BELOW: VIEW OF THE AGORA.

OPPOSITE LEFT: REMAINS OF AN ALTAR IN THE SANCTUARY OF HERACLES.

OPPOSITE RIGHT: A DORIC COLUMN IN THE AGORA.

Stores and shops (**H**) were open on the main road of the city that connected the **sanctuary of Dionysus** (**c**) to the **sanctuary of Heracles** (**j**). It crossed the passage of the *Theoròi* (**I**), unique in the Greek world, named for the lists of Thasian ambassadors (*theoròi*) found here which, from the second half of the 4th century BC until the late imperial age, were fixed to the walls on either side of the street. These walls were carefully built when the agora was enlarged in the early 4th century BC with blocks of local marble. On either wall 2 large reliefs were inserted (these were taken to the Louvre in 1863). A niche that used to contain an altar

in the east wall was lined on both sides by a relief of the 3 Graces (left) and Hermes, accompanied by a woman, reaching out to the Graces (right). A sacred law was also inscribed with the conditions of the sacrifices that could be performed there in honor of the Charites. On a single slab on the other side, with a shrine at the center, we see Apollo with a lyre being crowned by a female figure (left), and the three Nymphs offering him early fruit and vegetable produce (right). Here too there was a sacred law inscribed prescribing which animals could be sacrificed to the gods. Beneath the relief of the Graces on the east wall

there had once been a *bothros* lined with marble and dedicated to Hestia. At the north end of the same wall there was a niche dedicated to Athena *Propylaia*. The many cults in this area, all with protective functions, underscore the importance of the passage, which it is thought was the entrance to either the first settlement (7th century BC) or the first agora (late 7th–early 6th centuries BC). The sacred and official nature of the passage was further stressed with the posting of the annual lists of the most important magistracies in the city from the second half of the 4th century BC.

A third portico (1st century

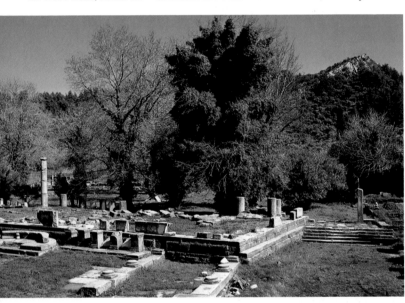

THASOS

BC) marked the northeast boundary of the square, behind which were more stores and shops (2nd century BC). A **base in the form of a ship's bow (J)** lay before the portico to support a naval monument at the center of a rectangular exedra (2nd century BC). Next to this was a portico with projecting wings built in the 4th century BC over an earlier structure, the residence of the archons, lists of whom were fixed on the inside walls. Behind the portico lie the ruins of an early Christian basilica (5th century AD) built over a building with a peristyle court (4th century BC). This district of the city came to an end on the west side of the *Bouleuterion* (**K**) built in the 3rd or 2nd centuries BC over an earlier building. The *Tholos* (**L**) is from the same period and also was built over an earlier building. It was probably dedicated to Hestia *Boulaia* and was later transformed into a place of worship honoring Augustus and Roma.

The cult of Hestia was linked to that of **Zeus Agoràios Thàasios** and was celebrated in a small Doric **temple (M)** *in antis* with an altar. These were enclosed by marble pillars and transennas.

The sanctuary dates to the 6th century BC and was rebuilt 200 years later. In the central section of the square, south of the *temenos*, stood the **sanctuary of Theogenes (N)**, the victorious athlete, winner of 1,400 crowns in 30 years of wrestling and pancratium (a sport that combined wrestling, boxing, kicking). A statue of the hero – who was thought to have curative properties against fevers – stood next to a circular marble base on which sacrifices were performed. One block of the

Statues of the brothers stood near the altar; today just bases are visible.

Also in the central area of the square are the **foundations of other altars (O)** and, to the south, 5 aligned semi-circular **exedras (P)** that face the south portico.

The west side of the square was closed off by a portico with 35 Doric columns built in the 3rd century BC over an Archaic building. Places for at least 13 honorary statues stood along the façade of the portico.

base still has the iron ring to which the animals were tied. There is also a cylinder into which offerings were placed and the 2nd-century BC inscription establishes the minimum price for a sacrifice (an *obolo* = 1/6th of a *drachma*).

The foundations of the altar of Gaius and Lucius Caesar, Augustus' grandsons and heirs, can be seen to the east of the sanctuary. Both, however, died young (in 2 AD and 4 AD respectively).

Return to the passage of the *Theoròi* and head northeast. Once you have crossed a square with a large cistern divided into 4 sections, you come to the **Artemision (e)**, whose oldest votive offerings indicate dates as to the foundation of the colony (7th century BC). The sanctuary was dedicated to Artemis *Pòlos*, the protectress of births, and filled 2 terraces connected by flights of steps. A large altar (5th century BC) stood

on the lower terrace, and an enclosure wall stood on the upper one. In the southeast zone of the upper terrace, statues of members of the aristocracy were exhibited from the Hellenistic age on to honor their generosity in various construction projects (Istanbul Museum).

From the passage of the *Theoròi*, take the road of the *Theoròi* eastward to the **Court of 100 Flagstones** (**f**). This was named after the number of flagstones that paved the Ionic peristyle of the building built during Hadrian's rule. In front of this lie the remains of the **exedra of Limèndas** (**g**), the sculptor who carved the monument, with the statues of the family of Tiberius Claudius Cadmus (first half of the 1st century AD), and, a little farther on, the exedras of the *odeon* (**h**), from Hadrian's reign.

Heading east along Odos Devambez, you come to the remains of the **arch with 3 fornices** (**i**), built in honor of Emperor Caracalla and his deified parents (213-217 AD). Sculptural groups on the attic show Caracalla at the center in the guise of Heracles about to kill the Nemean lion.

The link with the adjacent **sanctuary of Heracles** (**j**)— the protector of Thasos—is evident. The image of Heracles was stamped on the coins from the local mint and on handles of amphorae. One entered the sacred enclosure through a

propylaeum with a dual portico (Doric columns *in antis*) that stood at the center of a stairway. The altar dedicated to Heracles stood in front of a wide paved area and constituted the original nucleus of the sanctuary (7th century BC). To the right stood a 5th-century BC building with 5 rooms preceded by a portico. This was the *hestiatorion*. The second room from the east lay over a chamber with a rectangular *eschara* at its center that dated to the initial phase of the cult (6th century BC). Behind the construction lay a triangular court in which a circular building of uncertain function stood.

On the west side stood a gallery (early 5th century BC) with 7 entrances in the front. This was the grandest and most carefully constructed building in the sanctuary, as we know from the sculptural decoration (upper torso of Pegasus in the Thasos Museum).

The northern section (early 5th century BC) was occupied by an Ionic temple of unusual proportions: the naos was enclosed by an almost

square peristasis of 6 x 8 columns that may have been added at a later date. A little farther on you will see the ***Thersilochèion*** (**k**) on the other side of the road. This square building had an internal peristyle of 5 x 5 columns preceded by a portico and was dedicated to *Thersilocos* at the end of the 4th century BC. The street ends at the Gate of Zeus and Hera (end of the 5th century BC) that was reached up a stairway that belonged to an earlier gate (late 6th century BC). In a shrine crowned by an eagle on the right gatepost, Hera, accompanied by her messenger Iris, is portrayed enthroned holding the scepter in her right hand. Zeus, in a similar position, and Hermes were portrayed on the other gatepost (fragments in the museum). Follow the wall south to the gate of Heracles and Dionysus (these sons of Zeus by Alcmene and Semele were the guardians of Thasos City). It has two recessed antae (start of the 5th century BC) and a relief of Heracles (Istanbul Museum) that was positioned above the inscription over the east gatepost. The hero in his lion skin kneels as he fires an arrow from his bow. The gatepost opposite showed Dionysus with the Maenads (now lost).

The Gate of Silenus dates from the first half of the 5th century BC. It was defended by a Hellenistic tower and shows a nude Silenus (6' 6"

tall) on the left gatepost, holding a *kantharos* in his hand. The ruins of 2 residential blocks lie in the lee of the walls. The houses date from the first half of the 5th century, but were rebuilt a century later. From the Gate of Silenus the road leads to the **sanctuary of Arkouda (l)**. It was probably dedicated to Dionysus as there are a the terrace reached through a monumental propylaeum, stood the **temple of Athena Polioùchos (m)** with a pronaos and opisthodomus, but without a peristasis. It was built in the 5th century BC over an earlier building. On a small hill below, Pan was worshiped in a **cave (n)** (4th century BC). No traces remain of the third **sanctuary** on the frieze with triglyphs and smooth metopes dates to the 3rd century BC. The metopes were decorated during the Roman renovation when the theater was transformed into a site suitable for gladiatorial and animal games. The small steps below the cavea were removed and the orchestra surrounded by a balustrade.

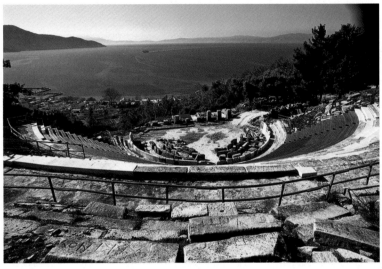

few remains of an Archaic temple and altar that were built for him. Continuing along the walls toward the acropolis you come to the Gate of *Parmenòn*, the only gate with an architrave. Parmenon was the craftsman who, around 500 BC, left his name on a block on the inside of the enclosure wall nearby. On the right of the path that rises, you will see a block that has fallen from the wall on which large eyes and a nose were carved to ward off the evil eye. On the acropolis, on acropolis, **dedicated to Apollo (o)**, and the chapel of a medieval palace was built over the site. Descending from the acropolis toward the port, you will find the **theater (p)** built in the Classical period but renovated during the 2nd century AD. The marble proscenium with 12 Doric columns, a Along the north side of the fortifications you come to the Evreòkastro promontory. The discovery of many inscribed dedications to Kore suggest the presence of the *Thesmophòrion*, to which the retaining wall on the north side of the terrace and the portico would have belonged. (C.T.)

OPPOSITE: A VIEW OF THE ACROPOLIS.

TOP: VIEW OF THE THEATER.

LEFT: SANCTUARY OF ATHENA *POLIOUCOS*.

THASOS

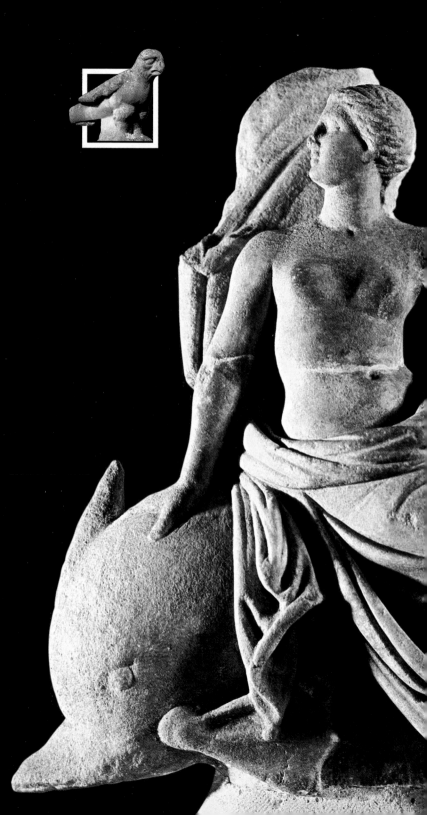

THASOS

THE MUSEUM

*Open Tuesday to Saturday,
8:45 am–3 pm; Sunday
and holidays, 9 am–2 pm.
Payment required.*
The museum exhibits the
pieces found on the island.
Among the Archaic exhibits,

note the uncompleted
colossal *kouros* that was
reused in the retaining wall
of the acropolis and the
architectural elements from
the sanctuary of Heracles
(the **upper torso of Pegasus,**

inspired by Achmaenid
toreutics (the art or process
of working in metal)). The
Classical pieces include
statues found in the
sanctuary of Dionysus
(mid-4th century BC) and
many votive and funerary
reliefs of quality.

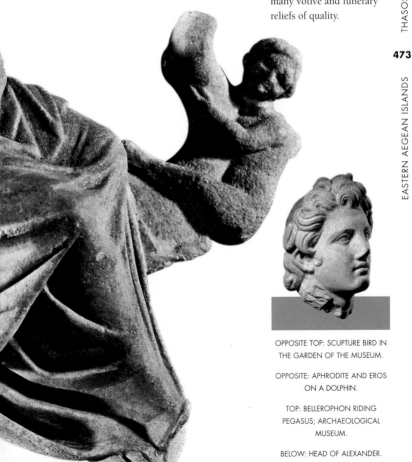

OPPOSITE TOP: SCUPTURE BIRD IN
THE GARDEN OF THE MUSEUM.

OPPOSITE: APHRODITE AND EROS
ON A DOLPHIN.

TOP: BELLEROPHON RIDING
PEGASUS; ARCHAEOLOGICAL
MUSEUM.

BELOW: HEAD OF ALEXANDER.

SAMOTHRACE

According to Homer, Poseidon watched over the battles between the Greeks and Trojans from the top of the highest mountain in the Aegean, Mount Fengari, which stands in the center of Samothrace. Inhabited from the 4th millennium BC, Samothrace was frequented by Thracians from the early Iron Age and, toward 700 BC, by Aeolians from Lesbos, who founded Paleopolis. Owing to its position on the routes to and from the Dardanelles, this city soon prospered and in the 6th century BC had grown to its largest size. During this period the fortifications were built (polygonal block walls on the west side of the mountain above the sanctuary), silver coins were minted, and the sanctuary of the Great Gods received its first major restoration and embellishment.

From 425 BC to until 340 BC Samothrace was under Athenian comtrol (except for a very brief Spartan interlude in 404 BC). In 340 BC Philip II of Macedonia (who had met his wife Olympia while he was being initiated into the Mysteries in the sanctuary of the Great Gods) declared Samothrace a "sacred island." The protection and munificence of the ruling house of Macedonia, and later of the Ptolemies, resulted in the city and sanctuary experiencing a new phase of great development.

The *Civitas libera* was declared in 166 BC; in 84 BC the city was seriously damaged by pirate raids and, at the start of the imperial era, by an earthquake.

Samothrace was very prosperous during the imperial and early Christian eras but, by the 8th century AD, decline set in and lasted until the 15th century when the Genoese Gattilusi (or Gateluzzi) family purchased the island from the Byzantine Empire.

THE SANCTUARY OF THE GREAT GODS

The island was particularly famous in antiquity for the sanctuary of the Great Gods and the mystery cults—into which anyone could be initiated.

The sanctuary was founded by Aeolian colonists, but it assimilated pre-existing cults centered on a goddess of nature called *Axièros*; the Greeks identified *Axièros* with Demeter and the Thracians with Cybele. This goddess was associated with *Cadmilus* (Hermes), a god of fertility, and a pair of gods of the underworld, *Axiokersos* (Hades) and *Axiokersa* (Persephone). The servants of the Mother Goddess were the Cabiri, who were assimilated to the Dioscuri, the Greek protectors of those who went to sea.

The earliest cult buildings (the "sacred rock" below the *Arsinoèion*, the first 2 wells in the *temenos*, the first apsidal building in the Hieron) date to the 7th century BC, but the "monumentalization" of the site only occurred between the first half of the 4th and the 3rd centuries BC. The Macedonian kings and their successors then turned the sanctuary into a place that celebrated their glories.

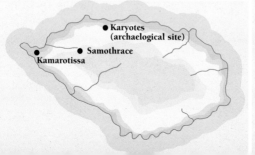

475: NIKE OF SAMOTHRACE, LOUVRE MUSEUM.

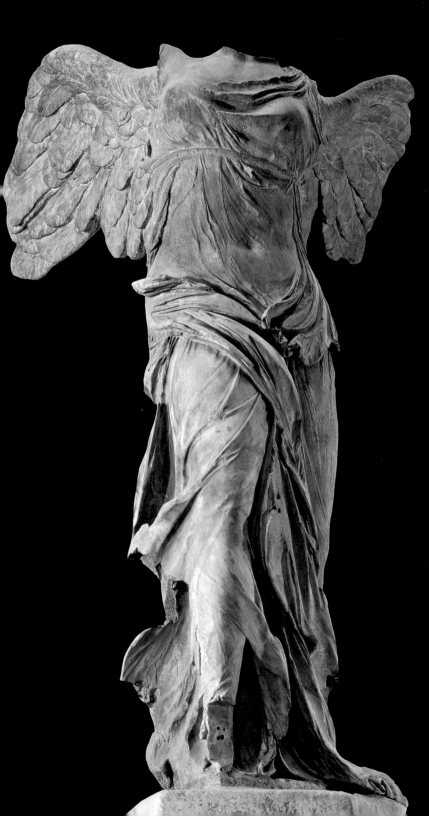

The visit begins on the west side. On the right there is the **Building of Milesia (a)**, so named because it was dedicated by a woman from Miletus (second half of the 3rd century BC). On the west side, mostly covered by the walls of the Byzantine fort, lie the ruins of a **rectangular building (b)** begun around 400 BC but left uncompleted. It may have been intended as a room in which initiation rituals would be performed. On the west side of the room were 3 Hellenistic *thesauroi* (c). The *Neorion* (d) lay to the south of these

buildings. It was a rectangular Hellenistic building divided into 2 aisles by a row of 5 columns, and contained a warship that rested on 2 rows of marble blocks. Next to this was the magnificent **portico (e)** with 35 Doric columns on the façade and 16 Ionic columns inside. Paid for by Antigonus Gonatas in the first half of the 3rd century BC, it closed off the west side of the sanctuary. The bases of various votive monuments lie in front of the portico. Continuing on the path you will see the

remains of the sacred **banqueting room (f)** on the right; it had 3 square rooms and originally had a portico in front (4th century BC). The **substructure wall (g)** of the portico terrace had a **niche used for cult purposes (h)**. Next to the wall are **2 rooms (i, j)** (use unknown) and the **theater (k)**. The **site where the Nike of Samothrace (l)** stood lies to the south of the theater. The Nike was the monument dedicated by the Rhodians to celebrate the naval victories won with their allies from Pergamum and Rome

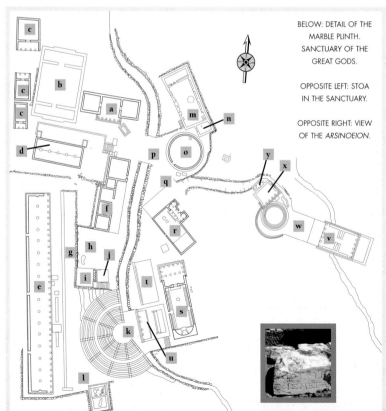

BELOW: DETAIL OF THE MARBLE PLINTH. SANCTUARY OF THE GREAT GODS.

OPPOSITE LEFT: STOA IN THE SANCTUARY.

OPPOSITE RIGHT: VIEW OF THE *ARSINOEION*.

against Antiochus III of Syria at Side (191 BC) and Myonessus (190 BC).

The attractive layout for the monument is typically Rhodian, combining architectural, sculptural and natural features. The Nike (the "Winged Victory" now in the Louvre) was shown as though gliding at entry points in the east wall, an earthen floor and a raised section on the north side for the initiates. Pilasters on the long walls supported a gallery. A sacrificial well stood in the southeast corner containing a sacred plate lodged in the ground, and almost at the center of the room are the

A high isodomum plinth made of Thasos marble was the base for 44 Doric pillars that supported a trabeation crowned by a conical, tiled roof. Inside there were Corinthian half-columns joined by parapets adorned with bovine skulls.

As the dedicatory

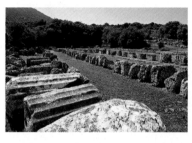
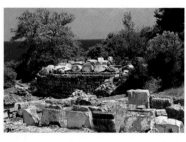

an angle on the prow of a ship and was placed over a pool of water. Beneath and in front of this pool was a second pool that surrounded rocks that were originally there.

Now you pass to the central section of the sanctuary where the *Anàktoron* (**m**) stood. This building was used for the first stage initiation rituals. It was rectangular, had 3 foundations of a round podium on which the initiates performed ritual dances. The remains currently visible are from the early imperial era.

Next door stands the **Sacred House (n)** with lists of names of initiates on the walls. Close by stood the largest circular building in ancient Greece, the *Arsinoèion* (**o**) (65' 6" in diameter, 41' 6" in height).

inscription records, the building was constructed between 288 and 281 BC by Arsinoë II, the daughter of Ptolemy I Soter, and the wife of Lysimachus, king of Thrace. The building's function is not known for certain. However, it must have played a special role in the performance of the Mystery rituals: inside is a porphyritic rock altar connected by steps to a sort of podium (7th or 6th century BC), and there are the foundations of an early-4th-century BC structure divided into 3 parts, with a raised platform on the east side, in all probability related to the Mysteries. This structure is known as the "Orthostat Building."

	SAMOTHRACE	
a *BUILDING OF MILESIA*	h *CULT SHRINE*	r *TEMENOS*
	i, j *ROOMS*	s *HIERON*
b *INITIATION ROOM (?)*	k *THEATER*	t *VOTIVE GIFT ROOM*
	l *NIKE OF SAMOTHRACE*	u *COURTYARD OF THE ALTAR*
c *TREASURIES*		
d *NEORION*	m ANAKTORON	v *PTOLEMAION*
e *PORTICO*	n *SACRED HOUSE*	w *THEATER AREA*
f *BANQUETING BUILDING*	o ARSINOEION	x *HEXASTYLE BUILDING*
	p *SACRED ROCK*	
g *SUBSTRUCTURE*	q *ROCK ALTAR*	y *PORTICO*

LEFT: DETAIL OF THE *HIERON*.

CENTER: THE DORIC COLONNADE IN THE *HIERON*.

BOTTOM: RECONSTRUCTION OF THE *TEMENOS*.

OPPOSITE: VIEW OF THE THEATER AREA BETWEEN THE *ARSINOEION* AND THE *PTOLEMAION*.

Above these structures stood the Anàktoron (290-280 BC) with the Sacred House and Arsinoë's rotunda, perhaps the "house" of the Great Mother Goddess herself, where, at the end of the initiation ceremonies, a ritual banquet was held. The last building phase occurred in the early imperial age, with the reconstruction of the *Anàktoron* and Sacred House, which had been destroyed during an earthquake, and the restoration of the *Arsinoèion*.

The sacredness of the *Arsinoèion* is confirmed by the presence of the **Sacred Rock (p)** in front of the entrance. This was composed of 2 blocks of porphyrite surrounded by a paved area (first half of the 4th century BC) and the **rock altar (q)** dedicated to Hecate *Zerynthia* (350-325 BC), which was a block of porphyrite on a platform near a spring.

Another building from the same era was the **Temenos (r)** (340 BC), a rectangular enclosure built by Philip II of Macedon to hold an *eschara* and a *bothros* that substituted 2 ancient wells (7th century BC). An elegant Ionic portico with projecting wings, aligned with the wells and perhaps designed by SCOPAS, functioned as a propylaeum. The central columns supported a trabeation decorated with a frieze featuring a chorus of girls who dance, sing and play the cithara, drums and flute. This may be a reference to the mythical wedding of Cadmus and Harmony supposed to have taken place in the sanctuary as part of the great festivities. The Archaizing style of the relief (the earliest example

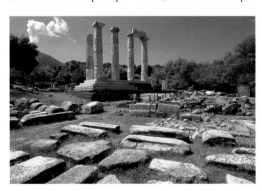

of Archaist style in Greece) reveals the antiquity of these rites. Carved busts (now in the Samothrace Museum) were placed in the coffers of the ceiling.

The remains of the **Hieron (s)** lie to the south of the enclosure. This building was reserved for the most advanced ceremonies in the Mystery initiation

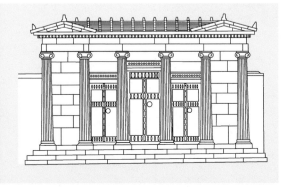

(*epoptèia*). Built around 325 BC, it had a large room with marble benches along the walls and a rectangular *eschara* in the middle. A wide raised apse in the back wall was covered by a curtain-like ceiling with the purpose of reproducing the cult grotto of the Great Mother: here the priestess revealed the sacred objects to the initiates.

Beneath the floor of the apse traces of earlier apsidal buildings were found (Archaic era and 5th century BC). The walls of the room were decorated with stucco in imitation of a pseudo-isodomum structure with projecting Doric half-columns. The wooden ceiling (35'2" wide) was decorated with bronze coffers.

Adjacent to this building on the west side were the **Room of Votive Gifts (t)**, a portico with wooden supports (540 BC) and the **Altar Court (u)**. The court was an enclosure with 4 columns *in antis* on the front, and a large altar at the center dedicated to the Great Gods by Philip III Arrhidaius between 323 and 317 BC. The monument was connected to the theater that lay in

front, the cavea of which was aligned with the altar. The ruins of the **Ptolemaion (v)** lie on the east hill. This was a monumental propylaeum dedicated by Egypt's pharaoh Ptolemy II, Philadelphus, brother and third husband of Arsinoë II. It was built between 285 and 280 BC and was the entrance to the sanctuary from one side of the city, as well as being a bridge over the torrent (which passed through an

open tunnel in the substructures). The propylaeum had the form of a double portico, with 6 Ionic columns to the east and 6 Corinthian columns to the west (some capitals can be seen in Samothrace Museum). The aperture in the gate was framed by an anta on either side. Continuing toward the center of the sanctuary

you come to the **theater area (w)**. The orchestra was surrounded by a flight of 5 steps (early 5th century BC) from which a priest would address initiates to the Mysteries. During the 4th century BC 2 square buildings were constructed to the west of the theater but were later replaced by the **hexastyle building (x)**, a rectangular room with a prostyle façade of 6 columns. It was dedicated by Philip III Arrhidaius and Alexander

IV, respectively the half-brother and son of Alexander the Great, during the period of their co-regency (323–317 BC). At this point on its way from the propylaeum, the Sacred Way joined with the steps to the *Arsinoèion*: a small **portico (y)** with a tetrastyle façade (400 BC) stood where the two met. (C.T.)

LESBOS

"And they have set up the low-born Pittacus
As a tyrant over our gutless and godforsaken city.
By acclamation …"
Alcaeus

The island was colonized first by peoples from Asia Minor (Thermì), then by Aeolians from Thessaly (12th-10th centuries BC) who founded the six city-states: Mytilene, Pyrrha, Arìsbe, Mèthymna, Antissa, and Eressòs. Mytilene emerged and, after a period of struggle between tyrants and the city's aristocratic families (of which an echo can be heard in the lyrical poetry of Alcaeus and Sappho), it reached its apogee in the 6th century BC under Pittacus (589–579 BC). Considered one of the Seven Sages of Greece, Pittacus re-established peace and promoted the development of the island, encouraging Lesbos' school of music and lyrical poetry. After the failure of the Ionic insurrection in 499 BC, Lesbos had to submit to the Persians and, in 477 BC, it joined the Delian-Attic League. In 428 BC the cities on the island attempted to create a confederation around Mytilene but Athens put an end to the initiative. After being freed by the Spartans in 406 BC, Mytilene returned to the Athenian sphere of influence (377 BC) while the other cities on the island remained in the control of pro-Persian tyrants. In 338 BC, Mytilene participated in the anti-Persian Hellenic League under Philip II and, 5 years later, was attacked by the Persian fleet and besieged by Memnon of Rhodes. Freed by Alexander the Great, Lesbos passed under the control of the Ptolemies but,

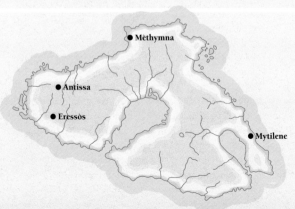

when the Romans took over, the island was punished for having supported Mithradates in the war against Rome (88-79 BC). With the support of Pompey, in 66 BC Mytilene was declared an ally of the Romans and from that time until the 4th century AD it enjoyed great economic and artistic prosperity.

Mytilene stood on a small island named Nisi that was separated from the mainland by a channel (today filled in and the Odos Ermoù road runs over it).

At the end of the 4th century BC, when Mytilene was preparing to become the leading city of the Lesbos confederation, plans were made to enlarge the city on the other side of the channel and port; part of this was achieved before Rhodes attacked the island. During the Hellenistic and Roman eras, luxury houses adorned with mosaics were built on the mainland.

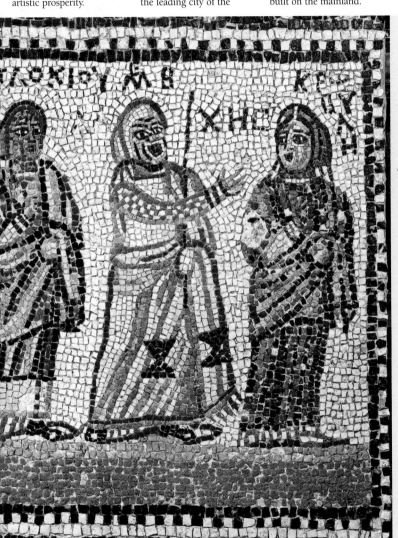

OPPOSITE TOP: EOLIC CAPITAL FROM THE NEW MUSEUM IN MYTILENE.

ABOVE: MOSAIC FROM THE HOUSE OF MENANDER; NEW MUSEUM.

L E S B O S

Little remains of the ancient city that was set out on a grid pattern. What can be seen are certain sections of the **walls (a)** (5th century BC, rebuilt in the 4th century and Hellenistic era), and the ruins of the **theater (b)** (3rd century BC) which, according to Plutarch, was the model for the theater that Pompey built in the Campus Martius in Rome in 55 BC. The "**House of Menander**" **(c)** was in fact the offices of an association of artists that honored Dionysus; it was found to contain a fine set of mosaics from the end of the 3rd century BC (now in the museum).

The remains of the sanctuary of Apollo Malòeis **(e)** have been found near the commercial port **(d)** (Malòeis), together with an apsidal building and a storeroom of vases in natural hollows that date to the tenth century BC. From Mytilene, the visit to Lesbos follows a counter clockwise circular route that touches on the most important archaeological sites. (C.T.)

TOP AND BOTTOM: MYTILENE KASTRO AND DETAIL.

ABOVE: THE THEATER IN MYTILENE.

BELOW: MARBLE LION IN THE GARDEN OF THE OLD MUSEUM.

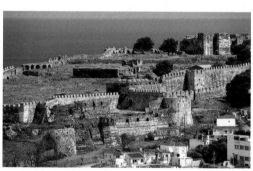

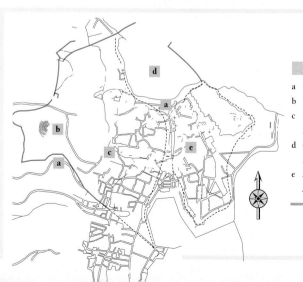

MYTILENE

a WALLS
b THEATER
c HOUSE OF MENANDER
d COMMERCIAL PORT
e SANCTUARY OF APOLLO MALOEIS

THE MUSEUM

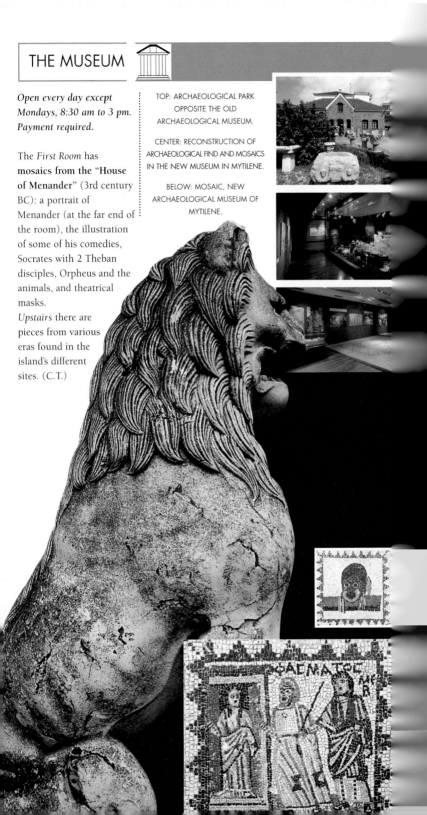

Open every day except Monibays, 8:30 am to 3 pm. Payment required.

The *First Room* has **mosaics from the "House of Menander"** (3rd century BC): a portrait of Menander (at the far end of the room), the illustration of some of his comedies, Socrates with 2 Theban disciples, Orpheus and the animals, and theatrical masks.
Upstairs there are pieces from various eras found in the island's different sites. (C.T.)

TOP: ARCHAEOLOGICAL PARK OPPOSITE THE OLD ARCHAEOLOGICAL MUSEUM.

CENTER: RECONSTRUCTION OF ARCHAEOLOGICAL FIND AND MOSAICS IN THE NEW MUSEUM IN MYTILENE.

BELOW: MOSAIC, NEW ARCHAEOLOGICAL MUSEUM OF MYTILENE.

CHIOS

Inhabited from the Neolithic period, around 1000 BC the island was colonized by peoples arriving from Thessaly and Boeotia. Thanks to the fertility of the soil and the inhabitants' commercial ability, the island quickly became very prosperous. According to tradition, Chios was the first city to trade in slaves and, at the end of the 7th century BC, it minted silver staters with the image of a sphinx. At the start of the 6th century, Chios had a democratic government. The Archaic era was a period of great cultural and artistic development for Chios. It was particularly famous for its sculptural school but

sources also mention GLAUKOS, who was a chaser and sculptor of metals who produced a silver crater for Alyattes II of Lydia to dedicate to Delphi. All this was brought to an end by the Persian conquest in 545 BC against which the island attempted to rise up, but even in league with Aristagoras of Mytilene, the rebels were defeated at the battle of Lade in 494 BC. From 477 to 412 BC Chios was a member of the Delian-Attic League but then changed allegiance and supported Sparta; however, Chios was obliged to return to the fold of the Athenian confederation. Next it fell to the Macedonians and, at the start of the 2nd century BC,

it allied itself with Rome against Antiochus III of Syria. It was looted of its wealth by Gaius Verres but managed to remain independent until Emperor Vespasian added it to the province of islands. Chios was occupied by the Venetians in 1172 and experienced great economic development under the Genoese (1261–1566), who strengthened the island's agriculture and trading in silk and mastic. After having become part of the Ottoman Empire, in 1822 Chios attempted to rebel, but the gamble ended with the destruction of its main town and 40 villages, the killing of 25,000 inhabitants and the selling of 50,000 into slavery. The museum holds finds from several sites on the island, in particular those from Emporios. Among the ceramic works, note the **polychrome chalices of Chios**; the torsos of **2 korai** are indicative of the quality of the local sculptural school.

Chios

Mesta

Pyrghi

Emporios

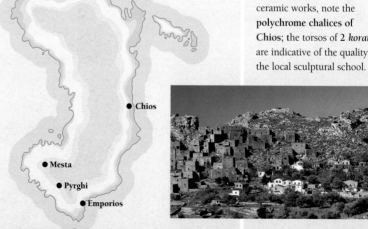

EMPORIOS

The inlet at the southeast end of Chios was the site of a prehistoric settlement (2200–1600 BC), and a Mycenaean settlement (1400 BC) that was destroyed about 1000 BC. A new settlement grew on the hill of the Prophet Elijah between the 8th and 6th centuries BC on 4 terraces. Inside an enclosure wall (early 7th century BC) on the highest level stood a long *megaron*-type building with internal supports, thought to have been the residence of a local king, and also the temple of Athena (mid-6th century BC) that incorporated an earlier altar (7th century BC) in the naos. The open area between the buildings may have been used for public assemblies.

The residential areas lay on the terraces below, with small houses and also *megaron*-type houses. The layout of the latter was based on a central room divided into 2 parts by a row of supports.

An Archaic and Classical sanctuary was built by the port, but the votive offerings reveal that the site was used for cult purposes from the 8th century BC. The first cult building was constructed in the 6th century BC but replaced almost a century later by an Ionic apsidal temple, tetrastyle prostyle, with fine moldings and door bases in the form of lions' paws; the paws seem to be peculiar to the local school of architecture. Other Greek and Roman buildings were built above the cut temple, and in the 6th century AD, a basilica with an apse and narthex was constructed.

From Emporios you can visit the region of Mastichochoria (where a resin is extracted from stands of mastic trees for use in pharmaceuticals and paints). There are several villages, such as Pyrghi and Mesta, where you can see excellent examples of medieval architecture.

At **Nea Moni** (9 miles west of Chios) you can visit the monastery founded between 1042 and 1055 by Emperor Constantine Monomachus after the discovery of a miraculous icon of the Virgin (*open every day from 8 am–1 pm, and 4 pm–6 pm*).

The church has magnificent 11th-century mosaics set on a gold background that show the influence of Constantinople. (C.T.)

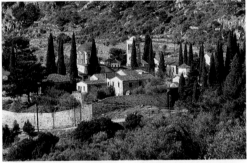

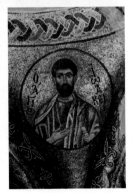

OPPOSITE TOP LEFT: MILLS IN THE VILLAGE OF CHIOS.

OPPOSITE TOP RIGHT: BYZANTINE MUSEUM IN CHIOS.

BELOW: THE ABANDONED VILLAGE OF ANAVATOS.

TOP: MONASTERY OF NEA MONI.

BELOW: MOSAICS IN THE DOME OF THE CHURCH OF NEA MONI.

SAMOS

Inhabited since the Neolithic period by Carian peoples, the island was linked culturally to Anatolia (settlement on Kastro hill in Tigani). In the 11th century BC Samos was colonized by Ionians from Epidaurus led by Prokles, whose descendants held power until 680 BC.

The landed aristocracy's rise to political power marked the start of the island's economic prosperity, based on its widespread trading throughout the Mediterranean. In 650 BC Kolaios passed through the Pillars of Hercules (the Strait of Gibraltar) and discovered the gold in the kingdom of Tartessos in southern Spain.

Under the tyranny of Aiakes and his son Polycrates (538-522 BC), Samos became one of the Aegean's leading cultural and economic centers. With his powerful fleet, Polycrates was able to control the islands in the Aegean and the cities of Asia Minor. The enormous wealth he accumulated allowed large public works to be built, and supported the development of the arts, lyrical poetry and philosophy. Samos became one of the primary centers in the development of the Ionic style in architecture and sculpture.

In the first half of the 5th century BC, Samos entered the Delian-Attic League but Athens was obliged to intervene on several occasions to support the democratic faction against the supporters of the oligarchy.

Samos was autonomous between 322 and 205 BC, but was conquered by Philip V of Macedonia, then given by the Romans to the kings of Pergamum. In 129 BC it was made part of the Roman province of Asia. After being occupied by Mithradates, it was sacked by Gaius Verres in 80 BC, but returned to prosperity during the praetorship of Cicero (62 BC). During the imperial era it was used as a holiday resort; under the Byzantines its decline set in and in 1453 it fell to the Turks, but was so depopulated that they settled Albanians and other peoples there.

.......................................

TOP: ROMAN BATHS, DETAIL.

BELOW: ARCHAIC *KOUROS*; ARCHAEOLOGICAL MUSEUM.

OPPOSITE: DETAIL OF RELIEF IN THE ARCHAEOLOGICAL MUSEUM.

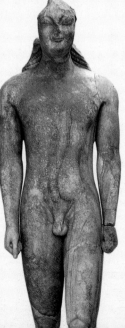

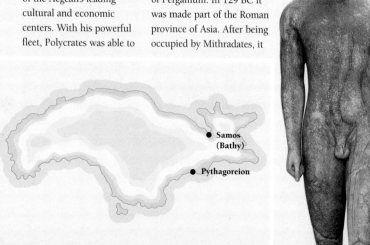

● **Samos (Bathy)**

● **Pythagoreion**

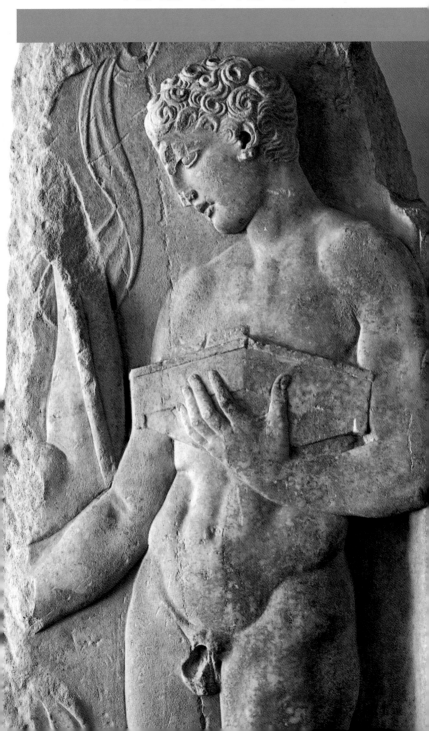

PYTHAGOREION VISIT

Called Tigani until 1955, the village is now named after one of its most illustrious citizens, the philosopher Pythagoras, the founder of mathematical thinking.

of **Mount Ampelos (d)** on the north side of the city; they were restored in 300 BC and again at the start of the 2nd century BC. The fortifications also enclosed the military and commercial

public buildings, the Greek gymnasium (3rd–1st centuries BC) and the magnificent **Roman baths (f)** (1st-4th centuries AD), over which a Byzantine monastery was built.

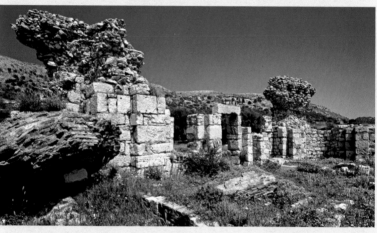

There are no remains of the earliest phases of the Greek settlement which, in the 8th century BC, had already spread far beyond **Kastro hill (a)**, where the first settlement and acropolis were built. The **west necropolis (b)** lies roughly 900 yards to the west of the hill.

During the Archaic period the city was ringed with **walls (c)** 4 miles long that featured towers, secret entrances and a dike along the west side. Many stretches of the fortifications can be seen along the ridges

sections of the large **port (e)**. The current south wharf was constructed over the ruins of an earlier one, 330 yards long, built by Polycrates and mentioned by Herodotus. Polycrates' residence stood on Kastro hill. Today you can see the remains of a Hellenistic villa with double peristyle, which in the Roman era may have been an imperial residence. An early Christian church (second half of the 5th century AD) was partially built over the villa. In the southwest area of the site there were several

The south slope of Mount Ampelos was the site of the **theater (g)** (currently being restored); to the west of this is the entrance to the **aqueduct (h)** (*open Tuesdays to Thursdays from April to October, 9 am to 2 pm, payment required*) built by Eupalinos of Megara to provide the city with water. This was another of Polycrates' projects that Herodotus admiringly recorded. The water from Argiades spring was channeled via a tunnel 1150 yards long that ran under Mount Ampelos to a

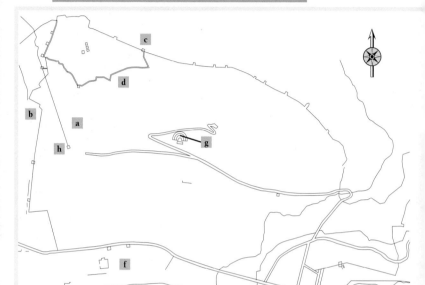

THE MUSEUM

Open Tuesday–Thursday and Sunday, 9 am–2 pm; Friday and Saturday, 12 pm–2 pm
This is a *one-room museum*. In it are displayed finds from ancient Samos and the *Heraion* (fragments of an ancient *kouroi*, funerary and votive reliefs, marble statues and portraits from the Roman imperial age), including a **statue of a seated female** dedicated to Hera by Aiakes, the father of Polycrates (540 BC).

distribution tank in the center of the city. The tunnel was dug from both ends contemporaneously and composed of a passage that contained the clay water pipe and a walkway above.

OPPOSITE TOP: TWO STRETCHES OF THE HELLENISTIC WALLS.

OPPOSITE BOTTOM: *PYTHAGOREION*, REMAINS OF THE BATHS.

LEFT TOP: EUPALINOS' AQUEDUCT.

LEFT BELOW: ENTRANCE IN A TOWER OF THE WALLS.

SAMOS

SAMOS

RIGHT: FRAGMENT OF AN IONIC
CAPITAL IN THE *HERAION*.

OPPOSITE: AERIAL VIEW OF THE
HERAION.

HERAION

a	*TEMPLE OF HERA*		*TEMPLE*	r	*TEMPLE A*
b	*HERAION III*	k	*BATHS BUILDING*	s	*TEMPLE B*
c	*ENCLOSURE*	l	*EXEDRA OF*	t	*TEMPLE E*
d	*HERAION I*		*THE CICEROS*	u	*TEMPLE C*
e	*ALTAR*	m	*PORTICO*	v	*TEMPLE*
f	*ALTARS*	n	*FOUNTAIN*	w	*PORTICO*
g	*SACRED POOLS*	o	*TEMPLE*	x	*BASES OF THE*
h	*HERAION V*	p	*FOUNDATION*		*DONATIONS*
i	*TEMPLE IN ANTIS*		*FOR VOTIVE SHIP*		
j	*CORINTHIAN*	q	*TEMPLE D*		

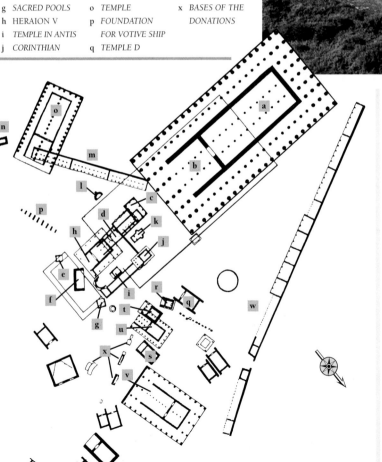

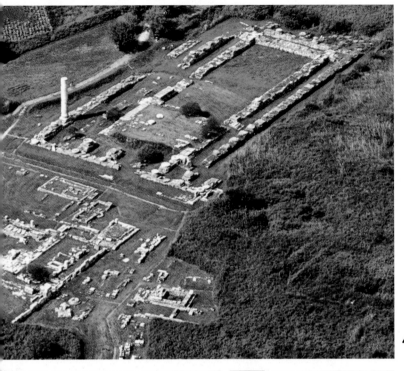

HERAION

VISIT

4 miles southwest of Pythagoreion; Tuesday to Sunday, 8:30 am–3 pm. Payment required.

The sanctuary stands in a marshy area on the left bank of a branch of the River Imbrasos where, according to tradition, the goddess was born and married. This was where the very ancient aniconic (not human or animal in form) image of Hera kept in the sanctuary was found. At the start of the 3rd millennium BC, the area was occupied by a settlement with defensive walls and *megaron*-type houses. The site was abandoned at the start of the 2nd millennium BC but reoccupied in the 13th

century BC and used for cult purposes (*bothroi* and terracotta figurines and pottery have been found). The cult of Hera was introduced in the 11th–10th centuries BC by Ionic colonists from Argolis and superimposed upon the pre-Hellenic cult of a goddess of nature. The earliest buildings date to the 9th and 8th centuries BC and the votive gifts at the end of the Geometric Age reveal contact between the site and Egypt, Phoenicia, Syria, Phrygia, Lydia and Cyprus. The monumental nature of the sanctuary belongs to the 6th century BC and is a clear expression of the power of the city during the

tyranny of Aiakes and Polycrates.Only a single column remains standing from the **temple of Hera (a)**, the largest ever designed in Greece. Constructed between 538 and 522 BC during Polycrates' rule (Heraion IV), it was a colossal Ionic temple that measured 172' x 356' 6". It had a double peristasis and a third row of columns on the façades. The deep pronaos and naos (there was no opisthodomus) were divided into 3 aisles by 2 rows of columns. All the columns and capitals were made of marble, the trabeation of wood and the other parts of *poros*.

Due to its enormous size, the building was never

completed though construction—halted in 522 BC—was restarted in the 5th and again in the 3rd century BC. The bases of the columns of the **previous temple (b)** (Heraion III) were used in its foundations, the construction of which had been begun between 570 and 560 BC by the

Greek feet long (107' 10") and only 21' 4" wide. It had a row of supports along the central axis to hold up the roof. Around the middle of

first to be aligned with the temple of the goddess; the altars are dated to the 9th to 7th centuries BC and all of them face in a different direction to the *Hekatòmpedon*. Several sacred **pools (g)** fed by the River Imbrasos had been excavated around these altars. Each year the wooden simulacrum of the goddess,

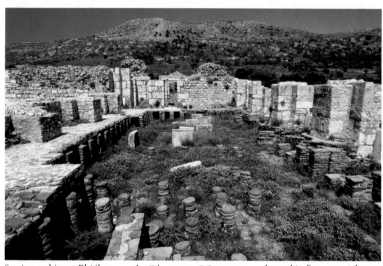

Samian architects Rhòikos and Theòdoros. That version too was a gigantic dipteral Ionic temple (172' 3" x 344' 6") referred to in ancient sources as the "Labyrinth" for its many columns.

The base of the cult statue from the oldest temple of Hera, the *Hekatòmpedon*, was incorporated in the pronaos. After the building was destroyed by an earthquake, the platform of the new temple was set back to create a **rectangular enclosure (c)** to support a canopy over the base.

The first *Hekatòmpedon* **(d)** (Heraion I) was built at the start of the 8th century BC with a narrow naos 100

the 7th century BC, it was replaced by a new building (*Hekatòmpedon* II, Heraion II, 22'4" x 110'7") ringed by a peristasis of 6 x 18 wooden columns. On the façade the columns were arranged in 2 rows of 4 to form a pronaos. There was no axial colonnade in the naos, as it prevented full visibility of the cult statue, and it was replaced by a series of pilasters set against the walls. The **altar (e)** also derived from the cult's earliest phases; in fact, the foundations of 7 other superimposed **altars (f)** were found beneath the monument that Rhoikos built. His version was the

dressed in fine materials, was immersed in the pools and then carried back into the temple. A Doric peripteral **temple (h)** dedicated to Hera (Heraion V) was built in front of the altar and aligned with Polycrates' Heraion in the Roman era. Over the ruins of the temple and adjacent **temple in antis (i)** (1st-2nd century AD) a basilica was built with a nave and 2 aisles. Then in the 16th century, a small church was built that included the front part of a **Corinthian temple (j)** on a high platform (second half of the 2nd century AD). Also in the Roman era (3rd century AD), a **baths complex (k)** was built to the south of the

temple. The **exedra of the Cicero family (l)** stood to the south of the altar. The monument was dedicated by the Samians to the orator who had defended them in the trial against Verres, who had sacked the sanctuary in 80 BC. The remains of the buildings excavated in the area behind the exedra have been buried once more. A **portico (m)** on the south side of the sanctuary, 200 Greek feet long (216' 6"), and a 7th century BC **monumental fountain (n)**. On the extreme south of the portico a **large temple (o)** was built between the middle and end of the 6th century BC, maybe dedicated to Aphrodite and Hermes. In the area in front of this group of buildings, the **foundations (p)** of a 7th-century BC votive ship were found, but this was covered by a rectangular building during the following century. The sanctuary's northern section contained a series of cult buildings, treasuries and votive gifts arranged along the Sacred Way. Some buildings thought to be temples have recently been identified as *thesauroi*.

These are **temple D (q)** (second half of the 6th century BC); **temple A (r)** with a naos and pronaos in antis (mid-6th century BC); and the Ionic **temple B (r)** from the same period, had a short naos from the 2nd or 1st century BC that was widened to make it almost square. **Temple E (t)** (3rd century AD, later than the sanctuary) was a Corinthian construction on a high platform lined with marble. Its structure partly required the demolition of **temple C (u)** which had an Ionic peristasis (11 x 6) on 3 sides (the front is missing), naos and pronaos divided into 3 aisles by 2 rows of columns. It was built in the second half of the 6th century BC and rebuilt in the 1st century AD. Nearby stood a **large temple (v)**, now covered, from the monumental facelift given to the sanctuary by Rhoikos. It originally had a naos and *adyton* with axial colonnade but at the end of the century a peristasis of 6 x 11 columns, doubled on the shorter sides, was raised around this nucleus. Behind this group of buildings stood

a **long portico (w)** (mid-6th century BC) that also functioned as an enclosure wall on the north side of the sanctuary. The **bases of various gifts (x)** to Hera can still be seen along the Sacred Way; one for a *kouros* (mid-6th century BC) and, next to it, lay the base of the *Gheneleos*, named for the sculptor who signed it (560–540 BC). This was a sculpture of the priestess *Phileia*'s family (the work is in the Vathi Museum). The base close by was made for the statues of Gaius and Lucius Caesar, grandchildren of Augustus, and perhaps also for the emperor's statue. In front of it is the base of the bronze statue by the sculptor MYRON of Heracles entering Olympus accompanied by Athena.

OPPOSITE TOP: GATEWAY IN THE ROMAN BATHS.

OPPOSITE BELOW: THE *CALIDARIUM* IN THE ROMAN BATHS.

BELOW LEFT: RUINS OF THE CHRISTIAN BASILICA.

BELOW RIGHT: COPIES OF STATUES IN THE GIFT OF *GHENELEOS*; *HERAION*.

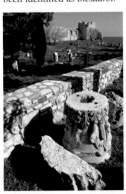

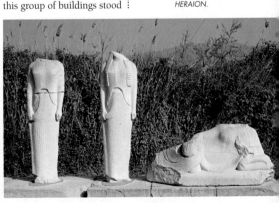

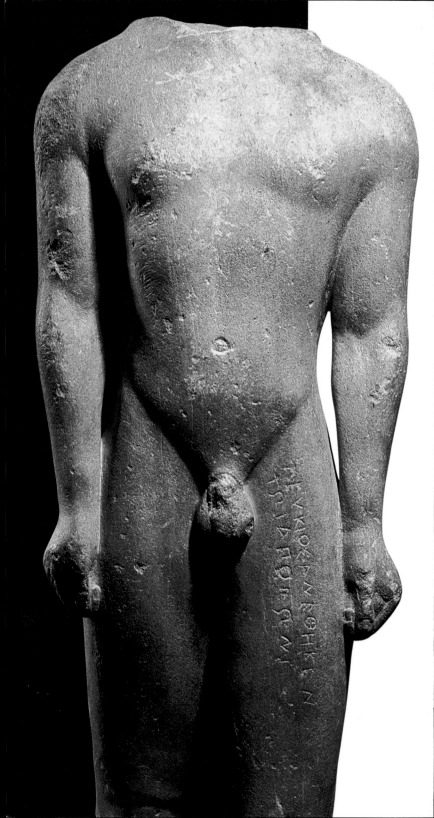

SAMOS

THE MUSEUM

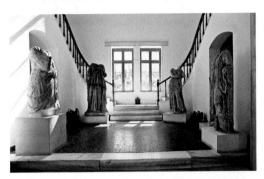

In Vathi, open every day except Mondays, 8:30 am to 3 pm. Payment required. Large room (on the right at the back): masterpieces of Archaic sculpture from the Heraion: the **headless *kouros*** dedicated by Leukios to Apollo, and the *kore* dedicated by Cheramyes to Hera (570-560 BC), by the master who produced the statue dedicated to *Cheramyes* in the Louvre.

Along the right wall you can see the **base of the Gheneleos** with 3 of the 6 statues in the group: the seated mother *Phileia*, with 2 of her 4 daughters, *Philippè* and *Ornithè* (this is a cast of the original in the Pergamon Museum, Berlin), and the father shown lying down at a banquet.

Another room is reserved for the **colossal *kouros*** (originally 15' 7" tall) discovered in fragments beneath the Sacred Way; it was dedicated by Ischès (son of Rhèsis) around 580 BC. (C.T.)

OPPOSITE: HEADLESS *KOUROS* FROM THE *HERAION*; ARCHAEOLOGICAL MUSEUM.

TOP: PROTOMAS WITH GRIFFIN-HEADS.

ABOVE: TWO ROOMS OF THE ARCHAEOLOGICAL MUSEUM.

RIGHT BOTTOM: ROMAN ERA STATUE; ARCHAEOLOGICAL MUSEUM.

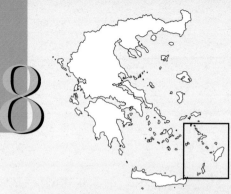

8

DODECANESUS

The name Dodecanesus signifies the twelve islands that in 1908 joined to form an autonomous province to defend the privileges accorded to them by the Turkish empire. Today the Dodecanesus comprises many islands, some uninhabited, that conserve archaeological remains and some excellent buildings dating from the occupation of the Knights of St. John (1306–1522), headquartered in Rhodes. Leaving from **Rhodes**, go to **Sìmi**; the capital **Chora** (*Archaeological Museum, open 10am to 2pm, Tuesday–Friday*) occupies the acropolis of the ancient city and is connected by a flight of steps to **Ghialos**, one of the most beautiful ports in Greece. The Castle of the Knights of Rhodes was constructed using ancient building materials and encloses the remains of a temple dedicated to Athena. The monastery of the Taxiarch Michele Panormitis (18th century) stands in the bay of the same name and has important frescoes and icons. Near the port on the **island of Nysiros**, in antiquity called *Porphyris* for the color

of its volcanic material, you can visit the ruins of the 5th-century BC city acropolis. After **Cos**, you can take a rest on **Kalymnos**. In the capital, **Pothia**, are the remains of a Hellenistic sanctuary and a Roman cistern (*Archaeological Museum, open 10 am to 2 pm, Tuesday–Friday*). The ruins of a 6th-century basilica dedicated to Christ of Jerusalem stand over the ruins of a temple of Apollo (4th–3rd centuries BC), who was worshiped with Asclepius. The temple dedicated to the latter lies beneath the nearby church of Aghia Sophia. On the **island of Telendos**, which used to be attached to the coast until the earthquake in 535, are the ruins of a baths building, a theater and two early Christian basilicas. On nearby **Leros** are only a few archaeological remains (near the port are ruins of a Classical Age city, and, at **Parthèni**, of a temple of Artemis *Parthenos*). In **Astipalea** the architecture is reminiscent of that in the neighboring Cyclades, but there are also traces of a

Venetian presence (Astipalea was a Venetian possession from 1207 to 1522). There are very few traces of the past except for an early-Cycladic village at **Vathi** and, on the west coast at **Armenochori**, a Mycenaean necropolis (*finds in the Archaeological Museum, open 8:30 am to 7 pm, every day*).

In the main port (Pigadia) of the **island of Karpathos**, Minoan and Mycenaean remains have been found, also of the Greek city of Potìdaia. At **Arkasa** (ancient Arkasèia) on the west coast, you can see the ruins of the 5th-century church of Aghia Sophia. The village of **Olympos** deserves a visit, even if the road is not one of the best, where the inhabitants still live and dress in accordance with past traditions.

Kastelorizo is named after the medieval fort (Castel Rosso) that overlooks the capital's port. There is a small Archaeological Museum (*open 9 am to 2 pm, Tuesday–Friday*). Near the port, you can see the remains of a citadel built on the acropolis of a Doric settlement (Paleokastro). (C.T.)

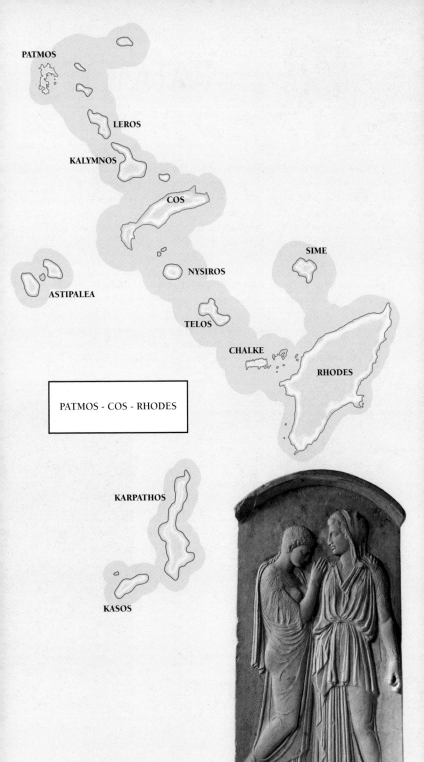

PATMOS

LEROS

KALYMNOS

COS

SIME

ASTIPALEA

NYSIROS

TELOS

CHALKE

RHODES

PATMOS - COS - RHODES

KARPATHOS

KASOS

CLASSICAL FUNERARY STELE OF
KRITOS AND TIMARISTA, RHODES
MUSEUM.

PATMOS

A few stretches of the fortifications (4th–3rd centuries BC) on Kastelli hill are all that remains of the ancient city founded by the Dorians. During the reign of Emperor Domitian, St. John the Evangelist was exiled to the island and is supposed to have written his *Revelation* in the cave where he lived as a hermit. This was later turned into a chapel and annexed to the Monastery of the Apocalypse (17th century). Abandoned until the 11th century owing to Saracen raids, in 1088 the island was given by the Byzantine emperor Alexius Comnenus to Christodoulos Latrinos, the Abbot of Bythinia, who founded the monastery of St. John the Evangelist on the site of an altar dedicated to Artemis (*open Monday, 8am-1pm; Tuesday and Thursday, 8am-1pm and 4pm-6pm; Wednesday, Friday and Saturday, 8 am-1:30 pm; Sunday, 10 am–12 pm and 4 pm–6 pm. Free*). The monastery resembles a fort and holds one important library, with 3,000 ancient works and 1,000 manuscripts. Chora, the village below the monastery, was founded in the 13th century by laymen who wished to live near the monastery. (C.T.)

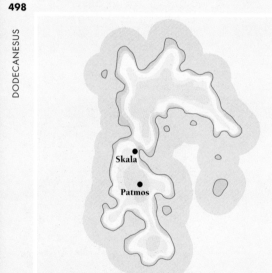

TOP: WOODEN PANEL; MONASTERY OF THE APOCALYPSE.

OPPOSITE TOP LEFT: EXTERIOR OF THE MONASTERY OF THE APOCALYPSE.

OPPOSITE TOP CENTER: FRESCO, MONASTERY OF THE APOCALYPSE.

OPPOSITE TOP RIGHT: WOODEN PANEL; MONASTERY OF THE APOCALYPSE.

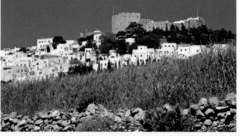

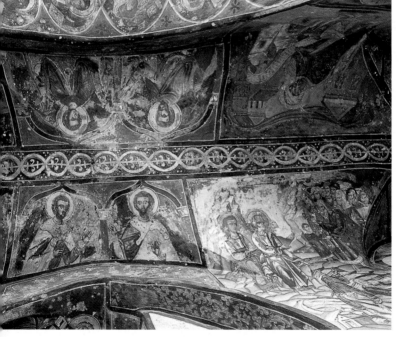

CENTER: VIEW OF
THE MONASTERY
AND VILLAGE OF
CHORA.

ABOVE: THE
EVANGELISTS,
CENTER, IN THE
MONASTERY ARCADE.

8.1

COS

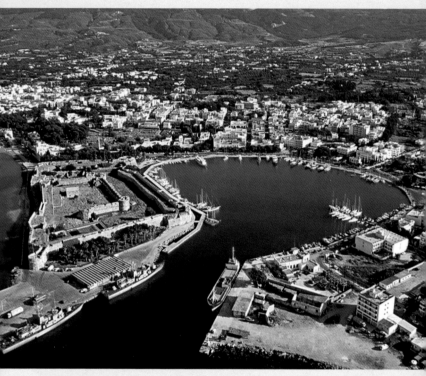

The settlement on Serraglio hill indicates that the site of the modern city of Cos was inhabited from the final phase of the Early Bronze Age. In 1600 BC there was a fairly large Minoan village, and this was followed around 1350 BC by its Mycenaean equivalent settled by colonizers from Thessaly and Argolis.

During the Early Geometric and Geometric periods (10th to 8th centuries BC), the prehistoric site was overlaid by a necropolis built by Dorians who arrived from Epidaurus; they constructed a new settlement for themselves on top of the hill.

The necropolis fell into disuse at the end of the Geometric Age and the shift to the graveyard at Marmarotò—550 yards southwest of Serraglio hill—coincided with the foundation of the city that sources refer to as Cos-Meropis.

Only the sanctuary of Demeter is known from the Archaic and Classical settlement, which lay to the west of the stadium. It was a large temple-like building with an oblong plan built at the start of the Classical era over a Mycenaean building. Deposits of offerings attest that the area was used for cult purposes from the Geometric Age to the Roman domination. A new city arose in 366

DODECANESUS

BC on the same site, which Strabo records as being "Not large but architecturally the most beautiful and pleasing to see as you arrive." Diodorus Siculus wrote in similar tone: "They built it splendidly and a multitude of inhabitants gathered there and magnificent walls and a splendid port were built." Laid out on a grid, it was surrounded by walls over 2 miles long.

The port was made particularly safe by 2 extensions of the city wall and by a small island that gave only two passages to the open sea. Inside the city there were magnificent buildings made of travertine over tufa (porous rock) foundations, at least until the end of the 3rd century BC when the opening of the quarries on Mount Diocheus (180 BC) led to marble being used. The successful export of wine and a particularly fine cloth (a sort of silky gauze that was dyed purple and threaded with gold) rapidly brought the island prosperity and turned it into a cultural center.

Thanks to its pro-Roman policies, Cos maintained a pre-eminent role in sea trade even after the foundation of the free port of Delos in 167 BC. After a disastrous earthquake in 142 AD, the island's residents set about rebuilding, as they did twice more, after the earthquakes of 469 and 554. Arab raids in 654 marked the beginning of Cos' decline until the era of the Knights Hospitalers (1303–1522).

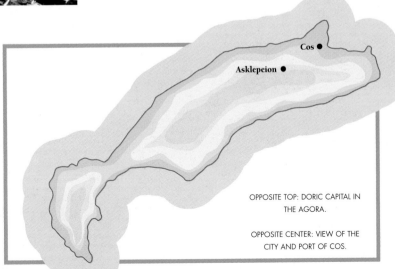

OPPOSITE TOP: DORIC CAPITAL IN THE AGORA.

OPPOSITE CENTER: VIEW OF THE CITY AND PORT OF COS.

The ancient city is well known as a result of excavations by Italian archaeologists after the 1933 earthquake that destroyed much of the Greek and Jewish quarters in the city center. Unfortunately, a lot of the ancient building materials were dispersed as early as the Roman period owing to reconstruction after various earthquakes. Plundering was completed by the Knights Hospitalers in the construction of a castle (1436–41) on the site of the agora and port district in what is today Platanou Square (named after the "plane tree of Hippocrates" which is, in fact, just a few hundred years old).

The excavations in the port district can be seen behind the Loggia Mosque. The north sector was occupied by the sanctuary of Aphrhodeste *Pandemos* and *Pontia* (tutelary deity respectively of the *demos* and sailors) but it was largely looted of building materials in the 5th and 6th centuries to build the Christian basilica, which has 2 side aisles, an atrium, a narthex and a baptistery. The ruins that can be seen today date to the first half of the 2nd century BC when the complex was a porticoed enclosure with 2 prostyle, tetrastyle Doric temples standing side by side; the outer walls of the enclosure were decorated with alternating Doric half-columns and windows.

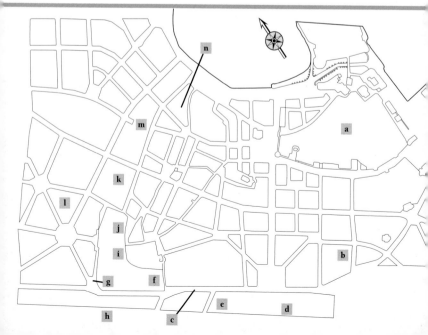

Each temple stood on a tall, stepped platform and was preceded by an altar and Corinthian tetrastyle propylaeum that faced northward.

As these were Roman-type temples (of which the platforms were characteristic), it is possible that the complex was built by Italic trading corporations, on the same model as in the sanctuaries of *Fortuna* and *Mater Matuta* in the Forum Boarium in Rome. Unlike the rest of the district, the sanctuary faced toward the entrance of the port so that it was immediately visible to those arriving by sea. The coeval temple of Heracles, with a naos set on a high platform, stood to the east of the sanctuary at the extreme northern section of earthworks thrown up by the inhabitants. In the 2nd and 3rd centuries, the temple was enclosed by a quadriportico. The area between the 2 enclosures was found to contain the ruins of a small temple, also from the Roman era, dedicated to an unknown god. The east side of the square was closed off by a large travertine portico dating from the 4th and 3rd centuries BC, but though it was rebuilt in the Roman period, it was obliterated by the 5th-century basilica when its materials were reused (the foundations contain 8 veined marble columns with Corinthian capitals from the end of the 3rd century). To the south of the basilica stands the square baptistery, with a round room at the center containing a cross-shaped font. The area to the south of the sanctuaries was an inhabited district bounded on the southeast side by the 4th-century BC wall. Roads running north-south created blocks of houses from the 2nd to 4th centuries AD.

The **agora (a)** lay in the far southwest corner of the district, in the area of the church of Aghios Konstantinos. This large square (218 x 90 yards) was surrounded by porticoes. It was built in travertine at the start of the 3rd century BC but relaid in marble in the first half of the 2nd. It ran up to the city walls on the north side, which it used as an enclosure. The ruins to be seen today date from the reconstruction that followed the 142 AD

THE CASTLE AND ROMAN SITE.

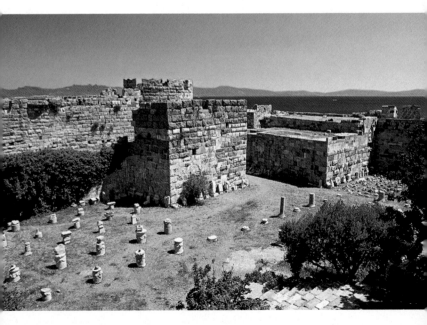

earthquake; the only original sections are the stylobate of the porticoes and a stretch of the east wall made from *isodomum* ashlar blocks. At the same time, a 3-span monumental entrance was built above the partially demolished walls. It was framed by Corinthian columns, covered by barrel vaults adorned with stucco, and connected to the port square by a wide flight of steps. The names of the church of the Panaghia tou Phorou (destroyed in the 1933 earthquake) and the gate of the current market, Porta tou Phorou, indicate that the forum built in the Roman era must have occupied the space of the Greek agora. The **sanctuary** street stood a huge **baths complex (d)** built in the 3rd century, and, to the west of this, a **large house (e)** built over a Hellenistic residence. The rooms of the house were arranged around 3 peristyle courts (one of which had one side of the peristyle higher and more lavish than the others) and were decorated with mosaic floors, wall paintings and polychrome marble facings. Following the *decumanus maximus* (now the Leoforos Grigoriou) west, you come to the excavation of a **quarter (f)** at the foot of the acropolis. It contained 3 blocks of Hellenistic houses that were rebuilt after the 142 AD earthquake and restored early in the 3rd the port from the first block. The city *odeon* **(h)** stood to the south of the junction of the *cardus maximus* with the *decumanus maximus*; it had marble seats and the orchestra was paved with patterns of marble chips. A large 3rd-century **baths building (i)** stood on the *cardus* but after it was destroyed in the 469 earthquake it was superseded by 2 basilicas. The first basilica, on the left, occupied the space of the *calidarium* (a large room with apses along the short side and a tank on the south side), while the second basilica, just to the north, overlaid the *hypokausta* and the *frigidarium*.

The remains of the baths

of Dionysus (b) stood on the south side of the agora. It dated to the early 2nd century BC and had a Doric temple *in antis*, and a large altar in the form of a Corinthian column on a platform decorated with Dionysian scenes.

The south side of the sanctuary was bounded by the *decumanus maximus* **(c)**, which was 36 yards wide and lined by porticoes and shops.

On the other side of the century. The first block is entirely occupied by the "House of the Abduction of Europa," named after the mosaic floor in one of the rooms. Besides having remarkable wall paintings, the house was also found to contain an exceptionally fine set of sculptures (statues of gods and portraits, now in the Cos Museum).

A stretch of the *cardus maximus* **(g)** has been excavated as it heads for basilica (a long building on a "forceps"-shaped plan) lie after the corridor that leads from the *cardus* to the gymnasium. A few yards farther north you will see the remains of the **"House of the Judgment of Paris" (j)** built in the 2nd century over a Hellenistic residence and restored in the 3rd century. The name is taken from the scene illustrated in the mosaic of the main room, which looked out onto a peristyle court. At the center

of the court there is a tondo depicting a Centaur; the west panel (the east one is missing) shows the Judgment of Paris and Apollo and the Muses at the sides.

On the other side of the *cardus* stood the **baths' latrine (k)** (rebuilt after excavation). This was an opulent building with a central court, and porticoes paved with mosaics on 3 sides. The **gymnasium (l)** stood to the west of the baths. Built in the first half of the 2nd century BC, it was a large rectangular travertine seats laid out along the slope of Serraglio Hill. The west stand was built in the Roman period on vaults of conglomerate supported by pylons. The marble, 2nd-century BC starting line (*aphesis*, near to Aghia Anna) is well preserved, with the complicated mechanism that permitted the simultaneous start of the runners.

The ruins of another **baths installation (n)** lie to the north of the stadium. This too was especially sumptuous, if the architectural fragments conserved are anything to judge by. However, it is still difficult to work out the plan of the building.

The city had also had a theater, built in the 3rd century. The tiers were made of marble and the stage lined with marble slabs.

..

OPPOSITE LEFT: THE ODEON.

OPPOSITE RIGHT: RUINS OF THE BASILICA AND EARLY CHRISTIAN BAPTISTERY.

BELOW: WESTERN GYMNASIUM.

construction (218 x 131 yards) with a central peristyle court. The east portico, with 81 Doric columns, was used as a covered track (*xystòs*) for winter training. Continuing toward the port along Odos Panaghia Tsaldari—which follows the course of the *cardus maximus*—you will see the ruins of the 4th-century BC **stadium (m)** to your left. Originally the building had a stand on the east side only, with

THE MUSEUM

Open every day except Mondays, 8:30 am to 3 pm. Payment required.

The museum holds finds from all the archaeological sites on the island.

West room: statues found in the *odeon* (2nd-1st centuries BC); a colossal head of Heracles, which was a late copy of an original by LYSIPPUS.

North room: a large number of statues,.

East room: statues from the Roman era including a seated Hermes (2nd century) and a death of Marcia.

The *central court* has a remarkable set of statues from the "House of the Abduction of Europa" (2nd-century gods and portraits from the age of Trajan).

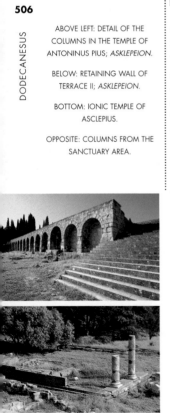

ABOVE LEFT: DETAIL OF THE
COLUMNS IN THE TEMPLE OF
ANTONINUS PIUS; *ASKLEPEION.*

BELOW: RETAINING WALL OF
TERRACE II; *ASKLEPEION.*

BOTTOM: IONIC TEMPLE OF
ASCLEPIUS.

OPPOSITE: COLUMNS FROM THE
SANCTUARY AREA.

ASKLEPEION

*Open every day except
Mondays, 8:30 am to 3 pm,
winter; 8:30 am to 7 pm,
summer. Payment required.
Located 3 miles southwest
on the road to Platani.*
The cult of Asclepius was
introduced to the island by
the Mycenaeans from
Thessaly. They worshiped
the god, associated with
Apollo, in a sacred wood of
cypress trees.
The sanctuary began to
acquire renown at the time
that Hippocrates founded
his medical school. This
event marked the start of
rational medicine based on
clinical observation of the
sick. After Hippocrates'
death in 375 BC, in
addition to its modest
temple and altar, the
sanctuary was given
buildings to welcome
pilgrims who visited the

island to follow the cures
recommended by
Hippocrates' teachings.
In the first half of the 2nd
century BC, the
monuments of the
sanctuary were overhauled
and reorganized on 4
terraces connected by
flights of steps located
centrally.
The lowest terrace (IV) has
the remains of a **baths
building (A)** (1st century
AD), and stairs with a
Doric propylaeum that led
to the next and largest
terrace (III). The square
was bounded on 3 sides by
Doric porticoes (B);
behind the east one there
was a Roman **baths
building (C)** where the
sick would take their cures.
The sulfurous and
ferruginous water used
came from a spring that fed

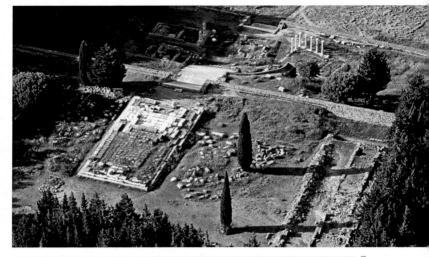

ASKLEPEION

A *BATHS BUILDING*	E *IONIC TEMPLE*	H *PRIESTS'*	K *DORIC PORTICOES*
B *DORIC*	F *ALTAR OF*	*HOUSE (?)*	L *PORTICO WITH*
PORTICOES	*ASCLEPIUS*	I *TEMPLE OF THE*	*WOODEN PILLARS*
C *BATHS*	G *TEMPLE OF*	*IMPERIAL CULT*	M *NEW TEMPLE OF*
D *POOLS*	*ASCLEPIUS*	J *MEETING ROOM*	*ASCLEPIUS*

the **tanks (D)** on the retaining wall of the higher terrace (II). This terrace was where the oldest buildings stood. To the right of the stairs lie the ruins of a small **Ionic temple (E)** dedicated to Nero by C. Stertinus Senophonte, the physician to Emperor Claudius. The stairs lead up to the foundations of the **altar (F) of Asclepius**, formed by a platform, and steps covered by an Ionic colonnade decorated with the family of Asclepius by the sons of Praxiteles. To the right, there are 2 columns from the east façade of the **temple of Asclepius (G)**, which was Ionic *in antis* (300–270 BC). A trench in the naos hidden by a marble slab held the offerings made by

pilgrims before they began their cures. Next to the temple stood a 2nd-century BC building that may have been the **residence of the priests (H)**.

To the left of the temple a peripteral **Corinthian temple (I)** made of white marble was consecrated in the 2nd or 3rd century to the imperial cult; its orientation, different from that of the other buildings in the sanctuary, may have been due to the presence of an earlier Doric temple, perhaps destroyed in the 5th century BC. The purpose of an adjoining building (4th-3rd century BC) is not clear but it was probably a **meeting room (J)**. A 3-ramp flight of steps led to the upper terrace (I) built at the start of the 2nd century BC; this was

dominated by the **new** Doric, hexastyle, peripteral **temple (M) of Asclepius**; the naos was raised on an additional flight of steps. The temple was transformed into a church in the 5th century.

The square was closed on the east and west sides by 2 **Doric porticoes (K)** and the **portico (L)** on the south side had wooden pillars. A small flight of steps led from the south portico to the sacred wood of cypresses. Roughly 30 minutes south of the sanctuary you come to the site of the Vourinna spring, the earliest cult site on the island. This fact is attested by the *tholos* built over the spring, perhaps as early as the Mycenaean period (rebuilt during the Roman age). (C.T.)

RHODES

Rhodes is the largest island in the Aegean. Its position on the shipping routes between the East and West and the fertility of its soil led to its inhabitation since the Neolithic period. Rhodes was first colonized by the Minoans and Mycenaeans, then c. 1100-1000 BC, the Dorians settled on the island and established themselves in three areas: Lindos, Ialyssos and Kamiros.

In 407 BC, the high-ranking Dorieus instigated the synoecism between the

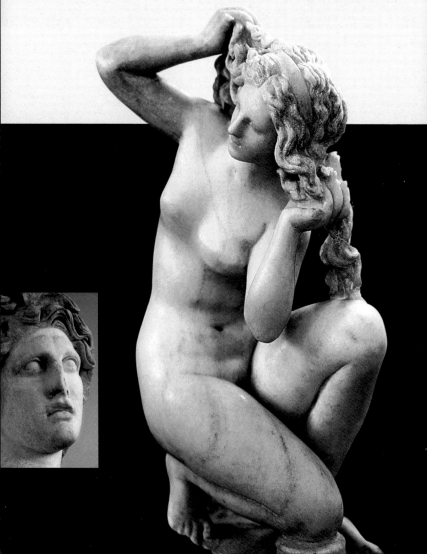

three to found a new city on the northern promontory. Governed by a philo-Spartan oligarchy until 396 BC, Rhodes then drew itself up a democratic constitution on the Athenian model that endured until 356 BC when Mausolus, the satrap of Caria set up a garrison in the city.

In 305 BC, the city was besieged by Demetrius Poliorcetes, but he was constrained to withdraw after only a year despite having war machines of unusual power.

The following century was Rhodes' period of greatest splendor; it became the trading center of the Mediterranean and an important banking center. At the time of Macedonia's expansion under Philip V, Rhodes took the side of Rome, with which it was also allied in the war against Antiochus of Pergamum (191–190 BC); in return for its loyalty Rome gave it Lycia and Caria. However, Rhodes paid heavily when it attempted to mediate between Perseus of Macedonia and the Romans; after Perseus' defeat in 168 BC, Rome punished Rhodes by setting up the free port of Delos (166 BC), to which most of the island's shipping trade shifted. Cassius sacked it during the Roman Civil Wars (44 BC). It remained prosperous in the early Christian era, but was sacked on several occasions during the 7th century.

In 1309 the Knights Hospitalers of St. John took control of the island. During their stay on Rhodes, a great deal of construction was undertaken that modified the city's appearance and, contemporaneously, resulted in the disappearance of almost all the ancient buildings.

For 200 years the Hospitalers succeeded in beating off the raids of the Turks but, in 1522, Suleiman the Magnificent took the city after a siege of 6 months. Rhodes remained under the Turkish yoke for 400 years. Then, in 1912,

Italy conquered the island. Rhodes only returned to the kingdom of Greece in 1947. Italian rule was positive for Rhodes in that it surveyed the island with the aim of drawing up an inventory of monuments. In 1914 the Italian Archaeological Mission was instituted on Rhodes with the task of creating a museum. In 1924 the Mission became the Superintendency of Monuments and Excavations and began archaeological research in earnest not just on Rhodes, but on other islands in the Dodecanesus. It also involved itself in large-scale restoration projects.

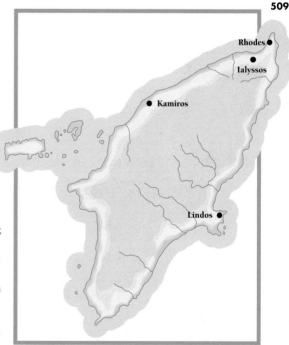

OPPOSITE TOP: ROMAN STATUE IN THE PALACE OF THE GRAND MASTER, DETAIL.

OPPOSITE BOTTOM LEFT: HEAD OF HELIOS IN THE ARCHAEOLOGICAL MUSEUM.

OPPOSITE BOTTOM RIGHT: APHRODITE OF RHODES.

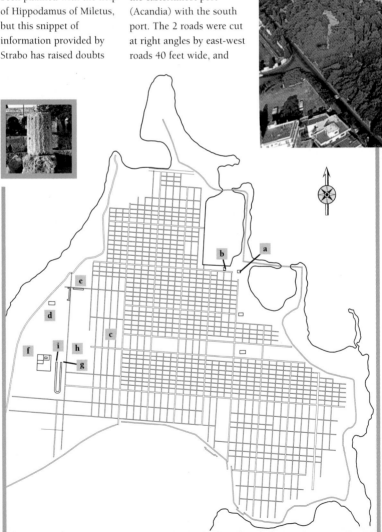
The city was largely rebuilt during 1303–1522, the period the Knights Hospitalers had possession of the island. Little is left of the Greek city celebrated by ancient sources for its many buildings. The regular layout of the Greek city at the time of its foundation is generally well known, and may have been planned with the help of Hippodamus of Miletus, but this snippet of information provided by Strabo has raised doubts because of chronological difficulties.

Attractively laid out on a series of terraces that slope down from the acropolis on St. Stephen's Hill on the west side toward the shoreline to the east, the plan had 2 very large north-south roads (54 feet wide) that joined the west port and the south gate and the easternmost port (Acandia) with the south port. The 2 roads were cut at right angles by east-west roads 40 feet wide, and

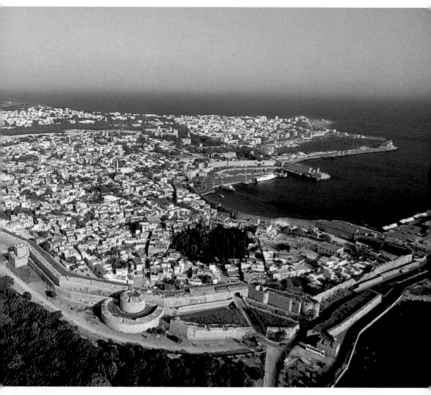

OPPOSITE: GROOVED
COLUMN, TEMPLE OF
APHRODITE.

ABOVE: AERIAL VIEW
OF THE PORT AND
CITY OF RHODES.

these were then flanked by streets 26–30 feet wide running both north-south and east-west that created residential blocks. The blocks were then further divided by streets just 18 feet wide. The site of the agora has not yet been identified but in all probability it lay in the city center, close to the large port (perhaps near Ippokratous Square). The agora was the location of the *Ptolemaion*,

the sanctuary dedicated by the Rhodians to Ptolemy II Euergetes, who had contributed to the city's reconstruction after the earthquake of 227 BC. The path followed by the walls is known, many sections of which have been discovered on the north, east and south sides. The Classical-era walls were rebuilt after the siege by Demetrius Polyorcetes in 305 BC,

but following a line outside the earlier ones. However, these too required rebuilding following the earthquake in 227 BC. Entering the walled city through the Liberty Gate (opened by the Italians in 1924), at the far end of Simis Square you see the ruins of the **Doric temple of Aphrodite (a)**, built in the 3rd or 2nd century BC with a distyle pronaos and opisthodomus *in antis*.

The remains of a cube-shaped, four-faced **Corinthian archway (b)** (*tetrapylon*) stand in Argirokastrou Square (behind the Ionian Bank). This was built at the start of the Severe age as the city's monumental entrance at the junction of 2 Hellenistic streets: one that ran west and climbed to the acropolis up flights of steps, and the other, lined with porticoes and shops, that led south to the agora. The tetrapylon stood over the buildings of the arsenal that occupied the southern section of the Hellenistic military port (today Mandraki), right in an area of the dry dock (a haulage ramp still stands on the north side) that reached as far as the temple of Aphrodite.

The discovery at the foot of the acropolis in the western section of the city of a **sanctuary (c)**, with bases inscribed with the names of the priests of Helios (Rhodes' greatest god), has raised once more the question of the identification of this famous place. This is where Lysippus' sculpture of the quadriga with the god stood, the only work of art left by Cassius when he sacked the city, and the famous Colossus of Rhodes, a gigantic bronze statue of Helios (105 feet tall) produced between 304 and 293 BC by Chares of Lindos, a pupil of Lysippus. It collapsed during the 228 BC earthquake and

LEFT: SANCTUARY OF THE "NYMPHS."

BELOW: TEMPLE OF APOLLO *PYTHIOS*.

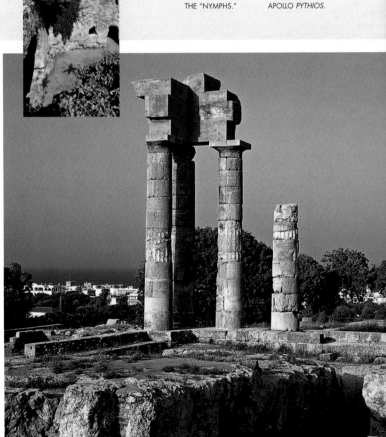

remained on the ground until 653 when the Arabs sold the remains to a Jewish merchant who took it to Syria. A little to the southeast, the remains have been uncovered of another sanctuary and 2 troughs used to cast the colossal bronze statues. These finds are important evidence of the artistic production for which this Hellenistic city was famous. The best preserved section of the ancient city is the acropolis (Mount Smith, named after the English admiral who located his headquarters here at the start of the 19th century). The upper of the 2 terraces of the acropolis is supported by a large dry wall made from rectangular blocks and was the site of a **portico (d)** and the Doric **temple of Athena *Polias* and Zeus *Polieus* (e)**. The sacred area was also where the "nymphaea" stood; in reality these were caves – part natural and part embellished with apses, niches for offerings and pools to collect water – where the divinities of the waters were worshiped. The lower terrace was occupied by the **sanctuary of Apollo *Pythios* (f)**, with the Doric, hexastyle, peripteral temples of the god (3rd century BC) and, on a lower level, the Corinthian temple of Artemis. An ***odeon* (i)**, **stadium (g)** and **gymnasium (h)** (3rd century BC), largely restored by the Italians in 1924–29, also stood on the slopes of the hill.

BELOW: RESTORED CAVEA OF THE THEATER.

BOTTOM: SANCTUARY OF THE "NYMPHS," ENTRANCE CORRIDOR.

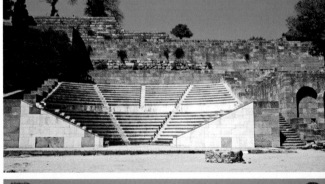

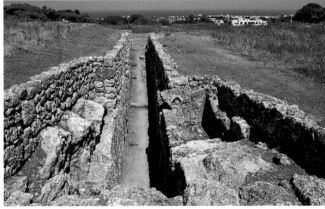

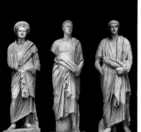

THE MIDDLE AGES

The largest and best conserved construction from the medieval period is the city fortifications, their large dike and several earthworks (*open to visitors on Tuesdays and Fridays, leaving from the courtyard of the Great Palace at 2:45pm. Payment required*).

The city walls (roughly 2.5 miles long) were raised in the early 14th century to replace the Byzantine walls.

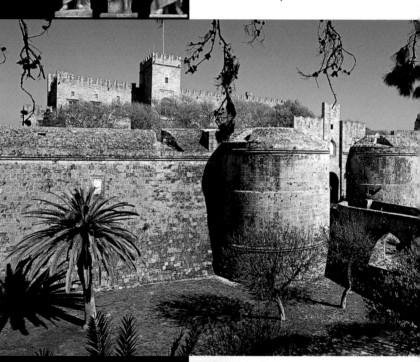

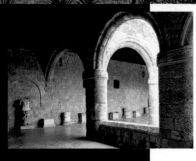

Rebuilt after the 1481 earthquake, they were strengthened with ramparts and towers in the late 15th-early 16th centuries to a thickness of 39 feet.

Inside the walls the quarter reserved for the Hospitalers (the Collachio) was defended by a second set of fortifications and contained the cathedral, the main buildings of the

Order, and the Inns of the Tongues that represented the various nations from which the knights came. The Inns of the Tongues (15th-16th centuries) lined the Street of the Knights (Hippoton), the most attractive street in the historical center. At the eastern end of the street stood the Knights' Hospital (today the Archaeological Museum); this imposing building was begun in 1440 and completed by the Grand Master Pierre d'Aubusson (1476–1505). Used to accommodate pilgrims and cure the sick, under Turkish dominion it was turned into a garrison but returned to its original appearance by the Italians (1913–18).

At the west end of the quarter stood the Palace of the Grand Master (*open Tuesday–Friday, 8 am–7 pm; Saturday–Sunday, 8:30 am-3 pm. Payment required*). Built in the 14th century,

its towers and crenellated walls make it look like a fort. It was turned into a prison by the Turks and mostly destroyed by the explosion of a powder magazine in 1856. It was rebuilt (1939–45) during the Italian occupation to host Mussolini and King Victor Emmanuel II during official visits. During rebuilding, 4 Hellenistic statues with unrelated Roman heads were stood on the west side of the courtyard and various figural Roman mosaics were reused on the floors of the rooms on the upper floor. The 2nd and 3rd century AD mosaics mostly came from the island of Cos.

A number of archaeological finds (Neolithic and Archaic ceramics, household furnishings, luxury and everyday items, marble and terracotta sculptures) are exhibited in the basement rooms.

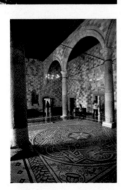

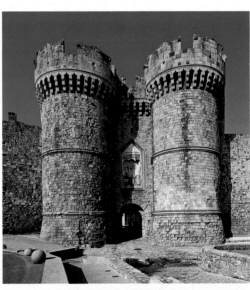

LEFT: LION SCULPTURE IN THE MUSEUM.

BELOW: SULEIMAN'S MOSQUE.

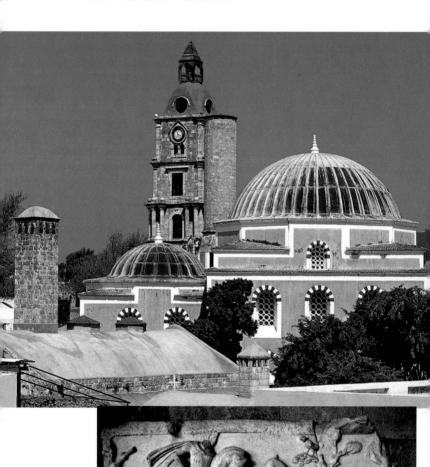

LEFT: LOW RELIEFS FROM TOMBSTONES; ARCHAEOLOGICAL MUSEUM.

OPPOSITE TOP: GOTHIC FOUNTAIN IN PLATIA IPPOKRATOUS AND CASTELLANIA.

OPPOSITE BOTTOM: COURTYARDS OF THE ARCHAEOLOGICAL MUSEUM.

OTTOMAN ERA

During Ottoman rule, only Turks and Jews were allowed to live within the walls. The Turkish quarter occupied the center of the old city; a maze of alleys is still filled with mosques (almost always created from 14th-and 15th-century Byzantine churches), minarets, Koranic schools, houses with porticoed terraces, and baths (generally 18th-century and still functioning).

The Jewish quarter at the east end of the walled city is also very lively. It was centered around the synagogue (Odos Dossiadou), which was founded in the 16th century by Sephardic Jews.

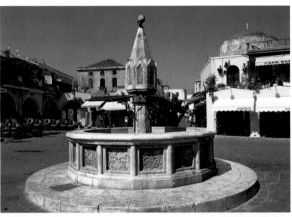

THE MUSEUM

(*Open Tuesday–Friday, 8 am–7 pm; Saturday–Sunday, 8:30 am–3 pm. Payment required*)

The *courtyard* contains a marble lion, sarcophagi (1st century BC) and inscriptions. *Room 1* (upstairs): tombstones of the Hospitalers and a **marble sarcophagus** used for Grand Master Pierre de Corneillan. *Room 2* (refectory): reliefs and funerary **stelae** from the Hellenistic and Roman eras.

Room 3 (kitchen): Archaic and Classical sculptures, in particular a *perirrhanterion* supported by 3 female figures standing on lions (7th century BC); **2 *kouroi*** from the third quarter of the 6th century BC; a stele from the end of the 5th century BC. *Rooms 4, 5 and 6*: Hellenistic sculptures from the Rhodian school (a demure Aphrodite, 3rd century BC) and the **Aphrodite of Rhodes** (early 1st century BC).

RHODES

KAMIROS

The myth that the founder of Kamiros was Althaimenes, the grandson of Minos, finds support in the Minoan grave goods found in the necropolis of Kalavarda (though articles from the Mycenaean period have also been found). The necropolises also demonstrate the refinement of the settlement in the 7th and 6th centuries BC. The Archaic and Classical city was largely destroyed by the earthquake that occurred in 226 BC. The ruins currently visible are those from the Hellenistic city (3rd and 2nd centuries BC) that developed on a grid pattern on 2 manmade terraces on the slopes of Mount Acramite. The lower section was occupied by a sacred area with 2 sanctuaries; the central area contained the housing district and the sanctuary of Athena *Kameiras* stood on top of the hill.The city was destroyed a second time by the 142 BC earthquake when it was abandoned.

VISIT

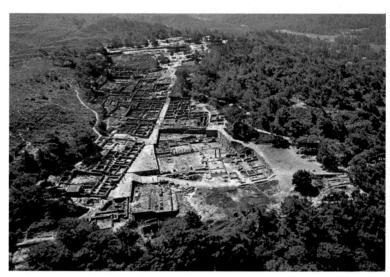

You enter the archaeological area from the west side of the lower terrace. Here you will see the ruins of the *Hierothytèion* (A), the place where foreigners could offer sacrifices; this was a 3rd-century BC rectangular enclosure with a large altar dedicated to Helios. On a higher level a row of 9 altars was named after the Kameiros gods.

The Doric **temple of Apollo Pythios** (B) stood at the center of the terrace with a distyle pronaos and opisthodomus *in antis*. Near the northwest corner of the temple there was an Ionic sacellum that could be entered on the north side. Adjacent to the sacellum to the east was the *temenos* of Apollo (C), a rectangular enclosure with a north façade characterized by Doric half-columns. Steps on the north and east sides climbed to the sacrificial area by the large altar. The south side of the enclosure was a sort of sacred agora where a **monumental fountain** (D) must have played an important cult role and was perhaps used for

oracular rituals. Built in the second half of the 4th century BC, the façade had Doric half-columns resting against pillars separated by light barriers. In the 3rd century BC, the fountain was transformed into a porticoed hall that continued to have an important religious function and the names of the city magistrates were inscribed on the columns. Furthermore, the alignment of the steps on the upper terrace that led to the temple of Athena fell right between the central columns of the porticoed façade. In the first half of the 2nd century BC, the façade was connected by a paved road lined with votive monuments to the monumental entrance at the center of the *temenos*. The sides of the road between the lower and upper terraces were lined with blocks of houses. To beautify the upper terrace of the city, a large **stoa (E)** was built at the end of the 3rd century BC with projecting wings 220 yards long, adorned with 87 Doric columns. Behind the portico (which overlaid a large cistern in use in the 6th-5th centuries BC) a series of 46 rooms was laid out, probably to accommodate pilgrims. Each one had a small basin to collect water that ran down from the roof. Water was also conveyed through galleries and cisterns dug out of the rock to the residential area. A few ruins from the 6th- or 5th-century BC **temple of Athena (F)** remain on the top of the hill. This was a Doric, hexastyle,

peripteral building with a pronaos and distyle opisthodomus *in antis*. The antiquity of the cult is confirmed by offerings dating to the 8th century BC. On a higher level of the hill stood a sacellum, perhaps dedicated to Zeus *Polieus*, but today it is no longer visible.

KAMIROS

A HIEROTHYTEION
B, C *TEMPLE AND TEMENOS OF APOLLO* PYTHIOS
D *MONUMENTAL FOUNTAINS*
E STOA
F *TEMPLE OF ATHENA*

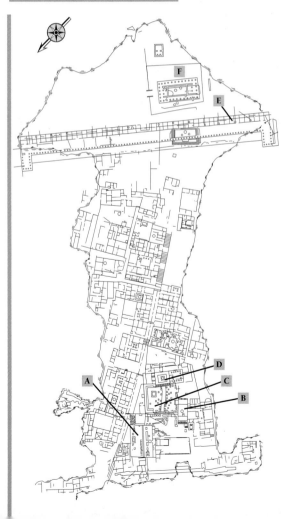

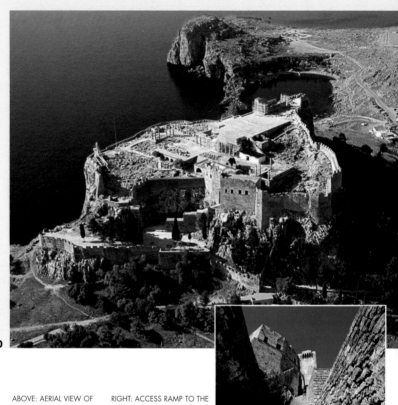

ABOVE: AERIAL VIEW OF
THE ACROPOLIS.

RIGHT: ACCESS RAMP TO THE
FORT.

LINDOS

Until the synoecism of 407 BC, Lindos was the most important city on Rhodes, especially during the Archaic tyranny of Cleobulus, one of the Seven Sages of Greece.

After the foundation of the city of Rhodes, Lindos was most famous for the sanctuary of Athena *Lindia*, which, from earliest times, was visited by famous individuals: the "Chronicle of Lindos" written by Timachidas in 99 BC listed votive gifts to the goddess being made by Cadmus, Minos, Heracles, Menelaus and Helen. The cult of Athena on the acropolis is said to have originated with Danaus, who, driven out of Egypt, hid at Lindos with his 50 daughters and consecrated a wooden image to the goddess. The original site of the cult was probably a cave beneath the southeast end of the plateau. Above that a small wooden temple may have been built in the 8th-7th centuries BC. Around the middle of the 6th century BC, Cleobulus had an amphiprostyle, tetrastyle Doric temple built of stone on the same site that was reached via a flight of steps in the center of the plateau. Reconstruction of the temple after the fire of 340 BC was part of a radical and unifying facelift given to the sanctuary begun in the first half of the 3rd century BC. The temple was built afresh at the start of the 3rd century BC and, between 275 and 250 BC, the upper stoa and monumental stairway between the two terraces were created. The rebuilding program was completed with the construction of the lower stoa between 210 and 200 BC.

R H O D E S

LINDOS

a *RELIEF OF AGESANDRUS*	d *TEMPLE OF THE IMPERIAL CULT*
b *LOWER STOA*	e *UPPER STOA*
c *EXEDRA*	f *TEMPLE OF ATHENA*

BELOW: RELIEFS WITH
THE STERN OF A RHODIAN
WARSHIP.

RHODES

521

VISIT

Open Monday, 12:30 pm-6:45 pm; Tuesday–Friday, 8:30 am–6:45 pm; Sunday, 8:30 am–2:45 pm. Payment required.

Leave from the sanctuary, with its Byzantine (13th century) and medieval (15th century) walls and cross the town, admiring its many fine houses (15th-18th centuries) and courts paved with black and white pebbles. Once you have entered the fortified citadel, a flight of steps will take you to the small square from which a second stairway leads to the upper

entrance. On the rock wall at the foot of the stairway you will see a **relief (a)** of the stern of a Rhodian warship on the bridge of which was originally the

bronze statue of the admiral Agesandrus. The relief was executed around 180 BC by PYTHOCRITUS, the sculptor of the famous statue of Nike at Samothrace.

You then come to the square of the **lower stoa** (**b**), a large portico composed of 2 jutting wings of 17 Doric columns on either side of a monumental stairway to the upper terrace. The two wings are joined at the center by 8 fully visible Doric columns. In front of the right wing is the **exedra** (**c**) dedicated by the family of a priest (second half of the 3rd century BC) and, next to the end of the stoa, the church of Aghios Ioannis (13th century) that uses the roof of the cisterns below as a floor.

The ruins of a Roman **temple** (**d**) **dedicated to the imperial cult** lie at the northern edge of the square.

The monumental stairway (69 feet wide) rises to the **upper stoa** (**e**) that has a façade of 10 Doric columns and is terminated at either end by 2 colonnaded avant-corps similar to those on the lower stoa. Five doors led into a court surrounded by porticoes; the sacred banqueting rooms lay behind the west arm. The amphiprostyle **temple of Athena** (**f**) stood in an off-center position on the southeast edge of the terrace above the sacred cave. Note the ruins of the theater on the slope of the acropolis; all you can see are the structures dug out of the rock, as the blocks used in the stage and proscenium were reused to

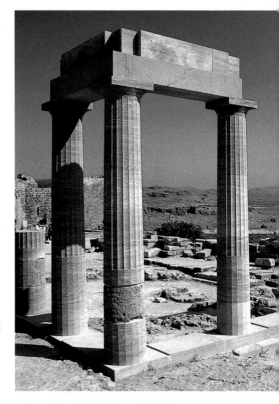

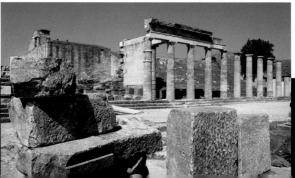

build the houses in the village.

The *tetrastoon* with a central peristyle court (3rd-2nd century BC) stood in front of the theater, while above it there was a choragic monument.

The necropolis on Mount Krana has some fine funerary monuments, like the one honoring the family of the priest Archokrates (225 BC). It has 2 orders of 10 Doric half-columns cut in the rock, and the burial chamber, preceded by a transversal vestibule, contained 6 chamber graves on each wall and a large altar reached by steps. (C.T.)

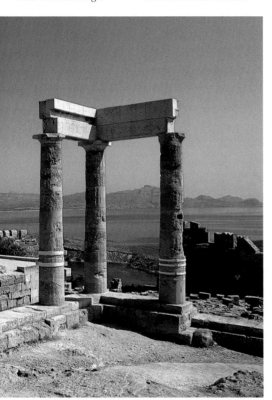

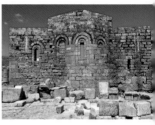

LEFT: RESTORED AVANT-CORPS, UPPER STOA.

OPPOSITE BOTTOM LEFT: LOWER STOA, VIEW FROM NORTHWEST:

OPPOSITE BOTTOM RIGHT: ENTRANCE TO THE ACROPOLIS.

ABOVE: AGHIOS IOANNIS, VIEW OF THE APSE.

BOTTOM LEFT: EXEDRA AND PROPYLAEA, SQUARE IN FRONT OF THE UPPER STOA.

BOTTOM RIGHT: DETAIL OF THE NECROPOLIS OF MOUNT KRANA.

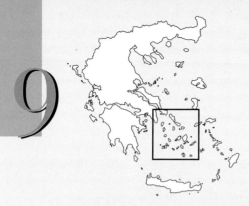

9

CYCLADES

This archipelago—the "Greek Polynesia," as the French like to call it—is composed of 39 islands, 24 of which are inhabited. There are also hundreds of tiny islands that are more like rocks above the water line. Assailed by the baking sun and often by a sea whipped up by the wind, the archipelago owes its name to its roughly circular pattern (*kyklos*) around **Delos**, the island sacred to Apollo. For several decades the Cyclades have been highly popular with tourists, which has revitalized its economy but also endangered the essence of the islands: their sense of freedom (which from Pythagoras onward has been linked with the concept of "island"). Their position almost as a bridge between Europe and Asia, the fertility of their subsoil, and the mild climate made the Cyclades the setting for a remarkable and outstandingly original culture that had its origins in the Early Bronze Age

(between 3000 and 2000 BC). Their history has its roots in the Neolithic when obsidian, a volcanic rock, was quarried to make cutting tools that were used throughout the eastern Mediterranean (Saliagos culture, from c. 4900 BC, named after the island between Paros and Antiparos; Kephala culture, from 3500 BC, named after Kephala on the island of Keos). The Cycladic culture during the Bronze Age was created with the help of Anatolian peoples who arrived at the start of the 3rd millennium and had distinct seagoing and commercial characteristics. Modern scholars have in large part focused on the Cycladic white marble idols whose "abstract" and "symbolic" forms fascinated many artists in search of a new artistic language at the start of the 20th century. But just as important, if not more so, are the recent discoveries on **Paros** (Phylakopi) and **Santorini**

(Akrotiri) – to mention the best known – regarding Cycladic modes of dress and living, the structure of society, artistic culture, and so on. The cities of the living have yielded abundant documentation, as have those of the dead (the necropolises), regarding artistic activities other than the idols, frescoes and pottery; today, the most important items are to be seen in Athens. But the Cyclades are also important for their Byzantine monasteries, Venetian forts and neo-Classical buildings, and particularly characteristic are the white houses with brightly colored doors, windows and pots of flowers! A tour of the archipelago could start from **Keos**, as it is so near to Athens, and pass through **Kythnos, Seriphos, Siphnos, Melos, Pholegandros, Santorini, Ios, Paros, Naxos** and **Amorgos**, to end with **Mykonos, Delos, Tenos, Syros** and **Andros**, which is close to Euboea. (S.M.)

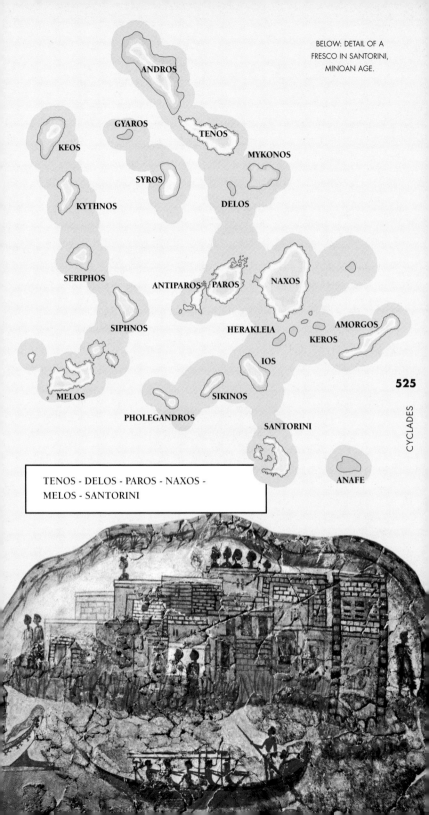

ANDROS

GYAROS

TENOS

KEOS

MYKONOS

SYROS

DELOS

KYTHNOS

SERIPHOS

ANTIPAROS PAROS NAXOS

SIPHNOS

HERAKLEIA AMORGOS

KEROS

IOS

MELOS SIKINOS

PHOLEGANDROS

SANTORINI

ANAFE

TENOS - DELOS - PAROS - NAXOS -
MELOS - SANTORINI

TENOS

Little is known of the past of Tenos, one of the least touristy of the Cyclades. Traces of civilization dating to the 3rd millennium BC can be seen in the museum; there are several Geometric and Archaic tombs and sources mention the island's prosperity in the Classical Age (it contributed 10 talents annually to the Delian-Attic League). During the Hellenistic era Tenos was an important island and a federal sanctuary of the League of Islanders was founded here. The remains of this sanctuary (*open every day except Mondays, 8:30 am to 2:30 pm*) lie 2 miles northwest of Chora in the Chionia plain. Dedicated to Poseidon and Amphitrite, it was founded by Demetrios Poliorcetes around 300 BC and completed by his son Antigonus Gonatas around 270. The project included a distyle **Doric temple** *in antis* (a), a **fountain** (b), and an *eschàra* (c), which was a

hearth used for sacrifices for a heroic cult, perhaps related to Achilles, the son of the nereid Tethys, the sister of Amphitrite. Around 180 the temple was rebuilt with more monumental forms (Doric amphiprostyle tetrastyle) by the new leaders of the League, the Rhodians. The third stage of building took place between the end of the 2nd century and start of the 1st century BC. It produced a **monumental altar (d)** in

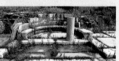

the center of a paved square, and a **gigantic portico (e)** with two façades, each with 73 Doric columns. The portico was divided into two aisles by a wall and had, at either end, a passageway. The length of the portico was about a *stade*, which suggests it was used as a covered running track (*xystòs*) associated with the race that, according to tradition, Achilles ran on the beach. During this same phase, the *eschàra* was "monumentalized" with a large enclosure. During the Julio-Claudian era a series of statues was raised inside the enclosure to celebrate the young Nero's adoption by Emperor Claudius. Other buildings complete the sanctuary: there was an *àbaton* (f) where pilgrims were accommodated, and a *hestiatòrion* (g), which was a refreshments building destroyed in the Trajan era by a baths complex in the form of an **anonymous temple (h)**.

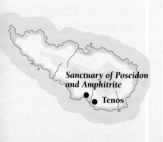

Sanctuary of Poseidon and Amphitrite
• Tenos

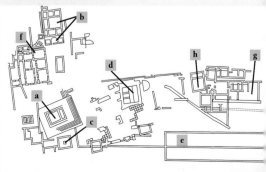

CYCLADES

OPPOSITE TOP: DOLPHIN'S HEAD;
ARCHAEOLOGICAL MUSEUM.

OPPOSITE CENTER AND BOTTOM:
SANCTUARY OF POSEIDON;
FOUNDATIONS OF THE *ESCHARA*
AND EXEDRA.

The 19th-century Panagia Evangelistrìa (Church of the Annunciation) was built using ancient construction materials. A trip to the almost unspoied and typically Cycladic villages inland offers lovely countryside and a small architectural jewel in the monastery of Kechrovouni 7 miles from Chora.
It was founded in the 13th century and built like a small village (*open 7 am to 1 pm, and 2:30 pm to 7 pm*).

THE MUSEUM

Chora museum (*open every day except Mondays, from 8.30am to 3pm*) has fragments of sculptures from the sanctuary, and Geometric and orientalizing pottery from the Exoburgo site. (S.M.)

TOP: PHALATADOS.

527

BELOW LEFT: VIEW OF THE
PANAGIA EVANGELISTRIA

BELOW RIGHT: HEADLESS ROMAN
ERA STATUE.

CYCLADES

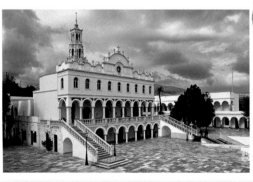

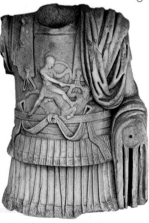

SANCTUARY OF POSEIDON AND AMPHITRITE	
a TEMPLE	e PORTICO
b FOUNTAINS	f ABATON
c ESCHARA	g HESTIATORION
d MONUMENTAL ALTAR	h BUILDING DESIGNED LIKE A TEMPLE

9.1

DELOS

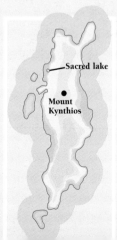

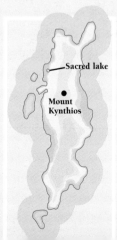

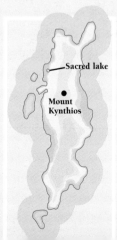

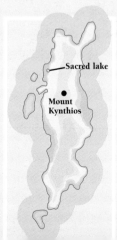

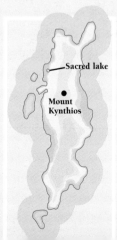

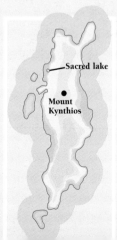

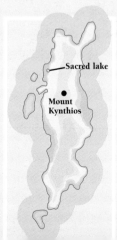

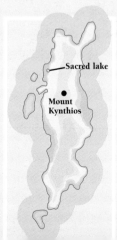

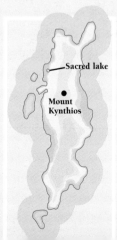

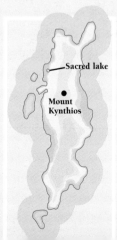

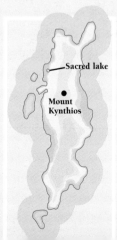

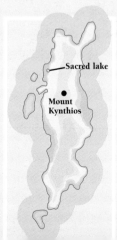

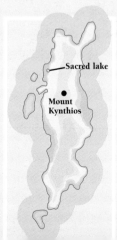

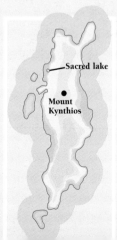

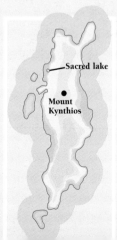

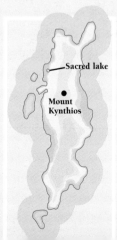

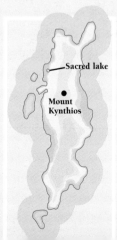

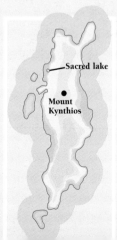

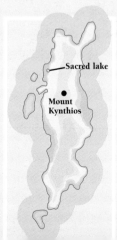

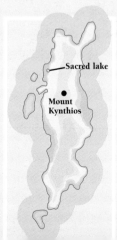

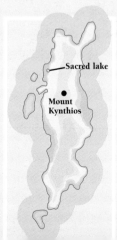

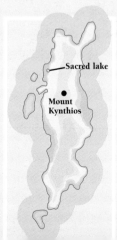

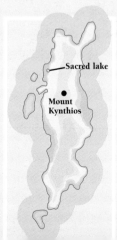

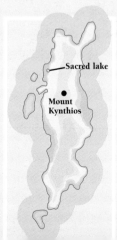

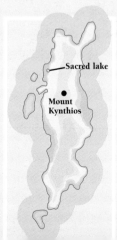

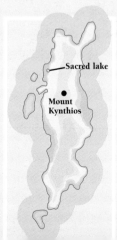

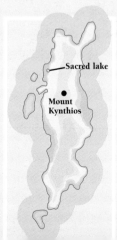

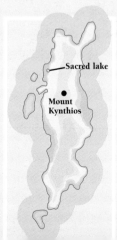

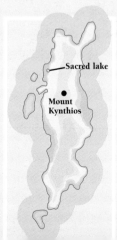

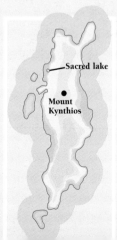

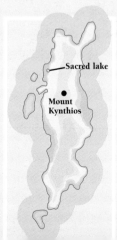

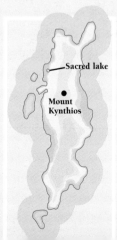

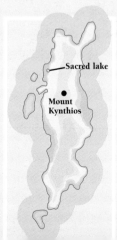

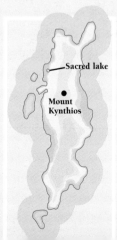

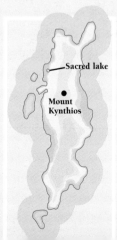

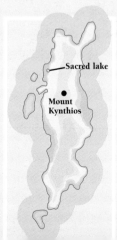

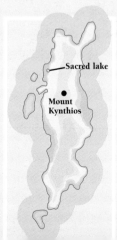

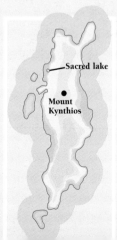

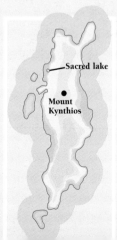

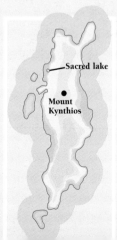

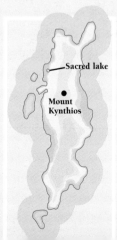

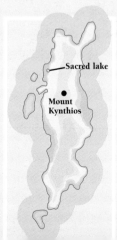

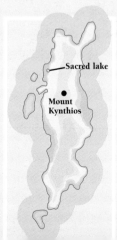

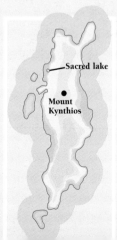

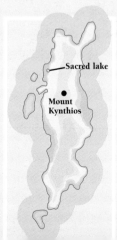

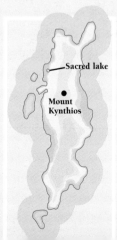

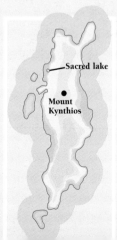

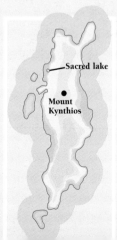

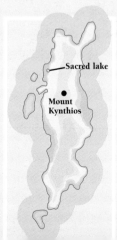

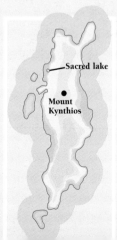

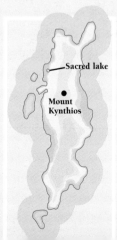

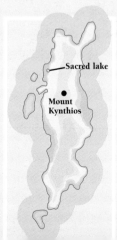

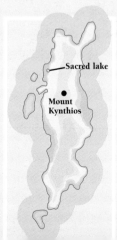

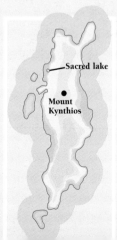

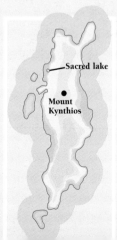

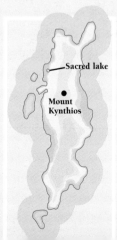

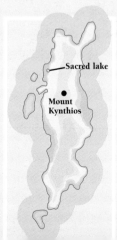

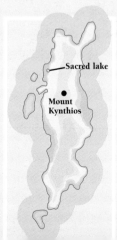

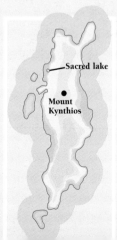

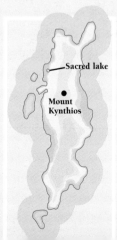

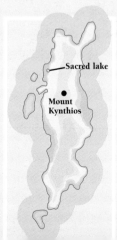

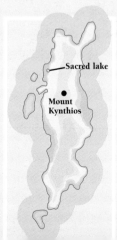

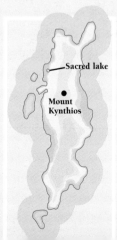

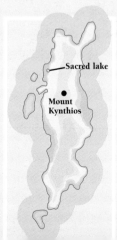

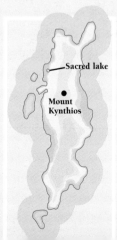

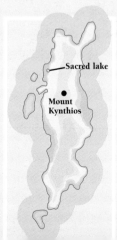

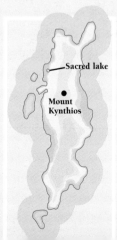

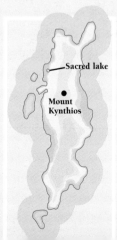

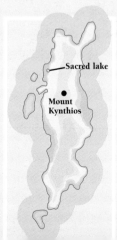

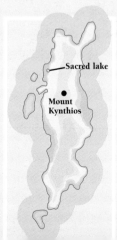

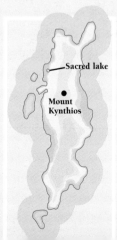

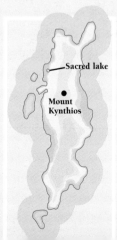

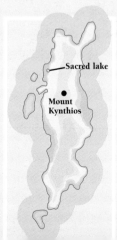

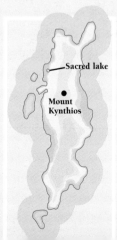

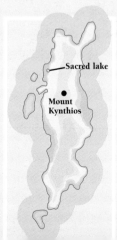

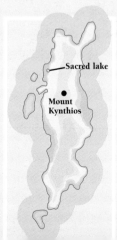

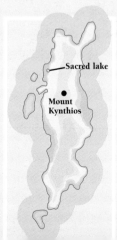

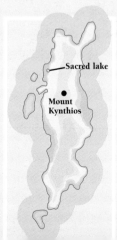

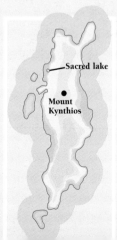

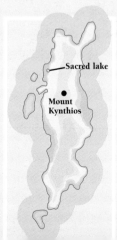

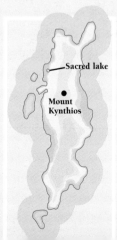

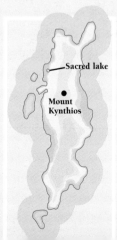

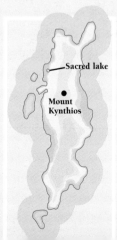

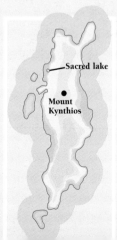

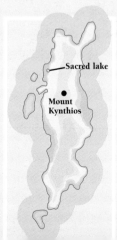

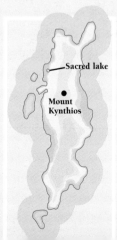

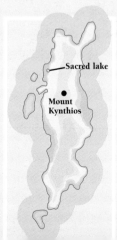

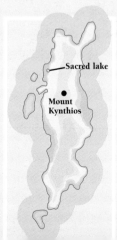

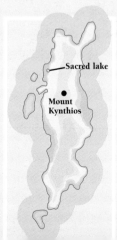

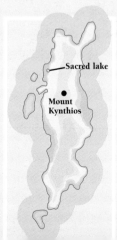

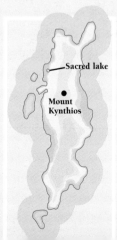

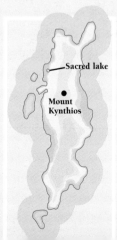

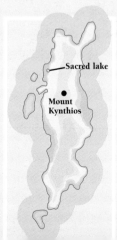

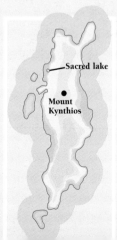

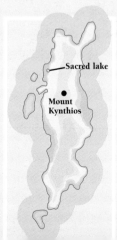

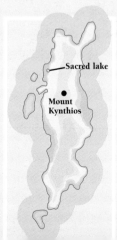

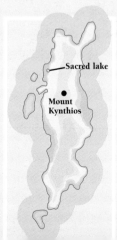

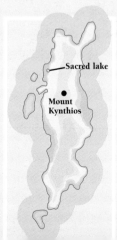

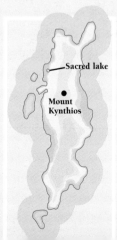

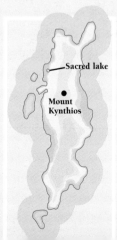

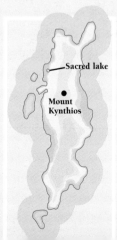

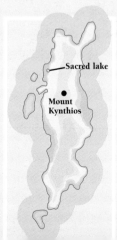

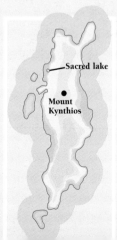

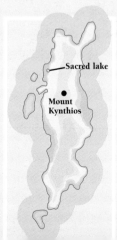

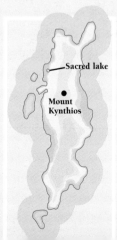

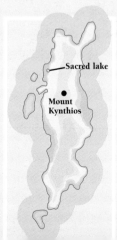

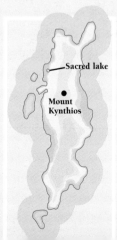

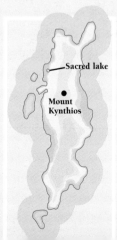

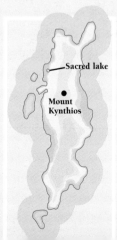

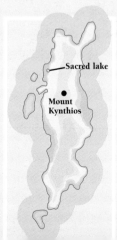

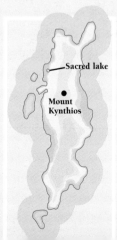

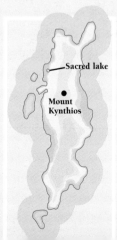

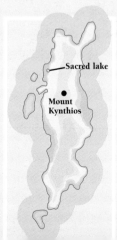

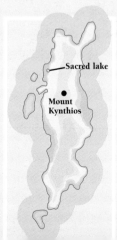

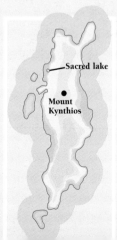

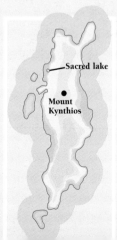

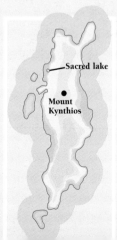

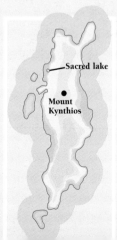

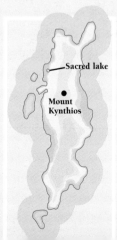

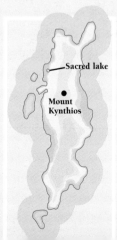

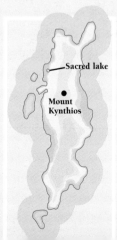

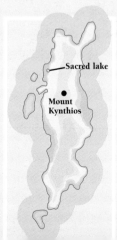

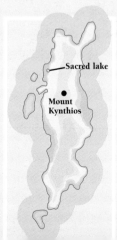

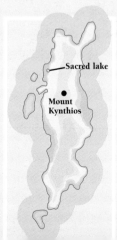

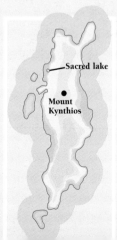

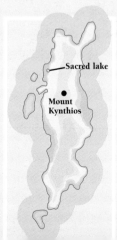

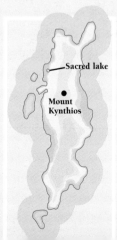

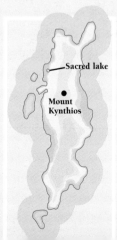

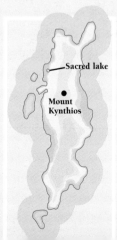

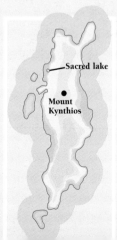

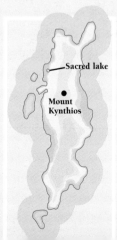

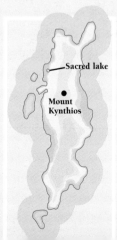

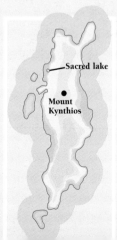

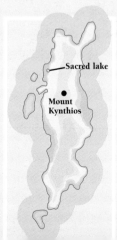

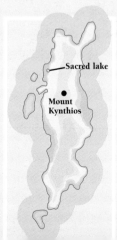

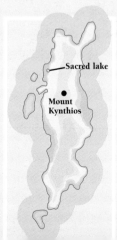

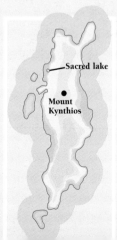

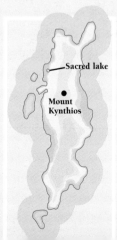

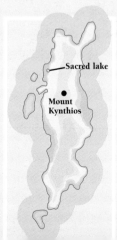

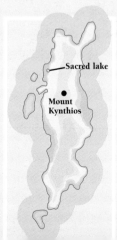

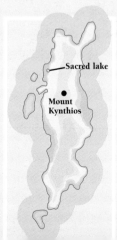

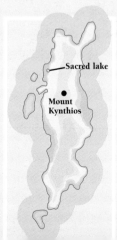

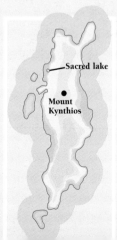

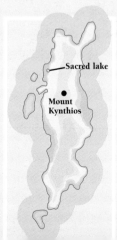

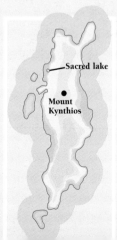

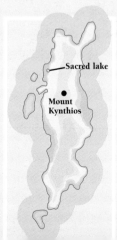

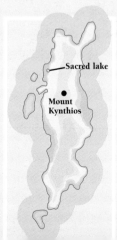

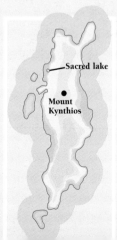

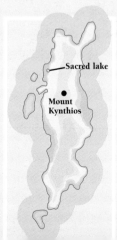

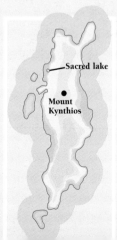

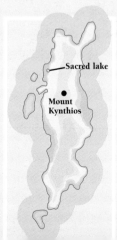

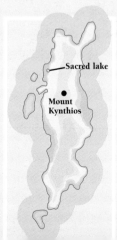

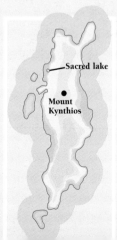

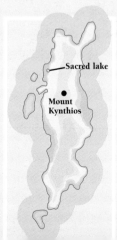

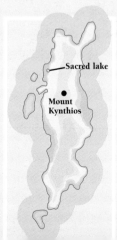

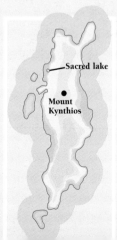

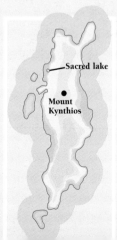

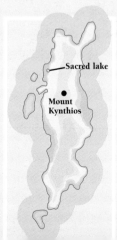

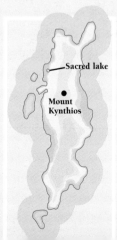

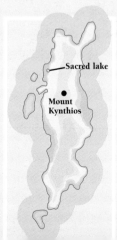

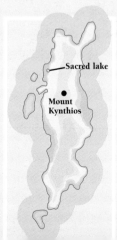

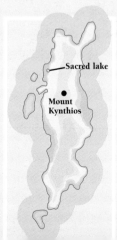

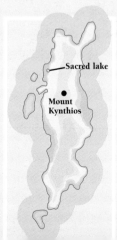

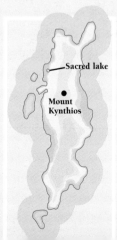

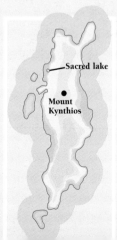

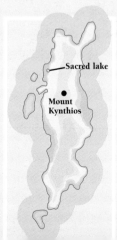

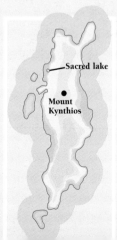

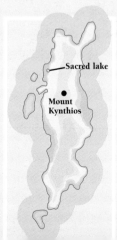

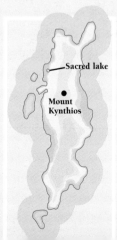

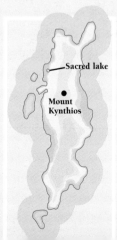

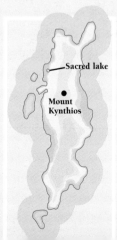

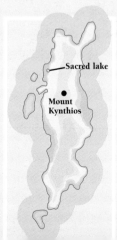

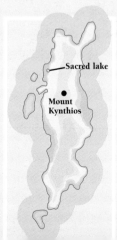

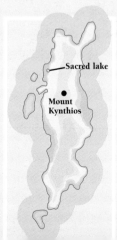

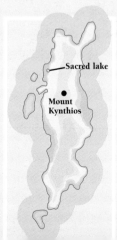

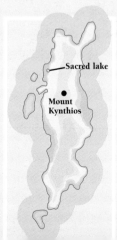

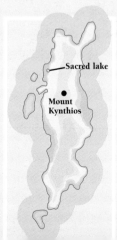

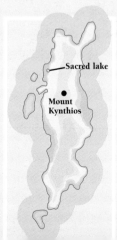

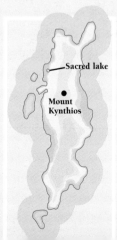

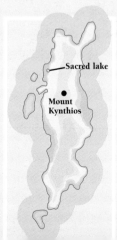

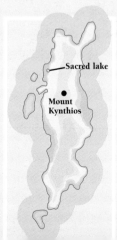

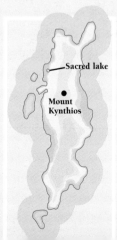

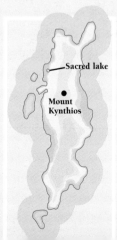

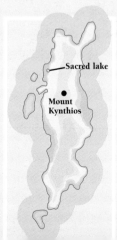

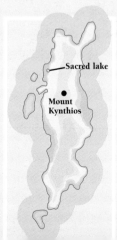

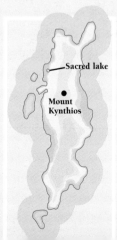

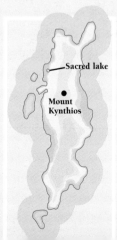

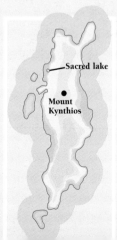

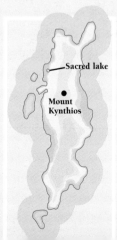

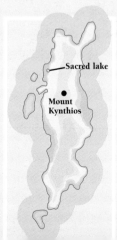

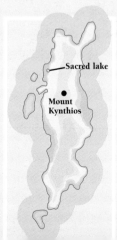

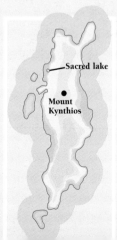

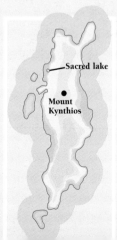

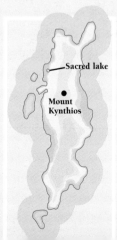

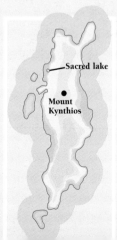

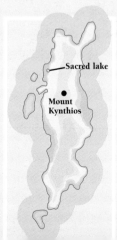

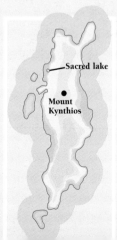

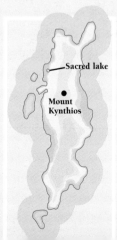

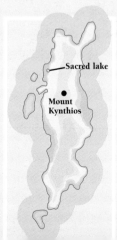

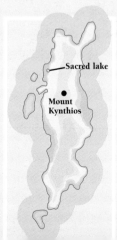

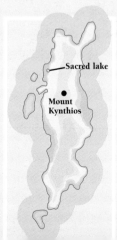

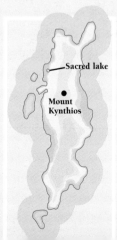

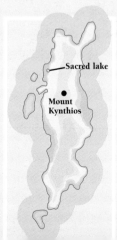

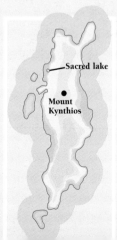

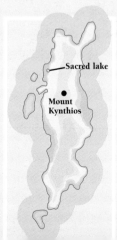

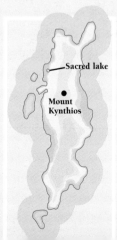

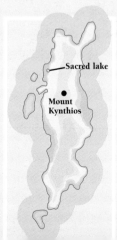

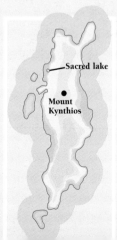

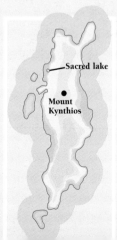

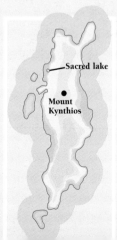

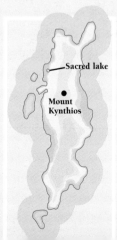

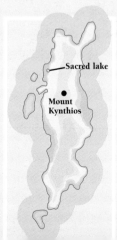

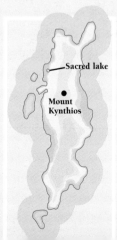

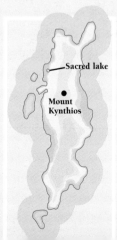

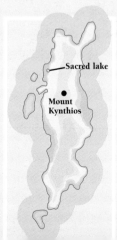

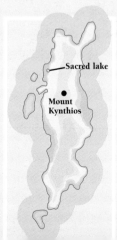

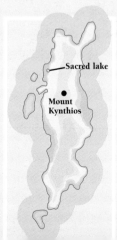

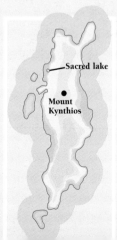

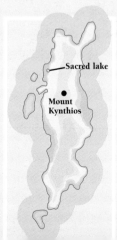

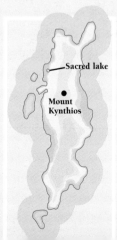

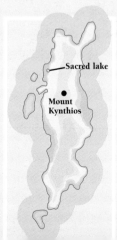

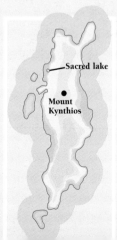

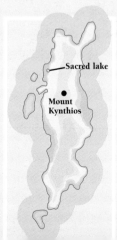

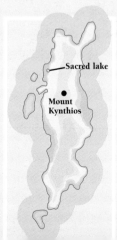



9.1

DELOS

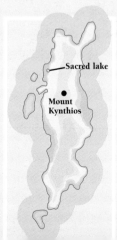

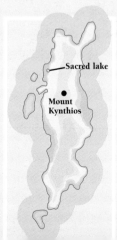

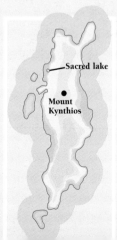



Delos, "the first of the islands" (Callimachus, *Hymn to Delos*, v. 16), is traditionally the homeland of Apollo, son of Zeus and Leto, the god of art (the cithara) and death (the bow). The island's mythology revolves around the birth of the god and his twin sister, Artemis; she was also an ambiguous goddess, the protector of animals but also a huntress, a virgin and also guardian deity of births. Hera, with jealousy and her desire for revenge, persecuted Leto, who was unable to find refuge anywhere until a rock that had until that moment been invisible (*àdelos*), emerged from the sea and became visible (*dèlos*). And there, at the foot of a palm tree, she gave birth to the divine twins. On his return from the Labyrinth, Theseus went to Delos where he made a sacrifice to Apollo, erected a statue to Aphrodite on the beach, and, with his young companions, improvised a dance that imitated the steps of a crane. Since earliest times, Delos was the island where the great festivals were held of all the Ionians, Athenians, islanders and inhabitants of the central coasts of Asia Minor, and, at these, the *gèranos* (dance of the crane)

THE HISTORY

was a central feature. The earliest vestiges of a settlement, on Mount Kynthios, date to the pre-Hellenic age, and the pottery found suggests it flourished during the second half of the 3rd millennium BC. During the Mycenaean age a large settlement stood on the site of the future temple of Apollo and was already a place of worship for the cult linked to navigation (14th to 12th centuries BC). After a period of stagnation, the arrival of the Ionians in the middle of the 9th century initiated a period of prosperity. The true "center" of the Aegean, at the start of the Archaic age the sanctuary succeeded in merging Ionic interests and became an instrument in the hands first of Naxos (ca. 650–550 BC), then Athens. After victory over the Egyptians at the battle of Salamis, the island became the seat of the Delian-Attic League and held the federal treasure in the temple of Apollo under the administration of Athenians. However, in 454 the treasure was transferred to Athens as a result of the city's dominant role in the

League. In 426, the entire island was completely purified by removal of all the graves (under Peisistratus a first area of the sanctuary was purified). The dead and their grave goods were deposited in a large common trench on the nearby island of Rhenea. From that moment, by decree, women in childbirth and the dying were transported to Rhenea, and death and birth were no longer permitted on Delos. The period from the 4th century to 166 BC (the year of Roman conquest) was one of relative independence, given that the island was contested between the Antigonids of Macedonia and the Ptolemies of Egypt. At the start of the 3rd century BC, the island developed as a

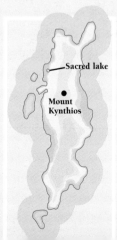

Sacred lake

Mount Kynthios

CYCLADES

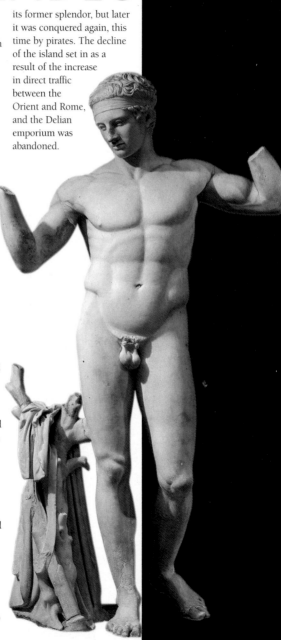

large commercial and banking center for the eastern Mediterranean, which had been unified by Alexander the Great. This role was bolstered by Rome when the senate declared Delos a free port and gave responsibility for its administration to the Athenians. As a result of the large maritime traffic that had previously passed through Rhodes, the population of the town reached 25,000 inhabitants, and it was in this setting that a "governing committee" was set up in the hands of the largest trading corporations. Of these the company of the Italics stood out. Profound social changes took place in the Italic peninsula following the Punic wars. The large estates owned by senators and powerful businessmen created an enormous demand for slaves, and Rome came to Delos to have that need satisfied. Strabo informs us that the slave trade on the island involved 10,000 individuals every day.

The prosperity that the island achieved in such a short period suffered in 88 BC when it was looted by Mithradates, the king of Pontus. However, the island was retaken by Sulla a year later (87 BC) and returned to its former splendor, but later it was conquered again, this time by pirates. The decline of the island set in as a result of the increase in direct traffic between the Orient and Rome, and the Delian emporium was abandoned.

THE EXCAVATIONS

Though a deserted island swept by the wind and burned by the sun, Delos today receives a ceaseless flow of visitors though its success is not exclusively the result of mass tourism. The surprisingly large and extensive archaeological remains have a long history; the first information about the island and its ancient ruins dates to the 15th century AD, thanks mainly to Cyriacus of Ancona (1391-1452). In the 16th and 17th centuries the island and the Cyclades in general received many visitors, including geographers, botanists and artists. The Turkish conquest certainly slowed the arrival of European scholars but, at the end of the 17th century, the island was visited by the Marquis de Nointel J. Spon and M. Wheeler. In 1753 J. Stuart and N. Revett confirmed the Turks' extensive removal of materials from the ancient sites to build their own houses or carve them into turbans for use as gravestones in the Turkish style.
The disastrous situation was surveyed by the French during a scientific expedition in 1829, and then the French Archaeological School of Athens began systematic excavation and examination in 1872, first on Mount Kynthios under

A. Lebègue, then in the Marmarìa zone ("the marbles") close to the shoreline under T. Homolle. And, having faith in the historical sources, it was Homolle who succeeded in finding the Sanctuary. The excavation quickly extended beyond the enclosure of Apollo to reach the zone of the Sacred Lake (by then it had shrunk and was finally drained in 1925), then, after the First World War, it investigated the residential district on the slopes of Mount Kynthios. Following the interruption caused by the Second World War, the work was taken up once more with great vigor and continues today.

DELOS

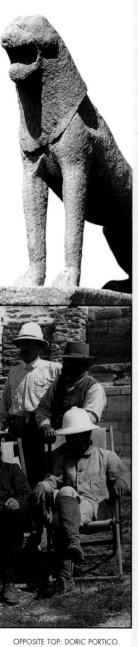

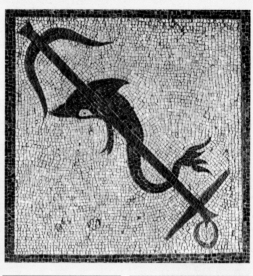

VISIT

The island is reached from Mykonos by ferry (in the tourist season boats leave every 30 minutes: for the 30-minute crossing). Organized excursions to Delos also depart from other islands.

A full visit to the site takes 5-6 hours (practically the entire time the excavation site is open). *Open every day except Mondays, 8:30 am to 3 pm.*

Partial sections of the site can be visited: starting from the Sanctuary of Apollo, head north to the Sacred Lake and then the Stadium. A stop in the museum also offers the chance of a drink in the cafeteria, and from there you can visit the areas of Mount Kynthios, the theater and the southern district.

It is essential to bear in mind (as is common in ancient sites that were used or inhabited for a long period) that excavation of the place—being arbitrary and "selective"—offers a false and unhistorical picture. What you will see here is the Delos of about 100 BC, i.e., at the height of its splendor, but also monuments from earlier eras that were not part of the site in 100 BC.

OPPOSITE TOP: DORIC PORTICO.

ABOVE: MEMBERS OF THE FRENCH EXPEDITION TO DELOS IN 1910.

TOP LEFT: ARCHAIC LION; LION TERRACE.

TOP RIGHT: DOLPHIN WITH ANCHOR; MOSAIC FROM THE HOUSE OF THE DOLPHINS.

DELOS

BULL'S HEAD.
ON THE BASE OF A
SMALL ALTAR

A SACRED PORT
B GREAT TEMPLE
1 AGORA OF THE
 COMPITALIASTS
2 PORTICO OF PHILIP V
3 SOUTH PORTICO
4 AGORA OF THE
 DELIANS
5 MONUMENTAL
 PROPYLAEUM
6 OIKOS OF THE
 NAXIOTS

7 TEMPLE Γ
8 APSIDAL
 MONUMENT
9 BUILDING 42
10 PORTICO OF
 THE NAXIOTS
11 SOUTH
 BUILDING
12 "HEXAGON
 MONUMENT"
13 TEMPLE OF
 ARTEMIS

14 EKKLESIASTERION
15 THESAUROI
16 BUILDING D
 (BOULEUTERION)
17 BUILDING 22
 (PRYTANEION)
18 STOA OF
 ANTIGONOS
19 MINOAN
 FOUNTAIN
20 LETÒON
21 AGORA OF

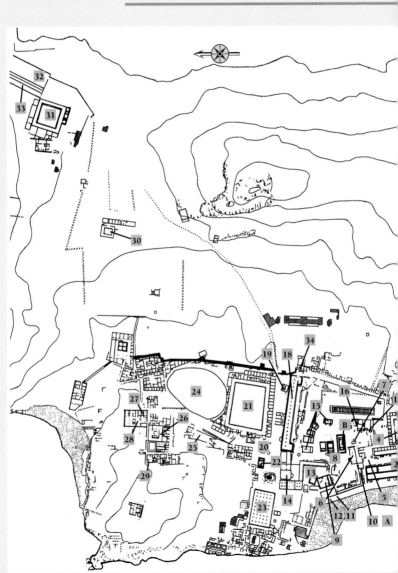

DELOS

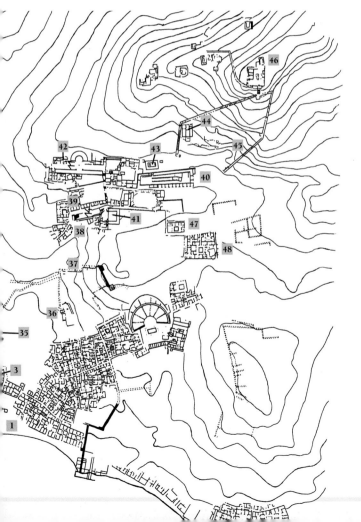

The modern wharf was built by the French in the early 1900s using the earth removed during excavations. The wharf clearly separates the **sacred port** (**A**) to the north (already in existence in the

6th century BC) from a second bay to the south onto which the **agora of the Compitaliasts** or **Hermiasts** (**B**) faced. These were two Italic trading corporations named on many epigraphs on the site. The agora contains the remains of two small sacred buildings from the republican age (c. 130 BC); a rectangular one dedicated to Hermes and Maia (the guardian deities of corporations), and the other round and anonymous (Vesta, Roma?) set inside a quadrangular wall. A third small temple in the form of a shrine dedicated to the Lares Compitales (tutelary deities of junctions and boundaries) stood against the side wall of the

portico of Philip V (2). This building and the **south portico** (3) frame the large *dromos* (entrance corridor) to the *temenos* of Apollo. This layout was 3rd century BC and required large engineering works to fill the sea inlet so as to give the sanctuary a monumental arrival point in line with the dictates of Hellenistic architecture. A dedication tells us that the first portico (c. 230 BC, with an addition in 180 BC when the second portico was built to the west to stock the goods from the nearby port) was built as a manifesto of Macedonian hegemony in the Aegean, with the commemoration of figures like Antigonus Gonatas and Demetrius Poliorcetes. It contrasts with the other portico, built a few years earlier (240–220 BC) by the Pergamum dynasties, who were the principal opponents to Macedonian expansion. The south portico contained shops and had a central entrance into the **agora of the Delians** (4). Also known as the "**tetragon**" due to its almost regular four-sided shape, this was a result of the city development plans of the 3rd century BC integrated with the construction (in the early 2nd century) of a portico with two wings (on the north and east sides). The portico had two orders

—ionic above and Doric below—and shops at the back that were mostly used for banking. Under Hadrian, a baths building was constructed near the exedras. Back at the *dromos*, you will see the *ergasteria* of the *Theandridai* on the right (the Theandridai were a Delian Archaic tribe). Through a **monumental Doric propylaeum** (5)—tetrastyle on the south side, distyle on the north (2nd century BC, built over a previous construction)—the Sacred Way begins. This divided the

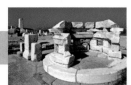

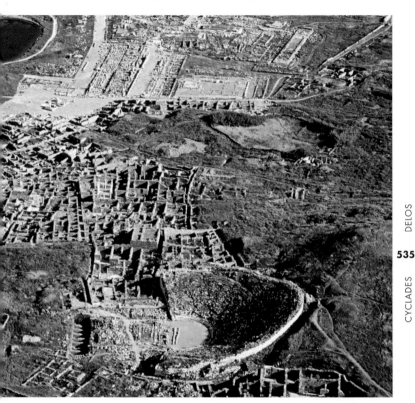

area of the temples of Apollo from the *temenos* of Artemis and other important buildings. Shortly after the propylaeum there is the **oikos of the Naxiots (6)**. The visible remains are from the last phase (mid-6th century BC) but the more ancient building dates from the second half of the 7th century. With an entrance on each of the north and east sides, there was also a naos with an *adyton* to the west and a double row of wooden supports that held up the flat roof. Around 575 BC the orientation of the building was changed, the *adyton* was transformed into a distyle pronaos *in antis*, and a central row of slender Ionic marble columns were installed to support the dual sloping roof; here, for the first time in the Greek world, marble beams and tiles were used. Around 550 BC, the tetrastyle temple of a *prostòon* (portico) was built to the east, though some scholars consider that the building was used for meetings or administration of some sort. The colossus of the Naxiots was installed during the later phase of the construction of the port; four times greater than lifesize, the statue was of a nude Apollo, holding a bow and quiver (the torso can be seen in the *Artemision*). The Archaic inscription on the east side of the base underscores the great importance of the cult statue and another, on the west side made two centuries later, restates the Naxiot dedication.

The ruins of the so-called **Temple Γ (7)** lie to the east.

From the Geometric Age (9th to 8th centuries BC), it was the earliest temple dedicated to the cult of Apollo. The Ionic *porinos naos* (probably tetrastyle prostyle) with *poros* foundations (hence its name) replaced the *oikos* of the Naxiots in the years 540-530 BC, the latter being transformed into a "house" for the votive donations. Its construction, probably to be attributed to Peisistratus, in practice marked the beginning of Athenian hegemony. The **Great Temple (B)** lay between the two buildings. The temple was begun shortly after 475 BC to hold the treasure of the Delian-Attic League, and in some way it eclipsed the *porinos naos*. When the treasure was removed to Athens in 454 BC, the temple remained unfinished. The works were finally

completed in 280 BC, shortly after the liberation of the island from the Athenians, and the building became a sort of banner of the island's independence. Another sign of the presence of Athens can be seen between the Great Temple and the *porinos naos* in the foundations of a hexastyle amphiprostyle Doric temple built between 425 and 420 BC and inaugurated in 417. The purpose of the building was to restate the city's presence in the Aegean during a period of great difficulty (the Peloponnesian War). It displays a number of elegant design solutions that were evidently implemented following the innovations introduced in the Parthenon and other great buildings of the period. The mid-6th-century BC cult statue by Tektaios and Angelion was

ABOVE: CREPIDOMA IN THE FOURTH TEMPLE OF APOLLO.

OPPOSITE: SMALL ALTAR DECORATED WITH BULLS' HEADS AND GARLANDS.

placed at the center of a horseshoe base in the naos. Originally produced for installation in the *porinos naos*, it was later transferred to the Great Temple; the god

holds a bow in his left hand and the Three Graces in his right. Two lovely acroters can be seen in the Delos Museum. The monument dedicated in the 3rd century BC by a certain Sosicrates to Phileterus, the founder of the Attalid dynasty in Pergamum, stands in front of the temple. Unusually, all the temples face west as it was there that the famous *keraton* ("altar of the horns") stood. This was built in accordance with the tradition of Apollo himself using the horns of the wild goats hunted by Artemis on Mount Kynthos. It was supposed to have been protected by a tiled wooden canopy, but this has not yet been identified with certainty. The most accredited hypothesis is that the "canopy" is the "**apsidal monument**" (8) in close connection with "**building 42**" (9); only the foundations remain of both. The first was built in the 5th century BC and rebuilt in the second half of the 4th century. Its shape is well suited to its function as an enclosure for the altar, and it was associated with the myth of Theseus and the *gèranos* (the crane dance). The second building had a rectangular plan measuring c. 75 x 56 feet, with an Ionic pronaos and naos similar to a *telesteria*. The huge room was probably used to welcome participants in the *gèranos* at the start of the dance. A little to the south is the L-shaped **portico of the**

Naxiots (10) built at the end of the 6th century to regularize the façade of the sanctuary that faces the port. The base of the bronze palm dedicated by Nicias in 417 lies in the southwest corner. At the north end of the portico stand the "**south building**" (11), of unknown function, and the "**hexagon monument**" (12), named after the honeycomb decoration of its marble blocks, which used to be the *hieropoìon*, the sanctuary's administrative seat (c. 500 BC). Then comes the *temenos* of Artemis. To close the front facing the sea, a portico with 3 columns was built sometime later than 166 BC, along with a small room (with a dedication from Sulla) that is considered to have been a sacellum dedicated to Aphrodite. It is evident that the **temple of Artemis** (13) also was built in stages. It was a building from the Mycenaean age with a rich set of votive gifts. Discovered inside the hexastyle, prostyle temple of the Hellenistic period (second half of the 2nd century BC), it was preceded by an Archaic temple (7th century BC) from which come the famous *korai* (that of NIKANDER is in the National Archaeological Museum in Athens). The 2nd-century BC rearrangement of the temple also led to the construction of an L-shaped portico, to

the north of which was the *ekklesiasterion* (14) of the people of Delos with, next to it, a central peristyle building and two banqueting rooms (mid-5th century BC). Toward the east, the semi-circular *Sèma* was cut out of the rock to contain a Mycenaean tomb known as the "tomb of Laodike and Hyperoche," two young virgin girls who had arrived from the land of the Hyperboreans to bring gifts to Apollo.

Returning to the *temenos* of Apollo, you will come across a series of *thesauroi* (15). The first is identified as the *oikos* of Karystos, then come those of cities of the League but they have not yet been identified. Next are the public buildings of Delos: **building Δ (16)** is the *bouleuterion*, and **building 22 (17)** with a *prytaneion*. The altars of the civic gods lie to the west of this. The only one identified is that of Athena and Apollo *Paion*. To the east are the foundations of the imposing "monument of the bulls".

Probably begun by Demetrius Poliorcetes to celebrate the naval victory at Salamis (306 BC) over Ptolemy I Soter, it was completed by his son Antigonus Gonatas. The south pronaos opened into a long gallery with a northern bay connected to it by two corridors characterized by half-pillars adorned with bulls' heads. A lovely frieze of Nereids on seahorses originally ran above the plinth of the gallery but is now seen in front of the façade. All this was purely to support Antigonus' flagship, which was dedicated to Apollo to commemorate another great victory over the Ptolemies in 255 in the waters off the island of Cos. The same Antigonus was responsible for the **large portico (18)** that bounds the enclosure on the north side.

Built between 275 and 250 BC – Doric on the outside, Ionic inside – with a decoration of bulls' heads on the metopes of the architrave.

Yet another example of dynastic celebration is seen in the monument of the *Progonoi*, with bronze statues of Antigonus' ancestors, and the *thèke* of Opis and Arge, which is a semicircular funerary monument around a Mycenaean tomb that tradition has assigned to another pair of Hyperborean maidens.

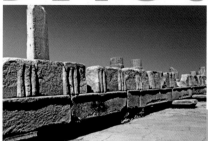

To the north of the complex there is a number of buildings: the **Minoa fountain (19)** (named after a Hellenistic fresco of the Minoid nymphs) monumentalizes the only spring in the sanctuary; a Hellenistic store; and the *Letòon* **(20)**, which was a marble temple built around 540 BC for Leto, the mother of Apollo and Artemis. Its hexagonal decoration has affinities with that in the *hieropoion*.

Farther north is the famous "**agora of the Italics**" **(21)**. This large area (c.223 x 157 feet) may originally have been dependent on the *Letòon*. As the agora had only two entrances (in the southeast and southwest corners), the most accredited hypothesis is that this agora was the slave market rather than the meeting place of the Italic traders. Built at the end of the 2nd century BC, it had a dual order portico (Doric below, Ionic above) behind which there were shrines closed by gates on the east and south sides. Votive monuments and honorary statues were found on the unpaved square. On the west side of the agora lie the ruins of the "granite monument" that was probably the seat of the commercial association of the Italics. The southwest corner of the agora was the site of the *Dodekatheon* **(22)**, a hexastyle Doric temple built by Demetrius Poliorcetes in the late 4th or early 3rd century BC. The nearby port square was paved in 126-125 BC by Theophrastos of Athens. On its north side there is a **hypostyle room (23)** used to store grain (end of 3rd century BC). To the north of the agora of the Italics lay the **Sacred Lake (24)** where Leto is supposed to have given birth to Apollo and Artemis. This area is dominated by the **lion terrace (25)** on which there is a sequence of Archaic lions that guard the *temenos* (second half of the 7th century BC). Still farther north you come to a residential area created during urban development between 120 and 90 BC.

This area was laid out in the customary grid pattern. It should be mentioned, however, that during the Hellenistic period the new layout of Delos was a result of quite random development: the number of agoras multiplied, many warehouses were built around the port, dense residential quarters built up around the theater, and the large houses of the rich were isolated from more populated areas to create their own residential areas, for example near the Sacred Lake and on the slopes of Mount Kynthos. The cosmopolitanism and interests of the individual corporations prevented careful organization. The economic boom accelerated building without a precise development plan, with the result that empty spaces were simply occupied on a private basis.

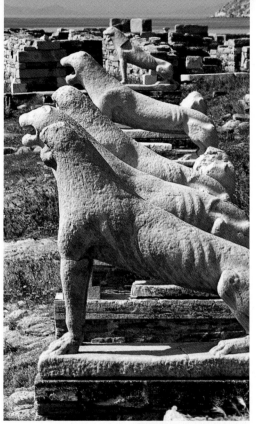

dedicated to the hero Anius, the mythical founder (*archigetes*) of the cult of Apollo. The **Gymnasium** (31) was built in the early 3rd century close to the **stadium** (32) with a **covered track** (33) (*xystos*). A housing district stands on the east side of the stadium and, nearby, there are the remains of an earlier synagogue built following the Diaspora. From the museum, go down to the east corner of Antigonus' portico where there is a small **chapel dedicated to Dionysus** (34) flanked by pillars with Dionysia reliefs (late 4th–early 3rd century BC). From here take the road south to the **monument of Tritopater** (35) built in honor of the mythical

After the **seat of the Poseidoniasts of Berytos** (26) (modern Beirut)—an association of traders and shipowners under the protection of the god of the sea and the goddess Roma—you come to some blocks (*insulae*) of lovely peristyle houses. In particular, the **House of the Diadumenus** (27) provided such sculptures as the famous "Pseudo-athlete" now in Athens and a copy of the famous Diadumenus by Polyclitus. The House of the Tritons in the *insula* of the **House of the Actors** (28) had a fine mosaic of a marine scene. At least 15,000 clay seals were found in the **House of the Seals** (29) which were used to fasten the rolls of

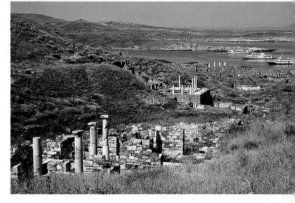

papyrus in the owner's archive. The owner was probably a rich banker or merchant.

Return to the agora of the Italics where you will find the museum. From here you can climb to the gymnasium and stadium, passing by the *Archegesion* (30), the sanctuary

ancestor of the Athenian Pyrrakides family. A path leads to the *Aphrodision* (36), a small private sanctuary from the end of the 4th century BC. On the slope you will see the **House of Hermes** (37), which is a lovely late Hellenistic peristyle house with 3 storys that climb the

hill. Climb to the earlier *Serapeion* of Delos (38): a central feature in the Egyptian cult of Serapis was the water of the Nile, which here is replaced by that of the River Inopos. There are **two more** *Serapeia* (39, 40) farther uphill, the second of which was monumental. Next comes the *Samotrakeion* (41) on two terraces dedicated to the Great Gods of Samothrace.

The **Sanctuary of the Syriac gods** (42) (Hadad and Atargatis, the equivalents of Zeus and Aphrodite) and the *Serapeia* are monumental examples resulting from the influx of Oriental merchants to Delos (128–111 BC). The real cult area of the building lay in a square courtyard that had chapels on the south side and service rooms on the north and east sides. To the north of this stretched a

Kynthos. Along the way you will see the sanctuary of *Agathè Tyche* (44) and, with a deviation to the right, the **Sacred Grotto** (45), thought to have been a Hellenistic sanctuary dedicated to Heracles. Since earliest times, the top of the mountain had been reserved for the cult of Zeus and Athena, and in Hellenistic times this cult was transferred into the 3rd-century BC *Kynthion*

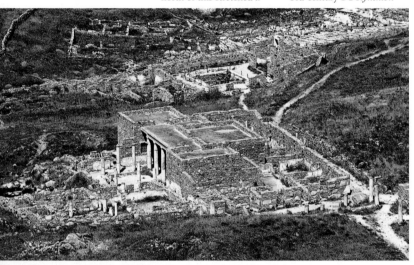

terrace bordered by a portico to the west and a cavea inside a triportico on the other side. This architectural design was later applied on Italic soil in many sanctuaries in Latium and Campania.

A *Heraion* (43) stands to the east of *Serapeion C* (40); its visible remains are those of a 6th-century BC, Doric temple distyle *in antis* with a few vestiges of an earlier building (7th century BC) inside the naos.

A steep flight of steps leads to the top of Mount

(46). Other eastern gods also received dedications in the zone. After descending the mountain, the visit can continue with two of the best known houses on Delos: the **House of the Dolphins** (49) and the **House of the Masks** (48); the names refer to the ornamental motifs seen in the mosaic floors. Note the raised peristyle in the reception wing in the latter. After the Inn you come to the theater that has a cavea dug out of the hill slope. It has 26 tiers

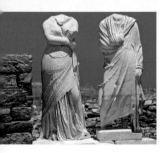

TOP: HOUSE.

ABOVE: CLEOPATRA AND DIASCURIS; DORIC PERISTYLE IN THE HOUSE OF CLEOPATRA.

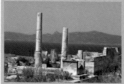

divided into 7 sections in the *ima cavea* and 8 in the *summa cavea*. The stage building was surrounded by porticoes on three sides and the front had a series of Doric half-columns topped

DELOS MUSEUM
Although the most remarkable pieces recovered in the digs have been taken to Athens, the small museum displays important items from the

and the deer) and *rooms 5, 6 and 7* contain **mosaics and frescoes** of high quality from private houses. A collection of **general objects** provides a view of the trade that went

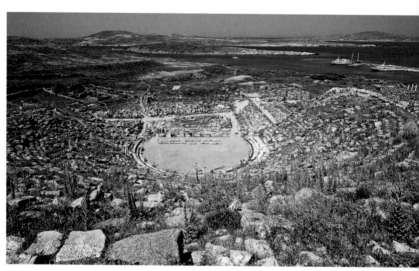

by a frieze with tripods and bucranes (3rd century BC). A large cistern lies to the west of the theater. In the Hellenistic period (3rd to 1st century BC) there was one other large residential district.

A number of upper class houses have been discovered along a paved road (known as "Theater Way"), including the House of the Trident, the House of Cleopatra (named after its rich Athenian owner) and the House of Dionysus.

Archaic, Classical and Hellenistic periods.
Rooms 1–4 contain votive sculptures, including several 6th-century BC **kouroi** and **korai** and a fine **sphinx** made in Paros (6th century BC).
Room 3 has the remains of the sculptural decoration of the 5th-century BC temple of Apollo, including fragments of the *acroter group* of the **abduction of Oreithyia by Boreas** (425–420 BC).
Room 4 has works from the Hellenistic era (**Aphrodite**

on in the large Hellenistic commercial center, with items made of gold, silver, bronze, iron, glass and bone. There is also a good display of **ivory and bone articles** from the Mycenaean age.
Room 8 has a collection of **pottery** and a model of the archaeological site. (S.M.)

PAROS

During the Early Cycladic period the island had proto-urban settlements. Subject first to Cretan, then to Mycenaean influences, Paros grew in size with the arrival of about 1,000 Ionian settlers. The island's famous marble was exported long distances, above all to the coast of Phoenicia. At the start of the 7th century BC, colonists set out from the new city of Parikìa (rather than the old Koukounariès to the north) to found new settlements, like Thasos around 680 BC. At the end of the 6th century, Paros managed to prevail over its neighbor Naxos for control of maritime traffic in the Aegean but it succumbed in its rivalry with Athens. It then entered the Delian-Attic League and succeeded in maintaining its prosperity, however, like

the other islands, it was later dominated by the Ptolemies, the Antigonids and Rhodes in that order. Under the Greek-loving Hadrian, its prestige was restored when the Roman emperor placed the island's famous marble caves under his direct control. Paros was to become one of the largest Christian centers in the Aegean. Traces of the site's flourishing past are far and few in Parikìa. The practice of reusing old building materials was assiduously maintained. For example,

the builders of a Venetian fort on the acropolis used the marbles from an amphiprostyle, hexastyle Ionic temple dedicated to Athena *Poliouchos* (temple A, end of 6th century BC), and also from a second sacred building, distyle *in antis* (temple B, end of 6th century BC). This second building may have been a *thesmophorion*.

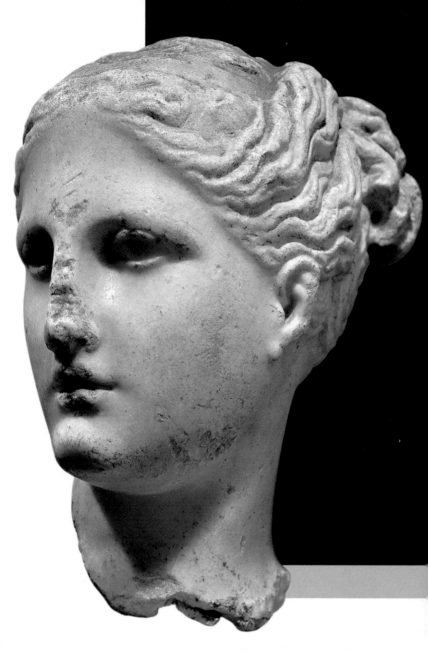

CYCLADES

OPPOSITE TOP: LOW RELIEF TILE;
ARCHAEOLOGICAL MUSEUM
AVENUE.

OPPOSITE BOTTOM: GRIFFIN'S
HEAD *OINOKOE* IN ORIENTALIZING
STYLE.

OPPOSITE CENTER: HARPY;
ARCHAEOLOGICAL MUSEUM.

ABOVE: HELLENISTIC WOMAN'S
HEAD IN WHITE MARBLE.

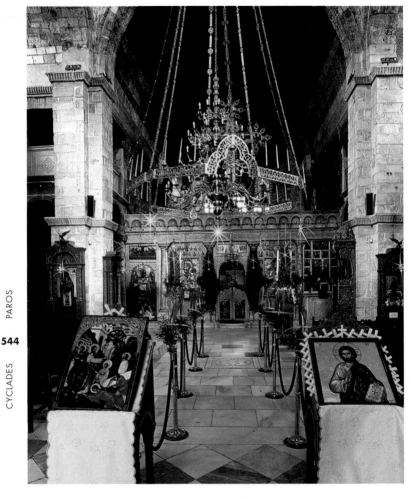

P A R O S

TOP: PANAGIA EKATOMPILIANI
(CHURCH OF ONE HUNDRED
DOORS).
ABOVE: FAÇADE OF THE PANAGIA
EKATOMPILIANI.

The 6th-century AD basilica of Katopolianì in the lower city (*open 8 am to 1 pm, and 4 pm to 9 pm*) stands over a 4th-century AD building that is traditionally connected to Helena, the mother of Emperor Constantine.

A mosaic from the earlier building showing the labors of Heracles is now in the Paros Archaeological Museum. The altar has been reused (unless it was a piece of the portal of the temple of Athena) and several marble seats in the *synthronon* of the choir came from a theater (not yet located).

A small Byzantine Museum is housed in a room in the complex (*open 9 am to 1 pm, and 5 pm to 9 pm*).

THE ARCHAEOLOGICAL
MUSEUM (*open every day
except Mondays, 8:30 am to
2:30 pm*) has 7th-century
BC vases, a Nike on an
acroter from the temple of
Athena (470 BC), and a

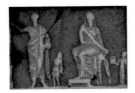

figure of a Gorgon from an
Archaic acroter. Not far
from the museum
excavations have recently
shed light on a housing
district and, near the
seashore, necropolises from
the 7th–2nd centuries BC.
Near the little church of St.
Anna, the ruins of a
sanctuary dedicated to
Apollo *Pythios* stand on
two separate terraces.
There was an
amphiprostyle hexastyle
Doric temple (c. 400 BC)
and an *Asklepieion* annexed
to an early 4th-century BC
sanctuary.
Three miles north of the
city at Dèlion there are the
remains of another
sanctuary dedicated to
Apollo. On a squarish
terrace a sacred rock used
as an aniconic (not human
or animal on form).
representation of the god is
surrounded by a small wall
(early 5th century BC). A
small Doric temple
dedicated to Artemis stood
in the northern section of
the site and the cult statue
is now in the museum. An
altar and a *hestiatorion*
(room for sacred banquets)
were also part of the
complex. A deposit for
votive objects was found to
contain items from the
Geometric Age, which is
when the cult (celebrated
outdoors) is thought to

have begun.
Naussa lies 6 miles
northeast of Parikìa and is
a pretty village with a
small port and Venetian
fort. The 17th-century
monastery of Logovarda
lies on the road to the
village (*open to men only,
from 9.30am to 12pm*).
Near Kolymbithrès beach,
in the bay in front of

Naussa, you can see the
vestiges of the site of
Koukounariès. Excavations
there have revealed a series
of terraces between
Mycenaean walls, and the
nucleus of a settlement
that lasted from the
Mycenaean period to the
end of the 7th century BC
when the populace
transferred to Parikìa. (S.M.)

TOP: LOW RELIEF TILE;
ARCHAEOLOGICAL MUSEUM
AVENUE.

CENTER: COURTYARD IN THE
ARCHAEOLOGICAL MUSEUM.

BOTTOM: INTERIOR OF THE
ARCHAEOLOGICAL MUSEUM.

NAXOS

Naxos, the largest and most fertile island in the Cyclades is une île où il fait bon flâner, but it also offers excellent archaeological walks.

Already busy in the Early Cycladic period (Grotta-Pelos culture, 3300–2500 BC) and influenced by the Minoans, a large settlement grew during the Mycenaean age that survived the phase of the collapse of the palaces on the mainland. In the 9th century BC the settlement moved from Grotta to the slopes of Kastro. Trade prospered in the Archaic period, nourished by successful agriculture. Thanks to its increasing prosperity, the island established a hegemony over the Cyclades and, with the Chalcidians, in 735–734 BC the Naxiots even founded a colony in Sicily, also called Naxos. The tyranny of Lygdamis (550–524 BC) represented the island's period of greatest power and splendor, when it was able to make impressive gifts to the large panhellenic sanctuaries, for example, the Sphinx in Delphi and the colossal statue of Apollo on Delos. After being sack by the Persians in 490 BC, Naxos entered into the sphere of

influence of Athens and its decline set in. The acropolis of the Archaic city lay near the Venetian castle built in 1207 by Marco Sanudo in Chora and stretched down to the sea (locality of Grotta). Very little can be seen today: the Hellenistic agora

(3rd century BC) in Platìa Mitropòlis was once surrounded by a triportico (see the bases for statues and commercial buildings). The monumental entrance to the naos of a large temple, probably dedicated to Apollo, stands at the entrance to the port. The

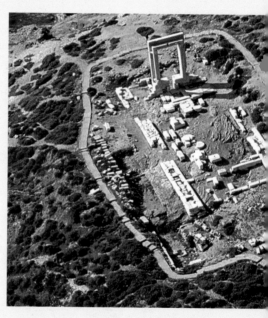

Ionic temple (6 x 12 columns, a double colonnade at the front, and three aisles in the naos) was built on the wishes of Lygdamis but left unfinished when the tyrant was chased out. It was turned into a Christian basilica in the 5th or 6th century AD. A small

OPPOSITE TOP AND CENTER: DETAIL
FROM THE ENTRANCE IN THE
TEMPLE OF APOLLO.

LEFT: NAXOS CATHEDRAL.

BELOW: COLOSSAL *KOUROS* IN
IONIC STYLE; MARBLE QUARRY AT
APOLONA.

BOTTOM: NAXOS, INTERIOR OF THE
ARCHAEOLOGICAL MUSEUM.

CYCLADES

museum in the old Jesuit school (*open every day except Mondays, 8 am to 3 pm*) has a lovely collection of prehistoric idols, Mycenaean objects, Hellenistic funerary stelae and Roman coins and glassware. A large sanctuary dedicated to Dionysus in

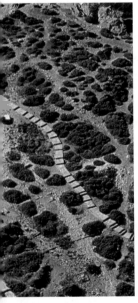

Irìa (2 miles south of Chora) was where the myth developed of Ariadne being abandoned by Theseus on his return from Crete, and of her union with Dionysus. There is a tetrastyle prostyle Ionic temple with three aisles and an *adyton* dating to the first half of the 6th century BC. This replaced

an earlier building (7th century BC) which, in turn, had taken the place of an open cult area from the Geometric Age. Another very interesting building is the 6th-century BC *telesterion* found inland at Sagrì-Giroulas. A *telesterion* was a temple where the Mysteries were celebrated, in this case dedicated to Demeter and Kore. The wide transversal room where the initiation into the cult was celebrated was divided into two aisles; it has five Ionic columns *in antis* on the two façades, a roof made completely of marble and tiles that let the light filter in. Also of interest inland are several Byzantine monasteries that have given the plateau of Traghea the name of "Little Mistrà." The most important is the one in Drossiani 12 miles east of Chora (*open from 10 am to 1 pm, and from 4 pm to 7 pm*). Picturesque Apèiranthos (16 miles east of Chora) is

known as the "marble village" for the wide use of this material in its architectural decorations and paving. The local museum has a small collection of 3rd-millennium BC marble plaques incised with scenes of everyday life. And finally at Apòllonas (17 miles northeast of Chora) there is an enormous statue of a bearded Dionysus (roughly 33 feet high and 85 tons in weight) in a cave. The statue was left little more than sketched out owing to damage that occurred during the work. A second colossal statue was found just a little downhill from the cave. (S.M.)

MELOS

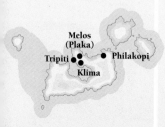

This almost desolate volcanic island of white villages and small beaches owes its fame to the famous statue of Aphrodite known universally as the Venus de Milo. This 2nd-century BC work was discovered by chance in 1820 and purchased by the French ambassador in Istanbul as a gift to Louis XVIII; since 1821, however, it has been exhibited in the Louvre. Its quality as a statue derives from the contrast between the softness and gentleness of the body with the gathers of the wrap, and the sinuous rhythm of the body that harks back to the work of PRAXITELES. In fact, Melos was both prosperous and important in the history of the culture of the Aegean back in the 3rd millennium BC due to its export of obsidian (see the excavations at Phylakopì 6 miles north of Plaka). On this site a modest settlement (referred to as Phylakopì I) was destroyed by an earthquake

c. 2000 BC. Over this a new, planned settlement was built with straight roads and frescoed houses (Phylakopì II, c. 2000–1650 BC); there was also a palatial residence in Minoan style in the northwest section (c. 1600

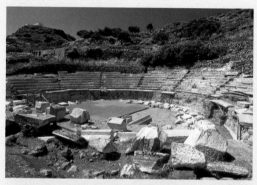

BC). After a fire destroyed the village, a new city (Phylakopì III) was raised with a double defensive wall around 1500 BC. The arrival of the Mycenaeans (c. 1400 BC) resulted in the transformation of the "palace" into a *megaron* and the construction of a

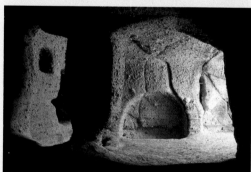

"western sacellum" (c. 1300) followed by an "eastern sacellum." A large necropolis stretched across a nearby hill. With the arrival of the Dorians (c. 1100 BC), the entire complex was destroyed. Today the ruins of

Phylakopi III are visible. The small Archaeological Museum in the island capital—Melos or Plaka— has a large collection of objects found on the site of Phylakopì, such as terracotta figurines, pots, marble idols, and Archaic, Classical and Hellenistic sculptures and

MELOS

548

CYCLADES

ceramics (*open everyday except Mondays, 8:30 am to 3 pm*).

Near the village of Trypiti (bus from Plaka) you can visit an underground necropolis from the early Christian era (*open every except Mondays, from 8.30am to 3pm*). Its catacombs – some of the most extensive outside of Rome – were used from the late-3rd to the 5th century AD. Heading toward the small port of Klima, you come to the remains of the Archaic city; this passed under the control of Athens, was "liberated" by Sparta in 405 BC, and prospered in the Hellenistic and Roman periods. Visitors can see the following: stretches of the walls with a round tower (6th-5th centuries BC); the agora (where the statue of Aphrodite was found), the 3rd-century BC theater, the later *odeon* with nearby gymnasium, and a building used by an association related to the cult of Dionysus (fine Dionysian mosaic from the imperial period). (S.M.)

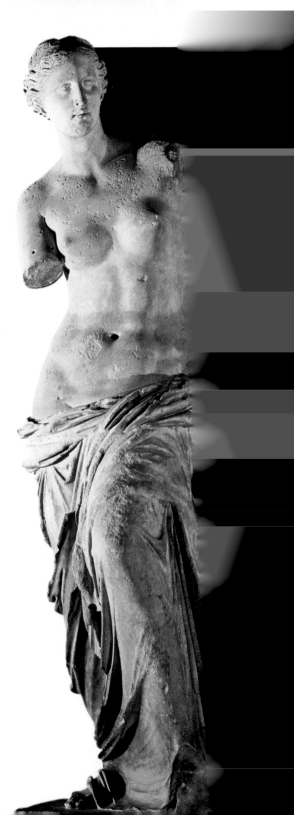

SANTORINI

Leaving aside the superficiality with which the tourist industry treats Santorini, with names like the "lost Atlantis" and the "Pompeii of the Aegean," the island is a place where vestiges of the life there almost 4,000 years ago have been marvelously preserved.

The origins of this island, the alterations in its landscape and its human history are all the result of a volcano, the only one still active in the Aegean. The crescent shape of the island (continued in the small islands of Therasìa and Aspronisi) forms the outline of the volcano's crater, which collapsed after a series of eruptions that almost ripped its insides out. The small islands in the bay—Palea Kameni, Mikrì Kameni and Nea Kameni—are the results of the volcano's most recent activity, in 1711.

Santorini is formed of black, grey, reddish and during the removal of the earth for this project that the first evidence of life in very ancient times began to appear.

A few remains found on the island of Therasìa in 1866 attracted the attention of the chemist M. Christomanos. Shortly after, the mineralogist M. Alafousos came across a very ancient and practically intact house. The magnitude of the discovery was not lost on the French vulcanologist M. Fouqué,

whitish lava. The layer of pumice and ash that covers it is over 160 feet deep in places and is the reason for the island's extraordinary fertility. Along the cliffs it is easy to extract earth that can produce cement with excellent hydraulic properties due to its chemical composition. This was used in abundance in the construction of the Suez Canal, and it was who continued to excavate, also on Santorini. In 1870 the French Archaeological School of Athens decided to intervene with more regular excavations but the method was, nonetheless, somewhat approximate. The results were not exceptional.

It was many years before a complete and correct understanding of the archaeology of the island

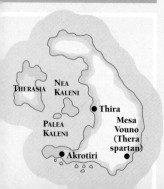

THERASÌA

NEA KALENI

PALEA KALENI

Thira

Mesa Vouno (Thera spartan)

Akrotiri

CYCLADES

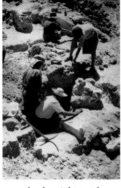

THE MYTH

ensued. This was thanks to Spyridon Marinatos, a Greek archaeologist. (In the 1930s he had theorized that Minoan Crete's decline and ruin could have been connected with a large eruption that vulcanologists estimated occurred around 1500 BC.) In 1962, Marinatos began a series of studies of Santorini that led to seven very successful excavations between 1967 and 1973 near Akrotiri. As the digs progressed, a

many lead weights and stirrup amphoras—used for oil and wine—have been found). As the

Ancient sources did not refer to the catastrophe of Thera directly, but a very distant echo may be heard in some of Plato's dialogues. Wishing to give an ideal model of the organization of society, in his dialogues *Timaeu*s and *Critias*, Plato tells how, during a voyage to Egypt, Solon had learnt of the existence of an

portion of a large built up area was revealed that still today provides one of the most complete pictures of life in the Aegean in the final phase of the Bronze Age.

Though heavily influenced by the Minoan culture, the Santorini community was not a Cretan colony but autonomous and prosperous from its maritime trading (a great

island's economy was based on commercial intermediation, the concentration of wealth, and therefore power, in the hands of a small number of people seems to have been prevented. The consequences of this fact seem to have been a system of collective government and an absence of palatial residences.

island situated beyond the Pillars of Heracles (therefore in the Atlantic Ocean) that collapsed beneath the sea once it had achieved great power. Although today the story is mostly considered a legend, a historical basis for it cannot be denied in the history of the Cretan mastery of the sea and the catastrophe of Thira.

VISIT

Akrotiri lies about 8 miles from Thira and can be reached by bus (*open every day except Mondays, 8:30 am to 3 pm*).

Having arisen around 2000–1900 BC, the city was organized around a north-south street layout with at least 3 types of multi-story houses: luxury residences,

The luxury houses can be seen in *Xestè 3* (**a**) (southwest zone of the excavations). On the west side there are buildings with private apartments on the upper floor and service rooms downstairs. The east side is occupied by a domestic sanctuary with annexes. **Room 3** (**b**), with

settlement, almost an agora. Facing onto it is the **"Western House"** (**j**), considered to have been the residence of an archon, from which come the frescoes of the "Fishermen" and the two "historical friezes" of a naval victory and subsequent celebration. Vases and cups with traces

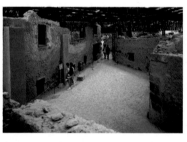

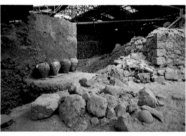

independent complexes and blocks of houses.

The building techniques seem to have been rather refined: wide foundation trenches were filled with blocks of volcanic rock at the base and unfired bricks above ground. Wooden frames were common, which was an effective technique in a region at high seismic risk, and windows and doors sometimes had stone supports. The walls were plastered on both sides and often frescoed internally. The entire settlement seems to have made use of a highly developed system of water drainage.

multiple entrances, has a lowered section for the celebration of rites linked to death and rebirth, and wall paintings that reflect those themes. Passing through the blocks of **houses Γ and B** (**c, d**) you reach **"Mill Square"** (**e**) (named after the mill, **room Δ 15** (**f**)). In the **complex Δ** (**g**), **room 2** (**h**) (probably used for sanctuary functions) was the location of the famous "Lilies fresco," which was an allegory of nature (now in the National Archaeological Museum, Athens).

You then reach the "Triangular Plaza (**i**) which was the focal point of the

of color have been found in this house. It seems probable that after one of the many earthquakes that occurred around 1500 BC, drainage and restoration was carried out. However, this work was interrupted by the major eruption that deposited a layer of pumice over 10 feet deep, then a further layer of pumice, and finally, in the cataclysmic stage, a blanket of ash over 175 feet deep. It was this massive explosion that made the upper section of the cone sink beneath the sea.

Experts have compared the destruction the event created to that suffered in

SANTORINI

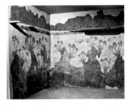

1883 when Krakatoa erupted in the Indonesian archipelago. Carbon dating at Pennsylvania University of a small tree still standing at the moment of the disaster dates the event to 1559 BC ± 44, therefore between 1600 and 1520 BC. Analysis of the pottery found tends to reduce the date by some decades, however, and today the accepted view is that the volcano blew between 1520 and 1450 BC. The absence of human skeletons suggests that the inhabitants may have been able to save themselves following a warning in the form of an earthquake. The later **House of the Women (k)**—named after

a fresco in **Room 1 (l)** — also had a domestic sanctuary connected with a goddess; the main room in the building seems to have been the one with the famous "fresco of the papyruses," which was a metaphor for marriage. Northeast of the excavation area there is the room referred to as the **"north storeroom" (m)**, in which large *pithoi* were used to store flour made with the mill in the western sector of the site.

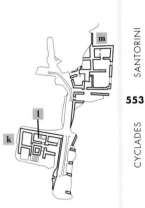

LEGEND

a XESTÈ 3
b ROOM 3
c, d RESIDENTIAL
 BLOCKS
e "MILL SQUARE"
f ROOM Δ15
g COMPLEX Δ
h ROOM 2
i TRIANGULAR
 PLAZA
j WESTERN
 HOUSE
k HOUSE OF THE
 WOMEN
l ROOM 1
m NORTH STORE

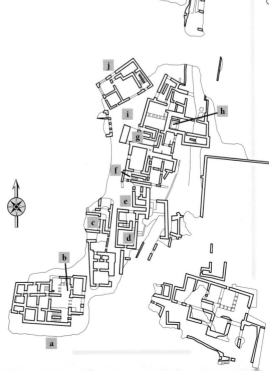

Seven miles southeast of the main town you come to Mesa Vouno and the site of Thira (*open every day except Mondays, 8:30 am to 3 pm*). This was the place of a Spartan colony founded research as yet. The history of the site remains obscure until the first half of the 3rd century BC when the Ptolemies of Egypt rebuilt the settlement and set up a naval base there as an 19th century). You climb steeply and pass a Byzantine basilica before arriving at rock reliefs from the sanctuary dedicated by the Ptolemaic admiral Artemidorus of Perge to

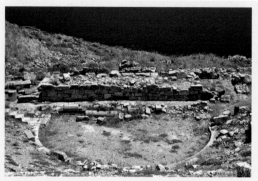

around the early 10th century BC (according to the sources) after a long period of abandonment. The indication provided by sources of a Phoenician "pre-colony" has not been backed up by archaeological outpost in the Aegean. The island, however, later passed to the Romans. Those remains visible today all belong to the Hellenistic period (a German team made the first excavations, in the second half of the various gods (Zeus, eagle; Apollo, lion; Poseidon, dolphin, etc.). Leaving behind the barracks of the Ptolemaic **garrison (a)**, a **gymnasium (b)** and the **"palace" (c)** that may have been the residence of the

ABOVE LEFT: REMAINS OF THE HELLENISTIC THEATER IN THIRA.

TOP RIGHT: RELIGIOUS BUILDINGS, THIRA

BOTTOM RIGHT: AGORA.

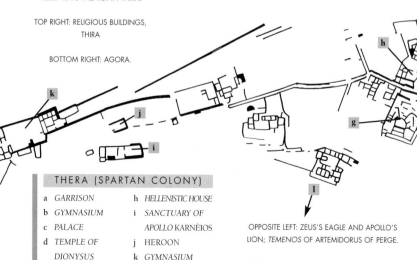

THERA (SPARTAN COLONY)	
a *GARRISON*	h *HELLENISTIC HOUSE*
b *GYMNASIUM*	i *SANCTUARY OF*
c *PALACE*	*APOLLO* KARNÈIOS
d *TEMPLE OF*	j *HEROON*
DIONYSUS	k *GYMNASIUM*
e *TYCHAION*	*OF THE EPHEBI*
f *BASILIKÈ STOA*	l *SANCTUARY OF THE*
g *THEATER*	*EGYPTIAN GODS*

OPPOSITE LEFT: ZEUS'S EAGLE AND APOLLO'S LION; *TEMENOS* OF ARTEMIDORUS OF PERGE.

OPPOSITE TOP RIGHT: PILLARS AND COVERING OF THE CISTERN.

OPPOSITE BOTTOM RIGHT: STOA IN THIRA.

governor, you reach the large agora with its entrance monumentalized by the "temple of Dionysus" (d) that was in fact dedicated to Tyche. It is a tetrastyle, prostyle Doric temple that was restored in the Augustan age as a *Kaisareion*, i.e., a place for the cult of the emperors. Dionysus in fact is attributed with a temple, the incorrectly named *Tychaion* (e) to the north of the theater. The square is dominated by a large portico known as the *basilikè stoà* (f) (from the body of administrators—the *Basilistài*—of the dynastic cult of the Ptolemies that was based here). It was a 2nd-century BC construction that was restored in the Antonine period and transformed into a new and more

monumental *Kaisarèion*. The cavea of the 2nd-century BC **theater (g)** is ringed by a square wall; the proscenium was rebuilt by Emperor Caligula (who had statues of his family placed there). To the west of the theater stands a lovely **Hellenistic house (h)**. Following the "Sacred Way," you come to the **Sanctuary of Apollo Karneios (i)**, who was the tribal god of the Spartans. The temple has a long and unusual plan, with a deep pronaos, naos, two back rooms cut out of the rock used as *adyta*, and no peristasis. It was probably built in the 7th century BC. The rectangular building close by is thought to have been the *heròon* (j) of the founder Theras (unknown date). Lower down is the "**gymnasium of the ephebi**"

(k) from the Hellenistic era. The visit to the sanctuary is completed by the **sanctuary of the Egyptian gods (l)** (Isis, Serapis and Anubis) that stands in front of a Byzantine church. The Archaeological Museum in Thìra (*open every day except Mondays, from 8.30am to 3pm*) has collections of Cycladic idols, Bronze Age pottery from Akrotiri, and Geometric, orientalizing and Archaic pottery from Thera. About 5 miles south of the little town you can visit the monastery of the Prophet Elijah (*open every day except Sundays, 8 am to 1 pm, and 2:30 pm to dusk*) built in the 18th century over two earlier chapels and restored on several occasions. Near Mesa Gonia, not far away, you will find the Panagia Episkopi, a church with lovely 12th-century frescoes founded in 1115 by Emperor Alexius Comnenus. (S.M.)

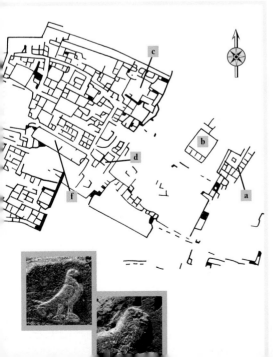

ITINERARY 1

IRAKLION - KNOSSOS -
ARCHANES

ITINERARY 2

MALLIA - DREROS - GOURNIÀ -
KATO ZAKROS - GORTYNA -
FESTOS - AGHIA TRIADA

Meleme

Kastéli

Episkopi Hania Aptera

Samaria

Lissos Rethimno

CRETE

Paleochora

Festos
Aghia
Triada

CRETE

The Minoan palaces, built
when the island was enjoy-
ing its greatest splendor, are
the most popular reason to
visit the place where the
ancients believed Zeus was
born. However, the island
also boasts many Byzantine
and Venetian buildings and
beautiful landscapes.

ITINERARY 1

Iraklion – Knossos – Archànes
Leave Iraklion on route 99
to Knossos, then continue
to **Ano Archànes**. Return on
the main road to reach
Vathìpetro (remains of a
residence, 1600-1450 BC.
*Open from 8.30am to 3pm,
Tuesday–Sunday*).

ITINERARY 2

*Mallia – Dreros – Gournià –
Kato Zakros – Gortyna –*
Festos – Aghia Triada
Leaving Iraklion on the E 75
in the direction of Aghios
Nikolaos, you can visit
Amnisòs (remains of a
residence destroyed by an
earthquake around 1450 BC)
and the villa at Nirou Chàni.
After a stop-off at the palace
of **Mallià** continue to Agios
Nikolaos (*Archaeological
Museum, open 8.30am to 3pm,
Tuesday–Sunday, payment
required*). Ruins of Latò,
7th–3rd centuries BC) from
where you can reach
Elounda. Sixteen miles
northwest of Elounda you

will find the ruins of **Dreros**.
Return to the coast road and
continue in the direction of
Gournià. When you come to
Sitia (*Archaeological
Museum, open 8.30am to
3pm, Tuesday–Sunday*) you
can make an excursion to
Itanos (inhabited from the
Geometric to Hellenistic
ages; remains of 2 early
Christian basilicas), to
Palekastro (remains of a
large Minoan city, 1900-1100
BC) and **Kato Zakros**.
Returning to Pachàmmos,
you can reach Ierapetra on
the south side of the island

(*Archaeological Museum, open 8.30am to 3pm, Tuesday–Sunday*) and **Gortyna** from where you can get to the sanctuary of Asclepius near Cape Lendas. The site can also be reached from Iraklion on the road that crosses Messara (97). Along the route, go to Aghia Varvara where you can visit the ruins of **Prinias**, inhabited 1190–1170 BC and the mid-4th century BC (two temples from the late 7th century BC and some residential quarters).

latest to the 18th century and the church has a splendid portal dated 1587. After **Rethimno** (*Archaeological Museum, open Monday to Friday, from 8.30am to 3pm, payment required*), visit the ruins of the city of **Aptera** (*8am to 3pm, Tuesday–Sunday, payment required*), continue to **Hanià** (on the site of the ancient Kydonia, where there are notable Venetian remains; *Archaeological Museum, open from 8.30am to 3pm, Tuesday–Sunday*).

ABOVE DETAIL OF THE RECONSTRUCTIVE DRAWING OF THE RELIGIOUS PROCESSION, FROM KNOSSOS.

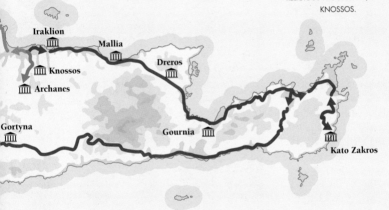

557

CRETE

Continue to **Gortyna** then **Festos** and **Aghia Triada**. Continuing on the coast road, you can visit the monastery of **Moni Previli**, in a marvelous spot at the mouth of the gorges of Kourtaliotiko (*open from 9am to 6.30pm every day*). If you have time, add an itinerary for the west of Crete as follows:
ITINERARY 3
From Iraklion to Kastelli
Leave Iraklion on the E 75 in the direction of Platanès to visit the lovely site of the monastery of **Moni Arkades** (the buildings date at the

From Hanià you can visit the **gorges of Samaria** (*1 May to 31 October, 6am to 3pm, payment required*; 10.5 miles from Xyloskalo to Agìa Roumeli, 5-6 hours walk; at the exit of the ravines there is a ferry to Sfakia which is connected to Hanià by bus). Return to the E 75 and head for Meleme where (near Kolimbari) you turn left for the village of **Episkopi** to visit the **Rotunda church** (built over the ruins of a 6th-century basilica enlarged in the 11th century, it is unique in

Cretan architecture for its stepped dome). Continue to **Paleochòra** on the south coast of the island to visit the *Asklepieion* in **Lissòs** (about 1 hour's walk; city inhabited from the Hellenistic to Byzantine eras). Return to the main road and continue to **Kasteli** (*Archaeological Museum*) from where you can make excursions to Phalasarna (11 miles west, remains of a Roman port) and Poliniria (4 miles south, ruins of a city, 6th century BC-Venetian age).

LADIES IN BLUE; FRESCO IN THE PALACE-CITY AT KNOSSOS.

TOP AND RIGHT DETAILS FROM A FRESCO IN THE QUEEN'S *MEGARON* AT KNOSSOS.

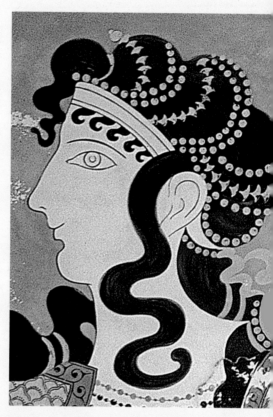

Since very ancient times, Crete's location in the mid-eastern Mediterranean has made it a meeting point for major shipping routes and an indispensable base for communications with the Near East. Until the palace of Knossos was discovered, our knowledge of the splendid civilization that flourished on the island in the 2nd millennium BC was provided purely by a myth. At its center was Minos, the son of Zeus and Europa, the beautiful young girl whom the god, disguised as a white bull, had abducted from the coast of Phoenicia. Minos became king of Crete with the help of Poseidon, the god of the sea, and should have sacrificed to the honor of the god the splendid bull that Poseidon had sent him. But the king saved the bull and sacrificed a less impressive beast, thereby arousing Poseidon's anger. To gain revenge, the god induced Pasiphaë – Minos' wife – to fall in love with the animal and their union produced the Minotaur, half man, half bull, that was locked away in the Labyrinth specially built by Daedalus.

It was to this monstrous creature that the city of Athens had to send a tribute each year of 7 boys and 7 girls until Theseus succeeded in killing the Minotaur in its lair. To escape the Labyrinth, Theseus followed a thread that had been given him by Ariadne, the daughter of Minos.

It was Thucydides' opinion, however, that Minos had been a historical figure: "He was the most ancient of those whom we know by tradition had a fleet and dominated the greatest part of what is now the Greek sea, who ruled over the Cyclades and colonized most of the islands, after having chased out the Carians and established his sons as rulers. And he rid the sea as much as he was able of piracy, as was natural, so that his tributes could reach him more easily." Although the Minoan civilization (named after Minos) provides the most important sites on Crete,

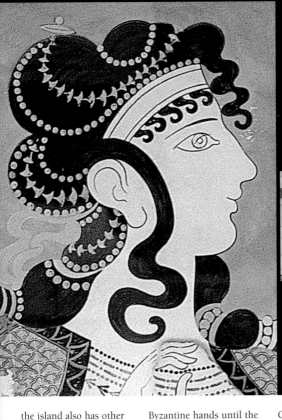

the island also has other impressive archaeological examples from later epochs. There is, however, little of the Roman period represented since Crete formed a single province with Cyrenaica (in North Africa), though the governor resided in Gortyna.

After the division of the Roman empire into its western and eastern components, Crete passed to Byzantium (395 AD). The island remained in Byzantine hands until the Arabs conquered it in 824. They founded Khandaq (today Iraklion). Emperor Nicephorus Phocas reconquered the island and Crete remained Byzantine until the fall of Constantinople in 1204. The long Venetian domination of Crete (1210-1669) is represented on the island by many monuments and spurred a phase of cultural development, in particular artistic. The famous Cretan pictorial school included Dominikos Théotokopoulos, known more commonly as El Greco (1541-1614). The two centuries of Turkish rule were very different. The Cretans attempted to rebel on several occasions and succeeded only in 1898 with the assistance of Great Britain. Having proclaimed itself independent, the island joined the kingdom of Greece in 1913. (C.T.)

Schliemann's spectacular archaeological discoveries at Troy and Mycenae undoubtedly persuaded Arthur Evans (1851-1941) to interest himself in the civilization that flourished on Crete. However, it cannot be doubted that the work of the Italian philologist and epigraphist Federico Halbherr (1857-1930), who began to explore the island in search of inscriptions in 1884, also contributed to the Briton's thinking.

In 1889, after Crete was pre-Hellenic civilization. This he called Minoan (from the name Minos). Evans' method of excavation was criticized for its lack of scientific rigor, which caused the loss of a part of the archaeological data, and for his rushed reconstruction of

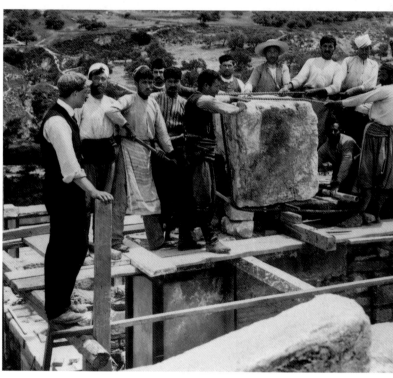

declared independent, Evans purchased the hill of Kefalà where some years previous Minos Kalokairinos had identified the site of the palace of Knossos. Evans began excavation the following year and continued until 1932, publishing his results in the four volumes of *The Palace of Minos*. Evans had unearthed a magnificent complex and, at the same time, discovered a splendid entire levels of the building, using concrete. The latter action Evans justified as the need to prevent the upper floors from collpasing during excavation.

From 1899 a permanent Italian archaeological team founded by Halbherr worked on the island. Halbherr himself, in the course of his search for epigraphs, had found the remains of many settlements. The work of the Italians (still in progress)

has concentrated in the central and southern zones of Messarà and has provided fundamental contributions to our knowledge not only of the Minoan civilization, but also that of later periods, right up until the period of the Venetians in Crete.

A law championed by Joseph Chatzidakis, a distinguished resident of Crete, encouraged the presence of foreign archaeologists on the island. The farsighted Chatzidakis (a doctor, scholar and founder of the Iraklion Museum) made agreements with countries that had supported Greek independence. He himself had discovered the residences of Tylissòs between 1909 and 1913 and had launched research at Mallia in 1915. He uncovered part of the palace, but reasons of health and financial difficulties obliged him to pass the works to the French Archaeological School of Athens. In addition to the Italian Archaeological School of Athens (the reconstituted Mission founded by Halbherr), several European and American archaeological schools are excavating in Crete today, working in collaboration with the Greek Archaeological Service. (C.T.)

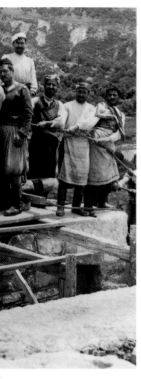

LEFT EXCAVATION OF THE GREAT STAIRWAY IN 1905 DURING ARTHUR EVANS' MISSION.

OPPOSITE BOTTOM ARTHUR EVANS AND HIS ASSISTANTS POSE WITH CLAY ARTICLES FROM KNOSSOS, 1905.

561

CRETE

ABOVE GRIFFIN; DETAIL OF FRESCO FROM THE THRONE ROOM.

BELOW FRESCO OF THE *TAUROKATHAPSIA*; FROM THE EAST SIDE OF THE PALACE-CITY AT KNOSSOS, FROM IRAKLION MUSEUM.

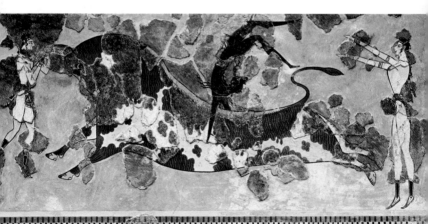

IRAKLION

The city of Iraklion has retained little of its past but has the most important archaeological museum in Greece after Athens.

Founded by the Arabs with the name of Khandaq, the city flourished during the Venetian occupation when, renamed Candia, it became the capital of Crete and the main stronghold on the island. In 1648 it was besieged by the Turks but resisted for 21 years. Once it was taken, Turkish domination marked the decline of the city.

The 16th- and 17th-century fortifications were built under the Venetians and the monumental fountain erected by Francesco Morosini (1628). It has 8 basins adorned with reliefs, all crowned by a tank (14th century) supported by 4 lions.

THE MUSEUM

Odos Xanthoudidou, open every day except Mondays, 8 am to 7 pm. Payment required.

The Minoan collections in the museum furnish the most complete documentation of the various phases of the Minoan civilization. They were begun in 1887 by the Greek Archaeological Society to promote education, and the first collections were exhibited in a dependency of the church of Aghios Minas. After the proclamation of Crete's independence, new premises were prepared to house the increasing number of articles found during the excavations by Sir Arthur Evans and the French and Italian missions. The museum built in 1937 was destroyed by bombing raids in 1941; the current

building was opened in 1952.

Room 1: finds from the Neolithic period (5000-2600 BC) to the Early Minoan (Pre-Palatial era, 2900-1900 BC): **pottery**, **stone vases** (window 7), **marble figurines**, **ivory** and **terracotta**, **weapons**, **jewelry**, **seals** (window 16, mostly from the tombs in Messarà, mostly made in Crete but with some imported from Egypt and Mesopotamia).

Room 2: finds from the Early Palatial period (1900-1650 BC): figurines, pottery (windows 23, 27 and 29; **vases in Kamarès**

style named after the cave on Mount Ida where the first examples were found).

Room 3: the best examples of Kamarès style (windows 31-36 and 43). Window 41 has the **terracotta disk from Festos** (1700-1600 BC) stamped with 242 hieroglyphics.

Room 4: Neo-Palatial period (1650-1400 BC). Objects from the palace of Knossos (window 50, **faïence statuettes** of goddesses with serpents and an **ivory acrobat**; window 51, **steatite** *rhyton* in the form of a bull's head, with encrustations in rock crystal, jasper and mother-of-pearl, 16th century BC; window 57, **chess board** with incrustations in ivory, lapis lazuli and rock crystal). And objects from the palace of Mallia (window 52, **royal sword**

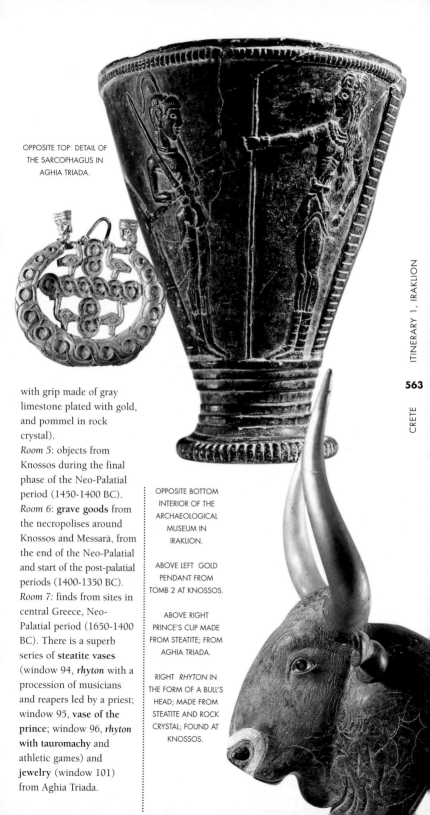

OPPOSITE TOP DETAIL OF THE SARCOPHAGUS IN AGHIA TRIADA.

with grip made of gray limestone plated with gold, and pommel in rock crystal).

Room 5: objects from Knossos during the final phase of the Neo-Palatial period (1450-1400 BC).

Room 6: **grave goods** from the necropolises around Knossos and Messarà, from the end of the Neo-Palatial and start of the post-palatial periods (1400-1350 BC).

Room 7: finds from sites in central Greece, Neo-Palatial period (1650-1400 BC). There is a superb series of **steatite vases** (window 94, *rhyton* with a procession of musicians and reapers led by a priest; window 95, **vase of the prince**; window 96, *rhyton* **with tauromachy** and athletic games) and **jewelry** (window 101) from Aghia Triada.

OPPOSITE BOTTOM INTERIOR OF THE ARCHAEOLOGICAL MUSEUM IN IRAKLION.

ABOVE LEFT GOLD PENDANT FROM TOMB 2 AT KNOSSOS.

ABOVE RIGHT PRINCE'S CUP MADE FROM STEATITE; FROM AGHIA TRIADA.

RIGHT *RHYTON* IN THE FORM OF A BULL'S HEAD; MADE FROM STEATITE AND ROCK CRYSTAL; FOUND AT KNOSSOS.

Room 8: objects from the palace of Kato Zakros (1650–1400 BC); **rock crystal vase** with handle made from crystal beading (window 109 and *rhyton* in green stone and gold plate with image of the sanctuary on the hill (window 111).

Room 9: objects from sites in eastern Crete from the Neo-Palatial period; **vases, figurines of worshipers, seals, weapons** and **tools**.

Room 10: objects from the Post-Palatial period (1400–1170 BC), especially **cult objects** (figurines of idols and worshipers).

Room 11: finds from the sub-Minoan and Proto-Geometric eras (1100–800 BC), in particular **statuettes of gods** with raised arms from the region of Lassithi, where local peoples took refuge on the arrival of the Dorian peoples.

Room 12: Geometric- and Orientalizing-period finds (800-650 BC).

Room 13: terracotta **Minoan sarcophagi**.

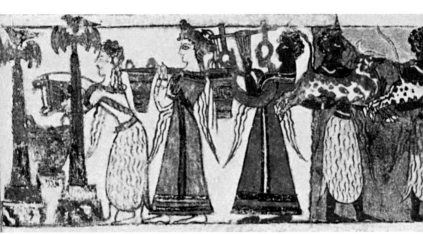

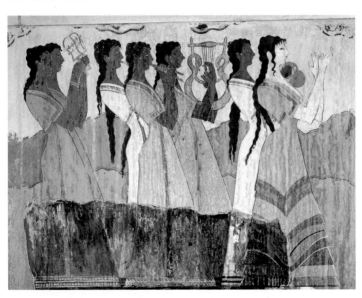

Second floor

Room 14: frescoes mostly from the Neo-Palatial period (1650–1450 BC). From Knossos: fragments of the **procession fresco** (windows 34–37), with male and female figures, musicians, offerings bearers, priests and priestesses (1400 BC); the palace of Knossos (sanctuary with 3 columns, window 10; the "**Parisienne**" (actually a priestess, window 12).

Room 16: frescoes from the palace of Knossos: the "**Saffron Collector**" (actually a dog-headed monkey, window 20) and the **Officer of the Black**

temples of Prinias (650–625 BC); the gate rebuilt as a passage in Room 20 from the same building, with an architrave decorated with an animal frieze, crowned by a symmetrical pair of enthroned goddesses, with high *polos*.

In window 20 there are rare examples of *sphyrélata*, sculptures made from hammered bronze sheets applied over a wooden core: figures represented are of Apollo, Artemis and Leto, the triad venerated in the temple of Dreros. Also impressive are the **bronze votive shields** (windows 208, 209) found with votive cups and drums in the cave on Mount Ida.

Room 20: collection of sculptures from the Classical period to the 4th century AD (C.T.)

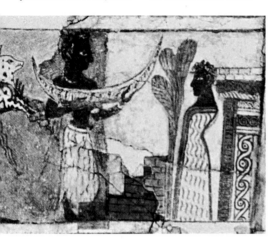

Prince of Lilies (window 6); the "**Ladies in Blue**" from the throne room (1600 BC); the tauromachy from the east wing; the dolphins (1600 BC).
From Aghia Triada: fresco with the **procession of the libations** (window 27) and, in the center of the room, the **stone sarcophagus** painted with funerary scenes (1400 BC).

Room 15: frescoes from the

Guard (window 22).
Room 17: Minoan and Greek objects from the Giamalakis collection (jewels, seals, weapons and pottery).
Room 18: crafts' objects from various eras.
Room 19 (entrance hall): important **Daedalic sculptures** from the Archaic period: the frieze with horsemen from the façade of one of the

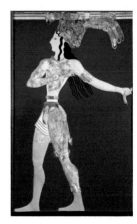

ABOVE OFFERINGS
MADE TO THE DEAD;
SARCOPHAGUS IN
AGHIA TRIADA.

OPPOSITE LEFT
PROCESSION; DETAIL
OF MINOAN ERA
FRESCO AT KNOSSOS.

RIGHT PRINCE OF
LILIES; DETAIL OF
MINOAN ERA FRESCO
AT KNOSSOS.

10.1

KNOSSOS

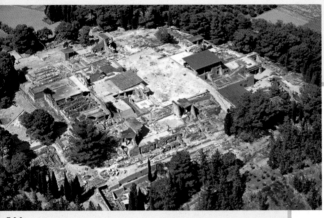

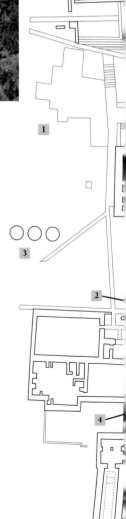

566

CRETE

Knossos was continuously inhabited since the Neolithic period (6000 BC). The first important residence stood in the area of the west court in the Early Minoan II (2900–2300 BC); and this was followed by a monumental building (Early Minoan III, 2300–2025 BC) that preceded construction of the first palace. The palace was built at the start of the Middle Minoan (c. 2000 BC) at the same time as the built-up areas to the northeast (village of Makrì Tichos) and to the south. Destroyed by a fire, the palace was rebuilt on a similar plan, but it burned down once ca. 1650 BC, probably following an earthquake. The palace, of which the ruins can still be seen, was constructed c. 1625 BC (Middle Minoan

IIIB) but was damaged by an earthquake, as were the houses, c. 1500 BC. After another fire c. 1400 BC, it was reoccupied until 1190 BC. At this time a new settlement arose in the area to the west of the palace which, the necropolises inform us, was prosperous until the end of the 7th century BC. There is little archaeological evidence of the city until the Hellenistic age, but its success is confirmed by inscriptions and the civilization's coinage. During this period it was often in conflict with other cities, in particular Gortyna, which it defeated in 220 BC to become the island's most important center. After the Roman conquest, a colony of Campanians (*Colonia Julia Nobilis Cnossos*) left the site and it was totally abandoned after the Arab conquest.

a	*CORRIDORS*		*SANCTUARY*	**16**	*GREAT STAIRWAY*
b	*MONUMENTAL*	**9**	*ROOM WITH THE*	**17**	*COLONNADE*
	STAIRWAYS		*HIGH PITHOS*		*COURT*
c	*VESTIBULES*	**10**	*TEMPLE*	**18**	*DOUBLE-HEADED*

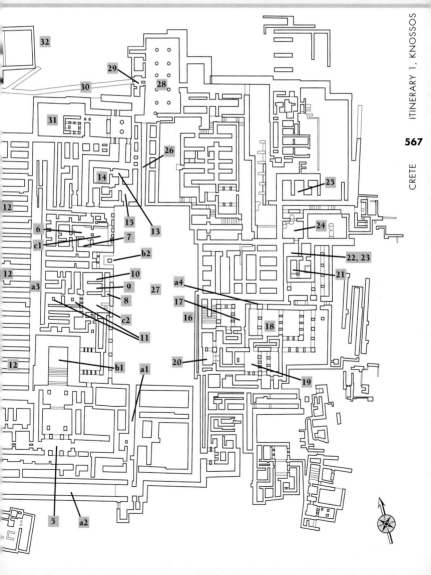

VISIT

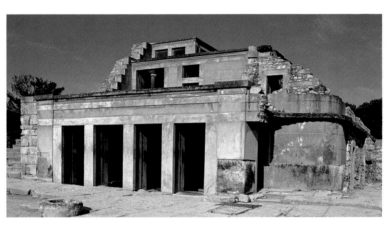

Open every day, 8 am to 7 pm. Payment required.
The palace is reached through the **west court (1)** onto which one of the 3 main entrances open. With its customary series of recesses and projections the west façade appears set back from the façade of the first palace, the limit of which is shown by a flagged strip to the left of the sidewalk that runs from the **theater area (32)**. Heading toward the **propylaeum (2)** you will see 3 **circular wells (3)** that were used to conserve cereals. The propylaeum led into a court with a passage in the southeast corner where the **Procession Corridor (4)** begins. This was named for the wall frescoes of a double procession of about 500 figures converging on a priestess and bearing gifts to the king (the original is in Iraklion Archaeological Museum). The corridor

makes a right angle to the east and then comes out in front of the large **south propylaeum (5)**.
The **Prince's Corridor (a1)** is named for the fresco of the "Prince of Lilies" on the walls (the original is in Iraklion Archaeological Museum) and led to the **central court (27)** from the south entrance to the palace. The court was also connected via a **corridor (a2)** (that no longer exists) from the southwest entrance where the ramp from Kàiratos valley arrived.
A **monumental stairway (b1)** led from the entrance to the second floor of the west wing where a propylaeum followed by 2 vestibules separated by a corridor entered the "**Sanctuary of the Three Columns**" **(A)**. This was a room with 2 rows of supports (the 3 columns but also 3 pillars) that was joined via a door in the

southeast corner to the "**Treasure room**" **(B)**. Stairs on the north side went to the upper floor and a long corridor on the west side separated this zone from the **storerooms (C)** and "**Sanctuary Room**" **(D)**. This was composed of a large **vestibule (D1)** with 2 columns and a rectangular **room (D2)** with 2 rows of 3 columns. From here it was possible to go down to the **vestibule (c1)** of the "**Throne Room**" **(6)**. This earned its name from an alabaster seat with a high backrest that stood against the north wall (the porphyry vase came from a corridor on the north side and was put there by Evans). A stone bench ran along the walls, which were frescoed with a frieze of griffins, two of which framed the throne. The presence of a "**lustral basin**" **(7)** in a side chamber aided in the interpretation of the room

as a place of worship that may have been dedicated to the Minoan Great Goddess, for whom the throne would have been destined.

Another cult area lay to the south of the monumental stairway that led to the second floor from the central court. Part of the cult area was a **tripartite sanctuary** (8)

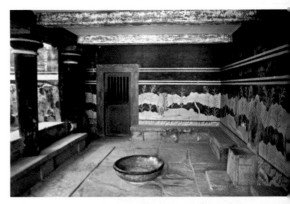

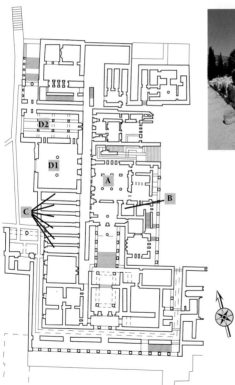

OPPOSITE TOP PAVING IN THE ROYAL ROAD.

OPPOSITE BOTTOM ENTRANCE TO THE THRONE ROOM SEEN FROM THE EAST SIDE OF THE COURTYARD.

TOP INTERIOR OF THE THRONE ROOM.

ABOVE LEFT VIEW OF THE WALLS.

RIGHT THREE LARGE *PITHOI* (FOREGROUND) AND A SECTION OF THE SOUTH PROPYLAEUM REBUILT BY EVANS.

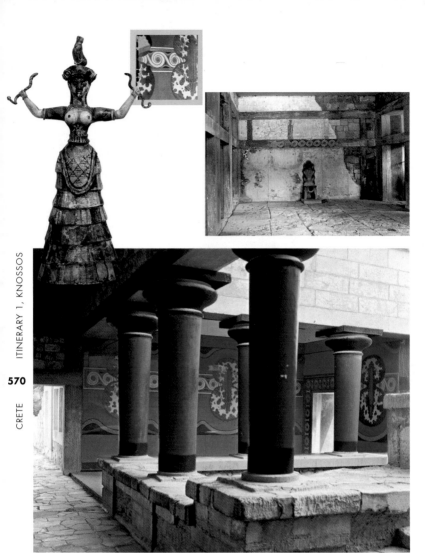

that opened onto the court
with a façade of 5 columns,
one large one at the
entrance to the central aisle
and 2 small ones on either
side in front of the side
aisles.

A **vestibule (c2)** with
marble benches led into
the "**room with the high
pithos" (9)** and the **temple-
storeroom (10)** which got
its name from the
discovery, under the floor,
of 2 important deposits of

cult articles (including the
faïence statuettes of the
serpent goddess (Iraklion
Archaeological Museum).
On the west side of the
vestibule lay the "**Crypt of
Pillars" (11)**, a rectangular
room divided into two
parts, each supported by a
pillar with incisions of
dark double-headed ax
heads. The proximity of
the **storerooms (12)**
suggests that the room was
probably used to celebrate

agricultural fertility
propitiation rituals. It was
only from here that it was
possible to reach the
corridor (a3) lined, for 55
yards, by storerooms for
wine, oil and cereals
containing colossal *pithoi*
(some 6' 6" tall).
This section of the palace
was connected with the
archives via a corridor to
the north. Two rooms in
the archives are known as
the "**Room of the Saffron**

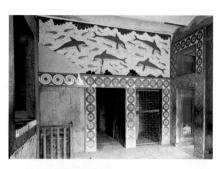

Collector" (13) from the
subject of the frescoes 3
(original in Iraklion
Archaeological Museum)
and the "Room of the
Stirrup Jar" (14). Linear B
tablets were found here,
while tablets with Linear B
and hieroglyphic Minoan
have been discovered in
the surrounding area.
Below these 2 rooms lies
the "Prison" (15). In
reality this was a cereal
store that dates back to the

building from the Early
Minoan III period (the
second residence).
Next you cross the central
court to visit the east wing
(and best preserved
section) of the palace,
which contained the
private apartments. The
layout of the wing is
absolutely innovative in
the manner that it exploits
the difference in level of
terrain. The Great
Stairway (16) opened onto

a light well and connected
the 2 floors lower than that
of the Great Court with the
2 upper floors.
The first landing led down
to the "Royal Guard
Room," which was
decorated with large
bilobate shields. On the
first floor there was the
"Colonnade Court" (17)
on the north side of which
lay the corridor (a4) to
reach the "Double-headed
Ax Room" (18), named

BELOW LEFT STAIRS TO THE
PIANO NOBILE.

BELOW RIGHT FRESCO OF "THE
BULL"; NORTH ENTRANCE
ARCADE.

OPPOSITE TOP NORTH ENTRANCE
TO THE PALACE.

OPPOSITE BOTTOM LEFT VIEW OF
THE EAST SECTION OF THE
PALACE.

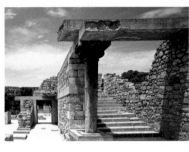
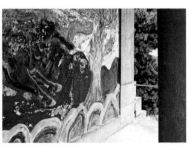

after the many incisions on the back wall of the light well.

The large room where the king held his audiences was divided into 2 sections by a *polythyron* with 4 doorways; the west one gave onto a light well, and the east one opened to the south and east with 2 *polythyra* on an L-shaped, colonnaded veranda that looked over a garden. The remains of a wooden throne and a canopy were found by the north wall of the audience room.

A bent corridor connected the audience room with the queen's **apartment (19)** that was illuminated by a light well on the east side and fitted with a *megaron* on the west. This was found to contain the remains of a terracotta vase. The walls were frescoed with dolphins and dancing girls (original in Iraklion Archaeological Museum). A corridor on the south side of the room led to the "**Queen's**

Bathroom" **(20)** illuminated to the north by a light well. It had benches running along the walls and the water plant for drawing water on the east side.

A narrow stairway between the king's and queen's rooms led to the upper floor where the royal family's private apartments were laid out on a similar plan.

The southwest section contained a place of worship – the "**Sanctuary of the Double-headed Axes**" **(21)** – which was a small square room containing female idols, offerings tables and a 13th-century BC sacrificial horn that documents the continued use of the palace in the Mycenaean period. Back in the "Colonnaded Court," take the **corridor (a4)** to the northeast section where craftsmen produced articles for the royal family. The corridor linked the **stone-cutters' workshop (22)** with that of

the **potter (23)** and the "**Court of the Stone Fountain**" **(24)**. On the west side of the court stood the "**Large Jar Store**" **(25)** where 4 enormous *pithoi* were found dating from the first palace. The area to the west was occupied by storerooms and administrative rooms.

The north section was organized around the **ramp (26)** that connected the **central court (27)** to the large **hypostyle room (28)** ("Customs") divided into 3 aisles by 2 rows of 5 pillars. This room opened onto the **north entrance (29)** (a court with 2 spans) where the **Royal Road (30)** ended. The Royal Road was the paved road that arrived from the port.

As you leave the palace you will see an entrance sanctuary to the left, with a portico that communicated with a "**lustral basin**" **(31)** and the "**Theater area**" **(32)**. This is a large square with monumental steps on the east and south sides

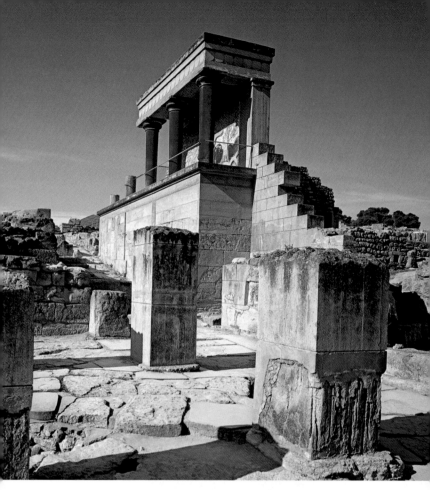

and a square foundation in the southeast corner, perhaps for a stage. The king's high functionaries used to live close to the palace in the so-called "Villas," none of which can currently be visited (Caravanserai Villa, Royal Villa and the Small Palace). (C.T.)

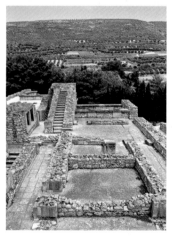

TOP RIGHT *PITHOI* IN THE STORES.

BELOW RIGHT RIGHT PAVED STEPS.

KNOSSOS

ARCHANES

10.1

The territory of Archanes has since been inhabited the Neolithic period (6000 BC). Around 1900 BC a palace was built on the site of Epano Archànes, and though it was destroyed twice by earthquakes (in 1700 BC and a century later), it was twice rebuilt. Then, destroyed yet again in 1450 BC, it was reoccupied during the prosperous Mycenaean era. Following the palace's final destruction, life in the settlement proceeded uninterrupted until the Byzantine epoch.

VISIT

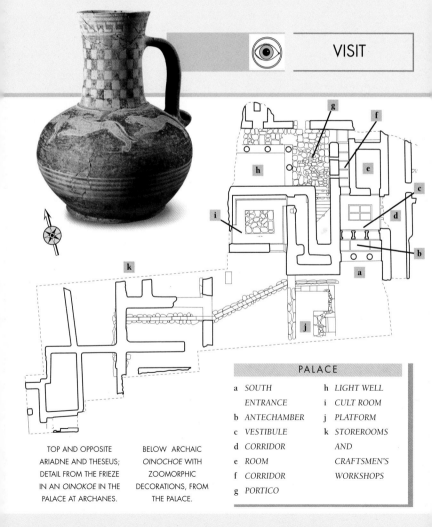

PALACE	
a SOUTH ENTRANCE	h LIGHT WELL
b ANTECHAMBER	i CULT ROOM
c VESTIBULE	j PLATFORM
d CORRIDOR	k STOREROOMS AND CRAFTSMEN'S WORKSHOPS
e ROOM	
f CORRIDOR	
g PORTICO	

TOP AND OPPOSITE ARIADNE AND THESEUS; DETAIL FROM THE FRIEZE IN AN *OINOKOE* IN THE PALACE AT ARCHANES.

BELOW ARCHAIC *OINOCHOE* WITH ZOOMORPHIC DECORATIONS, FROM THE PALACE.

The remains of the palace have been found in the district of Tourkoyeitonia in the modern town. It has therefore been possible to carry out only a very limited excavation, but the quality of the materials used in the construction, together with the fragments of fresco and stucco reliefs, indicate the sophistication of the building and its decoration. So far excavations have brought the following to light: the **south entrance (a)**, a distyle propylaeum, with four curved altars at the sides, that led, through an **antechamber (b)** into a wide **vestibule (c)** that led to the east to a **corridor (d)** and to the north to a **room (e)**.

A **corridor (f)** on the west side of the room gave onto a **portico (g)** that looked onto a **light well (h)** and had steps to the upper floor in the southeast corner. The room on the south side was one of the most important in the palace and finds indicate it was used as a cult **room (i)** (a stone vase containing a shell, a bronze scalpel and a marble pestle). The "**platform**" **(j)** erected in the courtyard in front of the southern side of the palace also had a cult function. A flagged area in the southeast corner may have been where the double-bladed ax stood, and a rectangular stone altar stood at the edge of the north section.

The area to the west of the courtyard had a series of rooms that have been only partially excavated; they were probably **storerooms or craftsmen's workshops (k)**. An element of the inhabited area was the necropolis found near Phourni 1 mile to the north (*open 8am to 12pm, free*). This was one of the largest in the prehistoric Aegean having been in use from ca. 2400 BC to 1200 BC; important grave goods found there (now in Iraklion Archaeological Museum) have provided a fair amount of information on the settlement.

The necropolis has different sorts of graves, some of which are unique to Crete and the Aegean as a whole. The earliest graves (E and G type *tholos* graves) were dug in the south sector. The grave goods included jewelry, precious objects, tools, stone vases, small marble Cycladic idols and obsidian blades, all of which confirm trading occurred with the islands in the Cyclades.

A unique funerary monument (*tholos* B) was built during the Middle Minoan period. It was used as a place of burial and worship for royalty until the Mycenaean age. A large building with 2 wings comes from the next period (Late Minoan). Two *tholos* graves were built in the Mycenaean era for high-ranking individuals.

One of the more important cult places frequented by the inhabitants of Archanes was Anemospilia ("the cave of the wind") on the northern slopes of Mount Iouktas. It was a building with 3 cells and a long corridor, all enclosed by a peribolos. The central room was found to contain the remains of a *xòanon* with 2 large clay feet, and the east room stone and clay vases for the offerings on a stepped altar.

The contents of the west chamber were much more surprising: the skeletons of a man and a woman whose heads had been crushed when the roof collapsed during an earthquake around 1700 BC (which also destroyed the temple). A third skeleton, of a young boy, lay on a low altar with a bronze knife on his chest. This was evidently a human sacrifice in an attempt to avoid the earthquake (C.T.).

MALLIA

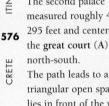

Mallia palace stood surrounded by a town in the middle of a fertile plain between the sea and Lasithi Mountains. Its ancient name is unknown, but the site was occupied in the pre-palatial period (remains of houses beneath the palace's west façade). The first palace was built, like the city, around 2000 BC but was destroyed by the massive earthquake that affected all of Crete around 1650 BC. It was rebuilt shortly afterwards but abandoned completely around 1450 BC.

VISIT

The second palace measured roughly 426 x 295 feet and centered on the **great court** (A) that lay north-south.

The path leads to a large triangular open space that lies in front of the west façade; the architectural features of this façade are its series of recesses and projections. The paved road that crosses the open area north-south leads to the 8 round **silos** (1) (26 ft. in diameter) used to store cereals that line either side of the road. Each silo has a central pillar that supported the cover. Continuing along the south façade of the palace you come to the quarters that could only be reached through a narrow entrance and which do not communicate with the interior of the building. The discovery of many cult objects indicates that this was a small **sanctuary** (2)

for the use of the city inhabitants.

The **main entrance** (3) lay in this façade and led into the **great court** (A) through a wide vestibule. Three doors in the vestibule opened to the right toward quarters with a complex layout of rooms (referred to as the "labyrinth"); one door in the vestibule that opens to the left led to an area with stairs to the upper floor, a **workshop** (4) for making stone vases, and a **storeroom containing** *pithoi* (5).

You enter the vestibule that leads to the **terrace** (6) from where you can see the large round, white limestone table with a hole in the center and 33 recesses around the edge. This was used for the ritual of the offering of first fruit or vegetables, or, according to another hypothesis, for a game similar to roulette.

Only 4 steps remain of the **monumental stairway** (7) at the side of the terrace; each one is roughly 26 feet long and has an unusual depth of between 31 and 39 inches. From here there is an overall view of the **great court** (A) where tauromachies were performed. A sacrificial well at the center is surrounded by a low clay wall with 4 corner pillars that may have supported an altar.

In the southeast corner of the court, visit the area used as a **store for luxury items** (8), to judge by the many fragments of gold found.

Once past the east entrance to the palace, you find a series of **storerooms** (9) for foodstuffs with rectangular storerooms connected by corridors. The east wing ends with what may have been a **kitchen** (10), at any rate, it contained a large

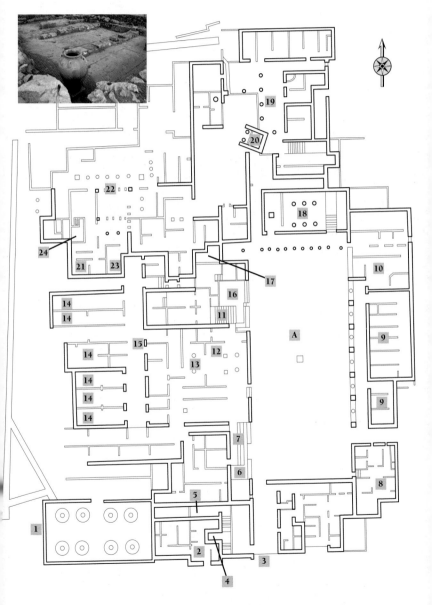

PALACE

A GREAT COURT	7 MONUMENTAL	AUDIENCE ROOM
1 SILOS	STAIRWAY	13 ROOM WITH
2 SANCTUARY	8 STORE FOR	PILLARS
3 MAIN ENTRANCE	LUXURY ITEMS	14 STORES
4 WORKSHOP	9 STOREROOMS	15 CORRIDOR
5 STOREROOM WITH	10 KITCHEN	16 LOGGIA
PITHOI	11 STAIRWAY	17 ROOM OF THE
6 TERRACE	12 KING'S	LEOPARD

18 HYPOSTYLE ROOM
19 NORTH COURT
20 RECTANGULAR
 BUILDING
21 REFINED QUARTERS
22 MEGARON
23 ARCHIVES
24 LUSTRAL ROOM

OPPOSITE AND ABOVE OFFERINGS'
TABLE AND VIEW OF THE STORES.

number of domestic objects. Cross the court again to visit the west wing of the palace, the larger of the two. The **stairway** (**11**) that led to the private quarters on the upper floor are particularly impressive. Originally they were closed off by a door at the level of the courtyard (the only example in Minoan palaces). The first 2 steps led to a landing from which

organized around a "**loggia**" (**16**) that was probably used to celebrate the public ceremonies performed by the king-priest.

Note the "**Room of the Leopard**" (**17**) (the name comes from a ceremonial ax made of schist with the handle in the form of a leopard [Iraklion Archaeological Museum]; similarly, a bronze dagger, long bronze sword with

obstructed by a **rectangular building** (**20**) oriented differently from the rest of the palace.

The northwest section contained the palace's **refined quarters** (**21**). They looked northwards over a garden. The *megaron* (**22**) of the lord of the palace had multiple openings on the south side, facing a vestibule illuminated by a light well. The vestibule led

it was possible to enter the main residential area; this had a vestibule that led into a large room divided into 3 sections.

This was the **king's audience room** (**12**) (from east to west: a small court, a portico with 2 columns, and a paved room with stucco walls and, on the south wall, a short bench). A door in the west wall led to a **room with pillars** (**13**) at the center that aligned with those in room (**12**). The floor's large flagstones were cut and positioned with great precision.

From this room you can reach the others and the many **stores** (**14**) at the west end of the palace, all of which open to the side of the open **corridor** (**15**). The corridor takes you to a series of small rooms

rock crystal grip and an armlet were also found in this room). The room to the north has a drainage channel against the north wall for the water probably used in cult ablutions. Continue toward the north wing of the palace. Standing in front of it was a portico with 11 columns (only bases exist now) onto which the vestibule of a large **hypostyle room** (**18**) opened. This was the largest hypostyle in the palace, with 6 pillars to support the ceiling, but its function is not clear. It may have been a reception room connected through the adjoining steps to a large banqueting room on the second floor.

A corridor led from the central court to the **north court** (**19**), though the passage was rather

to a small chamber containing the **archives** (**23**) of the palace, and communicated down a corridor with another chamber that was related to a **lustral room** (**24**). You then return to the north court lined with storerooms and service rooms and leave the palace through the north gate. The paved road takes you to the vast rectangular agora of the Minoan city. On the south side (beneath a canopy) you see the remains of the hypostyle vault that was probably a public building reserved for the city Council. (C.T.)

···

ABOVE LEFT BASES OF PILLARS IN THE LARGE HYPOSTYLE ROOM.

ABOVE RIGHT THE MONUMENTAL STAIRWAY SEEN FROM THE SOUTH.

10.2 DREROS

The Doric city of Dreros was built over a sub-Minoan settlement to which the necropolis on the north side of the hill belonged, but the history of the site is almost unknown. In the Hellenistic age it allied itself with Knossos in the struggle against Lyttos, but succumbed to the enemy at the end of the 3rd century BC. Excavations have unearthed the Archaic agora that lay in the flat area between the 2 acropolises, i.e., the 2 peaks of St. Antony's Hill. The **temple of Apollo *Delphinios*** (**a**), the tutelary deity of sailors, stood in the southwest corner; it was built in the 8th century BC and composed of a naos with a rectangular *eschara* (**b**) at the center and 2 north-south columns at the side. This was where statuettes of Artemis and Leto were found, made using the *sphyrélaton* technique in which a sheet of bronze was hammered into shape over a wooden model (Iraklion Archaeological Museum). To the east of the temple stood a large **cistern** (**c**) (3rd to 2nd century BC) in which blocks have been found inscribed with the city's constitution in the 7th century BC, which was fixed to the walls of the temple. (C.T.)

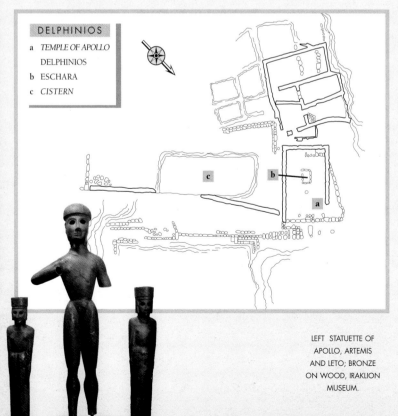

DELPHINIOS

a *TEMPLE OF APOLLO DELPHINIOS*
b *ESCHARA*
c *CISTERN*

LEFT STATUETTE OF APOLLO, ARTEMIS AND LETO; BRONZE ON WOOD, IRAKLION MUSEUM.

GOURNIA

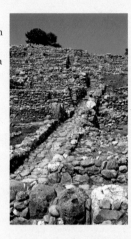

This site is the only known example of a Minoan village. It dates to 1550 BC and was destroyed roughly a century later. The village stands on a hill overlooking the coastal road between Mallia and Kato Zàkros. It grew up around a palace with 6 separate quarters defined by paved roads, each 4'9" wide, and a series of minor roads. During the Mycenaean period the village was reoccupied.

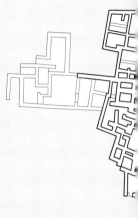

VISIT

Open every day except Mondays, 9 am to 3 pm. Payment required.

Take **road B (2)** to reach one of the best preserved **houses (a1)**, then continue on the cross road south of the house to reach a **sacellum (b)**. This has a bench on the south side and was found to contain cult objects from the Mycenaean period.

Take **road A (1)** and on the right you will see the remains of the **house (a2)** "of the Carpenter." Walking south you will come to the west façade of the **palace (c)** that has large niches on either side of the entrance. The palace was rather small (just 1/10th the size of Knossos) as it was the seat of a functionary dependent on Knossos (he was the governor of the Isthmus of Ieràpetra) but it had the same palatial plan, with a great court, storerooms to the west and private apartments to the north. The large **square (d)** is oriented north-south, which is peculiar to large Cretan palaces, and was laid out immediately south of the residence. An **L-shaped stairway (e)** stood in the northwest corner of the square and was connected to the palace's court via a bent corridor. A sacellum with a porticoed façade stood to the

southwest of the stairway, while a few houses from the period of Mycenaean occupation were built at the southern edge of the square. (C.T.)

GOURNIA	
1	ROAD A
2	ROAD B
a	HOUSES
b	SACELLUM
c	PALACE
d	SQUARE
e	L-SHAPED STAIRWAY

OPPOSITE TOP VIEW
OF THE RUINS..

OPPOSITE BOTTOM
AND
BELOW TWO VIEWS
OF ROAD A.

The bay on which the palace of Kato Zakros stood was the entry to Crete for ships coming from the east (Cyprus, Syria and Palestine). The ruins visible today belong to the palace built around 1600 BC in an area that had been inhabited since 2100 BC; the palace was destroyed by a violent earthquake around 1450 BC. So far it has been the only site discovered intact and, therefore, a great number of exceptional objects were found inside.

TOP LEFT DETAIL OF THE
BRICKWORK IN THE
PALACE AREA.

BELOW CISTERN-POOL IN
THE "PALACE".

VISIT

Open every day except Mondays, 8:30am to 3 pm. Payment required.
You enter the palace from the northeast following the **paved road** (a). On the left you will see the ruins of a forge from the era of the first palace. Cross the **court** (b) (under a canopy in the northwest corner are the remains of a **lustral basin** (c) to the large **central courtyard** (d). On the east side are 2 rooms preceded by a portico: this used to be the **royal quarters** (e, f). Lying behind this, and connected to it, was a **hypetral enclosure** (g) that had at its center a large underground pool, reached down steps and connected to the **spring room** (h) and a monumental fountain. On the other side of the central courtyard you come to the west part of the palace where the storerooms and

cult area stood. The entrance was in the north part of the façade.
A corridor led through the **vestibule** (i) to a large "Ritual Room" (j); the name was given by the discovery of objects used for cult purposes (Iraklion Archaeological Museum).
A **banqueting room** (k) lay on the south side and the series of rooms behind the west side was in some way connected to cult activity. The **sacellum** (l), at the center of the complex, was connected to a **lustral basin** (m). The south part of the complex was occupied by a **stonemason's workshop** (n), the **treasury** (o), with ritual vases, and a **store for cult objects** (p). To the west of the sacellum lay the **archive** (q) where 13 tablets of Linear B were discovered. The **storeroom** (r), on the other hand, was found to

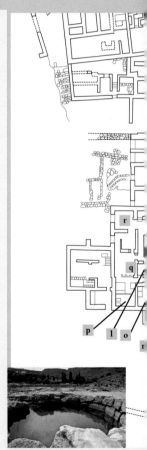

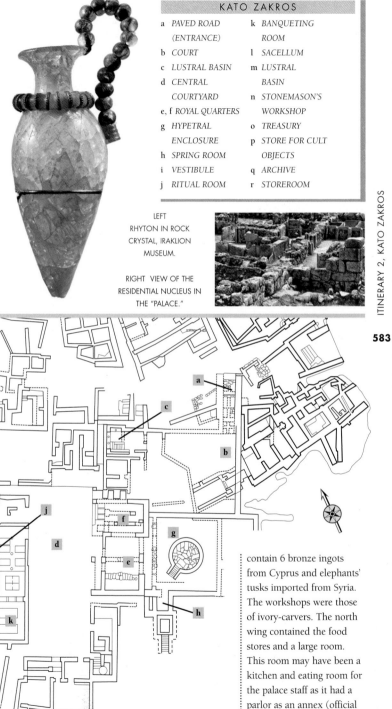

KATO ZAKROS

a PAVED ROAD (ENTRANCE)
b COURT
c LUSTRAL BASIN
d CENTRAL COURTYARD
e, f ROYAL QUARTERS
g HYPETRAL ENCLOSURE
h SPRING ROOM
i VESTIBULE
j RITUAL ROOM
k BANQUETING ROOM
l SACELLUM
m LUSTRAL BASIN
n STONEMASON'S WORKSHOP
o TREASURY
p STORE FOR CULT OBJECTS
q ARCHIVE
r STOREROOM

LEFT
RHYTON IN ROCK CRYSTAL, IRAKLION MUSEUM.

RIGHT VIEW OF THE RESIDENTIAL NUCLEUS IN THE "PALACE."

contain 6 bronze ingots from Cyprus and elephants' tusks imported from Syria. The workshops were those of ivory-carvers. The north wing contained the food stores and a large room. This room may have been a kitchen and eating room for the palace staff as it had a parlor as an annex (official meals were held on the upper floor). A portico preceded the parlor. (C.T.)

GORTYNA

Research has not yet resulted in consistent traces of a settlement from the Minoan epoch, however, there is archaeological evidence on the acropolis of a community that lived in the sub-Mycenaean period and continued until the 7th century BC. And this, tradition tells us, was the period of the foundation of Gortyna by the city of Tegea (or, according to another version, by the Achaeans from Amyklai in Laconia) and the synoecism (urban growth by fusion of small cities) of small centers on the surrounding hills in the Geometric Age. In this period Gortyna dominated the surrounding plain as far as Phaestos and played an

important cultural role in the development of Cretan Daedalic sculpture. This was because Gortyna was the home of Dipoinos and Skyllis (late 7th to early 6th centuries BC), both pupils of Daedalus, who worked in the Peloponnesus. From the 4th century BC Gortyna was often in conflict with other centers on the island, in particular with Knossos, which it defeated in the war of Lyttos (221–219 BC), and, around the mid-2nd century BC, it also subjected Phaestos. During the 3rd century BC, the city began to build a defensive wall on the north side but it remained incomplete despite being a gift from Ptolemy IV Philopater. A new, more

restricted wall was built between 85–82 BC with towers, but this was abandoned in 31 BC following an earthquake. After the Roman conquest in 67 BC, Gortyna was made the capital of Crete and Cyrenaica. Destroyed by an earthquake in 46 AD, it was rebuilt and enjoyed a period of prosperity on account of its cereal exports to Rome in the period from Trajan to Septimius Severus. With the advent of Christianity, Gortyna became an important religious center and was probably the seat of the Cretan metropolitan (bishop). Damaged by earthquakes in 618–620 and 670, its population declined after the Arab occupation of Crete in 826.

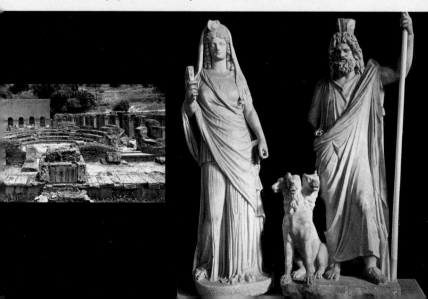

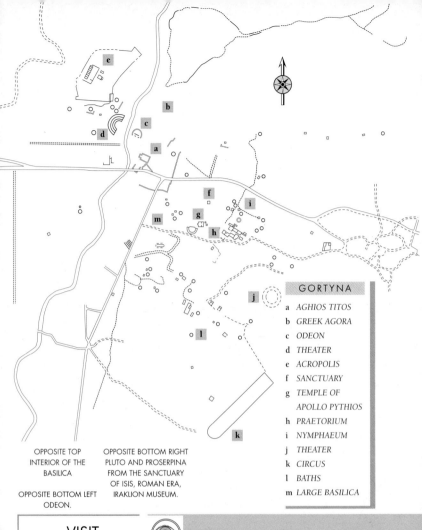

GORTYNA

a *AGHIOS TITOS*
b *GREEK AGORA*
c *ODEON*
d *THEATER*
e *ACROPOLIS*
f *SANCTUARY*
g *TEMPLE OF APOLLO PYTHIOS*
h *PRAETORIUM*
i *NYMPHAEUM*
j *THEATER*
k *CIRCUS*
l *BATHS*
m *LARGE BASILICA*

OPPOSITE TOP INTERIOR OF THE BASILICA

OPPOSITE BOTTOM RIGHT PLUTO AND PROSERPINA FROM THE SANCTUARY OF ISIS, ROMAN ERA, IRAKLION MUSEUM.

OPPOSITE BOTTOM LEFT ODEON.

VISIT

Monday-Friday, 9 am to 7 pm; Saturday-Sunday, 9 am-3 pm. Payment required.
After passing the basilica dedicated to **Aghios Titos** (a), the first Bishop of Crete, built in the Justinian era, you come to the area of the **Greek agora** (b) where the ruins of the **odeon** (c) from the early 2nd century BC can be seen. A text titled the "Queen of Inscriptions" is carved on four rows of curved blocks in the northwest part and represents the earliest text of Greek legislature to have survived (first half of the 5th century BC). The blocks come from the wall of a round Archaic public building that was dismantled in the Hellenistic period and rebuilt as part of a new round building. These materials were then used again in the construction of the 1st-century AD *odeon* on the site of an earlier, rectangular building whose function we do not know. Rebuilt by Trajan after an earthquake, it was restored in the 3rd to 4th centuries. The inscription is engraved in an Archaic Greek script and Doric dialect in 12 columns, each of 52 lines, reading from left to right, then right to left alternately, and contains a series of laws relating to public and private rights.

Two porticoes stood to the west and south of the *odeon*, each communicating with the stage building. The south building used the stylobate of a large Greek portico that faced north and was part of the agora. The river Lethaeos (today the Mitropolianos) flowed by the building and, during the 6th century BC, was crossed by a bridge that connected the agora to the acropolis. During Trajan's reign, the river was partly covered and turned into a road so as to create a common space with the **theater (d)**. The cavea rested on arched substructures made from conglomerate and the *frons scenae* was decorated with reliefs; one showing the Abduction of Europa is now in the British Museum. Emperor Heraclius (610–41) was responsible for the construction of the fort on the **acropolis (e)** and 40 fountains-cisterns connected to 3 branches of an aqueduct. Inside the fort the remains of the temple of (Iraklion Archaeological Museum). On the other side of the road, a path leads to the **sanctuary (f)** of the Egyptian gods. Here there is a sacellum with annexes of a tank and lustral basin that were probably used during initiation ceremonies (2nd century AD). Statues of Serapis, Isis and Anubis (Iraklion Museum) were found inside the naos. At the edge of the built-up area, just to the south, are the remains of the **temple of Apollo *Pythios* (h)**, the most

Athena *Poliuchos* (mid-7th century BC) have been found. Fragments of reliefs adorned with scenes of a divine triad and monumental female statues were found in the pronaos; the latter are important examples of Daedalic style (Iraklion Archaeological Museum). Interesting clay sculptures from the Geometric and orientalizing periods were discovered in the deposit of votive objects of which the most famous is the one known as the Palladio of Gortyna

important in the city. The original nucleus (7th century BC) was built over a Minoan building; it had a naos wider than it was long and a treasury in the northeast corner. In the Hellenistic era a pronaos was built with an entry door and 6 Doric half-columns in the façade, and the floor was flagged with limestone slabs. Renovations under the Romans (2nd century AD) divided the naos into 3 aisles with 2 rows of 4 Corinthian columns (the bases survive); the floor was

covered with marble slabs and a small apse was built at the back to house a statue of Apollo playing a cithara (head in Iraklion Museum). Also a line of slabs joined the temple to the altar in front. Today the 4 steps of the base and the plinth of the altar can be seen.

The **Praetorium (h)**, seat of the proconsul of the province of Crete and Cyrenaica, stood to the east of the temple at the meeting point of the late Hellenistic city (destroyed in 46 AD)

far eastern end, a temple on a high platform dedicated to the deified emperors, with a large quadrilateral portico. The north façade of the temple was given a monumental portico with large granite columns.

To the north of the *Praetorium* stood a lovely late-2nd-century **nymphaeum (9)** that was transformed into a cistern and public fountain under the Byzantines (6th–7th centuries). It had a rectangular basin built

the name of the village refers—were killed in the amphitheater itself and the church dedicated to them stands on the main axis of the arena, its nave at the same level as the original amphitheater floor.

The **circus (k)** lies to the south of the theater with tiers supported by vaults and north-east running *carceres*. It was still in use in the 6th century.

Heading west, you pass by the remains of a large 2nd-century AD **baths (l)**

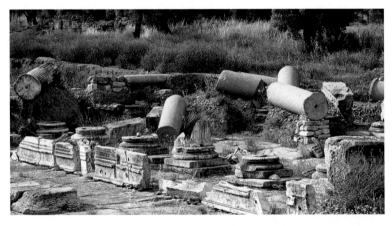

and the new Roman city. The complex consisted of various buildings from the early 2nd century built on the ruins of the first praetorium that had been destroyed by an earthquake. In the reconstruction that followed the earthquake of 365, the "new praetorium" or "basilica" was built with a basilica-like hall in which an apse on the south side opened toward the west with a magnificent north-south colonnade.

This was followed by a large baths complex with, at the

against a wall adorned with small pilasters and Ionic columns.

Heading in the direction of Aghii Deka, a path off to the right takes you to the **theater (j)** that until recently was thought to be an amphitheater. It was built at the end of the 2nd century, and stretches of its external wall remain with 56 arches on two orders. The actual amphitheater lies in the village of Aghii Deka, where the houses make use of the north wall. Probably the ten martyrs—to whom

complex and reach the ruins of a large **basilica (m)**. This is one of the most important on the island for its size and the quality of its materials. It was first constructed in the late Justinian era, rebuilt following the earthquake of 618–620, but destroyed once again after another earthquake in 670. (C.T.)

·······················

OPPOSITE TOP AND BOTTOM TWO VIEWS OF THE TEMPLE OF APOLLO PYTHIOS.

ABOVE STATUE OF A WOMAN.

10.2

PHAESTOS

The Minoan settlement of Phaestos lay across the hills on the left bank of the river in a dominant position over the Messarà valley. Inhabited since the 3rd millennium BC, the first palace was built in the 19th century BC but was twice destroyed by earthquakes in the next century. It was rebuilt on each occasion, however, and the rubble was covered by a layer of concrete to seal each building phase.

After the last earthquake, around 1650 BC, a new palace (II) was built but this was destroyed permanently around 1400 BC by a fire. During this period it seems that Phaestos played a subordinate role to Aghìa Triada, as is shown by the presence of Linear A tablets in the Aghìa Triada

"Villa" rather than in the palace archives.

The settlement enjoyed a certain prosperity after the collapse of Knossos and took a pre-eminence that it maintained until it was destroyed by Gortyna in the first half of the 2nd century BC.

Very little has been found of the Roman or Byzantine periods, a time when Phaestos was largely uninhabited.

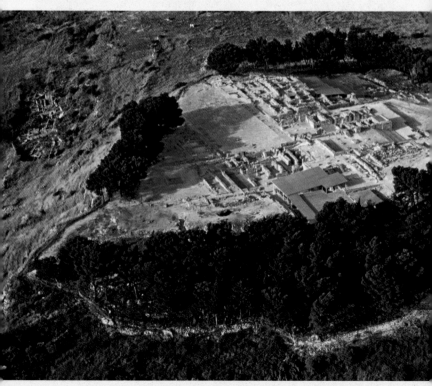

VISIT

*Open every day, 8 am to
7 pm. Payment required.*
The ruins are mostly from
the second palace that
partly covered and partly
incorporated the remains
of the earlier building (last
phase). From the **upper
square** (1) (overall view of
the site), go down to the
west square (2) referred to
as the "theater" due to the
tiers (3) on the north side;
from here the inhabitants
were able to watch the
religious and civil
ceremonies performed in
the open area. Both the
tiers and the square date

from the time of the first
palace. The limestone
plinth of the façade, the
three small rooms in the
corner of the flight of
steps—which, with
annexes, formed a
sacellum (4)—and the
sidewalk (5) were all part
of the palace. The sidewalk
crossed the square
diagonally southward and
veered left to the **west
propylaeum** (5b) of the
first palace. Later the
square was enlarged by
moving the front of the
second palace back. The
entrance to the palace
stood at the top of a
monumental stairway (6)
where a large propylaeum
formed one of the most
original examples of
Minoan architecture: it had
a **vestibule** (7) with
columns between the doors
that led into a second
vestibule (7b) followed by
a **portico** (8) with 3
columns. The axial
progression of the passages
came to an end in a
courtyard (9) that had an
off-center exit in the
southeast corner. The
portico (8) had 2 side
openings that led
northward into the private
quarters and southward
into the west storerooms
and central court. These
sections of the site could
be reached via the **stairway**
(10) reached from the

court (9). Turning left, you
come to a large **peristyle
room** (11) that contained
the ruins of a house built
long before the palace. On
the north side there was a
veranda (12) reached
through a *polythyron*. The
stairway in the northeast
corner led to the right to
the "Queen's *megaron*"
(13) and to the left to the
"King's *megaron*" (13b).
The queen's *megaron* was a
large, three-part room with
2 rows of columns and a
light well in the center. A
sacrificial trench found
beneath the floor has been
identified as the foundation
deposit of the previous
palace; in other words it
was a private place of
worship connected with
the floor above by stairs on
the west side. Similarly, the
king's *megaron* had a three-
part division created by
polythyra. He also had a
private sacellum that gave
onto a veranda on the
north side through a
partition wall with 7
openings. From the
veranda, the king had a
view of Mount Ida. A
corridor connected the
megaron with a series of
rooms thought to have
been related to cult
practices by the presence of
a lustral basin.
Continuing eastward, you
come to a group of
buildings that were part of

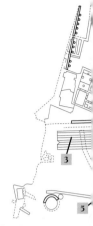

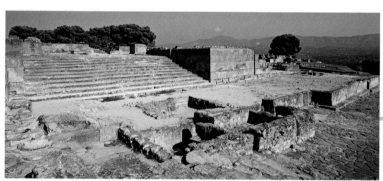

the first palace, the plans of some of which were adopted in the construction of the second version, for example, the **hypostyle room** (14) connected via a ramp to the **court** (15) where the east entrance stood. The famous terracotta disk that bears a hieroglyphic inscription (Iraklion Archaeological Museum) was found in one of the building of the area. This sector was separated from the royal apartments by a wide **corridor** (16) that started at the north entrance and led into the **court** (17); from here a **corridor** (18) led eastwards to the **craftsmen's quarters** (19), in particular, metal workshops (washing tanks and a forge).

Also from the **court** (17), a **corridor** (20) led to the large **central court** (21) where, on the right and left, groups of rooms lay that may have been used as kitchens and banqueting rooms. The central court was also part of the first palace. In the second version it was lined with porticoes with columns and pillars on the east,

west and perhaps south sides. During large festivals it was fitted out for tauromachies. In the northeast corner a two-step block was used as a springboard by bull-vaulters. Standing in the center of the court, you can admire the façade of the west wing; it had a doorway lined with 2 half-columns, large shrines, and niches halfway up the wall. The eastern side of the court was served by a **corridor** (22) and contained other **residential quarters** (23) (called the "Prince's Apartment") of which most has collapsed. The western area, where the storerooms lay, could be reached from the large court down a **corridor** (24). Another **corridor** (25) served a series of **administrative rooms** (26) where the administration and bureaucratic functions of the palace were carried out. The north part of the **storerooms** (27) included a series of rooms that lined a corridor reachable from a large **room** (28). This, maybe the "office," had 2 columns at the center and

walls lined with alabastrine plaster and looked out onto the central court. This room was found to contain more than 6,500 clay seals used to seal the doors.

An **exedra** (29), with benches along the walls, and a crypt with 2 pillars faced onto the court on the south side.

Two rooms could only be reached from the west square and were probably a place of worship for the inhabitants of the city. From here it is also possible to see storerooms dating to the first palace closed off on the west side by houses built in the Geometric Age. (C.T.)

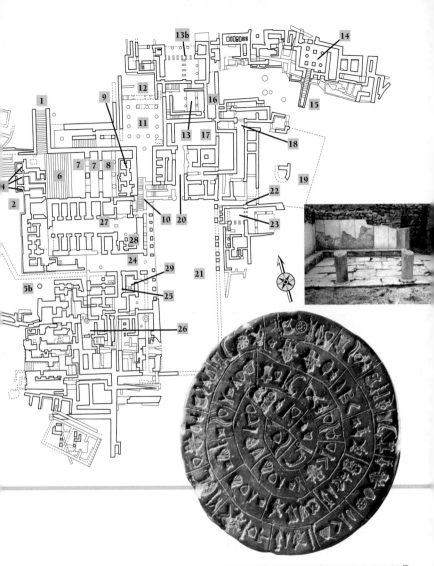

AGHIA TRIADA

The ancient name of the Minoan village in this locality is not known though its proximity to Phaestos would have placed it in its territory. The current name is taken from the church dedicated to the Holy Trinity, which the Venetians built in the 14th century, less than a mile from the ruins.

The site was occupied in the Early Minoan period by a large settlement that may have been split into different sections, but, like so many centers on Crete, it was destroyed by an earthquake around 1650 BC.

Around 1600 BC, a large aristocratic residence (the "Villa") was built and the village was organized at the same time. The next period was prosperous for the village and new buildings were constructed in the urban area and residence (a crenellated wall cut through the built-up area east-west) but it was all destroyed in 1450 BC by a fire.

In the 14th century BC another phase of intense building occurred that led to the new city. This had a political and religious focal point in the area of the Villa and a residential and commercial area in the north central zone. The

city was definitively destroyed around 1190 BC but the "Square of the Sacelli" was still visited for cult purposes until the Geometric Age.

A small temple was built to the god Velchanos (the indigenous Zeus) in the 2nd century BC over which a country house was built during the Roman domination.

AGHIA TRIADA,

1 SEA RAMP
2 COURT
3 ROOM
4 PORTICO
5 SMALL COURT
6 PORTICO
7 ROOM
8 BAY
9 BAY
10 FRESCOED ROOM
11 SMALL PORTICO
12 ROOM
13 ROOM
14 LIGHT WELL
15 POTTERY STORE
16 POTTER'S WORKSHOP (?)
17 SERVANTS' ROOMS
18 LIGHT WELL
19 BAY
20 STOREROOM

ABOVE AND OPPOSITE DETAILS OF THE PAINTED SARCOPHAGUS AGHIA TRIADA, IRAKLION MUSEUM.

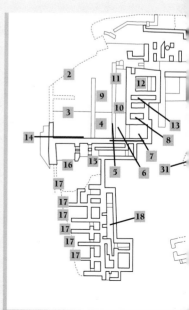

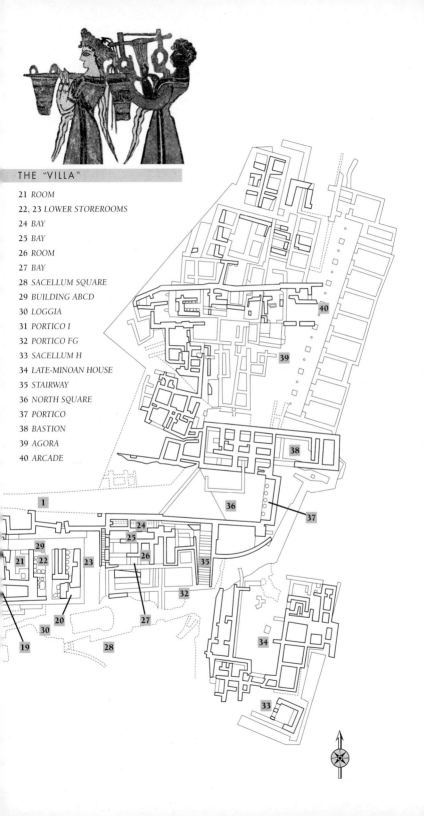

Monday-Saturday, 8:45 am to 3 pm; Sunday 9:30 am to 2:30 pm. Payment required.
The visit can begin from the Villa, which consists of 2 square sections that flank an open square. A second square, to the north, separated the Villa from the village. You reach the north wing from the "Sea Ramp" (1) up a flight of steps. The owners' apartments in the northwest section were not large but were carefully and

into a room (7) with a bench and walls lined with large plaster slabs. The door on the left led into a bay (8) that originally opened into the portico (6). Going north, you passed from the portico (4) into the bay (9) on the south side of which 6 toothed stone bases were kept. Two were used for the door, and the others (closed at the sides by plaster slabs) were used as cupboards for drawers of archival

headed axes were found in the room (13). Back at the portico (4), continue south to visit the servants' quarters and service rooms. Beyond the door a stairway with plaster steps was illuminated by a light well (14) and led to a pottery store (15) on the upper floor. The room next to it may have been a potter's workshop (16). From here you enter a series of bays that were probably used as

elegantly finished. They were set around a court (2) with a portico on 2 sides that gives a view over the gulf of Dibàki and the valley of Geropotamòs, closed to the north by the Mount Ida range. Passing through a *polythyron* with 6 openings, you entered a room (3) that to the east gave onto a distyle portico (4) illuminated by two windows looking onto a small court (5) and a second portico (6). This led

materials. This room was originally connected to the east to 2 bays, one of which was a frescoed room (10) (fragments of a woman seated in a garden and a wild cat following a pheasant can be seen in Iraklion Museum). A flight of steps on the north side descends to a small portico (11) to the east of which were rooms (12) accessible only from the upper floor; nineteen copper ingots in the form of incised double-

the servants' rooms (17). The bays could only be reached from the west side or from the upper floor, and were illuminated by a light well (18). Back at the court (2) you can visit the food stores in the central section of the north wing. Bay (19) was built particularly precisely and had, at the center, a pillar around which there ran a band of plaster slabs slightly raised to allow easier positioning of the

large *pithoi*, which were originally set against the walls like in **storeroom 20**. The walls of **room 21** were also covered with plaster slabs used to support the large liquid-storage vases; the slabs were made with a small circular groove to position the vases and a spout to allow excess liquid to drain off. From here you descend to the **lower storerooms (22, 23)**. Continuing east, you enter

discovery of votive cabinets) that was part of the residence from the earliest version. Between 1450 and 1400 BC, the square was extended and paved over. At the same time, a large rectangular building (building ABCD) **(29)** was constructed. Divided into 3 sections, it was typical of mainland Mycenaean architecture. Standing in front of it to the south was a small loggia

(1) to reach the **north square (36)** closed on the east side by a **portico (37)**. The **"Bastion" (38)** (Late Minoan I, 1600-1425 BC) stands on the north side; it was reinforced around 1400 BC when its north side was supported by the stairway to the so-called **"agora" (39)**. On the east side of "agora" was an **arcade (40)** with 8 rectangular bays with earthen floors used as

the other set of owners' apartments, with 3 rooms originally connected by *polythyra*. **Bay (24)** had a large window that opened onto the sea ramp and communicated with **bay (25)**, which in turn opened onto a portico and connected with **room (26)**. The adjacent **bay (27)** opened onto the stairway to the upper floor. The visit continues by climbing up to the "Sacellum Square" **(28)** (named after the

(30). Other sections of the complex are the portico I **(31)** and the portico FG **(32)** (the seat of a cult), and the sacellum H **(33)** (circa 1600 BC), with a floor of stucco painted with octopi and dolphins (Iraklion Museum). The square was lined on the east side by a paved road that went to Phaestus. On the far side of the road lie the ruins of a **Late Minoan house (34)** (1600–1425 BC). Take **stairway (35)** down to the "Sea Ramp"

stores or shops that were a surprising forerunner of the commercial agoras that developed in the Hellenistic era. To the left you will see the ruins of houses that generally date to the last reconstruction of the settlement (Late Minoan III, 1390–1170 BC). To the northeast of the village are the remains of 2 round tombs dating to the Early and Middle Minoan (grave goods in Iraklion Museum). (C.T.)

GLOSSARY

Abacus. Four-sided architectural element at the top of the capital on which the architrave rests.

Akrolithus. Statue with a wooden body, covered with fabric or metal sheets, and with the head and nude parts made in marble or stone.

Acroter. Element at the top of the pediment (or along the sloping roof of the building).

Adyton. Part of the back of the naos or separate room within the naos where the cult statue stood and used for particular ceremonies.

Agora. Main square in a Greek city.

Andròn. The dining room reserved for men in a private house.

Amphiprostyle. Temple with columns set out equally in front and behind.

Anta. Extension of the wall of the naos, with top section in the form of a pilaster.

Antefix. Decorative element in the form of plants, humans or monsters at the end of the outer row of tiles on a roof.

Aryballos. Small spherical or oval vase with a short, narrow neck and flat, wide lip. Used to hold oils and perfumes.

Bèma. The chancel in Byzantine churches.

Bouleutèrion. Building in which meetings of the city council (*boulè*) were held.

Calathus. Central part of a Corinthian capital or a capital in the form of a basket (*kàlathos*) on the head of a caryatid.

Caryatid. Carved female figure used instead of a column or pillar for support.

Chiton. Long, pleated female garment.

Cloisonnè. Honeycomb-like cells (*cloisons*) filled with vitrified material. Similarly, a *cloisonné* wall has small blocks of stone framed by one or two rows of bricks, horizontally or vertically.

Collar. Slim molding at the top of the shaft of a column.

Coroplasty. The art of terracotta modeling.

Crater. Large-bodied vase with wide mouth; types vary depending on the handle (column crater, volute crater) or body (chalice, bell). Mostly used for mixing water with wine.

Diakònikon. Room included in or annexed to a early christian church to receive offerings from the community. Later it was also or exclusively used as a sacristy, archive or library.

Distyle. Temple with two columns at the front.

Dipteral. Temple with a double peristyle.

Dromos. Access corridor to underground tombs.

Echinus. Ovolo molding of a Doric capital, above the collar and below the abacus; on an Ionic column, it lies below the section that unites the volutes.

Exedra. Semi-circular or curved section (sometimes even rectangular), often colonnaded, that adds extra space to a room.

Faïence. Soft clay ceramic pot painted or covered with opaque enamel.

Glyptics. Technique used for engraving gems.

Gymnasium. Building used for gymnastic exercises. In the Classical era it was more generically a meeting place and teaching area.

Gorgonèion. Decorative motif in the shape of a head of Gorgon (mythical winged monster with boar's teeth and hair in the form of snakes).

Hekatòmpedon. Sacred building one hundred Greek feet long (1 Greek foot = circa 11.5 inches).

Heròon. Funerary monument, tomb or temple of a hero or divinized person.

Himàtion. Cloak thrown over one shoulder, pulled around the back and falls down the front.

Hydria. Large vase for water. Similar to an amphora but has three handles, two horizontal and one vertical.

Iconostasis. The screen decorated with icons in Byzantine churches that separates the nave from the *bèma*.

Katholikòn. The church in a Byzantine monastery, generally situated at the center of a court.

Koilon (cavea). Seats in a theater, usually semi-circular, and built against a natural slope.

Kòre. Archaic statue of a female figure.

Koùros. Archaic statue of a male figure.

Krepis. Architectural term that indicates a base, step, parapet or platform.

Laùra/lavra. A series of monastic cells or caves.

Lebete. Large, handleless container placed on a tripod or support; used to store water, or as a prize in competitions, or as a funerary urn.

Lèkythos. Narrow-necked vase with bell-shaped mouth and long body. Used to hold perfume and associated with the realm of the dead.

Lesche. Public room with portico used to hold meetings or provide shelter.

Lesena. Portion of a pilaster, decorated with a base and capital, that hardly projects from the wall. Used for decorative purposes or to divide a space.

Mausoleum. Tomb of the king of Caria Mausolus (died in 350 BC), considered one of the Seven Wonders of the World. The term has come to mean a funerary monument.

Metope. Square, smooth or decorated architectural element which, alternated with triglyphs, makes up a Doric frieze.

Molding. Profiled and decorated element that connects two parts of an architectural structure or a decoration.

Monopteral. Temple with a naos surrounded by a single row of columns or, more commonly, a round temple without a naos, the roof of which is supported by a circular colonnade.

Naìskos. Votive or funerary shrine built like a miniature temple.

Naos. Innermost section of the temple, where the cult statue stands.

Narthex. Transversal vestibule in a church; it may precede the nave (endonarthex) or stand outside the facade (exonarthex).

Nymphaeum. Fountain sacred to the Nymphs; surrounded by architectural features (by extension, a monumental architectural fountain).

Odigìtria. Name related to the Virgin: "she who guides", "she who shows the way".

Oinochòe. Single-handed pitcher used to draw and pour wine.

Olpe. Pitcher similar to an *oinochòe* but the body tends to widen towards the base.

Opisthodomus. Portico located behind the naos and symmetrical to the pronaos.

Order. The forms and proportions of columns and the trabeation in Greek buildings.

Orthostat. Vertical stone slab that forms the lower series of elements in a wall, taller than those above it.

Panàgia. Attribute of the Virgin: "holiest".

Pantanàssa. Attribute of the Virgin: "queen of the world".

Pantokràtor. Attribute of Christ: "lord of the world".

Paraskènion. Each of the lateral parts of the stage in the theater, decorated with pillars or columns and with openings that lead off-stage.

Parigorìtissa. Name related to the Virgin: "she who consoles".

Pàrodos. In the theater, each of the two entrances to the orchestra at the sides of the stage.

Pediment. Triangular architectural element that crowns the façade of a temple.

Peplos. Women's garment made of a large rectangle of fabric held at the shoulders by pins, with a fold at waist-height.

Peribolos. An enclosure or court surrounding a temple; the wall bounding this.

Periblèptos. Name relating to the Virgin: "illustrious, distinguished".

Peripteral temple. Temple with columns on four sides.

Peristasis. Colonnade that surrounds the naos of a temple.

Peristyle. Court surrounded by columns or colonnaded porticoes.

Pòros. Easily crumbled soft limestone.

Prytaneum. Seat of the supreme magistrates (the prytanis) of the city.

Pronaos. Chamber in front of the naos.

Pròpylon (propylaeum). Monumental gate or entrance building.

Prostyle. Temple with columns only in the façade.

Pròthesis. The chamber in early Christian or Byzantine churches in which the Eucharistic bread and wine were prepared and kept.

Quincunx. Mathematical symbol similar to the pattern of the number 5 on a die, therefore the name was given to a building composed of nine bays, the larger central one being square and covered by a dome supported by four columns; four smaller corner bays also covered by domes, and the remaining four rectangular bays covered by barrel vaults.

Rhytòn. Vase in the shape of an animal or an animal horn used for libations.

Shrine. Small temple generally used to hold a statue.

Skyphos. Low cup with horizontal handles.

Stylobate. Temple platform composed of the top step of the platform and on which the columns stand.

Stoà. Long, rectangular structure with one open side. A porch or portico.

Synthronon. In Byzantine churches, the seats or benches reserved for the clergy. Placed in a semi-circle in the apse or in a straight line on either side of the *bèma*.

Tèmenos. Sacred enclosure reserved for the cult.

Theotòkos. Name relating to the Virgin: "mother of God".

Thesauròs. In a sanctuary a small temple dedicated by a city to contain the sacred objects and gifts donated for use in cult ceremonies and votive offerings.

Thòlos. Round building of prehistoric origin made from stone blocks with a pseudo-dome covering; typical of Mycenaean funerary architecture. In Classical architecture, the same term is used to indicate a circular building with or without surrounding columns.

Transept. In a church with a basilical plan, the transept is the transversal section between the nave and the apse.

Triglyph. Decorative element that alternates with metopes in Doric friezes. It is composed of a four-sided tablet with three vertical grooves (beneath it there is a horizontal fillet from which three drops hang).

Xòanon. In the sources the term refers to ancient divine simulacra, mostly made from wood.

Xystòs. Covered arcade in palaestrae, used for racing and exercises; in gardens it is a portico for shaded walks.

ESSENTIAL BIBLIOGRAPHY

Ancient art: general titles
H. van Effenterre, *Les Egéens. Aux origines de la Grèce, Chypre, Cyclades, Crète et Mycènes*, Paris 1986
P.M. Warren, *The Aegean Civilization*, Oxford 1989
M. Robertson, *A History of Greek Art*, I-II, Cambridge 1975
A. Giuliano, *Storia dell'arte greca*, Rome 1989
Lexicon iconographicum myithologiae classicae, I-...., Zurigo-Munich 1981-...
J. Overbech, *Die antiken Schriftquellen zur Geschichte der bildenden Künst bei den Griechen*, Leipzig 1868

Architecture
J.J. Coulton, *Greek Architects at Work*, London 1971
M.C. Hellmann, *L'architecture grecque. 1. Les principes de la construction*, Paris 2002

Sculpture
A. Stewart, *Greek Sculpture. An Exploration*, London 1990

P. Moreno, *Scultura ellenistica*, 2 vols., Rome 1994

Pottery
J. Boardman, *The History of Greek Vases*, London 2001

Ancient history
N.G.L. Hammond, *A History of Greece*, Oxford 1973
D. Musti, *Storia greca*, Bari 1999

Byzantine art
M. Chatzidakis, *Byzantine Art in Greece*, 2 vols., Athens 1980

Byzantine architecture
R. Krautheimer, *Early Christian and Byzantine Architecture*, Harmondsworth 1965

Modern history
R. Clogg, *A Concise History of Greece*, Cambridge 2002

PLACE INDEX

598

599

601

LIST OF MUSEUMS

AND PRINCIPAL WORKS ILLUSTRATED

604

PHOTOGRAPHIC CREDITS

top, 532-533, 553 bottom, 554-555, 567, 577 bottom, 581 top, 590-591, 592-593.

Marcello Bertinetti/Archivio White Star: pages 56, 350 top, 350 bottom, 352, 353 bottom, 354 bottom, 360 top, 361 top.

Yann Arthus-Bertrand/Corbis/ Contrasto: pages 54-55, 151 bottom, 213, 217 top, 222-223, 282-283, 286-287, 322 bottom, 351 top, 352-353, 358 bottom, 359 bottom, 360 bottom, 362 right, 362-363, 363 left, 363 right, 399 top, 424-425, 432-433, 458-459, 490-491, 500-501, 504 left, 504 right, 505, 507, 510-511, 518, 520-521, 534-535, 546-547, 566 bottom, 588-589.

Bettmann/Corbis/Contrasto: page 551 top.

Bibliotèque Nationale de France: pages 180 top, 417 left.

Livio Bourbon/Archivio White Star: pages 53 top, 57 top, 62 bottom, 65 bottom left, 72 top, 75 center, 80, 81 top, 81 bottom left, 81 bottom right, 82, 83 bottom, 87 top, 87 top center, 87 bottom, 88 top, 89 bottom, 94, 95 top left, 95 top right, 95 bottom left, 95 bottom right, 96-97, 97 left, 97 center, 97 right, 183 top, 183 bottom, 184 left, 184 right, 184 bottom, 186 top, 187 top, 188 bottom, 190 top, 191 right, 192 top right, 192 bottom left, 192 bottom right, 194 left, 194 right, 194-195, 195, 196 top, 196 center, 196 bottom right, 197 top, 570 top center

Gary Braasch/ Corbis/Contrasto: page 397 bottom right.

Chuzeville/Photo RMN: page 148.

Elio Ciol/Corbis/Contrasto: pages 168-169.

Gerard Clyde/Barnaby's Picture Library: page 63 top.

Corbis/Contrasto: page 239 top right.

Angelo Colombo/Archivio White Star: pages 4 top, 65 bottom right, 75 bottom, 86, 95 center, 99 right, 118, 119 top, 120 bottom, 124 bottom, 125 bottom, 127 bottom left, 132-133 bottom, 134 bottom, 141, 150 left, 153 top, 153 bottom, 156, 157 top, 160-161, 167 bottom, 171 bottom, 172-173, 176 bottom, 182-183, 188 top, 190 bottom, 193 top, 196 bottom left, 199 bottom, 208 bottom, 204-205, 210-211, 212-213, 220-221, 222 top and bottom, 224-225, 228 bottom, 231 bottom, 233 bottom, 234, 239 center right, 246-247, 258 top, 259 bottom, 264-265, 273 bottom, 282, 293 top, 297, 306-307, 308 bottom, 312 bottom, 314, 314-315, 316, 320 center, 321 left, 323 top, 328 bottom, 333 right, 334 bottom, 346-347, 377 center right, 382 bottom, 383 bottom, 386, 388 bottom, 393 center, 394 bottom, 401 bottom, 402 bottom, 407 bottom, 442 bottom, 444, 444-445, 446 bottom, 451 top, 454 top, 454-455, 456 bottom, 462, 463 left, 464 bottom, 466, 467 top left, 474 bottom, 476 bottom left, 480 bottom, 484 bottom left, 486 bottom a sinitra, 496, 497 top, 498 bottom, 501, 502, 509, 510 right, 524, 525 top, 526 bottom, 526-527, 528 bottom, 542 bottom left, 546 bottom, 548 bottom, 550 bottom, 556, 556-557, 582-583.

Gianni Dagli Orti/Corbis/ Contrasto: pages 5, 99 top left, 99 bottom left, 111, 138 bottom, 266, 343 top, 344 bottom, 438 bottom, 443

bottom, 525 bottom, 562 top, 564-565, 591 bottom, 592, 593.

Giovanni Dagli Orti: pages 2, 4 bottom, 5, 6 left, 6 right, 10, 11, 12, 13, 15, 16, 20, 23 right, 28, 40 top, 44, 67 top, 68 top, 68 bottom, 69, 71, 92 center, 92 right, 104, 107 top,110 bottom right, 114 top, 114 bottom, 115 top, 115 bottom right, 116, 117 top, 119 bottom, 152 bottom, 158 top, 158 bottom, 159 left, 159 right, 169 top, 169 bottom, 178, 186 center, 186 bottom left, 186 bottom right, 202 bottom, 203 top, 209 top, 209 bottom right, 217 bottom left, 270-271, 281, 300 top, 331, 342-343, 343 bottom, 344 top, 374 bottom, 374-375, 400-401, 401 top, 407 center, 408-409, 409, 410-411, 420-421, 430-431, 434, 439 center, 440 top, 440 bottom, 443 top left, 443 top right, 463 right, 465, 473 top, 473 bottom, 474 top, 475, 508 bottom right, 529, 543, 549, 563 top left, 563 top right, 563 bottom, 564, 553 top, 565, 570 bottom, 571 top, 574 top, 574 bottom left, 575, 579 top, 579 bottom, 583 left, 584 bottom right, 591 top.

Araldo De Luca: pages 5, 101 bottom left, 102, 107 bottom, 109 top left, 109 top right, 301 left, 301 bottom, 302 top, 435 top, 435 center, 435 bottom, 438 top, 441 top, 441 bottom, 454 bottom, 456 top, 457, 460 top.

Deutsches Archäolagisches Institut, Athen: pages 181, 256 bottom, 262-263, 263, 278 top, 278 bottom, 279 top, 279 center.

Ecole Française d'Athenes: pages 416-417, 418 top, 418 bottom, 418-419, 530-531.

605

THE AUTHORS

Stefano Maggi
is Professor of Archaeology in the Roman Provinces
in the Department of Sciences of Antiquity at the
University of Pavia, and specializes in the
development of city-planning and architecture in
the ancient world. His publications include a
book on the layout of the forums in the cities of
the Roman Cisalpine Republic, a monograph on
the Roman amphitheaters of northern Italy,
various essays on the theaters and amphitheaters
of the Roman world, and he has edited an edition
of *De Architectura* by Vitruvius, published by
Silvio Ferri. His research embraces portraiture
during the Roman era, ideal statuary and ancient
bronze-works, on which he has written many
articles for Italian and international magazines.
He runs the 'Archaeological Teaching Laboratory'
in his department.

Cristina Troso
is a researcher in Classical Archaeology at the
Department of Sciences of Antiquity at the
University of Pavia, where she teaches History
of Ancient Art. She is a specialist in Roman
pottery, in particular Arezzo table pottery, and
focuses on the transmission of iconographical
elements from Greece to Rome. Among her
many publications, the most important discuss
the Roman architectural materials discovered in
the area of the Cisalpine Republic. With the
Archaeology Teaching Laboratory, she is heavily
involved with schools and museums
throughout Italy.

Flavio Modena
is a graduate in Ancient History at the
University of Pavia and works in publishing.